THE GEORGE GUND FOUNDATION
IMPRINT IN AFRICAN AMERICAN STUDIES

The George Gund Foundation has endowed
this imprint to advance understanding of
the history, culture, and current issues
of African Americans.

The publisher and the University of California Press Foundation gratefully acknowledge the generous support of the George Gund Foundation Imprint in African American Studies.

THE JEAN-MICHEL BASQUIAT READER

WRITINGS, INTERVIEWS, AND CRITICAL RESPONSES

THE DOCUMENTS OF TWENTIETH-CENTURY ART

JACK FLAM, GENERAL EDITOR

ROBERT MOTHERWELL, FOUNDING EDITOR

The Jean-Michel Basquiat Reader

Writings, Interviews,
and Critical Responses

EDITED BY **JORDANA MOORE SAGGESE**

UNIVERSITY OF CALIFORNIA PRESS

The publisher and the University of California Press
Foundation gratefully acknowledge the generous support
of the Dedalus Foundation in making this book possible.

University of California Press
Oakland, California

Cataloging-in-Publication Data is on file at the Library of
Congress.

ISBN 978-0-520-30515-1 (cloth : alk. paper)
ISBN 978-0-520-30516-8 (pbk. : alk. paper)

Manufactured in the United States of America

29 28 27 26 25 24 23 22 21 20
10 9 8 7 6 5 4 3 2 1

CONTENTS

ACKNOWLEDGMENTS

This project has benefited from the aid, support, and expertise of many individuals. Series editor Jack Flam has provided tireless support at every stage of this book since its inception, and his excitement for the project has sustained me throughout. My assistant, Lauren R. O'Connell, was invaluable throughout the process of securing images and permissions, always keeping the seemingly endless spreadsheets and documents in perfect alignment. Archna Patel at University of California Press has shepherded the book from acquisition to production with great aplomb. I am grateful to those who have read versions of the proposal and the manuscript, especially the members of my former writing group: Kim Anno, Nicole Archer, Paula Birnbaum, Irene Cheng, Tirza True Latimer, Rachel Schreiber, and Jennifer Shaw. Jessica Ingram was always there to problem solve along the way; I am lucky to know her. Dieter Buchhart was generous with his knowledge and experience, and I hope to pay that forward to the next generation of Basquiat scholars. Special acknowledgment is also due to Bruno Bischofberger for his collaboration. Although there are too many to list here, many artists, curators, galleries, and museums provided images, and I am grateful for their generosity. I must also thank all the authors, who granted permission to reprint their interviews and their essays—eventually. ;) This project would have been nearly impossible without the generous support of the librarians at the University of Maryland, as well as my colleagues in the Department of Art History and Archaeology and the College of Arts and Humanities, which provided a generous subvention grant toward this publication. I would like to thank the estate of Jean-Michel Basquiat, especially Lisane and Jeanine Basquiat, for trusting me with the artist's legacy. And finally, I thank my husband and three children for their humor, their patience, and their willingness to remind me on a daily basis what really matters in this life.

INTRODUCTION

JORDANA MOORE SAGGESE

On the evening of May 18, 2017, the seventh-floor salesroom at Sotheby's New York headquarters was packed. Following two blockbuster days of auctions, where the world's wealthiest investors had dropped more than $200 million on Impressionist and Modern Art sales, speculators had turned their attention to the fifty lots in the upcoming contemporary evening sale as a potential bellwether for the recovery of an art market that had seen declining value the two preceding years.[1] As noted by the cultural economist Clare McAndrew in her annual report on the global art market, published just two months before the May auction, the 2016 market had seen a significant decrease in global sales "due to a continued cooling of sales in certain sectors of the market." McAndrew found that in 2016 the US market, specifically, was 8 percent lower than in the ten previous years. "It has become harder to maintain growth," she noted, "particularly in a supply-limited market."[2] Despite this discouraging news, however, the excitement of buyers in the room that night was palpable.

Almost halfway through the proceedings, lot no. 24, an untitled painting of a skull by Jean-Michel Basquiat that had been unseen by the public for more than thirty years, came up to the auction stage. Despite the fact that Basquiat was the highest-grossing American artist at auction the previous year,[3] the starting bid of $57 million elicited gasps from the audience, who then excitedly watched a bidding war between two unseen bidders, represented by Sotheby's employee Yuki Terase and the art dealer Nicholas Maclean.[4] After ten minutes of back and forth, the bidding finally closed at $110.5 million. Just as the raucous applause died down, the Japanese billionaire Yusaku Maezawa, who had set a previous record with his purchase of a Basquiat painting for $57.3 million the previous year, revealed himself as the winning bidder in an Instagram post.

The sale of *Untitled* (1982), for a price that surprised even the auction house, set several new records: for a work by an American artist, for a work by an African American artist, and as the first work created after 1980 to fetch over $100 million. This historic moment solidified Basquiat's place in a pantheon of artists, which includes Francis Bacon, Pablo Picasso, and Basquiat's close friend and collaborator Andy Warhol.[5] In an interview for the *New York Times,* published the morning after the auction, the collector Larry Warsh characterized the record-breaking sale as "mind-blowing."[6] Art dealer Jeffrey Deitch proclaimed, "I remember astounding the art world back in [the] 1980s when I set an auction record for Basquiat at $99,000 . . . I always thought he would be one day in the league of Picasso, Bacon and Van Gogh. The work has that iconic quality. His appeal is real."[7]

Indeed, Jean-Michel Basquiat was nearly famous from the very start of his career. He entered the consciousness of the New York art world as a teenager. Collaborating with high school friends, Basquiat began to spray-paint aphorisms, slogans, and poetry along the walls and doorways of Lower Manhattan under the pseudonym SAMO©. SAMO (an abbreviation of "same old shit") had begun as the main character of a comic strip Basquiat and his friend Al Diaz had created at the alternative high school City-as-School, but by 1978 it had evolved into a collaborative art project between Basquiat, Diaz, and another classmate, Shannon Dawson. The motives and the authors of the SAMO© texts were unknown to the larger public, and many residents of Lower Manhattan, where their work frequently appeared, openly questioned its origins. In December 1978 an article in the *Village Voice* propelled the mystery, identifying Diaz and Basquiat only by their first names and publishing a (miscaptioned) photo that obscured Basquiat's face.[8] The initial confusion surrounding the identity of SAMO was complemented by the cryptic nature of the messages the young men painted. Elaborate poems and phrases, such as "SAMO© a pin drops like a pungent odor" exceeded the more common tags or images typically associated with graffiti. Many tags (such as "SAMO [. . .] as an alternative 2 playing art with the 'radical chic' sect on Daddy$ funds") seemed directed toward the increasingly consumerist culture of the 1980s, which saw the SoHo and Tribeca neighborhoods of Lower Manhattan suddenly transform industrial spaces into chic galleries and restaurants for an upscale clientele.

Basquiat's beginnings as SAMO were more often than not later misconstrued by critics, who promoted false associations with street culture and graffiti, even calling Basquiat homeless or a runaway, despite his middle-class upbringing in a Brooklyn brownstone. In other words, the work of Jean-Michel Basquiat was misinterpreted from the start, and throughout his lifetime the artist struggled to break free of his alignment with stereotypes of the untrained, primitive artist that had been forced onto other African American painters in the twentieth century. For example, press surrounding the African American painter Palmer Hayden (1890–1973) similarly foregrounded his status as an "outsider," emphasizing his work as a janitor in discussions of his artistic achievements, despite the fact that he had received his artistic training in Europe. A *New York Times* review of Hayden's prizewinning work in the 1926 exhibition sponsored by the Harmon Foundation is typical: "For years, Palmer C. Hayden, a negro, has been cleaning houses and washing windows to make a living, and during his spare time has gone back to his room at 29 Greenwich Avenue to dabble in oil colors and paint coast and river scenes which appealed to him."[9]

Nearly sixty years later, Basquiat received the same treatment. The very first line of a 1982 review published in *Artforum* claimed that Basquiat "comes, infamously by now, from a graffiti tradition (nom de spray: Samo)."[10] The critic Donald Kuspit described Basquiat's early work as "an original primitivism, with a graffiti heritage."[11] Throughout his career (and even after his death), the mythologies around Basquiat's graffiti origins, his lack of artistic training, and his "primitiveness" have continued.

While it may be convenient to extrapolate this early SAMO work into reading Basquiat as a graffiti artist—perhaps because he used spray paint and markers—the content and the site-specificity of the SAMO© writings proves otherwise. It was no accident that those writings appeared most often on the walls outside the art galleries in these new neighborhoods; Basquiat and Diaz were writing specifically to an art audience.[12] As even Keith Haring recalled, "the need for labels and explanations [in the eighties] lumped artists into groups that were easy for the media. Thus, Jean-Michel got labeled a graffiti artist. The entire misrepresentation and manipulation of this hypothetical 'group' is a perfect example of the art world of the early eighties."[13]

We might instead look at Basquiat's language-based works as part of the SAMO collective, and indeed throughout his career, in relationship to the work of the artist Jenny Holzer, who already in the late 1970s was installing text-based works around New York City. For Holzer's *Truisms* series (1977–79), for example, she created nearly three hundred statements—many based on common sayings and clichés—on posters that were wheat-pasted anonymously throughout Lower Manhattan. Holzer's next project, titled *Inflammatory Essays* (1979–82), comprised one hundred paragraphs printed on different-colored paper and installed in public spaces. As a frequent visitor to the Mudd Club and a member of the artist collective Colab (discussed below), Holzer certainly was in Basquiat's orbit, and a further exploration of the relationship between the two artists' works in the late 1970s is an opportunity for future scholarship.

Basquiat was never a graffiti artist. Period. Graffiti artists, many of whom Basquiat befriended through an association with Fab 5 Freddy, belonged to an entirely separate movement that included a tightly controlled network of hierarchies and apprenticeships. Also, in comparison to some of the images produced by graffiti artists, Basquiat's own production at this time was more like public poetry; the prophecies, the criticisms, and other cryptic messages were unlike the graffiti artist's "tag" (i.e., a stylized representation of one's street name).[14] Basquiat himself explained the problems of linking his early work with graffiti, stating in his last known interview: "My work has nothing to do with graffiti. It's painting, it always has been. I've always painted. Well before painting was in fashion."[15] Fab 5 Freddy further summed up the implicit racism in the alignment of Basquiat with graffiti, explaining that at one point in the 1980s, "graffiti had become another word for nigger."[16]

One could certainly argue that the initial reception of Basquiat's works (and the attendant mythologies that were circulated early on) was related to an obsession with the so-called "primitive." The now infamous photograph of the artist for the cover of the *New York Times Magazine* in 1985 (see page 352) shows Basquiat in his studio in bare feet and a paint-splattered, pinstriped Armani suit. The tribal mask propped on the easel teases at the artist's relationship to the "primitive"—both as a person of African descent and as an artist in the tradition of modernism, which is itself based on white culture imitating the works and habits of nonwhite culture. This photo was published just one month after the closing of the Museum of Modern Art's controversial

exhibition *"Primitivism" in 20th Century Art: Affinities of the Tribal and the Modern* (September 27, 1984–January 15, 1985). The exhibition, which Basquiat visited both in New York and in Dallas,[17] was based on formalist comparisons between Western and non-Western objects, and many critics claimed that it not only rehearsed a very limited understanding of tribal objects but also reinforced the racist hierarchies of East/West. None of the so-called "primitive" objects in the show were displayed with information on the artist or the original context of the work. Critic Thomas McEvilley asserted that MoMA's exhibition simply repeated an outdated, formalist hierarchy that placed Western art, even those examples that obviously drew upon African precedents, as superior.[18] James Clifford, taking issue with the word "tribal," wrote in 1985 that the MoMA exhibition (and perhaps the art world in general) had failed to question the limits of modernism's unselfconscious appropriation of otherness.[19] The show at MoMA was part of a larger trend of primitive art shows[20] taking place in New York at this time and, by extension, an aspect of the dominant thinking with regard to white supremacy.[21]

Throughout his life, Basquiat maintained an ambivalent relationship to this primitive mythology. Basquiat's *Untitled (Picasso Poster)* from 1983 highlights the complex relationship between primitivism and European modernism (plate 14). The artist's strokes in pink acrylic, brushed onto the surface of the poster, are most emphatic in the upper right corner of Picasso's image. Here Basquiat flattens the curve of the figure's hairline with one long horizontal mark at the top, following the contour down and alongside the left side of the face. The resulting shape, which Basquiat has isolated from the background of Picasso's original image, looks more like a mask than a face and further accentuates Picasso's well-known appropriations of African art. As a person of African descent, frequently plagued by myths of primitivism, Basquiat was surely invested in the irony of a modern art history that systematically excludes artists of African descent while remaining indebted to them.

But what if we were to look differently at Basquiat's SAMO works—not as graffiti or as evidence of some sort of primitive impulse, but instead as part of the artist's larger interests in language, which continued throughout his career? What if we were to consider the SAMO works in dialogue with the artist's text-based drawings and paintings, or alongside the poetry culled from his notebooks? After all, in the late 1970s and the 1980s, text was the preferred medium for many artists who, like Basquiat, turned to language as the primary vehicle for their work. One motivation for this *Basquiat Reader* is to reframe the earliest responses to the artist's work and to reconsider their impact on his lasting critical reception. By looking anew (and collectively) at these documents, we can see how early myths were established, how Basquiat himself cultivated an ambivalent relationship to them, and how they continue to impact our understanding of the artist.

Although Basquiat has frequently been positioned by critics as "untrained," we might instead consider him as "self-taught." As a child growing up in Brooklyn, New York, Jean-Michel Basquiat frequented the museums and galleries of his surround-

ing neighborhood and made drawings on the office paper his accountant father, Gerard, brought home. He grew up listening to Gerard's collection of jazz and classical records, speaking Spanish with his mother, Matilde, and making cartoonlike drawings from comic books, Hitchcock films, and *Mad* magazine. Basquiat was hit by a car while playing ball in the street when he was just seven years old; his spleen had to be removed, and he was hospitalized for nearly a month. His mother brought him a copy of the medical textbook *Gray's Anatomy*, which showed the young artist the inner workings of the body in great detail; it would become a favorite source throughout his life.

In an untitled drawing from 1983 (see page 344), Basquiat also highlighted his early engagement with contemporary politics, writing under the category of "EARLY THEMES": "NIXON," "WARS," "WEAPONS." He also notes that he "SENT A DRAWING OF A GUN TO J. EDGAR HOOVER IN THIRD GRADE." The time of Basquiat's childhood was, in fact, a period of sweeping political unrest—on both the national and the local levels. In 1968 Black* radical protest gained an international audience when two members of the US track team (Tommie Smith and John Carlos) raised gloved Black fists in response to the playing of the national anthem after their victory at the Summer Olympics in Mexico City. In 1969—the year that Basquiat would have been in the third grade—Black Panther party leaders Fred Hampton and Mark Clark were killed by police during a raid in Chicago. Closer to home, in the 1960s New York City underwent a significant transition, from a city divided by religion (i.e., Catholics and Jews) to one divided by race and ethnicity.[22] The Immigration and Nationality Act of 1965, which eliminated the numerical limitations placed on immigrants from non-European countries, allowed increasing numbers of migrants from Africa and Asia to enter the United States. Although we typically think of the city as a "melting pot," open to new groups and with unimpeded access to opportunities for all residents, New York in reality was quite different. In the words of J. Faith Almiron, "the growing presence of a new Black, brown, and Asian labor force pushed up against white sovereignty in American's urban neighborhoods. Contrary to white flight, many white people stayed in the 'hood. They fiercely guarded their property and all that came with it, including the taxes to influence school districting."[23] There was a marked increase in violence against immigrants of color. The Brooklyn of Basquiat's youth was slowly moving from complacency to militancy as the Black intelligentsia (including the Nation of Islam) began to shape an environment of increased activism in response to these new conditions.

All these early influences—from both art and life—provided source material for Basquiat's artistic practice, and he continued his informal education throughout his

* Throughout this text I have capitalized *Black* and *Blackness* when in reference to race. Because the capitalization of these terms is becoming more widely accepted (e.g., institutions like the *New York Times* and the Associated Press have recently changed their style guidelines to capitalize *Black*), I have also reformatted previously published texts within this volume to capitalize *Black* and *Blackness*. This provides consistency throughout the text, but more importantly it recognizes the shared culture and history of peoples of the African diaspora—an explicit theme, to be sure, in the work of Jean-Michel Basquiat.

short life. Basquiat explored the Roman galleries of the Metropolitan Museum of Art and was deeply familiar with artists like Robert Rauschenberg and Marcel Duchamp. We also see the constant citation and appropriation of historical masters—Edgar Degas, Pablo Picasso, and Leonardo da Vinci—across numerous paintings and drawings. Basquiat was a close friend and collaborator of Andy Warhol. But he was equally invested in the radical potential of art. Slavery, oppression, and exploitation are constant themes. Black figures appear in these paintings as prisoners, servants, cooks, janitors, slaves, and sports heroes. Recent scholarship has continued to explore the social dimension of Basquiat's practice, particularly regarding the theme of violence against Black bodies.[24] Throughout his career, Basquiat demonstrated that he was keenly aware of his place in both the history of art and that of Black people.

Although he had been working downtown as part of the collaborative SAMO since 1978, Basquiat officially arrived on the art scene in the summer of 1980, as one of approximately one hundred artists exhibiting at the 1980 *Times Square Show,* in New York City. Basquiat covered the walls in the fourth-floor fashion lounge and a section of the stairwell with a combination of spray paint and loose brushwork, signing everything under the name SAMO. Art dealer Jeffrey Deitch specifically called out Basquiat's contributions to the group exhibition, characterizing these wall paintings as "a knockout combination of de Kooning and subway scribbles."[25] Less than a year later, Basquiat sold works to the major collector Christophe de Menil and to Henry Geldzahler, formerly curator of twentieth-century art at the Metropolitan Museum, and then the commissioner of cultural affairs for New York City. By 1982, at the age of twenty-one, Basquiat had been given solo exhibitions in galleries in Italy, New York, and Los Angeles. He was represented by the international art dealer Bruno Bischofberger, who introduced the young artist to his most famous client: Andy Warhol.

Basquiat's artistic career followed the rapid trajectory of Wall Street, which boomed during the mid-1980s. His work appeared in *GQ* and *Esquire,* he was interviewed for the new music television cable network MTV, and he walked in a Comme des Garçons fashion show. In 1985 Basquiat appeared on the cover of the *New York Times* magazine alongside the headline: "New Art, New Money: The Marketing of an American Artist." Just five years after his first public exhibition, this Black boy from Brooklyn had become one of the most famous American artists alive. And Basquiat's meteoric rise to fame was rivaled only by the quick ascent of the prices paid for his works.

As a consequence of Basquiat's celebrity and financial success, contemporary historians and critics tended to underestimate his significance during his lifetime. Critics from the period expressed fear that the marketplace had become *too* influential, usurping the role formerly played by critics and historians in establishing the critical reception (and value) of art and artists. Collectors who tried to donate Basquiat's work to major New York museums during the artist's lifetime were rejected. After he died, in 1988, there were echoes of lament in the obituaries, many of which are republished in the fifth section of this book, "The Afterlife of Jean-Michel Bas-

quiat," as critics realized too late the gravity of what had been lost. In an essay published less than three weeks after Basquiat's death, Peter Schjeldahl implored readers to think again about the significance of the artist's work, even calling for a retrospective exhibition for the artist, "which the art culture took up and then dropped so quickly and thoughtlessly."[26] It would be another four years until Basquiat would receive his first large-scale museum retrospective in the United States, at the Whitney Museum of American Art. On the occasion of that exhibition, in 1992, curator Richard Marshall proclaimed: "Jean-Michel Basquiat first became famous for his art, then he became famous for being famous, then he became famous for being infamous—a succession of reputations that often overshadowed the seriousness and significance of the art he produced."[27]

Yet, in the more than thirty years since his death, Basquiat's popularity has continued to grow exponentially—along with the prices paid for his art. In part because of his reputation as an enfant terrible, the sensational story of this young artist has cemented him into our public consciousness. As the world of pop culture and mass media has come to usurp the traditional processes of art historical canonization— think, for example, of the rapid circulation of images and ideas via social media—the line between popular and critical culture has become increasingly porous. The reputation of Jean-Michel Basquiat exists within this expanded reality, where canonization is not performed by singular critical voices; rather, it is a popularized process in which the media and popular culture play a role.

Basquiat's "mind-blowing" performance at auction in 2017 is, in fact, evidence of the artist's increasing relevance to contemporary art. We can see further proof in the number of large-scale retrospective exhibitions mounted in international venues— Basel, Paris, Frankfurt, Rio de Janeiro, London, Melbourne, Montreal, New York, Tokyo, Toronto—in the last decade alone. These shows bring in record-breaking numbers of visitors. For example, the *Basquiat: Boom for Real* exhibition, which debuted at the Barbican Centre in London in 2017 before traveling to Frankfurt in 2018, was viewed by an estimated 250,000 visitors—that is, 250 percent of the museum's original predictions.[28] More recently, in the spring of 2019, the Brant Foundation Art Study Center opened its new space in New York's East Village with a Basquiat exhibition, and the 50,000 free passes were completely distributed before the opening day.[29]

But the reasons we should study Basquiat do not lie simply in fame or market value. As I have written in a previous book on the artist, *Reading Basquiat: Exploring Ambivalence in American Art,* the work of Jean-Michel Basquiat is critically important to our understanding of the history of American art. This is an artist who probed the boundaries of Blackness before the term "post-Black" became current, as a way of describing sources and ideas from Africa, the Americas, and the spaces between.[30] His tendency to copy—from modern masters, as well as from his own drawings— was an attempt to rewrite the canon of art history, placing his own work in dialogue with other Black artists (Romare Bearden, Bob Thompson) who similarly attempted a revisionist history. Basquiat's reliance on the appropriation of existing works, a

technique better understood from the perspective of musicology than of art history, calls into question the rhetoric of spontaneity and originality that is so often applied to painting of the late twentieth century. Basquiat's use of language throughout his career complicates the legacies of Conceptualism and Expressionism—two polarities of 1980s art criticism. Moving outside the visual tradition, Basquiat built upon the processes and innovations of Beat writers such as William S. Burroughs and Jack Kerouac, just as he did with the appropriations and improvisations of bebop, in order to develop a practice that was simultaneously expressive and conceptual. Basquiat's interdisciplinary embrace of language, painting, and music forces a reconsideration of the limits of the discipline of art history itself.

As one of the most successful, popular, *and* critically important artists of the late twentieth century, Jean-Michel Basquiat's impact on contemporary art only continues to grow. But until now, the sustained study of this artist been inhibited by the lack of a dedicated public archive, as well as access to specific works. The overwhelming majority of the artist's output is still held by private collectors rather than public institutions. Most extant scholarship exists in the form of exhibition catalogues with limited circulation, while what remains of the artist's personal records and papers is divided between private collections and the artist's estate. This book, through a combination of writings by and interviews with the artist, hard-to-find critical articles, and previously unpublished research, provides a full picture of the artist's views on art and culture, and of his working process, as well as an overview of the critical significance of his work both during his lifetime and after his death.

The first section, "Jean-Michel Basquiat in His Own Words," is a collection of interviews with the artist. Although Basquiat did not frequently give interviews, the ones that remain offer rare glimpses of his views on art and culture, as well as a critical perspective on his own success.

Section two, "Basquiat's Language," includes writings by the artist and addresses his concern with language throughout his career. While establishing a comprehensive chronology of Basquiat's use of text remains difficult, this section includes a selection of writings—a combination of poetry, lists, and prose—excerpted directly from the artist's notebooks. Rather than scanning these texts directly as facsimiles, Basquiat's texts are presented in transcription, set in type. In removing the hand of the artist, we might more easily recognize these as written texts per se—another significant creative outlet for the artist. Shortly before his death, Basquiat even told several people that he wanted to give up painting to become a writer.[31] (Nevertheless, the artist's relationship to text has to date been only superficially explored. I can only hope that some future scholar will dig deeper into these texts, which were a constant preoccupation for the artist until the very end.)

The third section, "Contemporary Criticism and Commentary," is a collection of critical writing on Basquiat during his lifetime, beginning with his emergence in the downtown art scene in the late 1970s and running into the late 1980s. These primary documents provide a view into New York's downtown art scene as well as a first-

hand account of the early reception of the artist. We find critics struggling to inter-pret (and perhaps even to categorize) the artist's prolific output, sometimes getting lost in the artist's celebrity. We also find here the source of many of the early myths regarding Basquiat—as a street urchin, as a "Black Picasso"—that continue to reverberate today.

The fourth section, "Knowing Basquiat," includes my own interviews with close friends and collaborators of Jean-Michel Basquiat, who offer insights about the artist during his lifetime. Interviews with Basquiat's bandmate Michael Holman, his girl-friend Suzanne Mallouk, art historian Robert Farris Thompson, and gallerist Bruno Bischofberger were conducted while I was writing my scholarly monograph, *Reading Basquiat: Exploring Ambivalence in American Art.* These have been supplemented by interviews that I conducted more recently with curators Diego Cortez and Dieter Buchhart, as well as with the dancer Erika Belle. Both Cortez and Belle were friends with the artist and part of the same downtown New York scene. These interviews offer a distinct view of the artist's career, working process, and experience in the art world, and they provide insights and information that cannot be found in any public archive. As we move further into the twenty-first century and further away from the artist's early death, it is imperative that these voices and perspectives be preserved.

The fifth section, "The Afterlife of Jean-Michel Basquiat," begins with several memorial essays published after Basquiat's death in 1988 and includes nine of the most significant, scholarly essays published on the artist to date—many of them now out of print.

This volume concludes with an updated and comprehensive chronology, in which I have attempted to provide an overview of the artist's life and career that connects to his larger social, political, and artistic contexts—both locally and globally. In the chronology, as throughout the book, I am less concerned with the personality of the artist than with his critical position within the art world. More than a rehearsal of facts, this chronology provides a narrative of Basquiat's artistic life, his self-fashioning and cultivation of a public image, and his reception.

In bringing all these materials together, *The Jean-Michel Basquiat Reader* gives readers a sense of the artist's life and work, and also a broader view of his critical position within the landscape of contemporary art. It is my hope that this volume will provide all audiences with a greater insight into Jean-Michel Basquiat and his artis-tic legacy.

Notes

1. Sotheby's two Impressionist and Modern Art sales held on May 16–17 netted $173,840,000 and $40,876,125, respectively. In 2015 the global art market saw a decline of 7 percent with total sales coming in at $63.8 billion. In 2016 the global art market achieved total sales of art and antiques of roughly $56.6 billion—a decline of 11 percent over 2015. The Modern art sector fell by 43 percent in 2016 to $2.6 billion in value. See Clare McAndrew, *TEFAF Art Market Report 2016* (Dublin: Arts Economics, 2016) and *The Art Market / 2017* (an Art Basel and UBS report).

2. McAndrew, *TEFAF Art Market Report 2016.*

3. In 2016 Basquiat sales reached $171.5 million (for eighty works sold that year). See Robin Pogrebin and Scott Reyburn, "How Basquiat Became the $60 Million Dollar Man," *New York Times*, May 17, 2017, https://www.nytimes.com/2017/05/17/arts/design/jean-michel-basquiat-sothebys-auction.html; and Robin Pogrebin and Scott Reyburn, "A Basquiat Sells for 'Mind-Blowing' $110.5 Million at Auction," *New York Times*, May 18, 2017, https://www.nytimes.com/2017/05/18/arts/jean-michel-basquiat-painting-is-sold-for-110-million-at-auction.html?module = inline.

4. In January 2018 Terase was appointed Sotheby's head of contemporary art in Asia.

5. Basquiat's *Untitled* in fact exceeded Warhol's own highest sale on record: $105.4 million for *Silver Car Crash (Double Disaster) (in 2 Parts)*, which sold in 2013.

6. Pogrebin and Reyburn, "Basquiat Sells for 'Mind-Blowing' $110.5 Million."

7. See Katya Kazakina, "$110 Million Basquiat Sold by Family Who Bought It for $19,000," *Bloomberg*, May 18, 2017, https://www.bloomberg.com/news/articles/2017-05-19/basquiat-portrait-soars-to-record-110-million-at-sotheby-s.

8. This article identified only Diaz and Basquiat; Shannon Dawson was not named, although some agree that Dawson was an initial participant in the SAMO group. A fuller discussion of SAMO can be found in the chronology of this book. See also Henry A. Flynt Jr., "Viewing SAMO© 1978–1979," accessed December 12, 2018, http://www.henryflynt.org/overviews/Samo/viewingsamo.pdf; and Al Diaz, *SAMO © . . . Since 1978: SAMO © . . . Writings: 1978–2018*, ed. Mariah Fox (Santa Fe, NM: Irie Books, 2018).

9. "Negro Artist Wins Prize for Paintings," *New York Times*, December 8, 1926, 11. Cited in John Ott, "Labored Stereotypes: Palmer Hayden's *The Janitor Who Paints*," *American Art* 22, no. 1 (Spring 2008): 104.

10. Jeanne Silverthorne, "Jean-Michel Basquiat, Annina Nosei Gallery," *Artforum* (Summer 1982): 82.

11. Donald Kuspit, cited in Ellen Lubell, "New Kid on the (Auction) Block," *Village Voice*, May 29, 1984, 45. See this essay in its entirety on page 115.

12. Al Diaz was something of a graffiti veteran, having had his own tag published in the 1974 book *The Faith of Graffiti*, which featured an essay by Norman Mailer paired with the photographs of Jon Naar. The publication was reissued in 2009 by It Books.

13. Keith Haring, "Remembering Basquiat," *Vogue*, November 1988, 230. Reprinted in *Basquiat* (New York: Tony Shafrazi Gallery, 1999), 57.

14. For a more thorough analysis of Basquiat's writings and their role in his mature works, see Jordana Moore Saggese, *Reading Basquiat: Exploring Ambivalence in American Art* (Berkeley: University of California Press, 2014), 109–46.

15. Jean-Michel Basquiat, interview by Démosthènes Davvetas, *New Art International* (Lugano), no. 3 (October–November 1988): 10–15. See page 61 of this volume.

16. Brathwaite, quoted by Anthony Haden-Guest, "Burning Out," *Vanity Fair*, November 1988, 190.

17. Basquiat visited the installation at the Dallas Museum of Art with Jennifer Goode at the invitation of collector and socialite Marcia May. See Lotte Johnson, "Chronology," in *Basquiat: Boom for Real*, exh. cat. (London: Barbican Centre, 2017), 275.

18. Thomas McEvilley, "Head It's Form, Tails It's Not Content," *Artforum* 21, no. 3, November 1982, 50–61. For other key critiques of the MoMA exhibition, see Thomas McEvilley, "Doctor, Lawyer, Indian Chief: 'Primitivism' in Twentieth-Century Art at the Museum of Modern Art in 1984," *Artforum* 23, no. 3, November 1984, 54–61; James Clifford, "Histories of the Tribal and the Modern," *Art in America* 73, April 1985, 164–77, 215; and Hal Foster, "The 'Primitive' Unconscious of Modern Art, or White Skin Black Masks," *October* 34 (Fall 1985): 45–70.

19. James Clifford, "Histories of the Tribal and the Modern," in *The Predicament of Culture: Twentieth-Century Ethnography, Literature, and Art* (Cambridge, MA: Harvard University Press, 1988), 193.

20. Aside from the MoMA exhibition that fall, there were exhibitions of Maori sculpture at the Metropolitan Museum of Art, Asante art at the American Museum of Natural History, and Northwest

Coast Indian art at the I.B.M. Gallery; and a new museum, the Center for African Art, opened in September 1984.

21. See Douglas C. McGill, "What Does Modern Art Owe to the Primitives?," *New York Times,* September 23, 1984, https://www.nytimes.com/1984/09/23/arts/what-does-modern-art-owe-to-the-primitives.html.

22. American sociologists Nathan Glazer and Daniel Patrick Moynihan published their intensive study of New York's ethnic groups in 1963. It was subsequently revised and issued in a second edition in 1970. Nathan Glazer and Daniel Patrick Moynihan, *Beyond the Melting Pot: The Negroes, Puerto Ricans, Jews, Italians, and Irish of New York City,* 2nd ed. (Cambridge, MA: MIT Press, 1970).

23. J. Faith Almiron, "The Art of Basquiat Belongs to the People," *Basquiat's Defacement: The Untold Story,* exh. cat. (New York: Solomon R. Guggenheim Museum, 2019), 54.

24. This is mentioned in some of the earliest scholarship on Basquiat, including essays by Greg Tate and bell hooks published in this volume. A 2019 exhibition at the Guggenheim, curated by Chaédria Labouvier, was also organized on this theme. See *Basquiat's Defacement: The Untold Story,* exh. cat. (New York: Solomon R. Guggenheim Museum, 2019).

25. Jeffrey Deitch, "Report from Times Square," *Art in America* 68 (September 1980): 61.

26. Peter Schjeldahl, "Martyr without a Cause," *7 Days,* September 1, 1988, 54. See section 5 of this volume. In 1989 the Kestner Gesellschaft, in Hanover, dedicated an exhibition to Basquiat's graphic oeuvre. The first retrospective exhibition of his work was shown in 1992 at the Musée Cantini, Marseille. Thank you to Bruno Bischofberger for pointing this out to me.

27. Richard Marshall, "Repelling Ghosts," in *Jean-Michel Basquiat,* ed. Richard Marshall (New York: Whitney Museum of American Art, 1992), 15. The Whitney exhibition later traveled to the Menil Collection, Houston; the Des Moines Art Center, Iowa; and the Montgomery Museum of Fine Arts, Alabama. From then on, established museums and galleries all over the world organized one-man exhibitions dedicated to the artist.

28. Thank you to Thomas Kennedy at the Barbican Centre for providing this statistic. For further reference, the Basquiat retrospective at the Musée d'Art Moderne de la Ville de Paris in 2010 drew 360,000 visitors—a record for that institution at the time.

29. *Jean-Michel Basquiat* was on view March 6–May 15, 2019. Due to high demand, the Brant Foundation released an additional block of tickets in early April and expanded its capacity from 1,100 to 2,000 visitors per day.

30. See Thelma Golden's essay "Post . . . " in *Freestyle,* exh. cat. (New York: Studio Museum in Harlem, 2001), 14–15.

31. The photographer recalled that when he met Basquiat in 1988, the artist "wanted to stop everything, even painting, and go to Los Angeles, to get away from the East Coast, to start writing." Jérôme Schlomoff, email to the author, December 3, 2007. Kelle Inman also recalled that in a phone call from Hawaii in the summer of 1988, just months before his death, Basquiat told her that "he was giving up painting, he was going to be a writer." See Haden-Guest, "Burning Out," 196.

Between his emergence onto the downtown art scene in 1978 and his death a dec-
ade afterward, Jean-Michel Basquiat did not give many interviews. Whether this
was due to a lack of critical interest during his lifetime, his discomfort with the
interview process, or his short career, the spoken words that Basquiat left behind
are few. What we do have preserved are these seven interviews, published together
here for the first time. These interviews cover a period of five years, starting with an
interview with the young art historian and curator Marc H. Miller in 1982 and ending
with a short interview conducted by Démosthènes Davvetas, now a professor of
aesthetics; this was finished just months before the artist's unexpected death in
1988 (and published posthumously).

Reading the interviews against one another and in chronological order gives
readers a view of the artist's growing mastery of his own narrative, and also of the
motivations of the various interviewers. Many of the interlocutors seem woefully
underprepared for Basquiat's biting retorts to what must have been by then repeti-
tive questions about his upbringing, his inspirations, and his reputation as a "graffiti
artist."[1] In some cases, the young artist was a hostile subject, provoking and mock-
ing his interviewer's questions or attitudes about his works. In one of the more
famous examples, produced by the video magazine *ART/New York,* Basquiat chal-
lenges the awkward prompts of Marc H. Miller, such as "Where do you get the words
from?"[2] When Miller asks Basquiat to identify the iconography of one large canvas,
Notary (1983), the artist at first humors Miller by pointing out Roman belt buckles
and the like. But soon growing tired of Miller's line of questioning, Basquiat eventu-
ally asks his interviewer: "Would you ask [Robert] Rauschenberg [these ques-
tions]?" When Miller asked about Basquiat's time spent painting in the basement of
Annina Nosei Gallery, Basquiat quickly retorted, "If I was a white artist, they would
say I'm an artist in residence." In perhaps the most famous exchange in this video
interview, Miller rehearses the readings of contemporary critics, who have written
of Basquiat's approach to painting as "some sort of primal expressionism." Bas-
quiat immediately asks: "Like an ape? Like a primate?" As Miller, realizing the
greater significance of this characterization in real time, stammers, "I don't know,"
Basquiat refuses to back down, persisting, "You said it. You said it."

We can see the same sharp wit (and frustration) surface in Basquiat's interviews
with Lisa Licitra Ponti and Isabelle Graw. Speaking with Ponti in the fall of 1983 in
Milan, where the artist had traveled with his new friend Andy Warhol, Basquiat
offered laconic responses no longer than a few words. We see the same resistance
in Graw's interview three years later, which begins with open hostility. After she

asks the twenty-five-year-old artist to explain his absence from the opening of his museum survey at the Kestner Gesellschaft in Hanover and he apologizes, Graw continues to bait him, saying that his lack of attendance "did everyone a favor." Miraculously, Basquiat still sits for the interview, saying, "Let's just talk and get it over with."

While not as fraught as these more sensational examples, the remaining interviews reproduced in this volume still reveal Basquiat's awareness of his role in constructing his own legacy. In his conversation with Sandy Nairne and Geoff Dunlop for the British series *State of the Art* in October 1985, Basquiat speaks incisively and honestly, rebuffing attempts to know more about his childhood or characterizations of himself as an angry Black man. Basquiat repeatedly attempts to steer the conversation away from his personality and toward the work. Reading this, we are reminded of another interview with the artist from the same year, conducted by friends Tamra Davis and Becky Johnston in California. In that interview, Johnston asks, "What were you like as a kid?" One can almost hear the cringe in Basquiat's reply: "Here we're going now, it's going to be terrible now. [. . .] What was I like as a kid? See? I hate this."[3] He later complains that reviews of his paintings and drawings focus more on his personality than on the work itself, at times exaggerating the facts of Basquiat's life for dramatic effect. "They're just racist, most of these people. [. . .] They went and said my father was [an] accountant for a fast-food chain. And they talk about graffiti endlessly, which I don't consider myself to be a graffiti artist, you know? So they have this image of me: wild man running—you know, wild monkey man, whatever the fuck they think."[4] Throughout his interviews, Basquiat demonstrates a persistent awareness of the stereotypes surrounding him and his work. We also see him become increasingly wary of labels like *graffiti;* whereas he accepts the classification in his interview with Geldzahler in 1983, even naming particular trains that he painted (this remains unconfirmed), we see that by 1985 he has changed course. By the time of his last known interview, with Démosthènes Davvetas, he exclaims: "My work was nothing to do with graffiti. It's painting, it always has been."

A major theme of this book is the reconsideration of Basquiat's grossly underestimated contribution to the history of American art, rather than getting lost in the early mythologies that were attached to him: as a graffiti artist, street kid, or enfant terrible. We can read every invocation of Cy Twombly, Robert Rauschenberg, and Andy Warhol as Basquiat's assertion of his rightful place within this history. For example, in his interview with Henry Geldzahler, the Metropolitan Museum of Art's curator of twentieth-century art from 1967 to 1978, Basquiat discusses his admiration of the abstract expressionist painter Franz Kline and of Cy Twombly's 1975 large-scale collage *Apollo and the Artist*. In later interviews, such as that with Démosthènes Davvetas, Basquiat's points of reference expand; he cites the American artists Robert Rauschenberg, Jasper Johns, and Andy Warhol as well as Europeans such as Leonardo da Vinci, Titian, Francesco Clemente, and Enzo Cucchi.

Interestingly enough, Basquiat's attempts to situate himself within a history of Western art were not always a solo endeavor. Several early critics of the artist's work also compared it to European modernism and American abstraction. Rene Ricard claimed Basquiat as the forsaken child of Cy Twombly and Jean Dubuffet.[5] In one of the very first reviews of a solo exhibition of Basquiat's work at Annina Nosei Gallery in 1982, Lisa Liebmann wrote that "the speed lines and notations bear some relation to automatic drawing."[6] The admiration for earlier artists who inspired him that Basquiat expresses in these interviews, and which was recognized by these early critics, is further reinforced by the artist's direct appropriation of these modern masters.

But something is missing here as well. We must pay close attention to the fact that the content of Basquiat's paintings and drawings operates outside of this Eurocentric frame; we see the horrors of colonization, unmistakably Black bodies, and the reality of their commodification. In the words of bell hooks, "to see and understand these paintings, one must be willing to accept the tragic dimensions of Black life."[7] So why, then, do none of these interviewers mention Basquiat's Blackness, outside of the primitivist mythologies surrounding his move from the street to the studio? Why does Basquiat focus exclusively on naming white artists as his primary influences? These are unanswerable questions, but questions that I want to highlight here nonetheless. Maybe it would have been different if any of the people interviewing Basquiat were a person of color, or if the history of African American art was not in an early stage of being written at this time. All we can know now is that whether combative or contemplative, Basquiat's interviews offer a unique opportunity to hear the artist speaking about his own subjects, styles, and influences. These encounters make clear Basquiat's desire to be taken seriously as an artist, despite the stereotypes that may have plagued him and in spite of the lack of serious critical engagement with his work during his lifetime.

Notes

1. See the introduction to this volume for a more complete discussion of Basquiat's relationship to graffiti.

2. Portions of this interview with Basquiat were originally released in 1983 as part of a video titled *Young Expressionists*, which also featured artists Julian Schnabel and Francesco Clemente. The complete interview was released in 1988, also by ART/New York, as *Basquiat: An Interview*, and is transcribed in this volume on pages 17–31.

3. Jean-Michel Basquiat, "I Have to Have Some Source Material around Me," interview by Becky Johnston and Tamra Davis, Beverly Hills, California, 1985, in *Basquiat,* exh. cat. (Basel: Beyeler Foundation, 2010), xxii. See page 49 of this volume.

4. Basquiat, "Source Material."

5. Rene Ricard, "The Radiant Child," *Artforum* 20 (December 1981): 43. See also page 97 of this volume.

6. Lisa Liebmann, "Jean-Michel Basquiat at Annina Nosei," *Art in America* 70 (October 1982): 100. See also page 111 of this volume.

7. bell hooks, "Altars of Sacrifice: Re-membering Basquiat," in *Art in America* 81, no. 6 (June 1993): 68–75. See pages 253–262 of this volume for a reprint of hooks's essay.

INTERVIEW BY MARC H. MILLER

NEW YORK CITY, 1982

[As the interview begins, Basquiat and Miller are seated in the artist's Crosby Street studio. We can see the painting *Lodge* propped against a wall behind the two men.]

MARC MILLER: You were just saying before that you were tired of being the angry young man, or the angry young artist.

JEAN-MICHEL BASQUIAT: Oh.

MM: Is that a myth that is being perpetuated about you?

JMB: Yeah, that was something that I said two minutes ago.

MM: Yeah. [*Laughs.*] OK. We will go back to that. You stopped doing works in the street—that was something that you did a number of years ago?

JMB: That was a really, really long time ago. That was with some friends from high school and some other kids. We used to drink Ballantine Ale all the time, and just write stuff on the walls, and throw bottles, and [I] grabbed a wig off a lady who works in the transit system because she took my bus pass from me one day. You know. Just teenage stuff.

MM: There was no ambition in your . . .

JMB: No, there was really no ambition in it at all.

MM: You were working under the name of SAMO?

JMB: SAMO [same-oh].

MM: SAMO [same-oh]?

JMB: Yeah.

MM: And the works that were signed SAMO were done by you and by other people you were with?

JMB: No, no, it was me and Al Diaz.

MM: What were some of the things that you used to write down?

JMB: It would be too embarrassing to bring it up now. It was stuff from a young mind.

MM: And then the next thing I saw in the streets was mostly drawings that you were doing.

"Basquiat: An Interview," recorded for *ART/New York*, 34 minutes, © 1989 by Inner-Tube Video. Transcribed by Lauren R. O'Connell and Jordana Moore Saggese.

JMB: I did a couple of those, and then I got stopped by the cops more often. I guess I was getting taller and older, so it seemed like a waste of time by that point. I mean, I really didn't want to do it.

MM: So then you started working on canvas?

JMB: Yeah, more or less.

MM: How'd you make that transition? Is that something that you've always wanted to do or something that just sort of happened?

[*TV plays cartoon sounds.*]

JMB: [*Long pause.*] It just sort of happened. I just didn't want more drawings up to a certain point.

MM: And at this point you had ambitions for an art career, I'll put it that way, or that just sort of happened?

JMB: I don't remember. [*Laughter.*]

MM: I remember the first time I saw your works on canvas was at the PS1 show.

JMB: Yeah, right.

MM: Were those done especially for the show?

JMB: No, they were just done. But they weren't done for any reason or anything.

MM: How do you work? Do you just start with a blank canvas and just start painting?

JMB: Well, lately I've been taking these paintings that are older and some that I thought were less successful and cropping them to four-foot by three-foot squares, and then hinging them into these long, kind of comic strip–looking things.

MM: But when you paint them, are you coming from sketches or are you just spontaneously working on them?

JMB: Sketches, gluing paper down onto the canvases. I don't know. It's usually something to do with that day or . . .

MM: The images?

JMB: Sometimes, yeah.

MM: Are you quick? How quick do these things get done?

JMB: How quick? [*Laughs.*]

MM: Yeah.

JMB: It depends.

MM: From . . .

JMB: Approximately?

MM: Just a normal canvas, four feet by six feet, or something like that. What is that—a day's work? Then, pulled out again and reworked or something?

JMB: Yeah, usually like that. I usually put a lot down and then I take a lot away, and then I put some more down and take some more away. It's a constant editing process usually.

MM: What's determining what stays and what goes . . .

JMB: What determines? Me.

MM: You? And it's just intuitive?

JMB: Mostly. I take suggestions too. [*Laughs.*]

MM: People come in and say, "Scratch that." [*Laughs.*]

JMB: No, no, no, no. I mean, I work with some people. There may be something that my people are going to bring in on their own. Or I'll just ask somebody. It's about the same . . . Well, it's hard to say, it's not really one way.

MM: And one of the most conspicuous things in your works is the way things are crossed out. You must like the way they look crossed out.

JMB: Sometimes I just want to retract it. It might stick out a little too much—the words. So a line blends it into the rest of the painting at times.

MM: Are you surprised at your success?

JMB: Surprised? Hmm. I used to be more surprised.

MM: You used to be more, now you're spoiled. [*Laughs.*]

JMB: What? I wouldn't say I was spoiled.

MM: What do people like in your work?

JMB: Got me.

MM: I think that people are classifying you as an Expressionist.

JMB: An Expressionist? That happened a long time ago, didn't it?

MM: Expressionism? Well, there is a new Expressionism.

JMB: Oh, Expressionism. Well . . . art should be expressive. Of something or other.

MM: And you're seen as some sort of primal Expressionism?

JMB: [*Laughs.*] Like an ape?

MM: Well, it's . . .

JMB: A primate? [*Laughs*]

MM: Well, I don't know.

JMB: You said it. You said it.

MM: Well, OK, uh, uh, your art schooling is . . .

JMB: Oh, I've had none.

MM: You've had none?

JMB: I tried to get into Parsons. A couple of years ago I had no money for rent or anything. Someone told me that if you went to art school that they would pay your

outside life too. So I looked into this . . . But it never really happened. I'm kind of grateful.

MM: That you didn't . . .

JMB: You start working on illustration board and stuff, I guess, when you get to school. And you erase all the time. And if your art is really good, then you wouldn't be teaching.

MM: I don't know . . . I never went to art school so . . .

JMB: What do you do anyway?

MM: Oh, I mostly know art history.

JMB: Oh, that's good. I want to know some more about that.

MM: Do you know much about it?

JMB: I wouldn't say a lot, you know, but that's the majority of the kinds of books that I read.

MM: Now, of course, you know a lot of the artists working today. That must be true, at least coming from the graffiti side, I imagine.

JMB: The "graffiti side"? [*Laughs.*]

MM: The graffiti side, I mean, you must know, uh . . .

JMB: Oh, those people?

MM: Yeah, all those people.

JMB: Yeah, and I know some of the other ones coming from the academic side too.

MM: Let's talk a bit about your images. You just did this duck recently? [*Miller points to Basquiat's 1983 painting* Lodge, *which appears in the background, just inches from their two chairs.*]

JMB: Yeah, yeah, I like the duck because it's very simple.

MM: That actually looks less like a duck than one of these fake ducks that hunters use.

JMB: That's more what it is based on—a decoy duck [rather] than an actual duck.

MM: Most of your images you tend to repeat quite a bit. Is that true?

JMB: Such as?

MM: Well, such as, the bones. You've been working with bones quite a bit.

JMB: Oh, that's anatomy.

MM: Yeah? The anatomy?

JMB: Yeah.

MM: And what is that? How did you come upon that and what is it?

JMB: Because I like the way they look.

MM: You're just thumbing through some books, some pictures, and hit upon these pictures of skeletons?

20

JMB: No, no, no. No. I wanted to do some anatomy stuff.

MM: All right, and, uh ...

JMB: I went out and bought some books that were about anatomy.

MM: And then you started imitating ...

JMB: Well, not really imitating ... I use them as a source material.

MM: So why did you want to do anatomy stuff?

JMB: Because I felt like it.

MM: Because you felt like it? Is this becoming conscious of your own body? [*Laughs.*]

JMB: No, no, it's just for more academic references, to juxtapose them with what I do normally.

MM: And what do you say that you do normally?

JMB: I guess my first instinct would be to do a head. Which I try to fight every once in a while. That's why I like this duck.

MM: So you could get away from just the heads? There is a certain—let's use the term *crudity*—to your heads as opposed to ...

JMB: Uh-huh. [*Laughs.*]

MM: And you like it that way, or would you like to get them more refined in a realistic way?

JMB: I haven't really met that many refined people. Most people are generally crude.

MM: Yeah, and so that's why you keep your images crude?

JMB: Believe it or not, I can really draw.

MM: No, I believe it!

JMB: [*Laughs.*]

MM: I think you can really draw.

JMB: I try to fight against that usually.

MM: Yeah. And that's, of course, encouraged, isn't it?

JMB: Encouraged?

MM: Well, it's encouraged by the people that are appreciating your ...

JMB: By the market? Really? I didn't know that.

MM: Well, I mean you have a certain quick look. Your work's spontaneous. Does that encourage you to go [in] certain directions?

JMB: I don't know how much the market influences me really.

MM: No? How do you choose your colors?

JMB: By what's left.

MM: By what's left from ...

JMB: Well, I usually get the same colors every time: [*mumbles*] crimson, [*mumbles*] blue. I cut them with white sometimes.

MM: They are coming right out of the tube?

JMB: Sometimes out of the jar.

MM: OK, let's go back. You're, what, Haitian, Puerto Rican?

JMB: I was born here, but my mother is first-generation Puerto Rican. My father comes from Haiti.

MM: Do you feel that that's in your art?

JMB: Genetically?

MM: Um, yeah, genetically...

JMB: Yeah, I guess so.

MM: ... or culturally.

JMB: Culturally, hmm.

MM: I mean, for instance, Haiti is, of course, famous for its art.

JMB: Yeah, that's why I said genetically, because I've never been there. And I grew up in a pretty typical American vacuum. Television, mostly.

MM: No Haitian primitives on your wall?

JMB: At home? Haitian primitives? What do you mean? People?

MM: No.

[*Laughter.*]

JMB: People nailed up on my walls?

MM: I mean paintings.

JMB: No, no, no, no. Just typical prints, like you'd find in any home in America. Well, some homes in America. Nothing really special.

MM: You wouldn't really attribute anything in your work to those roots?

JMB: Probably the frustration of the way I grew up has something to do with it.

MM: You think that there is frustration in your art?

JMB: [*Long pause.*] No, no, but I think that frustration probably caused me to do a lot of it. I had to leave home to go out, in a way. My whole life, I went to school and I came home, and that was it. I really didn't have any friends or anything. I just stayed home and went to school, over and over again. I went to the movies once in a while.

MM: And so you started drawing as a way of...

JMB: Well, no, I always enjoyed drawing. What I'm saying is that I couldn't really do anything. Once I left home, that's when I started doing all that drinking and throwing bottles and all that kind of stuff.

MM: And drawing on the streets. That was rooted in a frustration?

JMB: I'd say so.

MM: Does that spirit carry over into your paintings, do you think?

JMB: Well, I hope so. I'd hate to think I was getting soft. [*Laughs.*]

MM: But you just said that you're tired of being the angry young artist.

JMB: That was just a joke.

MM: That was a joke? So you like being the angry young artist?

JMB: [*Long pause.*]

MM: Or you're indifferent . . .

[*Laughter.*]

JMB: What?

MM: You just . . . you are what you are.

[*Laughter.*]

JMB: I am what I am what I am.

[*Tape cuts.*]

MM: So you've just recently come out with a record?

JMB: Well, I just wanted to do a record. I was in some bands for a while. I played this club circuit. Actually, before I started painting a lot I was in this band.

MM: Which band was that?

JMB: It was called Gray.

MM: A lot of people see a correlation, say, between rap music and graffiti.

JMB: In my paintings?

MM: I must say, I've never heard it said about your paintings specifically, but . . . would you say it's true of your paintings?

JMB: Rap music and graffiti? Those have both evolved into fashions more than actual cultural expressions. See, a lot of people that do graffiti went to art and design high schools.

MM: So to you it's a distinct clique of people then?

JMB: More or less. More or less.

MM: What does that mean then? You were just saying it's become more . . .

JMB: I'm not in that clique. My graffiti was separate from all the other graffiti. I didn't hang with people. I didn't go to the [train] yards. I didn't hoard cans of spray paint. I just did it. But I don't see what this duck has to do with graffiti.

MM: I don't either. [*Laughs.*]

JMB: [*Laughs.*]

MM: But I've seen, for instance, your faces, you've done your faces on the street.

JMB: When did I do those? I don't really remember.

MM: There's still a few floating around today.

JMB: I don't know. I don't know. [They are] just little masks.

MM: Little masks? A little picture signature?

JMB: Yeah. I guess.

[*Tape cuts. Basquiat and Miller are now standing in front of the 1983 painting* Notary.]

MM: You must make your own stretchers, obviously.

JMB: My employee does.

MM: After your instructions?

JMB: After my basic plan, which I gave him six months ago.

[*VOICE OFF CAMERA:* OK. Both looking at the camera. Thanks so much, guys. What is this? Go ahead.]

MM: OK, OK. You make your own stretchers.

JMB: No, no, no. Steven Torton does. T-O-R-T-O-N.

MM: After your instructions?

JMB: I gave him a basic plan six months ago. I don't have to tell him anything now.

MM: Why do you make them with the edges showing? The corners showing?

JMB: Why? I don't know. Where, like there? [*Points to the top right corner of* Notary.]

MM: Well, for instance, the way you have the . . .

JMB: 'Cause it's nice.

MM: There's a kind of a rough finish to your works.

JMB: Yeah.

MM: You like that?

JMB: Yeah.

MM: What does that mean to you? Can you articulate what you like about it?

JMB: No, not really.

MM: Not really? And then you latch on . . . Now you've been putting . . . I can't remember the [*laughs*] . . . What are those things called? Hinges.

JMB: Hinges, right. That's purely functional, because I can't fit certain size paintings outside in the elevator.

MM: Where do the words come from?

JMB: Real life, books, television.

MM: And you just skim them and start including certain . . .

JMB: No, when I'm working, I hear them, and I just throw them down.

MM: Oh yeah? Things like "Punic Wars," I remember that was in one of your . . .

JMB: Oh, that was from a guidebook on Roman history.

MM: You had been reading it?

JMB: Well, it wasn't that long, the actual history part of it. It's like, "history of Rome" in five pages.

MM: So you snatched a few words from it?

JMB: I didn't snatch them.

MM: They caught your . . .

JMB: They caught my eye, and I took them.

MM: The sound more than anything else, or the other types of associations?

JMB: I don't know.

MM: What about Leonardo da Vinci? You've got a lot of . . .

JMB: [*Yawns.*] What?

MM: References to Leonardo da Vinci in that show at the Fun Gallery.

JMB: Oh. No, just one painting in particular. Just one painting referenced him. That was a "Leonardo greatest hits" painting. [*Leonardo da Vinci's Greatest Hits,* 1982]

MM: That was again, you were, uh . . .

JMB: He's my favorite artist.

MM: And so you quoted a few . . .

JMB: I didn't quote him, no.

MM: Then what's the relationship of the title to the work?

JMB: Aesthetic.

MM: Aesthetic? In what respect? I mean he's known for his careful, balanced compositions and fine finish. [*Laughs.*]

JMB: But they look even nicer with water damage.

MM: That painting [in the Fun Gallery] was water damaged?

JMB: No, no, no, I'm talking about Leonardo's work.

MM: Oh yeah.

JMB: But that's another artist's work, isn't it? It's got nothing to do with me.

MM: Let me try to remember some of the other works in the Fun show. Can you maybe name one? I remember one called *Hotel.*

JMB: I got that in the back.

MM: And that one was, uh . . .

JMB: It was a little hotel.

MM: Inspired by a specific hotel, wasn't it? It was actually named, what, Stanhope?

JMB: No. The Bond, the Earl, or the Stanhope.

MM: Have you stayed in those hotels?

JMB: I stayed at the Bond. I stayed at the Earl. And then Charlie Parker died at the Stanhope, so I threw that one in there too.

MM: When you start a painting like that, you have in your head that painting, or do you start with a canvas?

JMB: Usually Steve makes a bunch of blank canvases, and I just go at it.

[*Tape cuts. Basquiat now wears a tan blazer over his Wesleyan T-shirt.*]

MM: Let's talk a bit about the story that you are always being locked in the basement in order to paint.

JMB: That just has a nasty edge to it. I was never locked anywhere. Ah, Christ. If I was white, they would just say "artist in residence," rather than say all of that other stuff.

MM: You feel that the press is making a kind of certain mystique around you that is not really accurate?

JMB: What do you mean, "a certain mystique"?

MM: Well, a certain image of you.

JMB: [*Long pause.*] What do you mean by "the press"? Is the press one person?

MM: The art press.

JMB: It's not one person. They rely on third- and fourth-hand information too much. I'm reluctant to talk to them for fear of putting my foot in my own mouth. They quote me out of context.

MM: Do you think your ethnic background is hindering you or helping you?

JMB: I don't know. I don't exploit it.

MM: You don't exploit it? Do you feel others are exploiting it?

JMB: It's possible.

MM: That's, uh, OK, uh . . .

JMB: See, I put my foot in my own mouth, man.

MM: No . . .

JMB: Take that camera off me for a minute.

[*Tape cuts.*]

MM: OK, let's look at the paintings here, come over here. Let's just go through . . . What's this?

JMB: It's Pluto. It's based on the first drawing of the moon by Galileo.

MM: So this is actually an image of the moon there?

JMB: No, it's based on a drawing of the moon, but it's an image of Pluto.

MM: What's this?

JMB: That's a copyright, so I won't get sued for using the word *Pluto,* by Walt Disney.

MM: By Walt Disney? Yeah, oh, I see. Pluto from Walt Disney.

JMB: No, no, no, so I don't get sued by Walt Disney corporation for using the word *Pluto.* Walt Disney does not own the word *Pluto.*

MM: But you are claiming it.

JMB: Claiming what?

MM: [The word] *Pluto,* with your copyright.

JMB: No, I don't own *Pluto* either. I don't want to get sued for using the word *Pluto.* Understand?

MM: Yeah, I understand. Why did you cross out Pluto there?

JMB: Because it wasn't as good of a version of a Pluto as this one.

MM: And what's all this?

JMB: That?

MM: Yeah, these lines.

JMB: What are those? They're black.

MM: Just black lines?

JMB: Yeah.

MM: And we got another image of the moon down here.

JMB: That's a second draft of Pluto, based on a drawing by Galileo.

MM: Uh-huh. But why didn't you cross this one out?

JMB: Which one? This Pluto? Because I liked it a little bit.

MM: OK, and then you've got a third Pluto and another drawing. What's *salt* mean down there?

JMB: Salt was currency in old Rome.

MM: So, what's the link between . . .

JMB: Pluto and salt? None.

MM: None? OK, let's look at another section. What about over here? You have *notary?*

JMB: Yeah, like *notary public.*

MM: What's below that?

JMB: Three-quarters of the red seal.

MM: The red seal, I don't know the red seal . . . oh, you mean from a notary public?

JMB: Right, right, right.

MM: Oh. And these lines are again just lines?

JMB: They are astronomical diagrams.

MM: What do you have under here that you've painted over?

JMB: Some orange and some black.

MM: And what's this thing?

JMB: What's this thing?

MM: Yeah.

JMB: It's just a diagram.

MM: What, with *150*? *160*?

JMB: *150, 150*.

MM: What is that? A price?

JMB: No, no, no, no. My paintings only cost five cents.

MM: [*Laughs.*] And this looks like an eye.

JMB: That's the evil eye—the *malocchio*.

MM: Oh. Below there, what's this?

JMB: That's a Roman belt buckle. This says *parasites*.

MM: *Parasites*. Parasites meaning people?

JMB: No, meaning parasites.

MM: Meaning parasites. When you are working on this, this Roman belt buckle, how did you decide to . . .

JMB: That's from a drawing I did at the Metropolitan [Museum of Art] of a Roman belt buckle that was bronze.

MM: Uh-huh, and so you just decided you wanted to put a Roman belt buckle there and went to your drawing?

JMB: No, I wanted to put a Roman belt buckle on this painting. I had the idea to do it, and then I went all the way over to the Metropolitan Museum and I did the drawing of the buckle and I came back with it and I put it right there.

MM: Well, that's kind of a slow process.

JMB: I'm a slow person.

[*Laughter in the background. Tape cuts.*]

MM: This looks like a skull.

JMB: That's a *casco*.

MM: A what?

JMB: A *casco*.

MM: A gosgo? What's that?

JMB: *Casco,* C-A-S-C-O. That's a Puerto Rican word for helmet.

MM: Oh, for helmet.

JMB: Well, I guess a helmet. [Or] it could be a head, yes.

MM: This was also based on a drawing?

JMB: No, this was based on itself.

MM: Oh, here's the word *casco*.

JMB: [*Corrects the interviewer's pronunciation.*] *Casco*.

MM: Is there any relationship between the *casco* and the notary?

JMB: No.

MM: No? It's just spontaneous juxtapositions? There's no logic? Is there any logic here?

JMB: Is there any logic here? [*Laughs.*]

MM: Yeah.

JMB: God, man. If you are talking to Marcel Duchamp, or even [Robert] Rauschenberg, you couldn't tell them why something was next to something else except that it was just there.

MM: Just a personal . . .

JMB: Or any artist. Like, [ask] Julian [Schnabel]: why do you have this head drawn on top of another head or anything like that? I don't know.

MM: It's just a series of images that . . .

JMB: You talk to painters all the time. Don't you?

MM: Yeah. Some of them have explanations.

JMB: If a painter has something next to something else on a painting, he has a reason for it most of the time?

MM: Um, sometimes. It really depends on the painter. Like Marcel Duchamp would intellectually be able to explain everything.

JMB: Everything, really? He doesn't work with the random at all?

MM: Well, if he did, he would explain it as random. He would have an explanation for working randomly.

JMB: Oh, well. I was misinformed.

MM: But you work randomly. Is that . . .

JMB: Well, I feel through working randomly I come up with a more interesting narrative.

[*Tape cuts.*]

MM: So what do we have here?

JMB: That says *flesh*. [*With mouth full.*]

MM: *Flesh*?

JMB: Yeah.

MM: That you've crossed out.

JMB: That's *flesh*. [*With mouth full.*]

MM: When did you cross out *flesh*? Right after you drew the word?

JMB: [*Indistinguishable due to talking with mouth full.*]

MM: [*Laughs.*] Yeah, OK. What's this?

JMB: Teeth. [*With mouth full.*]

MM: Teeth? [*Laughs.*] You had a friend here just a little while ago, who had a necklace with bones. Is that related to Caribbean culture? Bones?

JMB: That was Al Diaz. [*With mouth full.*] That was Al.

MM: I'm just wondering right here what the teeth . . . just the teeth, there's nothing else?

JMB: Teeth, teeth, teeth. [*With mouth full.*]

MM: There's no symbolism of any sort?

JMB: I don't see [*indistinguishable due to talking with mouth full.*]

MM: [*Laughs.*] God. No one eats. They always say you're never supposed to photograph someone eating.

JMB: [*Continues chewing.*]

MM: [*Laughs.*] OK. Here we go. At least eat for the camera. So here we go, what's this?

JMB: Fleas.

MM: Fleas?

JMB: Mm-hmm.

MM: And below that?

JMB: A drawing of a flea.

MM: That's a flea? It looks like a chicken.

[*Talking in background.*]

JMB: What?

MM: That looks like a chicken.

JMB: It's a flea.

MM: That's a flea.

JMB: Mm-hmm.

MM: OK, and then . . .

JMB: That's some black paint on top of some green paint that's cut with a lot of white.

MM: Keep moving down here. What's this?

JMB: *Dehydrated.*

MM: Dehydrating?

JMB: *Dehydrated.*

MM: What's the relationship of *dehydrate* to fleas?

JMB: Like I said before.

MM: Do you find at certain times . . .

JMB: A big joke [*indistinguishable due to talking with mouth full*].

MM: [*Laughs.*] And then below that is some skulls and some . . .

JMB: All these drawings are [*indistinguishable due to talking with mouth full*].

MM: Yeah, and then we have *leeches*.

JMB: *Leeches.*

MM: What's the difference between a leech and a parasite?

JMB: Hardly any.

MM: Hardly any, oh. Why do you have *46* in front of *leeches*?

JMB: [*Chewing.*]

MM: Again, just stream of consciousness?

JMB: [*Laughs.*] There is a long list of leeches on this planet.

MM: Oh, so you have a . . .

JMB: This is only 46 and 47 of a series of thousands.

MM: Wow. OK, uh.

[*Tape cuts.*]

JMB: [*Indistinguishable due to talking with mouth full.*] Thank you very much.

[*BACKGROUND VOICE:* Thank you.]

MM: [*Laughs.*]

INTERVIEW BY HENRY GELDZAHLER

NEW YORK CITY, 1982

HENRY GELDZAHLER: Did you ever think of yourself as a graffiti artist, before the name became a middle class luxury?

JEAN-MICHEL BASQUIAT: I guess I did.

HG: Did you work on the streets and subways because you didn't have materials or because you wanted to communicate?

JMB: I wanted to build up a name for myself.

HG: Territory? Did you have an area that was yours?

JMB: Mostly downtown. Then the "D" train.

HG: How'd you pick the "D" train?

JMB: That was the one I went home on, from downtown to Brooklyn.

HG: But you knew Brooklyn wasn't going to be your canvas from the beginning. Manhattan was where the art goes on, so that was where you were going to work?

JMB: Well, SAMO wasn't supposed to be art, really.

HG: What were the materials?

JMB: Black magic marker.

HG: On anything? Or something that was already prepared and formed?

JMB: The graffiti? No, that was right on the streets.

HG: Did you have any idea about breaking into the art world?

JMB: No.

HG: But when I saw you, you were about 17 years old. You were showing me drawings, that was 4 or 5 years ago . . . I was in the restaurant, WPA in SoHo.

JMB: Yeah, I remember.

HG: So you already had work to show?

JMB: No, I was selling these postcards, and somebody told me you had just gone into this restaurant. It took me about 15 minutes to get up the nerve to go in there. I went in and you said, "Too young." And I left.

HG: Cruel, but true.

JMB: It was true at the time.

"Art: From Subways to SoHo: Jean-Michel Basquiat," interview by Henry Geldzahler, *Interview,* January 1983, 44–46.

HG: Were you furious?

JMB: Sort of. I mean, too young for what, you know? But I could see, it was lunchtime. "Who is this kid?"

HG: The next time I saw you was about two years later above a loan shop at the entrance to the Manhattan Bridge. I was very impressed; I was amazed, especially by the picture I got. Is that going to fall apart? Should I have it restuck, or put it behind glass?

JMB: Anything is fine. A little gold frame.

HG: What was your idea of art as a kid? Did you go to the Brooklyn Museum?

JMB: Yeah, my mother took me around a lot.

HG: Did you have any idea what Haitian art was?

JMB: No. I wanted to be a cartoonist when I was young.

HG: When I first met you, you mentioned Franz Kline.

JMB: Yeah, he's one of my favorites.

HG: I heard you'd been spreading a rumor that you wanted to have a boxing match with Julian Schnabel.

JMB: This was before I'd ever met him. And one day he came into Annina's gallery. And I asked him if he wanted to spar.

HG: He's pretty strong.

JMB: Oh yeah. I thought so. But I figured even if I lost, I couldn't look bad.

HG: Whose paintings do you like?

JMB: The more I paint the more I like everything.

HG: Do you feel a hectic need to get a lot of work done?

JMB: No. I just don't know what else to do with myself.

HG: Painting is your activity, and that's what you do . . .

JMB: Pretty much. A little socializing.

HG: Do you still draw a lot?

JMB: Yesterday was the first time I'd drawn in a long time. I'd been sort of living off this pile of drawings from last year, sticking them on paintings.

HG: Are you drawing on good paper now or do you not care about that?

JMB: For a while I was drawing on good paper, but now I've gone back to the bad stuff. I put matte medium on it. If you put matte medium on it, it seals it up, so it doesn't really matter.

HG: I've noticed in the recent work you've gone back to the idea of not caring how well stretched it is; part of the work seems to be casual.

JMB: Everything is well stretched even though it looks like it may not be.

HG: All artists, or all art movements, when they want to simplify and get down to basics, eliminate color for a while, then go back to color. Color is the rococo stage, and black and white is the constructed, bare bones. You swing back and forth very quickly in your work. Are you aware of that?

JMB: I don't know.

HG: If the color gets too beautiful, you retreat from it to something angrier and more basic . . .

JMB: I like the ones where I don't paint as much as others, where it's just a direct idea.

HG: Like the one I have upstairs.

JMB: Yeah. I don't think there's anything under that gold paint. Most of the pictures have one or two paintings under them. I'm worried that in the future, parts might fall off and some of the heads underneath might show through.

HG: They might not fall off, but paint changes in time. Many Renaissance paintings have what's called "pentimenti," changes where the "ghost" head underneath which was five degrees off will appear.

JMB: I have a painting where somebody's holding a chicken, and underneath the chicken is somebody's head.

HG: It won't fall off exactly like that. The whole chicken won't fall off.

JMB: [*Laughs.*] Oh.

HG: Do you do self-portraits?

JMB: Yeah, I guess so.

HG: What did you think of James VanDerZee?

JMB: Oh, he was really great. He has a great sense of the "good" picture.

HG: What kind of a camera did he use?

JMB: Old box camera that had a little black lens cap on the front that he'd take off to make the exposure, then put back on.

HG: Do you find your personal life, your relationships with various women get into the work?

JMB: Occasionally, when I get mad at a woman, I'll do some great, awful painting about her . . .

HG: Which she knows is about her, or is it a private language?

JMB: Sometimes. Sometimes not.

HG: Do you point it out?

JMB: No, sometimes I don't even know it.

HG: Do friends point it out to you, or does it just become obvious as time goes on?

JMB: It's just those little mental icons of the time . . .

HG: Clues.

JMB: There was a woman I went out with . . . I didn't like her after a while of course, so I started painting her as Olympia. At the very end I cut the maid off.

HG: Who's harder to get along with, girlfriends or dealers?

JMB: They're about the same actually.

HG: Did you have a good time when you went to Italy, for the first show, in Modena?

JMB: It was fun because it was the first time, but financially it was pretty stupid.

HG: It was a rip-off?

JMB: He really got a bulk deal.

HG: Has he re-sold them? Are they out in the world?

JMB: I guess so.

HG: Do you ever see them? Would you recognize them?

JMB: I recognize them. I'm a little shocked when I see them.

HG: Are there Italian words in them?

JMB: Mostly skelly-courts and strike zones.

HG: What's a skelly-court?

JMB: It's a street game, with a grid.

HG: What about the alchemical works, like tin and lead . . .

JMB: I think that worked.

HG: I think so, too.

JMB: Because I was writing gold on all this stuff, and I made all this money right afterwards.

HG: What about words like *tin* and *asbestos?*

JMB: That's alchemy, too.

HG: What about the list of pre-Socratic philosophers in the recent paintings, and the kinds of materials, which get into your painting always, that derive not so much from Twombly, as from the same kind of synthetic thinking. Is that something you've done from your childhood, lists of things?

JMB: That was from going to Italy, and copying names out of tour books, and condensed histories.

HG: Is the impulse to know a lot, or is the impulse to copy out things that strike you?

JMB: Well, originally I wanted to copy the whole history down, but it was too tedious so I just stuck to the cast of characters.

HG: So they're kinds of indexes to encyclopedias that don't exist.

JMB: I just like the names.

HG: What is your subject matter?

JMB: [*Pause.*] Royalty, heroism, and the streets.

HG: But your picture of the streets is improved by the fact that you've improved the streets.

JMB: I think I have to give that crown to Keith Haring. I haven't worked in the streets in so long.

HG: How about the transition from SAMO back to Jean-Michel, was that growing up?

JMB: SAMO I did with a high school friend, I just didn't want to keep the name.

HG: But it became yours . . .

JMB: It was kind of like . . . I was sort of the architect of it. And there were technicians who worked with me.

HG: Do you like showing in Europe and the whole enterprise of having a dealer invite you, going over and looking at the show . . .

JMB: Usually, I just have to go myself and I have to pay my own ticket 'cause I don't know how to ask diplomatically . . .

HG: You are a bit abrupt.

JMB: And then I usually want to go with friends so I have to pay for them as well.

HG: So you end up not making very much money out of your show.

JMB: It's OK.

HG: Do you like the idea of being where the paintings are?

JMB: Usually I have to check up on these dealers and make sure they're showing the right work. Or just make sure that it's right.

HG: I like the drawings that are just lists of things.

JMB: I was making one in an airplane once. I was copying some stuff out of a Roman sculpture book. This lady said, "Oh, what are you studying." I said, "It's a drawing."

HG: I think, "What are you studying" is a very good question to ask—because your work does reflect an interest in all kinds of intellectual areas that go beyond the streets, and it's the combination of the two.

JMB: It's more of a name-dropping thing.

HG: It's better than that. You could say that about Twombly, and yet somehow he drops the name from within. With your work it isn't just a casual list. It has some internal cohesion with what you are.

JMB: My favorite Twombly is *Apollo and the Artist,* with the big "Apollo" written across it.

HG: When I first met you, you were part of the club scene . . . the Mudd Club.

JMB: Yeah, I went there every night for two years. At that time I had no apartment, so I just used to go there to see what my prospects were.

HG: You used it like a bulletin board.

JMB: More like an answering service.

HG: You got rid of your telephone a while ago. Was that satisfying?

JMB: Pretty much. Now I get all these telegrams. It's fun. You never know what it could be. "You're drafted." "I have $2,000 for you." It could be anything. And because people are spending more money with telegrams they get right to the point. But now my bell rings at all hours of the night. I pretend I'm not home . . .

HG: Do you want a house?

JMB: I haven't decided what part of the world isn't going to get blown-up so I don't know where to put it.

HG: So you do want to live . . .

JMB: Oh yeah, of course I want to live.

HG: Do you want to live in the country or the city?

JMB: The country makes me more paranoid, you know? I think the crazy people out there are a little crazier.

HG: They are, but they also leave you alone more.

JMB: I thought they'd be looking for you more, in the country. Like hunting, or something.

HG: Have you ever slept in the country, over night?

JMB: When I said I was never gonna go home again I headed to Harriman State Park with two valises full of canned food . . .

HG: In the summer?

JMB: It was in the fall.

HG: And you slept over night?

JMB: Yeah, two or three days.

HG: Were you scared?

JMB: Not much. But yeah, in a way. You know, you see some guys with a big cooler full of beer. And it gets really dark in the woods, you don't know where you are.

HG: Do you like museums?

JMB: I think the Brooklyn is my favorite, but I never go much.

HG: What did you draw as a kid, the usual stuff?

JMB: I was a really lousy artist as a kid. Too abstract expressionist; or I'd draw a big ram's head, really messy. I'd never win painting contests. I remember losing to a guy who did a perfect Spider-Man.

HG: But were you satisfied with your own work?

JMB: No, not at all. I really wanted to be the best artist in the class, but my work had a really ugly edge to it.

HG: Was it anger?

JMB: There was a lot of ugly stuff going on at the time in my family.

HG: Is there anger in your work now?

JMB: It's about 80% anger.

HG: But there's also humor.

JMB: People laugh when you fall on your ass. What's humor?

INTERVIEW BY LISA LICITRA PONTI

MILAN, 1983

LISA LICITRA PONTI: In New York do you spend any time in the park, like today, sitting...

JEAN-MICHEL BASQUIAT: No hardly ever.

LLP: How many times have you been in Italy?

JMB: Nine times, ten times...

LLP: When you think of Italian painting you think of...

JMB: Leonardo.

LLP: The modern Italians you like?

JMB: Cucchi and Clemente.

LLP: The Americans?

JMB: Franz Kline, Norman Rockwell, Henry Ford, Wendell Willkie.

LLP: The books you read?

JMB: The Bible. I read it sometimes.

LLP: The Old Testament or both?

JMB: Both.

LLP: Music?

JMB: Miles Davis.

LLP: Architecture?

JMB: I don't know much about it.

LLP: You look at it?

JMB: I do, I just look.

LLP: You are seldom alone, very often with people.

JMB: I am trying to be more alone now.

LLP: You make music?

JMB: I produce records, I did one rap record. Now I am working on an African drum album.

LLP: Which works you make in collaboration with other artists?

"The House of Jean-Michel," interview by Lisa Licitra Ponti, *Domus*, no. 646 (January 1984): 66–68.

JMB: I am doing one now, but it's a secret.

LLP: You like this kind of nomadic life? Two continents, different towns?

JMB: Very much.

LLP: You have nostalgia for anything?

JMB: For everything. But just the objects, not the people. Just the objects.

LLP: You like to be called "the Black Picasso"?

JMB: Not so much. It's flattering, but I think it is also demeaning.

LLP: Do you think you are lucky?

JMB: Talented, too.

LLP: What do you think of the critics who say art is dead?

JMB: When they were making Dada, when Picasso was around . . . the same stuff about art being dead. Those guys are outside of art, you know what I mean? Too much free dinners, for them, you know? They drink cheap wine at the openings, they get drunk, and they get nasty . . . you know?

LLP: Which are the people you like to discuss art with?

JMB: I don't like to discuss art at all.

INTERVIEW BY GEOFF DUNLOP AND SANDY NAIRNE

NEW YORK CITY, 1985

GEOFF DUNLOP AND SANDY NAIRNE: *How did you get to be an artist?*

JEAN-MICHEL BASQUIAT: I always wanted to do this you know . . . as long as I can remember.

GD AND SN: *What age were you when you said, "I'm going to be an artist?" What was "an artist" in your mind?*

JMB: At that point, it was somebody who could draw, but my ideas have changed since then . . . now I see an artist as something a lot broader than that.

GD AND SN: *Could you tell me something of your background, what it was like when you were a kid?*

JMB: I came from a brownstone house with a back yard, you know, pretty quiet. My father worked hard, my mother stayed at home and looked after us.

GD AND SN: *Where from?*

JMB: West Indian, Puerto Rican.

GD AND SN: *You were born in Brooklyn. Can you give me a sense of your family?*

JMB: My two younger sisters are atheists and my mother religious . . . my father was an accountant . . . worked for the phone company sometimes. They got divorced when I was ten or so . . . I'd much rather just talk about art at the moment.

GD AND SN: *How did you learn to be an artist? Where did you learn your craft?*

JMB: I trained myself you know.

GD AND SN: *What kind of influences?*

JMB: I never went to art school, I failed all the art courses I did take in school. I just looked . . . that's where I think I learned about my art, by looking at it.

GD AND SN: *What did you look at?*

JMB: When I was younger I looked at Pop Art . . . Dada was the thing I looked most at.

GD AND SN: *In books?*

This interview transcript was originally published as "Interview between Jean-Michel Basquiat, Geoff Dunlop, and Sandy Nairne," in the exhibition catalogue *Basquiat: Boom for Real* (London: Barbican Centre, 2017), 262–67. The interview was filmed for the UK television series *State of the Art*, directed by Geoff Dunlop, produced by John Wyver, and written by Sandy Nairne. The questions were composed by both Dunlop and Nairne and were asked by Dunlop, who was behind the camera. The interview was broadcast on January 11, 1987.

JMB: Mostly in books and museums, yes.

GD AND SN: So you went to museums as a kid.

JMB: Yes.

GD AND SN: Was that because of a family influence, or did you just go alone?

JMB: Usually through the school, then it got to be a . . . thing to do on my own.

GD AND SN: When you were a kid you did drawings and paintings; who were they for?

JMB: Mostly drawings . . . I didn't paint 'til I was 12 years old.

GD AND SN: What got you painting?

JMB: I just worked bigger I guess . . . colors . . .

GD AND SN: Who was the painting for? Was it for you or were you trying to communicate to somebody?

JMB: I was trying to communicate an idea. I was trying to paint a very urban landscape and I was trying . . . to make paintings for . . . I don't know. I was trying to make paintings different from the paintings that I saw a lot of at the time, which were mostly Minimal and they were highbrow and alienating, and I wanted to make very direct paintings that most people would feel the emotion behind when they saw them.

GD AND SN: Are you talking about a time in your life when you'd actually decided you were going to be an artist already?

JMB: Yes.

GD AND SN: When did you decide that?

JMB: I did some drawings when I was 15, 16, 17 that were just teenage junk stuff you know, then when I was 19 and things got more realistic for me in my life you know, the work also became more realistic.

GD AND SN: And what happened to your work, did you just take it home and put it in a file or . . .

JMB: No, no, I tried to paint like the Lower East Side and what it was like to live there and you know . . . Spanish things from the neighborhood like . . . I don't know bodegas, images, and stuff like that.

GD AND SN: Did you feel there were people around you who were trying to do the same thing?

JMB: There weren't that many painters . . . there were a few . . . there were mostly punk rocker musicians and the New Wave filmmakers.

GD AND SN: You were involved in music; do you think your work is a bit like music, do you think it works in a similar kind of way?

JMB: Painting? No I wouldn't say so. Music, you have to work with other people, and I don't work with other people to do my painting. I mean I don't collaborate with other people . . .

GD AND SN: It's coming across really well, it's OK. Do you feel kind of tense about it?

JMB: No . . . I don't want to be too wordy . . . I want people to understand me, I don't want to mumble too much or anything like that.

GD AND SN: Is that because you think you can't actually talk about paintings, it doesn't get you anywhere, that words can get in the way?

JMB: No, I think it's more of a lack of practice 'cause I hardly ever do it really.

GD AND SN: Do you think your work is something you can actually talk about? Do you think that someone outside can take it to pieces, intellectualize it or write about it? Do you think it can be studied in that way, or should it be taken directly?

JMB: No, I think that people can write about my work, and I've seen people who have written about my work that I've really enjoyed. [Robert Farris] Thompson is my favorite writer on my own work, because of his knowledge of art besides European art you know.

GD AND SN: Did you learn anything from what people say about your work? Does that actually give you an insight into what people think?

JMB: Well sometimes yes . . . but I prefer the more offhand statements, more than the ones coming from you know . . . qualified sources.

GD AND SN: So you were 20 and you were starting to paint; was there any kind of training or formal organization, or were you still finding your way?

JMB: I was working under my own steam.

GD AND SN: Were people starting to notice?

JMB: Yes . . . they knew more about my graffiti and stuff like that, and [knew me] as more of a personality than as a painter, when I was younger.

GD AND SN: What do you mean by "a personality"?

JMB: Just through going to nightclubs and stuff like that.

GD AND SN: Is that part of your work? Does that relate to your work?

JMB: No no no, I mean the nocturnal part of it, working when I get home and stuff like that.

GD AND SN: Who do you make a painting for? Who do you think of when you make a painting?

[*Long silence.*]

GD AND SN: Do you make it for you?

JMB: . . . I think I make it for myself, but ultimately I think I make it for the world you know.

GD AND SN: Do you have a kind of picture of what that world might be?

JMB: Just for any person.

GD AND SN: Do you think your paintings work better in some places than in others, because you literally worked on the streets at one time, didn't you?

JMB: Yes.

GD AND SN: Do you think it has a different impact, or comes across in a different way in different places like a gallery or in a home . . . you know in the different ways in which you can see a painting?

JMB: I think I like seeing them in museums more than anything else, but I've seen them in all those different places, I don't object to seeing them there you know, it's just part of it.

GD AND SN: When you see them in a museum do you feel that you are a part of a tradition, you are moving along in a line?

JMB: Yes, very much so.

GD AND SN: Does that give you a good feeling?

JMB: Yes, I think art is very important.

GD AND SN: Why do you think it's important? What makes you think it's a good thing to be doing?

JMB: The greatest treasures of the world are art, pretty much . . . they are the most lasting, they are still here after people and . . . I don't know, it's just a clear picture you know.

GD AND SN: Is there something that's really affected you, from any age? A kind of thing you might see in a museum?

JMB: [Cuts in.] But anything can act as an influence. If I see a painting from the Middle Ages, I can see the life, I can see how people were . . . like seeing a sculpture from Africa, I can see the tribe, I can see the life around it.

GD AND SN: In a way it's like a report on a time . . . on the way people lived, when you see an old painting?

JMB: Even with things that aren't so obvious, like the Abstract Expressionist painters and so on and so forth, are really . . . you know it looks like New York in the '50s . . . they seem to be true historical documents you know, that I can get more from them than reading or other things.

GD AND SN: And do you think that you are making historical documents yourself?

JMB: Yes.

GD AND SN: What do you think you're saying about today?

JMB: I think there's a lot of people that are neglected in our . . . I don't know if for me it's the paintings or what . . . but . . . Black people are never portrayed realistically in . . . not even portrayed in modern art enough, and I'm glad that I do that. I use the "Black" as the protagonist because I am Black, and that's why I use it as the main character in all the paintings.

GD AND SN: But do you think that you are using the Black character in the same way as Matisse used the white character?

JMB: [*Cuts in.*] I'd say so, I'd say so very much for that reason, yes.

GD AND SN: Is it a political thing?

JMB: [*Cuts in.*] No no no . . . just for a change you know . . . I don't think bad of Matisse at all, his paintings are beautiful . . . that's what was around him.

GD AND SN: Do you feel that Black art has not been seen in Western society?

JMB: It could be something as simple as the racism of the gallery owner, or the racism of the museum directors you know . . . I mean that.

GD AND SN: But you've broken through that haven't you?

JMB: I think a little more than a lot of other people . . . yes.

GD AND SN: But do you find that being a Black artist puts you into a stereotyped role, that you have to do certain things, there's this kind of expectation of you? Or do you feel free?

JMB: I can't say that I'm the first recognized Black artist, because there's a lot of people . . . Jacob Lawrence and a lot of other people . . . Maybe I'm the first to get across to a lot of people . . . there's more media coverage maybe.

GD AND SN: You mean you maybe hit a different time in some way? That there is something special about today that makes it easier for you to . . . get through?

JMB: I don't know, maybe because of people like Andy [Warhol] I think that the artist can be viewed more as a "hero," an image.

GD AND SN: Do you see yourself as a "hero"?

JMB: The way an actor can be a hero, the way a musician can be a hero.

GD AND SN: Do you think that's a good thing for an artist to be?

JMB: I think it's good that people are more respectful to artists, instead of seeing them as junk oddballs or whatever they saw them as before.

GD AND SN: So you've hit a lucky time in a way?

JMB: I don't know . . .

GD AND SN: Do you think that if you'd been working 20 years ago, you might have been more obscure, more . . .

JMB: Probably . . . yes.

GD AND SN: Are there any problems from the media attention, the image thing?

JMB: Well James Rosenquist told me that art isn't show business, and I think that's something that I have to remember.

GD AND SN: Why?

JMB: [*Long silence.*] I think it's a bad frame of mind for the artist in a way.

GD AND SN: Do you know why?

JMB: Because it makes you too regular, and you don't want to be . . . I want clarity but I also want to have some sort of obscurity . . .

GD AND SN: Why do you want obscurity?

JMB: I want it to be sort of more cryptic, the work in some way you know.

GD AND SN: When you make a piece, does it have a clear meaning, does it say one thing?

JMB: It's usually how I feel at the moment.

GD AND SN: Can you talk about the kind of feelings that some of your work conveys?

JMB: I could tell you about Leon Golub, and what he might think . . . I guess his work is very political but I don't have that many political thoughts in my work at all. Most of my thoughts are just pretty personal.

GD AND SN: Like what?

JMB: Happiness . . . you know . . . just very simple thoughts . . .

GD AND SN: Let's just go back to this showbiz thing. Do you think that art has become like showbiz now?

JMB: Well, I'm not really sure if the stories of the artists in the studio quietly working are really true anymore. There's always photographers coming to the studio, and stuff like that. It's a life that's documented and put out there, you know, you go to a restaurant and they write about it in *The Post* on page six.

GD AND SN: Do you like that?

JMB: I'm sure in some ways it's fun, yeah?

GD AND SN: In some ways it's not fun?

JMB: I try to be a little reclusive, and not just to be out there and be brought up and brought down, like they do with most of them.

GD AND SN: Yes, sometimes they can turn on you.

JMB: Yes, they always do. I can't think of one big celebrity-type person they haven't done that to.

GD AND SN: They've done that to you?

JMB: Here and there.

GD AND SN: Tell me how they've got at you, and put you in a box.

JMB: [*Long silence.*] People expect you not to really change, they want you to be the same as you were when you were 19 you know.

GD AND SN: How do you think you've changed?

JMB: [*Long silence.*] I think my mind affects my work more now than it used to, I used to work more heart to hand . . . I think as you get older you can't help it, the mind just pulls into it. I hope it doesn't have too much effect on it [the art], but in some ways I think that it's been good.

GD AND SN: When I look at your paintings it looks as though you've read a thousand books, and that you've seen a thousand TV programs, just pouring in. Is that what it feels like to you?

JMB: I like to have information, rather than just have a brushstroke. Just to have these words to put in these feelings underneath, you know.

GD AND SN: Where do the words come from?

JMB: They're mostly from books and stuff like that.

GD AND SN: Do you read a lot?

JMB: Yes. I look at the words I like, and copy them over and over again, or use diagrams, or . . .

GD AND SN: What do you like about the word? What is it that makes the word work for you?

JMB: Words that just jump up off the page when I see them, you know.

GD AND SN: It's almost like they're shapes . . .

JMB: Exactly, exactly . . .

GD AND SN: What about materials? Do you just use wood, canvas . . .

JMB: I use a lot of canvas, but I've become bored with it now, and I just want to use wood for everything, as the base for the paintings.

GD AND SN: Why?

JMB: I think it looks much better, less academic . . . I don't know. I enjoy painting on canvas still, sometimes, but I really prefer wood and working with more odd shapes.

GD AND SN: You've always worked with different kinds of materials, haven't you?

JMB: In the beginning I worked on wood because that's always free, to work on the doors and windows of the Lower East Side. And then I started working on canvas when I got into a gallery. No cut that, I started to work on canvas before that. I like some of the canvases I've done, but I really enjoy the wood more.

GD AND SN: Is the look of the thing the most important thing, the impact?

JMB: I think that appearance is really a lot.

GD AND SN: What's the difference in your mind between paintings that work, and paintings that don't?

JMB: It's hard to say you know.

GD AND SN: Who are these figures in your paintings?

JMB: A lot of them are self-portraits and some of them are just . . . you know, my friends and stuff.

GD AND SN: Sometimes the figures look really angry . . . is that intentional?

JMB: [*Long silence.*] I'm not out to frighten people . . . just something to do with the rest of my way you know.

GD AND SN: Is there any anger in you?

JMB: Of course there is, of course there is.

GD AND SN: What are you angry about?

JMB: [*Long pause.*] I don't remember.

GD AND SN: Do you think it's different if you're Black and looking at your paintings, do you think they say different things?

JMB: I think Black people are glad to be represented and recognized in my paintings, and that's the feeling I get when we talk about it.

GD AND SN: Black people in this country [the United States] get a rough deal, is that part of what your work's about?

JMB: Yeah I have to say so, yeah.

INTERVIEW BY BECKY JOHNSTON AND TAMRA DAVIS

BEVERLY HILLS, CALIFORNIA, 1985

BECKY JOHNSTON: So I'm going to start with your childhood. What were you like as a kid?

JEAN-MICHEL BASQUIAT: Here we're going now; it's going to be terrible now. . . . What was I like as a kid? See? I hate this.

BJ: Well, what kinds of things did you do? Did you have a lot of friends or were you a loner? Did you start painting when you were really young? Were you a rebel? Were you a kid who got into a lot of trouble? You know, those are the kind of questions . . .

JMB: I don't want to give a one-word answer is what it is.

BJ: I know. I want you to go into it. So if you start then we can feed off your answers and keep going . . . Did you have any brothers or sisters? You were an only kid, right?

JMB: No, I have two sisters.

BJ: Oh, you do?

JMB: I think I was just pretty naïve as a kid, mostly.

BJ: What do you mean by naïve—you believed that if you wanted something you would get it?

JMB: I don't think I dealt with reality that much really.

BJ: But most kids don't. That's not unusual.

JMB: You know, I wasn't [bad]; I wasn't a troublemaker, I just didn't really participate much in school.

BJ: Are you younger or older than your sisters?

JMB: I'm the oldest. I'm the oldest brother.

BJ: Are you the black sheep of the family?

JMB: Well I was until I started doing well. [. . .]

BJ: What's your earliest, most vivid childhood memory?

JMB: Probably getting hit by a car, I guess.

BJ: How did that happen?

Tamra Davis first met Jean-Michel Basquiat in 1983, when the artist came to Los Angeles for a show at the Larry Gagosian Gallery, where Davis was working at the time. Davis often filmed the artist painting during his return trips to Los Angeles and on one occasion shot an interview with their mutual friend Becky Johnston asking the questions.

JMB: I was playing in the street.

BJ: How old were you?

JMB: I was seven—seven or eight years old.

BJ: Did you think: this is it?

JMB: It seemed very dreamlike. It seemed like the car . . . it was just like in the movies, where they slow it down. When a car's coming at you, it was just like that.

BJ: So it was a serious accident?

JMB: Yeah, yeah, I had an operation in my stomach, the whole business. I remember it just being very dreamlike, and seeing the car sort of coming at me and then just seeing everything through sort of a red filter.

BJ: Everybody talks about what a great memory you have. Can you remember specific details of things that happened in your childhood or have you blanked it out?

JMB: I think I remember pretty much all of it. That's not the earliest memory I have but it's probably the most vivid, the thing with the car. I remember all of it pretty much.

BJ: When did you first start painting or drawing? When did you realize this was something you really loved to do?

JMB: I just thought for as long as I could remember . . . I remember my mother drawing stuff out of the Bible.

BJ: Really?

JMB: Like Samson knocking down, breaking the temple down, stuff like this.

BJ: Was she a good artist?

JMB: Not bad. Pretty good.

BJ: So then you started just doing your own drawings?

JMB: I thought I wanted to be a cartoonist when I was younger and then I changed to painting when I was about fifteen or so.

BJ: So when you were about twelve years old or so, what did you imagine you'd be doing right now, at this age?

JMB: See, at that age, I never thought about professions or anything. That's what I mean by "naïve." I never thought about what I'd be doing to make money, stuff like that I never thought about it. [. . .]

BJ: What kind of student were you in grade school? Or high school? What did you like to learn?

JMB: I did well in English and history. I used to ignore . . . I just didn't participate in school at all. I'd just be drawing at my desk.

BJ: Really? Did you have pals or were you a real loner?

JMB: Usually the other kids who didn't have friends, I'd be friends with.

BJ: I read somewhere that you said you spent a lot of time in your teenage years in a park dropping acid?

JMB: Yeah, I never should have told the papers that 'cause it looks so terrible. I should have lied even and told them something else I don't think it's good to be honest in interviews. I think it's better to lie.

BJ: [. . .] I was just wondering why you thought sitting on a park bench doing acid was a good idea.

JMB: I was just taking a bad example from the wrong people, is what happened, I guess.

BJ: And soon after that you started doing SAMO?

JMB: That's after I went back home and started going to school again.

BJ: So can you go over the chronology of that? You left home and then you went back and then you started doing SAMO?

JMB: Ah, this is the worst time in my life, you know. It's the worst . . .

TAMRA DAVIS: Could you explain what SAMO is?

BJ: SAMO was his graffiti moniker. This is about what, seven years ago, Jean-Michel?

JMB: That was sort of high school stuff. High school graffiti.

BJ: But it was great, it was totally great. I remember when I first moved to New York, half the walls downtown were covered with SAMO graffiti. It was cryptic. It was political. It was poetic. It was funny. And it was always signed SAMO, with a copyright symbol next to the name, the "c" with the circle around it. There was a campaign for the entire first year that I was in New York, everyone was trying to figure out who SAMO was. And it turned out it was Jean-Michel.

TD: So SAMO was like somebody else, like a name that you used?

JMB: Yeah.

TD: What does SAMO stand for?

JMB: It was just something like a product sort of . . .

BJ: Didn't you do that with another guy?

JMB: Yeah, a friend from high school. Guy named Al Diaz.

BJ: Yeah. So at that time you were how old? You were like sixteen or so, right?

JMB: Seventeen.

BJ: Did you know at the time that you were going to stop doing graffiti and start painting on canvas? Did you have an idea that you wanted to hit the gallery circuit?

JMB: I was more interested in attacking the gallery circuit at that time. I didn't think about doing painting—I was thinking about making fun of the paintings that were in there, more than making paintings. The art was mostly Minimal when I came up

and it sort of confused me a little bit. I thought it divided people a little bit. I thought it alienated people from art.

BJ: Because it needed too much theoretical . . .

JMB: Yeah, yeah. It seemed very college oriented.

BJ: So what's the first piece of art you remember seeing that left a really strong impression on you?

JMB: Probably seeing *Guernica* was my favorite thing when I was a kid. I liked Rauschenberg a lot when I used to live on the Lower East Side.

BJ: Did you have any idols or any heroes in either the art world or outside of the art world?

JMB: Mostly Rauschenberg and Warhol.

BJ: OK, so you did SAMO and you were living in New York at that time and you were totally broke, right?

JMB: Yeah, I was living [. . .] from place to place.

BJ: But did you ever take a part time job? How'd you make money? Just something as simple as: how'd you have money to live on?

JMB: Used to look for money at the Mudd Club on the floor with Hal Ludacer. We used to find it too, most times. I used to hold a ladder for an electrician [. . .]

TD: I heard all these stories of—that you survived on the streets from having all these different girlfriends. Is that true at all? [. . .] That they helped you out a lot. That you could always—that at least you had a place to stay doing that.

JMB: That's some of it, yeah.

BJ: You had to paint on found stuff, right? You couldn't afford to go out and get a canvas and paints, could you?

JMB: No, the first paintings I made were on windows I found on the street. And I used the window shape as a frame and I just put the painting on the glass part and on doors I found on the street. And then when I first met [*inaudible*], I went and bought some canvas. I was living with Suzanne Mallouk at the time and I'd just finished doing that horrible movie with Glenn O'Brien and Edo Bertoglio.

BJ: What was so horrible about it?

JMB: I got taken advantage of. [*Inaudible.*] I got taken advantage of.

TD: Were you starring in it? You were acting?

JMB: Yeah, I was the star of the movie.

BJ: Well, he basically played himself, but he went all over downtown from the Mudd Club to Danceteria. Didn't you pick up Debbie Harry at one point and take her to a loft?

JMB: Well, she was a bag lady and I kissed her and she turned into a fairy princess.

BJ: The movie showcased everybody in the downtown art and music scene, and Jean-Michel was the tour guide. And this was long before he had hit it big.

TD: Did you ever see that film?

JMB: I never seen it, no. They used to keep me out of the rushes, 'cause they thought if I saw it, I would stop doing whatever it was that I was doing.

BJ: [*Laughs.*] Well, then it must have meant that you were doing something really well. So who was the first person who responded to your work professionally?

JMB: Diego gave me my first show—Diego Cortez.

BJ: Was that *New York/New Wave* at P.S.1?

JMB: Yeah, that was my first show. First person who bought it . . . I think the first person who bought a painting was Paula [Greif]. Do you know her?

BJ: You also painted on paper and sold them at Patricia Field's, didn't you?

JMB: Yeah.

BJ: So then after that show at P.S.1, didn't Diego arrange a big solo show of your work?

JMB: In Italy, yeah, had my first show in Italy. After that, about four or five months, I was living—this was more the time when I was living with the girls, around this time. But before that when I was doing the acid and living in the park, I wasn't living with anybody, I was just, you know, more of a bum.

And then I was staying at Wendy [Whitelaw's] house, I remember, and she was about to throw me out any minute and then Diego came through with this show, which was just great, you know?

BJ: Then you did the show in Italy, and this is where collectors like [Henry] Geldzahler and [Bruno] Bischofberger picked up on you, no?

JMB: No, Bischofberger saw the show at P.S.1 and he didn't like it. And then for some reason . . . I don't know, and then I was at Annina's [Nosei] for a while and then he came there and was begging me to do a show and I was being sort of, like I was playing it cool—telling him, you know, I didn't want to do it and so on and so forth.

BJ: What was your first reaction to selling work and making a little money?

JMB: I don't know. Over-confidence, I guess. Super confidence. I was just happy that I was able to stick it out and then get things I wanted, you know, after . . . I felt like it was right, you know what I mean?

BJ: Yeah.

JMB: And . . . I just felt really right. I felt like I was glad that I stuck it out and I was glad that I'd had these hard times . . .

BJ: And after you started to get famous and people started talking about your work, they also started talking a lot about you. I'm thinking in particular of the piece by Kay Larson in the *Village Voice,* after your show at Larry Gagosian's two years ago.

JMB: I've had this a lot. Most of my reviews have been more reviews on my . . .

BJ: —of your personality.

JMB: —of my personality, yeah. More so than my work, mostly.

BJ: So how do you react to that sort of thing?

JMB: They're just racists, most of these people. [. . .] They went and said my father was an accountant for a fast-food chain. And they talk about my graffiti endlessly, which I don't really consider myself a graffiti artist, you know? So they have this image of me: wild man running—you know, wild monkey man, whatever the fuck they think.

BJ: [. . .] It seems to me that of all the painters out there, you're the one who constantly gets singled out as the enfant terrible.

JMB: But at the same time, I enjoy that they think I'm a bad boy. I think it's great.

BJ: Compare the kind of press you get to someone like Julian Schnabel or David Salle.

JMB: They attack Julian's personality also sometimes. But they usually talk about the work and make art references and stuff because he coaches the interviewers.

BJ: Right. Has anybody ever written anything about your work that you think is on the ball?

JMB: Probably Robert Farris Thompson I thought wrote the best thing—the guy that wrote *Flash of the Spirit,* which is probably the best book I ever read on African art. It's one of the best.

BJ: And he wrote a piece about you for what?

JMB: For my show at Mary Boone's gallery (see page 128).

BJ: So when people ask you, do you ever comply with the request to describe your work?

JMB: I never know how to really describe it except maybe, I don't know, I don't know how to describe my work, 'cause it's not always the same thing.

BJ: Do you feel that that's important to you, though, not to be able to describe it? That if you did, it would reify or objectify the work? And you'd feel like you were stuck with a definition you didn't want?

JMB: It's like asking somebody, asking Miles [Davis], "How does your horn sound?" I don't think he could really tell you why he played—you know, why he plays this at this point in the music. You know you're just, you're sort of on automatic . . . most of the time.

BJ: Do you have a specific method of working? Are there certain hours when you always work?

JMB: I'm usually in front of the television. I have to have some source material around me to work off.

BJ: Like what?

JMB: I don't know . . . magazines, textbooks . . .

BJ: You don't mind having a lot of people around too while you're painting, do you?

JMB: I've discovered that I think I'd rather work alone, more than anything. I used to have assistants, a lot, around me. And then on days when they wouldn't come, I would be a lot more productive.

BJ: And do you work best late at night or do you have a certain time that's . . .?

JMB: Anytime is good, there's not one time better than the other.

BJ: You work all the time, too, don't you? You don't really take a break?

JMB: Depends on what time I got up has a lot to do with that, I guess.

BJ: What's the longest period of time you've ever gone without touching a pencil or a paintbrush? Have you ever taken a vacation and not worked?

JMB: I usually take paper with me when I go away, try to do as much of that as I can.

BJ: When you're watching a movie or reading a book, are there new ideas for paintings constantly popping into your head? Is everything source material?

JMB: Yeah, yes.

BJ: What music do you like?

JMB: Bebop's I guess my favorite music. But I don't listen to it all the time; I listen to everything. But I have to say bebop's my favorite.

BJ: And you listen to a lot of blues, right?

JMB: Yeah—a lot of funk [?] too.

BJ: And what books do you like?

JMB: You know, either ones that have facts in them or Mark Twain. I like Mark Twain books a lot.

BJ: You were reading William Burroughs when you were out here the last time.

JMB: I was going to say Burroughs, but I thought I'd sound too young. 'Cause everybody [says] Burroughs all the time. But he's my favorite living author, definitely. I think it's really close to what Mark Twain writes, as far as the point of view. It's pretty similar, I think.

BJ: Do you still see yourself as naïve, the way you described yourself as a kid?

JMB: Yeah. 'Cause I'm always embarrassed of the past—always. I always feel like if I knew more I wouldn't have done that, or . . .

BJ: I mean "naïve" too in relation to this incredibly high-pressure, competitive art world that you're part of. Do you maintain a distance from it so that you don't tend to get cynical about it? 'Cause you aren't very cynical about it at all.

JMB: I don't see what—being cynical about it doesn't make sense. It's like being cynical about yourself, 'cause it's just you, really; it has nothing to do with them. [. . .] I don't think there really is an art world. There's a few good artists and then everything else is extra. [. . .] I really don't think the art world exists. I really don't think

it exists. I mean there's people who like paintings and then there's dealers and then there's people who work at the museum, but I don't think they're collectively an "art world."

BJ: If you didn't paint, what do you think you'd be doing?

JMB: Directing movies, I guess. I mean ideally, yeah.

BJ: What kinds of movies would you want to do?

JMB: Ones in which Black people are portrayed as being people of the human race. And not aliens and not all negative and not all thieves and drug dealers and the whole bit. Just real stories. [...]

BJ: About three or four years ago, a wave of art came out of the East Village that was identified as being Black art, graffiti art. You made a specific point of saying, "I'm not part of graffiti art. My work has nothing to do with graffiti art." Why?

JMB: The thing is that graffiti has a lot of rules in it as to what you can do and what you can't do and I think it's hard to make art under those conditions—that it has to include your name and that it has to have certain ... I don't know.

BJ: If you look at what's happened with graffiti art, it's kind of reached a dead end right now.

JMB: It's pretty sad because to be washed up at nineteen is really ... is the worst. [...]

BJ: I want to talk more about the time when you were on the street and living in the park ...

JMB: Well, yeah sure. Again, I was a really, really naïve person. And I just left home and I didn't even think how I was going to eat or anything.

BJ: And how old were you?

JMB: Fifteen. [...]

BJ: Was this in Brooklyn or did you go to Manhattan?

JMB: I went to Washington Square Park.

BJ: Did you just meet people there? Or were you completely alone? You didn't bother to develop friends, you were just being weird?

JMB: I was just mostly being weird.

TD: What'd you look like then?

JMB: I think I shaved my head when I left home because I thought it would be a good disguise, you know? Because they wouldn't be looking for somebody with a shaved head. And I was hypertensive, just sort of walked around all the time.

BJ: So where did you live? How did you sleep?

JMB: When I first left I went down to this boys' home that was mostly criminals and stuff. And then I went out with these guys and they mugged somebody and I was with them and then that didn't seem to be the right thing. And then I left the boys'

home and I was living in the park, sort of just . . . I really don't know how I got through that. Just walking around for days and days without sleeping. Eating cheese doodles, or whatever. [. . .]

BJ: Did you think this was how you were going to live for the rest of your life? Or did you know that you'd stop at a certain point and either go back home or . . .?

JMB: I was determined not to go home again.

BJ: But did you think: I could be a bum, forever?

JMB: Yeah, sort of I did, yeah. [. . .]

BJ: But when you're living like that, when you're hanging out in a park, what's your vision of the world then?

JMB: Oh, I remember: everybody's rich—that's what you think. Everybody's rich, no matter who they are. You see people in the restaurant and you're like, "Oh those fucking rich people."

BJ: And you hate 'em of course.

JMB: You say, "Oh, for three dollars I could make myself a dinner." You see people spending twenty-five dollars. Everybody just seems rich and you're really bitter and you hate everybody.

BJ: That explains why you give so much money to bums on the street, right?

JMB: I guess so, yeah.

BJ: So you went back home after that? And then you started doing SAMO?

JMB: Yeah, I went home when I was about seventeen and started going to school for a little while. I never graduated. I fucked up there again, and I went on a camping trip and I just never went home after that.

BJ: You went on a camping trip and just lammed off? [*Laughing.*]

JMB: Yeah.

BJ: So how did the idea for SAMO come up? You and your friends sitting around and deciding this is something we should do?

JMB: No, it was sort of my idea, and I said let's do this, let's write these sentences.

BJ: Did you come up with the sentences and the statements?

JMB: Yeah, the sentences and the formula basically and then people had variations that were in our group.

TD: Is that stuff still around New York at all?

JMB: Most of it's gone, you know. Just my favorite ones are mostly gone. There's hardly any left, to tell you the truth.

TD: I have a friend who has one still on his door.

JMB: Oh yeah? There were some guys that went around and pulled them all off walls and stuff. And they sold them when I first started to sell some paintings.

BJ: How could you pull 'em off walls? You painted them right on brick . . .?

JMB: No, a lot of them were on signs. They had blow-torches and clippers and they went and removed a lot of them.

TD: Did that happen up here at the Roxy?

JMB: Oh yeah, somebody cut a piece of a wall out.

TD: I heard about that. And then you also painted in a sink and then they fired all the dishwashers 'cause they washed it all out of the sink.

JMB: They did? They fired the dishwashers? Wow, that's too bad, that's terrible. That's at Sunset, right?

TD: They were like, "You washed fifty thousand dollars down the drain!"

JMB: Hardly.

TD: [*Laughing.*] Save the sink. [. . .]

BJ: I remember Steve Torton once said something about you that struck me as so bizarre but true: [. . .] "You know, Jean-Michel is so cerebral, he lives so much in his brain that you could put him anywhere and it wouldn't matter." It's not like you're unaware of your environment, but it just doesn't matter.

JMB: I think I have to learn more not to work around what's around me and just work with what I think, I guess. I shouldn't let what's around me affect my work at all, I think. I should just work on what I normally work on. [. . .]

BJ: Why is that? I think it's fascinating to see the impact a place has on an artist's work.

JMB: Hmm . . . I don't know.

BJ: So do you go out in New York as much as you used to? You used to be out at the clubs . . .

JMB: Hardly ever now, no. Not too much, no. I mean sometimes, yeah. But not really as much, not as much as the old days. It's not the way it was then, anymore.

BJ: What was it like then?

JMB: The people were pretty interesting.

BJ: In what way? They were all struggling to do the same thing? I mean they're all the same people, so why are they less interesting now?

JMB: No, they're not the same, not really. No, they're not the same people. I'm just saying it's different. You know Eric Mitchell and John Lurie . . . it's not like that anymore. Danny, Vicki . . .

BJ: How come you never made a Super 8 film when the New Cinema was happening and all those people were doing . . .?

JMB: Couldn't afford it.

BJ: Did you want to?

JMB: No, I was more thinking about painting at that time. And I wanted to be in one, I remember.

BJ: So, should we talk more seriously about painting?

JMB: No. No, I hate talking about painting.

BJ: Which collector has the largest number of your paintings?

JMB: Probably my dealers. Probably one of my dealers, probably Bruno [Bischofberger], or . . . I know so little about my career, to tell you the truth. I don't know who has what or anything like that really, or even what they paid for it most of the time.

BJ: But you were pretty famous for setting up the deals that you have with your galleries, which is unusual, isn't it? I was under the impression that when you went with Mary Boone, you set the terms: you said you wouldn't be exclusive. And she had to buy the work directly from you.

JMB: Yeah, I make them buy the work right out, most of the time. [. . .]

BJ: You're perceived by people in the art world as being fully in control of what gets out there and how it gets out there. When you have a show, do you bring her [Mary Boone] work and she says, "I like this, let's show that"? Or do you just show her the stuff and say, "This is it . . . "?

JMB: Usually, yeah, it's "I like this, I like that," yeah.

BJ: And do you listen?

JMB: Usually she likes the stuff that looks like my old work, mostly. The most identifiable things are what they [the dealers] like. I did some portraits last year and they really hated those. [*Laughs.*] But the artists like them.

TD: The artists that you did the portraits of?

JMB: No, no the artists that saw the paintings. I didn't do 'em of artists. I did them of kids mostly.

BJ: So what about Andy Warhol? You did a whole series of paintings with him.

JMB: Yeah, we worked for a year on about, on a million paintings.

BJ: How did you do the collaboration?

JMB: He would start most of the paintings. He would put something very concrete or recognizable, like a newspaper headline or a product logo, and then I would sort of deface it, and then I would try to get him to work some more on it, and then I would work more on it. I would try to get him to do at least two things, you know? [*Laughing.*] He likes to do just one hit and then have me do all the work after that.

BJ: Did you have rules, like you couldn't actually paint over his stuff or . . .?

JMB: No, not at all, we used to paint over each other's stuff all the time.

TD: Was that the first time you did a collaboration?

JMB: Yeah, it was, yeah.

BJ: Well, you did the thing with Warhol and [Francesco] Clemente before that, didn't you?

JMB: That's right, yeah, right. But that was a little different because the paintings moved around. In this, with me and Andy, we worked in the same place on the same paintings, instead of moving the paintings from studio to studio as we did with Clemente.

BJ: Is Warhol the only artist you'd consider collaborating with?

JMB: I've been asked by other artists since then, so I really don't know what to do now. I don't know if I'll make it a practice. I don't know, I'll do whatever I want to do [...]

TD: What was it like working with Andy Warhol?

JMB: Well, listening to what he had to say was probably the most fun. Seeing how he dealt with things was probably the best part. 'Cause he's really funny. Tells a lot of funny jokes.

BJ: Does he talk about other artists or art a lot?

JMB: All the time, yeah.

BJ: What paintings do you have in your own collection?

JMB: I have a couple of Warhols and I have a Picasso.

BJ: Really, what?

JMB: A 1922 oil painting. I took all my money and I bought that so I wouldn't spend it all.

BJ: What else?

JMB: I have a Joseph Kosuth.

BJ: One of the old ones?

JMB: Yeah, a sixties one. And I got one Robert [*inaudible*] painting and those [James] VanDerZee photographs, and I have a small Keith Haring.

TD: Did you ever trade art? Did you trade something with Keith in order to get that?

JMB: Yeah, I traded with Andy. We used to trade all the time so I have a few of his paintings.

TD: You used to leave paintings lying in places where you were staying. Are you more conscious of not doing that?

JMB: Definitely, 'cause they've wound up at auction.

BJ: Yeah, I know people who've sold those things.

JMB: Like everybody I know has sold those things.

BJ: [...] If you were suddenly told that you only had twenty-four hours to live, what would you do in those twenty-four hours?

JMB: I don't know—go hang out with my mother and my girlfriend, I guess.

INTERVIEW BY DÉMOSTHÈNES DAVVETAS

NEW YORK/PARIS, 1985–1988

DÉMOSTHENÈS DAVVETAS: Was the graffiti on the buildings and streets of Brooklyn a rebellious reaction?

JEAN-MICHEL BASQUIAT: My father was Haitian, my mother Puerto Rican. I spent my whole childhood in Brooklyn. I left home at fifteen. I went to Washington Square Park where I spent eight months getting stoned on acid. Then I went to high school for a while. But I didn't like it there. I had a lot of problems with the authority figures and I had to leave again. At school I made typical teenager things. Psychedelic images on star backgrounds. I also sold postcards that I drew and sweatshirts painted by hand. In other words, I was all over the place, roaming the streets. A kind of survival.

DD: During that period you were writing poems on sidewalks, drawing and painting on walls. You sought a kind of "communication" with *Interview* magazine. That's when Andy Warhol asked you to draw on T-shirts. How did you go from "survival" to "recognition"?

JMB: At that time I wouldn't have been surprised if I'd died like a dog. But the problem of money became imperative. I couldn't even buy the necessary materials to finish a canvas. I thought about going to see the Art Students League. I had enough curiosity, enough will to find a solution, a way of reaching any goal. But in other respects, student work seemed so sad to me I preferred to continue wandering around until the day I decided to participate in the exhibition "New York—New Wave," organized by Diego Cortez. From then on, things started to change.

DD: In 1982 you had your first solo exhibition at Annina Nosei's gallery, while also being invited to Documenta. A lot of people attribute your success to the fact that you knew how to gain Andy Warhol's attention . . .

JMB: [*Angrily.*] I was the one who helped Andy Warhol paint! It had been twenty years since he'd touched a brush. Thanks to our collaboration, he was able to rediscover his relationship to painting.

Originally titled "Jean-Michel Basquiat," interview by Démosthènes Davvetas, published in *New Art International* (Lugano), no. 3 (October–November 1988): 10–15. Davvetas was introduced to Jean-Michel Basquiat through Andy Warhol in late 1985. Warhol encouraged the connection based on their shared interests. As Davvetas recently recalled, "[Warhol] told me, '[H]e is a poet who became an artist. You are a poet who makes drawings. So you have something in common.'" (Davvetas, email message to the author, April 19, 2020.) The two did become close interlocutors. The interview published here is a result of several conversations between the artist and Davvetas that started in New York and continued in Paris, where Basquiat had an exhibition at Yvon Lambert Gallery in January 1988.

DD: It seems like you don't like to be treated like a graffiti artist.

JMB: Labels don't mean anything. My work has nothing to do with graffiti. It's painting, it always has been. I've always painted. Well before painting was in fashion.

DD: There are almost always totems, primitive signs, and fetishes in your images. Is that a search for your African roots?

JMB: I've never been to Africa. I'm an artist who has been influenced by his New York environment. But I have a cultural memory. I don't need to look for it; it exists. It's over there, in Africa. That doesn't mean that I have to go live there. Our cultural memory follows us everywhere, wherever you are.

DD: In your work, the magical element doesn't seem like a cult. You use it with distance, like a child who plays with objects.

JMB: Magic doesn't especially interest me. What I like is the intuition that tells me that a work is finished. I'm not an elitist artist, but an autodidact who would like to be part of the family of artists.

DD: Someone who could use his art as a weapon against racism?

JMB: Making good art is revenge enough. That's why I feel no nostalgia for the misery I lived in. All my energy scattered then, without following any particular path. Now I'm a lot happier.

DD: What American artists do you like best?

JMB: Twombly, Rauschenberg, Warhol, Johns.

DD: And among the Europeans?

JMB: Da Vinci's and Titian's drawings. More recently, work by Penck, Clemente, Cucchi.

INTERVIEW BY ISABELLE GRAW

FRANKFURT, 1986

ISABELLE GRAW: Why didn't you come to Hanover? I waited for you at the airport.

JEAN-MICHEL BASQUIAT: I'm sorry about that. I was not in a travelling mood.

IG: You are mistaken if you think that you upset anyone. By not coming you really only did everyone a favor.

JMB: I don't think that's true.

IG: Do you feel like talking about your paintings?

JMB: Let's just talk and get it over with.

IG: Is it still a problem to be Black in America today?

JMB: Sure. You can't get a taxi. I go on the street, wave my hand and they just drive past me. Normally I have to wait for three or four cabs. A few taxi companies tell their drivers not to pick up Blacks.

IG: What will you do about it?

JMB: Nothing. Black taxi drivers drive past me too.

IG: You are the only Black man to have become a very successful artist . . .

JMB: I don't know if my being Black has anything to do with my success. I don't think I should be compared to Black artists but with all artists.

IG: How did you become an artist? What is true about your legendary graffiti career?

JMB: I wanted to be an artist ever since I was three years old. I drew a lot. What came next has nothing to do with graffiti. I just had a big fan club. I started to paint when I had enough money to buy supplies.

IG: Why do you cross out words on your paintings and what does that ubiquitous copyright symbol mean?

JMB: I cross out the words to move them into the background a bit. I like the copyrights because they look good.

IG: How do you work?

JMB: I start with a picture and then finish it. I don't think about art when I'm working. I try to think about life.

Originally titled "Waiting for Basquiat," interview by Isabelle Graw, published in *Wolkenkratzer Art Journal* (Frankfurt), no. 1 (January–February 1987): 44–51, 106–7. Graw interviewed Basquiat after he did not appear at the opening of his museum survey show at the Kestner Gesellschaft in Hanover in 1986.

IG: Do you think drugs can help you?

JMB: [*Flaring up.*] Why do you ask me that? Did the people in Hanover tell you that? I don't think my paintings look as if they were done under the influence of drugs.

IG: All the art critics see a mixture of Afro-Caribbean elements and Cy Twombly in your work . . .

JMB: I don't listen to anything that art critics say. I don't know anyone who needs a critic to find out what art is.

IG: Who are your favorite artists?

JMB: Very few. Franz Kline, Warhol, Robert Rauschenberg.

IG: How did your collaboration with Warhol come about?

JMB: It was very simple. I just had to push him, because he's a bit lazy. He hadn't drawn for twenty years.

IG: You don't make life easy for your dealers. You have recently left Mary Boone . . .

JMB: I didn't get on with her.

IG: Before that you made paintings in the cellar of Annina Nosei's gallery . . .

JMB: I didn't have a studio back then. She offered me her cellar to work in. The bad thing about this situation was that she sold paintings that weren't finished. She said someone was interested in the painting and sold it despite my protests. I was young then, I've learned a lot since then.

IG: Do you feel like a victim?

JMB: Yes.

IG: How are you going to protect yourself?

JMB: By seeing as little as possible of all these art people around me.

IG: Then why don't you leave New York?

JMB: I get bored everywhere else.

IG: Aren't you worried that you might run out of ideas and people won't be interested in you anymore?

JMB: Sure. There's nothing I can do about it.

IG: Is it true that your paintings have been selling at a discount recently?

JMB: I haven't noticed any of that. I'm making as much as I was before.

IG: Should I come to New York before I write the article on you?

JMB: What would you do if the artist you were writing about were dead?

IG: I would do as much research as possible, get together all the available information . . .

JMB: Then just do it like that. Pretend I'm dead . . .

The work of Jean-Michel Basquiat crossed the boundaries between language and image, literature and the visual arts. Beginning in May 1978, two years before the first exhibition of his paintings and drawings, Basquiat (along with his high school class-mate Al Diaz) was well-known for street writings signed with the name SAMO—an acronym for "same old shit." The three wrote maxims, prophecies, and jokes on the walls, buildings, and sidewalks around the School of Visual Arts and in the SoHo and Tribeca neighborhoods, where there were many prominent art galleries. The phrases at times pointed to SAMO as an alternative to the art economy: "SAMO AS AN END TO ALL THIS MEDIOCRE ART," "SAMO FOR THE SO-CALLED AVANT-GARDE." Others were more poetic: "MY MOUTH/ THEREFORE AN ERROR. ©"

The SAMO collective stopped posting work in early 1980, as the proclamation "SAMO© IS DEAD" began to appear throughout downtown Manhattan. Yet Basquiat's interest in language persisted throughout his career. Writing seeped into his paint-ings and drawings, sometimes in the forms of word games and cryptic messages. In one painting from 1987, we see just three words, all accompanied by the copyright symbol: BRAZIL ©, POLICE ©, THINK © (plate 33). In Basquiat's lifetime, he wit-nessed the brutalities of police violence firsthand; the death of his friend Michael Stewart in September 1983 at the hands of the NYPD left Basquiat distraught, think-ing that he could easily have been the victim—Black, young, dreadlocked. He memo-rialized this event in marker and acrylic, working directly on the plasterboard wall of his friend Keith Haring's NoHo studio in a work titled *The Death of Michael Stewart (Defacement)* (plate 22). Considered alongside Basquiat's other paintings of police (*Le Hara* or *Irony of Negro Policeman* [plate 5], both from 1981), this untitled painting from four years later similarly asks us to consider the brutality of police violence and the threat under which Black lives must persist.[1] Moreover, with a single word, BRAZIL ©, Basquiat links the killings of Black men like Stewart to a context outside New York. The reference to Brazilian police brings to mind the atrocities of the authoritarian military dictatorship that ruled the nation for twenty years, from April 1965 until March 1985; during this time, the regime censored all media and tortured dissidents. But more important, the inclusion of BRAZIL © brings the issues of police violence to a global scale. Paintings like this demonstrate not only Basquiat's interest in but his facility with language. With just three words, Basquiat calls up global histories of vio-lence and oppression, connecting the problems of the past to our immediate present.

The majority of words and prose fragments we find in these works were drawn from Basquiat's own library, which included books on jazz and classical history, encyclopedias, art history textbooks, the notebooks of Leonardo da Vinci, a large

collection of museum exhibition catalogues, Beat novels by Jack Kerouac and William Burroughs, and the Bible. These texts provided the artist with specific iconographic source material, as well as a mediated experience of the world.

Basquiat's interest in language was formal (his interest in the shapes and gesture of the written words) as well as conceptual. He did not often discriminate between the linguistic and imagistic functions of his texts, and he clearly played with the boundary between language and image. For example, in the painting *Hollywood Africans in Front of the Chinese Theater with Footprints of Movie Stars* (plate 20), Basquiat went so far as to replace portions of the image (in this case, the interior cavity of one figure's mouth) with text ("teeth"). And in his private notebooks, we see the artist transform letters into drawings: an image of a three-pointed crown, for example, emerges from the letter *W*. (This is a tendency that Basquiat shared with Cy Twombly, who similarly transformed letters into images in his mature drawings, exploring the materiality of language itself. We see a lotus flower on the surface of Twombly's *Apollo and the Artist,* of 1975, a cited favorite of Basquiat's, that simultaneously alludes to the letter *W* via its form.)[2]

I have argued elsewhere that Basquiat's cutting and mixing of language in his paintings and drawings recalls the models of spontaneous prose and collage that he found in the Beat writers, whose work he publicly admired.[3] In a 1985 interview, Basquiat declared William S. Burroughs to be his favorite living author.[4] Like Burroughs, Basquiat relied on the multiple and shifting significations of a single sign. What appears at first to be random text on a page can suddenly undergo transformation. The "VENUS" and "MADONNA" that appear in the upper left corner of *A Panel of Experts* (1982) could be, on the one hand, a simple homage to classical masterpieces of art history—the Venus de Milo or a Renaissance Madonna. But once we are aware of Basquiat's personal relationships with women, we read these same words differently. Considered in conjunction with the image of two stick figures directly below—one punching the other squarely in the head—these same words could also refer to an incident between girlfriends Suzanne Mallouk (whom Basquiat called "Venus") and Madonna Ciccone, when Mallouk reportedly punched Madonna at the Roxy nightclub.[5] In instances like these, Basquiat uses language to highlight the tension between what we *see* and what we *know*.[6] The words reproduced in this *Basquiat Reader,* drawn from the artist's notebooks, show a similar interest in epistemology, in the boundary between language and image, in the various ways words play with and against each other.

The total number of extant notebooks by Jean-Michel Basquiat remains unknown. Eight of Basquiat's private notebooks, from the collection of Larry Warsh, were most recently exhibited at the Brooklyn Museum in 2015.[7] The accompanying catalogue for that show reproduces all marked pages of these notebooks, which feature handwritten notes, poems, and drawings, in sequence.[8] Rather than scanning these texts directly as facsimiles for this *Basquiat Reader,* here the artist's texts are presented in transcription, set in type. Removing the hand of the artist allows us to more easily recognize these as written texts per se—another significant creative

outlet for the artist. The selections themselves were made with the intention of providing the reader with the widest range of material.[9] Their organization here is more curatorial than scientific. The provided transcriptions are as faithful as possible to the way the texts appear in the notebooks, with misspellings left intact and crossed-out words indicated.

Basquiat's texts reveal to us his promise as a poet. As Christopher Stackhouse has observed, "however dashed off the lines seem, they represent a compression of thought, sentiment, social observation, and critique."[10] The notebooks were a place for the artist to work through and revise his ideas, and in several cases, lines from the notebooks reappear in his paintings and drawings. Basquiat's texts offer up rich imagery within a daring economy of language. In them we find biting social critique and snarkiness, which are carried over from the days of SAMO, alongside a disarming sentimentality.

Basquiat's persistent interest in language is an important, though still underexplored, area of his artistic practice. In looking more closely at his texts, we find challenges to narrative and to the structure of meaning, as well as to narrow conceptions of the artist as simply a painter.

Notes

1. The exhibition *Basquiat's Defacement: The Untold Story*, organized by independent curator Chaédria LaBouvier for the Guggenheim Museum (June 21–November 6, 2019), was a compelling exploration of these themes in Basquiat's work that drew on photographs, documents, and artworks (by Basquiat and others) relating to the death of the twenty-five-year-old Michael Stewart. The painting *Untitled* (1987) was included in this exhibition.

2. For a full discussion of Twombly's playful use of letters, see Richard Leeman, *Cy Twombly* (London: Thames and Hudson, 2005), 289–93.

3. Jordana Moore Saggese, *Reading Basquiat: Exploring Ambivalence in American Art* (Berkeley: University of California Press, 2014), 109–46.

4. See page 55 of this volume.

5. Jennifer Clement, *Widow Basquiat: A Memoir* (Exeter, UK: Shearsman Books, 2001), 89. This book is written from the perspective of Suzanne Mallouk, whose stories are incorporated throughout.

6. See also Jordana Moore Saggese, "Knowing an Image: Jean-Michel Basquiat and the Question of Text," in *Words Are All We Have*, exh. cat. (New York: Nahmad Contemporary, 2016), 48–62.

7. The exhibition *Basquiat: The Unknown Notebooks* was held at the Brooklyn Museum April 3–August 23, 2015, and was curated by Dieter Buchhart and Tricia Laughlin Bloom.

8. The eight notebooks range in date from 1980–81 to circa 1987. They have been dated in *Basquiat: The Unknown Notebooks*, exh. cat. (New York: Brooklyn Museum, 2015) as follows: notebooks 1–4, 1980–81; notebook 5, ca. 1987; notebook 6, 1981–84; notebook 7, ca. 1983; and notebook 8, ca. 1985. Warsh's collection also includes several loose notebook pages, several of which are exclusively text.

9. In total, Basquiat's private notebooks in Warsh's collection include 132 pages of text (not including obvious lists and phone numbers) out of a total of 170 marked pages. This volume includes transcriptions of 55 texts, or roughly 40 percent of the total.

10. Christopher Stackhouse, "Basquiat's Poetics," in *Basquiat: The Unknown Notebooks*, exh. cat. (New York: Brooklyn Museum, 2015), 63. You can read this essay in its entirety on pages 316–27 of this volume.

TEXTS BY JEAN-MICHEL BASQUIAT

AN ADVERTISEMENT FOR SODA

~~PENGUINS ARE LIKELY TO STAY WITH THE SAME MATE FOR MONTHS~~

~~FIRE WILL ATTRACT MORE ATTENTION THAN ANY OTHER CRY FOR HELP~~

~~THIER DOGS THIER HARPOONS THIER WIVES~~

THE AVERAGE MAN LAUGHS 15 TIMES A DAY.

THE GIANT GORILLA LYING ON THE PAVEMENT

THE DREAM WILL NEVER DIE ACCEPT THE REALITY OF LIVING IN THE STATES

RUSHED INTO THE LIMO BY SECRET SERVICE

IT A FRONTAL ATTACK

—

AN ACTOR GETTING SHOT BY A MACHINE GUN

ADD TAPE WITH PLASTIC BAG ATTACHED TO CLOTH WITH PLATE ON SKIN

~~THIS KIND OF GREASE~~

~~TOOTHBRUSH~~

~~HOT FUDGE AND PEANUTS~~

—

Transcribed for this publication from the artist's notebooks, currently in the collection of Larry Warsh. Misspellings and single-line strikethroughs—features of Basquiat's texts as well as his drawings and paintings—have been reproduced here as they appear in the original. Texts that have been scribbled over or otherwise obscured in the notebooks have been interpreted as redactions and do not appear here. Although the order and dating of individual notebooks is not known, the texts here are arranged in the order in which they appear in each notebook. Transcriptions by Jordana Moore Saggese.

THE BAR WAS REALLY RED WITH CHINESE PAPER CUTOUTS
AND WOOD PANELING
THERE WAS A GLASS ARGUMENT AT THE POOL TABLE
IN THE BACK

"THAT'LL BE EIGHTY CENTS POP"

6 OR 7 OLD PUGS IN FELT

SHE LOOKED LIKE A VILLAIN FROM TERRY AND THE PIRATES

—

I'LL GIVE 20 LBS. OF OXYGEN FOR THAT DRAWING
YOU CAN'T SELL A HUMAN
YOU'VE DONE THIS SCRATCHING
THIS WAS NOT BLANK.

SCRATCHING ON THESE THINGS

—

I FEEL LIKE A CITIZEN IT'S TIME TO GO AND COME BACK A DRIFTER

—

~~IN THIS~~

I FEEL LIKE A CITIZEN IN THIS PARKING LOT COUNTY FAIR

IT'S TIME TO GREYHOUND AND COME BACK A DRIFTER

PUT IT ALL IN ONE BAG

—

CHARMED INTO BACKING THE SHOW

YOU'RE NEVER GOING TO BELIEVE THIS

GOLD HELMET

3-CARD SPREAD

ANTI-WHAT IT'S GOING TO BE LIKE

AT STAKES

CHIEF OF POLICE
STRIVING

LUMBERING WINO ON ASPHALT

FACE DOWN

—

LEAPSICKNESS

THE LAW OF LIQUIDS

THAT THORN IN MY HEAD NAGGING MY FISTS CLOSED

VICTIMS OF EMBELLISHED HISTORY

THE SPORES FLOAT

———

~~THE SPORES FLOATED ON EVERYTHIN~~
~~THE SPORES FLOATED ON A POTATO FOR~~

~~THE I~~

SPORES FLOATED ON THE POTATO FOAMING THRU THE SKIN

THE GERMS ON A SPOON BEHIND THE OVEN

THE COLONY OF ROACHES IN THE OVEN LAY EGGS
UNDER TINFOIL IN THE OIL SWAMPS OF
BROILED STEAKS.
COOKED AND RECOOKED

———

RUBBER MONKEY AT A BUFFET

CARTS OF SHREDDED WHEAT

LOOT

BOOTY

RANSOM

INFESTED BATHROOMS

HIGHER MONKEYS

SPRING ONIONS

THE HISTORY OF THE WORLD

—

THE MOTORCYCLE PULLS UP TO THE ROAD DINER MAN GETS OFF

ORDERS A HAMBURGER AND EGG HERO.

"WE PUT UP THE FAKE CACTUS EVERY YEAR AT THIS TIME"

A PROUD WORKER COMES OUT OF THE KITCHEN WITH A

LARGE BAG OF OATS

"THE BUS WILL BE HERE IN 20 MINS./MAKE SOME HOME FRIES.

THE KITCHEN BOYS WHOOP AND YELL AND MAKE TWICE AS

MANY DONUTS.

THE MANEGER BRINGS SOME COLOR POSTCARDS OF ROCKS

FROM UNDERNEATH THE COUNTER BY THE MINTS AND CIGARS.

THE DISHWASHER PLUGS IN THE JUKEBOX AND FRIES HIS WET

HAND WITH A SHOCK.

THE LAW SITS DOWN FOR FREE SLICE OF PIE.

—

HE HAD LEARNED TO IGNORE THE CRISP PART OF A 20 DOLLAR

BILL WITH AGE AND PLAYED NUMBERS FOR A FLIGHT TICKET.

REALLY OLD SHOES TAKE TRAINS.

THERE'SA FORTUNE IN NEWLYWEDS CROSSING THE

BORDER/ MOST OF THEM WOULD TAPE THE MINERALS

TO THIER STOMACHS FOR HALF OF WHAT WAS

OFFERED.

HIS DAY LASTED TAFFY HOURS OF SLOW SMELLS STEAMING.

NO ONE PLAYED CHESS ANYMORE IT SEEMED MORE

VAPID TO RENT A CAR OR TO EAT AT

ROADSIDE WAR RESTAURANTS THAT SERVE

SURVIVAL DISHES.

—

HOLED UP IN RENTED BED WAITING ON NEW WORD

STATIC IS HARD ON VOICES BUT BLOCKS OUT CHAOS ON THE RUNWAY

LESS TO LOOK BACK ON LESS HOT WATER ON CREDIT

I WAS LUCKY TO HAVE MY CANVAS SUIT DRY CLEANED BEFORE THE RIOTS

 OFF
WE THREW PAMPHLETS AND BANNERS ON CARS ^ THE ROOF

IN CROSS SECTION OF BAD ASTHETIC THE BLANK WINS OUT

HAMBURGER VETERANS IN MEDICAL CASEBOOKS

THESE BROWN PAPER JOHNNIES WITH RECORDED MEETINGS

~~WITH~~ MEMOS AND LETTERS

—

HE PUTS A CHALK MARK ON HIS BACK AND WATCHES
HIM GET HIT BY A CAR FROM A SAFE DISTANCE.

KAYO IN THE LUNA PARK
FREEZE FRAME ON A DRUNK IN THE PIAZZA
THAT'S WHAT HE HAVE FOR PIGEONS
LUMBERING ON ASPHALT FACEDOWN
LEAPSICKNESS THE LAW OF LIQUIDS

FURTHER RESISTANCE TO THE FORCES OF THE
NATION OF LAW AND JUSTICE LIKE SOME
BAD STUPID COWBOY TURNING TO SEE THE
CLOCK
 THE MAN IN THE WHITE HAT DROP IT
BEFORE DAWN WITH THEIR EXPRESSIONS
UNCHANGING SURROUNDED BY GUNS
THAT MELT SUNGLASSES

ECONOMICLY CRUMBLING FROM THE
B-29 RAY STALLING BEFORE IT ENDED
SUCCESS HAD BEEN ACHIEVED.

A YELLOW FLASH A2STORY HOUSE
BLOWN TO PIECES / WE TOOK PICTURES
RAPIDLY / IT'S TIME TO GET OUT OF
HERE.

WHAT ABOUT THIS MODERN EDUCATION

FLASH CARDS AND ALL THAT.

ALBERT DENTON OWNED 51 PERCENT

OF FAMOUS WRESTLER

A YOUTH WITH "CROW" SYNDROME:

~~AN ATR~~ (AN ATTRACTION TO SHINY OBJECTS/

SEES THE STONE AROUND HER NECK

 FAT MONKEY

WALK FOR A QUARTER MILE/ LEFT 3 BLOCKS

TO A RED PICKET FENCE

GIVE THE BALDHEADED MAN A QUARTER

LOCK THE DOOR

SEE THIS REVERSE SPELLS THE OTHER WAY

THAT'S WHERE THE PEOPLE ARE

I THOUGHT YOU SAID WEDNESDAY

THIS BUM NAMED BALTIMORE

~~THIS~~ VAGRANT NAMED CHICAGO
 A

A LOT OF BOWERY BUMS USED TO BE

EXECUTIVES—

———

SHE LOOKED HER THIRD EYE ACROSS THE
PARTY
 AT A SINSAE DIPLOT FROZE UNDER
PALM AT A BEACH RESORT 1000 MILES
AWAY—

HER VOICE TURNS INTO A BEGGAR IN SPAIN
A CRUCIFIX TRANSMITTING MONKEY HEAD
HYSTERIA INTO 20,000 TELEVISIONS—

AS THIEVES CUT THRU TWO THIN WALLS
TORCHING A HOLE THRU THE THIN METAL
OUTER COVERING.

THE TESTTUBE FALLS INTO GREEDY FINGERS
YELLOW FLASH
2 STORY HOUSE BLOWN TO PIECES
WE TOOK PICTURES
IT'S TIME TO . .
WALK DOWN ¾ LEFT 3 BLOCK TO
A RED PICKET FENCE . . .

———

GIVE THE BALDHEADED MAN A QUARTER
PULL IN A DOG TO DRAW SANDPAPER
CENSOR HIS HABITS
FREEZE-FRAME ON A B̶ DRUNK IN THE
PLAZA
LEAPSICKNESS
THE LAW OF LIQUIDS.

———

YOUTH HAS DICK CUT-OFF BY FOUR TRANSVESTITES

HE HAD BEEN RIDING WITH THEM ON

THE SUBWAYS AND FOUND HIMSELF

IN THE APT. THEY WERE SQUATTING

IN AND FELL ASLEEP.

SOMEONE SCREAMS TURN DOWN THE

RADIO.

———

ANTS ON A CHICKEN BONE

WORKING MEN BREATHE THE DIRT OFF

THE BIG WHITE

WHITEBREAD WITH THE CENTER ATE OUT

A BALDHEADED BOY ON A BYCICLE.

TEXTILE WASTE

A BIG ALBINO BOY COMES INTO THE DINER

2 COKES FOR A BIG BODY.

———

THE JIG IS UP

SO SAY GOODBYE TO THE NIGHTMARE

ON AUTOMATIC PILOT

~~SINGED~~ SIGNED HIGHER SOURCES.

I AM NOT THE FAMOUS DISK

JOCKEY YOU WERE LEAD TO BELIEVE

I WAS—

▬

VISE OF LOVE

A PILLAR OF SALT

~~TE THE~~

~~PANIC OF MALFUNTIO~~

PANIC OF MALFUNCTION.

▬

A QUICK TURN SWEATING TOO MUCH

LIGHT DISTURB

LIKE THE PY SYMBOL

SWEATING TOO MUCH

IS THAT A LIGHT?

SIMPLE BELLS

SWEATING TOO MUCH

THEY'LL SEE MY PAPERS WEARING AWAY IN MY FACE

FALSO

A SOIL RICH IN SULPHUR

—

A ROPE LADDER OF BEDSHEETS

A DESIRED SEXUAL EFFECT

LOW FUN > MINIATURE STATE

A MOUNTING NUMBER / A QUICK TURN SWEATING TOO MUCH

LIGHT DISTURB / SWEATING TOO MUCH

IS THAT A LIGHT / FALSO

A SOIL RICH IN SULPHUR / PULL IN A DOG TO DRAW SANDPAPER

PUT HIM ON A MAT / CENSOR HIS HABITS –

TO BRING TO THE POINT OF A SNAP-LOGIC TO TURN TO

THE CLOSEST AND OPEN THE AIR LOCK EXPIRING.

SIX OF US COURTING AN AMERICAN MADONNA —

—

THE WORLD'S FOUR MAJOR

 GRAIN, OIL AND IRON ORE

SIXTY BANKS

 A GROUP OF MONEYMEN

▬

TO BRING HIM TO THE POINT/ SNAP LOGIC/ TO TURN TO THE
ONES CLOSEST/ OPEN THE AIR LOCK/ EXPIRING >

▬

IT TOOK THE GUILT OF FOUR GENERATIONS
OF SWEATSHOP WORKER TO GAIN
ACCESS TO THE STATESMAN.

▬

SHE LOOKED HER THIRD EYE ACROSS THE PARLOR AT A SINSAE DIPLOMAT

FROZE UNDER PALM AT AN ESCAPIST RESORT ON THE BEACH

THRU THE WATER HER EYE BECAME A BEGGAR IN SPAIN

IN FRONT OF A TOURIST TRAP HER VOICE PARROTS A

SANDPAPER WHINE OVER TELEFONATA.

SLEEPING ON SIX TRAINS FLYING HOME WATCHING THE

WINGS SHAKE IS IT MY IMAGINATION BUT DO

THE BUILDINGS SHAKE FROM THE SUBWAY

THE TELEGRAPH OUTSIDE THE HOTEL LOOKS COLLAPSIBLE.

—

A CRUCIFIX ON THE TOWER TRANSMITTING INTO 20,000

TELEVISIONS (CIRCA 1938) GOLD DUBLOON ON

A MONKEY HEAD HYSTERIA TAMED BY A NATURAL

ORDER OF ~~QUENCHING SPIRITS~~

WATERTOWERS / HIGH-RISE

NO VACANCY ON AND OFF CRUSTY MENOSTAFF

RECIEVER NODDING PULLED BACK PLUGS –

OFF EAR PAUSE IRRIDESCENCE QUENCHING

BRICK FEAR OF THE TOWER

20 FIRE ESCAPES ERECTED ON THE SAME DAY

FALL PARALLEL.

—

LITTLE GLASS OFFICES SHATTERING OFF THE RUNWAY.

—

1000 YEAR OLD STREET

—

STOPPED IN TRANSIT SEVEN TIMES

—

A CRUCIFIX ON A TOWER TRANSMITTING INTO
20,000 TELEVISIONS CIRCA 1938
GOLD DUBLOON ON A MONKEY HEAD HYSTERIA
TAMED BY NATURAL ORDER
A TURN OF THE HEAD FINGERS ON A KNOB
SMILING TOO MUCH
JUST A THEF COLLABORATING

SHE LOOKED HER THIRD EYE AT A SINSAE DIPLOMAT
ACROSS THE PARLOR FROZE UNDER PALM
AT A BEACH RESORT

STILL BREASTFEEDS HER BABY ALL WITH TEETH

—

COLORS WITH NUMBERS ON THE BACK
BROOMING INTO MEZZO / ASPURIA

⸺

A SOIL RICH IN SULPHUR-FALSO / A QUICK TURN
SWEATING TOO MUCH. –LIKE THE PY SYMBOL
IS THAT A LIGHT? SWEATING TOO MUCH / FALSO

CRUCIFIX TRANSMITTING INTO 20,000 TELEVISIONS
CIRCA 1938)
MONKEY HEAD HYSTERIA TAMED BY A NATURAL ORDER
SMILING TOO MUCH A THIEF COLLABORATING

SHE LOOKED HER THIRD EYE ACROSS THE
PARLOR AT A SINSAE DIPLOMAT FROZE
UNDER PALM AT AN ESCAPIST RESORT
ON THE BEACH.

THRU THE WATER HER EYE BECOMES A BEGGAR
IN SPAIN.

IS IT MY IMAGINATION OR DOES THE BUILDING
SHAKE

TELEGRAPH OUTSIDE THE HOTEL LOOKS COLLAPSES—

⸺

SO SUFFERING THE WHOLE THING ABOUT HIS FOOT

STILL BREAST FED AFTER TEETH

STILL BREAST FED/SO SUFFERING

A SOIL RICH IN SULPHUR > FALSO

SWEATING TOO MUCH

IS THAT A LIGHT?

—

THE AREA CODE OF ST. LOUIS PRIOR TO THE ASSASINATION.

—

FLICK OF THE WRISK

JAPANESE ARCHITECTS

AREA CODE OF ST. LOUIS

—

A MARATHON SUICIDE CIRCLE GETS ON 20 COVERS IN 24 HOURS

ALL BARKING

LIVING COLOR

NO TREBLE

—

30 LOGS FOR A BAG OF SUGAR SCREAMS THE MERCHANT

2 ACCOMPLICES DRAG IN SOME CARROTS AND WIPE THEM

WITH KEROSENE TO STRIP THE SKINS.

—

A BARLEY RUN ON CHARTER AIRLINE CAUSE CHEMICAL

FUSION 2 SOURCES

—

A DARK ROOM/ SOUND OF RINGING PHONE LIGHT ON PHONE FLASHES

7 RINGS SILENCE/ SHOT OF TELEVISION STATIC/ LIGHT COMING

FROM BATHROOM ON PERSON/ NO MOVEMENT/ PHONE RINGS

AGAIN PERSON LOOKS OUT BLINDS/ DARK OUTSIDE

PUTS ON LIGHT GOES TO PHONE STOPS RINGING—

GOES DOWNSTAIRS NUDE DRINKS A GLASS OF SEVEN-UP

COMES BACK UPSTAIRS PHONE RINGS PICKS IT UPx—

(SHOTS OF FULL ASHTRAYS, DRUG PARAPHANAILA)—

(HI, I JUST WOKE UP OK I'LL BE THERE IN A WHILE)

PUTS ON AN UBEAT CALYPSO/ SOCA DANCES AROUND TO WAKE UP)

PUTS ON JAZZ AND TAKES A SHOWER———

TAXI TO SPANISH RESTAURANTx———

 CONVERSATION—

LOUIS THE 14TH + RIBBONS—

VILLAGE GREEN + GHOSTS UNDISCOVERED DEATH –

 ————————————

FLIRTATION WITH WAITRESS—

 ————————

CHRISTMAS [*ILLEGIBLE*]—

—

GAVIN: YOU MUST TRY THE PIG EARS (FABULOUS!) THIS IS MY

FRIEND SOPHIE

SOPHIE: I LOVE THE PAINTING IN THE BACK ROOM
AT THE GALLERY SOME OF YOUR PAINTINGS I HATE BUT

I WOULD DO A LOT OF THINGS FOR THIS ONE.

GAVIN:

LOUIS THE FOURTEENTH HAD THIS THING FOR RIBBONS

I CAN SEE HIM ROLLING DOWN VERSAILLE

THIS LITTLE SHOE WITH THIS BIG RIBBON

WOMAN: THAT WAS JUST TO HELP THE RIBBON INDUSTRY ALL THE COURT

 NOPE, ALL EUROPE + —

HE WAS PASTY WHITEx

NO HE WAS SWARTHY, DARK AND SEXY—

NO HE WAS PASTY WHITEx + -

―――――――――

YUCK, SPANISH BRANDY—

―――――――――

RUSSIAN BRANDY + -

▬

IN STOCKHOLM THEY HAVE THIER ROACHES IN A ZOO.

~~SHE TOLD~~

A COMBINATION OF WORRY AND THOUGHT—

A FOURTEEN YEAR OLD SWEDE IN NEW YORK

1951.—GOES TO BIRDLAND AND BEGS

TO BE PHOTOGRAPHED WITH CHARLIE FUCKING—

BIRD PARKER _SHE SHRUGS HIM OFF—

~~CHARLIE~~ [ILLEGIBLE] ~~H M ALL HIS~~

CHARLIE MAKES HIM BUY ALL HIS RECORDS—

————————

SWEDISH CHOCOLATE SOLDIERS—

▬

SHE MUST HAVE BEEN A DALLAS GIRL

YANKEES DON'T DRESS LIKE THAT

RIPPED UP JEANS, DENIM SHIRT

BIG OL' COWBOY HAT—

HIS WAFFLE THICK SHOES SMELLED LIKE A COP

BUT ALL HED WAS A WALKIE TALKIE—

THESE GIRLS THEY GET ON THE PHONE

AND JUST DON'T STOP TALKING—

THEY JUST YAK IT UP—

THEY HAD MORE STARLETS IN PARIS

[ILLEGIBLE]

▬

LADIES + GENTLEMEN THIS IS YOUR

ANNOUNCER INVITING YOU TO ANOTHER

EPISODE OF

 "CELEBRITY HEROIN ADDICT"

THE SHOW THAT SAYS, "OH NO! NOT HIM"

"I HAD NO IDEA."

A. WAS A JUNKIE

B. IS STILL A JUNKIE

C. TRYING TO QUIT.

—

 THIS IS NOT IN PRAISE OF POISON

ING MYSELF WAITING FOR IDEAS

 TO HAPPEN-MYSELF-THIS NOT

 IN PRAISE OF POISON IS THIS IS NOT

 NON

 THE NON POISONOUS POISONED

 SO SELF RIGHTOUS POISONED

 NO ONE IS CLEAN

 FROM RED MEAT TO WHITE

 IS POISON

 THIS NOT IN PRAISE OF ~~POISON~~

 THE BIGGEST BUISNESS

 UGLY, FAT LIKE A PIG

 THE CUSTOMER IN NEW YORK

 <u>CHICAGO DETROIT</u>

 <u>PSALM</u>

—

A PRAYER

NICOTINE WALKS ON EGGSHELLS
 MEDICATED

 M
 THE EARTH WAS FOR LE
 FORMLESS VOID

 K
 DAR NESS

 DARKNESS FACE OF THE DEEP

 SPIRIT MOVED ACROSS THE

 WATER AND THERE WAS LIGHT

 "IT WAS GOOD" ©

 BREATHING INTO HIS LUNGS

 2000 YEARS OF ASBESTOS.

 ▬

 LOVE IS A LIE

 LOVER = LIAR

 ▬

 EFFECTIVE 12:01AM ©

 ▬

AN EVIL CAT IN A TOP HAT

COMING OUT OF A SEWER

~~WITH A FIRECR~~

WITH AN M-80

—

A CAT POURING TACKS

ON HIS TONGUE ©

—

CROCODILE AS PIRATE

—

MADONNA

BRUCE WALLACE

WALTER CRONKITE

JARMUSCH

GODARD

PEE WEE

NICHOLSON

J. HUSTON

ALI

AMSTRO

JOHN GLENN

MILES DAVIS

KELLE

PRINCE

DAVID LYNCH

WILLIAM BURROWS

ELISABETH TAYLOR

ROBERT DE NIRO

BERNARD GOETZ

RINGO STAR

ELTON JOHN

STEVE WONDER

In the late 1970s Jean-Michel Basquiat capitalized on his early notoriety as SAMO and moved from the street to the studio. He appeared regularly on Glenn O'Brien's public access television show, *TV Party*, and even exhibited his works on canvas (still under the name SAMO) in June 1980 at the *Times Square Show*—an exhibition of more than fifty young artists that, for many, marked the genesis of the '80s art movement. Basquiat, because he had achieved some recognition in the East Village scene, was soon invited by curator Diego Cortez to exhibit work in *New York/ New Wave*—a massive group show of sixteen hundred works by 119 artists that opened on Valentine's Day 1981 at PS1. He was an immediate success.

Because of his early (though misinterpreted) associations with graffiti and the East Village art scene, Basquiat was of particular interest in the overhyped art market of the 1980s.[1] Many critics were displeased by the sudden embrace of artists like Basquiat, who had first gained notoriety as a street artist, and whose commercial success threatened to overshadow any artistic contribution. Some accused the media of exploiting East Village artists based on their own primitivist fantasies. Hal Foster, for example, called Basquiat "the new art-world primitive" in his review of the artist's 1982 exhibition at Larry Gagosian's gallery.[2] Foster assumed that promoting graffiti art was tantamount to economic and cultural exploitation—an example of the marketplace's tendency to fetishize minority cultures. The concerns of Foster represent a general anxiety among critics, who were skeptical of the rampant commercialization of the art market and what it might mean for the avant-garde. More specifically, would a sudden emphasis on the financial dimensions of the art world eclipse artistic and critical value? Basquiat's success strained an already tenuous boundary between culture and commerce.

The antagonism between art and its market was certainly not a new development in the American art context, but in the 1980s it became more explicit. As unprecedented amounts of capital flooded the art market, prices climbed precipitously; artists like Julian Schnabel could suddenly resell paintings at more than double their original price within a few years.[3] Artists were public celebrities, courted by both galleries and major businesses. Popular media outlets referred frequently to this new breed of successful young artists, who appeared in spreads in *Vogue* and *Vanity Fair*.[4] In response, artists made more work, and they made it bigger; dealers began to organize two-gallery exhibitions in order to keep up with demand.[5] Exhibitions sold out for extraordinary sums before they opened.

Many critics and scholars of the period expressed fear that the marketplace had become *too* influential on the critical reception of art and artists. In fact, in early

critical writing about Basquiat, we encounter frequent references to the prices of his work. A 1984 essay for the *Village Voice* gives us the price of the artist's first painting at auction ($20,900), while the bulk of Cathleen McGuigan's feature essay for the *New York Times Magazine* remains devoted to an exploration of Basquiat's intersections with the art market. In 1983 critic Robert Hughes called the new art environment a "'post-modernist' image machine, that powerful corporation which, modeled on corporate p.r. lines, has transformed the very nature of reputation in the art world over the last five years."[6] This volume reprints fifteen examples of contemporary criticism, selected from the entire range of the artist's career. The debates around mythology, commerce, and success are a persistent theme.

The contemporary criticism published here gives readers a good sense of how these early critical debates, not to mention Basquiat's supposed origins in the graffiti scene, affected his reception during his lifetime. Many critics employed the same stereotypes by which they had judged countless other African American artists; Basquiat was just another untrained, nonwhite artist. We frequently see the work described as primitive and spontaneous, even with the best of intentions. In other cases, critics compare the works to European artists—a way to perhaps legitimate Basquiat via his connection to traditional modernist concerns. For example, the first published criticism of Basquiat in the mainstream press immediately linked him to the legacies of expressionist painters Jackson Pollock and Jean Dubuffet. The critic Susan Hapgood, writing in *Flash Art* in 1983, draws extended comparisons to the work of Cy Twombly. In a 1982 essay Diego Cortez called him "the Black Picasso"—an association that followed Basquiat throughout his career.[7]

As we move to the artist's middle period (1985–86), we could argue that the critical backlash against Basquiat's early commercial success continues via his association with Andy Warhol.[8] For many critics in the 1980s, themselves steeped in the discourses of Marxism, artists who were successful within the art market (and who seemed to embrace it) were incapable of meeting the critical demands of modernism. The commodity fetishism that artists like Warhol explicitly cultivated put pressure on these constructions, and Basquiat became guilty by association. Ronald Jones's 1986 review even resorts to financial terms in his describing the collaborations between Basquiat and Warhol as a "merger," perhaps motivated by potential commercial gains.[9] In her review of the Basquiat/ Warhol collaborations, Vivien Raynor interprets the relationship as one of exploitation: "Last year, I wrote of Jean-Michel Basquiat that he had a chance of becoming a very good painter providing he didn't succumb to the forces that would make him an art world mascot. This year, it appears that those forces have prevailed."[10]

Calling Basquiat an "art world mascot," unfortunately, failed to recognize Basquiat's critical awareness of the connections between celebrity, commodification, and the art world. His 1985 painting *Boone* (plate 16), for example, appropriates Leonardo's *Mona Lisa* (via a photocopy pasted onto a large Masonite panel) and transforms it into a portrait of the prominent New York gallerist Mary Boone, blackening her

eyes and outlining her lips in a wide clown-like smile. Basquiat often commented publicly on the commercial side of the art world, especially his difficult relationships with dealers. He told an interviewer in 1985, for example, that he despised the assembly-line production that was often required of him. "They [the dealers] set it up for me, so I'd have to make eight paintings in a week, for the show the next week . . . It was like a factory, a sick factory."[11] One cannot help but notice Basquiat's evocation of Warhol (and the naming of his New York studio as "The Factory") via his description, as he rejects the association between his own artistic and commercial value.[12]

In the midst of these early reviews, one work of truly original scholarship stands out: an essay by Robert Farris Thompson written on the occasion of Basquiat's 1985 exhibition at Mary Boone, his second solo show with the gallery.[13] In this short essay, Thompson, a specialist in African and Afro-Atlantic art, plants the seed of inquiry; in refusing to label Basquiat simply as a graffiti artist, he calls for a serious consideration of the work within a framework of the Black Atlantic. Thompson rigorously considers the way Basquiat mobilizes politics, language, and modernist painting in the creative process. He reads Basquiat's Blackness outside of racist mythologies and sees it instead as the source of complexity, as a process of simultaneously being and making. It is no surprise that Basquiat specifically called out Thompson's essay when asked by friends Becky Johnston and Tamra Davis to identify any writing about his work that he liked.[14]

Although the contemporary criticism reproduced here is necessarily not comprehensive, it is nevertheless representative. Rereading these early reactions to and interpretations of Basquiat's works shows us the challenges that these paintings and drawings presented to the field of contemporary American art, many of which we are still trying to sort out.

Notes

1. See the introduction to this volume for further discussion of Basquiat's relationship to graffiti and street art.

2. Hal Foster, "Between Modernism and the Media," *Art in America* (Summer 1982): 15.

3. Michael Stone, "Off the Canvas: The Art of Julian Schnabel Survives the Wreckage of the Eighties," *New York Magazine,* May 18, 1992, 34.

4. An August 1983 issue of *GQ* magazine included work by Basquiat in a fashion spread. References to Basquiat also appeared in the December 1985 issue of *Esquire.* In February 1984, the cover of *Vanity Fair* featured a design by Keith Haring; Eric Fischl appeared in the same magazine three months later (an experience Fischl later cited as influential to his 1984 work *Vanity*).

5. Basquiat's 1985 exhibition in New York was split between the Mary Boone and Michael Werner galleries, for example.

6. Robert Hughes, "Three from the Image Machine: In SoHo, a Trio of Rising Reputations but Uneven Talents," *Time,* March 14, 1983, 83.

7. The title of Cortez's essay was omitted when it was included in the two-volume catalogue of Basquiat's known works, published by Enrico Navarra Gallery in 1996. For an extended discussion of Basquiat's relationship to "Blackness," see Jordana Moore Saggese, *Reading Basquiat: Exploring Ambivalence in American Art* (Berkeley: University of California Press, 2014), 13–59.

8. See Robert Hughes, "The Rise of Andy Warhol," *New York Review of Books,* February 18, 1982.

9. Ronald Jones, "Andy Warhol/ Jean-Michel Basquiat," *Arts Magazine,* February 1986. See page 140 of this volume.

10. Vivien Raynor, "Art: Basquiat, Warhol," *New York Times,* September 20, 1985. See page 38 of this volume.

11. Phoebe Hoban, *Basquiat: A Quick Killing in Art* (1998; repr., New York: Penguin, 2004), 116.

12. For further discussion of Basquiat's self-conscious appropriations of currency in works like *Mona Lisa* (1983) and *Untitled (Arm and Hammer II)*—a 1985 collaboration with Andy Warhol—see Jordana Moore Saggese, "Jean-Michel Basquiat and the American Art Canon," in *Re-envisioning the Contemporary Art Canon: Perspectives in a Global World,* ed. Ruth E. Iskin (London: Routledge, 2017), 59–73.

13. Thompson was invited to submit this essay at Basquiat's invitation.

14. Jean-Michel Basquiat, interviewed by Becky Johnston and Tamra Davis, 1985. See page 49 of this volume.

THE RADIANT CHILD

RENE RICARD, 1981

I remember the first tags (where is *Taki?*), Breaking (where you spin on your head), Rapping (where I first heard it). I know the names, but are the names important? Where is *Taki?* Perhaps because I have seen graffiti, then seen something else, thrown myself on the dance floor, then gone on to dance another way, I say that the reason for abandoning so much during the '70s was that each fad became an institution. What we can finally see from the '70s buried among the revivals and now surfacing (Tagging, Breaking, Rapping) was at least one academy without program. Distinct to the '70s, graffiti, in particular, was the institutionalization of the idiosyncratic that has led to the need for individuation within this anonymous vernacular. This is why the individuals (*Crazy Legs*) must distinguish themselves.

Artists have a responsibility to their work to raise it above the vernacular. Perhaps it is the critic's job to sort out from the melee of popular style the individuals who define the style, who perhaps inaugurated it (where is *Taki*) and to bring them to public attention. The communal exhibitions of the last year and a half or so, from the Times Square Show, the Mudd Club shows, the Monumental Show, to the New York/ New Wave Show at P.S. 1, have made us accustomed to looking at art in a group, so much so that an exhibit of an individual's work seems almost antisocial. Colab, Fashion Moda, etc., have created a definite populist ambience, and like all such organizations, from the dawn of modern, have dug a base to launch new work. These are vast communal enterprises as amazing that they got off the ground as the space shuttle and even more, fly-by-night, that they landed on solid ground.

The most accessible and immediately contagious productions in these shows were those of the graffiti stylists. The graffiti style, so much a part of this town, New York, is in our blood now. It's amazing that something so old can be made so new. There is an instant appeal in the way spray paint looks, ditto markers. Any Tag by any teenager on any train on any line is fairly heartbreaking. In these autographs is the inherent pathos of the archaeological site, the cry down the vast endless track of time that "I am somebody," on a wall in Pompeii, on a rock at Piraeus, in the subway graveyard at some future archaeological dig, we ask, "Who was *Taki?*"

Rene Ricard, "The Radiant Child," *Artforum* 20 (December 1981): 35–43. The original terms in Ricard's essay have been reproduced here without modification. Ricard's choice to capitalize a term like *Tag,* for example, may be read as an attempt to assert the historical significance of graffiti art. Readers may also notice that Ricard, like many early critics of Basquiat's work, writes *Samo* versus the more common *SAMO* we see in later publications. Maintaining this deviation underscores the nascent criticism surrounding Basquiat at this moment, when there was not yet a standard vocabulary for the work.

Graffiti refutes the idea of anonymous art where we know everything about a work except who made it: who made it is the whole Tag. *Blade, Lady Pink, Pray, Sex, Taki, Cliff 159, Futura 2000, Dondi, Zephyr, Izzy, Haze, Daze, Fred, Kool, Stan 153, Samo, Crash. (Crash* is still bombing.) But trains get buffed (the *damnatio memoriae* of the Transit Authority), and with the need for identity comes the artist's need for identification with the work, and to support oneself by the work is the absolute distinction between the amateur and the pro. Therefore, the obvious was to raise oneself by the supreme effort of will from the block, from the subway, to the Mudd, to the relative safety and hygiene of the gallery. Because an artist is somebody. Say what you will about group shows and collaborative enterprise: *Das Kapital* was written by one man. This is no graffito, this is no train, this is a Jean-Michel Basquiat. This is a Keith Haring.

Both these artists are a success in the street where the most critical evaluation of a graffito takes place. Jean-Michel is proud of his large *Samo* Tag in a schoolyard, surrounded by other Tags on top of Tags, yet not marked over. This demonstrates respect for the artist as not just a graffitist but as an individual, the worth of whose Tag is recognized. There's prestige in not being bombed over. There are also fake Samos and Harings as well as a counter-Haring graffitist who goes around erasing him. The ubiquity of Jean-Michel's *Samo* and Haring's baby Tags has the same effect as advertising: so famous now is that baby button that Haring was mugged by four 13-year-olds for the buttons he was carrying (as well as for his Sony Walkman). The Radiant Child on the button is Haring's Tag. It is a slick Madison Avenue colophon. It looks as if it's always been there. The greatest thing is to come up with something so good it seems as if it's always been there, like a proverb. Opposite the factory-fresh Keith Haring is Jean-Michel's abandoned cityscape. His prototype, the spontaneous collage of peeling posters, has been there for everyone's ripping off. His earlier paintings were the logical extension of what you could do with a city wall. (For the moment he's stopped the collage.) His is a literal case of bringing something in off the street but with the element of chance removed. I'm always amazed at how people come up with things. Like Jean-Michel. How did he come up with the words he puts all over everything, his way of making a point without overstating the case, using one or two words he reveals a political acuity, gets the viewer going in the direction he wants, the illusion of the bombed-over wall. One or two words containing a full body. One or two words on a Jean-Michel contain the entire history of graffiti. What he incorporates into his pictures, whether found or made, is specific and selective. He has a perfect idea of what he's getting across, using everything that collates to his vision.

Where is *Taki*. When writing or just thinking about say a movement or a style, we automatically attach progenitors of common appearance, attributes of an individual or stylistic precursor to the object of contemplation. I bought an assortment of Wild Style and Plain Style (Daze *Rocks,* etc.) Tags done in marker on a piece of newsprint at the Mudd Club graffiti show because it looked like a late 18th century Chinese literati-type thing, no, maybe more Japanese, yes Japanese. Even the names of the different

scripts are like Japanese calligraphic distinctions. (The underlying discipline is getting a character down so good you can repeat it exactly.) This of course leads one into the Zen calligraphic renovations of, say, Mark Tobey, Bradley Walker Tomlin, and just about everybody in the late '40s, early '50s. And you have no choice but to look at things this way because . . . "Does His Voice Sound Some Echo in your Heart." (Source available.) This is the double-headed monster of erudition, half seeing too much and half of it blind.

I asked Jean-Michel where he got the crown. "Everybody does crowns." Yet the crown sits securely on the head of Jean-Michel's repertory so that it is of no importance where he got it, bought it, stole it; it's his. He won that crown. In one painting there is even a © copyright sign with a date in impossible Roman numerals directly under the crown. We can now say he copyrighted the crown. He is also addicted to the copyright sign itself. Double copyright. So the invention isn't important; it's the patent, the transition from the public sector into the private, the monopolizing personal usurpation of a public utility, of prior art; no matter who owned it before, you own it now. After all, Judy Rifka did not invent the artist's dilemma. I think it's hers for the time being, however.

But influence, when we reach the peak and look down at what we've come from, see mists and clouds under mist, not the base of the mountain. As much as one would like to escape the idea of generation and decade in favor of something better, this provides an easy common way to track development. Where is *Taki?* Graffiti has been around in the way we recognize it now for about ten years and whether one considers this a long or a short amount of time (the entire High Renaissance from the painting of the Mona Lisa to the Sistine ceiling covered exactly ten years) it is already in its second generation. The transition, however, was neither sudden nor unexpected because in the past ten years we see the full exchange of graffiti from train-style to museum candidate. What's unusual is that the gallery bid was not made by the innovators but by the second generation. Graffiti has had a dyslexic development in that the second generation is capitalizing on territory pioneered by its lost innovators. More interesting and more possible to scan than the movement leading up to the picture is, rather, the picture's life after it leaves the artist. The picture must be protected. *(I'm not interested in the prestige of discovery. Part of the artist's job is to get the work where I will see it. I have to be aware of it before I can hype it. I consider myself the metaphor of the public. I'm a public eye. And I only hype the sureshot. The possibility of life without galleries? But how much time, when you really get going, can you spend crating, carrying on correspondences, hiring secretaries, negotiating your appearances in European museums, in fine all the little labors that galleries are supposed to do and that keep you away from your work? There is a place for responsible representation. This is an enormously important season in New York and to make a false step could have severe repercussions for years. In a city comprised of individuals it is important at some point to form the right connections; for your own protection you have to trust someone. Someone else has to have a personal commitment to your work so that it isn't shopped like merchandise. It's cute to be 20 and be pursued when*

hundreds of young artists are dropping their slides off at these same galleries, but the crass fast-turnover speculator's market can have a deleterious effect on an artist's future career if you don't have protection. We are no longer collecting art we are buying individuals. This is no piece by Samo. This is a piece of Samo. When the work tops a certain mark and the collectors begin their wholesale unloading of your old work in direct competition with your new work you're in trouble with no protection. Every time one of your old paintings is bought one of your new ones isn't. Plus, old more famous pictures always cost more and you don't get a cut off the resale. Of course a record price always helps an artist, but what if the artist has radically changed styles? In any event, it's clear that a good dealer is very careful about where the things land. If there's no personal commitment the chances are that the dealer-as-just-buyer will unload the stuff anywhere for the money, why not, without thought to possible repercussions it could have in the long run. Whereas if the dealer has a stake in your development they will, for example, save the best picture for a possible museum sale rather than just anywhere the cash is flowing. Besides, when anything goes wrong you can blame it on your gallery.)

"What's with art anyway, that/ We give it such precedence?" (Source available.) Most basic is the common respect, the popular respect for living off one's vision. My experience has shown me that the artist is a person much respected by the poor because they have circumvented the need to exert the body, even of time, to live off what appears to be the simplest bodily act. This is an honest way to rise out of the slum, using one's sheer self as the medium, the money earned rather a proof pure and simple of the value of that individual, The Artist. This is a basic class distinction in the perception of art where a picture your son did in jail hangs on your wall as a proof that beauty is possible even in the most wretched; that someone who can make a beautiful thing can't be all bad; and that beauty has an ability to lift people as a Vermeer copy done in a tenement is surely the same as the greatest mural by some MFA. An object of art is an honest way of making a living, and this is much a different idea from the fancier notion that art is a scam and a rip-off. The bourgeoisie have, after all, made it a scam. But you could never explain to someone who uses God's gift to enslave that you have used God's gift to be free.

What is it that makes something look like art? I can't answer that. I asked someone once why he liked Jean-Michel's work and why it was being singled out for acclaim and he said, "because it looks like art." But then again art doesn't always look like art at first. The way the space shuttle that lifts off doesn't much resemble the space shuttle as it lands.

My favorite Francesco Clemente, for instance, looks just like something in a junk store. It's even painted on one of those premade stretched canvases that are the stock in trade of amateurs. The direct and artless oil paint here, however it looks like a 13-year-old painted it, is very much about being 13. I remember still green ponds like that where I'd go . . . and the anomalous sexuality of the frog, that, no matter what sex it is, a frog's crotch, belly, and thighs, when viewed together, look like a woman. It was brought to my attention that the very thing that freezes this picture compositionally,

the flashbulb like shadow of the arm, is what keeps it from being the work of a child; children don't depict cast shadows. Clemente has frozen an instant here, and the sex object of the painting, the frog's crotch, is already underwater. This preservation of a lost moment from childhood, perfectly seen and remembered in a flash, sets this picture apart as art, yet it looks like something in a junk store.

Everybody wants to get on the Van Gogh Boat. There is no trip so horrible that someone won't take it. Nobody wants to miss the Van Gogh Boat. The idea of the unrecognized genius slaving away in a garret is a deliciously foolish one. We must credit the life of Vincent van Gogh for really sending that myth into orbit. How many pictures did he sell? One. He couldn't give them away. Almost no one could bear his work, even among the most modern of his colleagues. In the movie *Lust for Life* there is a scene of Kirk Douglas (as van Gogh) in front of *La Grande Jatte* being treated rudely by Georges Seurat. When I went to the Art Institute of Chicago to see the *Grande Jatte,* it was having a hard time competing with the white walls of the gallery. This habit of putting old pictures up against the white walls is deadly, the walls reflecting more light than the picture, but van Gogh's *Bedroom at Arles* was on the opposite wall and it was screaming at my back and I turned around and I listened. He had to be the most modern artist, still. Van Goghs don't crack. But everybody hated them. We're so ashamed of his life that the rest of art history will be retribution for Van Gogh's neglect. No one wants to be part of a generation that ignores another van Gogh. And yet looking at art history we see that these other guys were pros. They started when they were kids. They sold their work. They worked on commission. There is no great artist in all art history who was as ignored as van Gogh, yet people are still afraid of missing the Van Gogh Boat.

One of the obvious and more interesting developments that ensure a non-gallery look is the ready-made support, standardized stretchers, artist's panels: the vocabulary of the amateur. The throwaway is the handle absolute of junk, and in using the throwaway one is relieved of the responsibility of constructing one's own outside proportions. Pieces of foam rubber doors, subway cars, toilet walls make one's considerations, size of image, stroke, etc., purely inner ones. It is impracticable to enter a gallery carting the F-train. In the Mudd Club "Beyond Words" show, the most impressive work was either in documentation (photos of bombed trains) or actual junk sprayed over, not the specially-constructed-for-exhibition pieces that looked, frankly, headshop, and it seemed clear to me that whoever was going to get out of the subway was going to have to figure out a way of sophisticating their work into scale, to avoid the cloying naiveté and preciousness that inspire more condescension and "isn't that charming" than, say, awe in the viewer. I don't mean that they have to go big. The sense of scale is innate and relying on found size isn't good enough. When you cut up a roll of canvas you've made your biggest decision. Making something out of nothing is the prime artistic act and I don't mean, "Come to my studio I've got ten refrigerator doors finished."

So what defines the art look? When people say Jean-Michel looks like art, the occult significance of the comment is that it looks like our expectation of art; there is

observable history in his work. His touch has spontaneous erudition that comforts one as the expected does. In the first gallery piece I saw by Jean-Michel (as distinct from his Tag *Samo*) the observable relationship of his drawing to past art alienated me as immediately as it gratified. The superbombers in the same show, with their egregious lack of art history, had the repellent appeal that commands self-analysis in the viewer (me). I didn't want to miss the boat. When you first see a new picture you are very careful because you may be staring at van Gogh's ear. Then I stopped caring about what the pictures should (and might later) look like; regardless of what Jean-Michels look like now, they are transmitting signals that I can receive, that are useful, and finally the graffiti bomb style looks like what it's about and what it's about is packaging.

Bomb style packages itself. At its purest, it's a Tag, a perfect auto-logo, not the artists' names but their trademarks. Designer Jeans? You are buying the label proper: the essential iconic self-representation. In any event, the bombers in the show clearly defined a vernacular and made me wonder how long this would take to get off the ground in a big way. Here was, as much as it was predicated on commercial art of the past, the commercial art of the future. Here was the look of the times, this is what packaging should look like: kids would buy it. These guys should get themselves design jobs, before they get ripped off. Several have already worked their way into the applied arts, where they belong: on record covers, doing the art direction for movies, slides behind Rappers, backdrops for Breakers. Sitting by yourself on a wall is different.

An artist's attitude toward the work is telling. It's all hype, sure, but there can be quality in hype and I've caught some sleazy acts. A guy came to my house to deliver a small picture. With a friend. No picture. Broke. "Give me the money I'll come back later with the picture." "OK." While he was there he told me that he was entertaining the idea of giving Andy Warhol a picture. Well, Andy is everyone's culture parent, it's true, but I'm just a poor poet and Andy's turnover must be thousands and thousands a week in prints alone, and it hurt my feelings that I had to pay 50 clams and Andy would get it free. I could see, though, that this boy's climb was on. This was my advice: don't give him the picture. Kids do that. Trade. That's what real artists do with each other. Since Andy's a press junkie, and I see you're getting the taste, call up page six of the *Post* and get a photographer to the Factory on the "Graffiti goes legit/street kid trades Tag for Soup Can" angle. You both get your picture in the paper, Andy comes off looking like friend of youth, you get a press clipping, and it's gravy for all parties. Easily $50 worth of advice. So he left with the money, and, like copping drugs in the street, beat me for the picture. A month or so later, after some friends put on a little muscle, I finally got the doodad, and promptly gave it away. Foolish way to hype yourself. When you're climbing a ladder, don't kick out the rungs.

As much as undervaluation can kill, so can a false sense of the value of your work. Jean-Michel was advised to stop giving it away. But if your friends can't have it, why live? Overprotection is deadly; the stuff has to get out there to be seen. Making money is something between artists and their stomachs. To turn one's work into fetish that is almost indistinct from oneself, to over personalize and covet one's own work, is profes-

sional suicide. Fear of rip-off is paralysis. One is always ripped off. Keeping work a secret is the psychology of the applied artist, not the fine artist who must live in a dialogue.

Is innovation important? When one compares Jack Smith's *Flaming Creatures* with Fellini's *Satyricon* we see that Fellini manages with pasty millions a bad reproduction of what Jack Smith achieved with a sequin. The trick is to make it appear that the innovator ripped it off from you. A good example of this principle is the case of Judy Rifka's work at the debut of the '70s. Her single shapes on plywood are among the most important paintings of the decade. Every painter who saw them at the time recognized their influence. She could then be called a painter's painter if feeding ideas to others is what painters' painters do. I suspect that it would be a heartbreaking thing to watch others get credit for your invention. Her researches into Constructivist theory were groundbreaking, but a pioneer is never at a loss for uncharted territory. At the first group show at the Mudd Club I was arrested by a gray painting with a little red blob in it and some drawing on it of Patti Astor from her starring role as Vickie in the movie *Underground USA*. The application of the ground and the way that little red spot was laid on was obviously the work of an extremely sophisticated handler of paint. Although I'd never seen a Judy Rifka of this type the outline of the red left me in no doubt as to its author. There was no visible label and on inquiry I saw I was right. Hers is the poetry of New York. The joy in her new work, the reveling in these characters she creates superimposed on her earlier work, demonstrates that her concerns have dovetailed my own temporary ones: that a picture is only as interesting as its storyline. The Patti Astor iconography is supreme. One must become the iconic representation of oneself in this town. One is at the mercy of the recognition factor and one's public appearance is absolute. (The iconic representation of the artist, in manifestations from sublime to tedious, sublime in Manzoni and Warhol through the medium of Byars and Beuys, authorship as object, is the precedent for the legitimacy of the Tag. This is the individual as archetype, where we order a "Bud," where every bleach blonde is called "Blondie," the Tag name for the individual Deborah Harry. If Andy Warhol can't be used as an object lesson in how to become iconic then his life has been a waste. We become our name. I have spent my life becoming my name so that it would somehow protect the radiant child it has been created to arm.) Judy's perception of this is accurate. Her multiple-panel pictures are like movies. She has spent the last few years evolving a recognizable cast of characters to people her work. She is the eponymous lead. This is about her life in art, the frustrations and momentary ecstasies of painting a picture; the sub-mafia of artist's assistants; the domestication of pet boys refined into their specific types that become at once the original and the archetype.

Where is *Taki?* We can't escape the etymology or genealogy of art. It's not coincidental that the time that saw the gestation of graffiti was the period of gallery-referential art that flourished (wrong word) in the early '70s. During the era of the white wall, what would have the greater effect on us now was being produced by guerrilla artists

bombing trains during their mechanical slumber in Queens. Those teenage prophets are lost in the mists of their own maturity, reminiscent of the way the origin of the blues is lost, the simple expression of the individual followed much later by full-scale commercial exploitation. Contrary to the rules of modern art that hallow the innovator, here is the second generation capitalizing on the innovations of the first. The commercial exploitation of innovation is, conversely, the primary logic of commercial art.

Even as I write, the Transit Authority has unleashed police dogs around the Corona yard, so perhaps there is still hope. Bombing will continue even with the dogs. When it stops you'll know it's played out. If it's still alive the autopsy will kill it. What would happen if subway graffiti were recognized as the native art it is? Would they find *Taki* and declare him a National Living Treasure as the Japanese do their keepers of the flame of native craft? Or if the TA legitimizes it, i.e. encourages it with NEA funding? What happens when the revolution is televised? It bombs out. Train painting has already been severely formalized almost to decadence. It has become historically self-conscious, the progression from expression to Pop; there is a Campbell's Soup can train; sophistication to boredom.

Looking through the Mailer book on graffiti from 1974, was it photographer's optical bias, editorial selectivity, or was the classic period of graffiti as "abstract expressionist," '50s, as the book makes it look when compared to the Pop psychedelic '60s of the train I was on today? It looks so much more severe in the book, metallic style, less balloon style: tougher, *muy switchblade, mas barrio*. But who remembers what it looked like? I remember that it was very sexy, the feeling; I don't remember the look. Eidetic overlays can't be trusted. What did it look like?

Jean-Michels don't look like the others. His don't have that superbomb panache that is the first turn-on of the pop graffitist. Nor does his marker have that tai chi touch. He doesn't use spray, but he's got the dope, and right now what we need is information; I want to know what is going on in people's minds and these pictures are useful. This article is about work that is information, not work that is about information. No matter what the envelope looks like to get it there, the dope's inside. Let the Parisians copy the athletic togs *le look américain jeune Puma sneakaires le graffiti mignon,* style is spin-off; what the pictures are internally about is what matters. If you're going to stand up there with the big kids you've got to be heavy, got to sit on a wall next to Anselm Kiefer next to Jonathan Borofsky next to Julian Schnabel and these guys are tough they can make you look real sissy. There's only one place for a mindless cutie and it ain't the wall, Jack.

Judy Rifka and Jean-Michel Basquiat have both evolved a vocabulary, and so in his way has Keith Haring. In his gray eminence entrepreneurial capacity as director of the Mudd Club shows he was of particular importance in the general dissemination of work by other young artists, and not secondarily his own. His work is faux graphic and looks ready-made, like international road signs. This immediacy is his trump card. It is the already-existing quality of his characters that deceives one into accepting them as already there without the intervention of an individual will. But he did make them

up. In their impersonal code they are transmitting a personal narrative. The code is here to be cracked. These poor little characters wigging out from the radioactive communications they are bombarded with are super slick icons of turmoil and confusion. They are without will, without protection from impulses of mysterious source. We can laugh at their involuntary couplings and tiny horrified runnings around because we see them as we cannot see, as the fish cannot see the water, ourselves.

Of course, what artists see us as can tell us more about themselves than about us. The second-generation Pop artists who've been popping up behind their more innovative contemporaries show more interest in the(ir) poor victims of cocktail dresses, in the trials and tribulations of dressing up and going out, enchained by our fashion slavery, in Society, than in society. Chief of the Clubbists is Robert Longo who in his own way is concerned with our contemporary solipsism. As an undercover agent of the Fashion Police I am reluctantly placing him under arrest partly for being two years behind the times but really for forgetting that fashion imitates art, and that art that imitates fashion is two removes from the source. Art Deco comes after Cubism. On the subject of Troy Brauntuch, and the use of pictures, his work seems to have been anticipated by an Edwardian novelist: "'That habit of putting glass over an oil painting,' she murmured, 'makes always such a good reflection particularly when the picture's *dark*. Many's the time I've run into the National Gallery on my way to the Savoy and tidied myself before the Virgin of the Rocks'" (source available).

We need to see ourselves now but not this literally. For some reason we need recognizable evidence of our existence. Something has happened and we need, if not advice, at least a demonstration of the situation and many of our fears are in the words contained in Jean-Michel's pictures—Tar, Oil, Old Tin, Gold—we don't need a lexicon to know what these mean. These morphemes are self-evident.

> PHAEDRUS: Whom do you mean and what is his origin?
> SOCRATES: I mean an intelligent word graven on the soul of the learner, which can defend itself, and who knows when to speak and when to be silent.
> PHAEDRUS: You mean the living word of knowledge which has a soul, and of which the written word is no more than an image?
> SOCRATES: Yes, of course that is what I mean.
>
> —SOURCE AVAILABLE

I'm always amazed by how people come up with things. Like Jean-Michel. How did he come up with those words he puts all over everything? Their aggressively handmade look fits his peculiarly political sensibility. He seems to have become the gutter and his world view very much that of the downtrodden and dispossessed. Here the possession of almost anything of even marginal value becomes a token of corrupt materialism. This is the bum coveting a pair of Guston's shoes. When Jean-Michel writes in almost sub literate scrawl "SAFE PLUSH HE THINK" it is not on a Park Avenue facade that

would be totally outside the beggar's venue but on a rusted-out door in a godforsaken neighborhood. Plush to whom safe from what? His is also the elegance of the clochard who lights up a megot with his pinkie raised. If Cy Twombly and Jean Dubuffet had a baby and gave it up for adoption, it would be Jean-Michel. The elegance of Twombly is there but from the same source (graffiti) and so is the brut of the young Dubuffet. Except the politics of Dubuffet needed a lecture to show, needed a separate text, whereas in Jean-Michel they are integrated by the picture's necessity. I'd rather have a Jean-Michel than a Cy Twombly. I do not live in the classical city. My neighborhood is unsafe. Also, I want my home to look like a pile of junk to burglars.

Politics can come up by inference in a work, without pointing, without overt dialectic, by the simplest depiction (as in the case of John Ahearn) of an individual. When one looks at Ahearn's pieces, the sensibility is so specific and acute that we feel we would get the same feeling even if it looked entirely different. And his people are about feelings. I don't know how anyone who could afford them would put them in their homes. "Why would the boss want to be reminded at home of the people who keep asking him for a raise?" (source available). They are objects of devotion, of love and its ennobling ability, and are among the rarest and most moving in the history of art. They will command and dominate wherever they are hung and make all art that is anterior to it or that bears a resemblance seem like it was just leading up to Ahearn. They wipe out Segal. They make Duane Hanson seem like a snob and an insensitive jerk. When we look at Hanson's lumpen proles and their dazed stupefaction we feel superior. Ahearns, like most physically dominant art, don't reproduce well. The actual confrontation with the work is overwhelming. They are made to be seen from quite specific angles. Ahearn's work is hung high, and these people up against the white wall of a gallery are looking down at the viewer with dignity, sobriety, querulousness, perfectly precise and specific expressions, fleeting and miraculously caught. The man seems to be looking into the future with intense responsibility as the woman, with her arms around his neck, trusts his ability to confront the world. I am that woman. Ahearn works in the South Bronx the way Caravaggio probably would. He gives his models the first cast. They're poor and they're owed the grace of their image. This is no exploitation and yet I have heard him referred to (by an artist) as a racist, exploiter of his sitters. If going into the ghetto and commemorating its inhabitants is racist, then what do you call people who segregate themselves and plot genocide?

To Whites every Black holds a potential knife behind the back, and to every Black the White is concealing a whip. We were born into this dialogue and to deny it is fatuous. Our responsibility is to overcome the sins and fears of our ancestors and drop the whip, drop the knife. In Izhar Patkin's parable of racial cannibalism we see that when a man with a .45 meets a man with a shotgun I guess the man with the pistol is a dead man.

Where is *Taki?*

I think now about Anya Phillips who so briefly illuminated this fleeting world. I think about clothes worn by people so recently and yet how long ago it all seems that

Anya would show up in those cocktail dresses and of all things, a Chinese girl in a blonde wig. And now all the girls in their cocktail dresses who never heard of Anya and how quickly each generation catches the look of its creators and forgets the moral underneath. I think about how one must become the iconic representation of oneself if one is to outlast the vague definite indifference of the world. I think about how every bleach blonde is called Blondie in the street and Deborah Harry's refutation of her iconic responsibility to reify her name as a brunette. We are that radiant child and have spent our lives defending that little baby, constructing an adult around it to protect it from the unlisted signals of forces we have no control over. We are that little baby, the radiant child, and our name, what we are to become, is outside us and we must become "Judy Rifka" or "Jean-Michel" the way I became "Rene Ricard."

SCHNABEL AND BASQUIAT
EXPLOSIONS AND CHAOS

HUNTER DROHOJOWSKA, 1982

Nobody trusts an art star. Warhol created art stardom; his art was virtually indistinguishable from his manipulation of the media. That was the 1960s. Here it is the 1980s, and Julian Schnabel is the new reigning art star. Only everyone is so accustomed to deceptive labels that art-star status brings its own disadvantages.

So skepticism hangs heavy around Mr. Schnabel and his current exhibition at the Margo-Leavin Gallery. With good reason. At 31 years old, Schnabel has a waiting list of customers for paintings costing from $10,000 to $60,000. The media hype surrounding him is so thick that critic Rene Ricard went so far as to title an *Artforum* article "Not About Julian Schnabel."

[...]

Schnabel may employ unconventional materials and images but the paintings have nothing in common with kitsch or art parody. Thoughtfully, they explore high art concerns, specifically the limitations of modernism as the current academy. It is an attitude that has been coined "trans-avantgarde" by Achille Bonito Oliva, who wrote "taking a nomad position, which respects no definite engagement, which has no privileged ethic... not missing anything because everything is continually reachable, with no more temporal categories and hierarchies of present and past." In other words, declaring open season on art, the acceptance of innumerable new aesthetic tactics, the Post-modernist sensibility. Enter Jean-Michel Basquiat.

Basquiat came from New York on the shoulders of a very different personality cult from that of Schnabel. It is an exotic mythology: a 22-year-old Black street artist, also known as "Samo," bombing graffiti around the streets, is plucked from group show in alternative space by prestigious SoHo gallery. It's the Schwab's complex all over again. I don't know whether I believe any of it and, unlike Schnabel, Basquiat showed no interest in explanations. It's the paintings, however, that are important. If Schnabel's paintings are about surface aggression, formal concerns and impatient responses to a bankrupt culture, Basquiat's works are direct and furious reflections of a decadent, sadistic society.

Calligraphic markings, puerile stick figures, symbols of angels and devils, Black men and white men, teeth bared, wearing crowns, carrying scales of justice. Robotoid eyes roll back to show that the brains are fried, there is no hope there seems to be

Hunter Drohojowska, "Schnabel and Basquiat: Explosions and Chaos," *Los Angeles Weekly,* April 23–29, 1982, 19.

almost no distillation or interpretation. It is as if the city itself crawled up on these canvases and stomped around. All the clutter and sleaze, energetically defined in crayon, spray paint, Xerox and chicken feathers.

Images of oppression, apathy and insanity I would prefer them sprayed on the concrete walls of Chase Manhattan. Instead they sell for $6,000 to $10,000 at a local gallery. Isn't that ludicrous? Apparently, anything can be coopted, even mirror reflections of a society's own corruption. It is perpetual. Buying a piece of the protest absolves the feelings of guilt. Vicarious participation in the zones of psychological and societal malaise makes it possible to avoid all discomfort and still feel a part of things.

Artists as personality, as product of the gallery. None of this is new. Ultimately, only the work remains. It is the work of these very different artists that seems to be trying to say something. Something of more urgent description than Post-modernism. As Schnabel so aptly titled one of his pieces, *What Once Denoted Chaos Is Now a Matter of Record.*

JEAN-MICHEL BASQUIAT

JEFFREY DEITCH, 1982

Baseballs, boxing gloves, bananas, and buckets of tin. Crossword puzzle grids that freeze into foreboding grates. Halos that harden into crowns of thorns. Crowns that become Klansmen's hoods. Basquiat's canvases are esthetic drop cloths that catch the leaks from a whirring mind. He vacuums up cultural fallout and spits it out on stretched canvas, disturbingly transformed.

Back in the late seventies you couldn't go anywhere interesting in Lower Manhattan without noticing that someone named Samo had been there first. His disjointed street poetry marked a trail for devotees of below ground art/rock culture. Whoever this Samo character was, he certainly got around. By the time Samo the graffiti poet first appeared as painter Jean-Michel Basquiat at the Times Square Show two years ago, his knockout mural in the show's "fashion room" revealed that Samo had been absorbing much more than cultural fallout. By the age of twenty, he had already assimilated much of the vocabulary of modern painting.

Basquiat is likened to the wild boy raised by wolves, corralled into Annina's basement and given nice clean canvases to work on instead of anonymous walls. A child of the streets gawked at by the intelligentsia. But Basquiat is hardly a primitive. He's proficient but scornful of the tough discipline that normally begets such virtuosity. Basquiat reminds me of Lou Reed singing brilliantly about heroin to nice college boys.

Basquiat's great strength is his ability to merge his absorption of imagery from the streets, the newspapers, and TV with the spiritualism of his Haitian heritage, injecting both into a marvelously intuitive understanding of the language of modern painting. A news junkie could tabulate Basquiat's dozens of references to sports heroes, movie characters, and word clips from chemistry charts and atlases. An anthropologist could have a field day interpreting the artist's spectral images of shamans and voodoo effigies. The art critic could catalogue Basquiat's myriad borrowings from Dubuffet, Twombly, Motherwell, de Kooning, and Still.

Basquiat is the classic product of New York's melting pot, an astounding hybrid that could not have evolved anywhere else. His paintings are a canvas jungle that harness [sic] the traditions of modern art to portray the ecstatic violence of the New York street. His graft of street culture onto high art is a classic example of how modernism continues to rejuvenate itself.

Jeffrey Deitch, "Jean-Michel Basquiat," *Flash Art International*, no. 16 (May 1982): 49–50.

JEAN-MICHEL BASQUIAT AT ANNINA NOSEI

LISA LIEBMANN, 1982

Jean-Michel Basquiat's paintings and drawings are full of signs, written language and figures that suggest a surrealistic urban Pop. The composition of the paintings reminds one a little of Pollock's 1930s work influenced by Surrealism; the speedy lines and notations bear some relation to automatic drawing. Basquiat's art, on the whole, looks French; more specifically it suggests that particularly French esthetic that is rooted in language and linguistic signs. It is an esthetic that the Surrealists codified, that later artists such as Dubuffet improvised upon, and that the French then largely abandoned insofar as painting was concerned, leaving its development to foreigners like Twombly and Penck. Basquiat is not French, but it is to this highly cultivated, expatriated, and often self-conscious tradition that his work pertains, if at first coincidentally. His background is Haitian, and he is, or was, Samo, the New York City graffiti writer and artist par excellence, the Samo of cryptograms, crowns and copyright signs. This was his first one-man show.

Basquiat, over the last year and a half, has graduated from walls—traditionally the blackboard of history—to paper and the relative shelter of the official art-world fringe (exhibiting in clubs and other such venues), and now to canvas and a commercial gallery that places him within shooting distance of the big time. What has propelled him so quickly is the unmistakable eloquence of his touch. The linear quality of his phrases and notations, whether "graffiti" or "art," shows innate subtlety—he gives us not gestural indulgence, but an intimately calibrated relationship to surface instead. One suspects, for this reason, that his drawings would hold their own alongside the working sketches of any number of artists whose ages, reputations, techniques, and even conceptual reach far exceed Basquiat's.

The strongest presences in this show were the drawings, of which there were two kinds—those consisting primarily of written words, and those in which figurative elements predominate. Basquiat's poetic sensibility is somewhat uneven. At their best, his visual pseudo-haikus offer compellingly edgy, allusive messages like "PLUSH SAFE HE THINK," or "PAY FOR SOUP/BUILD A FORT/SET THAT ON FIRE." Others, however, like "A LOT OF BOWERY BUMS USED TO BE EXECUTIVES," point to a streak of banality. (Unlike, say, Jenny Holzer's verbal pieces, Basquiat's demand direct, earnest readings.) The other works on paper also contain words, but fragmented into letters and otherwise jumbled and dislocated to create a brightly colored collage effect. Basquiat's mock-ominous figures—ape-men, skulls, predatory animals, stick figures—

Lisa Liebmann, "Jean-Michel Basquiat at Annina Nosei," *Art in America* 70 (October 1982): 130.

look incorporeal because of the fleetness of their execution, and in their cryptic half-presence they seem to take on shaman-like characteristics. These drawings are also beautifully textured, often with layers of chalky paint that evoke the postered walls of abandoned buildings.

Basquiat's paintings have similar imagery, with a still greater emphasis on the figures. Done in bright shimmery colors punctuated with black, they manage, with their lyrical compositional rhythms, to sustain their large size without loss of eye appeal. The menacing quality of the works on paper, though, is gone, sacrificed to the new technical demands of canvas. That sense of menace was the result of frantic speed and a concomitant lack of self-consciousness—neither of which could survive this more painstaking process. Basquiat's vision is no longer solipsistic. What has replaced spontaneity is a formal sophistication, expressed in rather traditional constructs. One gets the sense that he has become aware of himself as an artist working within a world of precedent—aware, in short, that there is a particular tradition to which he might belong. While these works are not specific "hommages," they seem imbued with mid-20th-century art history: oddly enough, they give the impression of having been influenced by graffiti, rather than having evolved from it. Neither the process of emulation of other artists nor Basquiat's new state of self-consciousness seems unreasonable in a 22-year-old artist, however. These paintings are tentative rather than stiff, ambitious rather than cynical, giddy, maybe—but not complacent. If he does not give in to the glibness of which there are but hints here, he seems entirely capable of fulfilling his considerable promise.

JEAN-MICHEL BASQUIAT AT FUN GALLERY

SUSAN HAPGOOD, 1983

Fame isn't everything, but it seems to be fixated in the minds of many young artists these days. In his latest show at the Fun Gallery, Jean-Michel Basquiat was alternately repelled and attracted by it. Scrawled here and there are the names of superheroes, historical emperors, scholars, and artists, variously associated with words and images of power, violence, and mortality. Basquiat is cynical about society's values, yet hasn't given up heroes altogether—*St. Joe Louis Surrounded by Snakes* greets the viewer in Fun Gallery's vitrine. In *Jawbone of an Ass,* the list of Greeks and Romans, and the three-foot-long date (Roman numerals, of course), ridicule the concept of educational credentials. He must be mulling all of this over after having entered the Paris-Zürich-New York star circuit.

Basquiat's style is crude, raw, and dirty. Initially a graffiti artist, he still includes biting aphorisms in most of his paintings. Gut emotions lie behind the phrases and images; not the desire to make neo-expressionist commodities. Control shows its raw uneven edges and stretchers appear to be intentionally barbaric, handcrafted. This primitivism works in some places but not others. The stretchers and misspelled words end up looking too artificial, while Basquiat's painting and drawing style forcefully conveys unveiled anger, and occasional admiration. His work has been aptly compared to Twombly's, due to the feverish strokes and idiosyncratic written phrases. Basquiat has a war brewing inside him though, while Twombly is at peace.

The exhibition was of uneven quality, and should have been more selective rather than inclusive. Basquiat's best works need space around them, not filler. When this artist is hot, his work reveals painful truths with wit and urgency.

Susan Hapgood, "New York: Jean-Michel Basquiat," *Flash Art,* no. 111 (March 1983): 58–59.

BLACK PICASSO AND THE LIE DETECTOR

DIEGO CORTEZ, 1983

Jean-Michel Basquiat, the very young Black American, constructs in this detail from *Thor* an intensity of *line* which reads like a polygraph report, a brain-to-hand "shake." The figure is electronic-primitive comic. Like the monster "ghetto blaster" cassette players which link Summer New Yorkers together, Basquiat's characters portray *amplification*. Visiting again recently New York's MOMA permanent collection, I felt as though there was only one truly *free* artist of this century, Signor Picasso. All the others were proving theories about art. Picasso was only making pictures. More than that, he was having fun. Brooklyn has produced, for my eye, a Black Picasso, the rightful heir to Picasso's political bond with Black Afrika. Basquiat is yet another case in point of how *modern* the so-called primitive is.

Basquiat, americano, giovanissimo (Brooklyn, 1960), madre portoricana e padre haitiano: "FIRST AMBITION: FIREMAN. FIRST ARTISTIC AMBITION: CARTOONIST. EARLY THEMES: 1) THE SEAVIEW FROM VOYAGE TO THE BOTTOM OF THE SEA. 2) ALFRED E. NEUMAN. 3) ALFRED HITCHCOCK (HIS FACE OVER + OVER). 4) NIXON. 5) CARS 6) WARS. 7) WEAPONS . . ." Così Basquiat di sé (in "Champions" di Tony Shafrazi). Diego Cortez, per questo "Thor", "figura elettronico-primitivo-comica": "Ho la sensazione che l'unico artista veramente libero di questo secolo sia stato Picasso. Tutti gli altri dimostravano teorie sull'arte. Lui dipingeva. E si divertiva. Viene da Brooklyn un Picasso nero. . ."

Diego Cortez, "New York: Jean-Michel Basquiat: Black Picasso and the Lie Detector," *Domus*, no. 642 (September 1983): 99.

Translation of Italian text by Jordana Moore Saggese:

> Basquiat, American, very young (Brooklyn, 1960), Puerto Rican mother and Haitian father: [. . .] So says Basquiat about himself (in *Champions* at Tony Shafrazi). Diego Cortez on this [drawing] *Thor*, "an electronic-primitive-comical figure": "I feel as though the only true free artist of this century would have been Picasso. All the others were illustrating theories about art. He [Basquiat] painted. And had fun. Coming from Brooklyn, a Black Picasso . . ."

NEW KID ON THE (AUCTION) BLOCK

ELLEN LUBELL, 1984

As the Museum of Modern Art partied itself back into existence earlier this month, one of the hot young artists in its survey show proved that careers can indeed be propelled by the contents of a spray paint can. In one week, Jean-Michel Basquiat opened his first solo show at Mary Boone, appeared in the MOMA survey, received a featured rave review from the *Times,* and proved himself marketable in an even more concrete way. A 1982 painting by the 24-year-old artist, who began his public life as graffitist Samo, was offered for sale at a contemporary paintings auction at Christie's in the distinguished company of modem masters like Diebenkorn, Lindner, and Guston. Like his predecessors' work, the Brooklyn-born artist's painting of a large skull, colored predominantly in blue, red, black, and white, set a record price. Including the 10 percent commission, Basquiat's first major painting at auction brought $20,900.

The painting's seller, gallery owner Alexander F. Milliken, estimates the original price at around $4,000 (he bought it from a private collector). In only two years, then, this new artist's work has appreciated 500 percent. No wonder collectors have flocked to Basquiat's show at Boone, where they've paid $10,000 apiece for similarly sized (five-by-six-foot) new work. (Larger compositions are tagged at $15,000.)

"It's important to underprice the market," comments Boone, on what now seem like low prices for Basquiat's work. She insists these levels were set so the works will have a chance to grow in value and thus have a profitable resale potential—though for how long remains to be seen. Gallery owner Robert Miller considers Basquiat "a moderately interesting young artist," for whom time will be the ultimate test. "There are a lot of stones that flash in and out in a few seasons, though I'm not predicting that for him."

Critic/historian Robert Pincus-Witten, who bid on the painting for Emily Spiegel and accompanied her to the auction, thinks the work is "strong and aggressive and powerful, and not merely of period fascination." The auction painting is the third Basquiat the Spiegels have acquired for their extensive contemporary collection. "It's of a moment in his career that's extremely good," says Pincus-Witten, though he hesitates to say the same about the current show at Boone.

Critic Donald Kuspit's enthusiasm has also diminished. "The early work is of an original primitivism, with a graffiti heritage. The originality has quickly become stylized and somewhat self-conscious in this current show. And the colors seem inappropriate or awkward in relation to the 'drawing.'" Hilton Kramer preferred not to comment

Ellen Lubell, "New Kid on the (Auction) Block," *Village Voice,* May 29, 1984, 45.

on Basquiat, noting that he hadn't "sufficiently thought through his work." But Kramer observed, "[P]rices have never had anything to do with anything but prices."

Boone herself thinks a great artist's work has to embody universal, historical, and radical content. "Courage, almost obsession, makes an artist special, and I think he is," she maintains. Though happy with the show's success (at press time, 26 of the 29 paintings had been sold), Boone laments: "It's nice to have paintings around for unexpected people."

And what does Basquiat himself think of his meteoric rise to fame and fortune? Last seen at his customary haunt, the Odeon, the young star refused to speak to the *Voice*.

JEAN-MICHEL BASQUIAT

KATE LINKER, 1984

I've generally been a fan of Jean-Michel Basquiat, one of the few painters able to extend the graffiti issue of language from subway to gallery wall. Basquiat's lexicon of diagrams, animals, anatomical parts, and "Samo" crowns (to note only its most obvious elements) always seemed unusually broad in its conjunctive capacity; in its various manifestations, fused to a range of abstract pictorial marks, it seemed able to encompass much of the verve and jostling rhythm of the street. However, judging from Basquiat's latest one-man show, that language has become slightly strained.

My comment requires qualification, for the problem with these works lies less in their elasticity of means than in the decorative function they're increasingly forced to serve. There was too much here; often it seemed as though Basquiat had been required to churn out canvases purely through permutations and combinations of the code. At his best the artist is quirky and whimsical, but how witty can you wax in some twenty-plus variations? Basquiat's bright scumbled color grounds reek when most inspired of the subway's variegated walls, but at their worst they're chromatic slush, mere supports for the pullulating images. There were wonderful works here—an Andy Warhol-ish portrait, for example—and certain elements to my mind were new: a burning house, a fire truck, and a floral motif coexisted with the bones, machines, and so on. And throughout floated a disembodied eye, which seemed to allude both to the self—the "I"—and to the witness or seer. But one sensed little of what Basquiat is witness to, or of why it bears accounting. And one wondered why, oh why, the many works when five or six would have sufficed.

Kate Linker, "Jean-Michel Basquiat," *Artforum* 23, no. 2 (October 1984): 91.

JEAN-MICHEL BASQUIAT AT BOONE/WERNER

NICOLAS A. MOUFARREGE, 1984

It's quite absurd to speak of the decline of an artist who's barely 25. But at Boone/ Werner one wonders whether Basquiat has gone in or out. True, he always was a little hung up on elegance; that's very evident here: these are his slick designer paintings. The show is all orange juice and not enough beef. The colors are freshly squeezed and clean, the edge polished, the funk flattened.

The funkiest thing about Basquiat '84 is the occasional sneaker print on the canvas. Otherwise they're fresh out of the Factory, silver paint and all. *Brown Spots* unpeels the very banana of the Velvet Underground album cover. Warhol's formula is clear, but it doesn't work here. But then of course these paintings could make a fine set of prints.

Maybe I expected too much—definitely more than the show delivered—and I am disappointed. These new paintings are too charming, they lack the nitty-gritty hip-hop and the jagged power that his last New York show at the Fun Gallery emanated. There, Basquiat kept himself in the open with cadences that fascinated in their imperfections; the works rendered the extraction of a single meaning unfeasible. Now it is all there, all over the place, and only occasionally on the mark.

The ultimate ambiguity in Basquiat's work—and its profound appeal—lay in its manner of being at the same time ugly and beautiful, in its making the childlike undistinguishable from the superficially erudite. Esoteric allusions blended into figures contrived out of the most familiar objects of his and our surroundings. Intuitively it seemed, Basquiat discovered the emotive and vital substance that makes a work of art. It was immediately clear that Basquiat was ingenuously talented, but he was so rapidly absorbed by the cultural market that he scarcely had time to develop the life-giving zeal he both promised and conferred.

A new-found simplicity isolates complexities of the artist's vocabulary. *Eye* and *Deaf* hover dangerously in one-linear territory. *Earth* is an abstract expressionist piece, very au courant. And all in all, the works in this exhibition are at best transitional. I am not about to dismiss Basquiat. The best thing about him, his work and where he stands in his career is that I gladly hope that he'll turn around and show us work that'll make me eat my words.

Nicolas A. Moufarrege, review of the Boone/Werner Gallery exhibition, *Flash Art International*, no. 119 (November 1984): 41.

NEW ART, NEW MONEY

THE MARKETING OF AN AMERICAN ARTIST

CATHLEEN McGUIGAN, 1985

When Jean-Michel Basquiat walks into Mr. Chow's on East 57th Street in Manhattan, the waiters all greet him as a favorite regular. Before he became a big success, the owners, Michael and Tina Chow, bought his artwork and later commissioned him to paint their portraits. He goes to the restaurant a lot. One night, for example, he was having a quiet dinner near the bar with a small group of people. While Andy Warhol chatted with Nick Rhodes, the British rock star from Duran Duran, on one side of the table, Basquiat sat across from them, talking to the artist Keith Haring. Haring's images of a crawling baby or a barking dog have become ubiquitous icons of graffiti art, a style that first grew out of the scribblings (most citizens call them defacement) on New York's subway cars and walls. Over Mr. Chow's plates of steaming black mushrooms and abalone, Basquiat drank a kir royale and swapped stories with Haring about their early days on the New York art scene. For both artists, the early days were a scant half dozen years ago.

That was when the contemporary art world began to heat up after a lull of nearly a decade, when a new market for painting began to make itself felt, when dealers refined their marketing strategies to take advantage of the audience's interest and when much of the art itself began to reveal a change from the cool and cerebral to the volatile and passionate.

As an artist's hangout, the elegant cream-lacquered interior of Mr. Chow's is light-years away from the Cedar Tavern, that grubby Greenwich Village haunt of the artists of the New York School 30 years ago. But art stars were different then. Franz Kline, Jackson Pollock, Willem de Kooning and their contemporaries, all more or less resigned to a modest style of living, worked for years at the center of a small and intimate art world in relative isolation from the public at large.

But today, contemporary art is evolving under the avid scrutiny of the public and an ever-increasing pool of collectors in the United States, Europe and Japan; and it is heavily publicized in the mass media. Barely disturbed by occasional dips in the economy, the art market has been booming steadily.

As a result of the current frenzied activity, which produces an unquenchable demand for something new, artists such as Basquiat, Haring or the graffitist Kenny Scharf, once seized upon, become overnight sensations. In their circle, and certainly

Cathleen McGuigan, "New Art, New Money: The Marketing of an American Artist," *New York Times Magazine*, February 10, 1985, 20–35.

among the top artists whose careers took off a few years sooner, artists such as Julian Schnabel, David Salle and Robert Longo, annual earnings easily run into six figures. Not only are the numbers involved great—both the dollars and cents and the size of the art audience—so is the breathtaking speed with which work by a new artist can become a cultural fixture.

Take Basquiat. Five years ago, he didn't have a place to live. He slept on the couch of one friend after another. He lacked money to buy art supplies. Now, at 24, he is making paintings that sell for $10,000 to $25,000. They are reproduced in art magazines and also as part of fashion layouts, or in photographs of chic private homes in *House & Garden*. They are in the collections of the publisher S. I. Newhouse, Richard Gere, Paul Simon and the Whitney Museum of American Art.

His color-drenched canvases are peopled with primitive figures wearing menacing masklike faces, painted against fields jammed with arrows, grids, crowns, skyscrapers, rockets and words. "There are about 30 words around you all the time, like 'thread' or 'exit,'" he explains. He uses words "like brushstrokes," he says. The pictures have earned him serious critical affirmation. [. . .] His drawings and paintings are edgy and raw, yet they resonate with the knowledge of such modern masters as Dubuffet, Cy Twombly or even Jasper Johns. What is "remarkable," wrote Vivien Raynor in *The Times,* "is the educated quality of Basquiat's line and the stateliness of his compositions, both of which bespeak a formal training that, in fact, he never had."

That favorable review came after Basquiat's first solo show at the Mary Boone Gallery in May 1984. The same month, a self-portrait painted mostly in black and white—stark, powerful and sexually charged—was included in the international survey exhibition that celebrated the reopening of the renovated Museum of Modern Art. Then, proving the solid marketability of his work, a painting of his appeared for auction at Christie's spring sale of contemporary art. Painted only two years earlier and sold originally for $4,000, it fetched $20,900 on the block.

The extent of Basquiat's success would no doubt be impossible for an artist of lesser gifts. Not only does he possess a bold sense of color and composition, but, in his best paintings, unlike many of his contemporaries, he maintains a fine balance between seemingly contradictory forces: control and spontaneity, menace and wit, urban imagery and primitivism. Still, the nature and rapidity of his climb is unimaginable in another era. The audience for art is larger now than ever before, and collecting original art is no longer the sole province of the very rich. The upwardly mobile postwar generation, raised on art-history courses and summer trips to Europe, aspires to collect and has the cash to do it. Even when collectors lack cash, some institutions, including banks, now recognize their need. Sotheby's, the auction house, is willing to lend a portion of the price of an artwork at 2 to 4 points above the prime-interest rate. Given the extraordinary prices of the older blue-chip artists ($1 million for a vintage Jasper Johns, for example), a lot of collectors naturally turn to the young up-and-coming

painters whose works are still available for $50,000 and down. For many new art patrons, connoisseurship of contemporary art is a necessary part of the urban life style. They look for paintings that are esthetically aggressive, that physically assault space. The artworks offer proof of up-to-the-minute taste and have a perfect showcase in the reclaimed lofts or gentrified houses in which so many upper-middle-class urbanites now live. With all these new consumers, the number of dealers has mushroomed: in 1970, for example, there were 73 galleries listed in the *Art Now: New York Gallery Guide;* today there are nearly 450.

This expanding market for contemporary art coincided with a shift in the direction that art itself was taking. Since the late 1960s, the contemporary mainstream had been dominated by the austere constraints of Minimalism—Brice Marden's simple areas of solid color, for instance—or the cerebral concerns of Conceptualism, like the mathematical cubes of Sol LeWitt. The forms that art often took seemed to reject the collector—environmental art such as earthworks couldn't be neatly crated and taken home to hang over the stereo system. But in the late 1970s, artists such as Jonathan Borofsky, Neil Jenney and Susan Rothenberg began, in vastly different ways, to paint recognizable figures on canvas. Bold color and the sensuality of a richly painted surface returned, appealing to an art public that had been starved, baffled or bored for a decade. [...]

Not everyone in the art world is overjoyed at what is happening. Some think neo-expressionism, as much of the new work is called, is a hyped-up fad, doomed to a short life. "The new expressionism tends to be a generalized angst," says Thomas Lawson, a painter and editor of *Real Life Magazine,* a small-circulation artists' journal. "You can't tell what the artist is reacting to. It's not very reflective." Lawson thinks Basquiat is talented but that those of lesser skills will inevitably burn out.

In any case, Julian Schnabel's highly publicized success made him the first art star of the 1980s and created an atmosphere of expanded possibilities for any promising artist since. For someone as ambitious as Basquiat, high expectations are matched by the pressures of succeeding. Basquiat's sometimes-stormy rise and struggle with the art establishment provide a look at how the artists' names and their works are marketed in the art world today. His successful career demonstrates the competitiveness among dealers for artists; dealers' pricing and marketing techniques; their control of supply and demand and the importance of the European market for today's American scene. Further, Basquiat's example shows how an artist tries to create and to preserve his autonomy in this heady environment. The danger is always that the glamour and fuss will cloud the meaning of the artwork itself.

[...]

Neo-expressionist painting was having a growing impact on the SoHo scene in 1980. A trio of Italians, known as the three C's—Francesco Clemente, Sandro Chia and Enzo Cucchi, all of whom used the human figure in their epic-scaled, potent canvases—had major exhibitions in New York at the Sperone Westwater gallery. People began to talk about waiting lists for certain hot new painters. That summer, the emerging artists of the punk and graffiti underground had their own art event, at a

rather unusual alternative space. In a former massage parlor near Times Square, a loose confederation of artists from the South Bronx and the Lower East Side collaborated to turn the dilapidated structure into "a sort of art funhouse," as Jeffrey Deitch put it in *Art in America*. Crammed with a crude, energetic assortment of drawings, posters, low-budget scraps of film, exotic fashions and sculpture, the "Times Square Show," as it was called, had a trashy exuberance that lived up to the neighborhood [. . .] Basquiat had contributed to the exhibition by covering an entire wall in splashes of spray paint and brushwork. "A patch of wall painted by SAMO, the omnipresent graffiti sloganeer, was a knockout combination of de Kooning and subway spray paint scribbles," wrote Deitch. That was Basquiat's first press notice.

[. . .]

One day in 1980, Diego Cortez, who had been following Basquiat's work with interest and had begun to act as his agent, brought Jeffrey Deitch to the tiny tenement apartment on the Lower East Side where the artist was then living with a girlfriend. The first thing Deitch saw was a battered refrigerator that Basquiat had completely covered with drawings, words and symbols, the lines practically etched into the enamel. "It was one of the most astounding art objects I had ever seen," says Deitch. Scattered all over the floor of the apartment were drawings on all sizes of cheap paper covered with images and smudged with Basquiat's footprints. "Jean kept on working as if we were interrupting him," Deitch remembers. He picked out five drawings made on typing paper, and paid $250 in cash for them. This was probably Basquiat's first sale; Cortez had to remind him to sign the drawings.

In January 1981, Cortez put together a show called "New York/New Wave" at P.S. 1, the alternative-space gallery in Long Island City, Queens. Although the show featured work by graffiti artists, Cortez also showed some paintings by Basquiat, mostly minimal—lines of crayon or paint drawn in childlike fashion on unprimed canvas. The message was clear: though Basquiat had cruised onto the underground art scene on the crest of the graffitists' new wave, his work was distinctly different.

[. . .]

For the Italian painter Sandro Chia, then new to America, Basquiat's paintings captured the spontaneity and "emotional reality" of the city. The paintings were full of disparate elements that somehow worked together, though there was no apparent system linking them—"just like New York," notes Chia. He commended Basquiat's work to the Italian dealer Emilio Mazzoli, who promptly bought ten paintings for approximately $10,000 and set a date on the spot for Basquiat to have a show at his gallery in Modena. That spring, Basquiat went to Modena (his first trip to Europe), made a few more paintings there and had his first one-man show.

[. . .]

Annina Nosei, who had opened a gallery in SoHo in 1980, invited Basquiat to join it in September 1981 at the suggestion of Sandro Chia. He needed money and a place to paint. He was given cash to buy supplies and the use of the gallery's basement store-

room as a studio. "He had, perhaps, seen in me the mother type," says the dealer, who suggests that that image led to later conflicts.

Basquiat worked feverishly, encouraged by Annina Nosei, who sometimes brought collectors down to the basement while he painted. Now rich with color, his paintings began to evolve from the sparer look of the work in the P.S. 1 show: large, primitive figures were filled in and articulated with raw detail and there was less of the all-over drawing of symbols and words. [. . .]

The dealer was said to be selling canvases by Basquiat at a brisk pace—so brisk, some observers joked, that the paint was barely dry. Basquiat says he did not always feel the paintings were finished. Meanwhile, the basement-studio arrangement was gaining certain notoriety. Critic Suzi Gablik called it "something like a hothouse for forced growth," and Jeffrey Deitch referred to it when he reviewed in *Flash Art* magazine Basquiat's show at Annina Nosei's in March 1982. Deitch wrote: "Basquiat is likened to the wild boy raised by wolves, corralled into Annina's basement and given nice clean canvases to work on instead of anonymous walls. A child of the streets gawked at by the intelligentsia. But Basquiat is hardly a primitive. He's more like a rock star (He) reminds me of Lou Reed singing brilliantly about heroin to nice college boys."

What press attention Basquiat received from the show was mostly favorable, and one month later, when he made his West Coast debut with a show at the Larry Gagosian Gallery in Los Angeles, William Wilson of *The Los Angeles Times* wrote, "We are simultaneously convinced that he is a tough street-voodoo artist and a painter of astonishing precocity."

Basquiat began chafing in the hothouse. With a second show scheduled at Mazzoli's in Modena, he went to Europe again. "They set it up for me so I'd have to make eight paintings in a week, for the show the next week," says Basquiat. "That was one of the things I didn't like. I made them in this big warehouse there. Annina, Mazzoli and Bruno were there." ([Bruno] Bischofberger was now representing him in Europe.) "It was like a factory, a sick factory," says Basquiat. "I hated it." The Mazzoli show was canceled. After that episode, Basquiat decided to quit the Nosei gallery. "I wanted to be a star," he says, "not a gallery mascot." He returned to the basement, where there were about 10 canvases, most of them unfinished, that he wanted to get rid of. In a classic display of his notorious temper, he slashed them, folded them, jumped on them and poured paint on them. Although the dealer says that Basquiat simply was destroying work that he didn't intend to finish, the art world buzzed about the incident. "Jean-Michel more than anyone has made a success story out of scandal," says Cortez.

"Jean was ungrateful," Annina Nosei says. She believes she was responsible for launching Basquiat's career internationally. "But he was sweet in the end." According to the dealer, their relationship as artist and dealer was not clearly severed that fall. (As with most galleries, there were no contracts involved.) Many months later, in February 1983, she mounted a one-man show of his work while he was cementing a relationship with a new dealer.

[. . .]

Late that winter, he spent time in Los Angeles, preparing for a second show at Larry Gagosian's gallery and working at the dealer's house. Again, he felt pressure and regrets now that paintings were released that "I didn't want released." A number of dealers had been courting Basquiat in New York. ("It's no honor," he says wryly. "There're more dealers than artists these days.") One was Tony Shafrazi, an Iranian who had been interested in showing Basquiat in his SoHo gallery as early as 1981. In 1974, he had sprayed red paint on Picasso's *Guernica* when it still hung in the Museum of Modern Art. [. . .] Ironically, Shafrazi has helped legitimize the graffiti-art movement by becoming the dealer for such artists as Haring, Scharf and Ronnie Cutrone, but, partly because of the Picasso incident, he got nowhere with Basquiat. Others who had discussions with the artist included Metro Pictures (Robert Longo's gallery) and the Monique Knowlton Gallery.

[. . .]

When Basquiat finally did join a new gallery, he went straight to the major leagues and, to the surprise of some of his friends, joined Mary Boone. "I wanted to be in a gallery with older artists," he says. And he wanted to insure, as well, that any lingering associations with graffiti art were severed.

Mary Boone, perhaps reacting to a spate of publicity about herself and her business style, now is careful to avoid any appearance of hype and self-promotion. In fact, initially she regarded Basquiat with caution, she says, vaguely repelled by all the fuss. "There was a period of about a year and a half, when it was impossible to wake up in the morning and not hear about Jean-Michel Basquiat," she says. Introduced to him by Bischofberger, she says she waited until she became convinced that Basquiat had staying power. "I'd walk into some collector's home and there would be something by Jean, hanging next to Rauschenberg and Stella," she recalls. "It looked great. It surprised me." [. . .]

Though Annina Nosei encouraged his high productivity of paintings, since Basquiat joined Mary Boone's gallery he has tended to hold on to pieces longer and rework them more, with his new dealer's blessing. "His output is high," she says, "but he's getting more critical of what he holds back." He estimates that last year he finished 30 or 40 paintings. Yet any danger of the market's being flooded with Basquiats is off-set by the fact that Mary Boone represents the artist jointly with Bischofberger—they split the standard dealer's commission of 50 percent—who takes much of the work to Europe to sell. The Boone gallery's promotion of Basquiat has been low key; he didn't have a one-man show there until last May, his second season with the gallery, and the dealer charges $10,000 to $25,000 for a painting, a purposeful underpricing, she says.

For the most part, Basquiat is pleased, although the pricing of his work does bother him. Paintings by such Boone superstars as David Salle sell for $40,000 and up. "David Salle's been at it longer, I know," sighs Basquiat. "I should be patient, right?"

Down on the Lower East Side, in a small newly renovated building that he rents, which is owned by Andy Warhol, four big empty canvases are waiting for the touch of

Basquiat's brush. The vast whiteness of the canvases seems a world away from the dirty walls on which he first exhibited his work. Downstairs, a friend named Shenge, who acts as major domo, has his quarters, while the floor above the studio is Basquiat's domain, the place he keeps his VCR and a hundred or so cassettes of his favorite movies. In one corner is the director's chair the late Sam Peckinpah used while shooting *The Wild Bunch* and *The Osterman Weekend*.

Basquiat takes a tube of paint and squirts a blob of brown pigment directly onto the virgin canvas, which is actually white paint spread over a work he never finished. It gives the surface a layered texture he likes. In fact, many of his paintings deliberately expose the buildup of layer upon layer, the shadow of an earlier version poking through. He "edits" by painting over. Under his brush, a brown face soon begins to form on the canvas. "The Black person is the protagonist in most of my paintings," he says. "I realized that I didn't see many paintings with Black people in them." Some of the figures are taken from life. For example, one powerful painting was drawn from a sad old man in a wheelchair whom Basquiat saw on a neighborhood street last spring. "He would say to the young Puerto Rican helping him, 'Put me in the sun, put me in the sun.' He was a Cajun, from Louisiana. I gave him some money and he wanted to hug me, to pull me in. I pulled back." But the vision is transformed in Basquiat's bold painting. It is saturated with red, the wheelchair like a throne, the old man almost a god whose head is a primitive mask, frightening and defiant.

Flash of the Spirit: African and Afro-American Art and Philosophy, a book by Robert Farris Thompson, lies on his studio table, and thus it raises the question of influences on his art. His early rendering of primitive faces was instinctual, he says; he studied African masks later. He has never been to Haiti and there was no Haitian art at home when he was growing up. But his early inspirations include the master employer of primitive impulses, Picasso. Actually, says Basquiat, "I like kids' work more than work by real artists any day."

"Since I was 17, I thought I might be a star," Basquiat says. "I'd think about all my heroes, Charlie Parker, Jimi Hendrix I had a romantic feeling of how people had become famous. Even when I didn't think my stuff was that good, I'd have faith." In the last year or so, Basquiat has established a friendship with an artist who probably understands the power of celebrity better than anyone else in the culture. Once when he was trying to sell his photocopied postcards on a SoHo street corner, he followed Andy Warhol and Henry Geldzahler into a restaurant. [. . .]

In his show at Mary Boone's last spring, Basquiat exhibited a painting called *Brown Spots*. It is a portrait of Warhol as a banana, a sly reference to an album cover Warhol once did for the Velvet Underground. That same spring, in "The New Portrait" show at P.S. 1, a portrait appeared by Warhol of Basquiat, an acrylic and photo-silkscreen painting, with Basquiat posed like Michelangelo's David.

Their friendship seems symbiotic. As the elder statesman of the avant-garde, Warhol stamps the newcomer Basquiat with approval and has probably been able to

give him excellent business advice. In social circles and through his magazine, *Interview,* he has given Basquiat a good deal of exposure. Though Warhol teases Basquiat about his girlfriends, Basquiat finds the time to go with Warhol to parties and openings. In return, Basquiat is Warhol's link to the current scene in contemporary art, and he finds Basquiat's youth invigorating. "Jean-Michel has so much energy," he says. One acquaintance suggests that the paternal concern Warhol shows for Basquiat—for example, he urges the younger artist to pursue healthful habits and exercise—is a way for Warhol to redeem something in himself. When asked how Warhol has influenced him, Basquiat says, "I wear clean pants all the time now."

Through a series of working collaborations in the last year, the relationship between them has flourished. First, at the suggestion of Bruno Bischofberger, they made a suite of 12 paintings with Francesco Clemente, with each of the three artists working in turn on each canvas. [. . .] Thirty of these collaborative works, now owned by Bischofberger, will probably be exhibited in Europe. "I'd run out of ideas," says Warhol, to explain his involvement in the project.

But after Basquiat's show at Mary Boone last spring, some critics complained that his recent work had grown too soft, too slick—and one blamed the long shadow of Warhol. "They're fresh out of the Factory," wrote Nicolas A. Moufarrege in a blistering review in *Flash Art.* "These new paintings are too charming, they lack the nitty-gritty hip-hop and the jagged power that his last New York show at the Fun Gallery emanated." Geldzahler saw the influence, too, but not as a negative force: "The paintings had a lot of Warhol, but that's to be expected. Basquiat seems to be able to keep his balance." The artist himself is pleased with the work. "I think I'm more economical now," he says. "Every line means something."

Success, however, and sudden public scrutiny, can mean an end to artistic experimentation in private. [. . .]

"People think I'm burning out, but I'm not," Basquiat insists. "Some days I can't get an idea, and I think, man, I'm just washed up, but it's just a mood." What doubtlessly helps Basquiat and many other artists to transcend the pressure is simply their own deep drive to make art. "There's really nothing else to do in life, except flirt with girls," he jokes, then gets serious. "If I'm away from painting for a week, I get bored." Even when he had been painting at Warhol's studio during the day, or if he had been out in the evening, he would often go home alone to work. He still keeps rock-and-roll hours. "He'll run in here in an $800 suit and paint all night," says his friend Shenge. "In the morning, he'll be standing in front of a picture with his suit just covered in paint."

Meanwhile, once a painting is finished, it takes on a life of its own. As part of the never-ending marketing effort, paintings by Basquiat and other hot young art stars are always being crated and shipped. They are flown to an exhibition in Europe, a dealer on the West Coast, a collector's home. This winter, Basquiat's work was shown at London's Institute of Contemporary Arts, more work was part of a show of young Americans at the Museum of Modern Art in Paris and new paintings were unveiled for sale

in Bischofberger's Zurich gallery. And as the paintings move, their price escalates. [Eugene] Schwartz remembers the three Basquiats he bought less than four years ago. "They were just lying there," he says. "No one wanted them. Now you can't get them." Geldzahler says he has been priced right out of the Basquiat market. And while the art public waits to see Basquiat's newest work at his next New York show, next month at Mary Boone's, his early paintings continue to pump life—and money—into the market. The works surface at auction, as five did at Sotheby's last fall, or perhaps are quietly bought from a private collector by a dealer who will hold them and wait, dazzled by their meteoric appreciation. The artist, who does not profit from resales, may be off at work in a new direction, but even the paintings he said goodbye to long ago keep going round and round in today's heady art world.

ACTIVATING HEAVEN
THE INCANTATORY ART OF JEAN-MICHEL BASQUIAT

ROBERT FARRIS THOMPSON, 1985

The young man found the village of heaven very pleasant, full of movement and fine things.

<div align="right">Mbala myth, Zaire</div>

These stones represent your talents. They are rough. Take them, wherever you are, and place them in water. Immersed, they will become smooth and beautiful. Make your life fluid, make your life pure, or you will remain rough like these stones out of water. And pray, in creole, to these stones each day, asking of God the right decisions.

<div align="right">Afro-Louisiana ritual, New Orleans, 1971</div>

Bara orun gboun okin, a be gija [When heaven hears the visual voice of the feathers of the peacock, heaven is activated].

<div align="right">Yoruba saying, Nigeria</div>

The art of Jean-Michel Basquiat leads modern painting to a new intensity. He transforms paint into incantation, print into a mode of meditation. His colors frequently take on initiatory force. They are drenched with affect. His technique is auto-bricolage. This means all the bits and pieces he brings together in his compositions—painted writing, acts of erasure, spirit-heads, figures, diagrams, letters—he makes himself.

Afro-Atlanticist extraordinaire, he colors the energy of modern art (itself in debt to Africa) with his own transmutations of sub-Saharan plus creole Black impress and figuration. He chants print. He chants body. He chants them in splendid repetitions. Being is double. "Facts" spoken in one painting may recur within another. Forms are riffed and riffed and riffed again until he penetrates, for instance, the *weight* of crocodile, the *weight* of spirit-head, the *weight* of elephant, the *weight* of carbon, and the *weight* of alphabetic writing.

And once he has done this, intuited the mass and density of different icons through near-spiritualized repetition and ecstatic focus, becoming one with their pulse and weight, he moves on to other visions, in a process of ceaseless self-astonishment. The result, dare I characterize his meteoric rise, is a heroic embodiment of the impact of

Robert Farris Thompson, "Activating Heaven: The Incantatory Art of Jean-Michel Basquiat," in *Jean-Michel Basquiat,* exh. cat. (New York: Mary Boone Gallery and Michael Werner Gallery, 1985).

Afro-Atlantic civilizations on the world, at levels of spiritual insight and artistic ecstasy. He will force a new criticism upon us. He will bring into being a tough-minded and multilingual creole discourse on form and meaning appropriate to New York today, not only as center of world art but also as unique gathering place of Black Puerto Ricans, Haitians, Dominicans, Jamaicans, Colombians, and Brazilians, defining a not so secret African city. With his rise and with this context, it seems to me, the vanguard of Western art and Afro-Atlantic visual happening now are becoming one. This has enormous implications. One can well imagine that.

And one can well imagine how pleased I was to meet Basquiat at his studio near the Bowery in New York one afternoon in January 1985. Reggae blared from everywhere. Young women and young men were bustling about, preparing canvas, nailing hand-some slats of thick brown wood into supports for future works. Jean-Michel met me dressed in blue, his tie boldly striped dark blue and red. Speaking with quiet authority, no hesitation to his words or gestures, he led us to a dining area and served us star apples from Jamaica and glasses of excellent red Bordeaux. He introduced us to a personable young Black man in gentle dreadlocks named Shenge, an assistant in charge of general calm and cool.

I turned to a painting and asked a question. Basquiat: "It's a young Black kid, on the street." We were momentarily interrupted by an Australian reporter on assignment. And then he showed me another portrait and rewarded me with a different kind of comment: "No, that's *back* orange, that orange is not going to be there when the work is finished—it's just to focus the woman." In all this space the walls were clearly the work-intensive area. They supported painting after painting, collage after collage, in various stages of completion. I was particularly impressed with a composition with Egyptianizing figuration, dark heads with almond bird-slant eyes, making Basquiat the spiritual brother of Aaron Douglas, the great Black muralist of the thirties, who painted with an optic partially and deliberately deriving from the Nile. Wherever the eye roamed there was discovery: painted print proclaiming BO DIDDLEY, blues guitarist, and a diagram of an arm, ancient Egyptian, inscribed INNER ARM.

Because he is Black and because he is young some critics will not be able to resist the temptation to link Basquiat to the more obvious forms of New York Black and Puerto Rican street art. However, Basquiat, though fiercely loyal to his local Black friends, remains an avatar of a universalizing vision, multiply Black, Afro-Atlantic. In his hands Black vision becomes at once private, public, didactic, playful, serious, sardonic, responsible, and above all, deliberate.

In search of understanding that deliberate vision I returned to his studio on a snow-lit night in February. The door opened. This time Basquiat was upstairs. There I was summoned. I found him in his bedroom, seated on a king-sized bed before which blazed a giant television, animate with sci-fi images. Behind the screen, in the tricky distances of a complex room, were a library, a painting by Shenge, more books, a metal cabinet gleaming with the shade of green which enlivens *Frogmen,* a painting of 1983, and a dividing wall in gleaming black ceramic tile.

The television gave back images of burly American police staring with incomprehension at absurd extra planetary crystals, then firing bullets through transparent beings.

Through all this nonsense Basquiat's Afro-American intonation cut like a fiery knife through butter: "YO! ROBIN!" And Robin, a Black friend, brought refreshments. On a table, by a book of Warner Brothers movies, were color proofs of collaborations, dating from 1984, between Andy Warhol and Basquiat. I looked at one of them. Warhol had taken a photograph of a map of China, colored it yellow and edged it in red. Basquiat cut across this map with a Black figure that stared intently with yellow eyes. I turned the photograph over. Suddenly I was backstage in a theater of names. There, clearly in Basquiat's hand, were various trial titles: *Big Pagoda* (crossed out), *Pest* (crossed out), *Pagoda Point* (crossed out), *Diameter of the Pest*. The last bore no erasure and was presumably the working title. Now I had a clue to one of the reasons behind his frequent citations of TM (trademark) and © (copyright) in proximity to crossed-out words. For just as women and men playing jazz, with an attack principle of performance, bring weak notes up to the level of strong notes in what Gunther Schuller memorably terms "the democratization of the beat," so Basquiat, as part of his trademark, his copyright, demands that we consider the equal potency of statement and erasure.

Negative gesture can be just as important as positive thrust. Indeed I got a richer sense of this characteristic of his work when I showed Basquiat a quick sketch I made of one of his works, *Revised Undiscovered Genius of the Mississippi Delta,* a painting of Southern images, and all he would say was, "You forgot to cross out CATFISH." (On the other hand, TM and © have other meanings in other paintings: "Everything is so commercial.") While thinking these thoughts it occurred to me that someone inevitably will write a book linking this aspect of Basquiat's style with Jacques Derrida's writing on the nature of erasure. It also occurred to me that I will not be that person.

I looked up and there was Warhol, a walking laser in white hair and black clothes, intent upon a single purpose—getting Basquiat into the taxi waiting to whisk him away to Keith Haring's benefit exhibition for African relief.

I followed in my car with Basquiat's three friends. They laughed at the condition of the streets, the sliding of the automobile. Suddenly I thought of Nigeria, where once a person said to me, "The road is gallopy, of course." We slid into place in front of the gallery. Pictures by various artists hung on three walls, and Keith Haring stood in middle foreground, friendly and lithe. Warhol disappeared. Basquiat, presently, was ready to go home.

We returned to the studio together. His three friends immediately seated themselves tightly together in a quasi-huddle, and began to laugh and joke. Basquiat turned on Black classical music, also known as jazz, very sonorous, very pure. In the midst of all this, Jean-Michel began quietly to work. From cabinets full of already prepared drawings, of reptiles and printed letters and words and many other things, he selected an image of a crocodile, very narrow and very emerald. He pasted it onto an already

half-completed composition. And another crocodile. And another. He stepped back to consider the effect of the repetition. Then he tore into two pieces (a three-dimensional erasure) another drawing of a crocodile and let one half fall to the floor. The other half he pasted, just so, at the summit of an apparently abstract shape in gray.

As he worked, sometimes he took humor from his crew of three, sharing in their joke, and sometimes not. He responded to the jazz music in similar fashion, sometimes moving to the pulse, sometimes not, attentive to his pasting, standing, regarding, dipping into further drawings, making collage again. The composition began to gleam. Reptile green. Teeth against crimson. Everywhere fragments of painted print. For instance, he pasted on a fragment emblazoned with repeated X's and Y's. It came to rest in the middle of the composition. He found more pieces, identically decorated, and sited them, on a diagonal, left through center to lower right.

The blues appeared in certain portions of the work. There were painted titles like *Hardluck Blues,* recalling Sonny Boy Williamson's *Bad Luck Blues,* and a telling citation of Robert Johnson's masterpiece, *Hellhound On* Characteristically, the rest of the title (*My Trail*) was torn off. Basquiat's blues typography, at once interruptive and complete, makes visual Black song, with equivalents to pause, shout, spacing, and breath. Basquiat broke off work and rested in a chair. And then he went upstairs, turned on the television, and began another composition, a drawing of a mask in his collection, the same mask which appears in the lower right of *Wicker* (1984).

Basquiat's Sudden Entrance, or the Shape of Creole Time

Basquiat and his spiritual allies, Keith Haring and James Brown, do not so much portray historical progression in their works (though to be sure their styles, as in traditional art, are changing) as they proclaim a right to step out of time in the Western mode and into the timelessness of mind in its natural state. In other words, they are attracted to the traditionalist power to keep things prior and strong.

Keith Haring, for instance, has become a traditional art style of one. His flying saucers, barking dogs, angels, erotica, and innocence are all filtered through an instantly recognizable set of athletically silhouetted, moving forms. His forms are as confident and self-proclaiming as figurations from a San Blas *mola* from Panama, as tensile and wiry as the warrior god of old Dahomey rendered in schematic iron or brass.

Similarly, James Brown has seen things Picasso never saw, dreamt things Derain never dreamt—that Kongo blade—encrusted images of jurisprudence (called "fetishes" by modernist philistines) could, if drawn lovingly enough, if lived with enough, become affectionately quotidian. Brown's blade-images, amazingly transformed, take on the body and the stance of the guy next door without losing any of their power. It is one thing to commit an affinity with an ethnographic museum object in search of stylistic freshness and intensity in Paris at the turn of the century. It is quite another thing to live with the traditional forms, love them, stay with them, dream with them, until they are as natural to the touch and as amiably potential as cadmium yellow or

the laughter of a friend. There are no styles in competition here, African versus modern, and certainly no ugly attempts to read the whole of African creativity as if it were a footnote to modern Western art and sculpture.

The fires that fuel Afro–New York painting are real and active in the cauldron of Basquiat's colliding styles. In that fire we read the power to force future historians to redefine the terms of developmental discourse in modes culturally appropriate to what has really been going on in the largest city of the world, and in the works of Basquiat's brothers and sisters in key areas of the Afro-Atlantic world, over the past one hundred years.

For instance, if Saamaka and Njuga maroons (runaway slaves) in the rainforests of Suriname moved from a tropical archaic to a tropical baroque in less than one hundred years, if jazz leapt from plainsong to symphony, as it were, in less than sixty years, if New York subway graffiteros made, *in less than ten years*, an effective transition from tentative wall scrawls to polychrome interlace of complexity comparable to Irish or Islamic art, then something remarkable is going on here.

I think we are witnessing the revelation of an unsuspected form of artistic developmental time, running faster than ordinary Western archaic-classical-hellenistic, or early-middle-late, time clusters divided into sixty years of innovation and sixty years of consolidation. The hurtling velocity of jazz or New York graffiti history derives its energy from the collision of more than two traditions.

Jazzmen brought their intracultural stylistic development to a quicker effervescence through knowledge of already worked-out problems and solutions in parallel "folk," "popular," and "classical" traditions. This creates, I suggest, the shape of creole time. And by "creole" I mean something concrete and specific: a visual tradition emerging from three or more sources. Myriad African and Western and even Amerind sources fused in the formation of Suriname art in northern South America. It is a known fact that major jazzmen listen with affection and a pointed interest to everything.

Similarly, the genius of Jean-Michel is founded precisely on that ability to move in creole time. Various formal languages serve as auxiliary rockets behind his signature figurations, his spirit-heads and crossed-out words and columns of painted diagrams and legends. Each gesture is, potentially, a fugitive from a different art history, adding to his incredible velocity.

His famous frantic year, 1981, in the basement of a SoHo art dealer may have sharpened his compositional skills and honed his lines and colors. But he went into that room with variations and traditions already alive in his mind: street, museum, and a lot in between. Donatello and Jacobo della Quercia are unthinkable except in terms of the incredible ferment and complex styles of late Gothic times. So the diverse street rhythms and latin color preferences and other influences peculiar to the rich ethnicities of New York, as well as the advances of Pollock, de Kooning, Kline, Rothko, Gottlieb, and Warhol, fused in Basquiat's magnificent mind.

The stamp of genius is recognizable even in the embryonic works of his early years. An untitled composition dated 1980 that was published in *New York Magazine* docu-

ments his entrance into world art history with floriate color intact, vitalized body in outlines of Central African/Afro-American ecstasy, fingers, wide apart, held high above the head like flags of joy and spiritual attainment, like saying *mmmhnnnn* and meaning yes at the highest levels. In fact, the letters *m* and *n* appear in this painting, dragon seeds of future armies of rhythmized citations of alphabetic script. In *Dangerous Waters Poisonous Oasis* (1981) (plate 2), Basquiat holds his incantatory fire while working his way through various modernist modes of handling paint and the magical relation of paint to diagram, figure to lettered forms, is shy and tentative. In this painting there are arrows, five A's and an O, Alpha and Omega. Note that Alpha, freshness, origin, out numbers Omega in a way that belies the apparent bleakness of the composition.

Then, suddenly, in 1982–83, all hell breaks loose. In works like *Charles the First* (1982) color, figuration, and alphabetic writing are released in equal potency. The mnemonic and phonetic motors of the computer age, the keyboard instruments of instant retrieval, the fetters, the signs, are used, as it were, as another kind of brushstroke. This recalls hip-hop, the current New York musical revolution, at once funky and futuristic, in which certain rap recording studios have computer programmed the sounds of industrial noise, James Brown horn "hits," and many other pulsations for instant playback on electronic "pianos."

Basquiat is not afraid of the hi-tech wolf. He sees enormous fun and potency. He sees ways of rhythmizing phonetic writing, literary allusion, and chromatic structure, all at once. The trick is having the beat, the visual metronome sense, to keep these various tendencies going all at once. As if that were not enough, Jean-Michel, like Walter Benjamin before him, has the ability to work with "texts" that for most of us would not constitute texts at all. "The ancients may have been 'reading' the torn guts of animals, starry skies, dances, runes, and hieroglyphs, and Benjamin, in an age without magic, continues to 'read' things, cities, and social institutions as if they were sacred texts" (Peter Demetz, in his introduction to *Walter Benjamin's Reflections: Essays, Aphorisms, Autobiographical Writings,* New York, 1978, p. xxii).

Unlike Benjamin's reported situation, New York has magic. It is as near as the corner botánica; the Afro-Hispanic herbalistic stores that dot the city are filled with protective Yoruba beads, Kongo-derived twigs for spiritual medicine, and mystic sprays and oils. How strange that thus far, so far as I can see, no one has considered the mystic implications of Basquiat's hair—"high tension wires" believed to place their wearer in touch with the Lord. It does not matter if critics and dealers ignore his hair. The fact remains that every time Basquiat so much as suggests a self-portrait (there are instances) his dreadlocks instantly creolize acrylic and crayon as surely as his mixing of star apples and Bordeaux creolizes the entertainment of his friends. There is a marvelous *Self-Portrait as a Heel* (1982) where the artist's dreadlocks are cast in ironic juxtaposition with Ace combs. The combs bear plastic teeth, which, however commodified and copywrite, are inadequate to the spiritual turmoil of his hair.

Traditional Black respect is an equation in which well-being equals salutation. Basquiat lives in a confluence of cultures (Haitian, Puerto Rican, Mainland Black)

where it is considered odd, if not ominous, not to take time to greet one another energetically on the street. Basquiat shows, in his painting, analogous respect for art historical erudition, New York painting of the past twenty years, animals, newsprint, and African and Afro-American experience.

Because he slaps palms with time, time slaps back affectionately. Something like Barnett Newman chromatic abstraction, shorn of ritzy glints and sectionings, provides a color-field over which, in *Masonic Lodge* (1983), Basquiat makes gold and white notations of eyes and jaws and cranial structure. Here, in a sense, he is painting his way through medical school and loving every minute of it.

Frogmen, from the same year, unites incredible conceptual and stylistic jumps. We move from turquoise water filled with the outline of an octopus and a face, to a panel with Italian art police and a mask, to notations of deadly asbestos and a legend, "broken stones time," which is thereupon incredibly visualized by notations that read like neolithic attempts to copy the outlines of clocks on stones, "breaking" the regular outline of the familiar alarm-clock disk in a manner that is very likely the creolizing of modern form with styles borrowed from a very ancient source (I say this on the basis of testimony, from the artist himself, to which I will refer in a moment). There is a submarine in turquoise waters, releasing crimson bubbles that stream upward like red pearls. There is also a cat's head on a tower and a marvelously contrastive passage of warm browns and comic-strip whites loaded with citations.

One of these citations includes an enigmatic phrase

MⱭRIƧ

That mirrors portions of the same phrase in *Notary* (1983) and then again, the clearest reading, in *Chinese* (1983):

ƆVMⱭRIƧ

What is this phrase and why does it occur in three different paintings? I asked Basquiat. He astonished me by leading me to his source, Burchard Brentjes's *African Rock Art* (New York, 1970). At page 88, we find an illustration of an image of St. George with a Greek caption. The work, evidently to be dated late Roman/Early Christian era, is attributed to the Blemyans, nomads of the Eastern Desert of Africa.

The Blemyans are amazingly relevant to a young Black artist poised on the cutting edges of high, industrial, and neighborhood art and so clearly free-thinking that none of these worlds is enough to contain him. Brentjes writes that, "among these tribes of Upper Egypt, waging constant frontier war against the Romans, old African traditions

and Egyptian religious forms, Christian concepts and classical stylistic motives were mixed together." This sounds like New York art, 1985. There is more: "They painted on the rocks Egyptian gods, the ox with the ancient Libyan decorated horns, inscriptions in Greek, horsemen with an attitude of St. George, Bedouin cameleers and old Arabian altars, all side by side. The graffiti scratched on the rocks by the Blemyans all over Upper Egypt present a similar picture: they are the badges of clans or tribes."

Much of this sounds like Jean-Michel, and we can well imagine why he was attracted to this passage in African rupestral art history with its accompanying sign and why he copied out that sign. But copied out is actually inaccurate phrasing. Transmuted out or anagrammatically juggled might be closer to the truth, however strained the phrasing. Basquiat is allergic to the obvious. He does not passively cite Andre Pierre or paper his collages with Taino petroglyphs simply because his blood unites Haiti with Puerto Rico. Instead he takes an intra-African visual creole, Blemyan. He takes its graffitized Greek writing and then deepens the creole process by transforming it into Latin characters. Here is the Blemyan:

And here is what he does with it:

ɔVMЯRIϚ

That there could be so much invention in microcosm prepares us for large-scale explorations of paint-language and print-language and diagram-language, coded for deliberate creolized confusion. Basquiat seems to get his time and drive not from a dial with two arms and twelve numerals or from a square pulsing digital reminders, but from a kaleidoscope of various art histories and philosophies, filled with their fragments and shaken like a maraca to the beat of reggae, jazz, salsa, or blues.

A Galaxy of Recent Works

The multilingual brilliance of Basquiat's style, his personal creole, expands and contracts in recent works according to situation and inspiration. Faster than we can generalize he can shift into another mode while not seeming to shift at all. For instance, in *Emblem* he drops the use of repetition for intensification of motif and simply combines, in his own words, "a head, an elephant, and 'Italian' writing." The writing and the elephant shoot through one another in a manner recalling that classic trait of African rock painting, nonexclusivity of the image, or vivid use of the palimpsest. Three languages in contact, African, Italic, and Afro-American, result in a gentle improvisation.

Flexible is an iconic statement wherein a powerful figure names his wonder-working propensities with a gesture of geometry. As Basquiat recalls, "The arms took a nice shape, they fused together in a single curve." The X-ray vision of lungs and stomach imply dissection and arrest of motion, which makes the shift to mystical fusion of the arms memorable and striking. Art, magic, and science combine from their different sources. They fuse again in *Gold Griot* (plate 30), where vertebrae are medically examined, the power gesture, right hand up, left hand down, calls on God and the horizon in a manner that has come down to the Black Americas from ancient Kongo on the body line, and the marvelous golden slats, transmuting bone and armature to currency, honor image with aura.

The sign system shifts in *Wicker,* which according to the maker was painted at different times over a single week. Again, nonexclusivity of the image, in the manner of African rock art, allows a camera to share space with an elephant. The menacing icon in the wicker basket is a bit of visual "signifying" against a woman who criticized the work in progress. She criticized the wicker basket and the emergent fronds, saying Basquiat had no business painting *nature morte.* He solved that problem. Floral arrangement gives way to incarnation of the spirit but, all the while, Basquiat reminds us that the original setting was his house, where the mask in the lower left is actually to be found and where one uses the "bell" and the "buzzer," the telephone and the front door, as modern means of communication and relationship. There are other elements but Basquiat did not decode them, leaving the world to make what it will of bone and vertebrae set against brilliant orange.

Basquiat lives in a seething world of plural images and he is attentive and responsive to what he sees. Contingency and surprise present Basquiat, sometimes, with a precipitate as potent as handbooks of art and models. During a conversation in February he told me this story: "I opened my door one morning last spring at about ten o'clock and there was a guy in a wheelchair, with the chair placed to get the maximum amount of sun. He tells me he's a Cajun and behind him was his friend, sniffing glue. He was begging money and giving it to his friend. I gave him what he wanted and he tried to draw me close to him in gratitude. But he was dirty and I refused. Later I felt bad about that. He clearly was a visitation and I had to deal with him in paint this is one of the few paintings where I am purely documentary."

Basquiat builds this remembered scene in a painting titled *His Glue-Sniffing Valet.* By naming, and by physical gesture, he ennobles the trickster at the door and his associate. He builds an area of Rothko-like red which simultaneously puns on the sun of that unusual morning. Note that the companion is virtually idealized by the acrobatic perfection of his gesture. The Cajun himself has amazing prong lips. Trickster before our door, however pitiful or weak, conceals an accuracy of speech, measuring the level of our generosity.

I conclude these remarks on Basquiat by considering a crystalline painting of marvelous perfection, *Gua-Gua* ("Bus" in Afro-Caribbean Spanish), which in some respects reminds me of the Mbala vision of the village of heaven where everything is

flash and movement and fine things. But heaven is also blood descent. Here we meet Basquiat's maternal Puerto Rican grandmother, waiting under her parasol for a bus in Brooklyn. The bus appears, driven by a Black man. It is green, "an older color, an institutional color from the fifties, when buses were light green in Brooklyn." Above, he pictures an elephant trumpeting against a space in red, to add a note of Africa but, also, because "it is my favorite animal to draw."

Under the bus appear SPIN, DRYING, AGITATE, STRETCH, the play of one kind of mechanical motion ("these are washing-machine instructions") in proximity to another. Perhaps because this painting is unusually charged with a language of affection Basquiat suddenly began to speak about the implications of the language of print in his painting. He calls these citations "facts." This is what he said about them when we talked in January: "I get my facts from books, stuff on atomizers, the blues, ethyl alcohol, geese in Egyptian style. I get my background from studying books. I put what I like from them in my paintings. I don't take credit for my facts. The facts exist without me. A menu in a restaurant is a painting. I may not eat the roast pig on the menu but its legend remains before me. The menu, the text, go on without me."

The word *carbon* is perhaps the most challenging "fact" of this painting. Thirty-two times at least it appears in this painting, and by this Basquiat asks a question: "I want to see how Black they think this painting is." Whatever our judgment, *carbon,* the "fact," Blackness, the Afro-Atlantic art tradition, goes on forever.

ART: BASQUIAT, WARHOL

VIVIEN RAYNOR, 1985

Last year, I wrote of Jean-Michel Basquiat that he had a chance of becoming a very good painter providing he didn't succumb to the forces that would make him an art world mascot. This year, it appears that those forces have prevailed, for Basquiat is now onstage at the Tony Shafrazi Gallery at 163 Mercer Street, doing a *pas de deux* with Andy Warhol, a mentor who assisted in his rise to fame.

Actually, it's a version of the Oedipus story: Warhol, one of Pop's pops, paints, say, General Electric's logo, a *New York Post* headline or his own image of dentures; his 25-year-old protégé adds to or subtracts from it with his more or less expressionistic imagery. The 16 results—all "Untitleds," of course—are large, bright, messy, full of private jokes and inconclusive.

Reported to have been a serious but at the same time amusing collaboration, which was staged in Warhol's studio and on his canvases, it is a historic event for having inspired him to put brush to canvas for the first time since 1962. Nevertheless, the old master's contribution is hard-edged as if printed, except in the piece involving blue and yellow bowties, untied, Felix the Cat and two Black female nudes. Felix and the ties are his, of course, but so, too, is the only slightly less primitive of the nudes. Basquiat continues to alternate between African themes, inherited by way of his Haitian background, and cartoon figures, but the social comment implicit in his previous work has now become obvious and rather silly. Working on Warhol's headlines about a subway fire and the F.B.I.'s pursuit of a Soviet agent, he washes red over them so that the letters ASS stand out, and presses the point by adding the black shape of a mule. Elsewhere, he embellishes a headline about a subway fire with dead cartoon figures, one in a sweater with stripes that are melting, and, across the banner about a socialite falling to her death, he scatters Spider-Man heads.

Art historians may be able to relate this manifestation to the automatist poetry that certain Surrealists wrote collectively. They may even invoke Robert Rauschenberg's erasure of a de Kooning drawing and the mustache Duchamp added to a Mona Lisa reproduction. Anything is possible. But here and now, the collaboration looks like one of Warhol's manipulations, which increasingly seem based on the Mencken theory about nobody going broke underestimating the public's intelligence. Basquiat, meanwhile, comes across as the all too willing accessory.

Offered in the same spirit as the show's poster featuring photographs of the artists dressed as boxers at the ready, the verdict is: "Warhol, TKO in 16 rounds."

[...]

Vivien Raynor, "Art: Basquiat, Warhol," *New York Times*, September 20, 1985.

ANDY WARHOL / JEAN-MICHEL BASQUIAT

ROBERT MAHONEY, 1985

The Andy Warhol/Jean-Michel Basquiat collaboration at Tony Shafrazi is a success. Each artist draws the other out of himself, which can't hurt either. Blurbs tell us this is the first hand-painted work by Warhol since 1962; Basquiat has averted a complete decline into Cartesian copies of David Salle, so apparent in his last exhibit at Mary Boone. *Zenith* focuses on the blazing red logo of the TV company as painted by Warhol. The letters burn across gap-toothed headlines from the *New York Post*. A subtitle, "200 Trapped," underscores the menace in both. These Warholian stamps are given human figure by Basquiat. *Zenith* jolts one figure into becoming a red-shirted Superman. Black letters become heads wearing dark hoods. The T in "trapped" trips up a yellow figure, sprawled out like a corpse. A primitive figure in the corner makes *Zenith* his pyromaniac's torch. No one can be sure of the ultimate meaning, but letter and figure coherently relate.

Arm & Hammer (plate 26) prints lifted from the famous box show up, but other boxtop ingredients do not translate onto canvas (as they might have had Basquiat worked alone). Warhol enlarges the stamp until it takes on almost totalitarian significance. Block letters from the *Post,* again gap-toothed to knock out meaning, or to give the paper its shaky subway read, march under the Arm & Hammer. Here again Basquiat selects pithy figures to give meaning to the signs. A green snake slithers across the letters, and masked heads peer out of the headlines gaps like terrorists.

In *Negress* the Warholian element (we guess) is a color stencil of Felix the Cat. Two stamps make light of a Basquiatian woman, stamped as "negress" where other artists might have been inclined to paint breasts, and outlined in barbed wire. A second Felix the Cat guffaws and pops his eyes out, looking between the legs of the woman, resonating on a slang that goes back at least as far as Manet's *Olympia*. This whole scene is put on another edge by its landscape: undone formal neckties, blue ones, weave in and out.

A few of these works, of course, do not gel. That is the hit-and-miss nature of any collaboration. But a striking coherence in relation between Warhol's cool prints and Basquiat's hot neo-expressionist figures often enough creates a whole greater than its parts to call the collaboration a success. This cross-generational collaboration might be taken as a treaty by the Hot and the Cold, signed to establish a tepid peace for the mid-1980s.

Robert Mahoney, review of *Andy Warhol/Jean-Michel Basquiat* at Tony Shafrazi Gallery, *Arts Magazine* 60, no. 3 (November 1985): 135.

ANDY WARHOL / JEAN-MICHEL BASQUIAT

RONALD JONES, 1986

It has all the charm of a Roy Orbison/Billy Idol concert. It promises to make history, but at everyone else's expense. Like much of the art produced nowadays this exhibition swells with revivalism, but with the difference that Andy Warhol and Jean-Michel Basquiat recall those occasions, instead of styles, when art history was charged with a particular kind of significance. In the yellow advertisement for this exhibition the two artists stare out at us, dressed in boxing trunks and gloves, appropriately attired for this larger than life occasion. The ad implies that the two are at odds, ready to do battle along the lines of Ingres and Delacroix jousting in that well-known cartoon. Inside the gallery a different tone prevails.

The canvases were traded back and forth between the two artists over a period of time (perhaps to recapitulate the gentle relationship of Homer's Mentor and Telemachus?). This is not quite the rapport between the artistically deflated Verrocchio and his startling pupil Leonardo. These and other art-historical caricatures waft through these paintings so casually that they relinquish any pretensions to seriousness. Of all the pantomimes the most melancholy portrays Modernism as a contender, vital and fit. Its spent energy, originality, and its agent, the avant-garde, have been propped up as witnesses to this May-December marriage of artistic generations. Ironically, it is a gesture that counters its own best interests because the result pictures Modernism as hopelessly compromised, chasing its own tail.

At first, these paintings vacillate between amplifying the generational differences that naturally occur between artists and animating a version of the Surrealist *Cadavre Exquis.* They come to rest, slumping at the end of the tradition of great teachers and promising students, as a version of the "Grandfather Theory." Like Ingres' *Troubadour* pictures which permitted him to disavow his debt to David by falling for the virtues of Raphael, Basquiat cancels (graffitis over) Warhol's influence with an expressionist tag. These paintings indiscriminately footnote artistic collaboration and generational differences to valorize their investments in the stuff art history is made of: *they build in greatness.*

Typical is the large canvas picturing two red steaks Warhol has quoted from the generic supermarket ad. Necessarily, the older artist has worked on the canvas first: the means to prepare the monument for his successor to efface with exaggeration; the maneuver, one imagines, to set the Wölffliniar pendulum in motion. The painting gives no suggestion that Warhol returned to it after this initial contribution. Basquiat

Ronald Jones, "Andy Warhol/Jean-Michel Basquiat," *Arts Magazine* 60, no. 6 (February 1986): 10.

then was permitted free play to conjure yet another art-historical episode: turning Rauschenberg's *Erased de Kooning* inside out. Basquiat reinvents one steak as a dog and the other as a ski slope. An alligator superimposes, binding the K-9 and K-2 steaks together, thus mixing art-historical metaphors to make canceling and claiming history the same expression.

At the bottom of the painting Basquiat has scrawled two labels: "MUY FAO" and "HYBRID." The claim is for a third meaning, a third thing. Basquiat proclaims a faithfulness to the "progress of art" and the heterogeneous result of mixed origins, of different species. His is the ambition to make something yet unthinkable, something that may first appear unfamiliar, even unlovely. Basquiat's ambition is to revive the anthem of the avant-garde. It is the familiar cadence that taps out the rhythm meant to rally Modernism's faithful by staging something of a Mystery Play around the corpse of the avant-garde and the spirit of originality.

All in all, these pictures are attempts to infuse anemic Modernism with the vigor and radicality it once could boast. Their effect is to etch Warhol's profile alongside those of de Kooning and David in the Pantheon of great masters where, art history tells us, significance is measured by the degree of a legacy's repudiation. These pictures, then, are reduced to soap operas of art history whose mission is to quell the rumors about Modernism. From this vantage the Warhol-Basquiat exhibition is little more than an anthology of picture perfect, textbook models for "the significant moment in art history." That is to say, these paintings seem to be more about making the proper appearance than about making paintings. They are, in fact, a merger, a managed consolidation of two parties' best interests. The streamlining effect allows them to work together toward a common end, feigning traitorousness at the proper cues.

History repeats itself, again. Whenever stale and anachronistic art-historical models are used indiscriminately, stylistic relativity is suspended and distinctions diffused. These paintings recite the gestures of "collaboration" and "cancel" so that their meanings elide; and in turn, art-historical metaphors, types, cycles, and personalities collapse into one another. The result willfully admits that Basquiat's expressionism is simply another way of saying Warhol's commercialism while the effect is a highly stylized but all-too-familiar veneer that resonates with a shrill stylistic false-heartedness.

JEAN-MICHEL BASQUIAT

BARRY SCHWABSKY, 1986

It is amazing (and some will find it depressing) that we are already being given a historical view of a 25-year-old painter: Basquiat's paintings from way back in 1982. But the idea is not as farfetched or presumptuous as it may sound. These paintings look better than most of the work in Basquiat's last show at Mary Boone, and we (and he) would do well to use the opportunity to understand why.

The limits of Basquiat's technique are clear. It can accommodate any kind of mark that remains fixed at the level of inscription, that does not inject any ambiguity into its status as an addition to a surface to which it remains flatly parallel, but it is incapable of assimilating anything suggestive of representational space. So far, no problem, because Basquiat has a fairly large vocabulary of inscriptive marks at his disposal, and he usually lays them down with remarkable authority, energy, and elegance. But because these marks are by their nature self-contained entities, they can be combined only by simple juxtaposition. Composition becomes arbitrary and piecemeal. Notice how limited Basquiat's repertoire of images is, and how even these tend to look like mere pretexts for covering the support in a tastefully aggressive way. Basquiat's technique dooms him to be a decorative painter, although in 1982 he was a very good one.

But Basquiat is very ambitious. He needs to be more than merely decorative, and so, as his career continues, we see him flailing more and more against the limitations of his technique. At an age when most aspirants are still drifting among received styles, he has created a distinctive one of his own and is also discovering (as he hadn't three years ago) that it is a trap. His escape will depend on his ability to open himself up to a more sophisticated concept of space, one that allows for description as well as inscription. In doing so, however, he risks losing the graphic freshness he has until now been able to count on. He might, on the other hand, be able to renew it.

Barry Schwabsky, "Jean-Michel Basquiat," review of the Annina Nosei Gallery exhibition, *Arts Magazine* 60, no. 6 (February 1986): 129–30.

The following section of this book presents interviews that I have done over several years with people who knew and often worked with Jean-Michel Basquiat. Since all the interviews were done by me, I think it might be useful to give some idea of how they were conducted and of some of the challenges that research on this artist entails.

Growing up in Nashville, Tennessee, I did not have much, if any, exposure to the world of contemporary art. There were no major art museums, and my public-school art classes were not particularly memorable. My singular experiences with art were portraits and landscapes that I encountered during school tours of Andrew Jackson's Hermitage—the seventh president's home in Nashville. I first encountered the work of Jean-Michel Basquiat in the 1996 film *Basquiat,* which I had rented from my local Blockbuster video store when I was in high school. Like many, I was initially fascinated by the personality of the artist and his associations with celebrities (David Bowie played Andy Warhol in the film, after all). But more importantly, the paintings were unlike anything I could have imagined art to be. Basquiat's work seemed messy, complicated, and nothing like the examples of art I had seen before. I entered college the next year, and while I did not initially set out to study Basquiat (or even art history), I cannot deny that this initial curiosity led me to enroll in an art history course as my first elective in my sophomore year.

Years later, when I set out to write a doctoral dissertation on Jean-Michel Basquiat, the first challenge I faced was access to the physical works, considering that there were very few in public collections. It is estimated that Basquiat completed nearly eight hundred paintings over the course of his career. But 90 percent of those works were (and still are) held in private collections. This meant that I had to find a way to make some new friends.

In the summer of 2002, while visiting my mother in Basel, I attended the annual Art Basel fair and came across the booth of Bruno Bischofberger, who had been Basquiat's dealer. I immediately began to take extensive notes on the works, which puzzled nearly everyone around me. But I didn't have much time—day passes to Art Basel were far outside my graduate school budget.

When I returned to Art Basel the following summer, I worked up the courage to approach the Bischofberger gallery booth attendants, asking whether I might be able to travel to Zurich to see more works by Basquiat. They suggested that I wait to speak with the gallery director, Tobias Mueller, who would return that afternoon. When Tobias did return, he seemed confused but intrigued by my request and invited me to visit the gallery the following week. And so started a collaboration that would make my project possible.

During that summer, I traveled from Basel to Zurich and spent entire days in the sunlit, top-floor conference room of the gallery, where I had a direct view onto Lake Zurich, and where Tobias would leave paintings for me to study that I would never have seen otherwise. He walked me into the storage rooms of the gallery and quizzed me about Basquiat's work. During my second summer of research, Tobias showed me the gallery files, filled with scraps of notes, exhibition announcements, reviews, and a few previously unseen photographs. He promised to introduce me one day to Herr Bischofberger, but he also gently warned me that any serious research project on Jean-Michel Basquiat would be difficult. Why not just wait thirty years, he asked, when these works would eventually move into public collections?

Whether it was a curiosity for him or a distraction from the routine of the gallery's schedule, Tobias was a constant interlocutor for me during the summers of 2003 and 2004. It was an incredible experience (I think for us both) to finally talk with someone with a deep knowledge of Basquiat's work. Most of all, Tobias's kindness and generosity reaffirmed my commitment to studying this artist and provided a buffer to the difficulties I would later face during the course of my research.

In 2006, as I moved into full-time research on the dissertation, I encountered another significant problem: the lack of archives and primary documents related to the artist. At that time the Smithsonian's Archives of American Art (the first stop for any serious art historian writing a monograph) held almost nothing related to Jean-Michel Basquiat. What I had was a biography by Phoebe Hoban, a painstakingly assembled collection that I had put together of nearly every review published during the artist's lifetime, a library copy of Basquiat's two-volume catalogue raisonné published by Enrico Navarra in 2000, and a few essays from exhibition catalogues (most of which, luckily, I had collected before they went out of print or had received as gifts from Tobias). While comprehensive, this collection of primary and secondary sources did little to help my analysis. For the most part, the exhibition reviews published during Basquiat's lifetime repeated the same mythologies and stereotypes that I wanted to avoid in my study; and the essays from exhibition catalogues provided broad overviews of the major themes but not particularly detailed analyses. And so I set out to interview the close friends of the artist in order to gain insight into his working processes. I wanted to know whether some of the ideas I wanted to explore in the dissertation could be supported by firsthand accounts.

My first interview was in 2007, with Michael Holman, whom I had cold-emailed after finding his address via a web search. During a September heat wave, I flew from my home in California to New York and found my way to Michael's apartment in Yorkville. We spoke for nearly three hours—about Basquiat, about music, and about the downtown scene of late 1970s New York. Michael told me about meeting Basquiat (then SAMO) and the founding of their short-lived noise band Gray. Michael and I talked about hip-hop, especially its emergence in the early 1980s, and the relationship of this new music to Basquiat's own aesthetic sensibility and techniques of sampling. In the course of the interview, I found evidence for my own ideas

about Basquiat's relationship to music and began to formulate new questions as well. Clearly impressed by my enthusiasm and knowledge of the topic, Michael picked up the phone at one point to call Fred Brathwaite, whom I had tried unsuccessfully to contact using a phone number given to me by a friend. (Read: He hung up on me. Twice.) Michael implored Brathwaite to talk with me while I was still in town. This is what I heard:

> I'm sitting down here with a young lady from Santa Clara, a young sister who's doing her doctorate thesis on Basquiat. I've just been sitting with her for the last two and a half hours and she knows her shit.
> [*Pause.*]
> . . . Based on my conversation with her, I decided that I would give you a call and try to at least see if you have time to give her an audience. . . .
> [*Pause.*]
> I don't know if you have time, um, but can she call you? I don't know what number she called you on or whatever.
> [*Long pause.*]
> Yeah, right.
> [*Long pause.*]
> Yeah, but she had no other way to reach you. I think she couldn't . . . yeah.
> [*Pause.*]
> Right.[1]

I have no way of knowing what happened on the other end of that phone line, but Brathwaite clearly was not going to talk to me. At the tail end of our conversation, Michael informed me that he was attending a birthday party that evening for Suzanne Mallouk—Basquiat's former girlfriend—at the newly opened Bowery Hotel. Would I like to join him?

Most likely because Michael had vouched for me, Suzanne spoke to me that night about Jean (as they all called him) and gave me her email address. I flew back to New York seven months later to interview her in a coffee shop (not a location I would now recommend for the sake of recording quality, but I was new to this). We spoke for nearly an hour, and Suzanne told me about her experiences living with Basquiat and watching him work. She recounted his initial anxieties surrounding his success and its attendant wealth, as well as his frustrations when fame did not insulate him from racism. I asked her about Basquiat's familiarity with and knowledge of African diasporic practices and was disappointed when her recollections did not match my presumptions. And, in fact, my interview with Dr. Robert Farris Thompson four years later, as I revised the dissertation into my first book, *Reading Basquiat: Exploring Ambivalence in American Art,* did little to prove that Basquiat publicly discussed practices of the diaspora. According to Thompson, he and Basquiat talked mostly about "girls and things like that." Nevertheless, as Thompson explains, we can still see the ways that Basquiat absorbed and appropriated the histories of Africa and

African America (from texts such as Thompson's own *Flash of the Spirit*) into his paintings and drawings.

I sought out Thompson for an interview between the dissertation and the book, and I did the same with Bruno Bischofberger, who had remained elusive throughout the dissertation process. I finally met him in the summer of 2010, when I returned to Switzerland for the Basquiat retrospective curated by Dieter Buchhart. I attended the exhibition preview at the invitation of Mueller, chatted with Suzanne Mallouk and Michael Holman, and survived a very awkward run-in with Fred Brathwaite. The following day, Tobias picked me up at the Zurich train station and drove me over to Bruno's home for my long-awaited interview. There I interviewed Bruno for more than an hour, as he paged through his heavily annotated, dog-eared copy of my dissertation, asking questions and clarifying certain errors I had made. Bruno also gave me his perspective on Basquiat's early career and on the 1980s art market. When we took a break, he walked me into his kitchen and made me a cheese sandwich. We went out afterward for lunch with Tobias, and Bruno then took me out to his warehouses, where he had started building a private museum for his collection.[2] I stood, transfixed, in front of Basquiat's multipaneled painting *Touissant L'Overture versus Savonarola* (1983), installed along one long wall, until he told me it was time to go.

The remaining interviews in this section—with the curator Dieter Buchhart, the dancer and friend of Basquiat Erika Belle, and the curator Diego Cortez—were all specifically conducted in preparation for the publication of this book. Using the credibility I had established with my first book, I sought out these voices in particular to give additional context to my earlier interviews, filling out different aspects of Basquiat's life and legacy. Buchhart is a prolific curator and has been the chief organizer of eight Basquiat exhibitions since 2010 (with another three—in Melbourne, Montreal, and Mexico City—being planned as I now write).[3] I particularly wanted to talk with him about his experiences studying Basquiat, about how he sees his own role in shaping the discourse around Basquiat, and about his thoughts regarding future directions for Basquiat scholarship. Diego Cortez, by contrast, was the *first* curator to include Basquiat's work in a public exhibition. In his interview, he focuses on Basquiat's early career and on his own role in helping to shape it. For his part, Cortez spoke only briefly about the downtown art scene of Basquiat's moment. And that is addressed in depth by the interview with Erika Belle, who, as a dancer, is well positioned to give a firsthand account of the downtown clubs of the late 1970s and early 1980s and who, as a close friend of Basquiat's, was intimately familiar with his studio on Great Jones Street.

Taken together, all the hard-won interviews published here give a very full picture. But I should also add that I was not able to interview all whom I had hoped to in the course of this project. Some hung up on me; others simply never picked up the phone.[4] One subject interviewed for my dissertation suddenly (and unfortunately) refused permission to publish his interview in this book. Such is the work of the contemporary art historian, and I imagine that others may someday succeed where

I have failed. Nevertheless, this collection of interviews by those who knew (and know) the artist best at least provides a point of entry and an opportunity to think deeply about Basquiat, his working process, and his legacy.

Notes

1. Michael Holman, interview by the author, New York City, September 8, 2007.

2. Bischofberger purchased a dozen warehouse-style buildings on a factory site in suburban Männendorf, just outside Zurich. In 2015 he opened a new 250,000-square-foot space on this site; it was designed by his daughter Nina Baier-Bischofberger and her husband, Florian Baier.

3. *Basquiat* (Basel: Beyeler Foundation, 2010); *Ménage a Trois: Basquiat, Warhol, Clemente* (Bonn: Bundeskunsthalle, 2012); *Basquiat: The Unknown Notebooks* (Brooklyn Museum, 2015); *Jean-Michel Basquiat: Now's the Time* (Toronto: Art Gallery of Ontario, 2015); *Jean-Michel Basquiat: Words Are All We Have* (New York: Nahmad Contemporary, 2016); *Basquiat: Boom for Real* (London: Barbican, 2017); *Jean-Michel Basquiat I Xerox* (New York: Nahmad Contemporary, 2019); *Jean-Michel Basquiat* (Paris: Fondation Louis Vuitton, 2019); *Jean-Michel Basquiat* (New York: Brant Foundation, 2019); and *Jean-Michel Basquiat: Made in Japan* (Tokyo: Mori Art Gallery Center, 2019).

4. I tried unsuccessfully for many years to secure interviews with Basquiat's US-based dealers. My attempts included phone calls, faxes, letters, and at one point flying across the country to sit for several hours in the lobby of one New York gallery without acknowledgment.

MICHAEL HOLMAN

2007

JORDANA MOORE SAGGESE: In the process of writing this dissertation, I started to see throughout the paintings that there were more jazz references in Basquiat's paintings than just those in *Charles the First* and *Horn Players*. There are tiny little references within separate canvases that point particularly to this era of music, and these references are not simply jazz. Basquiat is painting bebop, which is completely different. Bebop has its own interests, protocols, and strategies that are very different from the whole [general] history of jazz.

MICHAEL HOLMAN: This [discussion about jazz] is an interesting thing. You're reading all this stuff and then saying, "Wait a second. I'm seeing a different pattern." I actually like what you're saying, when you said you started to notice that it was more bebop than it was jazz.

JMS: I'm not looking necessarily at just the iconography—you know, every time he writes "Pree," he's talking about Charlie Parker's daughter. I'm looking at how musicologists understand improvisation—how these long compositions are constructed.

What jazz provides for me is a structure for looking at these paintings that are so different from any other painting that is going on or that has gone on.

MH: You know how Jean painted, right? Or how he drew?

He would oftentimes watch TV or write down things that were interesting, or he might be listening to a jazz album—he would listen to Coltrane, Miles Davis, or Charlie Parker—and then write down their names or "Cherokee." I'm sure that for a lot of the references he made, he didn't particularly like that music. He liked the sound of it; he liked the idea of Charlie Parker, this antihero who died of heroin, and he saw himself going down that same road.

Michael Holman arrived in New York in 1978 and met Jean-Michel Basquiat in April of the following year at an event Holman organized (along with friends Fab 5 Freddy and Stan Peskett) in a downtown loft dubbed the Canal Zone party. Basquiat invited Holman to form a band that night, which—with the addition of Shannon Dawson and later Wayne Clifford—would become the noise band Gray. Basquiat played synthesizer, bell, and occasionally a guitar with a metal file run across its loosened strings. Band members employed unconventional materials (tape, files, tape recorders) and capitalized on ambient sounds and reverb. Gray performed from 1979 until 1981 in well-known downtown venues such as the Mudd Club, CBGB, and Hurrah's.

This interview has been edited for clarity and for length and is reproduced here in a naturalized transcription.

To say that Jean was this big jazz aficionado listening to his jazz is bullshit. He listened to everything. Our music, for example, with Gray was sonic landscapes. It wasn't even music sometimes; it was sound sculpture. We weren't trying to do jazz. Jean would pick up the clarinet or whatever, but it was all about not being musicians. We were taking instruments and using them as means of improvisation and abstraction, really. If you were a great musician, then you couldn't be in Gray, you weren't allowed in the band.

For example, I played percussion. I would rip masking tape off the drumhead, tape a microphone to the drum head, tighten it up really tight and put it through a Marshall amplifier I had set on heavy reverb[eration], and then put masking tape down on the drumhead and record that sound. Then I would pull the masking tape off. So it's a Yoko Ono approach, taking instruments and deconstructing them.

If you ask me, in creating these canvases and these images, one of Jean's most singular objectives is obfuscation—to fuck with people's perception of what he is doing, to fuck with people's assumptions about him as a Black painter, as a Black artist. Referencing other Black artists and then drawing these really obvious conclusions that are so far afield. His referencing jazz is so obvious that it's actually very contextualized, very hidden, and very subtle, and very something else.

JMS: I agree. From my perspective, the jazz references were just a jumping-off point. Jazz itself is a type of subversive culture. Playing with your back to the audience. Putting little riffs in that only [some] people would know. Charlie Parker put [the notes from the] Woody Woodpecker [theme into his live improvisations].

MH: Well, yeah, it's improvising standards. Or improvising clichés.

JMS: So when Jean-Michel put Leonardo drawings into his paintings, people like Robert Hughes have in the past read them as an inability to come up with something new.[1] But people don't look at Charlie Parker that way. If he's taking a piece of the "Habañera" from *Carmen* and inserting it into a solo, people say, "Wow, that genius." How do you take something from Bizet's *Carmen* and transpose it onto this chord structure and these harmonic regressions to make it fit in a split second? I think that is something that is shared between [Parker and Basquiat].

MH: Well, I can say this about Jean, being the biggest Black art star, you can't get away from racism and American racism when you are dealing with Jean, and that cuts both ways.

JMS: You have so many years of art history trying to Westernize everything. "He's just like Jackson Pollock. He's just like Cy Twombly. He's just like Jean Dubuffet." They are all white Europeans, and, yes, they are very influential, but what do you do with his Blackness? They [scholars and critics] usually say, "Oh, well, it's primitive and it's chaotic." The reason that jazz makes such a connection is because they are very similarly misread [by outsiders]. The paintings may look chaotic—the same as if you had never listened to a live performance of bebop, it may sound chaotic. But as you start to listen or to look, it makes sense.

But let's talk about Gray. Can you describe how the band started?

MH: I can tell you exactly how it started. On April 29, 1979, Fab 5 Freddy, my friend Stan Peskett, and I threw a party at Stan's loft, which we called the Canal Zone. Stan and I were old friends. I knew him from San Francisco. I was in this band called the Tubes.

Stan lived in New York since '74, and I'm like, "I'm coming to New York," in '78, so I go, and I'm hanging out with him all the time while I'm working at Chemical Bank as a credit analyst, as a junior executive. We are doing all these performance pieces and art pieces. I read in the *Village Voice* this little blurb about this guy Fab 5 Freddy and the Fabulous Five, five rap artists, and there is contact information. I contact him, and he comes over—he and I and Stan would smoke a joint, hang out, and talk about where we were going to [party].

Canal Zone was a party organized by me, Freddy, Lee Quiñones, and some other guys whom I forget. It was a huge thing; it had to have been the first party of what would become the hip-hop scene. But, of course, that term—*hip-hop*—wasn't even used until around 1982. There were flyers and art and invitations; it brought the downtown art scene together with the uptown. There was rap and a little bit of music. I remember deejaying.

I'm going around with this camera. I'm "Word Man"—that's what Stan used to call me, because I was always fascinated with words and wordplay. I'm interviewing people, and I'm doing this really stupid thing. I've just come from California and, you know, I'm not a New Yorker, I'm not hip. I was nervous, and I did this thing, which I think was passive-aggressive, where I would interview people, ask them questions, and put the microphone in front of their face so they could answer the question, but before they could answer, I would pull it away and then ask another question.

JMS: [*Laughs.*]

MH: Right. Why did I do that? Maybe I did that because I wanted to be asked questions.

JMS: You knew the answers you wanted?

MH: I was just doing something silly. I don't know why. It was just silly. Before all this, Jean hears about the party. Now, I don't know Jean, and Freddy doesn't know Jean. And Jean is like, "Oh, there's some kind of art party where there is graffiti? I want to be down. I want to come too." He shows up, and Stan gave him a big roll of photo paper for him to write on.[2]

JMS: Fab 5 Freddy told this story.[3] This must have been the same party, where he met Jean for the first time, as well.

MH: Exactly. So I'm interviewing these people, and I get to Jean. Of course, he wants to be on camera. I say, "OK, this is SAMO. You see his name all over the place," because Jean used to write SAMO underneath. He says, "It's *same-oh*, not *sam-oh*." Yeah, OK, whatever, *same-oh*. I asked him a question and the same thing—take away the microphone as he'd go to answer. I do it a couple of times, and then he

realizes that I'm being a jerk and doing this fucked-up thing. Once he realizes it, he looks at me with this look—all judgment, all emotion, all thought, all everything that one can see on one's face is drained from his face. His face became a mask, and then a mirror, and I am looking at myself. I'm befuddled, and then I cut the recording off.

Not much later, I took off my lab coat and stopped doing the interviews. I go up to Jean (I'm contrite) and say, "I'm sorry, man. I was just fucking around." And he said, "No, that's OK. You want to start a band?" And I was like, "Yeah! Sure! [*Laughs.*] Gosh! Yeah!" And I didn't know him. I had seen his SAMO stuff, but I didn't put the two together.

But that thing that he did to me by showing me myself—and this is the first time, right now, talking to you, that I'm really grasping the enormity of it—it was that moment, when he became a mirror, that made ten minutes later him inviting me to start a band with him so important. It wasn't like, "You want to start a band?" "Uh, maybe. We can hang out and jam and see what happens, but I don't have a lot of time. I work at Chemical Bank but give me your number." It wasn't like that. It was like, "Yeah, sure, yeah, let's do this!" I remember this immediacy; I have to do this with this guy because he put me in check. In a benevolent way, he taught me my first of many lessons at Basquiat University.

Jean asking me to start this band together, the two of us, was like someone saying, here's an all-expense-paid academic career from undergrad to PhD at Yale, or Princeton, or Stanford for free. It was that night, or soon after, we got together. It was that night, actually. We went around smoking joints and stuff. We were running into people regularly that we would see at the Mudd Club who dressed cool and looked good.

I remember one guy who was Madonna's boyfriend, Kenny Compton—Jean became Madonna's boyfriend years later. Kenny was this really cool, tall, blond white guy. Dressed really slick. We all wore suits in those days, and there was a posse of people at the Mudd Club who would wear '30s thrift shop suits, '60s suits—baggy, weird, awkward, but sharp. Sometimes ties. I remember we were on the street in SoHo at night, and we were like, "What do you want to play?" I had these drums, and I was tapping out this drum thing. Kenny had a guitar—and we were on the street, it was an electric guitar that we couldn't plug in anywhere. It was just this craziness. Then we would go to the studio, and we invited Felice [Rossen]. She jammed with us, and we made tapes together. Then we worked with Shannon [Dawson]; then, later on, we kicked him out of the band. He was playing trumpet in this blaring, ignorant style that just didn't make sense with what we were doing. At first, we were just loud chaos. We wanted to take it down to something else, and he wasn't there. But before he left the band, it was myself, Jean, and Shannon. Jean played clarinet. I played drums. Then we met Wayne [Clifford], who would play (I think) keyboard. It was all just artists using instruments as noise generators in skillful or in John Cage, Yoko Ono, Fluxus-type ways.

JMS: I have a quote from Glenn O'Brien about Gray. I want to read it to you to see if you think it seems close to what you think Gray was about. It says: "There was nothing rock 'n' roll about Gray. It was a sort of new wave jazz concept that existed in an audio space explored by Miles in his electric albums like *In a Silent Way, Bitches Brew,* and *Jack Johnson.* It was what was sometimes known as a noise band, like Theoretical Girls or DNA, but it was 'in a silent way'—they liked the space, the vacuum inside the sound."[4] Do you think that is accurate?

MH: Nice, yeah. The first few months, we were just reaching and doing crazy things. I remember a gig we did at A's space. Jean got this woman, was it a guy or a girl, I think it was a woman, to play bagpipes with us. That was a really crazy idea—bagpipe player with this band. We would always try these alternative things. Eventually, something happened when we got rid of Shannon and we brought Nick on board. We gelled when it was Nick, Jean, Wayne, and myself. We really started to explore sonic landscapes. Looking at music as sculpture—sound sculpture. I can give you an example of one song. Unfortunately, all of these songs are gone because Wayne, who kept all the tapes, threw them away.

There was this one song called "Six Months." I would always start out the track with drums. It would be me on drums with just this casual kind of warming up. Like an orchestra warming up, you hear these random sounds. It would be me going [*random sounds*], and then Jean would [*random sounds*]. He eventually started playing things like the Wasp synthesizer, this little English synthesizer. He'd play a guitar lying on his back with loosened strings and then run a metal file over it. Crazy shit. Tape loops, whatever. Then he would start doing his thing on the clarinet or the synthesizer. Nick would start doing a thing on the guitar. Wayne would start doing a thing on the keyboard. It would be this building of random sounds, like [*random sounds to a crescendo*]. We would somehow know to start playing faster, louder, and harder, with more frequent notes, until we would come to a crescendo. We would get to this point of approaching diminishing returns where there is nowhere else to go, and we knew where to stop. We would stop together at the very same time. You'd almost stumble. Then we would wait for four or five seconds and then I'd start it again. Then a third time. That was the song "Six Months." Nothing else.

JMS: How long had you been together before you finally decided on the name Gray? Around what time do you think that was?

MH: We had different band names. One was called Channel Nine and Test Pattern. Those are both named by Jean. I named the band Bad Fools, which lasted for like a rehearsal or something. He loved that title, Bad Fools. Jean was truly the leader of the band. He was the youngest of us all, but he was still the leader of the band, no question. Then one day we were walking along Washington Park, and Jean said, "I've got the name of the band. Gray, with an 'a'." It was him and me and maybe Nick, I forget who, but more than just him and me. We were on our way to

something as a band. We stopped and went, "Gray. Yeah, that's it. That really captures us."

JMS: OK, and you had a repertoire of composed songs? How many did you have?

MH: Oh, we must have had fifteen songs. Not a lot.

JMS: Did they all have a similar structure to "Six Months"?

MH: No. They're all radically different. "Six Months" was real sound sculpture. "Braille Teeth" or "The Rent"—some of them were real songs that had beginnings, middles, and ends. They were constructed like a song, but they were really harsh. It's sad that there is no record . . . Well, here's the thing that's interesting about [Wayne] throwing [the tapes] away. Nick, whose parents died recently, found some Gray tapes. We are going to be fixing them and cleaning them up and putting them out.[5]

JMS: That's great. I've been generally disappointed that there's not a lot of writing about Gray, about the music. It seems to me a logical extension to deal with opera, jazz, all these things that he was interested in and to also look at his own music.

MH: But we didn't have a lot of music.

JMS: I would like to know more about how the songs were composed. Who was responsible for contributing to each composition?

MH: Everything was extremely democratic, with Jean having the last word. We weren't musicians, and we had no idea about composing music. Most of the time I would start out with a beat, a riff, or a sound on the drums. Gradually, people would join in and we would start to mold some kind of sonic piece, a sculpture. Things would be taken away, or things would be added. I can remember so many times playing something, and there would be Jean on the floor looking up at me with a pained look. Again, this is Basquiat University. I knew to take a turn from what I was doing, that what I was doing was tired. He made it so easy to be cool. You just surrendered to his better judgment. The reason why it was so easy to surrender to his better judgment—because we are all egocentric, he and I used to fight a lot, but it was always over logistical things—because you knew he wasn't guiding you or asking you to change an idea or telling you to do something or not do something out of his need to control or his ego. Once you got to know him, you would understand that bad ideas hurt him, like fingernails on a chalkboard. It just pained him in a very natural and automatic way. So all you had to do was look at his face to see if what you were doing or playing was registering on his face—like some kind of meter.

JMS: He was the barometer of . . .

MH: Exactly. The barometer of hip. And he was the ultimate arbiter of hip on the scene. He was the king of the scene. Before he was even painting, everyone knew [who he was].

We would create in a very organic way. Without talking much, we could figure out a song, work on it, and record it. We would play it back to ourselves at home.

We were able to capture some very strange compositions and repeat them almost verbatim, which was not easy because the songs were very strange and very hard to repeat. We didn't know how to write them down, so technically they weren't easy to capture and repeat. If we had known what we were doing, if we were real musicians, we could have written down the notes. But if we had been real musicians, then we would never have done those ideas.

JMS: To what extent did you improvise in performance, not just in rehearsal? And how did you improvise?

MH: The performances weren't improvised at all. The compositions were improvised in their conception, but once we got an idea we would try to repeat it.

JMS: What about sampling? I heard of Jean playing tapes on stage . . .

MH: Sure. Jean did. Wayne did. Nick did, as well. In that photograph there, you see it on the bottom of the photograph, there is a tape machine. I think it was Nick's tape machine. In rehearsal, we would set that tape machine up and get an audio tape, a regular cassette, take the thing apart and take that piece of tape—it might be twenty feet long—and we would make a loop of it. We would go around the head of the tape machine, go around that TV and a mic stand and keep going around. We would play to that some kind of weird sonic thing.

There was a lot of avant-garde experimentation. A good way to describe our music would be, if you walked into a heavy duty industrial, mechanized factory with big machines shaping metal, sheet metal, stamps, presses, and gears. The factory is closed and all the people have gone home. Then you go there in the middle of the night and somehow a magical spell comes over the factory and all the machines come alive—become sentient beings. Their machine parts and mechanically generated noises start to make beautiful melodies and compositions as best they can. That is kind of what Gray was, in a way.

JMS: When and why did the band break up?

MH: Like I told you, Jean was the leader of the band. There was this crucial moment. I remember this like it was yesterday. We did this great gig at the Mudd Club, which I have talked about a hundred times to different people, the one with the ignorant geodesic dome. After that gig was over, I remember Jean coming to me, and he had obviously known this all the while, but didn't tell me until after the gig, that he was going to be in PS1 and that he made the decision that he wasn't going to be in a band and be a painter. That he was going to focus on painting and that he was leaving the band.

I remember being dumbfounded. Without Jean, at that time, it felt like there was just no point in going on. When Jean left the band to pursue his painting career, we broke up at that point. It was Jean leaving [to focus on painting] that broke the band up.

Notes

1. See Hughes's essay "Requiem for a Featherweight" later in this volume.

2. In an interview with Jeffrey Deitch, Holman explained that this drawing included the text "Which of the following symbols are omnipresent: (a) Lee Harvey Oswald; (b) Coca-Cola; (c) Disney; (d) SAMO." "Michael Holman Speaks Music," in *Jean-Michel Basquiat: 1981, The Studio of the Street* (New York: Deitch Projects, distributed by Edizioni Charta, Milan, 2007), 104.

3. Ingrid Sischy, "Jean-Michel Basquiat as Told by Fred Brathwaite," *Interview,* October 1992, 119.

4. Glenn O'Brien, "Basquiat and Jazz," in *The Jean-Michel Basquiat Show,* exh. cat. (Milan: Fondazione La Triennale di Milano, 2006), 49.

5. In 2011 Holman and Taylor produced the first Gray album, titled *Shades Of . . . ,* on their own label, Plush Safe Records. It included new tracks in addition to several sample tracks from the band's earlier recordings and performances with Basquiat.

SUZANNE MALLOUK

2008

JORDANA MOORE SAGGESE: Did race cause a problem for him [Jean-Michel Basquiat]? In the pop culture of mythology, some of the struggles have been forgotten. We've celebrated him, and perhaps put him up on this pedestal. But this may be a huge disconnect from the reality of his experience.

SUZANNE MALLOUK: He absolutely, definitely had racism that I witnessed. He was unable to hail a cab. He was unable to get into restaurants where all of his friends and contemporaries and peers were; he was turned away at the door. He experienced severe racism once he started making money. Of course, he purposefully contrived a look that was threatening in order to shock people. To a big opening at Mary Boone Gallery, for example, he wore very expensive Comme des Garçons clothing, but he also wore this straw hat to give the impression of an ignorant, uneducated Black guy—from the farm, almost. He was doing it on purpose. He would play with these Black stereotypes and present himself in the form of threatening Black stereotypes to fuck with people. To be subversive. To make people stare at their own racism in the face.

JMS: Well, Jean's experience of race is very similar to what I've heard of people like Charlie Parker, who was a successful musician but still experienced discrimination. And I wondered if you knew anything about or could talk about his relationship or his fascination with Charlie Parker and his music. Do you know anything about that?

SM: He wouldn't talk much about these things, but, of course, he loved Charlie Parker and Max Roach and all of those Black jazz musicians. Miles Davis, and he played a lot of that when we were together. But he didn't talk about why he liked it. He just liked it.

JMS: Michael [Holman] was saying that he knew of Jean going out on the street and begging toward the end of his life. Did he have a fascination with homelessness?

Suzanne Mallouk moved from Canada to New York in 1980, at twenty years old. She met Jean-Michel Basquiat while bartending at the Lower Manhattan bar Night Birds, and the two remained close until the artist's death. Mallouk witnessed Basquiat's earliest successes as a painter, including the sale of his first painting to Deborah Harry (lead singer of the punk band Blondie), and his move in early 1982 into the loft that he rented from Andy Warhol at 151 Crosby Street. She is represented in several works in the painter's oeuvre and posed for the Neo-Expressionist painter Francesco Clemente.

This interview has been edited for clarity and for length and is reproduced here in a naturalized transcription.

SM: He did have a fascination with homelessness. And when he was wealthy, he used to give the bums $100 bills.

JMS: It reminded me of Charlie Parker, being banned from the nightclub that was named after him, Birdland, toward the end of his life and dying penniless. And also Joe Louis—you know, the story where he was found working at a hotel as a bellman in Florida?

SM: And Billie Holliday not having a gravestone. And Jean-Michel wanted to design it. You know that. I don't know what came of that.

JMS: Some of these ideas about race appear in the paintings, particularly the idea of stereotypes in popular culture—for example, where he's talking about the *Amos 'n' Andy* television show, the Kingfish and Sapphire characters [in *Untitled (Rinso)*, 1982].

SM: It was all to turn things on its head and to make people question taboo perceptions that they were guilty of. For example, when he started really selling his work, very quickly he started getting really angry, and this is what makes him such a brilliant artist, in my opinion.

What Jean-Michel did was when he sensed he was coming up with a gimmick, he would change—instantly change. And when he was in a rut, creatively, and thought, "I can't just do another painting so that I can sell it"—because he was selling a lot—I think if he couldn't figure out how to alter it so that it wasn't a gimmick, so that he wasn't just parodying himself, what he did was he decided to just stop selling the work. And he wrote "Not for Sale" on all of the paintings. And, of course, that made people want them more. But he would stop painting rather than paint what people wanted.

There was always a dichotomy. It was always dialectic. The copyright symbol was at the same time an embossed invitation to the party and a searing branded tattoo on the skin. He was Black, and he was the mascot, and he was the only Black artist in the blue-chip galleries at the time. That could not be changed. And I think that was his brilliance.

[Jean-Michel] questioned everything. He was constantly trying to really see the truth. Trying to be very aware of a historic lens, put by other people or culture or himself and his own history. He was vigilant about that. And that was natural for him. That was a natural state for him to be in. He didn't have to work at it. And that was from exquisite intelligence. That was his natural state.

JMS: What about his relationship with museums? Did he visit a lot of museums?

SM: His mother would take him to art museums when he was a little boy.

JMS: And did he continue to go?

SM: Yes.

JMS: I've found a lot of drawings that deal with objects in museums, reproducing the object. So I didn't know if he had actually gone and visited museums a lot or . . .

SM: No, he went to museums a lot. He was very aware of other artworks. He was very educated, but he didn't go to school. He was self-taught. He knew about all of the other artists. He would read a lot, or he would ask people questions.

JMS: That's fascinating. Talking about this hyperawareness, I keep going back to that. I think it is something that's relevant, because he's really the exemplar (in terms of painting) of someone who just absorbs everything, and it comes onto the canvas. You've obviously seen him paint and draw. Was he working on several canvases simultaneously? How did that process work?

SM: He would work on several at the same time, and he would have the television on and be taking iconography from the television. He would be looking at books. He would have people over talking. Someone would say something, and he'd write it on the canvas. Yeah, it was like that. It was filtering everything from reality or all of the stimulus, and he would just arrange it in a certain way [so] that it had some sort of meaning.

JMS: And the drawings. Is he photocopying?

SM: The drawings, sometimes, he would photocopy. And tear them up and glue them to the canvas and then paint over top of them. He would do color Xeroxes.

JMS: Color Xeroxes?

SM: And black-and-white Xeroxes.

JMS: OK. But he had a Xerox machine in his studio?

SM: He might've at a certain point, but he used to go to a copy shop downtown.

JMS: Oh, really? Because Bruno [Bischofberger] was telling me that he had this Xerox machine in his studio at a certain point.

SM: He probably did. I don't know.

JMS: Whereas you talk about a certain duality, I also look at double and triple meanings for things within these works. One example is a large painting [The Nile] where there are references to Africa and salt.

SM: Right, I know the painting.

JMS: And then there's a reference to Memphis in that painting as well.

Everyone talks about salt and argues that its inclusion in the painting is very political and Basquiat is using salt to refer to the exploitation of [the African] continent. But there was an exhibition in Brooklyn in 1973, a huge show in Egyptian art, and in the catalogue, all the object labels are printed. One of them says, "Acquired by Henry Salt, possibly in the Memphis region." Finding that just blew my mind. It's this idea [that] you don't really know where these references are coming from. And it doesn't really matter. It's just once they're in the painting, they're in the painting. And that's what I'm trying to do with this work. I find that with music—which is why I think maybe he listened to music so much—this idea of taking things out from the world and putting them

159

into a new song is much more accepted. People aren't concerned with identifying the origins.

SM: Exactly. No, you're getting it. I haven't thought about it before in exactly that way, but yeah. And if anybody said to him, "What does that song represent?" he would say, "If I could talk about it, I wouldn't paint it. I'd write about it." He said, "And I'm not an art critic." It was poetic. It was musical.

JMS: I think this idea of composing was very similar. Looking at people like Charlie Parker, who literally taught himself how to play the saxophone by watching Lester Young up in the rafters at this club in Kansas City and fingering his own saxophone as he watched Lester play. [He was] literally copying to learn . . .

SM: I didn't know that.

JMS: I think Jean's doing the same thing by copying Picasso and Leonardo.

SM: There's another good story that you might not know. At a certain point, when we were on Crosby Street—it must have been about 1982—he was selling a lot of work for the first time ever, and he came home and he was very worried. And he knew I had gone to art school. And he said to me, "Suzanne, I'm really worried. I feel like a fraud because I'm now selling my work and I don't know how to draw." And I said, "Then you must teach yourself. Go and get some how-to-draw books." We were sort of joking, but at the same time, we were sort of serious. So he went and he got those "how to draw a horse" book, "how to draw a flower," whatever, and he practiced. And he learned to draw.

JMS: So when you're taking sketchbooks from Leonardo and putting them into the painting, it's about that process. It's not about copying.

SM: No. It's about learning how to draw.

JMS: [There is a painting] called *Leonardo's Great Hits,* which has its own association with musical greatest hits and covering other people's songs (in terms of bands doing covers for albums). But it's not incomprehensible that people would learn this way. Because musicians learn this way, writers learn this way. If you want to be a writer, you read.

SM: Right, exactly. You want to be an artist, you go to art galleries, and you draw and you learn from looking at other people's work.

JMS: And that's how old masters [worked]. Picasso copied Cézanne.

SM: He [Basquiat] definitely did that.

JMS: I wanted to ask you about [apartheid in] South Africa and the 1980s. This is also from your own experience, and being [in New York] during that period. What was it like? Was it in the news a lot in terms of the divesting and all that?

SM: It was in the news a lot. I never discussed it with Jean-Michel, but it was in the news a lot. And it was heartbreaking.

JMS: I think more in terms of right now, [when] everyone talks about the election. Everyone knows every little thing about Obama and Clinton. I wondered if there was that sort of investment in the goings on in South Africa in terms of the violence.

SM: No. No, no. You have to understand about the movement that we were involved in. The early '80s East Village was very insulated. It was so counterculture, the East Village back then. I was a waitress in this hippy-dippy little place called Binibon restaurant. I was sitting at the bar of the restaurant drinking a coffee, and they announced that Ronald Reagan had been shot, and everyone cheered. Those were the kinds of people that lived in the East Village. It's not that we didn't care about the goings-on in the world; we consciously made a choice to live a counterculture life.

Everyone had their own reason, but the people that ended up in the East Village in the late '70s and early '80s were people that found it painful to live in the mainstream world. It wasn't like we were intelligent college students discussing South Africa. Most of us were heroin addicts and drug addicts that stayed up all night and slept all day. It was very narcissistic. It was very insulated. It was very self-involved.

There [were] about fifty of us that went to clubs every night. There weren't that many people living this lifestyle. Most of those people are dead because how long can you shoot heroin for? Most people died of AIDS or hepatitis C from that era.

It attracted a tortured kind of soul that was self-involved, just because they were so tortured. We weren't really that focused on the bigger issues. We knew about the bigger issues. But none of us paid taxes; none of us had bank accounts; none of us were really gainfully employed.

We weren't intelligent, well-educated college students sitting around talking about world issues. We were very tormented. Most of us had horrendous childhoods that were drawn to that kind of life.

JMS: Right, and so you all found each other.

SM: We had to make a new family. And for whatever reason, we could not streamline ourselves to fit into the mainstream culture. Does that describe it?

JMS: It does. I think of the '60s and the idea of "plugging in." You're pulling the plug out.

SM: We chose to really not live in society.

JMS: This is surprising. I think most people's concept of New York in that period is this sort of Madonna Danceteria kind of thing.[1] That's the version we know.

SM: No, no. Most of us started out as punk rockers. This was the late '70s. We were the original punk rockers. But this is before the Ramones. When I saw the Ramones, I thought that they were phony. I thought they were fake. I can't even remember the

bands before the Ramones, but we were the original punks. That's what our era came out of.

JMS: Bad Brains, those guys . . .

SM: Right. And a lot of the British bands.

I was a punk rocker before I moved to New York. I moved to New York in 1980. I was twenty. But I was a punk rocker in 1976 when I was fifteen, sixteen. That was 1975.

So was Jean-Michel. He was a punk rocker before we did the 1980s thing. We were huge fans of Iggy Pop. We were punks. It was the punk movement. It was the punk movement that was instrumental in my life. And Jean-Michel and I are the same age.

When I heard and saw Iggy Pop play in Toronto, which was where I was from, I was like, "I've seen God. There's somebody else out there like me."

And that's why I moved to New York—to find people like me.

JMS: Wow. It reminds me of a Velvet Underground song where the lyrics say something like, "She heard rock-and-roll music on the radio one day and it kept her alive."[2]

SM: Velvet Underground was huge. Lou Reed was huge.

So, a very similar story.

JMS: You think that's a connection that you might have had to Jean, with difficulty in your early life?

SM: Oh, absolutely. We didn't feel like we could relate [to mainstream culture]. I mean, I had never had a superficial conversation in my whole life. When I found Iggy Pop and I found that there was a scene happening in New York, I came. I wanted to be around people like me.

Notes

1. Danceteria was a nightclub that operated in New York City from 1979 to 1986. Originally located at 252 West Thirty-Seventh Street, the club moved to 30 West Twenty-First Street in 1982. The club was a center of new wave music, frequented by many artists and musicians who would become famous during the 1980s, including Madonna, Billy Idol, the Smiths, the Cult, Nick Cave and the Bad Seeds, Sonic Youth, Cyndi Lauper, Depeche Mode, Run-DMC, and New Order.

2. "Rock & Roll" is a song by the Velvet Underground, written by Lou Reed, that was released originally on their 1970 album *Loaded.* The line is "You know, her life was saved by rock 'n' roll."

BRUNO BISCHOFBERGER

2010

JORDANA MOORE SAGGESE: Could you describe the 1980s art market for me? It has been discussed as sensational, and as very different from the 1970s . . .

BRUNO BISCHOFBERGER: There were different artists and different people; it was a breakout of a number of new artists in America, in Germany and in Italy mostly, but also in Spain and the UK, known as the Neo-Expressionist painters. There were Conceptual artists as well, but let's speak about painting. The Conceptual and Minimal artist, who reigned in the period just before, thought that painting in the classical way would not be possible anymore. But the "New Expressionists" did exactly that. Also, the economy was going better and better throughout the eighties, until about 1988 or '89, when suddenly there was a commercial decrease. Of course, in the art market, people felt this economic decline, and in the early nineties for a few years everything cost half from the price before and the market was much slower.

There were a few people who, in the eighties, became big stars overnight, like Schnabel and Salle, who were shown also by Leo Castelli in New York. Some people thought that they behaved like they had invented art. It was what they called hype—produced by the market but also by journalists who helped make this possible. I remember when Schnabel's big paintings (eight by nine feet or something like that) still cost between $3,000 and $4,000. Then he made an especially large one which was ten by sixteen feet, and his gallery asked $15,000 for it. The German

The Swiss art dealer and collector Bruno Bischofberger has been a major figure in the contemporary art market for more than five decades. He was among the first art dealers to show American Pop art in Europe. In his gallery he also showed works by the Nouveau Réalistes in France and leading exponents of Conceptual, Minimal, and Land art. Starting in 1966, he had a long-standing relationship with Andy Warhol with a right of first refusal on all his works. From the late 1970s throughout the 1980s, Bischofberger represented many emerging American and European so-called Neo-Expressionist artists such as Miquel Barceló, Jean-Michel Basquiat, Mike Bidlo, Francesco Clemente, Enzo Cucchi, Dokoupil, David Salle, and Julian Schnabel, to name some. As he recounts in this interview, Bischofberger became Basquiat's worldwide exclusive representative in May 1982, after Basquiat left the gallery of Annina Nosei, which had represented him for four months. Bischofberger was Basquiat's most consistent dealer from that point until the artist's death in 1988. Over the course of their working relationship, Basquiat spent much time with Bischofberger and his family, even vacationing with them in St. Moritz, a scenic Alpine resort in Switzerland.

This interview has been edited for clarity and for length and is reproduced here in a naturalized transcription.

who bought it paid $10,000, but it was in the newspaper. And the same journalist wrote half a year later that Peter Ludwig from Cologne for his famous collection bought another large painting for $30,000.

Basquiat went through a similar market. Within a few years, he got very recognized. In general, not a lot of speculation was going on in the eighties, and not every painting had ten people in wait. But the journalists wrote about Mary Boone that she had a waiting list for works by Schnabel and others.

JMS: In the book *Unpackaging Art of the 1980s,* one of the claims made by the author is that the 1980s art market was so radically different.[1] It was fast paced, shows selling out before they opened. Artists became famous for becoming celebrities more than being artists . . .

BB: That's a little bit true, but it's always exaggerated.

JMS: OK.

BB: Some shows were sold out, but I never had a show which was sold out before it opened. I have had the majority of times in the last fifty years shows in which we didn't sell anything. But I'm sure some artists like Schnabel or Salle probably did in those days, and maybe also Basquiat. I remember when Basquiat did his first show with Annina Nosei, it was a sellout. But what does that mean? There were seven big paintings or so in the show. Maybe she kept some for herself; I remember one museum curator of the Museum Boijmans Van Beuningen in Rotterdam, who had for a few thousand dollars the right to purchase a painting by himself without his committee and got a really great one, an untitled work (*Boxer*). The paintings cost probably like $2,000 or $3,000, or maybe $4,000 or $5,000, a maximum for a big work.

JMS: I think it could very well be an exaggeration. I'm thinking of the show about Andy Warhol in Philadelphia, where there were so many people in attendance, they had to take all the paintings off the walls to protect them from damage. It was a blockbuster exhibition, but without any art.

BB: Coming back to Warhol, in the eighties, he normally sold nothing. He did a show with Leo Castelli of the dollar sign paintings, not in the West Broadway gallery or even around the corner in the big space on Green Street. Castelli put that show in the basement of the Green Street Gallery. I thought that this was a disgrace for the artist. The most expensive painting was $25,000, and nobody bought one painting in the whole show. The show traveled to Paris, and again they didn't sell a painting. And the critics in the eighties wrote nothing favorable about him. They were saying that Warhol's great works were made in the sixties and the actual "commercialized" work was of no importance and no value. The same thing they wrote about the New York exhibition of the collaboration paintings which Warhol had done with Basquiat; they wrote that Basquiat was a mascot of Warhol.

JMS: What about the first meeting with Jean-Michel? Where and when did that happen?

BB: That happened in May 1982 when my assistant in New York called to tell me that Basquiat left Annina Nosei's gallery. I asked her to find out Basquiat's phone number so I could call him up at his apartment or wherever he was. I had never met him before. I saw him once from twenty yards away, when I went to see the *New York/New Wave* [exhibition]. Diego Cortez [the main curator of the *New York/New Wave* exhibition] called me in Switzerland and asked me if I was going to be in New York to see the show. I didn't go to the opening, but he asked me if he could give me a tour. He didn't mention Basquiat, whom I had never heard of before. Only many months later did I realize that Diego brought me there in order to show me the work of Basquiat. The last big room of the show on the main wall was Basquiat's. I wish I could find more pictures of that show. I only know of one picture of it. I would love to see all of the paintings that were there (see page 336). They were mostly small paintings, the biggest one was something like the two skyscrapers, which Suzanne [Mallouk] said he painted out of the window. She told me that in her first apartment (Eighth Street and Third Avenue, I think), the only window to the outside was exactly between two other big buildings, the two towers [in the painting]. She told me yesterday that's exactly the two towers [in the painting]; they always look the same.

JMS: What about when you saw his works?

BB: Ah yes. Diego asked me, "How do you like these?" And I told him I thought they were great. They reminded me maybe a little of Twombly, especially that painting with the two skyscrapers with all the little scribbling.[2] Or maybe Dubuffet—another great artist who made primitive types of works, almost like a child would do.

I later found out that Basquiat knew that Diego brought me out there and was eager to know my reaction. So, I came by a few days later to visit Annina [Nosei], who I always visited and sometimes bought works from. She would go down to the storage basement to show me a painting by Francesco Clemente. She had works of Clemente very early. I think she was the first in America [to have his paintings], because she went to Italy for a few months every year to vacation. She had Cucchi and Clemente and Chia and works like that [in the basement]. I bought the Clemente painting from her that day. So I went to the basement with her, and there was this person in the corner. I realized it was Basquiat painting something, but she went out with me again afterward, and he didn't come over to say hello. I didn't go there either to say hello because I just wanted to be discreet. I didn't ask her, "Could you please introduce me?" We just went off again.

Basquiat later on told me, "Oh, I realized immediately who you were, but I was angry at you because I heard you compared my work with Twombly and Dubuffet, which is really not true." I think he even told me that he didn't know them. Certainly, later on he knew them, but it doesn't matter. I didn't mean it to be disrespectful, or that he's a rip-off of those. I just saw something in the same spirit. So that's where I first saw him. That was probably in November or December of 1981.

In May, when I heard that he left [the gallery of] Annina, I went to him and proposed to be his dealer. He immediately agreed to it. He told me, "I also would like that you find a gallery here so that I can show eventually in my hometown New York too, but I'm not in a hurry, I don't want to show right away." He told me, "I left Annina because she repeatedly sold works that I haven't declared to be finished yet." On Basquiat's wish to ask Leo Castelli first, who declined, I finally convinced, after more than half a year, Mary Boone, Basquiat's second wish, to become my partner in representing him worldwide.

JMS: You often saw him working—painting and drawing...

BB: Yes, in America and here [in Switzerland].

JMS: Could you tell me what that looked like?

BB: Not much different than you could imagine. Sometimes he was working on a stretched canvas on the wall, but quite often [he worked] on the floor, walking on his paintings. You can see footprints on some works, which he liked as well.

JMS: Would he work on several canvases simultaneously?

BB: Sometimes on several [canvases]. Sometimes [there] was music running. Sometimes he would work, go to have a little bite of something or a drink, and then continue. It was very irregular. I never saw that he started one work and finished it, unless [it was] a portrait. He did a portrait once of my son called *Swiss Son,* where I'm on it as well, on the terrace of my house in St. Moritz. Also, he did a big painting outside in the sunshine on the gravel in front of my house in St. Moritz of my whole family, called *The Bischofbergers.* There, he started off and painted until it was finished. But if the paintings were in the studio, he might have put other things on it and change it later on [. . . .] I think some of the portraits he did from memory. It was not like that he would accept commissions for portraits like Warhol did. That was not the case. Sometimes I came to his studio to see works that he did in the last week, about three or four paintings in a short while. Other times I would come to New York, and for months, I would see the same four or five paintings. They were more or less finished, but on some he had done more work. He would sometimes ask me what I thought about the new works. I almost always liked them very much and told him that. Then he might have answered me, "Oh, you do like any old shit!" But, if I would dare to say one little criticism, then he would be on the roof, saying, "I know exactly what I'm doing! Don't you think that things are by chance. I work with chance, but it's very much my decision to do it that way. I know exactly when a painting is finished." Also he did not want that I offer to a collector a drawing which had only two words written in the corner for less money than another drawing of the same size that he worked on for hours and hours and was completely filled and more interesting to look at in some ways.

But I was telling him that the art market works differently. And he said, "That doesn't matter. For me, it has to be like that."

JMS: When he was working, did he have books around? Did he ask for books or . . .

BB: He didn't ask for them, but he had books, all kinds of source material around that he used, like *Gray's Anatomy.* The book of hobo signs he even had in St. Moritz, when he was working in the studio there—I remember that, and a few other books as well. He was constantly reading something. When we went to visit this friend of mine, Claudio Caratsch, who was the Swiss ambassador in Africa for four countries with a seat in Abidjan on the Ivory Coast, he told Basquiat, "You know, in Africa art is made in a different way. Here it is art for art's sake, and in Africa art is only made in order to do something with it, 'to repel ghosts,' for instance." Basquiat didn't say anything, but when we drove home Basquiat said to me, he knew of course about repelling ghosts, but he didn't want to offend him so he didn't say anything. He was quite amused that the ambassador, a studied ethnographer, was telling him about things he already knew. Right after, back in St. Moritz, he wrote "to repel ghosts" on two little paintings. The next week in Zurich he painted a bigger work "to repel ghosts" on the piece of wood [plate 29], which was broken off in an old storage of my gallery, when it was standing there to be transported away.

JMS: What about the photocopying? Did he have a Xerox copier?

BB: Yes, he bought for quite some money a secondhand Xerox copier. I think he paid $12,000, something crazy for it. Nobody owned a color Xerox copier privately at that time, but he got it secondhand so he could do color Xerox. He had that at home in the studio, and he used it for backgrounds of all kinds of paintings, as you know. Have you ever seen paintings or some Xeroxes which have over time become very pale? In a way they [the Xeroxes] hold up quite well. If you see felt pen drawings by Picasso, which were done with a normal felt pen, they mostly fade if they are exposed to light too much, even indirect light. This makes a very big difference that we have recently seen in Basquiat's works. The white of the paper turned yellow over time.[3] Most of the collages of Picasso done with newspaper turned brown. I have one hanging over my bed (a still life from 1912), and there's a piece of newspaper glued on it and it's pretty dark and brownish. I'm sure it was almost white when it was new, but it still looks fantastic. In this still-life the newspaper represents the inside of a brandy-bottle, so the brownish color makes a lot of sense by now.

JMS: Were all the works titled by Jean-Michel, or were they titled after?

BB: Sometimes after, but mostly by him, certainly if the title is written by him on the back. If it's not there, either the painting was untitled or people gave it a title afterward.

JMS: OK, there's a painting I'm thinking of that has been published as both *El Gran Espectaculo* and *History of Black People* [Plate 25]. Each title has a very different meaning.

BB: They call it *The Nile.* Maybe that was Basquiat's title, but I don't think so if you have all these other things. I have some problems [with attributing titles] unless

something is written on the back [of the painting], or if it [was published] in an early catalogue, when Basquiat was around.

JMS: What about the discography paintings [plates 17 and 18]? Did Basquiat paint those in Switzerland?

BB: No. I brought them from New York. And one of them was for sale, and nobody ever bought it. Most people wanted color.

JMS: I'm surprised someone didn't buy both.

BB: Well, I always wanted to keep one, and nobody was ever interested in [buying] just one.[4]

JMS: Are there other discographies?

BB: There is a similar painting, but not a discography. It has the same width but is much higher. It hangs in the house here. I can show it to you. It's all made in silk screen, but it's one of a kind . . .

JMS: Is it like *Tuxedo?*

BB: No, no. Much greater, very simplistic. It's about Quetzalcoatl. Do you know who Quetzalcoatl was? The feathered serpent, a god of the Aztecs.

JMS: I do. What about *Now's the Time* (1985)? Do you know how that was made?

BB: I think that [the painting] is dated '85, but it looks like '82. It's so heavy. I want to look [to see if] there's another date written on the back. *Now's the Time* belonged to Andy Warhol, and two or three times the estate of Andy Warhol made little group-ings of Basquiat works they wanted to sell. They would offer these to three or four selected people, who were mostly working with Basquiat for a secret bid, and they would give it to the person with the biggest offer. Each time I participated, I got eve-rything I wanted. There I bought the *Untitled (Refrigerator),* which was Suzanne Mallouk's. She used to own it and put it up for auction, because she had no money to pay the rent and Warhol bought it there for $1,000. Suzanne said Basquiat came home and said, "There were two or three other paintings in that auction, and this refrigerator brought down all the prices of the other paintings, because it costs only $1,000! If Warhol wouldn't have bought it, it wouldn't have been sold at all!"

But anyhow, this record, the painting *Now's the Time,* I knew from standing around in the Warhol Factory, but it was never in any of these auctions. I once asked the person who was in charge of all that if it would go up for our private sale, so I could try to buy it. But some years later, I heard that Peter Brant had bought it from the estate of Andy Warhol.

JMS: Do you know when and where Basquiat learned silk screen?

BB: I do not know exactly, but he was interested in every technique. He also did mono-prints and etchings. He did only five or six monoprints and was very proud of them. He showed them to me and asked, "Do you want to buy them?" They did cost at least as much as a drawing, even more, and so I took the one I liked best. I still have that.

Basquiat also did lithographs. He sat down here in Switzerland and worked with this lithographer for only one night until four in the morning. He gave me a couple of proof prints. I can't find them anymore, but I know which storage [unit] they are in. Soon we will move that storage, and then they should appear again.[5]

Notes

1. Alison Pearlman, *Unpackaging Art of the 1980s* (Chicago: University of Chicago Press, 2003).

2. Bischofberger is likely referring to an untitled painting from 1981. This is illustrated as no. 7 in the appendix to the catalogue raisonné *Jean-Michel Basquiat* (Paris: Galerie Enrico Navarra, 2000), 6–7.

3. Here, Bischofberger is comparing a photograph of Basquiat with the painting *One Million Yen* in 1982 (fig. 8, page 343) to a more recent reproduction of the work. You can see this comparison on pages 84 and 86 of the catalogue for Basquiat's show at the Fondation Beyeler in 2010.

4. *Discography (Two)* was acquired by the Brant Foundation after this interview.

5. For more information on Jean-Michel Basquiat, Andy Warhol, and the collaborations, consult Bruno Bischofberger's gallery webpage: www.brunobischofberger.com.

ROBERT FARRIS THOMPSON

2011

JORDANA MOORE SAGGESE: I am arguing in my book that a lot of Jean-Michel Basquiat's persona—as an artist and a Black artist, specifically—depended a great deal on his reading of text. I look, for example, at his use of museum exhibition catalogues, history textbooks, et cetera. I found many references to your book *Flash of the Spirit* throughout his paintings and drawings. Could you speak to your knowledge of his access to, or use of, this book?

ROBERT FARRIS THOMPSON: Well, I first met him in his studio down in the Bowery, and *Flash of the Spirit* was prominently displayed on his coffee table. I thought, "Wow! He's reading the book." He liked it, and then he asked me to do a catalogue [essay], which I did. It was really exciting working with him. I don't know if you've seen the movie where someone asked him, "Who do you trust among critics?" And he said, "The only person I liked was Robert Farris Thompson." That [statement] reflects that he was hungry for data about the great Afro-Atlantic world. He quoted from it in this wonderful way. He never copied directly; in fact, he always adjusted them, but you can see these wonderful turns on *nsibidi* figures from eastern Nigeria.

Sometimes I give an hour-long test to my students [in African art], and I flash on the screen another painting of Basquiat's that gives all the traits of the Yoruba—the animals, the gods [who are] supposed to come down and give the world the power to do things. It's all in one painting, and it's just amazing.

That's really it. He told me, "I get my facts from books." And some of his facts were Afro-Atlantic, but he had a wide, curious mind. You get black boxers and Chinese workers on the railroad. Everything.

Robert Farris Thompson is an American historian and writer specializing in the art of Africa and the Afro-Atlantic world. He has been a member of the faculty at Yale University since 1965 and currently serves as Colonel John Trumbull Professor of the History of Art. His ideas have proven instrumental in looking at cultural transfer and adaptations from African art and religion via aesthetic strategies and traditions in the Americas.

When asked whom the artist considered to be the most informed about his work, Jean-Michel Basquiat pointed directly to Thompson. The two first met in 1984, when Thompson was writing an essay about the relationship between art and hip-hop, less than a year after the publication of his influential text *Flash of the Spirit: African and Afro-American Art and Philosophy*. Thompson's *Flash of the Spirit* was particularly influential on the artist, as it reinforced many of his own ideas about cultural memory and connections to Africa. Several of the artist's images even reproduce figures and text from the 1983 publication, which was in Basquiat's personal library.

This interview has been edited for clarity and is reproduced here in a naturalized transcription.

JMS: Do you recall speaking with him specifically about Africa and the diaspora?

RFT: No, not really. When we went out, we talked about girls and things like that. [*Laughs.*] He was bilingual, and when I'd have lunch with him, he'd take me to a little place in Chelsea where [*speaking in Spanish*] they give everything in Spanish, including the check. That was one thing that people didn't quite get. His mother's influence was very strong on him. It came out in the fact that her bus that she rode becomes a painting; [other paintings have] Spanish phrases all over the place.

JMS: Right. I've also noticed a few references to Haiti, specifically.

RFT: Well now, that's problematic. His father was Haitian, but his father was a businessman, playing tennis and [such]. He was about as traditional Haitian as I am. Many people have stampeded in that direction, and I've only seen one painting of all of his works that had a *veve*—a sign to call down a Vodou spirit. I could be wrong, because I don't know every single painting he did, but among the ones I do, there was only one painting. And that was it. So it's not comparative to the Spanish impact, the Puerto Rican impact of his mother. [The references to Haiti] are negligible.

JMS: I tend to agree with you. I think that his references to Haiti mostly deal with dictators and political affiliations, which connect back with his concern with South Africa, Jamaica, and so on.

RFT: Yeah.

JMS: I do also see a lot of references specifically to Africa.

RFT: Oh yeah, Africa and African Americans, constantly. What I love about him is particularly the way he glorified jazz. There were several references to Charlie Parker.

Charlie Parker haunts his breakthrough painting—the one where you can see the word CHEROKEE.[1] He has the date [of] the night Charlie Parker died in the Stanhope Hotel, all of that.

"Cherokee" was the famous composition where Parker discovered that by playing the tops of a chord, he could play the thing he'd been hearing.

JMS: In what ways do you think Basquiat's work reflected some of your own theories of diaspora that you are working through in the 1980s?

RFT: Well, I don't deal with the theory of diaspora; I deal with the reality of it. The fact that you have Black religions—Vodun, Santeria, Candomblé—from all over the place and the fact that half of the world's dances have Kongo names. *Mambo* is a Kongo word. *Rumba* is a Kongo word. *Samba* is a Kongo word. *Cumbia* is a Kongo word. It just gets to be ridiculous after a while. So there is no theory about diaspora. All you have to do is turn on the radio, if you want instant verification.

JMS: That's a great point. It seems to me that in many ways, Basquiat had been schooled in Africa by your book. Would you say that there was any explicit conversation between you two about this?

RFT: No, I don't think so.

JMS: Basquiat does speak a lot about cultural memory in interviews.

RFT: Well, he was a scenarist also. The most dramatic example of that—in fact, he told me that it was the only time that he documented an event, but of course he documented everything—was when a beggar came to the door with a person who was sniffing glue pushing him in a wheelchair. [Jean-Michel] gave this guy money, and he wanted to hug him to say thank you, but he was dirty. So [Jean-Michel] really shrank [away] from that. Later he felt guilty about it and did this wonderful painting called *His Glue-Sniffing Valet*. Do you know it?

JMS: Yes, I do.

RFT: That's an example of him being a scenarist or documentarian. And it goes farther than that, the very green-colored bus that his mother used to wait for that becomes a protagonist in another painting. *Guagua*, from the Afro-Cuban word for bus. *Guagua* is literally an instrument, you play [it] by pounding a piece of wood called a "bus." He was into all of that.[2]

JMS: Do you remember the title of that painting you show your students in class?

RFT: I don't remember. I don't even know if it had a title.

But it is a wonderful thing to put that painting on the screen and then [the students in African art] start to scribble immediately. Because he talks about Ashe, and he talks about the Gaboon viper.

But every time he took something from my book, it always was changed. He has "Gaboon viper" and then "gababoon, jigaboon viper." He starts playing with it, riffing with it. Never ever passively copies; he is always readapting it at the very least for rhythmic phrasing on the page.

Notes

1. Thompson refers here to Basquiat's 1982 painting *Charles the First*.
2. Thompson refers here to the Cuban percussion instrument. The *guagua* is classified as a directly struck idiophone. It is traditionally made from a hollowed-out tree trunk; the player hits it with wooden sticks or mallets to produce the sound.

DIETER BUCHHART

2019

JORDANA MOORE SAGGESE: How did your interest in Basquiat specifically start?

DIETER BUCHHART: In the '80s I was aware of his art. I never met him, but I had this great interest in expressionism at that moment.

I saw the same energy that you see in the works of Edvard Munch in the 1880s in Basquiat of the 1980s. Munch was radical. He would scrape off all the paint from his canvases. He was like no other artist before him at that time. I saw this same energy in Basquiat and started researching his work. Very soon, it was clear to me that he is not a Neo-Expressionist or Expressionist artist at all. He was a very intellectual, conceptual artist. And that's what got me really interested.

The starting point for the Fondation Beyeler retrospective in 2010 was my father. He was an [art] historian as well and gave me a book a couple of years prior to this exhibition, telling me, "You have to do a show with him. He is of our time." And he was right. Basquiat is just as much about our time as he was about his own time.

So I suggested the exhibition to Sam Keller [director of the Fondation Beyeler], and he said to me, "You know what? I just had the same idea. Let's do it."

JMS: How long did it take you to put that show together?

DB: A year and a half. It was the first big show since the Brooklyn Museum [in 2005] and the Whitney [in 1992], but the work really needed a show in a museum outside of New York. The exhibition then traveled to Paris, to the Musée d'Art moderne de la Ville de Paris, which was an incredibly successful show as well.

JMS: Why do you think your interest in Basquiat has continued? What questions remain to be answered for you?

DB: I always start from the original work, which I study a long time. From there I develop a thesis, and then I research. Every time I'm confronted with a great work by Basquiat, and I reread it, I discover something new.

JMS: What percentage of the work do you think you have seen?

The Austrian curator and critic Dieter Buchhart has organized several large retrospectives of Jean-Michel Basquiat's work over the last decade—many in high-profile locations, including Basel, London, Berlin, and Paris.

This interview has been edited for clarity and is reproduced here in a naturalized transcription.

DB: Truly a lot. In reproduction, I've seen most of Basquiat's paintings and drawings. In life, I would say I've seen at least half of the paintings at least, if not two-thirds, and I've seen hundreds of drawings. But I fear that some drawings have most certainly been lost over the years.

JMS: What do you think are some of the challenges that you have faced in working on Basquiat, or what do you imagine other people have faced in trying to do similar work?

DB: I believe that the academic research on Basquiat, besides your own work and that of a few others, is rather thin. There are those who think they comprehend his oeuvre after having only looked at a selection of works briefly. I feel that the biggest misconception is that people think they can grasp Basquiat in his entirety after just a brief interaction [with] or study of his works. But it is a very complex, conceptual oeuvre, meaning it requires extensive research and a lot of studying of the works in order to really be able to say something.

JMS: Access was one of the biggest challenges I faced early on. I started working on Basquiat around 2003 and a huge barrier was trying to convince people I was serious about the work. It was difficult to get interviews or access to the works. I found that people were very hesitant and reluctant to share resources or information with me, for whatever reason.

DB: And many of the eyewitnesses cannot remember. Others don't want to share their knowledge. Archives are closed and not accessible. What is fundamental to my approach is access to the original artworks, which, thankfully, over time I have had the privilege of gaining. I do the same with Munch, Keith Haring, or any other artist I have the pleasure of working on: I look at the work, and I develop my ideas around that.

So perhaps my approach is a different kind of research. I know from my collaboration with Eleanor Nairne [curator at the Barbican Centre], who is a very ambitious researcher, that there are limits—not in terms of ability, but in terms of accessibility. And then I have to say there is a lot of information you get, which is filled with racism or misunderstanding. A lot of information you get from people you cannot use.

JMS: The Barbican show was reflective of Eleanor's deep dive into archival materials, and it was really wonderfully done. It was likely the most deeply researched exhibition I have seen.

When you walked into that show, for example, you immediately saw [a film of] Basquiat dancing. That was a very striking image and a use of archival footage that you don't very typically see. It brought personality to the show.

But, that being said, I also wondered if we would do the same for a white artist. What does it mean to have a prominent Black artist dancing in this way, given the complicated history of Black entertainment and minstrelsy? How do we negotiate

that boundary with a Black artist, especially one who is so famous and whose personality sometimes threatens to overtake the work? What were your thoughts behind that choice [to install the film]?

DB: My idea of the show at the Barbican Centre was that you were entering the mind of the artist. I did not choose that video. I have to say, I'm not a fan of this kind of material, because I just want to look at the work itself. But because I co-curated the show, I am co-responsible.

Would I use this material for any other artist? One hundred percent. I would use it for any artist.

While I understand where your association of this video with minstrelsy is coming from, and it goes without saying that this was not what we were aiming for, I feel we had a good argument for showing the film. As we documented in the exhibition, Basquiat worked in a dance-like style. Not just that he sampled or used improvisation, like in jazz, but it was actual physical movement during the working process. So, in that sense, the video shows a working process, and I do hope that this is how the visitors of the exhibition, who saw the video embedded in the context of the whole exhibition, understood it.

JMS: Well, I often think of that very famous footage of Jackson Pollock shot by Hans Namuth, where we see a choreography of those moves [of Pollock painting]. Perhaps in that context a video of Basquiat dancing could fit within the larger frame of the artist in process.

DB: Good point. It is really about making the art. It is like that famous series of photographs [by Martha Holmes] of Pollock painting.

JMS: I had a colleague once tell me that working on Basquiat would be much easier in twenty or thirty years, once works move into public collections. That the project [of my dissertation] was impossible. Do you believe that some of the challenges that academics have now in terms of access will become less burdensome for us in the future?

DB: I do think there's more and more research material being published and that access to it has become easier thanks to museums and archives making their holdings available online. There's more and more access without primary source access.

Your story reminds me that when I was working on the show for the Fondation Beyeler, colleagues from other museums and universities told me, "Dieter, you are going to ruin your career."

And I said, "No. I believe in this artist." People didn't really take the art seriously, strangely enough. I said to them: "Come to my show. I will convince you of the opposite."

JMS: For an academic researcher and for someone who wants to be in the professoriat, the project you pick for your dissertation will be your first book. If you do not pick [your topic] carefully, it could all go down in flames. You could just be on the out-

skirts of academia or never have a job. So, it is a big risk . . . Actually, what does it say about *us* that we are willing to do this work anyway?

[*Laughter.*]

Why do you think there aren't more curators organizing Basquiat shows?

DB: It is very expensive to do a Basquiat show, but there will be more now. There is a really great interest in Basquiat.

JMS: I would imagine that it would be a challenge for a museum to deal with so many individual loans and so many individual collectors. That seems like a very onerous and resource-heavy task.

DB: It is very hard to source the works and then to secure them, even for big museums. I would very much welcome more Basquiat exhibitions. More voices would be good.

JMS: And how does that happen?

DB: I keep on doing my shows and my books. It will happen. Basquiat is about our time. Basquiat connects like no other artist. He is very much part of the youth culture today, one that I think he would have identified with. He is certainly one of the ten most influential artists of our time. Ten years ago, people would have laughed at you if you said that. Now, when you say it, people take it seriously.

Over time, curating his exhibitions will become less difficult concerning the accessibility of works. I am certain more works will come into museum collections.

JMS: We have been talking, somewhat tangentially, about the art market. As Basquiat is becoming more and more popular, what do you see as the effect of the market (if any) on his critical reception?

DB: It goes both ways. The *Wall Street Journal* published a review about the Brant Foundation Art Study Center show with a terrible title, "$110.5 Million Basquiat Lands in New York's East Village." That doesn't help. On the other hand, I am convinced that Basquiat's connection to youth culture is so powerful that those words don't have much value.

And it is worthwhile to point out that the most expensive US-American artist at auction is of Haitian and Puerto Rican descent, a person of color. That is big.

JMS: I don't think it is a secret that the foundation of my argument [in *Reading Basquiat*] is that the market success that Basquiat experienced during his lifetime was so overwhelming that it completely eclipsed critical responses [to the work]. That was also very specific to the conditions of art criticism in the 1980s and the impact of Marxism.

But I wonder if you agree that there is now a much more porous line between popular culture and critical culture. And that perhaps, in some ways, market success is not necessarily counting against Basquiat but instead actually solidifying his reputation. A question that arose during his lifetime—Will this last, will this work

stand the test of time?—has been answered. It has been thirty years since the death of Basquiat, and we are still talking about the work.

DB: Yes. That is a good sign. More than one hundred years ago, at the end of the nineteenth century, Harry Willson Watrous recounted a dinner party in Paris with a dealer and some twenty then well-known artists. They asked themselves, among the artists living at the time, who was going to be considered a great artist in the future. They picked two names that, today, no one except for a few specialists knows. So, if thirty years later the artist is becoming more important, this is a good indication [of lasting value].

Basquiat also has a crucial role in changing society. Accepting that there is not just a Eurocentric view of history has an everlasting influence.

JMS: I agree with you. Questioning a Eurocentric canon or colonialist practices in art history—whether curatorial or scholarly—is a critical part of this work today. Mechanisms of canonization have also radically changed in the last one hundred years. You were talking about the 1870s and the academy; we don't have that [system] anymore. Today we have Instagram and Twitter, and Jay-Z rapping about Basquiat. Even if we don't have critics in the '80s recognizing Basquiat and his importance in the same way we happen to recognize the other artists at that moment, it almost doesn't matter anymore, right, because we have all of these instances of popular culture telling us that this [artist] is critically important. I often wonder whether Basquiat would have liked that or not. It's an impossible question to answer, but I do think about it.

DB: I think he would be OK with it.

JMS: What do you think of these private collections [of contemporary art] opening to the public? There is obviously the Broad Collection in Los Angeles, and now the Brant Foundation Art Study Center in New York.

DB: I think it's wonderful that these private individuals open up their collections in a way that very few museums can provide today, because of funding and space constraints. Where can you put contemporary art or postwar art? The National Gallery of Art in Washington, DC? Even the extension is not big enough. Why not accept that the Brant Foundation Art Study Center on the Lower East Side is adding to the borough? It will, as I understand, show part of the collection from the family. People will see great Andy Warhols, Glenn Ligons, or Basquiats; they will see great art here, just as they can in the Swiss Institute, the New Museum, or innovative galleries. For me, any access to art is good.

Most of the museums here [in the United States] are private anyhow, not like in Europe. So I am smiling here about this debate of public versus private. Even the MoMA is a private institution; in the end, they may have to sell their whole collection one day if they don't have the right economy.

JMS: Well, one thing that is different about MoMA is that it has an explicit, outwardly focused research mission. You make an appointment, they pull out the

archives for you. There is a level of access that is very different, and I have not seen yet how that will work with these new private collections.

DB: Museums usually have the mission to cooperate with the needs of researchers. But I have also found that they do not always keep up with this philosophy. It is not always that easy.

Some aspects certainly may be lacking in the private institutions, but at least you can see the works. They have made public what you would otherwise not see.

JMS: But the question of "public" is also very interesting. For example, there are no tickets available for the Basquiat exhibition at the Brant Foundation Art Study Center. So how "public" can it be?

DB: They have found a way to give more people access, but the problem is the maximum capacity of the space. It is not about exclusivity at all.

At the Guggenheim Bilbao, you pay an entrance fee, and the space is huge. So they make great shows accessible, but you also pay for it. You don't pay to enter the Brant Foundation Art Study Center. You can go there and study the work in situ.

JMS: What is the biggest lesson you learned in working on Jean-Michel Basquiat?

DB: I have learned about artistic genius. I have learned that some artists are just ahead of their time; they are visionaries, sensing the time to come. I have also learned that Basquiat and his works have the potential to really make a change.

JMS: Yes. The thing that I have learned in studying Basquiat for so long—almost twenty years at this point —is that there is always something more to learn. I'm constantly discovering something, and that's what keeps me engaged. The more I work on [Basquiat], the more I realize that I may not know as much as I thought I did. I am constantly surprised.

DB: People tend to think that they know his work, but few do. You can only know what you *don't* know about it. Suddenly, you see another work that you have never seen before, and you are completely thrown off.

JMS: [*Laughs.*] I had that experience in Switzerland once. I was writing an essay in which I was very convinced about a connection between the drawing PPCD from the Daros Collection and the painting *Touissant L'Overture.* I had this theory about Haiti and the connection between these two figures—one labeled as Toussaint L'Ouverture and another as François Duvalier (or Papa Doc). I thought it was so significant that the artist had painstakingly reproduced by hand these two faces to create a conceptual connection between these two men.

And here is where you will laugh ... I go to Zurich and am walking up the stairs to the offices at the Bruno Bischofberger Galerie, and I suddenly see another painting with that same face. I was shocked. Tobias [Mueller] told me, "Oh yes. That's just a photocopy. There are quite a few of those faces on the paintings." My theory just went out the window, and that was in a way my first lesson [on Basquiat].

DB: When we are very young, we sometimes have the arrogance to think we have mastered a subject after one week of studying.

JMS: It is interesting to know that you started out working on a much more historical subject, because even as a contemporary art historian, I find that my methods are very much rooted in historical approaches. For example, when working on a typical artist of the twentieth century, you have an idea of everything they made; there are clear records and archives. But in researching Basquiat, you are working in a similar space to a medievalist who does not have complete records and does not know what other works are out there. A work could emerge at any moment and upend everything you thought previously.

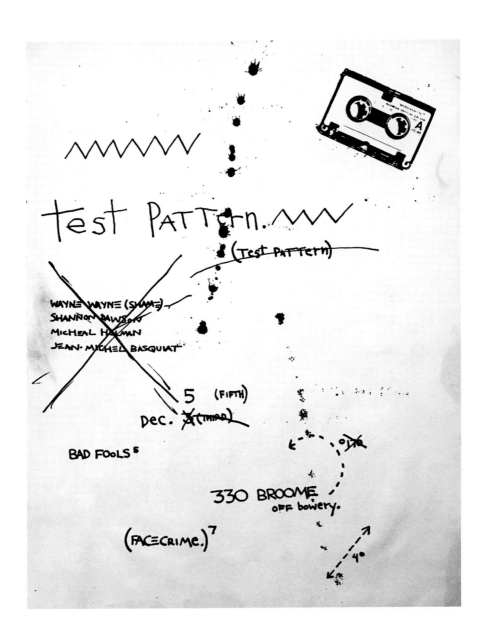

Plate 1. Flyer for Test Pattern at Wednesdays at A's, December 5, 1979.

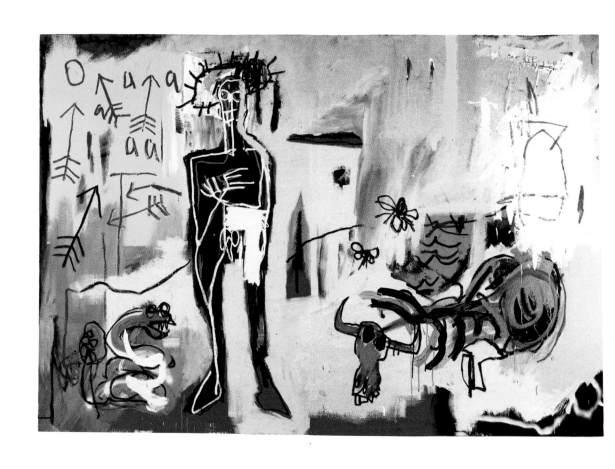

Plate 2. *Acque Pericolose (Poison Oasis)*, 1981.

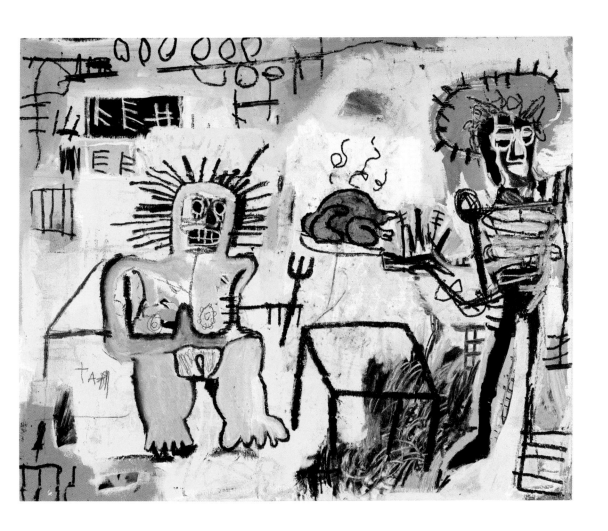

Plate 3. *Arroz con Pollo*, 1981.

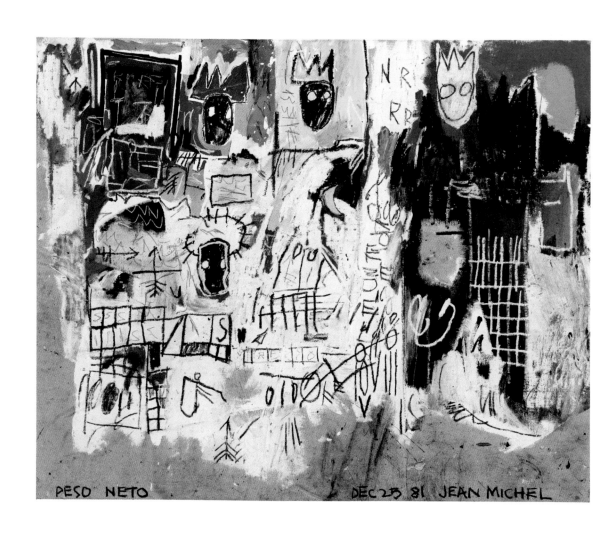

Plate 4. *Peso Neto*, 1981.

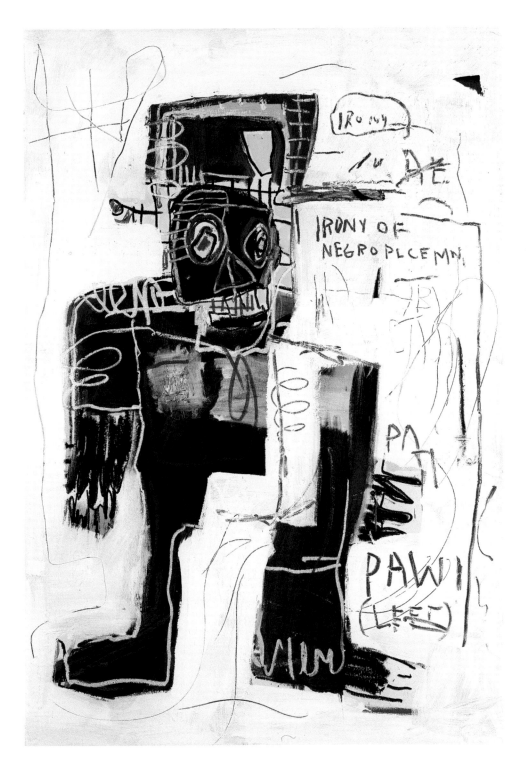

Plate 5. *Irony of Negro Policeman*, 1981.

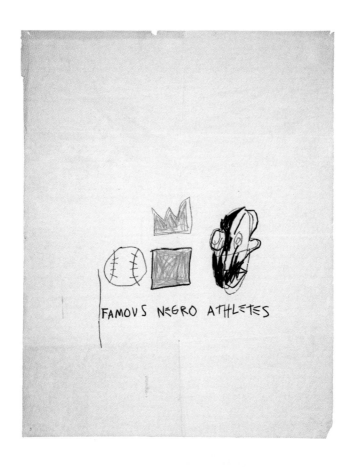

Plate 6. *Untitled (Famous Negro Athletes)*, 1981.

Plate 7. *Untitled (Helmet)*, ca. 1981–84.

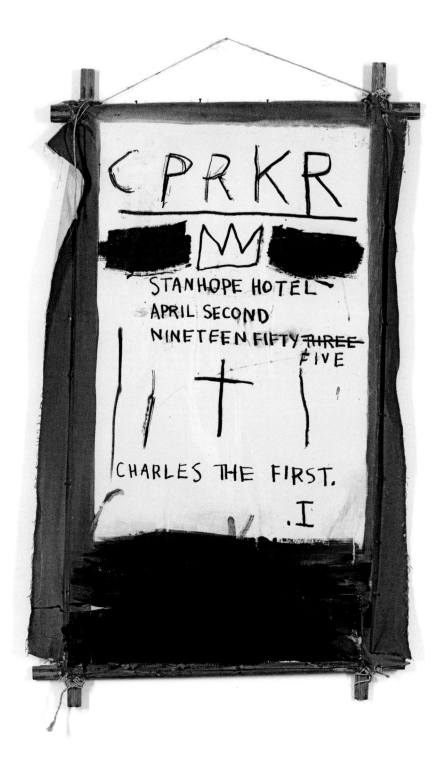

Plate 8. *CPRKR*, 1982.

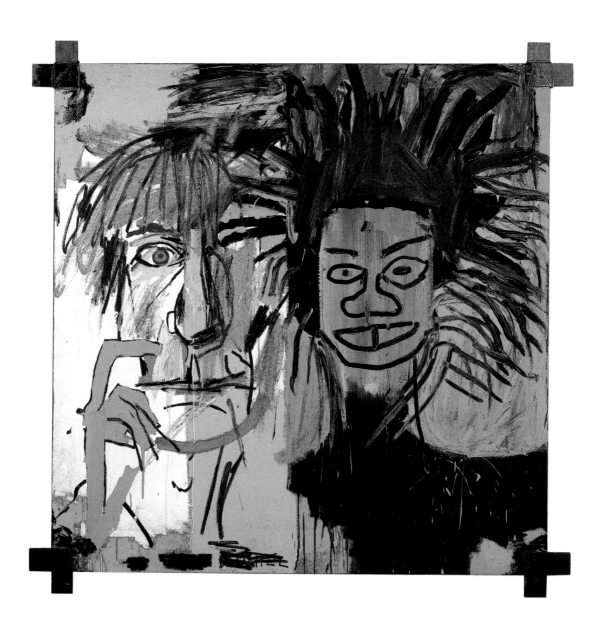

Plate 9. *Dos Cabezas*, 1982.

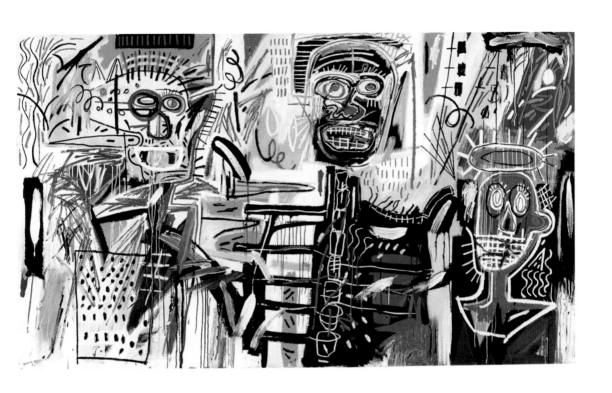

Plate 10. *Philistines*, 1982.

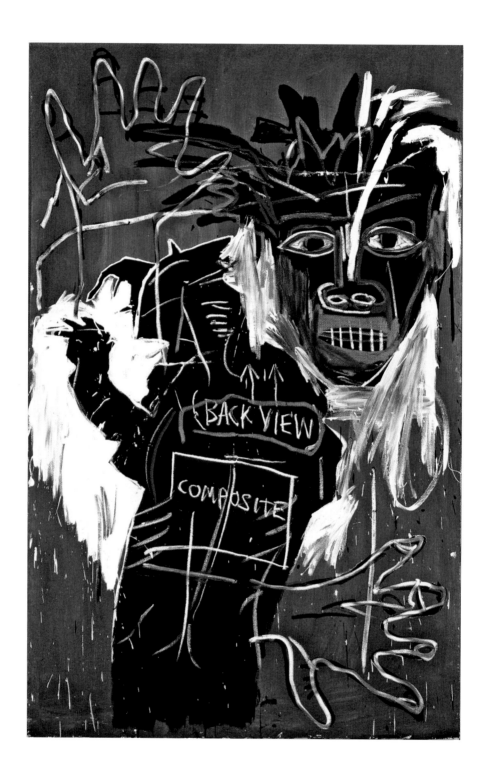

Plate 11. *Self-Portrait as a Heel, Part Two*, 1982.

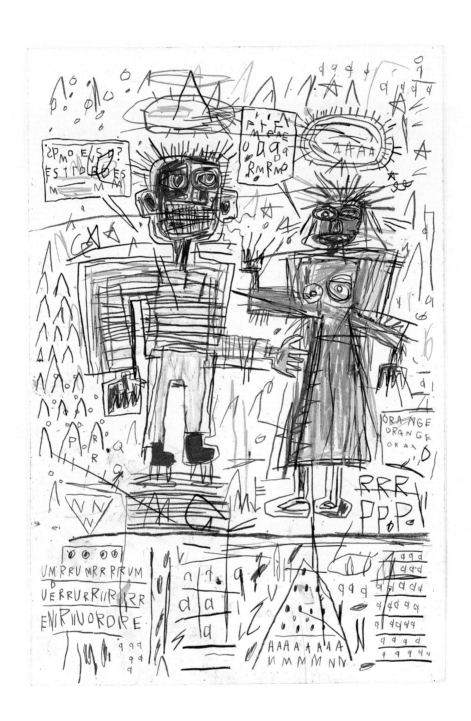

Plate 12. *Self-Portrait with Suzanne*, 1982.

Plate 13. *Untitled (Sugar Ray Robinson)*, 1982.

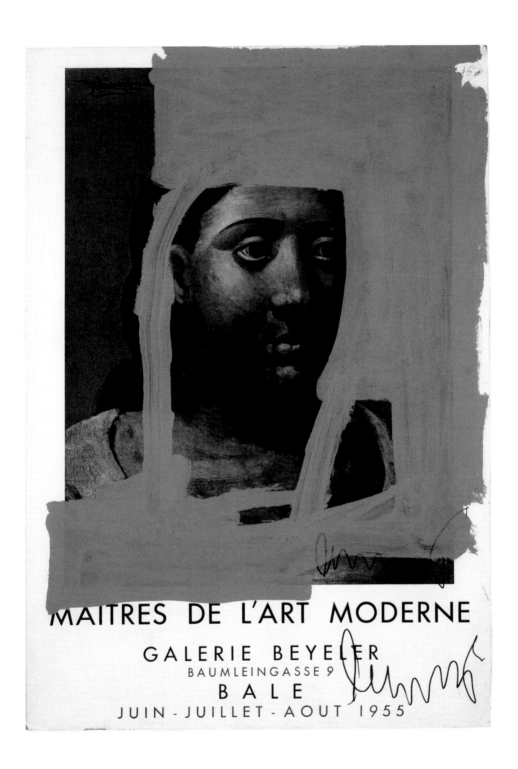

Plate 14. *Untitled (Picasso Poster)*, 1983.

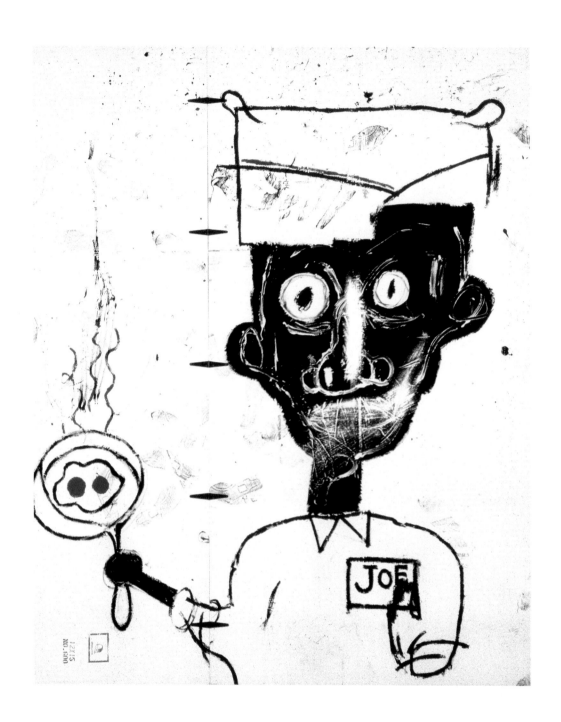

Plate 15. *Eyes and Eggs*, 1983.

Plate 16. *Boone*, 1983.

Plate 17. *Discography*, 1983.

Plate 18. *Discography (Two)*, 1983.

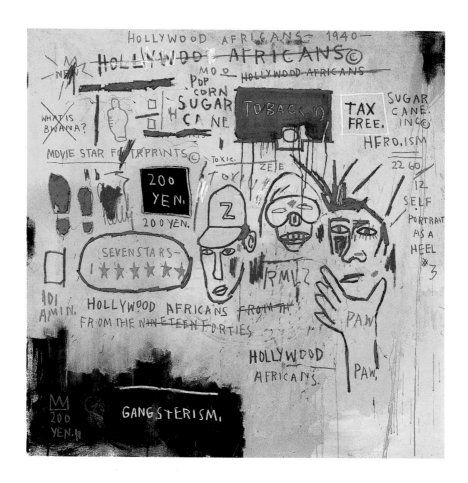

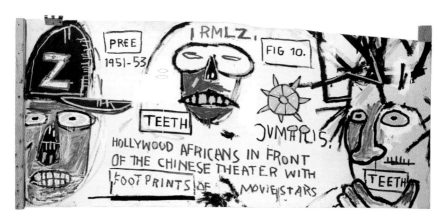

Plate 19. *Hollywood Africans*, 1983.

Plate 20. *Hollywood Africans in Front of the Chinese Theater with Footprints of Movie Stars*, 1983.

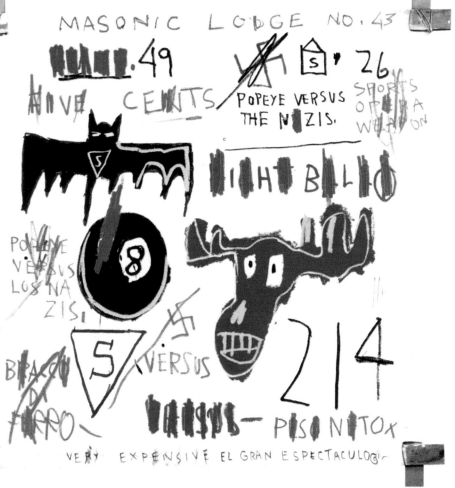

Plate 21. *Television and Cruelty to Animals*, 1983.

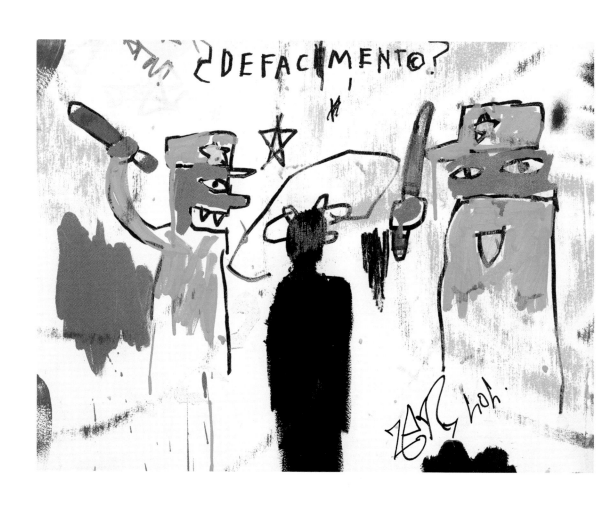

Plate 22. *The Death of Michael Stewart (Defacement)*, 1983.

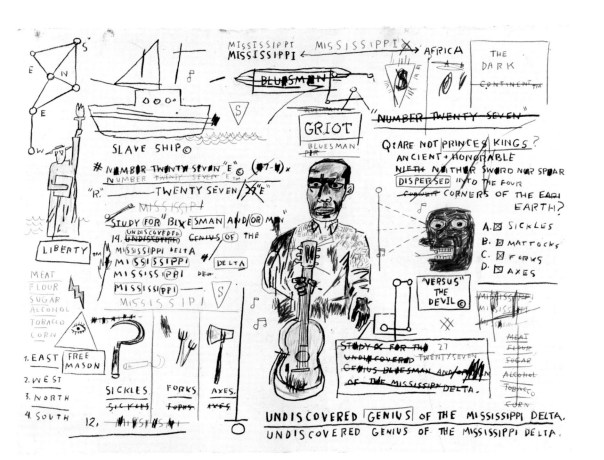

Plate 23. *Undiscovered Genius*, 1983.

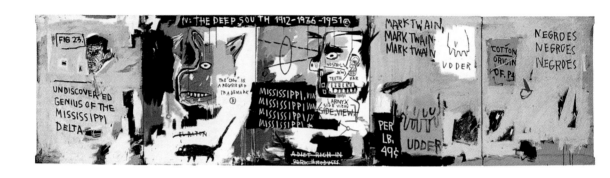

Plate 24. *Undiscovered Genius of the Mississippi Delta*, 1983.

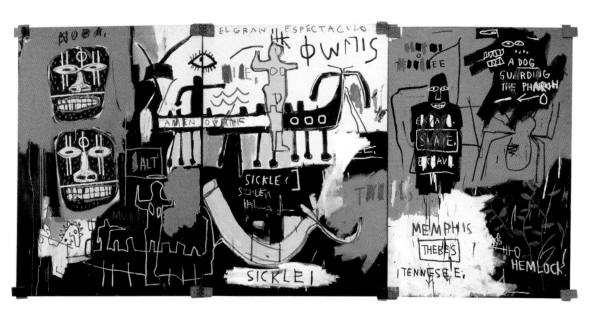

Plate 25. *The Nile (El Gran Espectaculo)*, 1983.

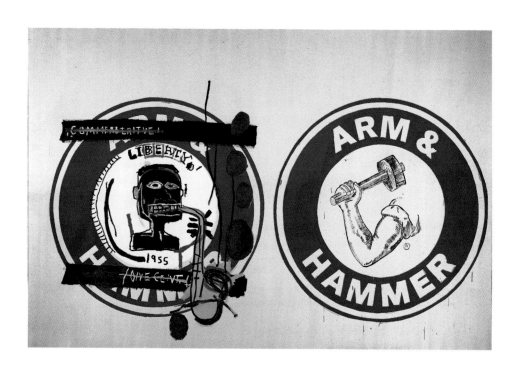

Plate 26. Jean-Michel Basquiat and Andy Warhol, *Untitled (Arm & Hammer II)*, 1984.

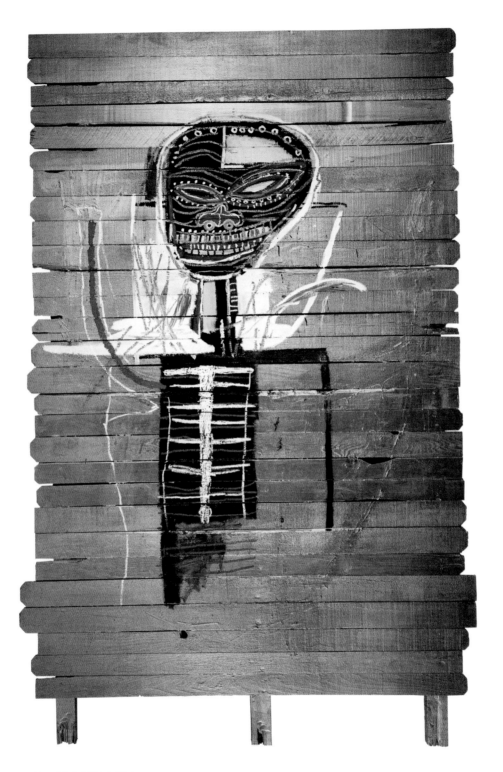

Plate 27. *Gold Griot*, 1984.

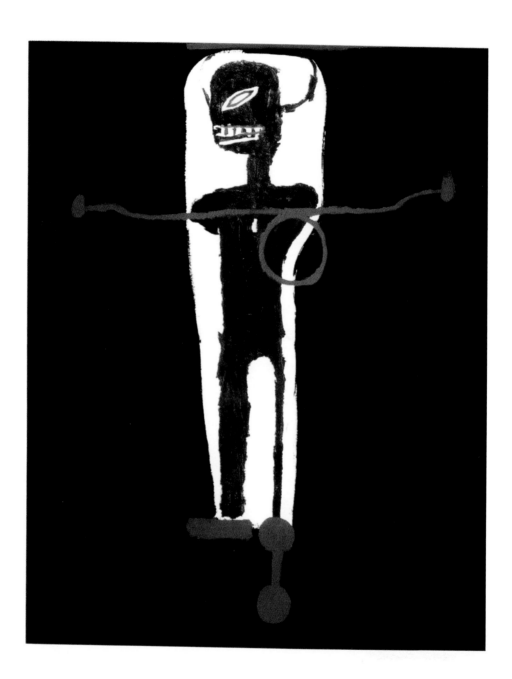

Plate 28. *Gri Gri*, 1986.

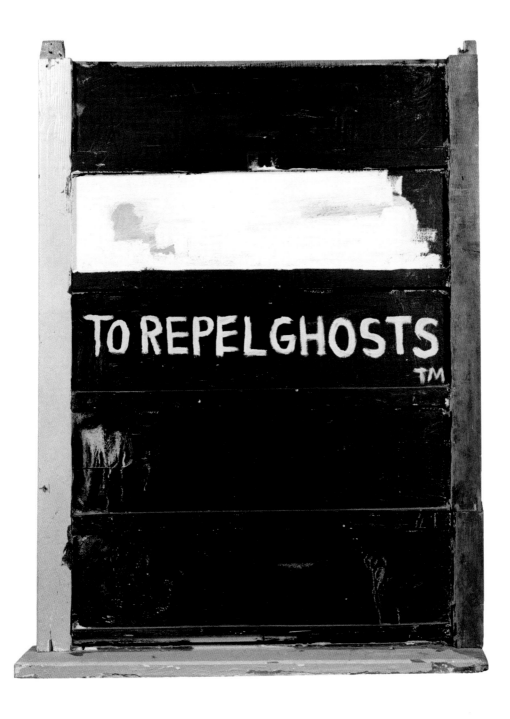

Plate 29. *To Repel Ghosts*, 1986.

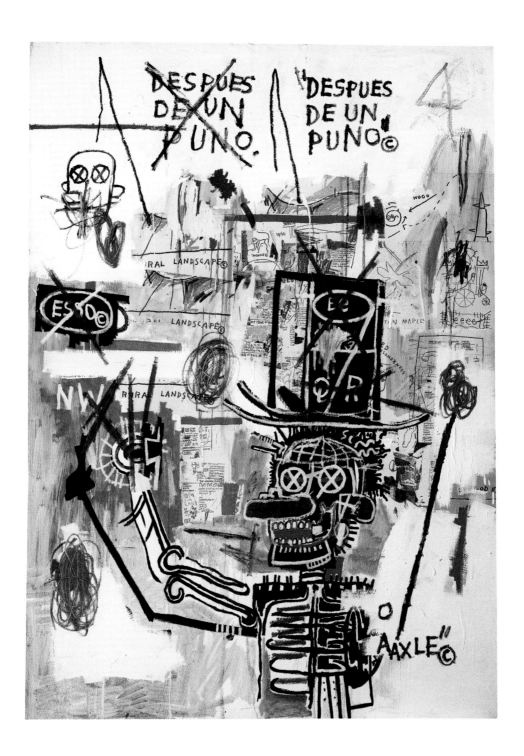

Plate 30. *Despues de un Puño*, 1987

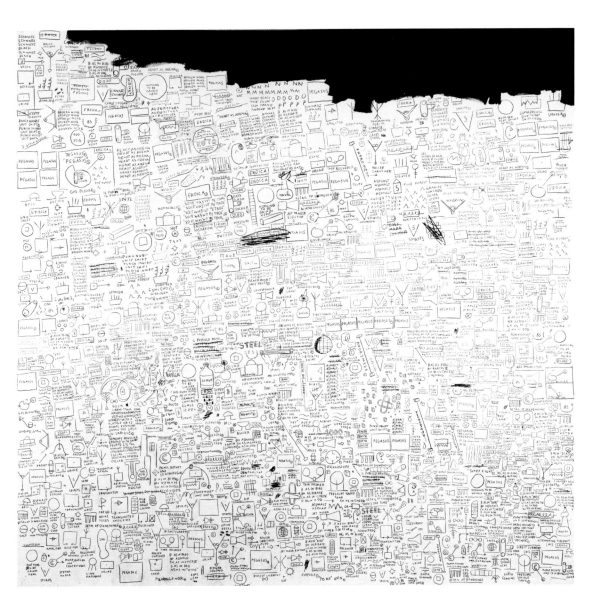

Plate 31. *Pegasus*, 1987.

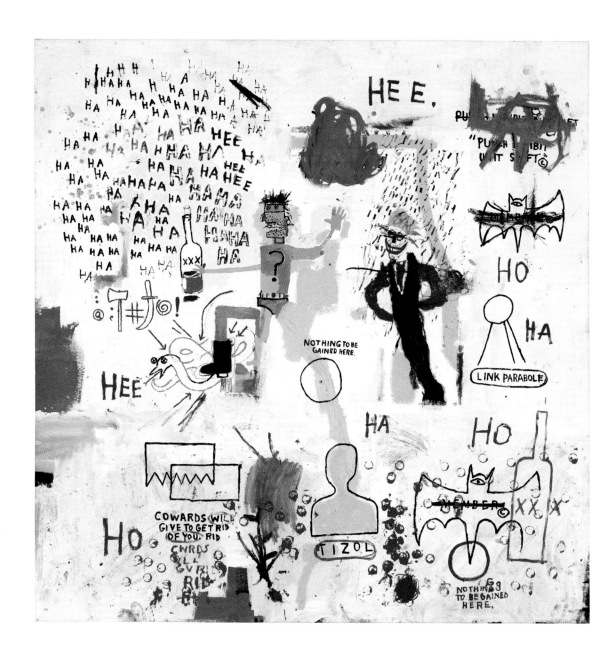

Plate 32. *Riddle Me This, Batman,* 1987.

BRAZIL©
POLICE©
THINK™

Plate 33. *Untitled*, 1987.

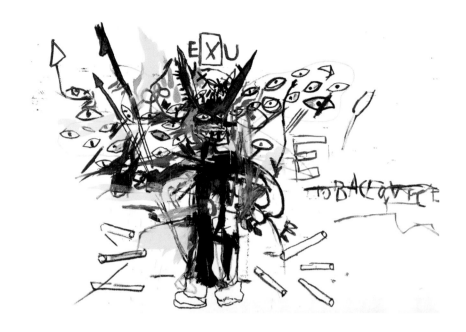

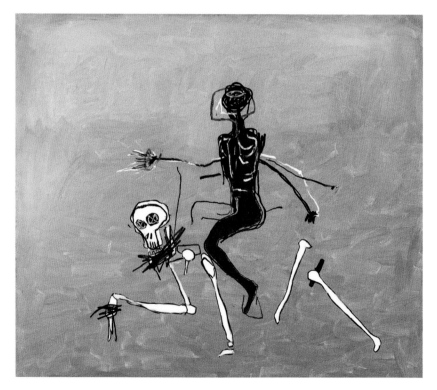

Plate 34. *Exu*, 1988.

Plate 35. *Riding with Death*, 1988.

ERIKA BELLE

2019

JORDANA MOORE SAGGESE: How did you meet Jean-Michel Basquiat? Do you remember the first time you encountered him?

ERIKA BELLE: You know, I would always see him around. Haoui Montauk, a very good friend of mine who worked at Danceteria, called us something like "the downtown five hundred." There were five hundred of us who were really fortunate to be able to go to nightclubs for free and get drink tickets. You didn't really have to pay for anything except for transportation to the nightclub. Those were the rewards. You got to see great bands and be a part of downtown New York nightlife. I never saw Jean dancing. He was usually standing off to the side and watching people.

But you had to have something unique. Usually that would be the way you dressed. Provocative is so different now; "provocative" back then was wearing black. In any case, we all congregated around a few clubs. There were a lot of tiny little bars and clubs that opened: Mudd Club, Peppermint Lounge, Hurrah's, Danceteria, Berlin, Laight Again. There were loft parties and renegade parties. Because rent was very cheap, you could rent a loft for one hundred or two hundred bucks and throw a fabulous party.

I remember seeing Jean around. Those of us who were people of color really knew each other, even if we pretended not to. There weren't that many of us. So we all knew each other.

This was a time in New York when rents were cheap and the town was very dangerous. This was after Gerald Ford told New York to "drop dead" and refused federal funding. It was a fun time—lots of rap, lots of roaches—for those of us who were brave enough to live in New York City.

I remember seeing his hair, like, "Who the hell is this guy?" These were not the average dreadlocks; they were matted and sticking up "punk" style, and sometimes he would shave the sides of his head (or maybe one side) in a kind of Mohawk. He was just absolutely radical looking for someone like me, who grew up on Long Island. I just thought, "Wow! This guy is really something. Who is he?" I was just intrigued by him.

Erika Belle is an American socialite, art curator, fashion designer, and dancer, most known for her friendship and work with pop singer Madonna in the 1980s. She was a fixture of the downtown club scene of the late 1970s and the 1980s and close friends with many of the artists and musicians of the period.

This interview has been edited for clarity and is reproduced here in a naturalized transcription.

And also there were some rumors that he was the guy who was SAMO. I had seen all the SAMO tags and thought they were brilliant and so funny. He also had the experimental band Gray at the time.

My relationship with Jean really did change [over time]. It went from the curiosity and excitement of meeting him to actually not wanting to know him. I just didn't understand his cryptic way of being.

He also was dating my friend Suzanne Mallouk, and I knew that they had broken up, or had some sort of acrimonious situation. So he was also the ex of my friend.

On my twenty-third or twenty-fourth birthday, Steve Rubell kindly offered to throw a party for me in the upstairs VIP room at the Palladium. I wore a vintage gold dress with strings that hung down from it, kind of like tinsel. I was riding high and feeling fabulous. We were at a dinner beforehand, and I think it was Keith [Haring] who first started to "tag" my dress. He drew something, and Andy [Warhol] signed his name, and Kenny Scharf drew something. I was completely flattered.

So we all get into our taxis or walk over to the Palladium. When we get there, Jean just walks up to me and starts fiddling with my dress in the back. He wrote "Kick me" with a trademark symbol on my dress. It was really funny. Part of me was pissed off, but it was genius. It was my peacock moment, and it was as if someone pulled a couple of feathers out.

Jean was such a trickster. Part of me was appalled, and part of me was absolutely intrigued.

JMS: I want to go back to something you mentioned earlier. It really strikes me as unique that you are going to places like the Mudd Club and Hurrah's, but also to places like Danceteria. These all seem like very different venues and crowds. Could you talk a bit about the downtown scene and navigating these sites, specifically as a person of color? How exactly are you moving in between these very different kinds of spaces?

EB: That's such a great question. My parents were very good to me in terms of my education. As a young person, I got to study violin and take French. I think we performed *Macbeth* in sixth grade. It was a really nice education. But I didn't really have a sense of myself as "the other." If I think of it now, yes. I was probably the only Black student around. I didn't understand at the time that I was the odd one out. I think my parents instilled in me a sense of belonging anywhere.

There was Robin Newland and other girls like me, who liked to dress, go out, have fun. There weren't many of us—Robin, Cheyenne, Sheba, Belinda Becker, and Jean. We knew of each other, but none of us were really close friends.

I was in my skin. I had the brief luxury to not have to think about it so much, and that might be the naivete of youth, by the way. I'm pleased to say that I think for a certain period in downtown it just felt very much like a melting pot. And I think that's why so many of us really gravitated to it.

JMS: It seems to me there was also a degree of fluidity between media at this moment. The fact that someone could be interested in music, painting, writing, and film-making, all simultaneously, is very characteristic of that specific moment in New York.

EB: Yes. We all had a side band. My band was Spin and Marty, with Jonathan Sender. "Spin and Marty" was a cartoon or some live-action segment from *The Mickey Mouse [Club]* show, which was before my time. (I am not quite that old.)

JMS: I'm wondering if that degree of fluidity translated to the social dynamics as well?

EB: You know, it didn't feel like, "Oh, this is this thing we're doing," because we were in the middle of it. You just had a side band. Jonathan and I had a band. He was a musician and worked also as a chef. I was a dancer. We all felt like everybody had like ten different side gigs. Suzanne Mallouk sang and wrote poetry.

JMS: Did you spend time at Jean's studio?

EB: Well, at the time, my boyfriend, Jonathan Sender, who was a musician in the band Konk, was working as a deejay at a place called the Zulu Lounge—all of the way uptown at Eighty-Eighth and York—and I was alone a lot.

Now, mind you this. [At first] Jean and I just didn't get along; it was just something about him I didn't like. I don't know why, but this went on for a while. I guess the expression now would be "throwing shade."

It was John Lurie who actually said, "You need to stop that. He's a really great guy. He really wants to get to know you. Let it go." And for whatever reason, when we were at some nightclub, I thought, "OK, all right. I will [give him a chance]." So, [Jean and I] exchanged numbers.

And that was that. I would call him up, go over, and hang out. The "hanging out" would be Jean working on his art, of course.

Jean was really good at having people around who were interested in something different than [he was] interested in, who could introduce [him] to a poet or a book or a record or type of music or an opera or a fashion designer or just another artist. He was very thirsty and wanted to know as much as we all knew of everything. We all wanted to absorb and learn more information.

So it was a time of trading books and finding new great authors. Sometimes I would just bring a book over and read, and Jean would paint. We started with Dostoevsky. I really liked Angela Carter, who wrote [the story] "The Company of Wolves."

In the beginning, we would play music, and oh my God, it was so much fun. I really wanted to be there. I could not wait to be there at the loft. It was like playtime to watch him work and listen to music. We listened to punk and hip-hop (which was called rap at the time), baroque music, even opera.

He was always working. He would be drawing or writing in a notebook. I don't recall a lot of leisure time with Jean.

We did play hangman. That just came back to me. But that was toward the end [of his life].

I brought him an African American slang dictionary, and we just thought that was great; it was the funniest thing. It was wordplay. It had some obvious words, like "pimp" or "apple." There were certain jazz terms. We would just laugh, because it was [written] very formally. We were like little kids. I know some of those books in part ended up in the paintings.

I didn't find this out until I bumped into Rene Ricard on the street, who said to me, "Erika, do you have any idea that you are all through Jean's latest paintings?" You could have knocked me over with a feather, because when I was with Jean, there was absolutely no sense of me feeding him anything that would later come into his work.

Some of the hangman figures ended up in the later paintings, and it's just shocking and moving. It's beautiful and devastating.

JMS: What, if anything, can you share about watching Basquiat in process?

EB: When Jean painted, he used different techniques. Sometimes a single canvas would lie on the floor, and there would be two, perhaps, leaning against the wall. Everything had been gesso-ed, so it was primed and ready to go.

He would start one canvas maybe with words [written in] oil stick. Another one would have a wash of background color, or maybe some background shapes—a drawing of a truck or similar. And the canvas on the floor would be a whole other type of media—Xerox [collage] or whatever.

But it wasn't frantic. I would talk to him, and he would listen to every word I was saying, but [he was] working, drawing on one canvas and doing something else on another. He would come back down to the floor (from a ladder or stepladder) and sit with me, writing or gluing. And that was being in the studio. The whole time I would just sit and talk to him. He was super focused, in a way that most people are not. He knew exactly what he wanted to do.

Toward the end [of his life], it was slower; he was drawing in notebooks and painting. It was more [about] taking drugs, which for me was very scary. It shifted a bit to [me saying], "Jean, man, let's not do this. Why don't we go for a walk?" He did get clean, and he actually asked me to go with him to Hawaii. He was going to Africa; he had all these plans [before he died], and then he was no more.

His death was devastating [to me], and I still remember where I was when I heard [he had died]. No one wanted to tell me or call me [at first], it actually fell to the editor of *Island* magazine, Steven Neuman. He asked me if I had heard about Jean, and I asked, "Oh, is he back?" [Steven] told me that he had died. Overdosed. And I just remember falling to my knees on Houston Street. It was ten or eleven o'clock in the morning. It was a sunny day.

There is something about Jean-Michel that still really resonates so deeply with me, and that hasn't really [changed] with time. I mean, there is a distance, but I just

miss him. That has not changed. It hasn't really altered with time. I mean time supposedly is the killer of pain, and there is a distance. And I have lots of time for reflection because I'm alive, he isn't. But I just miss him.

He was phenomenally generous. He gave $50 and $100 bills to the window washer or to the taxi driver. If someone was begging [on the street], he would stop and say, "Do you need something to eat? Let's go get a sandwich." And he would stay and talk.

He did that a lot. That was just who he was. He was very, very sensitive.

[Jean] wanted to be remembered forever and was devastated that he was not accepted like other artists because of his skin, his melanin content.

MOMA didn't want his work, or a certain gallery was not interested in having him in a group show, or certain collectors did not want to buy his work and wouldn't even meet with him. He hated that he was considered primitive or uneducated, as if he were some weird fluke. "How did he get this talent? He could not have possibly heard of Cy Twombly. What school did he go to?" That stuff devastated him.

JMS: Really?

EB: He hated being talked down to. He would do interviews and tell me it was really disgusting. He would stop interviews after a few sentences. He had horrible things said to him, really horrible things. He just found [interviews] so condescending and disrespectful. I wasn't there, but he would focus on something derogatory someone had said to him, and it would just wreck him.

He was someone who practiced his art. He read. He studied. He managed to absorb and learn and read and filter. He knew who [Joseph] Beuys was. In some interviews he would say, "No. I don't know [who that artist is]." But he would just be appalled. He would say, "Would you ask someone with fair skin those kinds of questions? Someone who graduated from Yale's art school, or is it just me?"

We couldn't get taxis sometimes. And for Jean those taxis going by were just a slap in the face. We would give [the driver] a $50 bill for a $5 ride.

He absolutely wanted to be remembered. He wanted to be known. He wanted to be respected. He wanted to have the same accolades as people like Julian Schnabel, or his artist friends like Kenny [Scharf] and Keith [Haring].

It just wasn't the same for him.

DIEGO CORTEZ

2019

JORDANA MOORE SAGGESE: Could you tell me a little bit about the first time that you became aware of Jean-Michel Basquiat? I would imagine at that point you knew him as SAMO. Is that right?

DIEGO CORTEZ: Well, no. I knew him as Jean-Michel Basquiat. I met him at the Mudd Club on the dance floor and we became friends.

In that period [fall 1979], I was organizing a show which would become *New York/New Wave* and was commissioned by the Galleria d'Arte Moderna in Bologna. Sometime in the spring or the summer of 1980, the show's funding fell apart because of a change of regional government. I had already done most of the research, but then the exhibition languished. I hadn't yet added Jean-Michel to the show. He had told me about his SAMO graffiti works, but I hadn't seen them.

Finally, in midsummer of 1980, I witnessed the first SAMO graffiti works on Prince Street off the Bowery. I was shocked and loved them instantly. When I ran into him a few days later, walking out of a sandwich place on Prince Street in SoHo, we sat down on the stoop, and I told him that I really liked his SAMO work. I proposed to be his agent and suggested that if he put his work on canvas or paper, I could sell them to collectors.

I gave him a couple hundred dollars to buy materials at Pearl Paint. A couple days later, he said that he had works to show me. They were beautiful—small canvases and a few drawings, similar to the ones in the PS1 show that appeared the following February. Then there were paintings and works on old or broken windows from tenement buildings. I sold these initial works to Barbara and Eugene Schwartz, Jeffrey Deitch, Henry Geldzahler—serious people in the art world. Jean-Michel gave me more works to sell from the fall of 1980 through the spring of 1981.

Before working with me, Jean-Michel had sold a major canvas to Debbie Harry and Chris Stein and gave one to Glenn O'Brien, with whom he had shot the film *Downtown 81* in the fall of 1980. Jean-Michel probably met Debbie and Chris

Diego Cortez (born James Curtis in Geneva, Illinois) is an American art curator closely associated with the no wave period in New York City. In 1981 he curated the landmark exhibition *New York/New Wave*. Cortez was also a cofounder of the Mudd Club—the downtown, punk alternative to the uptown, disco-oriented Studio 54 that opened in 1978—and the interdisciplinary artists' group known as Collaborative Projects (a.k.a. Colab). Working as an art adviser since the early 1980s, Cortez was Basquiat's first art agent, introducing him to many of the dealers and galleries that would first show his work.

This interview has been edited for clarity and is reproduced here in a naturalized transcription.

through Glenn. Debbie and Chris bought what was technically his first major painting for less than $500.

JMS: How did you know these "serious art people" like Henry Geldzahler and Jeffrey Deitch? What were your connections to them, and how fluid were the social connections in that moment between agents and dealers?

DC: Well, I received my MFA from the School of the Art Institute of Chicago and moved to New York in 1973. I got to know most of the artists in SoHo and Tribeca at that time. I also traveled a lot in the '70s to Europe, spending half my time there, so had met many of the important dealers and major artists there.

I met Jeffrey Deitch when he was working at the John Weber Gallery around 1975. He soon decided to attend Harvard for his MBA with the idea to start an art magazine. But upon graduating, he instead went to work in art advisory services for Citibank.

It was a much smaller scene than it is now. I wasn't an art dealer. I wasn't an art advisor. I wasn't even a curator until I did *The Batman Show* for Colab in 1979.[1]

My first big show was *New York/New Wave,* which, as I said, was commissioned in Bologna. After that fell apart, Alanna Heiss asked me to mount it at PS1. After the show opened, Henry Geldzahler contacted me. I put him in touch with Keith Haring and Jean-Michel, and he bought their work.

Jean-Michel was living with Suzanne Mallouk at the time in a four-story walkup building on First Street, between First and Second. I would visit to look at new works he was making.

JMS: Did you ever see Basquiat working in the studio?

DC: In 1980 and 1981, yes. I only visited the basement at Annina Nosei's gallery once, but he wasn't working; we were just talking. From May 1982 to about a year later, I was in the Crosby Street studio several times a week. I wasn't working with him as an agent then, but I offered support for his problems with dealers or this, that, and the other thing.

I remember sitting on his bed in his Modena hotel in May 1981, talking about his drawings. He began ripping drawings that he didn't like away from the sketchpad and throwing them into the trash. I encouraged him to keep the good parts of each drawing and use them in other works. Later, he also told me about the Xeroxing of his drawings and that it was so helpful for him to be able to work so much more quickly. Maybe he had some sort of subconscious feeling he wasn't going to be around too much longer. I don't know.

JMS: In the process of working quickly, did you see him working on several canvases at once?

DC: In the summer of 1982, on Crosby Street, he had the paintings for the Fun Gallery exhibition all around the room—about twenty paintings. They were all being worked on here and there, and Jean-Michel was moving from one to the other. In

the middle of the loft was a huge pile of drawings—maybe two hundred drawings stacked on top of each other. He and his assistant, Steve Torton, and I would have to walk across the drawings to go from one end of the studio to the other or from painting to painting. The drawings all have that gritty texture from being walked on—sneaker prints, dirt.

JMS: And would he make drawings and paintings at the same time?

DC: Not literally at the same time, but yes, in the same day, he might go from drawing to painting. Many artists work like that.

I remember going to Prinzendorf, Austria, in 1975 for a Hermann Nitsch *aktion* that I was in, and I met Arnulf Rainer, an expressionist artist who painted on top of self-portrait photographs. He had scores of these works around the large attic studio in Nitsch's Schloss, and he would run around the perimeter adding something to each work in sequence.

I do that myself, when I work. I have maybe twenty different things to do in one day, and most are unrelated. It makes it more interesting to move from one thing to another rather than fixating on one thing, one project, et cetera. It's more creative to keep going back and forth, constantly segueing into other things.

JMS: Compared to other artists working in this period, what was so special to you about Basquiat's work?

DC: In the late '70s, I knew many of the emerging artists—Clemente, Cucchi, Chia, Schnabel, Salle, Fischl, et cetera. I had become friendly with them. But when I met Jean-Michel and Keith, it all came much closer to home for me. I guess I was looking for something more radical. For example, I have always loved Clemente's work, but I think Jean-Michel became much more important because he represented something new because of the relationship to graffiti. It took a while for Keith and Jean to catch up with those artists, but they eventually did and finally eclipsed the others.

For me, Jean-Michel was the most incredible artist. His work was not really graffiti art from the street, but rather graffiti-related studio art. He did have the initial SAMO period—philosophical slogans graffitied on the walls of the downtown artist neighborhood. Those SAMO works were not only meant for the general public; they were meant for the art world because of their proximity to SoHo.

JMS: I agree with you there. I think it was very targeted; it was a form of Conceptual art.

DC: Totally. Fluxus and Conceptual art were also obliquely related to Jean-Michel's work. Joseph Kosuth, an old friend of mine from the '70s, called me a traitor or turncoat when I switched my interests from '70s Minimal and Conceptual art to '80s Neo-Expressionist work. Joseph was really angry with me. But then when I showed him Jean-Michel's work and his use of text, he responded more positively. I got them to collaborate on a cover of *Arts Magazine* where Jean-Michel scribbled over Kosuth's definition of "Meaning" work.[2]

Basquiat's work was related to graffiti, the street, Pop art, and the music scene, but it came from a different place. It wasn't "postmodern" the way the rest of them were. It wasn't coming from a Euro tradition of regressing back into a historical, often metaphysical, European style of art.

JMS: Why did you want his work in the exhibition *New York/New Wave?*

DC: The focus of the show was not just to showcase emerging visual art. It was to document the recent nexus of the art and music scenes. There were Nan Goldin and Robert Mapplethorpe, but you also had many music documentary photographers like Allan Tannenbaum, who had photographed Sid Vicious being taken out of the Chelsea Hotel by the police. The exhibition documented all kinds of things related to the punk and new wave music worlds, and Jean and Keith were very involved with these downtown scenes. That's why I included them in the show.

Leading up to the February 1981 opening, I felt that Jean-Michel was the only artist from that scene who actually made great works in the traditional media of paintings and drawings. All the other material in the exhibition consisted mostly of graffiti works, found objects, and photography. There were no paintings in the show aside from Jean-Michel's, so that helped Jean-Michel's works jump out to the public. He had a whole wall to display his paintings and drawings. The recent Barbican retrospective re-created that wall from the original *New York/New Wave* installation.

So it had to do with music. That was a qualifying reason for including Basquiat in *New York/New Wave.*

JMS: Could you tell me about the art market and the early 1980s? As you were Basquiat's earliest agent, what can you tell me about that particular moment? How was the energy around the art market then, as compared to what we're seeing now?

DC: It was much smaller. Jean-Michel emerged just at the moment when the art market was starting to take off—both in Europe and in the US.

When I proposed to be Jean-Michel's agent, I explained I would not become his dealer, rather find him his dealers. That would be my role. I did sell some of his art before and after the PS1 show, but not a lot.

A lot of art dealers came to the PS1 show. Leo Castelli was there. I asked him pointedly if he liked Basquiat's work, and he said, "I prefer Futura 2000." I asked Annina Nosei if she liked it and she said, "Oh, it's OK." I asked Bruno Bischofberger the same question—because I was hoping he would become Basquiat's dealer in Europe, as he represented Clemente and Schnabel, artists that I knew personally. He was not very keen on the work either! The only person I remember really freaking out was the artist Sandro Chia. Sandro had a lot to do with Jean later getting his first solo gallery show in Modena, Italy, in May of 1981, at Galleria Emilio Mazzoli.

Jean-Michel and I were disappointed that no dealers responded to his work in February. I decided to contact Emilio Mazzoli through Sandro Chia. I was told

that Emilio was coming to New York with Achille Bonito Oliva, the Roman art critic. They came to my loft which I shared with Sylvère Lotringer, editor of *Semiotext(e),* in April of 1981 to look at the work and immediately bought everything for the show.

The Mazzoli show, in May 1981, was presented under the name SAMO and quickly sold out at very low prices. Mazzoli had bought the whole show for something like $25,000. After the Modena show, I ran into Annina Nosei, who was friends with Mazzoli and Bruno Bischofberger, at a restaurant in Berlin in August 1981, and she said, "Diego, I want to talk to you about my working with Jean-Michel. I really like his work and would love to show him." I told her "OK," and when I got back to New York the next week to talk with her, Jean-Michel wasn't returning my calls. I found out that he had already joined her gallery.

So my relationship with Jean was severed at that point, even though I had many of his works in my possession. In the fall I got a letter from Annina's lawyer asking me to turn those works over to her. She had been an old friend. I went to her gallery and told her, "These are works that Jean-Michel gave me on consignment. If he asks for them back, I'll give them back to him, but I don't appreciate getting a letter from your lawyer."

Jean-Michel was working in the basement, and Annina screamed to her secretary, "Get Jean-Michel up here!" He came upstairs with his tail between his legs. Annina told Jean-Michel: "Diego is not going to give the works back, unless you ask for them." Then he sheepishly said to me, "Oh, you can keep them." Annina let out a scream at the top of her lungs.

I told Annina and Jean-Michel, "I'm not going to keep them. These are Jean's property. I will keep them until he leaves your gallery, which I'm sure won't be too long, and then he can have them back." Sure enough, six or eight months later, in May of 1982, I got a call from Jean-Michel saying he had just left Annina and had taken all of his finished works back to his Crosby Street studio and slashed any unfinished works in Annina's basement. He asked me to be his agent again, and I said no. I told Jean that Bruno Bischofberger expressed an interest to represent him, but not through Annina. I phoned Bruno, and within days he was represented by Bruno's gallery in Zurich.

I began to hang out with Jean-Michel almost every day over the summer of 1982. He was working on a show for Patti Astor's Fun Gallery. When Bruno tried to cancel the Fun Gallery show, I insisted to Jean-Michel that he honor his commitment with Patti. I think that was the only great show of Jean-Michel I ever saw in New York before he died. It was a brilliant show—a funky gallery setting for his new funky artworks painted on irregular stretchers purportedly designed and made by his assistant, Steve Torton. I was able to sell two or three of those works to the Schorrs and to Henry Geldzahler.

Strangely, Patti didn't want to cooperate with me or give me a commission, even though I saved her show from cancellation. There was already a bit of backbiting.

There was also the colonialist syndrome of people who claimed they "discovered" Jean-Michel. At a certain point, I stopped thinking like that myself because there were so many others saying it, and it sounded ugly.

JMS: As artists like Jean-Michel, Keith Haring, and others who were working in the streets started to move into the studio, there was criticism from that period that positioned their success as an appropriation of the primitive myths that we have around untrained, and especially Black, artists.[3] Do you see race as a factor in his early success?

DC: Well, the people that claimed to have "discovered" him were his friends, not particularly art historians or critics. They were good friends who helped him a lot in different ways—Maripol, Glenn O'Brien, Rene Ricard, et cetera. But I don't think that they were racist at all or that they were trying to manipulate a Black artist. The art criticism and art world itself was inherently racist at that time, but in a subtle, coded way.

I did help Jean-Michel in different ways, including critiquing his art to him directly, but my connections with galleries and collectors were the most beneficial thing for him in terms of making that initial entry into the art world.

Jean-Michel's relationship with white friends was somewhat constant, and he had perhaps more white friends than Black. He had grown up in a middle-class neighborhood in Brooklyn. Some people feel comfortable or even more comfortable in "other" contexts. I am gay, but most of my friends are straight. Jean-Michel was not uncomfortable with my being gay.

Overall, I don't buy into the narrative that Jean-Michel was manipulated by a white art world that ruined his life followed by a tragic death. That was the premise of the first biography of Basquiat, by Phoebe Hoban. I felt betrayed by her after I had persuaded so many of Jean-Michel's friends to talk with her for her book. They had initially refused, wanting nothing to do with it. She had written a postmortem piece in *New York Magazine,* which was already suspect. She promised she wasn't going to frame the book in that negative way but ended up using the title *A Quick Killing in Art,* as if the white art world had killed him.

I'm sorry. He used drugs. He liked drugs. I don't have any moral judgment on that. But I think Jean-Michel used drugs to speed himself up, so he could get a lot more done with greater focus. He accomplished more in seven or eight years than most people accomplish over a forty-five-year career.

JMS: What do you make of the current popular culture obsession with all things Basquiat?

DC: It's actually two things: it's "all things Black" and "all things Basquiat"—two different trends. Both are happening right now. I would almost say that "all things Black" is a much larger phenomenon and much more important. We are finally at a point where there are over one hundred viable Black artists in the world who are doing quite well. And maybe I only like half of them. I can now be critical as we've reached a healthy situation at this point.

In talking about "all things Basquiat," there are some problems. The problem right now is that he may be getting overexposed to both the art cognoscenti and the general public. Basquiat seems to get much of the public's attention, and many other artists get much less attention. In the '70s there were hundreds of Sol LeWitt shows internationally in a year. Basquiat's work is extremely valuable, but it is also very popular with the public. I just hope that the work and the narrative around the work don't get overexposed and people [don't] lose interest.

I remember when Francesco Clemente began to appear in scores of magazine articles around the world every month. It took about five years of that type of overexposure for the art world to begin to shun him. I don't think that will happen as much to Jean-Michel as he is still on top of the art market. That means a lot to both the general public and the speculators. The public weirdly respects that.

Today, the Basquiat estate gets many demands for exhibitions. Fortunately, we are at a moment when we are not just doing "Basquiat" shows, but we are finally seeing shows with a more curatorial, critical, or intellectual vision. This is "part B" of his exhibition career.

JMS: We do get a lot of exposure to Basquiat. I just got an email from a backpack company that's licensing his image. There's also Uniqlo. We have all these examples of his work circulating in popular spheres.

DC: I love that. The merchandising of Jean-Michel's work—perhaps initially because of his connections with Warhol—has been successful, beautiful, and of high quality.

The estate now seems to be in very good order. A few years after Jean-Michel's death, I had a conversation with Jean-Michel's father, Gerard Basquiat. I asked him how many works were in the estate. He told me about eighty to one hundred paintings and six hundred to eight hundred drawings—something like that. I immediately suggested he close the estate, to not sell anything anymore. He said he didn't fully understand.

He said he had a great gallery and was saving money for his daughters. I told him, "The works you are selling are going to be more valuable than anything you could buy with the money from gallery sales. You must hold on to every single piece." In the end, the merchandising was a second phase for the estate—a way of earning income after the cessation, for the most part, of selling original artworks.

The art world is a slippery slope, and we must remember that the Basquiat family tragically lost a son and brother—they were forced into this situation. It's great that Jean-Michel's family are very savvy themselves and have chosen good people to advise and help them. Both Dieter Buchhart and David Stark have proven themselves with regard to the exhibitions and merchandizing. I totally respect what they do.

My relationship with Jean-Michel was a private business relationship, even if I was his friend. All my work after Jean-Michel's death with the father and the

authentication committee was about further advancing Jean-Michel's work and career.

I'm very content where Jean-Michel's career has ended up. I'm sad about his being gone, but many of my other friends are gone too. Soon, the rest of us will also be gone. What remains is what's important: the artworks. That's the lasting beauty of the art game. Jean-Michel knew that his art, his gift, would outlive him.

Notes

1. Cortez was a founding member of Collaborative Projects (Colab), a not-for-profit cultural organization of artist members formed in 1977 that organized several notable exhibitions, produced a TV series on Manhattan cable, and even published a magazine from the late 1970s through the mid-1980s. See Max Schumann, ed., *A Book about Colab (and Related Activities)* (New York: Printed Matter, 2016).

2. Cortez refers here to a work from Kosuth's *Art as Idea as Idea* series (1966–68).

3. See Robert Hughes's essay "Requiem for a Featherweight" later in this volume.

During his lifetime, the work of Jean-Michel Basquiat continually suffered from a lack of critical interpretation. As one can see in the third section of this volume, which reproduces a selection of contemporary criticism and commentary from this period, the artist's personality and celebrity often eclipsed serious consideration of his paintings and drawings. Basquiat's associations with Warhol, who himself built a career on denying any critical depth to his Pop works, certainly did not help. And finally, we must consider that the art world of the late 1970s and the 1980s frequently promoted minimal and conceptual art at the expense of the more expressionist painting styles with which Basquiat was most often (if not wrongly) associated.[1]

The dominant strain of criticism in Basquiat's moment belonged to a group of Marxist historians, who published in the pages of *October* magazine, privileged the intellectual content of an artwork over its form, and held up art of the 1960s and 1970s as the only true avant-garde. In his essay "The End of Painting," Douglas Crimp argues that these earlier movements "sought to contest the myths of high art, to declare art, like all other forms of endeavor, to be contingent upon the real, historical world. Moreover," he continues, "this art sought to discredit the myth of man and the ideology of humanism which it supports. For indeed these are all notions that sustain the dominant bourgeois culture."[2] From Crimp's perspective as a Marxist, the ultimate function of art was to critique the bourgeoisie; minimal and conceptual art achieved this by purposely devaluing the art object, creating artworks that could not be easily bought or sold (as in the earthworks created in the landscapes of the western United States) or works without any material form (as in text-based installations). The Neo-Expressionist painters, however, consciously cultivated the art market, selling works for inflated prices and reaffirming the fetish status of the art object. Crimp and his fellow critics believed that the most successful paintings were self-referential and considered the "painting as object"; artists Daniel Buren and Robert Ryman were celebrated, while Neo-Expressionist painters like David Salle, Francesco Clemente, and Julian Schnabel were dismissed.[3]

Initially associated with Neo-Expressionist painters like Salle and Schnabel—both of whom also showed with gallerist Mary Boone in the 1980s—Basquiat was spurned early on by most serious art critics. As I have written elsewhere, the sharp divisions between Conceptual art and Expressionism maintained by Crimp and his colleagues in the pages of *October* did not account for an artist like Jean-Michel Basquiat, who explored both the form and the content of his paintings, working with both language *and* gesture simultaneously.[4] Contemporary criticism, as a result,

fell short of acknowledging the critical potential of these paintings and drawings. In fact, it was only after the artist's premature death in 1988 that curators, critics, and historians began to address this lacuna in Basquiat's critical reception.

The essays in this section, organized chronologically, offer a comprehensive overview of the slow evolution of the interpretation of Basquiat's work. The first six essays are obituaries, where critics (and sometimes friends) of Basquiat oscillate between reifying the early mythologies of the artist and lamenting the art world's failure to acknowledge his contributions to the history of contemporary American art. As an example of the first category, the obituary written by Constance Hays includes a section titled "Temperamental Artist," where Hays curiously highlights Basquiat's "temper, which once led him to destroy a number of unfinished paintings. In another incident," Hays continues, "he leaned out of a window and poured dried fruit and nuts onto the head of a dealer as she left his building." Hilton Als takes the opposite approach, developing a very different image of the artist through descriptions of Als's personal encounters with Basquiat, whom he describes as "one of the most beautiful young men—with one of the most original minds—I have ever met."

Robert Hughes's incendiary essay posits Basquiat as a no-talent hack. He describes Basquiat's life as "a tale of a small, untrained talent caught in the buzz saw of artworld promotion, absurdly overrated by dealers, collectors, and, no doubt to their future embarrassment, by critics." Throughout his essay, Hughes repeatedly insults Basquiat, claiming that his success was due to his Blackness (and the art world's fascination with it). Reading Hughes's essay can be a painful experience, but such perspectives are critical to our understanding of the later scholarly reappraisals of Basquiat's work also republished here. Lorraine O'Grady even namechecks Robert Hughes in her review of Basquiat's retrospective at the Whitney Museum of American Art.

We could also read Greg Tate's 1989 essay as a critical response to opinions like Hughes's. Tate's review of Basquiat's posthumous gallery exhibition at the Vrej Baghoomian Gallery includes excerpted texts from the *Narrative of the Life of Frederick Douglass* and the poetry of Amiri Baraka (formerly LeRoi Jones), as well as the proclamations of Rammellzee and David Hammons; throughout the essay, Tate reaffirms Basquiat's Blackness, framing the artist's constant search for a compromise between Black culture and "the white art world" as part of the larger historical project of Black cultural politics. Tate also calls for a reconsideration of Basquiat's use of text that connects to the history of Black America.

Tate reminds us to consider the work of Basquiat as that of a poet, as well as that of a painter. Christopher Stackhouse, whose essay closes this section of the *Basquiat Reader*, takes up Tate's call. Stackhouse, writing more than twenty-five years after Tate, argues for a consideration of Basquiat's language in the context of proto-Beat poet Bob Kaufman, who similarly explored the use of sans serif block-capital letters, improvisatory composition strategies, and the social reality of race in

America, and in comparison to the relatively unknown Norman H. Pritchard, who explored the abstract potential of language in his concrete poetry.[5]

The essays reprinted here by Dick Hebdige, Thomas McEvilley, bell hooks, and Lorraine O'Grady are what we might consider the first phase of Basquiat scholarship. All were published in relation to the artist's first major retrospective exhibition, at the Whitney Museum of American Art in the winter of 1992, which was, in several ways, a landmark event for scholarship on the artist. Not only did the exhibition bring together one hundred works in a single venue, but its catalogue (now out of print) provided the first collection of critical essays on his work. An essay by the exhibition's curator, Richard Marshall, for example, provided a sweeping chronological and analytic overview of Basquiat's production from 1979 to 1988 that served as the foundation for much future research (including my own).[6] Marshall's essay (which we could not include here) highlights significant themes and motifs in Basquiat's work (crowns, the notary seal, Black figures) and also provides insights into his source materials. Marshall also summed up an attitude that was fairly common at the time, lamenting that "Jean-Michel Basquiat first became famous for his art, then he became famous for being famous, then he became famous for being infamous—a succession of reputations that often overshadowed the seriousness and significance of the art he produced."[7] As we shall see, although that statement rang true in 1992, in texts written during the following decades, Basquiat gradually transformed from an object of fascination to a subject of critical inquiry.

"Welcome to the Terrordome: Jean-Michel Basquiat and the 'Dark' Side of Hybridity," written for the Whitney catalogue by sociologist and media theorist Dick Hebdige, deals directly with the critical reception of Basquiat's work. Hebdige interrogates the stereotypes that surrounded Basquiat during his lifetime (in his words, "the slippage from Basquiat to 'bastard'") and the ways in which the artist's Blackness prevented him from fully entering the mainstream art world of his moment. Looking closely at Basquiat's painted self-portraits and even his self-presentation on the cover of the *New York Times Magazine* (see page 352), Hebdige argues for the artist's cultivation of an ethnographic gaze. His consideration of Basquiat's performance—that is, his use of the body as "a studio unto itself"—provides a pathway for future scholarship that still remains underexplored.[8]

The essays by Thomas McEvilley, bell hooks, and Lorraine O'Grady were written in response to the 1992 retrospective. Taking up the reassessment of Basquiat from within the context of Blackness posited by Greg Tate, the essays by bell hooks and Lorraine O'Grady similarly criticize the presentation of Basquiat from within a white art history. O'Grady explicitly takes on the art world, warning that "in Basquiat's art there is a fine line between rehearsing the legend and examining the art impulse itself. . . . Under the compulsion to find hegemonic origins for him, such as Jean Dubuffet and Cy Twombly, analysis is being strangled." She asks us to focus on the *why* of Basquiat's quotations of white European artists or even of jazz life that was by then "a quarter-century out of date." hooks makes a similar argument for looking

at this artist from a perspective outside white, European models, writing that "though Basquiat spent much of his short life trying to get close to significant white folks in the established art world, he consciously produced art that was a *vattier*, a wall between him and the world." hooks looks closely at themes of "ugliness" and isolation, paying close attention to the Black figures that populate many of Basquiat's paintings and drawings.

Thomas McEvilley similarly attempts to resuscitate Basquiat's critical reputation, exploring the "primitive" stereotype so often associated with the artist. While problematic in its understanding of race, this essay is important for its assertion of Basquiat's self-awareness of his relationship to white art history. "By taking on the role of the white borrower," McEvilley claims, "Basquiat collapsed the distance between the colonizer and the colonized, embodying both at once."

Indeed, Basquiat confronted the conventions of the (overwhelmingly white) art world by self-consciously painting in a style that conformed to primitivist notions: the quick brushstrokes, jagged lines, and seemingly chaotic compositions all speak directly to the stereotype. In more contemporary terms, we might interpret this inversion of the primitivist model—imitating the production of white culture as a nonwhite artist—as a move toward "disidentification," as theorized by José Esteban Muñoz.[9] That is, Basquiat deployed modernist codes and practices of the mainstream in order to highlight the politics of the marginalized. We can see Muñoz's theory realized in his 1996 essay, where he argues that Basquiat's use of comic book superheroes and cartoons was a way to reimagine (or even rewrite) the ideology of white supremacy—that is, he takes mainstream subjects (Popeye, Superman) and renders them incomplete, their powers diminished.

What is perhaps most remarkable about this first generation of Basquiat scholarship, including the work of Muñoz, is the way in which it foregrounds some of the debates around identity politics that would come to dominate visual and cultural studies soon after. In fact, the study of identity's intersections with art practice has exploded in the years since Basquiat's death. Beginning in the 1990s, museums and other cultural venues made a concerted effort to engage with and to push against the politics of identity. These efforts were notably addressed in a number of exhibitions during the 1990s. The 1993 Whitney Museum of American Art's biennial, in particular, has been read by scholars as *the* turning point for identity-based art discourse. It is ironic that such ideas were not readily applied to the work of Jean-Michel Basquiat, even though this landmark biennial opened just one month after Basquiat's large retrospective at the Whitney closed.

The remaining essays in this section respond to these earlier authors, taking into account the broad range of references and influences at play in Basquiat's work. In his essay, curator Franklin Sirmans offers nuanced readings of works that consider the entangled perspectives of gender and race. Sirmans also directly engages the large amount of criticism that emerged after the artist's death in 1988 (the texts by Robert Hughes and Peter Schjeldahl among them) that failed to recognize his true

impact. Basquiat, in Sirmans's estimation, disguised his polemical subjects in a masterful manipulation of color and line.

And finally, Kellie Jones offers an insightful analysis of Basquiat's place within a larger constellation of African diasporic culture. Jones argues for the complexity of both the artist's racial identity and the concept of Blackness itself—a product of migration and cross-cultural contact and synthesis, a hypothesis rather than a fixed set of terms.

As Basquiat's fame has grown, the world of pop culture has embraced him in a way that critical culture has failed to do. With the rapid circulation of images and ideas via social media, artists have as a whole become less dependent on the traditional image machine of art criticism for gaining visibility. The line between popular and critical culture has become increasingly porous, as celebrities such as the hip-hop musician and producer Swizz Beatz publicly exhibit their own art collections and as artists (e.g., Kalup Linzy) take up YouTube as their medium. Similarly, the parameters of traditional art history have expanded, as scholars look more broadly at visual culture outside the boundaries of traditional fine arts. The work of Basquiat now exists in a world where canonization is not performed solely by institutions and critics but rather is a popularized process in which the media and pop culture play a significant role. It is in this expanded art world that we might look again at the life, work, and legacy of Jean-Michel Basquiat and discover something new.

Notes

1. I have argued elsewhere that Basquiat's early associations with expressionist painting occluded the recognition of the conceptual dimensions of his work. See, most recently, Jordana Moore Saggese, "Knowing an Image: Jean-Michel Basquiat and the Question of Text," in *Words Are All We Have: Paintings by Jean-Michel Basquiat,* exh. cat. (New York: Nahmad Contemporary, 2016), 48–63.

2. Douglas Crimp, "The End of Painting," in *October* 16 (Spring 1981): 75.

3. For a nuanced discussion of the state of 1980s art criticism, see Alison Pearlman, chap. 1, *Unpackaging Art of the 1980s* (Chicago: University of Chicago Press, 2003).

4. See Jordana Moore Saggese, chap. 3, *Reading Basquiat: Exploring Ambivalence in American Art* (Berkeley: University of California Press, 2014).

5. For further discussion of Basquiat's relationship to language, see also Saggese, *Reading Basquiat,* 109–46.

6. See Marshall, "Repelling Ghosts," in *Jean-Michel Basquiat,* exh. cat. (New York: Whitney Museum of American Art, 1992), 15–27.

7. Marshall, 15.

8. See, for example, Eleanor Nairne, "The Performance of Jean-Michel Basquiat," in *Basquiat: Boom for Real,* exh. cat. (London: Barbican, 2017), 20–27.

9. José Esteban Muñoz, *Disidentifications: Queers of Color and the Performance of Politics* (Minneapolis: University of Minnesota Press, 1999).

JEAN BASQUIAT, 27, AN ARTIST OF WORDS AND ANGULAR IMAGES

CONSTANCE L. HAYS, 1988

Jean-Michel Basquiat, a Brooklyn-born artist whose brief career leaped from graffiti scrawled on SoHo foundations to one-man shows in galleries around the world, died Friday at his home in the East Village. He was 27 years old.

His agent, Vrej Baghoomian, said the cause of death appeared to have been a heart attack or drug overdose. Mr. Basquiat had been planning to depart last weekend for a month long trip to the Ivory Coast, Mr. Baghoomian said.

The son of a Haitian accountant, Mr. Basquiat began drawing on sheets of paper his father brought home from the office. He never received formal training, Mr. Baghoomian said, and his paintings incorporated images of angular people and symbols with lone words or phrases. In an interview in The New York Times Magazine in 1985, he said he used words "like brushstrokes."

During his graffiti period, he worked with a friend, Al Diaz, and the two signed their work Samo, followed by a copyright symbol. When the friendship fizzled, Mr. Basquiat wrote "Samo is dead" prominently around lower Manhattan.

Established Career at 20

Critics praised his work for its composition, color and balance between spontaneity and control. While still in his early 20's, his work was shown at leading SoHo galleries, including the Annina Nosei Gallery and the Mary Boone Gallery, and his work was exhibited in galleries from SoHo to Paris, Tokyo and Dusseldorf. His paintings sold for $25,000 to $50,000, Mr. Baghoomian said.

Mr. Basquiat formed a close friendship with Andy Warhol, immortalizing it in a double portrait that sold in the auction of Warhol's collection at Sotheby's last spring, Mr. Baghoomian said. The two also collaborated on a series exhibited in 1985 that featured cartoon characters and corporate logos.

At the time of his death, Mr. Basquiat was living in a building he rented from Warhol's estate. "Andy's death really affected him," Mr. Baghoomian said. But Mr. Basquiat had long been moody, he added: "Emotionally, he was always in turmoil."

Constance L. Hays, "Jean Basquiat, 27: An Artist of Words and Angular Images," *New York Times*, August 15, 1988.

Mr. Basquiat also achieved renown in the contemporary art world for his temper, which once led him to destroy a number of unfinished paintings. In another incident, he leaned out of a window and poured dried fruit and nuts onto the head of a dealer as she left his building.

Mr. Basquiat's paintings are included in the collections of the Whitney Museum of American Art and the Museum of Modern Art.

He is survived by his father, Gerard, and mother, Matilde, both of Brooklyn, and two sisters, Lisane and Jeanine.

JEAN-MICHEL BASQUIAT, 1960–1988

HILTON ALS, 1988

Since learning of 27-year-old painter Jean-Michel Basquiat's accidental death by drug overdose last week, what I live over and over again are not so much the hideous and hideously stupid circumstances surrounding his premature demise, nor the fact that so much splendor has been left by someone so young. He was a vibrant painter, a complicated artist, who produced work that meant more to the viewer, to me, than met the eye. But what I missed immediately was the figure of Jean himself, one of the most beautiful young men—with one of the most original minds—I have ever met.

It began with his eyes. I saw them—and him—for the first time in Brooklyn, our hometown. Never before and never since have I felt someone's eyes *pierce* my consciousness in such a direct and directly personal way. Looking across the room at him and he at me, I saw the largely white cocktail party in which we stood grow smaller; the sea of faces that did not look like ours became a force that made us recognize each other to a degree that made at least my side of the conversation halting, stilted, naked. Sometimes love at first sight is like that.

And it was at first sight, too, that you realized Jean lived his life as if he had nothing to lose. At that same party he replaced the tape being played—Debussy—with a scratched bootleg recording of the Sex Pistols. As he danced about alone, I saw him watch, from the corner of his eye, to see just how long the others would take to pretend they would *not* react to the spectacle of dreadlocks, paint-splattered khakis, and brown limbs. As it happened, the others didn't react. But then again, he did not stop dancing.

That image was replaced, in later years, by the image of the artist as commodity, enfant terrible, bad Black bitch, nasty lout, charming gadabout. Initially identified with a group of artists who reached "blue-chip" status through their efforts as graffiti guerrillas (Jean's tagline: SAMO, as in Same Old Shit), he rapidly progressed to other forms of visual expressions. His paintings, drawings, and sculptures challenged the European idea of the "primitive"; as a disciple of Dubuffet and Twombly, he wanted to give his heroes the Black face of his history.

It became increasingly difficult then to see him across the crowded rooms where so many of his paintings—in such a short time—loomed. The images he created always resonated for me because they were the truest representation of the "Negro" from my generation. In his last show, paintings with words like MISSISSIPPI and SOUTH

Hilton Als, "Jean-Michel Basquiat, 1960–88," *Village Voice*, August 30, 1988, 82. The quotation at the end is from Owen Dodson, *The Harlem Book of the Dead* (Dobbs Ferry, NY: Morgan & Morgan, 1978).

AFRICAN DIAMONDS appear repeatedly in reference to what was being bought, sold, and lived outside of the world of his canvases. I think the words were metaphors for his position in the world just then, too. But that degree of self-knowledge is not what many people saw. Mostly what they saw was a boy so anxious for his life to begin—accompanied by love, by trust—that sadly enough he wanted to buy it all.

Death not only happens once, but time and again to those of us who are left to speak of the dead. But sometimes we don't. This has become a time in which we are more and more disinclined to speak of so frequent an event, essentially because, as Owen Dodson once said:

> *The dead are the signs*
> *Of our cross;*
> *The bury-hour:*
> *Our living crucifixion*

MARTYR WITHOUT A CAUSE

PETER SCHJELDAHL, 1988

"What else could he have done?" So said somebody in the art world to a friend of mine apropos the death on August 12, probably by heroin overdose (autopsy results have not yet been released), of 27-year-old artist Jean-Michel Basquiat. My friend didn't tell me who said it. It doesn't matter. The repulsive suggestion that Basquiat died as some sort of career move belongs to the genre of cynical wisecracks passed around after any tragedy to reassure us that we're shockproof. In the words of John Donne, it is "A Valediction Forbidding Mourning," late-'8os style.

"What else could he have done?"

As well as being slimy in the way of such pleasantries, the remark is notably cruel as a parting shot at an artist often scorned, among the envious or otherwise mean-spirited, as an upstart product of hype. According to this projection, Basquiat, who rocketed to fame in the neo-Expressionist early '8os, had become a failure. He had worn out his vogue among the minions of fashion. His style was outdated. With the death of his mentor Andy Warhol, he lost social cachet. So presumably he needed to pull off something dramatic.

"What else could he have done?"

In point of fact, Basquiat could have done what he was already doing: making good paintings and selling them. Though not his best work, his most recent pictures have an undiminished, crackling edginess and authenticity. Across 9-foot-wide expanses of bare or colored ground, they deploy his familiar but always surprising stick figures, funny-savage mask faces, and block-lettered words. Their effect is kinesthetic, as engaging to our sense of bodily attitude and gesture as good dance. Like Franz Kline and Cy Twombly, Basquiat made form of a kind of extended, exploded handwriting. Also like them, he seemed incapable of moving his hand in a way that was uninteresting.

Pending the autopsy report, there is no confirmation of a rumor, which Basquiat's death made plausible but which I have come to doubt, that he had AIDS. In any case, he was relatively healthy and active, just back from a trip to Hawaii and preparing for another to the Ivory Coast, at the time of his death. According to his dealer, Vrej Baghoomian, Basquiat was well-off, with a ready market in the range of $25,000 to $30,000 per painting (and a sturdy demand, at much higher prices, for resales at auction).

Basquiat may be a martyr to nothing except the Russian roulette of a dope habit he vainly believed he could control without help. But there is no denying that his

Peter Schjeldahl, "Martyr without a Cause," *7 Days*, September 1, 1988, 53–54.

reputation, which will ultimately rest (rather securely, I think) on the quality and significance of his art, underwent weird inflations and deflations in the Byzantine art world of the '80s. It was a world that enabled his rise that he helped to define, and that got bored with him.

I met Basquiat in March 1981 at the opening of a strenuously hip P.S. 1 show of scene-making artists and photographers called "New York/New Wave." His work was the hit of the occasion. At that stage, it was still a fairly direct transfer onto portable surfaces of the frenetic and gnomic markings he had strewn downtown as leader of a two-man graffiti team named Samo, but the freshness of its spiky cartoons and stuttering non-sense writing was electric. At first glance, it seemed to clinch the breakthrough into art of demotic, up-from-the-streets energy that was a tenet of the then burgeoning (now defunct) Lower East Side scene (to which Basquiat never really belonged but which, like his contemporary Keith Haring, he supported in return for maximum exposure).

But the notion that this dreadlocked Haitian-American was an untutored wild child didn't square for me with the elegantly elliptical composition of his pictures—so unlike the formulaic centering and *horror vacui* of work on canvas by the subway graffitists. His stuff looked awfully sophisticated to me. I mentioned Dubuffet to him.

"Who?" he said coolly. I got that we were not going to be friends.

Though a dropout and runaway, Basquiat was actually an upper-middle-class kid from Brooklyn who knew plenty about art from school study and from childhood museum going with his cultured mother. He was simply playing along with a mythologizing bent of the moment, when people were eager to see a whole truth in the half-truth of an innocent, hotly expressive, democratizing trend in culture. (Now it all seems like a very long time ago.)

There followed Basquiat's legendary months of working in the basement of the Annina Nosei Gallery, by some accounts with unlimited supplies of drugs and girls; social shepherding and career guidance by Henry Geldzahler; entrance into a ravenous European market through Swiss dealer Bruno Bischofberger; erratic behavior that included a reported readiness, graying the hair of his dealers, to swap work from his studio for whatever cash or drugs he required on a given day; a tempestuous stint with the Mary Boone Gallery; and the improbable, temporarily sustaining father-son relationship with Warhol.

The eclipse of neo-Expressionism by frigid, geometric modes around 1986 deprived Basquiat's warm, jazzy style of chic but scarcely invalidated it. He was a leader, not an epigone, of neo-Expressionism, with an aesthetic sense rooted in New York big-painting tradition and with imagery drawn from heartfelt primitive and urban-pop veins. Nor was he a retailer of faddish angst. To the end, his graphic ferocity—typically with oil sticks rather than brushes, which he used mainly for erasure and filling in—had an unshadowed naturalness and buoyancy. He was a real artist, living to work instead of working to support a life-style.

The life-style was quite something, though. In 1985 I was asked to do an article on him by *Vogue* (which for some reason anticipated a hatchet job, as I learned when my

piece was killed for being "too positive"), and I visited him in the converted carriage house he rented from Warhol on Great Jones Street. The dimly lighted place was a sort of busy womb, with a steady traffic of assistants and hangers-on, an attentive girl-friend, phones ringing incessantly, and a big table piled with Mediterranean delicacies and many bottles of incredibly good Bordeaux.

Basquiat in the midst of it looked like a soft young African prince, imperious and wistful. "It was getting worse, but now it's getting better," he said of his work, in a tone of anxious self-assessment. He spoke nostalgically of his earliest days of making art in New York. He seemed to worry that what he called the "messy and earthy" feeling of those days was growing too far distant. Meanwhile, he showed me photos of collabo-rative paintings he had done with Warhol and Francesco Clemente. Bischofberger had just bought the body of work for $1 million.

Basquiat was a young man plainly in for a tough time. He might well have come through it if he had kicked drugs, but it wasn't going to be easy. His artistic subject had been the passion of disaffected youth in a crazy metropolis. He was inevitably leaving that passion behind, even as its distillations were adorning the walls of rich, white, perhaps in every sense, patronizing collectors from Dusseldorf to Tokyo. His later work displayed some resourceful use of African themes, to the possible end of develop-ing a new identity as a Black artist. Maybe something awaited him in the Ivory Coast. Then again, maybe he knew that he would be disappointed.

That's not the question now. The question, in these harsh and distracted times, is what Basquiat did do, which the art culture took up and then dropped so quickly and thoughtlessly. A proper retrospective of his work, which I hope won't be too long in coming, will be an occasion for reflecting on this and other things.

REMEMBERING BASQUIAT

KEITH HARING, 1988

I remember the first time I met Jean-Michel just as clearly as the last time I saw him. In fact, every encounter with Jean-Michel or his work was a memorable experience. In 1979, soon after I first arrived in New York City, I began "following" his work. The simple sentences sprayed onto buildings, bridges, and crumbling walls appeared to be the utterances of some newborn philosopher. They were immediately identifiable, not only because of the SAMO© signature but because of their unique clarity and unnerving wisdom. For a year before I met Jean-Michel or his partner, Al Diaz, I followed his graffiti writings religiously, sometimes jotting them down and often discussing them with friends. By the time I met Jean-Michel I already had a great deal of respect for him. When I met him I understood why.

Even in those early days when he was doing collage drawings and color Xeroxes, his work had a kind of power which was unmistakably "real." The intensity and directness of his vision was intimidating. Jean-Michel was maybe a little bit too real for us. He was uncompromising, disobedient, and rude if the situation required it. Not malicious, but honest. From the beginning, SAMO© graffiti warned against the conformity of the "9 TO 5 CLONE" and "PLAYING ART WITH DADDY'S MONEY." When he began exhibiting his paintings, he remained true to his teachings and broke as many rules as possible.

Every aspect of his work seemed symbolic of this disdain for conformity: watching him paint, wielding his brush like a weapon, walking on piles of finished and unfinished drawings spread across the floor, the transformation of things found in the garbage into beautiful *objets d'art,* the "almost" stretched canvases that he tied and nailed together. The supreme poet; every gesture symbolic, every action an event.

He once told me of an appointment he had at the offices of Fiorucci in New York City. He arrived carrying a canvas he had just completed that was full of wet paint. He proceeded to get paint all over the carpet and leather couch and was thrown out of the reception area, never to return. Another time he tossed a huge stack of dollar bills from a passing taxi to the panhandlers on the corner of Houston Street and the Bowery. Jean-Michel was constantly doing things that other people secretly wished they had the nerve to do themselves. This was his true genius. He revealed things. He removed the Emperor's clothes. When he provoked you to criticize him, it usually turned out that you were criticizing yourself and your own narrow-minded attitudes.

Keith Haring, "Remembering Basquiat," *Vogue,* November 1988, 230–34.

The last decade was not an easy time to be an artist, especially if you were young, unusually gifted, and honest. Achieving success was not a problem for Jean-Michel. Almost as quickly as people began to see his work, they recognized its value and began to collect it. Success itself was the problem. The art world is always eager to add some flavor to its increasingly tired, market-oriented establishment. However, in their haste to find new blood, honesty is sometimes replaced by superficiality. The hype of the art world of the early eighties became a constant blur. There was very little criticism that actually talked of the works themselves. Rather, the talk was about the circumstances surrounding the *success* of the work. The need for labels and explanations lumped artists into groups that were easy for the media. Thus, Jean-Michel got labeled a graffiti artist. The entire misrepresentation and manipulation of this hypothetical "group" is a perfect example of the art world of the early eighties. People were more interested in the phenomena than the art itself. This, combined with the growing interest in collecting art as an investment and the resultant boom in the art market, made it a difficult time for a young artist to remain sincere without becoming cynical.

"THINGS ARE VERY CONFUSING AT THIS POINT." SAMO© 1979.

People got paid and people made money. Much to some people's dismay, Jean-Michel was not only a genius in his work but he was also very clever about the selling of his pictures. He was incredibly generous with his work but he hated feeling tricked or cheated, hence the long list of confrontations with dealers over the years. From slashing unfinished works to emptying a bowl of dried fruits and nuts onto the head of a pesky would-be collector, he defended his right to be respected as an artist. Perhaps his antics helped to show the art world its own face. Maybe they even learned something.

Through all of this success he retained his own rebellious personality and the freshness of his artistic vision. He didn't compromise his individuality or his work. The paintings got better and better. His obsession with drawing and painting produced hundreds of works. He truly created a lifetime of work in ten years. Greedily, we wonder what else he might have created, what masterpieces we have been cheated out of by his death, but the fact is that he has created enough work to intrigue generations to come. Only now will people begin to understand the magnitude of his contribution. There are many things that remain a mystery to the casual observer. As Jeffrey Deitch pointed out, the literary quality of his paintings has not even begun to be explored. His expertise at the assembling and disassembling of language has revealed new meanings to old words. He used words like paint. He cut them, combined them, erased them, and rebuilt them. Every invention a new revelation.

The ease with which Jean-Michel achieved profundity convinced me of his genius. A seemingly effortless stream of new ideas and images proved the potency of his vision. His life and philosophy, which taught by example and bold gestures, elevated him to the role of a teacher. But perhaps it was his simple honesty that has made him a true hero.

REQUIEM FOR A FEATHERWEIGHT
THE SAD STORY OF AN ARTIST'S SUCCESS

ROBERT HUGHES, 1988

A few years ago, an art teacher at Cooper Union in New York showed me the results of a computer survey designed to establish which artists the incoming class of freshmen had heard of. They did not have to describe a work, let alone to discuss it; only to name names. Picasso, as one might expect, topped the list with 61 mentions. Right under him were Michelangelo and van Gogh, with 54; Rembrandt, with 53; and Monet, with 50. The curiosities began lower down. Andy Warhol scored 33, Watteau 1. And Jean-Michel Basquiat, not much older than the freshmen themselves, was recognized by as many of them as Tintoretto and Giacometti; by five times more than Nicholas Poussin or William Blake.

If any artist may be said to have parodied, not just illustrated, the contemporary-art boom of the 1980s, he was Jean-Michel Basquiat, who died of heroin in New York last August at the age of 27. Basquiat was living proof, and not only for the freshmen at Cooper Union, that one could make it straight out of the egg—no waiting. One marveled at such innocence. For the truth about this prodigy was rather less edifying. It was a tale of a small, untrained talent caught in the buzz saw of art world promotion, absurdly overrated by dealers, collectors, and, no doubt to their future embarrassment, by critics.

This was partly because Basquiat was Black. The otherwise monochrome Late American Art Industry felt a need to refresh itself with a touch of the "primitive." There were infinitely better artists than Basquiat who happened to be Black, such as the sculptor Martin Puryear, but they did not have to contend with this kind of boom-and-bust success. One would not call it luck; at least not the luck a sane talent would envy. For the very nature of Basquiat's success forced him to repeat himself without a chance of development.

Jean-Michel Basquiat first appeared around 1980 as half of a two-man street artist team, leaving gnomic graffiti in neat block letters around lower New York under the tag SAMO, which was an acronym for "Same Old Shit." (The "work" on my building in Prince Street read, "SAMO as an antidote to nouveau-wavo bullshit." It was a claim not without its retrospective ironies.) You couldn't call SAMO a master of aphorism, but his stuff read a little more snappily than most of the spraying and paint pissing on downtown walls: needling, discontented, detached.

Robert Hughes, "Jean-Michel Basquiat: Requiem for a Featherweight: The Sad Story of an Artist's Success," *New Republic*, November 21, 1988, 34–36.

Likewise, Basquiat's paintings, when they appeared in 1981 at P.S. 1, in a sprawling survey called "New York/New Wave," were clearly better than the common run of graffiti art. Though he had dropped out of high school and scarcely set foot in an art school, Basquiat had an instinct for putting things—words, masks, marks, disconnected phrases—on canvas with space between them (rather than just scribbling and void filling, edge to edge, like most of his street colleagues). This, coupled with his coarse but zappy line, suggested a seed of unformed talent. His use of color was rudimentary and schematic. However desultorily, Basquiat had looked at some museum art—mainly Dubuffets and Picassos, from which his "primitive" conventions were gleaned.

In a saner culture than this one, the 20-year-old Basquiat might have gone off to four years of boot camp in art school, learned some real drawing abilities (as distinct from the pseudo-convulsive notation that was his trademark), and in general, acquired some of the disciplines and skills without which good art cannot be made. But these were the 1980s. And so he became a star.

Graffiti were in fashion in the early '80s, and collectors were ready for a wild child, a curiosity, an urban noble savage—art's answer, perhaps, to the Wolf Boy of Aveyron. Basquiat played the role to the hilt. He had enough distance from it to carry it convincingly, for a time: far from being a street kid, he was in fact an upper-middle-class, private school boy of Haitian parentage, whose father owned a four-story brownstone in Brooklyn and drove a Mercedes. By 1985, the peak of his career, when he made the cover of the *New York Times Magazine,* his larger paintings were going for $25,000 in the galleries, and sometimes for more at auction.

Deeply wounded by a rift with his father, Basquiat seems to have fixed on celebrity as a substitute for parental esteem. For the last few years of his life, his mentor was the late Andy Warhol. He made worthless "collaborative" paintings with Warhol, lived in Warhol's spare studio on Great Jones Street in downtown Manhattan, and seems to have accepted Warhol as a surrogate father—along with the pale rider's own values about art, money, and fame. It was not the best of humidicribs for an infant artist; but Warhol's friendship certainly kept Basquiat going for a while. What finished him off, after Warhol died, was drugs.

Like most junkies, Basquiat thought he was invulnerable. To feed the monkey, he had to crank out paintings by the hundred. Wired, he lost whatever capacity for aesthetic reflection he might have had. The result was a run of slapdash pictorial formulas, whose much discussed "spontaneity" and "energy" were mostly feigned. Far from being the Charlie Parker of SoHo (which was what his promoters claimed), he became its Jessica Savitch.

Basquiat was not ideally lucky in his choice of representatives. His social groom was Henry "Freebie" Geldzahler, who had failed long ago as a writer, curator, and historian, but still wielded influence as a tipster, at least among new collectors. His first dealer, Annina Nosei, kept him in the basement of her gallery turning out canvases (now esteemed as "early Basquiats," to distinguish them from the less sought-after

"late Basquiats" of three years later), which she sold before they were dry and some-times before they were finished. Her successor, for a time, was a disturbed Iranian sleaze ball named Tony Shafrazi, who in the '70s had vandalized Picasso's *Guernica* in the Museum of Modem Art by spraying the words "KILL LIES ALL" across it in red. (For some reason the trustees of MOMA chose not to prosecute Shafrazi; he soon re-emerged as a prosperous dealer in graffiti art, a dazzling act of chutzpah.) But Basquiat's unreliability, and his need for the drug money, prevented him from staying long with anyone—certainly not long enough to rig a safety net. When he died, about 35 dealers were said to have been holding a stake in him.

Basquiat's career appealed to a cluster of toxic vulgarities. First, to the racist idea of the Black as naïf or as rhythmic innocent, and to the idea of the Black artist as "instinc-tual," outside "mainstream" culture, and therefore not to be judged by it: a wild pet for the recently cultivated white. Second, to a fetish about the infallible freshness of youth, blooming amid the discos of the Downtown Scene. Third, to an obsession with novelty—the husk of what used to be called the avant-garde, now only serving the need for new ephemeral models each year to stoke the market. Fourth, to the slide of art criticism into promotion, and of art into fashion. Fifth, to the art-investment mania, which abolished the time for reflection on a "hot" artist's actual merits; never were critics and collectors more scared of missing the bus than in the early '80s. And sixth, to the audience's goggling appetite for self-destructive talent (Pollock, Hendrix, Montgomery Clift). All this gunk rolled into a sticky ball around Basquiat's tiny tal-ent and produced a reputation.

The reputation may survive, or it may not. If it does, it will only show once more, as if further proof were needed, that a perch in the pantheon of the 1980s does not neces-sarily depend on merit. Basquiat's stardom was waning badly when he died, because the fashion that had raised him up was already tired of him. The urban graffiti move-ment that Basquiat had used as a conduit in 1981–83 had no fans left among collectors five years later. Moreover, the "adventurous" collectors who had bought his work in the beginning were now into Neo-geo; the hot young artist with his dreadlocks had been thrust aside by the cool one with his paperback Baudrillard.

But now we have a gush of posthumous Basquiat hype—a codicil, as it were, to the media overkill that surrounded the auction of his mentor Warhol's chairs and cookie jars last spring. There are so many Basquiats floating out there that the only possible strategy for maintaining their value is to romanticize their author, loudly claiming him as a potentially "major" artist, a genius cut off in his first flower.

The *New York Times,* as one might expect, festooned his bier in column inches. "Martyr Without a Cause," ran Peter Schjeldahl's headline in *7 Days,* treating Basquiat as a veritable St. Sebastian, bristling with syringes flung cruelly by the Zeitgeist. Com-paring him to "a soft young African prince, imperious and wistful," Schjeldahl invoked Cy Twombly and Franz Kline, claimed that Basquiat, like them, "seemed incapable of moving his hand in a way that was uninteresting." Schjeldahl called for "a proper ret-

rospective of his work." Doubtless he will get his wish, given the Whitney Museum's helpless commitment to the trendy and the number of its financial supporters who have been left holding Basquiats whose price needs to be sustained by that "proper retrospective." Then the Museum of Contemporary Art in Los Angeles could do it too, because its trustees own lots of Basquiats as well. This is known as Postmodernist Museum Ethics. It's how art history gets made, bub.

Then, in *Vanity Fair,* Anthony Haden-Guest got worked up about "the brilliant, intense life of a most remarkable artist—America's first truly important Black painter," as though Jacob Lawrence and others whose brushes Basquiat was scarcely qualified to clean had never lived. And in *New York* magazine, Phoebe Hoban weighed in with a piece to rival Julie Baumgold's treatment of the fraud Arianna Stassinopoulos Huffington three months before: nine full pages of heavy breathing on Basquiat. It was stuffed with exequies, mainly from dealers, though relieved by such flashes of comedy as a cameo appearance by Rene Ricard of *Artforum.* "Ricard is hysterical He says the bottle of champagne he planned to pour on Basquiat's grave has exploded." "Jean-Michel was touched by God," Ricard raves. "He was a Black saint. There was Martin Luther King, Hagar, Muhammad Ali, and Jean-Michel." There spoke the voice of critical detachment, '80s-style.

Confronted by such puffery, the cynic might conclude that if the *système de la mode* likes anything better than a hot new young artist, it is a dead hot new young artist.

The only thing that brought Basquiat back into the spotlight was his death. Schjeldahl waxed indignant at some unnamed shrugger who wondered, "What else could he have done?" The remark was an appropriation of the famous line about Elvis Presley's death, that it was a shrewd career move. The difference is that, whereas rock 'n' roll would be immeasurably the poorer without Elvis, Basquiat never looked like he was turning into a painter of real quality. His "importance" was merely that of a symptom; it signifies little more than the hysteria of instant reputation that still so grotesquely afflicts American taste. His admirers are like a posse of right-to-lifers, adoring the fetus of a talent and rhapsodizing about what a great man it might have become if only it had lived. Apparently Neo-Expressionism has at last found its Thomas Chatterton—Wordsworth's "marvellous boy," the fame-struck baby poetaster whose name, thanks to his suicide at 18, lives on, while his work remains wholly unread.

NEW YORK
MORE POST-MODERN THAN PRIMITIVE

GREGORY GALLIGAN, 1988

The image of a mask with a saw-toothed mouth was Jean-Michel Basquiat's most potent sign for human frustration in the mid-1980s. How could one forget a first encounter with this mask in Basquiat's one-man show at Mary Boone Gallery four years ago? Part incubus and part alter ego, it seemed less the face of a primitive than a sordid disguise of the modern self. To be sure, Basquiat's mask was the perfect symbol for an amoral age, the blind visage of an urban automaton who has been emptied of his soul through his very own eye sockets.

The Boone show marked Basquiat's brightest moment, for in the spring of 1985 Basquiat was at the crucial stage of a painter's ascent when he takes a first, fleeting glimpse of his full potential. Yet even then it would have been absurd to condone the inflated claims being made about Basquiat's "Afro-Atlantic" genius, as were trumpeted for instance, in the catalogue of this show. It seemed, rather, that Basquiat's work itself was a crass product of the times, a queer hybrid induced by a hitherto unlikely coupling of big money with the pluck of a confessed social delinquent.

Yet regardless of his arrogance, Basquiat's raw talent gave one reason to believe that he might one day prove an exception among the otherwise faceless gang of graffitists from which he had originally emerged. Indeed, it was evident from the Boone show that as early as 1984—only three years after his debut—Basquiat was already able skillfully to evoke a tragic, psychic collision between feelings of urban frustration and a will-to-power, so to speak of primitive instincts.

It was out of such a violent sensibility that Basquiat's mask with the saw-toothed mouth emerged in paintings such as the panoramic *Grillo* (1984), or a more intimate, untitled "double portrait" of 1985, where Basquiat painted directly on wooden shed panels, their weathered hinges still intact. So ruthless was his invocation of urban torture and abuse that Basquiat's dismal signs would loom up in one's memory at the sight of every street corner.

After the Boone show, Basquiat's development was increasingly difficult to track. There was his departure from Mary Boone in search of another dealer, which was promptly followed by several shows in Europe, a brief collaboration with Andy Warhol (the outcome of which was badly received by the critics) and an eventual one-man

Gregory Galligan, "New York: More Postmodern than Primitive," *Art International*, no. 5 (Winter 1988): 59–63.

show with the Vrej Baghoomian Gallery in New York last spring. Come mid-August, there was the sudden announcement that Basquiat had died in his Manhattan studio one night, apparently of a heroin overdose.

As one reviews the collective import of such a tragedy and what it betrays about the nature of today's overstrung art world, the image of Basquiat's mask, racked with rage, seems ever more central to his message. In fact, this mask seems to demand the final word, whereas we would rather bury it in the recent past for fear of seeing ourselves in its shrouded profile.

It was on the tail of this murky state of affairs that the autumn art season in New York commenced in mid-September. And as an odd, yet befitting coincidence, a mute diffidence seemed to underscore the local art world all the way from SoHo to 57th Street. There was an eclectic array of shows to be seen, yet for all their timely qualities, one was at a loss to relate them to a larger aesthetic current.

[. . .] Continuing a train of thought he established at Leo Castelli Gallery two years ago, [Joseph] Kosuth most recently presented excerpts from texts by Sigmund Freud in the gallery's new space at 578 Broadway. These he stenciled backwards, in white, on black walls of a single dark room. Contiguous fragments of text were also stenciled on large panes of glass, which Kosuth set leaning against the black walls, thus creating a witty visual overlay of Freud's hypotheses.

On a purely optical level, Kosuth forces the eye to consume language as a merely arbitrary, near-ornamental phenomenon. Yet the recognition of a text leads the observer into the predicament of trying to wrest rational meaning from mere fragments of thought—a dearly frustrating experience.

Yet eventually this confrontation goads the observer, by a feeling of conceptual default, into the task of stringently re-examining principles of perception which he had formerly assumed to lie outside the domain of educated doubt. Words once virtually sacred to us are now abruptly cropped, and even the Herculean psychoanalyst himself has joined a species of pure literature, if not myth.

In this vein Kosuth slips the observer into a great metropolis of text, where it is apparent that reality, never mind truth, may hardly yield to a clear-cut definition. Jean-Michel Basquiat, of all people, may have been pursuing a parallel idea, for he frequently placed his mock-primitive, masked demon in such a cityscape, where words, strung into slogans, fill empty space like a genre of psychotic trash.

And in this regard it becomes clear that Basquiat's mask is not that of a primitive at all, but of his Post-Modern equivalent, the deranged pimp who reigns over a kingdom of sado-masochism. What bitter irony that only weeks after his death, Basquiat's mask should appear in real life as a prime piece of evidence in a Manhattan murder trial. A mask, stitched of slick black leather, with its mouth zipped shut, was retrieved from the corpse of a murdered young man, found naked behind a tool shed on a Manhattan art dealer's estate. For his brutish rendering of such times in the form of painterly premonitions, Jean-Michel Basquiat should be missed by even his worst detractors.

SAINT JEAN-MICHEL

FREDERICK TED CASTLE, 1989

> Desire for Pleasure attaches us to the Present. Care for our safety makes us dependent upon the Future.
>
> He who clings to Pleasure, that is, to the Present, makes me think of a man rolling down a slope who, in trying to grasp hold of some bushes, tears them up and carries them with him in his fall.
>
> To be, *before all else,* a *great man* and a *saint* according to one's own standards.
>
> Baudelaire[1]

I met Jean-Michel Basquiat at the villa-warehouse of Emilio Mazzoli in Modena in June, 1982. This encounter opened my eyes to the venality of the world and also to the possibility that sainthood can be achieved today. Shall I tell the short version, or the long? I hope at best to be able to combine them.

Annina Nosei, whom I call one of the five best art dealers in the world, rented a car in Venice and I drove her, via Bologna, which I had never seen, to the former seat of the famous Este family (after they lost Ferrara in 1598). Now reduced to manufacturing, Modena is a not-very-fashionable city. It is clean and prosperous. What I found was Basquiat rather permanently trying to telephone a friend in Japan. Anyone who has ever used the phone system in Italy will realize that such a task, on the best of days, might consume hours. I looked at a lot of art and conversed with Mazzoli through the good graces of Nosei, since, like many Italians, Mazzoli refuses to bow to the hegemony of the English language. When he hired him, he probably thought Jean-Michel was French. Did I say "hired"? Basquiat was executing a series of graphic works for Mazzoli. Mazzoli was impatiently awaiting their production. He is a large man who smokes cigars and does not defer to anybody. I was surprised that he knew or liked art, and I was also surprised at the quality and diversity of the art he had warehoused in his unlived-in villa. He showed me many big pictures. I was trying to figure out to whom he would sell them. He was trying to sell a Rauschenberg and perhaps a Twombly to Nosei, but she wasn't buying. Then it was time for dinner.

After he got off the phone, I found Jean-Michel Basquiat to be skittish and mistrustful of anybody known as a critic—a profession I don't make but which is often made for me. I am a writer, not that that profession inspires much confidence either. Mazzoli drove us to a restaurant with an important reputation. Refusing any drink,

Frederick Ted Castle, "Saint Jean-Michel," *Arts Magazine* 63 (February 1989): 60–61.

Basquiat ordered only clear broth, which he did not consume. I probably had roast fish and some wine, Mazzoli was eating a plate of sausages, and Nosei kept ordering another thing, which she consumed like a bird—eating constantly and remaining birdlike. It turned out that I was present at a negotiation. Both Basquiat and Mazzoli refused to understand what the other was saying, and between bites Nosei had to translate everything. As I recall, though the details aren't important, Mazzoli was offering to publish Basquiat's prints and pay him by giving him a few artist's proofs, whereas Basquiat was holding out obdurately for Mazzoli to buy the entire edition. Basquiat won. Mazzoli was furious. At the end of the conference, as I was deposited at my hotel, I thanked Nosei for the education. By this time, Jean-Michel and I understood and respected each other. When I saw him again at the art fair in Basel, we familiarly shared a rare marijuana cigarette, and noticed with pleasure that we had both selected exactly the same kind of sneakers for the trip. We became friends. Annina Nosei had showed me Basquiat's work as soon as she had it, and when I first saw it, I felt a kind of recognition, a fellow-feeling. I also knew that the work was excellent.

At this time I was 44 years old and Basquiat was 21. Now, six years later, he is dead and I am 50. In his *Journaux Intimes* Baudelaire remarked, if I am not mistaken, that the best thing an artist can do for a critic is to die. In this travesty of good advice, the poet advanced the autonomy of "critics." With the artist dead, the critic can say anything at all without the possibility of being contradicted. I have never adhered to this cynical view, which I believe Baudelaire held satirically. I have written and continue to write about my friends' art, because it is the work I know and love best. Basquiat was an intransigent—a revolutionary who refused to compromise. Since his death, the critics are having a field day marveling that the forces of evil who practically deny critics a livelihood, while wining and raping the *nouvelle bourgeoisie,* were able to destroy such a great graphic talent in such short order. Contrary to popular misinformation, nobody dies at the wrong time. Jean-Michel is a paradoxical figure. One day I went around the corner to see him, and a young assistant answered the door and said, "Oh, he's out driving around in his limousine." He didn't have a car but he had a classy car service, like poor people do all over his native Brooklyn where Manhattan cabbies won't work, and like rich people in Manhattan do all the time. My friend Martim Avillez wrote an article for a Lisbon paper comparing Basquiat to Dean and Monroe as sacrificial heroes. Henry Geldzahler spoke to a New York paper saying, "It's so sad One knew that it was going to happen at the same time as one avoided the possibility."[2] Geldzahler acknowledged being present when Jean-Michel met Andy Warhol when the former was 17. Andy, who died two years ago, also "by mistake," always supported young artists and, like most people I know, instantly recognized that Basquiat was great. In a sense, Basquiat became a nouveau Warhol—controversial artist who controverted nothing; mythic being who became the age. Whether the work of Basquiat or even the work of Warhol will survive the disintegration of the Present cannot be known. In the Future, we must all be careful lest we unintentionally sacrifice ourselves to gods we didn't worship. Saint Jean retained his composure to the end. He never trusted people,

and he figured they were out to screw him. Nevertheless, he knew how to draw and he insisted on doing it no matter what was being done with his drawings. Like his mentor, Andy Warhol, Basquiat came out of nowhere. He wasn't like Warhol in any other way. Andy probably used him like other people did. Once, when I embraced Basquiat, he told me that everybody who said they loved him always wanted something from him. He had just given me a bottle of champagne with the price tag of $56 on it. I drank it, nursing a new wound. He was working on his collaborations with Warhol and Clemente at the time, intransigently breaking the rules of art practice in the Present, and getting ready for the Future, of which he would get to see so little in this life.

Notes

1. *The Intimate Journals of Charles Baudelaire,* trans. Christopher Isherwood (Boston: Beacon Press, 1957), 39.
2. Karin Lipson, "Very Famous, Very Young," *Newsday* (New York), September 1, 1988.

NOBODY LOVES A GENIUS CHILD
JEAN-MICHEL BASQUIAT, LONESOME FLYBOY IN THE '80S ART BOOM BUTTERMILK

GREG TATE, 1989

> I did not, when a slave, understand the deep meaning of those rude and apparently incoherent songs. I was myself within the circle; so that I neither saw nor heard as those without might see and hear. They told a tale of woe, which was then altogether beyond *my* feeble comprehension. . . . I have often been utterly astonished, since I came to the north, to find persons who could speak of the singing, among slaves, as evidence of their contentment and happiness. . . . The singing of a man cast away upon a desolate island might be as appropriately considered as evidence of contentment and happiness, as the singing of a slave; the songs of the one and of the other are prompted by the same emotion.
>
> *Narrative of the Life of Frederick Douglass, An American Slave, Written by Himself,* 1845

In these scant lines, Frederick Douglass succinctly describes the ongoing crisis of the Black intellectual, that star-crossed figure on the American scene forever charged with explaining Black folks to white folks and with explaining Black people to themselves—often from the perspectives of a distance refracted by double alienation. *If you want to hide something from a negro put it in a book.* Douglass knew from experience the compound oppression of being poorly fed and poorly read, but also of having to stand Black and proud in isolated situations where nobody else Black was around to have your back. When the wind chill factor plummets that low, all that can steady you is the spine of cultural confidence and personal integrity.

This business of speaking for Black culture and your own Black ass from outside the culture's communal surrounds and the comforting consensus of what critic Lisa Kennedy once described as "the Black familiar" has taken many a brilliant Black mind down to the crossroads and left it quite beside itself, undecided between suicide, sticking it to the man, or selling its soul to the devil. The ones who keep up the good fight with a scintilla of sanity are the ones who know how to beat the devil out of a dollar while maintaining a Black agenda and to keep an ear out for the next dope house party set to go down in Brooklyn, Sugar Hill, or the Boogie-Down Bronx.

[. . .]

Greg Tate, "Nobody Loves a Genius Child: Jean-Michel Basquiat, Lonesome Flyboy in the '80s Art Boom Buttermilk," *Village Voice*, November 14, 1989, 31–35.

*Dull unwashed windows of eyes
and buildings of industry. What
industry do I practice? A slick
colored boy, 12 miles from his
home. I practice no industry.
I am no longer a credit
to my race. I read a little,
scratch against silence slow spring
afternoons.*

LeRoi Jones, "A POEM
SOME PEOPLE WILL HAVE TO
UNDERSTAND," from *Sabotage*

To read the tribe astutely you sometimes have to leave the tribe ambitiously, and should you come home again, it's not always to sing hosannas or a song the tribe necessarily has any desire to hear. Among the Senegambian societies of the West Africa savannah, the role of praise singer and historian is given to a person known as the griot. Inscribed in his (always a him) function is the condition of being born a social outcast and pariah. The highest price exacted from the griot for knowing where the bodies are buried is the denial of a burial plot in the communal graveyard. Griots, it is decreed, are to be left to rot in hollow trees way on the out skirts of town. With that wisdom typical of African cosmologies, these messengers are guaranteed freedom of speech in exchange for a marginality that extends to the grave.

The circumscribed avenues for recognition and reward available in the Black community for Black artists and intellectuals working in the avant-garde tradition of the West established the preconditions for a Black bohemia, or a Blackened bohemia, or a white bohemia dotted with Black question marks. Remarkable in the history of these errant Sphinxes is certainly Jean-Michel Basquiat, posthumously the benefactor of a loving and roomy retrospective at Vrej Baghoomian gallery. When Basquiat died last year at the age of 27 of a heroin overdose he was the most financially successful Black visual artist in history and, depending on whether you listened to his admirers or detractors, either a genius, an idiot savant, or an overblown, overpriced fraud. Besides affording an opportunity for reappraisal of Basquiat's heady and eye-popping oeuvre, the exhibition invites another consideration of the Black artist as bicultural refugee, spinning betwixt and between worlds. *When the fire starts to burn, where you gonna run to? To a well without water?*

Given the past and present state of race relations in the U.S., the idea that any Black person would choose exile into "the white world" over the company and strength in numbers of the Black community not only seems insane to some of us, but hints at spiritual compromise as well. To be a race-identified race-refugee is to tap-dance on a tightrope, making your precarious existence a question of balance and to whom you concede a mortgage on your mind and body and lien on your soul. Will it be the white, privileged, and learned or the Black, (un)lettered, and disenfranchised?

. . . When I die, the consciousness I carry I will to
black people. May they pick me apart and take the
useful parts, the sweet meat of my feelings. And leave
the bitter bullshit rotten white parts
alone.

<div align="center">LeRoi Jones, "leroy," from Black Art</div>

Spooked, dispossessed, split asunder by his education, his alienation, and his evolving race-politics, Amiri Baraka (formerly LeRoi Jones) sought to perform an exorcism on the learning he'd done at the laps of white men, vaccinate himself against the infectious anxiety of influence that came with investment in that knowledge he'd codified as Western. But we can say that African history and the history of border crossings made by Black artists and intellectuals from this country's earliest founding to the present have blurred, blotted out, and disrupted any proprietary claims the Eurocentrists among us would care to make on the languages of ethics, aesthetics, and logic. In light of the mounting evidence of anthropologists and archaeologists and the revisionist scholarship of peoples of color, there is no province more in danger of dwindling to a vanishing point than that of "white knowledge." Increasing the store of human knowledge has been everybody's project since the beginning of womankind. The idea that the human brain first began functioning in Europe now appears about as bright as Frankenstein's monster.

What remains, however, is the entrenched racism of white-supremacist institutions bent on perpetuating, until their dying breaths, that popular fantasy of slaveholders and imperialists that the white man represents the most intelligent form of life on the planet.

No area of modern intellectual life has been more resistant to recognizing and authorizing people of color than the world of the "serious" visual arts. To this day it remains a bastion of white supremacy, a sconce of the wealthy whose high-walled barricades are matched only by Wall Street and the White House and whose exclusionary practices are enforced 24-7-365. It is easier for a rich white man to enter the kingdom of heaven than for a Black abstract and/or Conceptual artist to get a one-woman show in lower Manhattan, or a feature in the pages of *Artforum, Art in America,* or *The Village Voice.* The prospect that such an artist could become a bona fide art-world celebrity (and at the beginning of her career no less) was, until the advent of Jean-Michel Basquiat, something of a fucking joke.

My maternal grandfather used to say, Son, no matter where you go in this world and no matter what you find, somewhere up in there you will find a Negro. Experience has yet to prove him wrong, especially where the avant-garde is concerned. In Wifredo Lam we had our Cubist adventurer. Ted Joans, Bob Kaufman, and LeRoi Jones bopped heads with the Beats. The British Invasion got vamped on by Jimi Hendrix while Arthur Lee and Sly Stone were spear-chucking protopunk and funk into San Francisco's psychedelic Summer of Love. Bad Brains reclaimed Rasta and hardcore

rock and roll from the punks. And we won't even get into separating the Black aesthetic inspirations for all these movements, or raising up the counterhegemonic monument that is Black cultural difference.

What's often as exceptional as the artistic talents of the aforementioned Black crossover acts is their genius for cultural politics, the confidence and cunning with which they established supportive bases for themselves in white circles of knowledge, power, and authority. *Nobody loves a genius-child?* Basquiat, lonesome fly-boy in the buttermilk of the '80s Downtown art boom, was hands down this century's most gifted Black purveyor of art-world politics. He not only knew how the game of securing patronage was played, but played it with ambition, nerve, and delight. Like Jimi Hendrix he had enormously prodigious gifts and sexual charisma on his side. He was also, to boot, another beneficiary of being the right Black man in the right place at the right time. Eric Clapton attributed Hendrix's whirlwind ascendancy in the English rock scene to his arriving just when the scene was in desperate need of some new blood. The blues and soul boom was decaying. Hendrix, Black and from the birthplace of blues, soul, and rock, was extraordinarily fluent in all three styles, could whip up a frenzy from the stage like Dionysus on a tear, and was a preternatural innovator besides. The question with Hendrix is never why him, but how could the British rockers resist?

> There is a sickness to the black man
> living in white town. Either he is white
> or he hates white, but even in hating, he
> reflects, the dead image of his surrounding
> There is a sickness to the black man in white town, because
> he begins to believe he can beat everybody's ass, and he can,
> down there, where each man is an island, and the heaviest bomber,
> throwing down tnt can establish some conditional manhood in the land
> of the dead, in the country of the blind

<div align="center">Amiri Baraka, "Poem for Religious Fanatics," from Target Study</div>

The period of ferment that produced Basquiat began on British soil and was then transplanted stateside. *1981 the number, another summer, sound of the harmolodic drummer!* Let's go back to postpunk lower Manhattan, no-wave New York, where loft jazz, white noise, and Black funk commune to momentarily desegregate the Downtown rock scene, and hip-hop's train-writing graffiti cults pull into the station carrying the return of representation, figuration, expressionism, Pop-artism, the investment in canvas painting, and the idea of the masterpiece. Whether the writers presaged or inspired the market forces to all this art commodity fetishism and anti-Conceptualist material is a question still up for grabs. But just as the classic blues, rock, and soul cats were the romanticized figures who made the very idea of a Hendrix seductive to the Mods, it was the invigorating folk culture of the graffiti writers—operating at a sub-

terranean remove from the art world that made them all the more mysterious, manageable, and ultimately dismissible—that set the salon stages and sex parlors of the postmods up to be bedazzled by Basquiat. Phase II, Daze, Crash, Lee, Blade, Futura 2000, Lady Pink, Fab Five Freddy, and Ramm-El-Zee. These writers, and others might have tunneled their style wars out of "Afrerica" (© Vernon Reid) and into the gallery affairs of the snooty, the elite, and *la bohème,* but it would be the Haitian boy-aristocrat with the properly French name who'd get to set their monkey-ass world on fire.

> *Jean-Michel is the one they told you must draw it this way and call it black man folk art, when it was really white man folk art that he was doing. That's what he draw . . . white man folk art. He does not draw black man folk art because they told him what to draw. . . . They called us graffiti but they wouldn't call him graffiti. And he gets as close to it as the word means scribble-scrabble. Unreadable. Crosses out words, doesn't spell them right, doesn't even write the damn thing right. He doesn't even paint well. You don't draw a building so that it will fall down and that's what he draws, broken-down imagery.*

> RAMM-EL-ZEE, *B. CULTURE*, NO. 1

> *I just love the houses in the South, the way they built them. That Negritude architecture. I really love to watch the way Black people make things, houses or magazine stands in Harlem, for instance. Just the way we use carpentry. Nothing fits, but everything works. The door closes, it keeps things from coming through. But it doesn't have that neatness about it, the way white people put things together; everything is a 32nd of an inch off.*

> DAVID HAMMONS TO KELLIE JONES IN *REAL LIFE*, NO. 16

> *Negative gesture can be just as important as positive thrust. Indeed I got a richer sense of this characteristic of his work when I showed Basquiat a quick sketch I made of one of his works,* Unrevised Undiscovered Genius of the Mississippi Delta, *a painting of Southern Images, and all he would say was, "You forgot to cross out* CATFISH.*"*

> ROBERT FARRIS THOMPSON, CATALOGUE ESSAY FOR
> BASQUIAT'S 1985 MARY BOONE EXHIBITION

Clearly, Basquiat's conception of making it in the Western art world transcended those of the train-writers. To Basquiat, making it did not just mean getting a gallery exhibition, a dealer, or even collecting big bank off his work. Making it to him meant going down in history, ranked beside the Great White Fathers of Western painting in the eyes of the major critics, museum curators, and art historians who ultimately determine such things. What he got for his grasping for immortality from the gaping mouths of these godheads was a shitload of rejection, (mis)apprehension, and arcane or inconclusive interpretations. That he refused to let the issue of his genius die on the spent pyre of his accumulated earnings reminds me of some cautionary advice I was given by filmmaker Haile Gerima: "Whenever white people praise you, never let it be

enough. Never become satisfied with their praise, because the same power you give them to build you up is the same power they can use to tear you down."

By all accounts Basquiat certainly tried to give as much as he got from the American art dealers, critics, and doyens, most effectively in the end by his sustained levels of production, excellence, and irreducible complexity. Though we can certainly point to racism for the refusal in certain quarters to consider Basquiat a serious painter, we shouldn't overlook the fact that Basquiat, like Rauschenberg and Warhol, his brothers in canvas bound iconoclasm, made paintings that were unrepentantly about American culture. There is a strain of Europhilia among our art historians and critics that is as uncomfortable with American artists looking to this culture for subject matter and vernacular as they are with artists holding the celebrity of household names. Looking to the uncertainty and reticence that abounded—and still abounds—in so much writing about Stuart Davis on down through Robert Rauschenberg, Bob Thompson, Roy Lichtenstein, Andy Warhol, Romare Bearden, Red Grooms, Betye Saar, David Hammons, Alison Saar, and Jeff Koons, it seems that the surest way to be consigned dilettante-hick status, ruining your chance for fawning art-historical hagiography, is to act as if you thought the United States was spilling over with the stuff of Art.

That Basquiat, like Bearden, made work that was unmistakably and vehemently about being a Black American male did not help matters any. Basquiat was as visually fascinated as anybody in our culture by cartoons, coon art, high-tech, and the idea of private ownership. References to these elements are constants in his work, sometimes framed critically and other times as a stream-of-conscious shopping list, pointing up our daily overdose of mass culture's effluvia. But he also gave equal attention to exhuming, exposing, and cutting up the nation's deep-sixed racial history, in all its nightmarish, Neo-Expressionist glory. If you're Black and historically informed there's no way you can look at Basquiat's work and not get beat up by his obsession with the Black male body's history as property, pulverized meat, and popular entertainment. No way not to be reminded that lynching and minstrelsy still vie in the white supremacist imagination for the Black male body's proper place. (Anyone doubting the currency of this opinion need only look to the hero's welcome Spike Lee got in see-a-nigger-shoot-his-ass Bensonhurst or to Robert Hughes's *New Republic* "review" of Basquiat's death in which he defames the brother by calling him the art world's answer to Eddie Murphy.)

In the rush to reduce the word games found in Basquiat works to mere mimicry of Cy Twombly's cursive scrawls, we're expected to forget that Basquiat comes from a people once forbidden literacy by law on the grounds that it would make for rebellious slaves. Expected to overlook as well that among those same people words are considered a crucial means to magical powers, and virtuosic wordplay pulls rank as a measure of one's personal prowess. From the perspective of this split-screen worldview, where learning carries the weight of a revolutionary act and linguistic skills are as prized as having a knockout punch, there are no such things as empty signifiers, only misapprehended ones.

Basquiat's exhausting lists of weights, numbers, anatomical parts, cuisine, and pop icons function as autopsies on forms of knowledge, reading the historical entrails of

literacy and numeracy for traces of their culpability in the subjugation and degradation of Black people. In so many paintings it seems Basquiat is on a mission of retribution against the Anglos' precious and allegedly value-free banks of information, here gutting the store of numbers for racking up the surplus-labor of human chattel, there looting the warehouse of words for legislating the difference between slaveholder and savage. Similar abstract historicizing can be found in the work of Basquiat contemporaries, playwright Suzan-Lori Parks, Conceptualist photographer Lorna Simpson, and performance art collaborators Alva Rogers and Lisa Jones.

All of which is one way of reading Basquiat's wordiness. But remember that this is also an artist who began his public career, roughly around 1978, as SAMO©, a street-level graffiti writer of non-sequiturs. The tag, spoken twice, is Black slang for "the same old shit" but also invites the cruel and punning to identify the writer as Sambo. Poised there at the historical moment when Conceptualism is about to fall before the rise of the neoprimitive upsurge, Basquiat gets the last word and the last laugh during '70s conceptualism's last gasp, pronouncing the brute shape of things to come by way of the ironic, sardonic slur he'd chosen for a name. Having a voice, giving a name to new things, multiplying and refracting meaning were always a part of Basquiat's survival game and image-making procedures.

So Basquiat enters the field as a poet. Truly, many of his paintings not only aspire to the condition of poetry, but invite us to experience them as broken-down bluesy and neo-hoodoofied Symbolist poems. Often the cerebral pleasures of his work are derived from sussing out the exquisite corpses he's conjured up through provocative conjunctions of words and images. One painting entitled *Catharsis* is a triptych whose left panel abounds with symbols of power drawn on what appears to be the inside of a subway door: a crown, a clenched Black fist, a circus strongman's barbells, a model of an atom, and the word RADIUM. On this last we find the vowels scratched out to produce the Jamaican patois term RIDIM or rhythm, another radioactive source of energy. The middle panel lumps the words LIVER and SPLEEN with THROAT and positions the term IL MANO, Italian for "the hand," between the thumb and forefinger of a limp and possibly blood-drained hand.

Things get more active again in the right panel. The top left half is dominated by a leg with a dotted line cutting across the base of the foot, over which reads SUICIDE ATTEMPT, an inscription that invokes race memories of the risks undertaken by runaway slaves as well as the tragedy of urban dance-floor guerillas without feet to fly their escapist maneuvers. (Much has been made of Basquiat's ruder street-connections, but his links with hip-hop are high-handed deployments of scratch noise, sampling, free-style coloring, and bombing the canvas.) Named and labeled throughout the rest of the panel is a plethora of other detached or phantom limbs, four left paws, two thumbs—a dissection chart whose mix-matched labels for animal and human body parts speak to the fate of the captive Black body as much as the energy sources surging through the first panel allude to the Black body in motion, bionic and liberated.

Just as diagrammatic and zigzag with meanings is *Wicker,* where the scratched up name of Black boxer Henry Armstrong is boxed into a rectangle crowned by the words

BUZZER and BELL. Nearby hovers a Romanesque figure with exposed intestines and a tag indicating its bladder. The boxing anecdote forms a parenthesis around a text all about the bestial bodywork done to the image of Black men. On one side of the painting a speared elephant is being levitated, his (he has tusks) physique branded with a black band like that used on TV reports to keep the interviewee's identity protected and disguised. Implanted into the elephant's hide is a tacky Instamatic camera. Floating around the right side is one of Basquiat's patented Black-ghost figures, this one materializing out of the urbanized jungle of a willowy potted plant in a wicker basket.

In juxtaposition these images hit us as loaded symbols: of Western man haunting the wild with his voyeuristic technology, and of Black spooks haunting the living spaces of the privileged with their irrescindable presences.

The one thing Vladimir Nabokov said that left a lasting impression on me was that the only thing a writer has to leave behind is her style. When people ask Miles Davis what he wants from a musician, he usually croaks, "Somebody who can play a style," by which I've always thought he meant a musician with a unique sound and a personal way of turning a phrase. The best contemporary musicians to come through the academy of Miles have developed styles that enfold emotion and intellect into a captivating species of lyricism. Like any of those musicians, or like Baraka's poetry in his *Dead Lecturer,* what's finally so compelling about the Basquiat corpus is the indivisible meshing of style and statement in his sui generis tones and attacks.

Initially lumped with the graffiti artists, then the Neo- Expressionists, then the Neo-Popsters, in the end Basquiat's work evades the grasp of every camp because his originality can't be reduced to the sum of his inspirations, his associations, or his generation. For all his references to pop America and the gestural vocabulary of the late-modern American Abstract Expressionists, Basquiat's signature strokes dispossess themselves of any value but that of being in a Basquiat painting. He has consumed his influences and overwhelmed them with his intentions, leaving everything in his work a map of his imagination and intellect. In the same way that the music made by Miles's bands always sounds like orchestrations of Miles's trumpet-persona, Basquiat's paintings read as hieroglyphic ensembles that glow with the touch of his hands and the unmistakable sign language that evolved out of his free-floating psyche.

*But can't you understand that nothing is free! Even the floating strangeness of the poet's head? The crafted visions of intellect, named, controlled, beat and erected to struggle under the heavy fingers of Art.**

LEROI JONES, "GREEN LANTERN'S
SOLO," FROM *THE DEAD LECTURER*

* The text from Jones's original poem:

> . . . Can you understand
> that nothing is free! Even the floating strangeness of the poet's head
> the crafted visions of intellect, *named, controlled,* beat and erected
> to work, and struggle under the heavy fingers of art. . .

You are the only very successful Black artist. . . .

I don't know if the fact that I'm Black has something to do with my success. I don't believe that I should be compared to Black artists but rather to all artists.

<div style="text-align: right">BASQUIAT TO INTERVIEWER ISABELLE GRAW</div>

In the November issue of *Elle* there's a Peter Schjeldahl essay about Basquiat and the Baghoomian retrospective in which the critic attributes Basquiat's significance to his difference from other Black artists: "Most work by non-whites in the New York mainstream has been marked by a tendency, mordantly popularized by Spike Lee in *School Daze* as 'wannabe': a diffident emulation of established modes, whether already academic or supposedly avant-garde. So I would not have suspected from a Black artist Basquiat's vastly self-assured grasp of New York's big-painting esthetics—generally, the presentation of mark-making activities as images of themselves in an enveloping field I would have anticipated a well-schooled, very original white hipster behind the tantalizing pictures."

In a recent Sunday *Times* essay about African-American artist Martin Puryear's first-place award in the São Paulo Bienal, Michael Brenson asks, "Why is he [Puryear] the first Black American artist to be singled out for international attention?" To Brenson's mind the answer boils down to Puryear's difference from other Black artists: "Part of what distinguishes Puryear from many other minority artists is his lack of defensiveness about mainstream American art. He remains something of an outsider, with one foot outside the mainstream, but he has one foot comfortably within it as well. Many Blacks feel too alienated from the mainstream, or too angry at it because of its continuing failure to make room for Black artists."

Taken together these two opinions present us with quite a conundrum. Whom can we trust? Schjeldahl, who believes that Black artists can't make the grade because they're trying too hard to be white, or Brenson, who thinks they're too busy being Black, mad and marginalized to take notes during art history class or keep up with the "mainstream" (read white, male, upper-middle class) art world? But, of course, I'm much too coy and polite.

What's wrong with these patronizing and patriarchal pictures is their arrogance and presumptions. Most of the serious Black artists I am familiar with know as much about art as any of their white contemporaries but would certainly have no interest in proving their Blackness to satisfy Schjeldahl or in taking a quiz from Brenson. In trying to help other white men figure out by what freakish woogie magic Basquiat and Puryear made it out of Coontown and into Cracker Heaven, Brenson and Schjeldahl regurgitate two very old and very tired ploys. Divide-and-Conquer is what we call one, One-Nigger-at-a-Time-Puh-Leeze names the other.

The cold fax is this: the reason that Puryear's work came before the judges in São Paulo, and thereby under Brenson's scrutiny, is because of Kellie Jones, the first Black female curator with the unprecedented clout to nominate a Puryear and have it mean something to the art world's powers that be. Before we can even begin to

appraise Puryear's exceptional talents we need to recognize the political struggles that positioned Jones in her exceptional historical position.

In every arena where we can point to Black underdevelopment or an absence of Black competitiveness there can logically be only two explanations: either Black folks aren't as smart as white boys or, racism. If the past 20 years of affirmative action have proven anything it's that whatever some white boy can do, any number of Black persons can do as good, or, given the hoops a Black person has to jump to get in the game, any number of times better. Sorry, Mr. Charlie, but the visual arts are no different. Black visual culture suffers less from a lack of developed artists than a need for popular criticism, academically supported scholarship, and more adventurous collecting and exhibiting.

During the furor that arose around Donald Newman's "Nigger Drawings," I recall hearing talk in the art world demanding to know why Black people should expect to be exceptional at anything else just because they were so good at music. If the Eurocentric wing of the art world wants to remain a stronghold of straight-up white-boyism, one has to suspect it's because the white-boyists want something they can call their own. This might be understandable if they didn't already own every fucking thing under the sun and made no bones of dehumanizing the rest of us to maintain hegemony.

The bottom line for people of color is that we don't need any more Basquiats becoming human sacrifices in order to succeed. We don't need any more heroic Black painters making hara-kiri drip canvases of their lives to prove that a Black man or woman can do more with a tar brush than be tainted by it. What we need is a Black MOMA, or, barring that, a bumrushing Black MOMA-fucker.

WELCOME TO THE TERRORDOME
JEAN-MICHEL BASQUIAT AND THE "DARK" SIDE OF HYBRIDITY

DICK HEBDIGE, 1992

1988: The brief meteoric career of the twenty-seven-year-old Jean-Michel Basquiat ends tragically with his death from a drug overdose.

<div align="right">Jean-Louis Ferrier, Art of Our Century</div>

He was too externalized; he didn't have a strong enough internal life.

<div align="right">Mary Boone[1]</div>

In a sense those two short statements say it all: the "brief meteoric career" of a young artist with the kind of French-sounding name we expect to find in books on art terminated prematurely; another casualty, like Pollock or Van Gogh, of uncontrollable urges, an excessive Lust for Life. And, anyway, "he didn't have a strong enough internal life" so what did he—or we—expect? Tossed up into history for a season on the horns of a bull market in contemporary painting that has since gone decidedly bearish, Jean-Michel Basquiat is now consigned to a one-sentence biographical footnote in the history of twentieth-century art. (Apparently his internal life wasn't strong enough to merit a single description of any of his work in a 1000 + page survey.)

From the time he was "discovered" by a *Village Voice* reporter, at the age of seventeen, scribbling SAMO slogans on buildings in the suspiciously close vicinity of Manhattan's down-town galleries, to his appearance as a rags-to-riches rock star in *The Face,* from his performance as a model at a Comme des Garçons fashion show to his later collaborations with Andy Warhol, Basquiat was always regarded as a dubious contender for entry into the art world Hall of Fame. Like a graffiti tag sprayed onto the side of a subway carriage, the name "Basquiat" circulated too publicly, too fast and across too many boundaries to earn the unmitigated approval and respect of the appropriate validating bodies. His manically prolific output, together with his Warholesque propensity for signing any surface makes attribution a continuing nightmare for dealers, critics and collectors, creating problems that were only compounded by his reckless tendency to give work away to friends and beggars in the street and by his willingness to barter paintings for cigarettes, little packets of white powder, or a phone

Dick Hebdige, "Welcome to the Terrordome: Jean-Michel Basquiat and the 'Dark' Side of Hybridity," in *Jean-Michel Basquiat,* ed. Richard Marshall (New York: Whitney Museum of American Art, 1992), 60–70.

number. If the importance of the artist's death in market terms is "related to the clos-ing of the series," if it functions as "that essential limitation which allows a far more definitive post-mortem valuation of the work than is possible while the artist is alive,"[2] then, in a sense, Basquiat is still with us, hanging in the air like the Cheshire Cat's smile: "new" Basquiats are likely to go on turning up for years to come.

> If Cy Twombly and Jean Dubuffet had a baby, and gave it up for adoption, it would be Jean-Michel.

> RENE RICARD[3]

His debut had been no more auspicious than his departure. Basquiat's early press was full of anxious references to his suspect ancestry. (Was he a rich kid renegade or a street urchin? Was he Black or Hispanic, Puerto Rican, Haitian, or Afro-American?) Allusions were made to foundlings, "the wild boy raised by wolves."[4] The racist impli-cations of the conditions attached to Basquiat's adoption by the art world were pain-fully apparent. If Jean-Michel was to be taken seriously as an artist he had first to be skinned alive, bleached of his Blackness and delivered into the hands of the right fos-ter parents. This is the price he would have to pay for the privilege of being integrated into the royal house of Western painting.

Throughout his career, the slippage from Basquiat to "bastard" proved as irresisti-ble to the collective unconscious of white reviewers as the invitation secreted in Jean-Michel's old SAMO tag for the reader to insert an extra "b" between the "m" and "o." From the outset Basquiat presented himself as an outsider, as a shadow cast on other peoples' walls like the sinister human silhouette stenciled on the facades of buildings in Manhattan in the early eighties: "The stuff you see on the subways now is inane," Basquiat's graffiti partner Al Diaz declared in 1978 in their first (paid) media inter-view. "SAMO was like a refresher course because there's some kind of statement being made. It's not just ego graffiti."[5]

SAMO© AS AN ESCAPE CLAUSE
SAMO© AS AN END TO MINDWASH RELIGION,
NOWHERE POLITICS AND BOGUS PHILOSOPHY

He seemed to come from nowhere, from underneath the sidewalk of Manhattan's dreams.

> Rush hour was just ended. . . . Waiting for his uptown express, Herzog made a tour of the platform, looking at the mutilated posters—blacked out teeth and scribbled whiskers, comical genitals like rockets, ridiculous copulations, slogans with exhortations: *Moslems the enemy is white. Hell with Goldwater, Jews! Spicks eat SHIT. Phone, I will go down on you if I like the sound of your voice.* And by a clever cynic, *If they smite you, turn the other face.*

> SAUL BELLOW, *HERZOG*

The last line on Herzog's hit list bears SAMO's telltale trademarks: brevity, sarcasm, a paradoxical logic attuned to the compact resonance of the sound bite and the clever ad campaign—the ability to cut through the surrounding signage like a stone dropped in a lake.

SAMO© IF THEY SMITE YOU, TURN THE OTHER FACE

smite: administer a blow to . . . superseded in general use by *strike* and *hit* except in past participle in figurative uses ("struck," "impressed," "infatuated"). Old English; past participle *smitten* smear, pollute (also *besmītan* defile).

<div align="right">OXFORD DICTIONARY OF ETYMOLOGY</div>

For much of the eighties, Jean-Michel Basquiat, smitten by an overbearing muse, by the clamorous demands of dealers in a booming market, by the muddled projections of critics and peers, did exactly what the "clever cynic" said. Smitten by the shades of long-gone Charlie Parker, Jack Johnson, Jimi Hendrix, and by Andy Warhol's "living" bleached-out shadow, by a regressive myth of origin that insisted on sending him "back home" to Puerto Rico, Haiti, Boerum Hill in Brooklyn, "africa," the Mudd Club, blue note, bebop, cave painting, Art Brut, early Pop, Ejagham-Cuban *anaforuana* signing, subway graffiti, Picasso circa 1910[6] . . . smitten by the heady upward rush from "the street" to international "art-star" status, by the equally violent, visceral elevations (and comedowns) that scratched a roller-coaster outline through a decade of committed drug abuse . . . he turned and turned and turned the other face.

You only have to be singular to become plural.

<div align="right">MICHEL NEDJAR, SCHIZOPHRENIC ARTIST[7]</div>

Basquiat's paintings turn back on us too. The sense of the uncanny sometimes triggered by a first exposure to a Basquiat piece doesn't just stem from what one critic called (referring here to Keith Haring's work though I think the observation is equally applicable to Basquiat): "the already-existing quality of his characters that deceives one into accepting them as already there without the intervention of an individual will."[8] It also proceeds from the feeling that we are being watched by the object, that the crowds of skulls, cartoon characters, masks, and disembodied eyes that stare and peek out from the picture plane are all looking back directly at us, not over us or round us—from a place that is not our place but in which we are nonetheless thoroughly enmeshed and implicated (though we never feel "at home" there). The canvas can suddenly turn into a mirror or (if you're white, as I am) a photographic negative from a book of family snapshots mutated in a dream. Hence, perhaps, the back-to-front logic of so many of the catachreses and verbal puns, e.g., the words PAW (LEFT)—left poor?—placed over the left foot (on the viewer's right) of the figure in a painting entitled *Irony of Negro Policeman* (1981) (plate 5).

The analogy between a mirror and the picture plane is rendered explicit in *Self-Portrait as a Heel, Part Two* (1982) (plate 11), which turns the trope into a perceptual puzzle. A representation of Basquiat's face and hands is clearly visible, pressed against the "glass" as if trying to escape in one direction, while the words BACK VIEW and COMPOSITE are posted on the back of (presumably, given the title) the same figure which is fleeing in the other direction. However, on closer inspection the left hand in the foreground (on our right) appears not to match its "partner" (which nonetheless matches it exactly in scale). We can see now, by the fingernails, that it's the back of the hand that is facing us rather than the palm (i.e., the "heel"). As soon as we make the requisite adjustment in perspective, the figure with the words on what appeared to be its back (because Basquiat's label had cued us to see it like that) shifts round and begins running off to the left (our right) because the hand with its back turned to us now belongs to this "Basquiat" not the one facing us. See?

The self-portrait merely translates the artist's permanent state of self-alienation into concrete visual terms. Basquiat always looked back at himself—as well as us—from the place of the Other. This is what, for all its exuberance and generosity, is ultimately so austere about his project. He never let up. He never gave himself a break.

Tomorrow we go to the big new show by Monet or Manet or Money or some such guy.

MARTIN AMIS, *MONEY*

I wanted to be a star not a gallery mascot.

JEAN-MICHEL BASQUIAT[9]

A 1985 photograph of Jean-Michel by Lizzie Himmel on the cover of *The New York Times Magazine* (page 352) shows him reclining in a director's chair, glowering down into the camera with the studied hauteur of the professional fashion model—that frosty, slightly hostile look which affects to resist our curiosity in order to excite it, which seems to say to the viewer "who the hell are *you* looking at?" He's wearing a dark designer suit, white shirt and tie, elbows resting on the arms of the chair, hands clasped and raised almost to the mouth in a posture of relaxed proprietorship. A long, thin paintbrush protrudes from the loose nest of fingers like a cigarette in an extravagantly oversized holder.

But in true Basquiat style the coherence of this carefully assembled pose is threatened on all sides by incongruous, alien elements. (Trying to "read" a Basquiat painting is like trying to listen to a melody on a radio with a faulty tuner—the dominant signal is constantly under attack from static interference, unannounced intrusions from other stations.) Thus the Noel Coward image he assumes for this portrait is deliberately frayed around the edges: the hair raises up like an exclamation mark in a startled, knotty block. The exposed wrist is cuffless. A large pale paint stain at the bottom of

one trouser leg is made even more conspicuous by its proximity to Basquiat's bare foot, which is resting on an upturned chair in a parody of one of those "white hunter" shots where some pith-helmeted *bwana* is posed with his boot on the carcass.

Basquiat was always one piss-elegant dude.

Sprawled across the cover of *The New York Times Magazine,* he looks (as the photographer no doubt intended him to look) like a young king on his throne. As the "first Black artist to achieve anything close to blue-chip status in the contemporary art market,"[10] Basquiat had been charged with the mission of taking painting back to its "elemental" roots. Such a therapeutic return to primal sources was regarded as one possible cure for modernism's ills. Other complementary cures included hyping Keith Haring, Kenny Scharf, David Salle, and Julian Schnabel, the new German expressionists, and the three Italian C's—Clemente, Chia, and Cucchi. Art's terminal impotence as a spiritual and/or political-cultural force when laid against the combined powers of the electronic media, mass consumption, and the military-industrial machine would hardly be reversed by an influx of young men with paint brushes. Nonetheless, within the narrow sphere of institutionally legitimized taste, supporters of this strategy held that it might just succeed in rehabilitating painting as the master visual art. Basquiat was to play his part in the restoration of the canvas-kings whose authority and privileged Truth claims had been seriously eroded by two decades of art theory and practice. Painting had been pushed off its pedestal by, among other things, the continuing ascendancy of simulation technologies and mediated imagery, by Pop's flattening of the painterly mark, Minimalism's dematerialization of the object, Conceptualism's critique of art's commodity forms, and the feminist interrogation of modernism's self-centered patrilineage and the myths that stoked its "bachelor machines." Basquiat's function was, in part, to quote the incantation on one of his own paintings, TO REPEL GHOSTS: to keep at bay for a little while longer the unadmitted questions crowded round the edges of the frame (plate 29). In the intervening years, the conservative agenda subtending this prescription for art's ailments has been thoroughly analyzed and repudiated in detail *ad infinitum.*

However, what is often glossed over in these dismissals of masculine painterly heroics is the singularity of Basquiat's position as American modernism's first (and last?) officially appointed Black savior, his equivocal position as inside-outsider. For all his "meteoric" success, Basquiat could never escape the conviction that he was at best a tolerated guest in Art Land, albeit (at least after his liberation from what one friend called his "dungeon period" in the basement of Annina Nosei's gallery) a lavishly indulged one.[11] He could never get away from the knowledge that he was, as it were, both Banquo *and* Macbeth: a ghost at his own coronation banquet. So here he sits on the cover of *The New York Times Magazine,* the Dalai Llama of late twentieth-century painting—a poor boy plucked from obscurity by the priests and whisked off to the palace. Here was a messiah for painting suited to the New World in the eighties: a Picasso in blackface.

The comparison with Picasso has its limitations though it is not as facetious as it may at first sound. Picasso in his day could evince a similar regality for the camera, that sense of being perfectly at home with his charisma. Basquiat, for his part, always singled out Picasso as a significant early influence (citing also Warhol, comic books, and a copy of *Gray's Anatomy* which his mother gave him when he was recovering from a spleen-removal operation at the age of seven).[12]

But, in the end, the differences between Picasso and Basquiat—the different relations they adopt to the ethnographic gaze leveled from the West on traditional African art, the different investment they make in the construction of their own celebrity—are more pronounced than any formal affinities in their work. Picasso, for instance, never had to contend, in his apprenticeship years, with the Faustian dilemmas thrown up by the eighties bull market in contemporary art and the parallel rise of the art-star. He never had to make his mark in a world that knew—if it knew nothing else about twentieth-century modernism—that Picasso had reinvented the language of painting. He never had to make his name in a world where the fetish of the signature conspires to reduce entire oeuvres ("complete" before the age of thirty) to sets of trademark signs—Schnabel's broken plates, Warhol's soup can, Haring's stubby baby—where the art of self-promotion can turn an artist overnight into his own designer label.[13] After all, Warhol's silver wig, Beuys's homburg hat and fishing jacket, Gilbert and George's spectacles and suits have had such felicitous results in terms of sales and product recognition that, these days, Walter Benjamin's prediction that the last *flâneur* will be a sandwich board man is most palpably borne out not on Madison Avenue but at the Venice Biennale.[14]

> I first met him at the Mudd Club in 1979. He looked like a combination of a fashion model and a nineteen-year-old Bowery bum.
>
> DIEGO CORTEZ[15]

The first masterpiece Basquiat constructed was himself. Memoirs from the East Village new wave/no wave days chart his progress through a series of disposable but memorable incarnations, from the punk with a green-painted face and a Nosferatu haircut to the jazz and funk freak in dreadlocks and a Comme des Garçons coat. "He knows just what looks good on him," Warhol confided to his diary (the envy disarmingly transparent). "He's 6 feet or 6 feet 1. He's really big."[16]

Picasso could afford to leave the marketing and manufacture of the iconic self to future generations (e.g., Paloma), but for Basquiat, who set about establishing himself in a club and street-style scene dominated, in Edit DeAk's words, by "the image of the artist on a shallow, non-existent stage,"[17] the body was a primary expressive tool: a 6-foot stylus for inscribing his mark, an instrument for writing out (eventually for crossing out) his life.

> Because if I want people to accept me as a king, I must have the kind of glory which will survive me, and this glory cannot be dissociated from aesthetic value. So political

power, glory, immortality and beauty are all linked at a certain moment. That's the
mode d'assujettissement, the second aspect of ethics.

<div align="right">

MICHEL FOUCAULT[18]

</div>

For Basquiat, performance was never just an act. The punishing regime of self-abuse
had less to do with unmitigated self-loathing or sensual gratification pure and simple
than with the *mode d'assujettissement*—his submission to the disciplines imposed by
the principle of inverse asceticism to which he was so resolutely committed. ("No
truth without ascesis": Foucault.) Those disciplines, productive of quite specific kinds
of knowledge, included never going back (Basquiat left home at seventeen), seeking
out intensities, developing a tolerance to their effects, then intensifying the intensities
by upping the dosage. The motto for this (per)version of a caring for the self (it used to
be known as the "jazz life") is that the body exists to be tested. The envelope is there to
be stretched and the payoff (if it arrives in time before death cuts in) consists in the
translation from one kind of intensity to the next: from the eye to the hand to the
body of the work, from the sounds to the lung and the breath that blows them. To con-
tradict for a moment the fashionable consensus on authorship and agency, it would be
futile in Basquiat's case to try to disentangle the hyper driven body from its superlative
gestures or either the body or its gestures from the extraordinary legacy of paintings
left lingering in their wake. Each remains immanent within the other. Wired from
head to toe like William Burroughs' Subliminal Kid,[19] Basquiat's body became a
mobile switchboard, a portable converter capable of turning the "wasted time" of end-
less nights out on the social circuit, the "dead time," of heroin, the "panic time" spent
coming down off coke into the "now time" of a solid four-day painting binge. (Color
photocopies of Basquiat's rendition of the label from Charlie Parker's 1947 recording
"Now's the Time" appear on two of the twenty-seven boxes topped by a bootblack
stand that make up his 1985 installation *Brain*.)

> There seemed to be a definite fear of the future. People gave up on planning things. It
> was all for that moment, that night.
>
> <div align="right">
>
> CARMEL JOHNSON-SCHMIDT, MUDD CLUB LUMINARY[20]
>
> </div>

For Basquiat the body was a studio unto itself and his aspirations for the work per-
formed there were no less stellar than those he harbored for his two-dimensional crea-
tions. The common goal in each case was to make the most of his talent, to find the
right line, to acquire grace and stature: to walk without fear through the fire. He knew
that to walk that way without burning yourself out, you simply have to let the flames
lick over you and turn the ashes into kohl. He knew you had to make yourself up on a
daily basis.

> I walked forty-seven miles on barbed wire
> I use a cobra snake for a necktie

I've got a brand new house on the roadside
Made out of rattlesnake hide
I've got a brand new chimney made on top
Made out of a human skull
Now come on and take a little walk with me, Arlene
And tell me: who do you love?
Who do you love?
Hoodoo you love?

Elias McDaniel [Bo Diddley], "Who Do You Love"

But the materials out of which Basquiat composed and recomposed himself as gesture and image existed independently of and prior to his individual entry on the scene. His trademark images and the fractured modes in which they were presented (for the camera, on the dance floor, in the paintings) came *from* somewhere and the traces of their passage through circuitous migrations from other times and places to here and now—to what Robert Farris Thompson calls the "creole time" of Basquiat's work[21]—remain to be listened to and read.

There are, however, dangers in reading them too literally. Traditions of specifically Black vernacular performance played an integral part in shaping Jean-Michel's approach to strategies of "face" and "mask," rhetoric and signing—what Kobena Mercer, writing in a different context, describes as "the aesthetics of masquerade that carnivalize the visual depiction of Black bodies in their works."[22]

In such an aesthetic, duplicity, doubleness, and undecidedness are divested of the negative connotations generally attached to them in Western culture. The framework of binary oppositions, which make distinctions between terms like "negative" and "positive" (or "true"/"untrue"; "good"/"not-good" ["bad" or "evil"]) possible and meaningful is itself placed in question. If the notion of self-expression which underpins the mythology not just of expressionism but of modern art in general derives from a subject-object opposition based "on the spatial model of an 'inside' [opposed] to an 'outside' world—with the inside privileged as prior,"[23] then the mask-in-performance (rather than the image of the mask, e.g., in Picasso's *Les Demoiselles d'Avignon)* works to suspend that opposition altogether.

The mask-in-performance is an ecstatic mode of transport: an object which transfigures by contiguous magic both the subject who is wearing it and those who witness the performance. It seizes and dethrones the knowing subject by issuing its commands in the present tense. A white-robed voodooiste dancing to the rhythm of the drum won't know in advance if or when a spirit will possess her or which spirit it will be. He won't be in the saddle when Damballah or Ayida-Wedo or Erzulie Red-Eyes comes down into the ring to mount the empty body and ride it in convulsions across the temple floor.[24]

But for the uninitiated onlooker—the observer in but not "inside" that scene—the stakes are altogether different. Basquiat, the metropolitan Black hipster, knew the power of the "savage" mask and how and where to play it, elaborating strategies, like

Fanon or Césaire, for reversing the flow of fear and fascination which threatens to transfix the Black subject as exotic zoological/anthropological specimen.

One such strategy involves a shamanistic descent[25] into the space of death in which the viewer is compelled to take a part (there are different parts for different viewers). Basquiat takes us on a voyage directly into Joseph Conrad country. We sail against the stream back into the center of the darkness that supplied the counterpoint (and the human cargo) required by colonialism's "civilizing" mission until we reach the boneyard at its source. Basquiat's flag is the cartoon skull and cross bones of all our recollected childhoods, and what he brings back is made available for all of us to see (though here the "us" disintegrates: this is the point at which the viewing body is split into pieces along the intersecting axes of ethnicity and gender, sexuality and class). The frame becomes a threshold over which some of us may hesitate to step, fearful of confronting our complicity in the barbarism perpetrated somewhere else beyond our worst imaginings in our name and for our benefit. However, Jean-Michel is a perfect host. He is there to reassure us and to meet us at the door. In accordance with the custom, he hails the white museum visitor, using our ceremonial guest name ("Mr. Kurtz")[26] and offering the ritual words of greeting reserved for such occasions (the interested reader can hear them delivered to the traditional percussive accompaniment on a record by the traditional rap band Public Enemy):

Black to the bone
My home is your home
So welcome to the Terrordome.
 "Fear of a Black Planet"

The idea that Jean-Michel Basquiat was an "idiot savant" who merely poured out his heart in the white heat of his genius and put it on display for all and sundry is palpably misguided. It is as ludicrous and patronizing as the implication that he didn't speak with the authentic "voice of the street" because his daddy lived in a three-story brownstone in Boerum Hill. Basquiat's masks were real enough (they'd been fashioned in fires that will burn the next time as intensely as they burned the last time). They were as real as the vocal mask donned by Bo Diddley when on the back of a bone-shaking rhythm he asked Arlene the voodoo-hoodoo question "Who do you love?" back in the fifties. Basquiat had as much right to pull the terror face on us as the gangsta-rappa LL Cool J, whose rage, in the words of Barry Michael Cooper, "caricatures the anger of Black male teenagers . . . [and] . . . makes punk rock's tantrums look like something from *Captain Kangaroo*."[27] And LL Cool J is no more an Uzi-wielding crack dealer than Jean-Michel was a cannibal: "They're hipped on that ghetto from the streets shit," LL Cool J complained in one interview, exasperated by the literalism fueling the moral panic round rap. "I ain't from the ghetto. I'm from Queens. The beat is from the street. The hardcoreness. Just being real ill and live and hard but I'm not from the ghetto. I live with my grandmother. Shit."[28]

And in the same way the accusations that Basquiat's talent was purely "instinctive" or that his work simply exhibits "raw emotion"—the exclamations of surprise on the part of accredited art experts at the "educated quality" of his line—all miss the point entirely. Basquiat's work is as complexly coded and oblique, as passionate, as technically sophisticated, as intellectually daring as a saxophone solo by Bird or Coltrane. Like his bebop heroes, he just went to different schools. He honed his technique with a felt-tip pen and a spray can by bombing flats on the BMT, by transcribing imagery that worked for him wherever he found it and by living (sometimes literally) on the street in the same way that a Black jazz musician in the forties and fifties learned to master an instrument by playing it in public, listening to other musicians, by stealing their signatures, masking the theft, and incorporating the mask into his repertoire. The fleetness and dexterity with which Basquiat moved in and out of different voices, masks and scenes (the "street"-style magazines, the Black music scene, the avant-garde "no wave" music scene, the experimental film and video networks, the East Village, the international art-star circuit) were both his strength and his undoing.

Tuesday, October 30, 1984

Jean-Michel was in bed with some new girl and didn't show up. Bruno [Bischofberger] arrived and surprised us. And his wife—Yoyo. And they looked at the big paintings that Jean-Michel has been doing silkscreens on, and they had a sour look, they said it ruined his "intuitive primitivism." But he'd always Xeroxed before and nobody knew, it just looked like new drawings.

THE ANDY WARHOL DIARIES[29]

Basquiat's birthright did not include a hotline to Haiti and he grew up in a household where Caribbean and African art were things you learned about in books and museums. His "primitivism" was neither more nor less authentic or intuitive than Picasso's, though the desire to play back the loaded carousel of white racist projections in its alternately grim and ludicrous entirety was, it goes without saying, more acutely motivated in Basquiat's case. In the end, the cartoon blackbirds, cigarette-card pugilist portraits, and the coon art chef with the popping fried-egg eyes simply merge with the *griot* heads (often in the same pictorial space) to expose the underside of the ideal scene of "integration." Basquiat's disjunct compositions sometimes look like the jolly aftermath of a surgical experiment gone badly wrong. We peer into a bin filled with discarded bits and pieces that can never be made whole again because there wasn't any "whole" there in the first place, just a jumbled set of contradictory images. The metaphor of dismemberment can hardly be avoided here: it is as motivated as Basquiat's own image-repertoire. The paintings draw us in and cut us up in one incisive gesture. Anyone seeing the work is forced to acknowledge that these aren't just textual cut-ups, that the incisions have been inflicted time and time again on actual living flesh.

With Basquiat we are brought face to face with what Homi Bhabha has called "the ambivalent identifications of the racist world . . . the 'otherness' of the self in the racist

world . . . the 'otherness' of the self in the perverse palimpsest of colonial identity."[30] Basquiat was himself fully—that is, authentically—implicated in that ambivalence (after all, this was not an academic exercise—Basquiat's project had nothing whatsoever to do with "illustrating theory"). He located (and finally lost) himself inside that perverse, Byzantine palimpsest. In his regressive enactment of childhood forms and memories, in the reduction of line to its strongest, most primary inscriptions, in that peeling of the skin back to the bone, Basquiat did us all a service by uncovering (and recapitulating) the history of his own construction as a Black American male.

As with Art Spiegelman's *Maus* books, which tell the story of the Holocaust in comic book form, the disarmingly child-like quality of Basquiat's imagery and execution produces an apparent discrepancy of scale between the story and the mode of narration that merely serves to magnify the sense of horror.[31] As Greg Tate has pointed out elsewhere, Basquiat was obsessed "with the Black male body's history as property, pulverized meat and popular entertainment."[32] By narrating that history in the language of the nursery and the schoolyard through the simulated infantilism of stick figures and scribbled skylines, he draws us right into the terrordome—the arena in which the chaotic play of fear and desire conducts its endless surgery, cutting back and forth from "Black" and "white," performing the splitting, doubling, and stitching-up procedures which lie behind a production of identity that opens with the child's entry into language and only ceases with the closure into death.[33]

In the discussion of *The New York Times Magazine* cover photograph, one conspicuous element went unremarked: the presence of another figure which threatens to overwhelm the image of the artist in a way that freeze-frames one moment in the identity production that went (on) under the name of Jean-Michel Basquiat. A froglike, matte-black silhouette, its thin handless arms dangling like whips from a thick, squat body, grins out from a block of wooden boards to one side of Basquiat's reclining figure. Two stripes of white squares indicate teeth. A single white oval signals "this is an eye." Basquiat's head and the black frog's head line up exactly like bookends to produce a portrait of the artist as a double act: Basquiat and his shadow, Basquiat and the unwritten history of his race, Basquiat and the lost objects of a fabulated origin, his "africa" under erasure, an "africa" driven down and out of the official picture but ready to erupt anytime, anywhere, to rise up center stage terrifying and magnificent, lowdown and laughing and monstrously armed, ready at any time to push the Other face right up into your face, right up into mine. It's in his profoundly ambivalent relation to his own historically determined doubleness, to the equivocal nature of his status (star or mascot?) as the chosen Black man set loose in the wilderness of an art world still massively dominated, to quote Diego Cortez, by "white walls, white people and minimal white art"[34] that Basquiat and his European mentor finally, decisively part company. If, as his singularity may sometimes have suggested, Basquiat was (mis)cast as Messiah, as King of Kings, who or what was he supposed to be redeeming? The fall of modern painting? The "reputation" and heritage of his race (and if so, the heritage of which particular tribe is being salvaged here—the "african," the Afro-American,

the Puerto Rican [African, or Spanish or Afro-Spanish?], the Haitian [African or French or Creole?]. Or maybe he was redeeming the culture of the tribe of educated upper-middle-class Brooklyn accountants to which his father belongs? Maybe he should have stuck to saving his *own* skin

Look at the two figures in that photograph again. Picasso simply could never have claimed this degree of literal merger, of isomorphic symmetry (however sarcastically Basquiat [and the photographer] intended it) with Western culture's constitutive, repudiated Other. He could never have put himself so firmly in the shade.

Perhaps his antics helped to show the art world its own face. Maybe they even learned something.

KEITH HARING[35]

In Jean-Michel's case, the "burden of representation"—the urge, on the one hand, to stand up and stand in for his race, and, on the other, to move up into another whiter world . . . the urge to lapse into silence and to "resist with all his energy," as Henri Michaux puts it, "the fundamental drive to leave no trace"[36]—finally proved fatal. In what Robert Storr once described as Basquiat's "eye rap,"[37] the visible tension between silence and strategic disclosure, between dancing on a line and holding something back across the beats becomes, at times, almost too painful to watch. Nathaniel Mackey has explained how "the apparent mangling of articulate speech [in scat singing] testifies to an 'unspeakable' history such singers are both vanquishers and victims of."[38] It is the unspeakability of the African-American experience and the terror and effacement of its history which maybe accounts, too, for Basquiat's recognition of what Thompson calls "the equal potency of statement and erasure,"[39] his awareness that the empty intervals between articulated forms can be as telling as the forms themselves—often more so. As in scat singing (or a crack from de la Soul), words and image-signs in Basquiat's work float free of logic and semantics. They are allowed to settle on the picture surface as pure utterance, reverb, unwilled resonance, so that the origin is intentionally lost, disguised, or "dubbed": transformed—sometimes literally—into a mask.

The silences and riddles of Basquiat's work are motivated by a refusal to make sense which, in the end, bears little relation to the refusals and silences of Dada or Duchamp (or Twombly or Dubuffet come to that). They remain as inaccessible to the formulaic modes of academic deconstruction as they are irreducible to the modern myth of the agonized artist-priest—even in its pathologized late-modern version, i.e., "the crazy mixed-up kid." To use the metaphor generally preferred today when people talk about the links between empowerment and articulation, it is not that Basquiat suffered because he could not "find his voice." He found too many voices (or they found him). It is not that he didn't "have a place to speak from" but rather that the places kept multiplying. At a time when hybridity is being recommended as an alternative starting point for the development of a new non-essentialist "politics of identity" (as opposed to the old sixties style "identity pol-

itics"),[40] it is important that we recognize, as Kobena Mercer has argued, the value of ambivalence (and the trouble it causes), "the sheer difficulty of living with difference."[41]

Basquiat's achievement consists not solely in the work, remarkable as it is (the work would surely be enough), but in the way both his painting and the manner and timing of his death testify to the high existential price paid by some of those who strive to live without certainty between the categories. At the point where the signature, the tag and the trademark, the crown and halo blur, Basquiat's ecstasy becomes spacialized. Basquiat came (from) everywhere at once . . .

POST(MORTEM) SCRIPT

I do not think it is an exaggeration to suggest that the young Black American male is a species in danger.

LOUIS SULLIVAN, SECRETARY OF HEALTH AND HUMAN SERVICES[42]

To be a race-identified race-refugee is to tap-dance on a tightrope.

GREG TATE[43]

. . . but he still stands there at the crossroads. Like the stalemated figure caught between a snake and a cow's carcass in his 1981 painting *Acque Pericolose (Poison Oasis)* (plate 2), head jammed into a halo of thorns, gender prominently displayed, Basquiat still stares back at us from his work as we peer in at him through a buzzing cloud of alphas, omegas, arrows, flies. The spirit in which he undertook to send our scrutiny back home where it belongs, to make us other to ourselves, remains as inscrutable as the expression on the face of the figure in that painting, as unreadable as the arms folded flat against the chest. Is this crossing of the hands a pose of resignation or defiance? A plea for reciprocation and mutual embrace or a gesture of exclusion? Is this a man seeking recognition from all lovers everywhere or an LA Crip gang member signing to his crew? In the case of Jean-Michel it was, in any event, never clear who was most smitten ("beaten," "infatuated," "polluted") by what or by whom—him or the masterpiece tradition, him or his admirers, friends, critics, lovers . . .

Wednesday, January 30, 1985
And now Jean-Michel doesn't even like his girlfriend from Comme des Garçons . . . because she borrowed money from him. He likes to give people money but then he resents them for taking it . . . in a moment of passion once he told her he loved her and she told him that she was a "free woman," so he tied her up and told her how dare she think he *meant* it.

THE ANDY WARHOL DIARIES[44]

Or as Jenny Holzer put it on a billboard once:

AMBIVALENCE CAN RUIN YOUR LIFE

(We might add . . . AND THE LIVES OF ANYONE WHO GETS TOO CLOSE.)

There are other ways of reading the pose of the figure in *Acque Pericolose* which reinforce still further the strangulated pathos, irony, and rage condensed at times on canvas in Basquiat's ambivalent address to a predominantly white audience. For instance, what if that's a cloth draped over the left arm? What if the other hand is reaching out to take the viewer's menu? A deracinated portrait of general existential dread—Man adrift in a godless desert—decomposes in this reading along with the global pretensions of the disenchanted modern *Weltanschauung* which lends Neo-Expressionism its supposed *gravitas*. The Great White Artist as angst-ridden seer at the End of History/Meaning/Faith (a type recycled in the epic broodings of Baselitz and Kiefer) is replaced here by the Black performer as professional service worker, dancing attendance at the end of the table. In this *détournement* of expressionist cliché, the notoriously vague post-modern sense of mourning is suddenly given real bodies to grieve over. The cartoon steer skull and Disney snake play a part in this black comedy as the Big Themes of Western art are simultaneously reworked, reinvested from a different angle, and pulled apart, lampooned. Detached from their moorings in Western mythology, these icons have quite a different weight. The figure with the outstretched hand beggars glib description, becoming at once supplicant, creditor and plaintiff (i.e., the joke—if joke it is—is in the end on us).

And eventually, however long it takes, we'll have to pay. Not for this picture especially—after all, someone else has already paid for that—but for the history that bore Basquiat and which brought him down before his time (even if he asked for it), just as one day we shall have to pay for all the other Black American Kings cut down in their prime including, incidentally, Martin Luther King and Rodney King.

For in Basquiat's painting, Beckett's procrastinating tramps have been trumped at the Poison Oasis by a new Every-man, more suited to the post-colonial scene: Eshu-Elegba, the Yoruba trickster god who waits for unsuspecting travelers at the crossroads.[45] Now crisis has a face (in fact, two faces, one for each of his names: this is the god of deception, the double take and the double cross). After Beckett, Basquiat goes one better: not a waiting but a waiter for Godot.

Can I take your order, madam? Would sir prefer Sex or Death, the plat du jour or soul food?

> Let us consider the waiter in the café. His movement is quick and forward, a little too precise, a little too rapid. He comes toward the patrons with a step a little too quick. He bends forward a little too eagerly: his voice, his eyes express an interest a little too solicitous for the order of the customer. Finally there he returns, trying to imitate in his walk the inflexible stiffness of some kind of automaton while carrying his tray with the recklessness of a tightrope walker by putting it in a perpetually unstable, perpetually broken equilibrium which he perpetually re-establishes by a light movement of the arm and hand. All his behavior seems to us a game He is playing,

he is amusing himself. But what is he playing? We need not watch for long before we can explain it: he is playing at being a waiter in a cafe.

<div align="right">JEAN-PAUL SARTRE, *BEING AND NOTHINGNESS*</div>

It was covered with as dense and rewarding an array as a 1955 Rauschenberg. I decided to overpay. I offered $2000 for it. I knew he was authentic and I wanted to say, "welcome to the real world."

<div align="right">HENRY GELDZAHLER, DESCRIBING HIS ACQUISITION OF A BASQUIAT PIECE IN 1981.[46]</div>

Notes

1. Quoted in Phoebe Hoban, "SAMO© Is Dead: The Fall of Jean-Michel Basquiat," *New York*, September 26, 1988, 43. Basquiat had been introduced to the highly influential though initially skeptical gallery owner by Bruno Bischofberger in the early eighties. Boone explained to Cathleen McGuigan the circumstances of her conversation: "I'd walk into some collector's home and there would be something by Jean, hanging next to Rauschenberg and Stella. It looked great. It surprised me" (quoted in Catherine McGuigan, "New Art, New Money: The Marketing of an American Artist," *New York Times Magazine*, February 10, 1985, 21). Basquiat's first solo show at the Mary Boone Gallery in May 1984 marked his arrival in the major leagues and the moment when his work was publicly disassociated from graffiti art. The high-profile opening was followed by a legendary party catered by Mr. Chow (Keith Haring: "Everyone from David Byrne to Julian Schnabel was there"). In the same month, a Basquiat self-portrait was included in an exhibition at the Museum of Modern Art and another painting, completed two years earlier and sold originally for $4,000, fetched $20,900 at Christie's spring sale of contemporary art. For Boone, signs of Basquiat's undeveloped interior included his being "too concerned with what the public, collectors and critics thought . . . too concerned about prices and money" (quoted in Hoban, "SAMO© Is Dead," 43). During the eighties, Mary Boone received more publicity than most of her artists. Suzi Gablik quotes Julian Schnabel's tetchy response to the suggestion that he was Boone's "protegé": "Basically she is known because of me. I think Mary is famous because Leo Castelli famous. But what artist is really famous compared to Burt Reynolds?" (Quoted in Suzi Gablik, *Has Modernism Failed?* [London: Thames and Hudson, 1985], 95.)

2. Eric Michaels, "Bad Aboriginal Art," *Art & Text*, no. 28 (March–May 1988): 60.

3. Rene Ricard, "The Radiant Child," *Artforum* 20 (December 1981): 43.

4. Jeffrey Deitch reviewing Basquiat's show at the Annina Nosei Gallery, *Flash Art* 16 (May 1982): 50. The phrase occurs as part of Deitch's summary of earlier characterizations of Basquiat as a "freak of nature." His preferred analogy is highly suggestive and apposite in the context of the arguments laid out in the present essay: "But Basquiat is hardly a primitive. He's more like a rock star. Basquiat reminds me of Lou Reed singing brilliantly about heroin to nice college boys."

5. Philip Faflick, "SAMO© Graffiti: BOOSH-WAH or CIA?," *Village Voice*, December 11, 1978, 41. SAMO (short for "same old shit") was the tag used by Jean-Michel and his (then nineteen-year-old) partner, Al Diaz, whom he'd met two years before at the experimental City-as-School (CAS). The duo were paid $100 by the *Village Voice* to explain, in effect, how they had managed to graduate from cave painting (i.e., "bombing" subway trains) to Conceptualism (e.g., SAMO© AS AN ALTERNATIVE TO GOD, STAR TREK AND RED DYE NO 2). For an excellent discussion of the issues raised by graffiti's (partial) legitimization as gallery art, see Susan Stewart, "Ceci Tuera Cela: Graffiti as Crime and Art," in *Life after Postmodernism: Essays on Value and Culture*, ed. John Fekete (New York: St. Martin's Press, 1987), 161–80. Stewart describes the conflicts of value attending the passage of (some selected) graffiti from "something indelible calling for erasure to something eternal calling for curating" (174).

The invasion-imagery foregrounded in many white critics' characterizations of subway graffiti as, for instance, visual "intimidation" (Michael Craig Martin), "the impulse of the jungle to cover the walled tanks of technology" (Norman Mailer), "monkey scratches on the wall" (Paul Theroux) gives explicit voice to the fears aroused for these critics (even for those, like Mailer, who set out to celebrate graffiti tagging) by the prospect of the (mobile) young non-white male unconstrained by the old gangland sense of ethnically homogenous "turf." Such fears suggest that Basquiat, unlike Haring or Scharf, was compelled, on the strength of his skin color, to shed the graffiti connection in order to find acceptance "above ground" though invasion-anxieties on the part of white tastemakers, dealers, etc., continued to impede Basquiat's reception as a "serious" (i.e., marketable) artist. Either way, Basquiat never altogether relinquished the legacy of his years as a graffiti artist. The cartoon crowns remained. (In the argot of the graffiti subculture a "King" is the "best with the most"; see Martha Cooper and Henry Chalfant, *Subway Art* (New York: Thames and Hudson, 1984, 1990). Warhol tells his diary that Basquiat, like some graffiti-tagger secure in his kingship, used to paint over Francesco Clemente's contributions to the collaborative canvases the three artists produced, at Bruno Bischofberger's instigation, in the mid-1980's. See Victor Bokris, *Warhol* (Penguin, 1989), and Pat Hackett, ed., *The Andy Warhol Diaries* (New York: Simon and Schuster, 1989).

6. Basquiat's obsession, in his own words, with "heroism, royalty and the street" (Henry Geldzahler, "Art: From Subways to Soho: Jean-Michel Basquiat," *Interview* 13 [January 1983], 46), combined with his determination to make the "Black man . . . the protagonist," accounts for the tributes in his paintings to Black jazz musicians like Miles Davis, Max Roach and Charlie Parker (with whom the artist had a particularly strong identification) and boxing champions like Jersey Joe Walcott, Roosevelt Sykes, Jack Johnson, and Sugar Ray Robinson. Basquiat first met Warhol (with Henry Geldzahler) in the late 1970s when he sold him a postcard, and the two became close during the mid-1980s when they produced a number of collaborative pieces later shown (to a mixed critical reception) at the Tony Shafrazi Gallery. Basquiat grew up in relative affluence in a three-story brownstone in Brooklyn's Boerum Hill. His mother was Puerto Rican, his father from Haiti. The Mudd Club, epicenter of the East Village new wave/no wave scene in the late 1970s and early 1980s, was opened by Steve Mass in a building on White Street owned by Ross Bleckner in 1977. Basquiat soon became a fixture, forming Gray, an art-noise band with other Mudd Club aficionados (Vincent Gallo, Michael Holman, Nick Taylor, and Wayne Clifford); see Steven Hager, *Art after Midnight: The East Village Scene* (New York: St. Martin's Press, 1986), 55. The references to cave painting, Picasso, Pop, etc., hardly need elucidating. Afro-Cuban *anaforuana* writing stems from the *nsibidi* (literally "cruel letters") tradition of the Ejagham people of southwestern Cameroon and southeastern Nigeria. According to Robert Farris Thompson, *Flash of the Spirit: African and Afro-American Art and Philosophy* (New York: Random House, 1984), 229, most of the *anaforuana* Cuban ideographs "are hypnotic variants of a *leitmotif* of mystic vision: four eyes, two worlds, God the Father—the fish, the king—and the Efut princess who in death became his bride. These signs are written and rewritten with mantraic power and pulsation. Mediatory forces, the sacred signs of the *anaforuana* corpus, indicate a realm beyond ordinary discourse. They are calligraphic gestures of erudition and Black grandeur, spiritual presences traced in yellow or white chalk (yellow for life, white for death) on the ground . . . bringing back the spirit of departed ancestors." Many *anaforuana* signs (e.g., crossed arrows) occur in Basquiat's work though this is hardly surprising since he had read Thompson's *Flash of the Spirit* and met the author. Thompson examines connections with other African runic and calligraphic traditions in "Activating Heaven: The Incantatory Art of Jean-Michel Basquiat," in *Jean-Michel Basquiat*, exh. cat. (New York: Mary Boone–Michel Werner Gallery, 1985), n.p.

7. Michel Nedjar, "I Am Tied to the Threads of the World," in the "Art Brut: Madness and Marginalia" issue of *Art & Text*, no. 27 (December 1987–February 1988): 59. Nedjar's work with masks and figurines, sometimes incorporating organic materials (vegetation, etc.) is, in Roger Cardinal's words, "the by-product of an unusually intimate engrossment, whereby the maker of an object engages so unreservedly with the materials at hand that the two entities—creator and created work—seem one." See Roger Cardinal, "Within Us These Traces," *Art in Text*, no. 27

(December 1987–February 1988): 46. I would suggest that the model of merger between subject and object in Nedjar's shamanistic practice is as applicable to Basquiat's *modus operandi* as the more frequently cited comparison with Jackson Pollock and Action Painting (if not more so). Basquiat's incorporation of apparently arbitrary incidentals (street signs, random lists, pop culture memorabilia, song lyrics, diagrams from technical manuals, etc.) into the "now time" of his collage-convocations recalls Nedjar's transformation of tree roots into rhizomes: "I noticed that once I put a root into a doll, the thing became a whole. Now I don't have to add on any roots, the thing is already a root" (55). The ambivalence exhibited by many critics to Basquiat's output (i.e., is this "nature" or "culture"?) strongly recalls controversies in the art world over the status of Art Brut, "outsider," "naïve," and children's art. For an incisive analysis of what is at stake in parallel disputes over the status of Australian aboriginal art (as commodity, as embodiments of "other" values, as a set of objects "authored" by a collective subject), see Michaels, "Bad Aboriginal Art."

8. Ricard, "Radiant Child," 36. As Ricard points out, the graffiti tag displayed in public space "refutes the idea that anonymous art where we know everything about a work except who made it." For Hal Foster (following Baudrillard) the art of the signature in graffiti art inverts Roland Barthes' famous description of photography as a "message without a code" (i.e., graffiti becomes a "code without a message"; see Hal Foster, *Recodings: Art Spectacle, Cultural Politics* [San Francisco: Bay Press, 1986], 51). More dismissively, Richard Sennett, in *The Conscience of the Eye: The Design and Social Life of Cities* (New York: Alfred A. Knopf, 1990), 207, describes subway graffiti as "simple smears of self" whose meanings are reducible to one word "*feci:* I made this" or "we exist and we are everywhere. Moreover you others are nothing: we write all over you." (Sennett goes on to contrast New York ego graffiti with the discreet charms of stencil-based Parisian street slogans which, he claims, betoken a will to "experiment with the environment.")

Nonetheless, the paradox of the anonymous and barely legible signature that comes from "nowhere" (e.g., the projects), can appear anywhere, respects no boundaries (between inside/outside, public/private space) and announces itself unexpectedly as pure (threatening, sublime) presence may recall another "awful" inscription: the terrible traces left behind by Jehovah's moving finger on the wall. If the art effect in general derives, in part, from the logic of the "unexpected move," then the success of both Basquiat's and Haring's work within the art world may have been tied to their ability to make the association with sacred writing work for them. (Significantly, Basquiat and Diaz were described as "Magic Marker Jeremiahs" by Faflick, "SAMO© Graffiti.") At the same time, the popular appeal of Haring's radiant child, barking dog, and mushroom cloud logos and of SAMO's enigmatic calls for self-reflection may have stemmed partly from the way in which both (apparently egoless) inscription strategies seemed to reinvest public space with traces of divinity via an explicitly apocalyptic mode of address (the "shock effect" being further intensified by the profane/criminal associations of graffiti as [self-] expressive form). From this perspective, Basquiat and Haring were rewarded for redeeming Satan's works in the name of Go(o)d Art.

9. Quoted in McGuigan, "New Art, New Money," 32.

10. Hager, *Art after Midnight,* 38.

11. Diego Cortez, quoted in Hager, *Art after Midnight,* 99. Basquiat joined the Annina Nosei Gallery in 1981 on the recommendation of Sandro Chia, who had been impressed by his contribution to Diego Cortez's "New York/New Wave" show at P.S. 1 that February. Nosei installed Basquiat in the large basement storeroom underneath the gallery and supplied him with money and materials. This novel arrangement became that year's scandal in the Manhattan art world and may have inspired the scene in Martin Scorsese's film *After Hours,* in which the disoriented protagonist, Hackett, is encased from head to toe in plaster of Paris by a predatory sorceress/sculptor as he hides from a lynch mob in her basement studio beneath a Mudd Club-lookalike called "Club Berlin." (In the film, the sculptor tapes up his mouth to complete the mummified effect.) "He had perhaps seen in me the mother type," says Nosei, who suggests that the image led to later conflicts; quoted in McGuigan, "New Art, New Money," 74. The relationship ended in acrimony: Basquiat destroyed several works in progress before storming off, eventually to join Mary Boone.

12. Hager, *Art after Midnight*, 40. Some critics suggest that Basquiat's obsession with anatomical drawing, body parts, bones, etc., can be traced back to the bizarre circumstances in which the budding artist was first invited to contemplate his own mortality (the spleen-removal was necessitated by his having been knocked down by a car). Here I argue that Basquiat's concern with dismemberment was overdetermined at other levels, too.

13. See, for instance, Deyan Sudjic, *Cult Heroes: How to Be Famous for More Than Fifteen Minutes* (London: Andre Deutsch, 1989), especially chap. 6, "Art for Art's Sake: The beer bottle as limited edition, portrait of the artist as a dinner guest, and how Warhol went from soup to vodka." The packaging of graffiti art in the 1980s (from the Fashion Moda boutique selling T-shirts, multiples, etc. at Documenta in 1982 to the opening of Keith Haring's Pop Shop in 1986) provoked renewed controversy over the conflation of art and commerce and provided (along with the title of Donald Trump's best seller, *The Art of the Deal*, and the image of the art-collecting arriviste-tycoon Gordon Gekko in the film *Wall Street*) one of the most pervasive metaphors for the fate of art (as investment and status symbol) in the "decade of greed." See also Louisa Buck and Philip Dodd, *Relative Values or What's Art Worth?* (London: BBC Books, 1991), especially chap. 2, and Scott Lash, *The Sociology of Postmodernism* (London: Routledge, 1990), chap. 1. For a more theoretically driven examination of art's equivocal position (as commodity and "cultural capital") in competing hierarchies of taste, see Pierre Bourdieu, *Distinction: A Social Critique of the Judgement of Taste* (London: Routledge, 1984).

14. Walter Benjamin, *Das Passagen-Werk,* quoted by David Frisby, *Fragments of Modernity: Theories of Modernity in the Work of Simmel, Kracauer and Benjamin* (Cambridge, MA: MIT Press, 1986), 253. Frisby continues: "Ultimately, Benjamin saw the final apotheosis of the *flâneur* in the commodity of advertising itself: 'The sandwichboardman is the last incarnation of the flâneur'; 'The true *flâneur salarie* (Henri Béraud) is the sandwichboardman.'"

15. Quoted in Hoban, "SAMO© Is Dead," 40.

16. *Andy Warhol Diaries*, 613. This volume provides detailed insights not just into the hectic round of parties, social visits, and interminable cab rides in which Warhol and Basquiat were immersed in the mid-eighties; it also documents the pulse of fear and fascination which shaped the older artist's relationship with his young protegé, who appears to be the first (and only) Black person Warhol ever got close to. Basquiat's ambivalence toward Warhol appears to have been equally developed. All in all the complexities of that relationship (from Basquiat's adolescent hero-worship of Warhol through Warhol's initial revulsion, mid-term voyeurism, and latter-day affection and concern, to their uncannily close, avoidable deaths in 1987 and 1988) would warrant another essay.

17. Quoted in Hager, *Art after Midnight*, 56.

18. Michel Foucault, interviewed by Paul Rabinow and Hubert Dreyfuss, "On the Genealogy of Ethics: An Overview of Work in Progress," in *The Foucault Reader,* ed. Paul Rabinow (New York: Pantheon Books, 1984), 334. Foucault is assuming the voice of Nicocles, a ruler of ancient Cyprus who boasted of not having sexual relations with any woman other than his wife: "Because I am the king, and because as somebody who commands others, I have to show that I am able to rule myself." Foucault distinguishes this mode of self-discipline (which is, precisely, not intended to be normative) from the universal, Stoic formulation: "I have to be faithful to my wife because I am a human and rational being." See also Michael Foucault, *The History of Sexuality, Volume 3: The Care of the Self,* trans. Robert Hurley (London: Penguin, 1990), 40–41. Just as Nicocles exhibited his leadership credentials by submitting voluntarily to an atypical regime of sexual restraint, so Basquiat set about demonstrating his qualifications for stardom through his cultivation of what might be described as "extraordinary bio-competences." According to one friend interviewed by Hoban, "SAMO© Is Dead," 42: "He took a great deal of pride in the amount of drugs he could consume. He knew drugs better than anyone I knew. He seemed to know what he could or couldn't do." Suzanne Mallouk, who lived on and off with Basquiat in the early eighties, told Hoban: "He was on drugs from the day I met him . . . He took everything, anything—a lot of acid, a lot of pot, a lot of coke," and as early as 1981 "was spending $2000 a week on coke and pot" (40). Stories about Basquiat's rabelaisian drug intake, his promiscuous sex life and his disregard for money and possessions

(beggars given $100 bills; the paint-smitten Armani suit) circulated along with his name in the galleries and art magazines and functioned to consolidate his image as a prodigious natural force. The argument of the present essay is that Basquiat's regime is no more a "surrender to instincts" or a sign of an over-"exteriorized" personality than Nicocles' submission to an arbitrary code of relative sexual abstinence. Both regimes stipulate the performance of specific acts of self-cultivation. Those acts in turn figure as publicity in the assertion that the difference between a king and his subjects in intrinsic to the ruling body.

19. William Burroughs, *Nova Express* (London: Jonathan Cape, 1966). David Toop invokes this figure in a suggestive discussion of contemporary rappers like Public Enemy, N.W.A. (Niggaz with Attitude), and Ice Cube. He quotes Burroughs' description of the Subliminal Kid who "brought back street sound and talk and music and poured it into his recorder array so he set waves and eddies and tornados of sound down all your streets and by the river of language—Word dust drifted streets of broken music car horns and air hammers—The Word broken pounded exploded in smoke . . . "; see David Toop, *Rap Attack 2: African Rap to Global Hip-Hop* (London: Pluto Press, 1991), 180. The applicability to Basquiat of both Burroughs' fictional figure and Toop's appropriation-by-analogy is justified by Jean-Michel's translation of the antiphonal "versioning" aesthetic of the urban African-American music tradition into two-dimensional graphic language.

20. Quoted in Hager, *Art after Midnight*, 51.

21. Thompson, "Activating Heaven," n.p.

22. Kobena Mercer, "Dark and Lovely: Notes on Black Gay Image-Making," *Ten* 8, no. 2 (Summer 1991): 84.

23. Foster, quoting Paul de Man, in *Recodings,* 61.

24. See Thompson, *Flash of the Spirit*, 172–73, 180–81; and Frederick Iseman, "Cannons of the Cool," *Rolling Stone,* no. 435 (November 1984): 26–28, 81.

25. For a politicized exegesis/invocation of the significance of shamanistic practice in the (post-) colonial scene, see especially Michael Taussig, *The Devil and Commodity Fetishism in South America* (Chapel Hill: University of North Carolina Press, 1983), and the same author's *Shamanism, Colonialism, and the Wild Man: A Study in Terror and Healing* (Chicago: University of Chicago Press, 1987). For an extraordinary essay that brings the question of the complicity between terror and the state literally "home" to the Western academy, see Michael Taussig, "Terror as Usual: Walter Benjamin's Theory of History as State of Siege," chap. 2 in *The Nervous System* (London: Routledge, 1992).

26. The white representative of the Company, whose dying words, "the horror, the horror," encapsulate one response to the "unspeakable rites" witnessed in Joseph Conrad's *Heart of Darkness.*

27. Barry Michael Cooper, "In Cold Blood," 1986, quoted in Toop, *Rap Attack 2,* 166.

28. Cooper.

29. *Andy Warhol Diaries,* 610.

30. Homi Bhabha, foreword to Frantz Fanon, *Black Skins, White Masks* (New York: Grove Press, 1987), 109.

31. Art Spiegelman, *Maus I: A Survivor's Tale: My Father Bleeds History* (New York: Pantheon Books, 1986); and *Maus II: A Survivor's Tale: And Here My Troubles Began* (New York: Pantheon Books, 1991). A *New York Times* review on the jacket of *Maus II* concisely summed up the technique: "an epic story told in tiny pictures."

32. Greg Tate, "Fly Boy in the Buttermilk: The Crisis of the Black Artist in White America," *Village Voice,* November 14, 1989, 33. The present essay and argument is greatly indebted to this authoritative and intensely perceptive piece.

33. The theoretical framework for the idea of identity as production (rather than organic trace) comes from Stuart Hall, "Cultural Identity and Diaspora," in *Identity: Community, Culture, Difference,* ed. Jonathan Rutherford (London: Lawrence and Wishart, 1990), 225. At the beginning of this extraordinary excavation of Caribbean hybridity, Hall writes: "Cultural identity . . . is a matter of

'becoming' as well as 'being.' It belongs to the future as much as to the past. It is not something which already exists, transcending place, time, history and culture. Cultural identities come from somewhere, have histories. But, like everything which is historical, they undergo constant transformation. Far from being eternally fixed in some essentialized past, they are subject to the continuous 'play' of history, culture and power. Far from being grounded in a mere 'recovery' of the past, which is waiting to be found, and which, when found, will secure our sense of ourselves into eternity, identities are the names we give to the different ways we are positioned by, and position ourselves within, the narratives of the past."

34. Quoted in Hager, *Art after Midnight,* 98.

35. Keith Haring, "Remembering Basquiat," *Vogue,* November 1988, 234.

36. Quoted in Jean Baudrillard, "Beyond the Vanishing Point of Art," in *Post-Pop Art,* ed. Paul Taylor (Cambridge, MA: MIT Press, 1989), 187.

37. Robert Storr, "200 Beats a Minute," in *Jean-Michel Basquiat: Drawings,* exh. cat. (New York: Robert Miller Gallery, 1990), n.p.

38. Nathaniel Mackey, *Bedouin Hornbook* (Louisville: University of Kentucky Press, 1986), 148–56.

39. Thompson, "Activating Heaven," n.p.

40. This is the distinction underpinning recent work by, among others, Stuart Hall, "Cultural Identity and Diaspora," and Kobena Mercer, "1968: Periodizing Postmodern Politics and Identity," in *Cultural Studies: Now and in the Future,* ed. Lawrence Grossberg et al. (London: Routledge, 1991), 424–38; Kobena Mercer, "Welcome to the Jungle: Identity and Diversity in Postmodern Politics," in Rutherford, *Identity,* 43–71. For example, Hall distinguishes between the two approaches to Caribbean identity: "The first position defined 'cultural identity' in terms of one, shared culture This 'oneness' . . . is the truth, the essence of 'Caribbeanness,' of the Black experience. It is this identity which a Caribbean or Black diaspora must discover, excavate, bring to light and express through . . . representation [The] second position recognizes that, as well as many points of similarity, there are also critical points of deep and significant difference which constitute 'what we really are': or rather—since history has intervened—'what we have become.' We cannot speak for very long, with any exactness, about 'one experience, one identity' without acknowledging its other side—the ruptures and discontinuities which constitute, precisely, the Caribbean's 'uniqueness.' Cultural identity, in this second sense, is a matter of 'becoming' as well as of 'being'" (223–25). Hall goes on: "It is only from this second position that we can properly understand the traumatic character of 'the colonial experience.'"

41. Mercer, "1968: Periodizing Postmodern Politics and Identity," 430.

42. Quoted in Toop, *Rap Attack 2,* 169.

43. Tate, "Fly Boy in the Buttermilk," 32.

44. *Andy Warhol Diaries,* 629.

45. For a detailed analysis of Eshu-Elegba and the god's association with the crossroad, see Thompson, *Flash of the Spirit,* especially chap. 1.

46. Quoted in McGuigan, "New Art, New Money," 28, 32.

ROYAL SLUMMING
JEAN-MICHEL BASQUIAT HERE BELOW

THOMAS McEVILLEY, 1992

Perhaps understandably given Jean-Michel Basquiat's shockingly early and still recent death, the critical literature on his work has been rather uncritical. Emphasizing the anecdotal, the elegiac, and the sacramental, many writers drift from analyses of his art into personal recollections of the artist, and seem at times to vie for the distinction of having known him best. Little art historical comparison is offered; there is a widespread reluctance to venture outside the sphere of Black culture heroes such as Charlie Parker, Joe Louis, and Thelonious Monk, who dominate discussions of his work as if it did not occupy art history in the way of most art. Surely the work of few other important contemporary artists is more consistently talked about in terms from outside the visual arts.

This special treatment of Basquiat, an African-American artist of Haitian and Puerto Rican descent, may in part be attributed to a queasiness about addressing the racial issues surrounding his work. One way to begin to remedy this situation is by contemplating the fact that Basquiat, though an artist of undeniable sophistication, chose to practice a form of primitivism. Why? A "primitive" artist, of course, is one whose sole means of expression lies in one of the visual modes associated with pre-Modern or traditional societies, and who comes from such a society, so that his or her exposure to global culture is comparatively limited. A primitivist, on the other hand, is an artist to whom various modes of expression are available, but who chooses to imitate the look of so-called "primitive" objects.[1] Basquiat was a primitivist, not a primitive. And the primitivism of his work was a canny reversal of tactics from the white art tradition, a reversal that resonates with assertions, ironies, and claims.

Primitivism as practiced by Pablo Picasso and other white artists early in this century, in the late-colonial heyday of Modernism, was a matter of white culture imitating the products of nonwhite culture. To white Europeans and Americans of the time, generally speaking, white culture was the norm and nonwhite cultures were aberrations. To borrow from them showed not the impoverishment of white culture, its need for vital input from outside, but its imperial generosity in recognizing the nonwhite.[2] This was a kind of royal slumming, as it were, like the visits of downtown white esthetes to upper Manhattan during the Harlem Renaissance.

Thomas McEvilley, "Royal Slumming: Jean-Michel Basquiat Here Below," *Artforum* 31, no. 3 (November 1992): 92–97.

Basquiat's practice of primitivism was an ironic inversion of all that. At first, for a young Black man to confront the contemporary art world—still overwhelmingly white—with works looking conspicuously like those it called "primitive" seemed to confirm its expectations: a young Black male is a primitive. But soon edges of question appeared in the equation, incommensurabilities confounding the same white expectations that seemed to have just been fulfilled. Certain elements in the work did not conform to its supposedly primitive nature: its highly self-conscious irony, for example, and its deconstruction of European culture through fragmented and jumbled lists that portrayed its coherences as breaking down. In fact, it became clear, these were the works not of a primitive but of a consummate primitivist. This Black artist was doing exactly what Classical-Modernist white artists such as Picasso and Georges Braque had done; deliberately echoing a primitive style.

While seeming to behave like a primitive, Basquiat was actually behaving like white Westerners who behave as they assume primitives do. He was behaving like white men who think they are behaving like Black men. So it was not just a question of his imagery glorifying African roots and so on—hymning negritude (though he certainly did celebrate Black culture). Basquiat was also focusing on the white art world's expectations, and on the assumptions and ideologies underlying them.

The enthusiastic acceptance that Basquiat's work received so quickly from the still predominantly white art world reflects this strategy. The white art world is not necessarily disdainful of or put off by "primitiveness" or "Blackness," which can in some cases have its own cachet and act as its own selling point, especially when it comes packaged in a modern intelligence, as in Basquiat's case. The element of irony helps make the primitiveness more palatable rather than functioning subversively. This may throw some light on how a 28 [27]-year-old with only eight or ten years of work behind him is accorded a Whitney retrospective.

At the same time that this identity game was going on, the situation had historical resonances too: for a Black man to practice primitivism demonstrated that we had once and for all entered the postcolonial era.[3] By taking on the role of the white borrower, Basquiat collapsed the distance between colonizer and colonized, embodying both at once. A famous photograph of him, which appeared on the cover of the *New York Times Magazine* in 1985 (page 352), demonstrated this duality. Basquiat sat in his studio, a brush in his hand, a painting like a primitive tribal mask on the easel behind him. His feet were bare. Yet he wore an expensive Giorgio Armani suit—which, however, was soiled with paint. The dirty Armani brought up the cliché of the primitive who comprehends use value but not exchange value, the bare feet similarly suggested a denizen of a pre-urbanized culture. At the same time, the *atelier* venue, the expensive apparel, the exaggerated chic of one beyond caring about exchange value even if he understood it well enough, the elitist act of oil painting itself, not to speak of the gaze of the *Times* reader, on Central Park West or in the Hamptons, for whom this sight was prepared, all cast Basquiat as a cultural aristocrat. Carelessly yet carefully enthroned, he evoked the mood of *sprezzatura,* that feigned or studied casualness cultivated by the Italian nobility of the Renaissance.

This ambiguous or double self-image—barefoot in Armani—embodies the paradox that W. E. B. Du Bois described as "this double-consciousness ... an American, a Negro; two souls, two thoughts, two unreconciled strivings; two warring ideals in one dark body."[4]

The iconography of Basquiat's work parallels this duality. The crown that he often represented on the head of a primitive-looking Black male stick figure, for example, points to a sense of double identity, a royal selfhood somehow lost but dimly remembered, overlaid by a voodoo mask. The relic of ancient royalty peers from behind the shattered cultural surface like a Yoruba deity concealed in a Santeria statue.

In its spiritual aspect, this subject matter is orphic—that is, it relates to the ancient myth of the soul as a deity lost, wandering from its true home, and temporarily imprisoned in a degradingly limited body and an infuriatingly reduced social stature. The theme was fairly typical of the early-to-mid '80s; Keith Haring's iconography was also orphic in its formative period. The Wild Child and the Radiant Child are both visitors from outer space, exiles from other dimensions, lost princes or gods who have wandered from a glorious beyond, cloaked in hidden signs of royalty, their divinity sunk briefly in the prison of matter, and so on. Basquiat himself was engaged in royal slumming, as a dethroned Black prince.

In Basquiat's oeuvre, the theme of divine or royal exile was brought down to earth or historicized by the concrete reality of the African diaspora. The king that he once was in another world (and that he would be again when he returned there) could be imagined concretely as a Watusi warrior or Egyptian pharaoh. The soul's exile could be related to slavery, and its return, to the not-yet-completed civil rights movement. If, when we looked at the *Times Magazine* cover, we saw dandyism, it was in the serious sense that Disraeli suggested when he observed that the dandy is the prince of an imaginary kingdom. Basquiat's Armani suit, like the cartoon crown he used to paint, was a sign of that kingdom; the paintbrush in his hand indicated the means through which he recovered the outlines of his true nature, and the channel through which he would find his way back to it. Art appears, then, as a path at once to a primal beginning and to an ultimate beyond.

There are great simplicities in this system of feelings, but Basquiat's great subtlety, his desire to keep himself clear of them, emerges when one asks exactly what was this imaginary kingdom in the regalia of which he sat enthroned in the *Times Magazine*. The image of it that he left differs not only from the idealized African past of Alex Haley's *Roots* but also from the idealized American future of Martin Luther King's dream. Pictured through the glyphic disintegration that surrounds the haunted king in Basquiat's paintings, this is the kingdom of post-civilization, the disintegrated, post-kingdom kingdom in which everything is falling apart, fragmenting into atomic bits that look like evidence—clues stacked, sorted, and organized in some purposeless microanalysis. Here Basquiat's orphic dandyism merges with his iconographic celebration of the idea of the end of the world, or of a certain paradigm of it—at any rate the end of the stranglehold that Western civilization has had on the rest of the world.

In this subject matter his oeuvre is late-Cold War art, somewhat casually apocalyptic. It rather serenely contemplates the moment of civilization's passing away, or its cyclical sinking into a simultaneously pre- and post-literate swamp of representational decay where the center no longer holds, the image no longer holds, language no longer holds. Skeletal figures glare from a depthless, fragmented plane that is not an adequate arena for selfhood. Language is conjugated meaninglessly in a field of splintered phonemes. It is with great irony that Basquiat presents this afterworld, this world of disintegration and ruin—which also contains an implicit possibility of recombination, renewal, and rebirth—as the primal kingdom of which his rakish crown is both tarnished relic and anticipatory sign.

He will regain his real selfhood, that of the lost godhood of the soul, through a cataclysmic reversal of Western history, turning it upside down and inside out and sorting its ashes for bones while a transistor radio duct-taped to a painting blares Crazy Eddie. In this aspect, the work can almost be read as an inverted joke on Hegel; the Euro-ethnic who said that Africa was ahistorical must accept the revenge of an Afro-Euro-Amero-ethnic who parodied the "end of history" with a chaos of fragmentary language—European literacy disintegrating into lists that aren't of anything anymore.

Coolly manipulative in a cunning adolescent way, the young Basquiat, barefoot and aloof, gazes out in his oil-paint-spattered Armani, and through the masklike face in his work. Both activist and parodist, he uses the marks and gestures of white Modernist masters to redraw their own civilization as an archaeological ruin of the dream of its own future.

Notes

1. This is the distinction that was so laboriously made in the "Primitivism" show at the Museum of Modern Art, New York, in 1984.

2. As Modernism waned, white artists like James Brown practiced another form of primitivism in the 1950s. Their practice was somewhat more ironic than Picasso's; it involved a meditation on the possible end of white hegemony and a raised-eyebrow gesture toward early-20th-century primitivism, with its implicit colonialism. Basquiat's primitivism was the consummate gesture of this type, and was further inflected and complicated by his identity as an African-American.

3. Basquiat was not the first Black artist to practice primitivism, but he surely was the first to force the situation on our awareness in a highly focused and self-conscious way.

4. W. E. B. Du Bois, *The Souls of Black Folk* (1903; repr., New York: Penguin Books [Signet Classics], 1982), 45.

ALTARS OF SACRIFICE
RE-MEMBERING BASQUIAT

BELL HOOKS, 1993

> Is your all on the altar of sacrifice laid?
> Black church song

At the opening of the Basquiat exhibition at the Whitney last fall, I wandered through the crowd talking to the folks about the art. I had just one question. It was about emotional responses to the work. I asked, what did people feel looking at Basquiat's paintings? No one I talked with answered the question. They went off on tangents, said what they liked about him, recalled meetings, generally talked about the show, but something seemed to stand in the way, preventing them from spontaneously articulating feelings the work evoked. If art moves us—touches our spirit—it is not easily forgotten. Images will reappear in our heads against our will. I often think that many of the works that are canonically labeled "great" are simply those that lingered longest in individual memory. And that they lingered because while looking at them someone was moved, touched, taken to another place, momentarily born again.

Those folks who are not moved by Basquiat's work are usually unable to think of it as "great" or even "good" art. Certainly this response seems to characterize much of what mainstream art critics think about Basquiat. Unmoved, they are unable to speak meaningfully about the work. Often with no subtlety of tact, they "diss" the work by obsessively focusing on Basquiat's life or the development of his career, all the while insisting that they are in the best possible position to judge its value and significance. (A stellar example of this tendency is Adam Gopnik's piece in the Nov. 9 issue of the *New Yorker*.[1]) Undoubtedly it is a difficult task to determine the worth or value of a painter's life and/or work if one cannot get close enough to feel anything, if indeed one can only stand at a distance.

Ironically, though Basquiat spent much of his short adult life trying to get close to significant white folks in the established art world, he consciously produced art that was a *vattier,* a wall between him and that world. Like a secret chamber that can only be opened and entered by those who can decipher hidden codes, Basquiat's painting challenges folks who think that by merely looking they can "see." Calling attention to this aspect of Basquiat's style, Robert Storr has written, "Everything about his work is

bell hooks, "Altars of Sacrifice: Re-membering Basquiat," *Art in America* 81, no. 6 (June 1993): 68–75.

knowing, and much is *about* knowing.[2] Yet the work resists "knowing," offers none of the loose and generous hospitality Basquiat was willing to freely give as a person.

Designed to be a closed door, Basquiat's work holds no warm welcome for those who approach it with a narrow Eurocentric gaze. That gaze which can only recognize Basquiat if he is in the company of Warhol or some other highly visible white figure. That gaze which can value him only if he can be seen as part of a continuum of contemporary American art with a genealogy traced through white males: Pollock, de Kooning, Rauschenberg, Twombly, and on to Andy. Rarely does anyone connect Basquiat's work to traditions in African-American art history. While it is obvious that he was influenced and inspired by the work of established white male artists, the content of his work does not neatly converge with theirs. Even when Basquiat can be placed stylistically in the exclusive, white male art club that denies entry to most Black artists, his subject matter—his content—always separates him once again, and defamiliarizes him.

It is in the content of his work that serves as a barrier, challenging the Eurocentric gaze that commodifies, appropriates and celebrates. In keeping with the codes of that street culture he loved so much, Basquiat's work is in your face. It confronts different eyes in different ways. Looking at the work from a Eurocentric perspective, one sees and values only those aspects that mimic familiar white Western artistic traditions. Looking at the work from a more inclusive standpoint, we are all better able to see the dynamism springing from the convergence, contact and conflict of varied traditions. Many artistic Black folks I know, including myself, celebrate this inclusive dimension of Basquiat, a dimension emphasized in an insightful discussion of his life and work by his close friend the artist and rapper Fred Brathwaite (a.k.a. Fab 5 Freddy). Brathwaite acknowledges the sweetness of their artistic bonding, and says that it had to do with their shared openness to influence, the pleasure they took in talking to one another "about other painters as well as about the guys painting on the trains."[3]

Basquiat was in no way secretive about the fact that he was influenced and inspired by the work of white artists. It is the multiple other sources of inspiration and influence that are submerged, lost, when critics are obsessed with seeing him solely connected to a white Western artistic continuum. These other elements are lost precisely because they are often not seen, or if seen, not understood. When art critic Thomas McEvilley suggests that "this Black artist was doing exactly what classical Modernist white artists such as Picasso and Georges Braque had done: deliberately echoing a primitive style," he erases all of Basquiat's distinct connections to a cultural and ancestral memory that linked him directly to "primitive" traditions.[4] This then allows McEvilley to make the absurd suggestion that Basquiat was "behaving like white men who think they are behaving like Black men," rather than understand that Basquiat was grappling with both the pull of a genealogy that is fundamentally "Black" (rooted in African diasporic "primitive" and "high art" traditions) and a fascination with white Western traditions. Articulating the distance separating traditional Eurocentric art from his own history and destiny and from the collective fate of diasporic Black artists and Black people, Basquiat's paintings testify.

To bear witness in his work, Basquiat struggled to utter the unspeakable. Prophetically called, he engaged in an extended artistic elaboration of a politics of dehumanization. In his work, colonization of the Black body and mind is marked by the anguish of abandonment, estrangement, dismemberment and death. Red paint drips like blood on his untitled painting of a Black female, identified only by a sign that reads "Detail of maid from 'Olympia.'" A dual critique is occurring here. First, the critique of the way in which imperialism makes itself heard, the way it is reproduced in culture and art. This image is ugly and grotesque. That is exactly how it should be. For what Basquiat unmasks is the ugliness of those traditions. He takes the Eurocentric valuation of the great and beautiful and demands that we acknowledge the brutal reality it masks.

The "ugliness" conveyed in Basquiat paintings is not solely the horror of colonizing whiteness; it is the tragedy of Black complicity and betrayal. Works like *Irony of Negro Policeman* (1981) (plate 5) and *Quality Meats for the Public* (1982) document this stance. The images are nakedly violent. They speak of dread, of terror, of being torn apart, ravished. Commodified, appropriated, made to "serve" the interests of white masters, the Black body as Basquiat shows it is incomplete, not fulfilled, never a full image. And even when he is "calling out" the work of Black stars—sports figures, entertainers—there is still the portrayal of incompleteness, and the message that complicity negates. These works suggest that assimilation and participation in a bourgeois white paradigm can lead to a process of self-objectification that is just as dehumanizing as any racist assault by white culture. Content to be only what the oppressors want, this Black image can never be fully self-actualized. It must always be represented as fragmented. Expressing a firsthand knowledge of the way assimilation and objectification lead to isolation, Basquiat's Black male figures stand alone and apart. They are not whole people.

It is much too simplistic a reading to see works like *Jack Johnson* (1982), *Untitled (Sugar Ray Robinson)* (1982) (plate 13), and the like, as solely celebrating Black culture. Appearing always in these paintings as half-formed or somehow mutilated, the Black male body becomes, iconographically, a sign of lack and absence. This image of incompleteness mirrors those in works that more explicitly critique white imperialism. The painting *Native Carrying Some Guns, Bibles, Amorites on Safari* (1982) graphically evokes images of incomplete Blackness. With wicked wit, Basquiat states in the lower right-hand corner of the work, "I WON'T EVEN MENTION GOLD (ORO)," as though he needed to remind onlookers of a conscious interrogating strategy behind the skeletal, cartoonlike images.

In Basquiat's work, flesh on the Black body is almost always falling away. Like skeletal figures in the Australian aboriginal bark painting described by Robert Edward (X-ray paintings, in which the artist depicts external features as well as the internal organs of animals, humans, and spirits, in order to emphasize "that there is more to a living thing than external appearances"[5]), these figures have been worked down to the bone. To do justice to this work, then, our gaze must do more than reflect on surface appearances. Daring us to prove the heart of darkness, to move our eyes beyond the colonizing gaze, the paintings ask that we hold in our memory the bones of the dead while we consider the world of the Black immediate, the familiar.

To see and understand these paintings, one must be willing to accept the tragic dimensions of Black life. In *The Fire Next Time*, James Baldwin declared that "for the horrors" of Black life "there has been almost no language." He insisted that it was the privacy of Black experience that needed "to be recognized in language." Basquiat's work gives that private anguish artistic expression.

Stripping away surfaces, Basquiat confronts us with the naked Black image. There is no "fleshy" Black body to exploit in his work, for that body is diminished, vanishing. Those who long to be seduced by that Black body must look elsewhere. It is fitting that the skeletal figures displayed again and again in Basquiat's work resemble those depicted in Gillies Turle's book *The Art of the Maasai.*[6] For both Maasai art and Basquiat's work delineate the violent erasure of a people, their culture and traditions. This erasure is rendered all the more problematic when artifacts of that "vanishing culture" are commodified to enhance the esthetics of those perpetrating the erasure.

The world of Maasai art is a world of bones. Choosing not to work with pigments when making paintings or decorative art, the Maasai use bones from hunting animals in their art to give expression to their relationship with nature and with their ancestors. Maasai artists believe that bones speak—tell all the necessary cultural information, take the place of history books. Bones become the repository of personal and political history. Maasai art survives as a living memory of the distinctiveness of Black culture that flourished most vigorously when it was undiscovered by the white man. It is this privacy that white imperialism violates and destroys. Turle emphasizes that while the bones are "intense focus points to prime minds into a deeper receptive state," this communicative power is lost on those who are unable to hear bones speak.

Even though socially Basquiat did not "diss" those white folks who could not move beyond surface appearances (stereotypes of entraining darkies, pet Negroes and the like), in his work he serves notice on that liberal white public. Calling out their inability to let the notion of racial superiority go, even though it limits and restricts their vision, he mockingly deconstructs their investment in traditions and canons, exposing a collective gaze that is wedded to an esthetic of white supremacy. The painting *Obnoxious Liberals* (1982) shows us a ruptured history by depicting a mutilated Black Samson in chains and then a more contemporary Black figure, no longer naked but fully clothed in formal attire, who wears on his body a sign that boldly states "NOT FOR SALE." That sign is worn to ward off the overture of the large, almost overbearing white figure in the painting. Despite the incredible energy Basquiat displayed playing the how-to-be-a-famous-artist-in-the-shortest-amount-of-time-game—courting the right crowd, making connections, networking his way into high "white" art places—he chose to make work in a space where that process of commodification is critiqued, particularly as it pertains to the Black body and soul. Unimpressed by white exoticization of the "Negro," he mocks this process in works that announce an "UNDISCOVERED GENIUS OF THE MISSISSIPPI DELTA," forcing us to question who makes such discoveries and for what reasons (plate 24).

Throughout his work, Basquiat links imperialism to patriarchy, to a phallocentric view of the universe where male egos become attached to a myth of heroism. The

image of the crown, a recurring symbol in his work, calls to and mocks the Western obsession with being on top, the ruler. Art historian Robert Farris Thompson suggests that the icon of the crown reflects Basquiat's ongoing fascination with the subject matter of "royalty, heroism, and the streets."[7] McEvilley interprets the crown similarly, seeing it as representative of a "sense of double identity, a royal selfhood somehow lost but dimly remembered."[8] He explains that "in Basquiat's oeuvre, the theme of divine or royal exile was brought down to earth or historicized by the concrete reality of the African diaspora. The king that he once was in another world (and that he would be again when he returned there) could be imaged concretely as a Watusi warrior or Egyptian pharaoh."[9]

There is no doubt that Basquiat was personally obsessed with the idea of glory and fame, but this obsession is also the subject of intense self-interrogation in his paintings. Both Thompson and McEvilley fail to recognize Basquiat's mocking, bitter critique of his own longing for fame. In Basquiat's work the crown is not an unambiguous image. While it may positively speak the longing for glory and power, it connects that desire to dehumanization, to the general willingness on the part of males globally to commit any unjust act that will lead them to the top. In the painting *Crowns (Peso Neto)* (1981) (plate 4), Black figures wear crowns but are sharply contrasted with the lone white figure wearing a crown, for it is that figure which looms large, overseeing a shadowy world, as well as the world of Black glory.

In much of Basquiat's work the struggle for cultural hegemony in the West is depicted as a struggle between men. Racialized, it is a struggle between Black men and white men over who will dominate. In *Charles the First* (1982), we are told "MOST YOUNG KINGS GET THIER [SIC] HEAD CUT OFF." Evoking a political and sexual metaphor that fuses the fear of castration with the longing to assert dominance, Basquiat makes it clear that Black masculinity is irrevocably linked to white masculinity by virtue of a shared obsession with conquest, both sexual and political.

Historically, competition between Black and white males has been highlighted in the sports arena. Basquiat extends that field of competition into the realm of the cultural (the poster of him and Andy Warhol duking it out in boxing attire and gloves is not as innocent and playful as it appears to be), and the territory is music, in particular jazz. Basquiat's work calls attention to the innovative power of Black male jazz musicians, whom he reveres as creative father figures. Their presence and work embody for him a spirit of triumph. He sees their creativity exceeding that of their white counterparts. They enable him not only to give birth to himself as Black genius but also to accept the wisdom of an inclusive standpoint.

Brathwaite affirms that Basquiat felt there was a cultural fusion and synthesis in the work of Black male jazz musicians that mirrored his own aspirations. This connection is misunderstood and belittled by Gopnik in his essay "Madison Avenue Primitive" (note the derision the title conveys) when he arrogantly voices his indignation at Basquiat's work being linked with that of great Black jazz musicians. With the graciousness and high-handedness of an old-world paternalistic colonizer, Gopnik

declares that he can accept that the curator of the Basquiat show attempted to place him in a high-art tradition: "No harm, perhaps, is done by this, or by the endless comparisons in the catalogue of Basquiat to Goya, Picasso, and other big names." But, Gopnik fumes, "What *is* unforgivable is the endless comparisons in the catalogue essays of Basquiat to the masters of American jazz."[10]

Gopnik speaks about Basquiat's own attempts to play jazz and then proceeds to tell us what a lousy musician Basquiat "really" was. He misses the point. Basquiat never assumed that his musical talent was the same as that of jazz greats. His attempt to link his work to Black jazz musicians was not an assertion of his own musical or artistic ability. It was a declaration of respect for the creative genius of jazz. He was awed by all the avant-garde dimensions of the music that affirm fusion, mixing, improvisation. And he felt a strong affinity with jazz artists in the shared will to push against the boundaries of conventional (white) artistic tastes. Celebrating that sense of connection in his work, Basquiat creates a Black artistic community that can include him. In reality, he did not live long enough to search out such a community and claim a space of belonging. The only space he could claim was that of shared fame.

Fame, symbolized by the crown, is offered as the only possible path to subjectivity for the Black male artist. To be un-famous is to be rendered invisible. Therefore, one is without choice. You either enter the phallocentric battlefield of representation and play the game or you are doomed to exist outside history. Basquiat wanted a place in history, and he played the game. In trying to make a place for himself—for Blackness—in the established art world, he assumed the role of explored/colonizer. Wanting to make an intervention with his life and work, he inverted the image of the white colonizer.

Basquiat journeyed into the heart of whiteness. White territory he named as a savage and brutal place. The journey is embarked upon with no certainty of return. Nor is there any way to know what you will find or who you will be at journey's end. Brathwaite declares: "The unfortunate thing was, once one did figure out how to get into the art world, it was like, Well, shit, where am I? You've pulled off this amazing feat, you've waltzed your way right into the thick of it, and probably faster than anybody in history, but once you got in you were standing around wondering where you were. And then, Who's here with me?"[11] Recognizing art-world fame to be a male game, one that he could play, working the stereotypical darky image, playing the trickster, Basquiat understood that he was risking his life—that this journey was all about sacrifice.

What must be sacrificed in relation to oneself is that which has no place in whiteness. To be seen by the white art world, to be known, Basquiat had to remake himself, to create from the perspective of the white imagination. He had to become both native and nonnative at the same time, to assume the Blackness defined by the white imagination and the Blackness that is not unlike whiteness. As anthropologist A. David Napier explains, "Strangers within our midst are indeed the strangest of all—not because they are so alien, but because they are so close to us. As many legends of 'wildmen,' wandering Jews, and feral children remind us, strangers must be like us but dif-

ferent. They cannot be completely exotic, for, were they so, we could not recognize them."[12]

For the white art world to recognize Basquiat, he had to sacrifice those parts of himself they would be interested in or fascinated by. Black but assimilated, Basquiat claimed the space of the exotic as though it were a new frontier, waiting only to be colonized. He made of that cultural space within whiteness (the land of the exotic) a location where he would be re-membered in history even as he simultaneously created art that unsparingly interrogates such mutilation and self-distortion. As cultural critic Greg Tate asserts in "Nobody Loves a Genius Child," for Basquiat "making it meant going down in history, ranked beside the Great White Fathers of Western painting in the eyes of the major critics, museum curators, and art historians who ultimately determine such things."[13]

Willingly making the sacrifice in no way freed Basquiat from the pain of that sacrifice. The pain erupts in the private space of his work. It is amazing that so few critics discuss configurations of pain in Basquiat's work, emphasizing instead its playfulness, its celebratory qualities. This reduces his painting to spectacle, making the work a mere extension of the minstrel show that Basquiat frequently turned his life into. Private pain could be explored in art because he knew that a certain world "caught" looking would not see it, would not even expect to find it there. Francesco Pellizzi begins to speak about this pain in his essay, "Black and White All Over: Poetry and Desolation Painting," when he identifies Basquiat's offerings as "self-immolations, Sacrifices of the Self" which do not emerge "from desire, but from the desert of hope."[14] Rituals of sacrifice stem from the inner workings of spirit that inform the outer manifestation.

Basquiat's paintings bear witness, mirror this almost spiritual understanding. They expose and speak the anguish of sacrifice. A text of absence and loss, they echo the sorrow of what has been given over and given up. McEvilley's insight that "in its spiritual aspect, [Basquiat's] subject matter is orphic—that is, it relates to the ancient myth of the soul as a deity lost, wandering from its true home, and temporarily imprisoned in a degradingly limited body," appropriately characterizes that anguish.[15] What limits the body in Basquiat's work is the construction of maleness as lack. To be male, caught up in the endless cycle of conquest, is to lose out in the realm of fulfillment.

Significantly, there are few references in Basquiat's work that connect him with a world of Blackness that is female or to a world of influences and inspirations that are female. That Basquiat, for the most part, disavows a connection to the female in his work is a profound and revealing gap that illuminates and expands our vision of him and his work. Simplistic pseudo-psychoanalytic readings of his life and work lead critics to suggest that Basquiat was a perpetual boy always in search of the father. In his essay for the Whitney catalogue, critic Rene Ricard insists: "Andy represented to Jean the 'Good White Father' Jean had been searching for since his teenage years. Jean's mother has always been a mystery to me. I never met her. She lives in a hospital, emerging infrequently, to my knowledge. Andy did her portrait. She and Andy were the most important people in Jean's life."[16]

Since Basquiat was attached to his natural father, Gerard, as well as surrounded by other male mentor figures, it seems unlikely that the significant "lack" in his life was an absent father. Perhaps it was the presence of too many fathers—paternalistic cannibals who overshadowed and demanded repression of attention for and memory of the mother or any feminine/female principle—that led Basquiat to be seduced by the metaphoric ritual sacrifice of his fathers, a sort of phallic murder that led to a death of the soul.

The loss of his mother, a shadowy figure trapped in a world of madness that caused her to be shut away, symbolically abandoned and abandoning, may have been the psychic trauma that shaped Basquiat's work. Andy Warhol's portrait of Matilde Basquiat shows us the smiling image of a Black Puerto Rican woman. It was this individual, playfully identified by her son as "bruja" (witch), who first saw in Jean-Michel the workings of artistic genius and possibility. His father remembers, "His mother got him started and she pushed him. She was actually a very good artist."[17] Jean-Michel also gave testimony, "I'd say my mother gave me all the primary things. The art came from her."[18] Yet this individual who gave him the lived texts of ancestral knowledge as well as that of the white West is an absent figure in the personal scrapbook of Basquiat as successful artist. It is as if his inability to reconcile the force and power of femaleness with phallocentrism led to the erasure of female presence in his work.

Conflicted in his own sexuality, Basquiat is nevertheless represented in the Whitney catalogue and elsewhere as the stereotypical Black stud randomly fucking white women. No importance is attached by critics to the sexual ambiguity that was so central to the Basquiat dive persona. Even while struggling to come to grips with himself as a subject rather than an object, he consistently relied on old patriarchal notions of male identity despite the fact that he critically associated maleness with imperialism, conquest, greed, endless appetite and, ultimately, death.

To be in touch with senses and emotions beyond conquest is to enter the realm of the mysterious. This is the oppositional location Basquiat longed for yet could not reach. This is the feared location, associated not with meaningful resistance but with madness, loss and invisibility. Basquiat's paintings evoke a sense of dread. But the terror there is not for the world as it is, the decentered, disintegrating West, that familiar terrain of death. No, the dread is for that unimagined space, that location where one can live without the "same old shit."

Confined within a process of naming, of documenting violence against the Black male self, Basquiat was not able to chart the journey of escape. Napier asserts that "in naming, we relieve ourselves of the burden of actually considering the implication of how a different way of thinking can completely transform the conditions that make for meaningful social relations."[19] A master deconstructivist, Basquiat was not then able to imagine a concrete world of collective solidarities that could alter in any way the status quo. McEvilley sees Basquiat's work as an "iconographic celebration of the idea of the end of the world, or of a certain paradigm of it."[20] While the work clearly calls out this disintegration, the mood of celebration is never sustained. Although

Basquiat graphically portrays the disintegration of the West, he mourns the impact of this collapse when it signals doom in Black life. Carnivalesque, humorous, playful representations of death and decay merely mask the tragic, cover it with a thin veneer of celebration. Clinging to this veneer, folks deny that a reality exists beyond and beneath the mask.

Black gay filmmaker Marlon Riggs recently suggested that many Black folks "have striven to maintain secret enclosed spaces within our histories, within our lives, within our psyches about these things which disrupt our sense of self."[21] Despite an addiction to masking/masquerading in his personal life, Basquiat used painting to disintegrate the public image of himself that he created and helped sustain. It is no wonder then that this work is subjected to an ongoing critique that questions its "authenticity and value." Failing to accurately represent Basquiat to that white art world that remains confident it "knew" him, critics claim and colonize the work within a theoretical apparatus of appropriation that can diffuse its power by making it always and only spectacle. That sense of "horrific" spectacle is advertised by the paintings chosen to don the covers of every publication on his work, including the Whitney catalogue.

In the conclusion to *The Art of the Maasai,* Turle asserts: "When a continent has had its people enslaved, its resources removed, and its lands colonized, the perpetrators of these actions can never agree with contemporary criticism or they would have to condemn themselves."[22] Refusal to confront the necessity of potential self-condemnation makes those who are least moved by Basquiat's work insist on knowing it best. Understanding this, Brathwaite articulates hope that Basquiat's work will be critically reconsidered, that the exhibition at the Whitney will finally compel people to "look at what he did."

But before this can happen, Brathwaite cautions, the established white art world (and I would add the Eurocentric, multiethnic viewing public) must first "look at themselves." With insight he insists: "They have to try to erase, if possible, all the racism from their hearts and minds. And then when they look at the paintings they can see the art."[23] Calling for a process of decolonization that is certainly not happening (judging from the growing mass of negative responses to the show), Brathwaite articulates the only possible cultural shift in perspective that can lay the groundwork for a comprehensive critical appreciation of Basquiat's work.

The work by Basquiat that haunts my imagination, that lingers in my memory, is *Riding with Death* (1988) (plate 35). Evoking images of possession, of riding and being ridden in the Haitian *voudoun* sense—as a process of exorcism, one that makes revelation, renewal and transformation possible—I feel the subversion of the sense of dread provoked by so much of Basquiat's work. In its place is the possibility that the black-and-brown figure riding the skeletal white bones is indeed "possessed." Napier invites us to consider possession as "truly an avant-garde activity, in that those in trance are empowered to go to the periphery of what is and can be known, to explore the boundaries, and to return unharmed."[24] No such spirit of possession guarded Jean-Michel Basquiat in his life. Napier reports that "people in trance do not—as performance

artists in the West sometimes do—leave wounded bodies in the human world."[25] Basquiat must go down in history as one of the wounded. Yet his art will stand as the testimony that declares with vengeance: We are more than our pain. That is why I am most moved by the one Basquiat painting that juxtaposes the paradigm of ritual sacrifice with that of ritual recovery and return.

Notes

1. Adam Gopnik, "Madison Avenue Primitive," *New Yorker,* November 9, 1992, 137–39.

2. Robert Storr, "Two Hundred Beats per Minute," in *Basquiat Drawings,* ed. John Cheim (New York: Robert Miller, 1990), n.p.

3. Fred Brathwaite, "Jean-Michel Basquiat," *Interview,* October 1992, 119.

4. Thomas McEvilley, "Royal Slumming: Jean-Michel Basquiat Here Below," *Artforum* 31, no. 3 (November 1992): 95.

5. Robert Edward, *Aboriginal Bark Painting* (Adelaide: Rigby, 1969), n.p.

6. Gillies Turle, *The Art of the Maasai* (New York: Knopf, 1992).

7. Robert Farris Thompson, "Royalty, Heroism, and the Streets: The Art of Jean-Michel Basquiat," in *Jean-Michel Basquiat,* ed. Richard Marshall (New York: Whitney Museum of American Art, 1992).

8. McEvilley, "Royal Slumming," 96.

9. McEvilley, 96.

10. Gopnik, "Madison Avenue Primitive," 139.

11. Brathwaite, "Jean-Michel Basquiat," 123.

12. A. David Napier, "Culture as Self: The Stranger Within," in *Foreign Bodies: Performance, Art, and Symbolic Anthropology* (Berkeley: University of California Press, 1992), 147.

13. Greg Tate, "Nobody Loves a Genius Child," *Village Voice,* November 14, 1989, 33.

14. Francesco Pellizzi, "Black and White All Over: Poetry and Desolation Painting," in *Jean-Michel Basquiat,* exh. cat. (New York: Vrej Baghoomian Gallery, 1989).

15. McEvilley, "Royal Slumming," 96.

16. Rene Ricard, "World Crown ©: Bodhisattva with Clenched Mudra," in Marshall, *Jean-Michel Basquiat,* 49.

17. Gerard Basquiat, quoted in M. Franklin Sirmans, "Chronology," in Marshall, *Jean-Michel Basquiat,* 233.

18. Jean-Michel Basquiat, Sirmans, "Chronology," in Marshall, *Jean-Michel Basquiat,* 233.

19. Napier, *Foreign Bodies,* 51.

20. McEvilley, "Royal Slumming," 97.

21. Kalamu ya Salaam, "Interview with Marlon Riggs," *Black Film Review* 7, no. 3 (Fall 1992): 8.

22. Turle, *Art of the Maasai,* n.p.

23. Brathwaite, "Jean-Michel Basquiat," 140.

24. Napier, *Foreign Bodies,* 69.

25. Napier, 69.

A DAY AT THE RACES

LORRAINE O'GRADY ON BASQUIAT AND THE BLACK ART WORLD

LORRAINE O'GRADY, 1993

Projecting an endearing combination of self-effacement and plantation cynicism, Shaquille O'Neal, the #1 NBA draft pick, said in a recent TV profile, "I've got three different smiles: the $1 million smile, the $2 million smile, and the $3 million smile." It went beyond playing the game: with a $40 million contract and limitless prospects for endorsement, O'Neal was a winner. His situation seemed to shed light on the art world's own Black-player-of-the-moment. For there is no doubt that the most bizarre aspect of the recent Jean-Michel Basquiat retrospective at New York's Whitney Museum of American Art was its aura of sport. Analysis of the work was put on hold, pending results of two different horse races.

First: could Basquiat's prices hold with this much exposure? Answer: yes. The match race between Basquiat and Julian Schnabel continues. At the big New York and London auctions following the opening, Schnabel's best was $165,000; a Basquiat made $228,000. His prices are at 50 or 60 percent of the earlier bull market and steadily rising. His work has become more, rather than less, financially interesting now that its obsessions with colonialism, creolism, and history can be plugged into the market's three-year-old concern with multiculturalism.

Second: would jamming 100 pieces together help or hurt his critical reputation? Answer: maybe; the air still hasn't cleared. But he certainly wasn't done in. Initially, the gushing catalogue may have been checked by the vitriol of a Robert Hughes. But getting the contending views out, like piercing a boil, seems to have eased the way for tougher thinking. In the end, the gradually changing perceptions of a Roberta Smith, from "savvy imitation" and "illustrational stylishness" (1982) to "roiling, encompassing energy" (1989) and on to "a distinct form of visual speech" and "one of the singular achievements of the 80s" (1992), stand to gain credibility.[1]

Still, there was something embarrassing about all the hysteria, including my own. It was an uncomfortable reminder that more was at stake than a game. (At some point between the Greeks and the free-agent clause, sport gave up its pretense to a cultural meaning beyond narco-catharsis.) The barely submerged violence for and against Basquiat was a sign that even the '80s couldn't turn art into basketball. Whatever the post-Modern condition, art was more than a decorative anodyne; it was a locus of values for which we were willing to kill.

Lorraine O'Grady, "A Day at the Races: Lorraine O'Grady on Basquiat and the Black Art World," *Artforum* 31, no. 8 (April 1993): 9–12.

Luis Camnitzer has argued that although, in the capitalist context, whatever can be *sold* as art *is* art, the market itself knows there's more to it than that. For work to come into existence in the first place requires a communication between artist and viewer. This exchange can be quite disjunct from the art's final consumption; for example, in both film and literature, the preponderance of readers and viewers of *The Color Purple* may have been white, but most would have sensed that the enabling audience, the one addressed by the work, was Black.

Nevertheless, Camnitzer continues, control of the art's final context is what determines its destiny and function. Who buys, wins; and the destiny of crossover visual artists is an auction house that will be ruled by white money into eternity. This is a market of stripped-down, absolute values. The secondary market may, at a spiritual level, realize that art is the link between what is known and what needs to become known, but it will not permit divergent values to confuse or upset it. To retain its power to judge the work, it will remain willfully ignorant of nonhegemonic original contexts.

The result is that "peripheral" art can only be absorbed into the market when the politics of that market's values allow for its recognition. Hegemonic artists and critics have first to create appropriate references and spaces for it. As Camnitzer says, this condemns our work to being derivative *avant la lettre*. Whenever "peripheral" art is allowed to exist in a hegemonic context, it is derivative by definition, because it "enters as a consequence, not as an originator." If its originality can't be reduced, the work is too discomfiting and must be ignored.[2]

The hysteria generated by the Basquiat show, the extremes of ideology and emotion, even among those who said it was a yawn (on boredom, see Freud), came from a sense that this was one of those raw moments when the final context sat in judgment on the original. But the moment proved ineffectual. Faced with naively unresolved comments on graffiti, the '80s, and race, the work held on, if only tenuously.

It was disconcerting: Basquiat's habit of painting canvases that shatter at the edge of the mind appeared to defeat all but the most adventurous of critics. And "neutral" comments on discourse about the show often illustrated Camnitzer's argument. There were heated objections to referencing jazz by writers who seemed not to realize that jazz was not only an art form but a style of Black intellectual life, and even well-intentioned calls to substitute formalist analysis for overworked ad hominem arguments were based in Eurocentric assumptions. In dealing with Basquiat's art there is a fine line between rehearsing the legend and examining the art impulse itself. With precedents still undetermined, it's not just biography to analyze the intersections of the life with art history. But which art history/ies do we mean?

Under the compulsion to find hegemonic origins for him, such as Jean Dubuffet and Cy Twombly, analysis is being strangled. The debate needs air. If Basquiat *did* copy the painters so often mentioned, why *them?* What echoes made their styles appropriable to the experience of a late-20th-century Black man? And has the Black painter Raymond Saunders, whose work resonates with Basquiat's, heard them as well? Quotation in isolation is hardly interesting. Everybody quotes—*vide* Picasso.

Basquiat's biography is fascinating, but discussion of it is so uncomprehending that not even his legend has room to breathe. His romantic notion of the jazz life was a quarter-century out of date. Forget his internal resources—what does it mean that he didn't have access to the kind of information that might have saved him? Would knowing the lessons of Bob Thompson, the '60s Black painter with eerie parallels to him, have helped him move on? One effect of Basquiat's isolation is *not* speculation: the thinnest aspect of his art was not lack of training, which is irrelevant, but his separation from the audience that could have enabled and challenged him.

When I saw Jean-Michel's pieces in Annina Nosei's 1981 group show, I was stunned. I knew what I was looking at; and what I didn't know, I sensed. I never had to *translate* Jean-Michel, perhaps because I too came from a Caribbean-American family of a certain class—the dysfunctional kind, where bourgeois proprieties are viciously enforced and the paternal role model of choice is Kaiser Wilhelm. It was the sort of background that in the first generation of rebellious adolescents, kids no longer Caribbean and not yet American, faced with the inability of whites and Blacks alike to perceive their cultural difference but convinced they were smarter than both combined, often produced a style of in-your-face arrogance and suicidal honesty. At their best, these traits sometimes ascended from mere attitude to the subversive and revolutionary.

It was the next-to-last day of the show, a Friday. Out on the street, I made calls from a pay phone. To Linda Bryant, founder of Just Above Midtown, the Black not-for-profit where I showed with David Hammons, Fred Wilson, and others. I could tell Linda thought I was crazy: Haitian? From Brooklyn? Only 21? It was too weird; she'd catch up with him later. I hadn't even mentioned graffiti. With the artists I spoke to, disbelief hardened further: on Prince Street? When there are guys out here who've been working 30 years?

It took over a year to find a way. The "Black and White Show" I was curating in the spring of '83, at the Kenkeleba Gallery, was to feature black-and-white work by Black and white artists. It would star Jean-Michel, *not* David Hammons: David was already overexposed in the Black art world, though he wasn't to be discovered by the white one for another six years. Of course, I didn't know if Jean-Michel would agree.

He had split with Nosei and was without a gallery. I'd heard the stories about exploitation (the studio in her basement, etc.), but these were less frightening to me than a white friend's tale of late-night calls from a Jean-Michel in despair after white patrons had physically recoiled from him. The simplest handshake was a landmine. I knew the art world was about to eat him up and before it did, I hoped to connect him to Black artists who, picked up in the '60s and then dropped, could give him perspective on its mores in a way his graffiti friends could not. I also wanted to connect *them* to his hunger, his lack of fear. There were some who had stopped reading art magazines because they knew they would not see themselves there.

Keith Haring, a former student of mine, introduced us. I think Jean-Michel agreed to be in the show both because of Keith and because I'd sent him documentation of my performance persona, Mlle. Bourgeoise Noire, and he'd thought she was great. But when I

talked to him about the Black art world, he was perplexed; he'd never heard of it. If he came to the opening, he asked, could he meet Amiri Baraka? I thought it could be arranged. He had confirmed that, like others, we learn about ourselves from white media.

In anticipation of the pieces he said he would make for me, I visited his loft on Crosby Street several times. We talked about art, performance, and the places he'd been, especially Rome, and about the need to hold on to his best work, and as we talked, he sat in the middle of a canvas writing with oilstick. "I'm not making paintings," he said, "I'm making tablets." I ransacked my library for books for him. His line, the way he arrayed figures in space, made me settle on Burchard Brentjes' *African Rock Art* and, for an overview, *Prehistoric Art,* by P. M. Grand. But there was an aura in the loft that I'd identified as cocaine paranoia (later I hear the heroin started that summer). I understood my pieces were not forthcoming. Someone told me Basquiat had already mounted his campaign on Mary Boone, that exhibiting in the East Village would not be cool. I replaced him in the show with Richard Hambleton, whose Black, spray-painted figures exacerbated urban fear.

"The Black and White Show" came either too late or too soon. The press release spoke of "black-and-white art for a black-and-white time," "a time when cadmium red costs $32 a quart wholesale"—which shows how out of it I was. This was the '80s; only Black people were getting poorer, only Black artists seemed to worry about the price of paint. And the white art media remained the same. For all my exertions, the show got a three-line notice in the *East Village Eye* and a review in the *Woodstock Times.* I had to admit, there were things Jean-Michel knew more about than I.

For Basquiat, of course, it was just another no-show. He couldn't realize a chance had been lost. Except for pieces in "Since the Harlem Renaissance" at Bucknell University in 1984, his work was not shown in an African-American context while he lived; nor did it have to be. Whatever the degree of exploitation, he had been validated by the white gallery system, and in 1983 was included in a Whitney Biennial for which none of Just Above Midtown's artists received studio visits.

By 1986, Just Above Midtown would close, and Linda Bryant would drop out of the art world, leaving much of the Black avant-garde in limbo. Looking back, it's easy to see irony and heartbreak in all that's happened since. At the time of "The Black and White Show," the Black avant-garde was about to reach critical mass. But unlike black literature, it couldn't consolidate. Whereas every Black writer seemed to have half-a-dozen Ph.D.'s to support them, the numbers of Black artists appeared to have grown faster than those of teachers, curators, and critics. Advanced Black art, while esthetically vibrant, was institutionally fragile. It would shortly enter the mainstream, but in a fragmented way, and with limited means to frame its reception and contest its positioning by hegemony.

We are in a transitional moment, hoping our increased visibility will translate into increased effectiveness. But municipal politics show us that's not how it works. Given a Basquiat retrospective, there's always a horse race, and when Black art historian Judith Wilson says, "only Black people will monumentalize him," it's less germane

than Judd Tully's comment, "The interest of international collectors in protecting their investment in Basquiat's work will help his viability long-term."

The 1993 Whitney Biennial will go down as the Multicultural Biennial, but what will have changed? A white curator at a major out-of-town museum told me:

> The kinds of things I hear from patrons you wouldn't believe. The attention span at that level of the art world doesn't permit looking at the whole fabric of multicultural art. For many of them, every Black artist is a Black artist by definition. There aren't artists who are Black and bring this in varying degrees to their work. And since they are interested in what's *new,* they think of the issues Black artists raise as something they can only spend so much time on, then they want to go on to the next thing. They're looking for the one typical, quintessential Black artist, so then they can say, "I've done it," and not do any more.

In an odd reversal, Hammons, in less than three years, has become the quintessential Black artist for today. Hammons tries to make art in which white people can't see themselves, but may not have reckoned on their seeing themselves in the power to name the trend. He keeps trying not to play the game, but they keep letting him win.

In 1983, when Basquiat was in the Biennial, David had already done some of his best work. That year, he made the first and most magical of his "Higher Goals," a 55-foot basketball pole erected across from his studio, warning passersby on 121st Street not to dribble away their dreams. But ten years later, an accidental Shaquille, he is attempting to restore his equilibrium by instituting changes in the rules. Through absence, he has made himself the sharpest presence of the last two Biennials.

For the Basquiat retrospective, Hammons provided an answer to *the* unspoken question: was the event a priority for the hegemonic market or for Black culture? One thousand people a day went to the show, including two hundred of color, grateful to see themselves. At the opening, Hammons stood outside, watching, occasionally chatting, refusing to go in.

Notes

1. Roberta Smith, "Mass Productions," *Village Voice*, March 23, 1982, 84; "Outsiders Who Specialized in Taking Pictures," *New York Times*, November 19, 1989; and "Basquiat: Man for His Decade," *New York Times*, October 23, 1992.

2. Luis Camnitzer, "Art, Politics and the Evil Eye / El arte, la politica y ei mai do ojo," *Third Text* 20 (Autumn 1992): 69–75.

TIP-TAPPING ON A TIGHTROPE

FRANKLIN SIRMANS, 1994

> There is the memory of Bob Thompson, who seemed in the 1960s to be trying to paint all the history of art . . . Thompson and his '80s successor Jean-Michel Basquiat are the only two Black artists who were treated like stars, and they were dead before they turned 30.
>
> Michael Brenson, *New York Times,* 1989

With these words art critic Michael Brenson summed up the special place of Jean-Michel Basquiat in the history of visual art. A lone dark star in the artistic firmament of the 1980s. Though a thoughtful statement, Basquiat had to become a casualty before getting the attention of Brenson and many other art critics.

Although Basquiat's work was shown and selling well at prestigious galleries like Annina Nosei, Larry Gagosian, Mary Boone and Bruno Bischofberger in Europe, throughout the early and mid-'80s critical analysis of the work was always hard to find. Some reviews touched on Basquiat's use of line and tended to establish a patriarchal genealogy with Dubuffet, Twombly, de Kooning, and/or Pollock, seldom Saunders, which I am sure he enjoyed. Stating the obvious: rarely delving into what is really there. As if to say, "If he has something to do with them, then maybe he can possibly get down." Looking at the work with these blinders on only allows for a limited degree of comprehension concerning the art, and perpetuates the depth of misapprehension surrounding the career of Basquiat. There was, and there is, a marked contentment with describing Basquiat's work through the refracted gaze of the "Other." The Other, being the Black artist through the eyes of the historical vision of white critics. This vision is often exercised in a consistent pattern of usurping "cultural permission" in the practice of "art criticism." Permission, usually defined as something granted, instead is taken. Cultural permission manifests itself today most obviously in the art form of music (e.g., Vanilla Ice, Young Black Teenagers, etc. . . .). Vanilla Ice used "cultural permission" to fabricate himself into a commodified view of Blackness. In critical analysis, the same commodified and easily consumable version of Blackness was used in discussion on the art of Jean-Michel Basquiat. "The wild boy corralled in a den." It is this romantically inclined assumption of permission that is parallel to the historical European imperialist idea of manifest destiny, in which "other" peoples are there to be exploited for the purpose of commodification. This assumption in art criticism allows for a shallow and often inconclusive analysis.

Franklin Sirmans, "Tip-Tapping on a Tightrope," *Acme Journal* 1, no. 3 (1994): 94–101.

The manifest permission appropriated by some critics to commit diatribes to paper that perpetuate a dated and simplistic view of Black artists has led to an easily digestible fabrication of the nature of much Black art. This tendency becomes more apparent when we examine the criticism written on Basquiat while he was alive. With the exception of some recent work, this is the story of analytical discussion on his work. Greg Tate, Robert Farris Thompson, bell hooks, Richard Marshall and others have taken the first steps. With two museum retrospectives (on both sides of the Atlantic) now realized, it seems more appropriate than ever to assess this criticism and enact change. I think back to the early '80s (the decade we love to hate) on the Lower East Side of Manhattan. New galleries flourished with "alternative" art and Neo-Expressionism loomed on the brink of the art historical horizon. Jean-Michel Basquiat opened the Fall season of 1982 with his first New York solo exhibition at the Annina Nosei Gallery. Lisa Liebmann's review in *Art in America* (October 1982), in response to Basquiat's show, offers a typical example of the earliest criticism on his art. Liebmann wrote, "Basquiat is not French, but it is to this highly-cultivated, expatriated, and often self-conscious tradition that his work pertains."[1] Of course Liebmann's assumption is that a Black boy from New York is not, or cannot, be part of another highly contemporary, highly cultivated and equally self-conscious Black urban tradition. It's as if to say, "never mind that properly French name, this is a Black kid!"

Jeffrey Deitch earlier wrote in *Flash Art* (May 1982), "Basquiat is likened to the wild boy raised by wolves, corralled into Annina's basement and given nice clean canvases to work on instead of anonymous walls . . . But Basquiat is hardly a primitive."[2] Jean-Michel Basquiat was born in Brooklyn, New York into an upwardly mobile, middle-class family. Deitch goes on to say, "Basquiat is the classic product of New York's melting pot, an astounding hybrid that could not have evolved anywhere else. His paintings are a canvas jungle that harness the traditions of modern art to portray the ecstatic violence of the New York street." While Deitch's characterization of Basquiat's hybrid background comes closer to the roots of his work, his conception of Basquiat's background is essentially romantic. Violence as ecstatic? Never mind the drugged-crazed-Black-artist-trip, i.e., the doomed jazz musician, Basquiat was metaphorically lynched in a loincloth, swinging on a vine in 1982. This misguided dependence on stereotype and cultural mythology pass as informed opinion on the Basquiat oeuvre even now after his death.

This show at Annina Nosei displayed works like *Crowns (Peso Neto)* (1981) and *Arroz con Pollo* (1981), which depicts a haloed, Black, male figure offering a steaming chicken to a white, female figure, that in turn offers her breast (plates 4 and 3). The two figures are depicted frontally inside a domestic interior. Their historical roles are reversed. But the Black male figure is not whole, rendered, as usual in Basquiat's work, with skeletal stick-like strokes. The full-figured woman seems to be bartering with her breast and large exposed vaginal area. There is a lot more going on there than "violence and the street." This painting offers a glimpse at Basquiat's renderings of female figures and the subject of male-female interaction, which has yet to be properly discussed. It

is also one of the few Basquiat paintings depicting an interior space. In *Arroz con Pollo* could Basquiat be suggesting a certain connection between white women and Black men? The female offers her own body—not goods of some kind—as an object of exchange. The concept of exchange is heightened by Basquiat's placement of the couple at the center of the canvas. In gender terms, the male clearly dominates the female. Basquiat here suggests, as he does throughout his oeuvre, that white male cultural powers remains insensitive to gender questions, not to mention those of race. It is a phallocentrism prevalent in the very nature of art history, where women continue to suffer from marginalization in much the same way as artists of color. Despite the art world's inherent social contradictions, it is within this white, male-dominated space where Basquiat tried to carve out his own niche. He wanted to be judged on these terms. Few of his other pictures show such give-and-take relationships. Usually his paintings and drawings show white males doing the taking amidst visually and symbolically incomplete, Black figures. Basquiat was, in effect, criticizing the kind of "cultural permission" used to define Black artistry so that it might be more effectively usurped by white males throughout art history. The Black figures are rendered repeatedly as mere skeletons of former selves or as a diminished self, struggling within. Often these Black males take the place of the colonized in the face of the colonizer. Haloed, as they often are, one is confronted immediately by a spiritual quality. At times I stand in awe before Basquiat canvases, the way I would imagine the earliest visitors to the Sistine Chapel stood before the work of Michelangelo.

Another narrative, *Self-Portrait with Suzanne* (1982) (plate 12), in which Basquiat drew an intimate male-female relationship provides a dramatic contrast to *Arroz con Pollo*. Both figures seem whole and familiar. Haloed and rendered in bright reds, oranges and yellows, they converse with each other via the word boxes above their heads. Yet, within the flattened space the male figure looms above the female. The elimination of depth lends a quality of preternaturalism. The two bodies hint at a position of embrace. The bright palette and figural presentation create a feeling of intimate, surreal serenity. From a distance, the colors make a wonderful abstract expressionist composition. In the paintings and drawings of 1981–1983, S's in little houses and boxes abound, perhaps referring to Suzanne. Curiously, he usually places his symbol for female femininity within domestic space. In addition to the figurative representations of women, Basquiat, poet that he is, filled the drawing *Untitled (Cheese Popcorn)* (1983) and the print *Tuxedo* from the same year with the names of women: Felice, Mary Anne Wright or Monforton, Alexis, and Miriam—all connected by arrows. Billie Holiday, as Basquiat's genealogical mother, appears alongside the names of the many jazz entertainers he showed a preoccupation for within his work.

Only after his death did more prominent critics consider Basquiat's work worthy of serious comment. Robert Hughes, art critic of *Time Magazine,* wrote pages of indignant prose in the *New Republic*[3] reducing Basquiat's work to '80s hype and the mere reflection of a period gone awry, a period that he would rather forget. Andrew Deck-

er's piece, "The Price of Fame," in *Artnews*,[4] discussed failed friendships, drugs and money; it read like something out of *The National Enquirer*.

Even Peter Schjeldahl, whose writing is usually as beautiful as it is elucidating, couldn't resist joining the clamor. He proceeded to write two postscripts, one for *Elle Magazine* (hmmm?) and one for his column in the now defunct magazine, *Seven Days*. Schjeldahl, who was up on the cultural politics game that Basquiat played, wrote in reference to the paintings:

> Would I be surprised to learn that the author was a young Black man? Frankly, yes. Most work by non-whites in the New York mainstream of styles has been marked by a tendency, mordantly popularized by Spike Lee, as "wannabe." So I would not have expected from a Black artist Basquiat's vastly self-assured grasp of New York big-painting aesthetics. The *license* (my italics) to tap energy from "primitive" forms has often defined Euro-American, white modernism ever since Picasso circa 1907. I would have anticipated a well-schooled, very original white hipster behind the tantalizing pictures.[5]

Schjeldahl's "primitive" is African, as was the source for Picasso's *Demoiselles d'Avignon*. But, for Schjeldahl as well, "African" has little, or nothing, to do with Black urban traditions. These traditions are obvious in the musk and dance of American popular culture. But combining "African" and Western esthetics can apparently only be done by a knowledgeable, white man; the product then can be called "modernism."

The hand was definitely stacked against Basquiat, and he knew it. He was trying not to go out like many a good Black artist: bitter, angry, painting the same shit that once got them a piece in a big museum collection back in 1972; getting dissed by everybody, except within the context of the occasional "African diaspora" show. Thus, as Greg Tate asserted in his posthumous *Village Voice* essay (the first to make a serious consideration of Basquiat in light of other Black artists), "Making it to him [Basquiat] meant going down in history, ranked beside the Great White Fathers of Western painting in the eyes of the major critics, museum curators, and art historians who ultimately determine such things."[6] Basquiat had to do something, if he were to get his. Otherwise, he was going out like the brothers in his paintings, halfless and skinned, like Daffy getting blown up by Bugs.

Basquiat, himself a shrewd practitioner of the manipulation of "cultural permission" and art world politics, played the game with a panache only matched by the obliviousness of his contemporary critics. As a young Black male, he could take advantage of white critics' usurpation of "cultural permission." By playing into the parameters of his own commodification by whites he could in fact wield some sort of power in the control over his own fate. bell hooks, in the June (1993) issue of *Art in America*, added a necessary article that became timely thanks to Richard Marshall's Whitney Museum retrospective of Basquiat in the Fall of 1992:

Despite the incredible energy Basquiat displayed playing the how-to-be-a-famous-artist-in-the-shortest-amount-of-time-game—courting the right crowd, making connections, networking his way into high "white" art places—he chose to make his work a space where that process of commodification is critiqued, particularly as it pertains to the Black body and soul.[7]

Pictures concerned with slavery and the triangular trade of Blacks, molasses and gold speak poignantly, unless people just don't get it, e.g., the painting, *Untitled (History of Black People)* (1982) (*The Nile*, plate 25)* or the drawing study, *Undiscovered Genius* (1983) (plate 23). In *Undiscovered Genius*, Basquiat poses the question "Q. ARE NOT PRINCES KINGS?" Just underneath these lines are the words "VERSUS THE DEVIL" in a box. Here, as in many paintings, Basquiat referred to an African past based in royalty and often showed this by drawing or painting crowns over the heads of his Black, male figures. The text of this drawing, juxtaposed with images of a male figure, a ship and the Statue of Liberty, speaks of the same, eery jargon espoused by the Five Percent Nation—which Basquiat was familiar with through his good friend and fellow artist, Rammellzee. Nowhere has anyone touched on the depth of anger in the work. Instead, criticism has been dominated by descriptions of childlike playfulness, "ecstatic violence" and naiveté in the work, all furthering the image of Basquiat as somehow less than a man—*un naïf.* That is if the writing is remotely about the art at all and not just biographical, where people can really go off in strange directions.

Though he could work subtle wonders within his art (the slave songs that massa' thought so beautiful and melodic), the true test came in daily life, projecting an image that was desired by collectors, museum curators and critics. At the age of 18, Basquiat rode the crest of the wave of the graffiti artists. He broke with graffiti when he saw where it was going—to extinction. Because the strength of graffiti lies in its ephemeral quality, showing it in galleries, museums and collectors' homes presents problems few graffiti artists have been able to resolve. A train bombed under cover of night and fear of the law contribute raw immediacy to color and line in the finished piece. When graffiti artists create works for the gallery system, this is usually lost. Graffiti's overnight popularity could only be matched by its instant demise. Put on canvas, graffiti became an art world fad.

SAMO, Basquiat and Al Diaz's tag name, was nothing like the graffiti of the moment; they were colored people; they wrote on walls; and Basquiat knew they could make it work within the conventions, biases and romantic racial misconceptions of the art world. In December of 1978, Philip Faflick, in the *Village Voice,* called the duo, "the most ambitious of the Magic Marker Jeremiahs."[8] Although the spray-painted and scribbled SAMO messages lacked the immediate intensity and chromatic vibrancy of the graffiti artists, it did not matter. Basquiat was quoted in the article saying, "the stuff you see on the subway now is insane. SAMO was like a refresher course because

* Sirmans refers to a painting that has since been known as *The Nile* and dated to 1983.

272

there's some kind of statement being made." He knew how to walk a fine line; SAMO's scribbled messages were social commentary:

SAMO as an end to mindwash religion, nowhere politics, and bogus philosophy.
SAMO saves idiots

Graffiti was hot for the moment but history would dictate that an art historical movement dominated by people of color could not really coexist within the white Pantheon. But Faflick's article helped fan Basquiat's desire for fame. The formula had been laid out early, simply put: that many critics would just not understand and that it wouldn't matter if they understood or not. To be talked about would be better than not to be talked about.

Just where SAMO writings popped up shows how Basquiat took cultural permission himself. The manifestoes were done in SoHo, not in the train yards far from Manhattan's artistic focal point. Basquiat wanted to start the expectant tongues of the art world wagging. Artist and friend, Fred Brathwaite said in reference to the writings, "They were aimed at the art community but at the same time he resented that crowd."[9]

Forever calculating, Basquiat wanted to go all the way down in history. He would exploit the notoriety of the graffiti movement in order to set up his painting career. To be a painter was to be the quintessential *artiste,* even if he resented the people who established such things. SAMO was poetry, a poetry continued especially in Basquiat's numerous drawings and notebooks.

Yet, the most pointed example of Basquiat's penchant for playing with the dynamics of cultural politics and the appropriation of cultural permission on his own part would be his relationship with Andy Warhol, whom Rene Ricard, in the Whitney catalog, likened to Basquiat's long lost Great White Father. But Basquiat always had his own father. He had a mother too, Matilde Andrades Basquiat. Basquiat's mother, an artist herself, had been placed in a psychiatric hospital while he was of the tender age of eight years old. Though she must have played a role in some of the psychic trauma that lends itself to her son's work, he continued to see her throughout his short life. When Basquiat was seventeen Nora Fitzpatrick moved into the household, taking his mother's place as his father's companion. It was at this time that Basquiat began a life of his own making in downtown Manhattan.

Instead of searching for a father, Basquiat was searching for fame. Warhol, provocateur, image-conscious image-maker, helped popularize Basquiat's art by exploiting Basquiat's image as the "exotic-other." At the suggestion of Tony Shafrazi, for their collaborative show the two posed in a sparring position: bare-chested, dressed in boxing gloves and trunks. Warhol could open avenues to success that Basquiat, as a Black artist alone, would not have had access to. This type of a relationship has a particular and suggestive history. Henry O. Tanner had Thomas Eakins; Aaron Douglas had Carl Van Vechten. Eakins, Van Vechten, and Warhol were validating sources for the work of their Black peers. Basquiat already had the top galleries of the moment.

Neo-Expressionism was the mode of the moment and he had that, too. Though his work persistently questioned white supremacy, he knew who would have the final word on the ultimate value of his critical output.

In the drawing *Untitled (Quality)* (1983), an arrow points to a ship labeled "PIL-GRIMS," from the phrase "ORIGINAL THIEVES FROM THE MAYFLOWER." In another drawing of the same year *Untitled (Plaid),* we read "TRAIN TRACKS BUILT BY MEN OF CHINA FOR CHUMP CHANGE OF 1850." Basquiat is clearly and succinctly calling out the history of exploitation by white men within these compositions. At the same time, he is soothing white, male guilt, in allowing the perpetrators to atone for their sins by consuming their own troubled historical role as a commodity—in the form of the art object. Buy a piece of your guilt and it'll be all right.

Basquiat's ability to focus so clearly on such loaded subject matter all in the space of a mere piece of paper inspires feelings of joy and liberation. As drawings, the pieces are first and foremost well executed. No matter what Basquiat is "saying," it looks right. Color, line and mark-making technique combine to fill a space with something eye-catching, before we can even recognize his polemic.

Further evidence of Basquiat's personal practice of cultural politics can be seen by comparing two photographs made of the artist within a three-year span. Together, they represent a reciprocal dynamic of "cultural permission"—one an instance of giving it, the other, taking it. In 1982, at the suggestion of Diego Cortez, Basquiat posed for the eminent Black photographer and chronicler of the Harlem Renaissance, James VanDerZee (page 339). The photograph was featured in Henry Geldzahler's interview with Basquiat in the January 1983 issue of Andy Warhol's *Interview Magazine.* It shows Basquiat sitting frontally in a throne-like chair, much in the same manner as many of VanDerZee's other portraits of important Black artists, singers, and entertainers. Basquiat wears a modest jacket and tie. It is said that he came wearing a paint-splattered, leather jacket but Mr. VanDerZee would not have it. A soft Siamese kitten rests upon his lap. It is an exceptional portrait: unique and moving, Basquiat admired the work of VanDerZee and was willing to sacrifice his style to that of the elder statesman; he later painted a portrait of VanDerZee. The photograph, however, was to be a VanDerZee, not a Basquiat. As a Black man and witness of decades of Black art and American history, VanDerZee would decide the proper way to present this art world *enfant terrible.* It would be his way or nothing. Basquiat permitted himself, in this instance to be defined by caring hands. Nonetheless, he was aware where this photograph was going. It would not be reproduced in a daily paper with a large circulation, nor in a small Black press weekly.

In contrast, the cover of the *New York Times Magazine* (page 352) provides a good example of how Basquiat took cultural permission for himself. The photograph, taken by Lizzie Himmel, shows Basquiat reclining with his bare feet resting assuredly on a coffee table, furthering the exotic-other image of the Black savage. He is dressed in a pinstriped suit and tie and holds a paintbrush. This internationally circulated cover promoted the already mythic image of Basquiat splattering Armani suits with paint

and hinted at a degree of recklessness and unencumbered behavior that served to promote his work as a "primitive" or an Outsider. The image sold well; although (or perhaps because) this image proved to be so palatable to whites, Basquiat himself promoted it. Oddly enough, Roberta Smith of the *New York Times* later heralded Basquiat's work as that of an Outsider Artist in her review of a retrospective at the Vrej Baghoomian Gallery. Included in her review, entitled "Outsiders Who Specialized in Talking Pictures," are the "Black gatekeeper and devout Christian who had visions and painted them"; Minnie Evans, "an evangelical preacher from Georgia who took up the paintbrush at the age of 60"; Howard Finster; and "a precocious Black poet-painter, who died of a drug overdose in August of 1988 at the age of 27," Basquiat.[10] It is significant that the cosmopolite, Basquiat, should wind up in an extensive review of Outsider Artists in 1989. bell hooks explains this phenomena as part of a "current wave of imperialist nostalgia": "This longing is rooted in the atavistic belief that the spirit of the primitive resides in the bodies of dark Others whose cultures, traditions, and lifestyles may indeed be irrevocably changed by imperialism, colonization, and racist domination. The desire to make contact with those bodies deemed Other, with no apparent will to dominate, assuages the guilt of the past, even takes the form of a defiant gesture where one denies accountability and historical connection."[11] The "outsider artists" are just that. They are "outside" the scene and treated as such: "primitive," "naive," etc. These labels allow them to be dealt with as less than human. They are, in effect, transformed into playful creatures who have somehow managed to preserve their childhoods in a manner that appears controllable and non-threatening to the dominant culture.

Jean-Michel Basquiat lived the life of his painted figures, X-rayed, loose-limbed, and torn open for all to see. He made his peace with a troubled existence by departing from that existence. I have no doubt that he understood all of this as he understood the challenge of life under the largely white gaze of the "art world," a gaze he consciously chose to accept. He succumbed to the fate of his own poetic declarations, yet left us with challenging work rich with traces of individual lives and the larger concerns of our world. A late painting, *Riddle Me This Batman* (1987) (plate 32), declares at its center "NOTHING TO BE GAINED HERE"; just below to the left are the words, "COWARDS WILL GIVE TO GET RID OF YOU." The juxtaposition of words with depictions of comic characters is exemplary of the irony prevalent in most of his work. The composition seduces you visually, then slaps you awake with its message.

With a legacy of so much confused criticism, we must reassess Basquiat's artworks firsthand before drawing any conclusions. In order to accomplish this it seems that people have to come to terms with their own pasts—and perhaps their own racism—in order to approach the work critically. Is this possible in a time when things surrounding us only seem to be getting worse? When acts of hatred seem to be occurring with ever greater frequency? Yet, for those of us concerned with art in a period of such turmoil, there remains a chance to rethink this criticism and its premises.

Notes

1. Lisa Liebmann, "Jean-Michel Basquiat at Annina Nosei," *Art in America*, no. 70 (October 1982): 130.

2. Jeffrey Deitch, "Jean-Michel Basquiat: Annina Nosei," *Flash Art*, no. 16 (May 1982): 49–50.

3. Robert Hughes, "Jean-Michel Basquiat: Requiem for a Featherweight," *New Republic*, November 21, 1988, 34–36.

4. Andrew Decker, "The Price of Fame," *Art News*, no. 88 (January 1989): 96–101.

5. Peter Schjeldahl, "Martyr without a Cause," *7 Days*, September 21, 1988, 53–54; and "Paint the Right Thing," *Elle*, November 1989, 214–16.

6. Greg Tate, "Nobody Loves a Genius Child: Jean-Michel Basquiat, Lonesome Flyboy in the '80s Art Boom Buttermilk," *Village Voice*, November 14, 1989, 31–35.

7. bell hooks, "Altars of Sacrifice: Re-membering Basquiat," *Art in America*, no. 81 (June 1993): 68–75, 117.

8. Philip Faflick, "SAMO c. Graffiti: BOOSH-WAH OR CIA?," *Village Voice*, December 11, 1978, 41.

9. Ingrid Sischy, "Jean-Michel Basquiat as Told by Fred Brathwaite," *Interview*, October 1992, 119–23.

10. Roberta Smith, "Outsiders Who Specialized in Talking Pictures," *New York Times*, November 19, 1989.

11. bell hooks, "Eating the Other," in *Black Looks: Race and Representation* (Boston: South End Press, 1992), 25.

FAMOUS AND DANDY LIKE B. 'N' ANDY
RACE, POP, AND BASQUIAT

JOSÉ ESTEBAN MUÑOZ, 1996

Disidentifying in the Dark

I always marvel at the ways in which nonwhite children survive a white supremacist U.S. culture that preys on them. I am equally in awe of the ways in which queer children navigate a homophobic public sphere that would rather they did not exist. The survival of children who are both queerly and racially identified is nothing short of staggering. The obstacles and assaults that pressure and fracture such young lives are as brutally physical as a police billy club or the fists of a homophobic thug and as insidiously disembodied as homophobic rhetoric in a rap song or the racist underpinnings of Hollywood cinema. I understand the strategies and rituals that allow survival in such hostile cultural waters, and I in turn feel a certain compulsion to try to articulate and explicate these practices of survival. These practices are the armaments such children and the adults they become use to withstand the disabling forces of a culture and state apparatus bent on denying, eliding, and, in too many cases, snuffing out such emergent identity practices. Sometimes these weapons are so sharply and powerfully developed that these same queer children and children of color grow up to do more than just survive. And sometimes such shields collapse without a moment's notice. When I think about Andy Warhol, I think about a sickly queer boy who managed to do much more than simply survive. Jean-Michel Basquiat, painter and graffitero, a superstar who rose quickly within the ranks of the New York art scene and fell tragically to a drug overdose in 1988, is for me another minority subject who managed to master various forms of cultural resistance that young African Americans need to negotiate racist U.S. society and its equally racist counterpart in miniature, the eighties art world.[1]

These practices of survival are, of course, not anything like intrinsic attributes that a subject is born with. More nearly, these practices are learned. They are not figured out alone, they are informed by the examples of others. These identifications with others are often mediated by a complicated network of incomplete, mediated, or crossed identifications. They are also forged by the pressures of everyday life, forces that shape a subject and call for different tactical responses. It is crucial that such children are able to look past "self" and encounter others who have managed to

José Esteban Muñoz, "Famous and Dandy Like B. 'n' Andy: Race, Pop, and Basquiat," in *Pop Out: Queer Warhol*, edited by Jennifer Doyle, Jonathan Flatley, and José Esteban Muñoz (Durham, NC: Duke University Press, 1996), 144–79.

prosper in such spaces. Sometimes a subject needs something to identify with, sometimes a subject needs heroes to mimic and in which to invest all sorts of energies. Basquiat's heroes included certain famous Black athletes and performers, four-color heroes of comic books, and a certain very white New York artist. These identifications are discussed in a recent recollection of the artist by *Yo MTV Raps!* host Fab 5 Freddy:

> We [also] talked about painting a lot. And that was when Jean-Michel and I realized we had something in common. There were no other people from the graffiti world who knew anything about the painters who interested us. Everybody was interested by comic book art—stuff sold in supermarkets with bright colors and bold letters. Jean-Michel discovered that my favorite artists were Warhol and Rauschenberg, and I found out that Jean-Michel's favorite artists were Warhol and Jasper Johns. Which was great because we could talk about other painters as well as the guys painting on trains.[2]

In this nostalgic narrative, identification with highbrow cultural production, coupled with a parallel identification with the lowbrow graphic genre of the comic book, is what sets Basquiat apart from the rest of the subculture of early eighties New York graffiti artists. This double identification propelled Basquiat into the realm of "serious" visual artist. This powerful and complex identification is what made the movement from talking *about* Warhol to talking *to* Warhol so swift for Basquiat.

For Basquiat, Warhol embodied the pinnacle of artistic and professional success. One does not need to know this biographical information to understand the ways in which Basquiat's body of work grew out of Pop Art. But biographical fragments are helpful when we try to understand the ways in which this genius child from Brooklyn was able to meet his hero and gain access and success in the exclusive halls of that New York art world where Warhol reigned. At the same time, a turn to biography is helpful when we try to call attention to the white supremacist bias of the eighties art world and the larger popular culture that the Pop Art movement attempted to capture in its representations. Although it should be obvious to most, there is still a pressing need to articulate a truism about Pop Art's race ideology: next to no people of color populate the world of Pop Art, as either producers or subjects. Representations of people of color are scarce and, more often than not, worn-out stereotypes. Warhol's work is no exception: one need only think of the portrait of a Native American, which is titled *American Indian,* the drag queens of *Ladies and Gentlemen,* and the Mammy from the *Myths* series. The paintings reproduce images that are ingrained in the North American racist imagination. There is no challenge or complication of these constructs on the level of title or image. Pop Art's racial iconography is racist. A thesis/defense of these images is an argument that understands these representations as calling attention to and, through this calling out, signaling out the racist dimensions of typical North American iconography. I find this apologetic reading politically dubious

insofar as it fails to contextualize these images within the larger racial problematics of Pop Art.

With this posited, I will swerve back to the story this paper wants to tell, the story of how a Black child of Haitian and Puerto Rican parents from Brooklyn becomes famous like Andy Warhol. The line I want to trace is one that begins with identifying with one's heroes, actually becoming like one's role model, and then moving on. This line is not easy to follow inasmuch as it is neither linear nor in any way straight. It is, in fact, a very queer trajectory. There are some identifications that the culture not only reinforces but depends on. An example of this would be the way in which some young Black males identify with famous Black athletes and entertainment media stars. Such a normativized chain of associations transmits valuable cultural messages while at the same time, depending on the identifying subject, it reinforces traditional ideas of "masculinity." Other identifications are harder to trace: how does this young African American identify with a muscular red, blue, and gold and yes, white, "superman," not to mention the pastiest of art world megastars?

In what follows I will consider these different identity-informing fixations and the ways in which they resurfaced in Basquiat's body of work. Central to this project is an understanding of the process of "disidentification" and its significance to Basquiat's artistic practices. I understand the survival strategies that subjects such as Basquiat and Warhol utilize as practices of disidentification. The psychoanalysts J. Laplanche and J. B. Pontalis define "identification" as a "psychological process whereby the subject assimilates an aspect, property or attribute of the other and is transformed, wholly or partially, after the model the other provides. It is by means of a series of identifications that the personality is constituted and specified."[3] A disidentifying subject is unable to identify fully or to form what Freud calls that "just-as-if" relationship. In the examples I am engaging, the obstructive factor that stops identification from happening is always the ideological restrictions of a set identificatory site. In the case of Basquiat, it was often a specifically racialized normativity that foreclosed any easy identification.

The French linguist Michel Pecheux extrapolates a theory of disidentification from Marxist theorist Louis Althusser's influential theory of subject formation and interpellation. "Ideology and Ideological State Apparatuses" was among the first articulations of the role of ideology in theorizing subject formation. For Althusser, ideology is an inescapable realm in which subjects are called into being or "hailed," a process he calls "interpellation." Ideology is the imaginary relationship of individuals to their real conditions of existence. The location of ideology is always within an *apparatus* and its practice or practices, such as the state apparatus.[4] Pecheux built on this theory by describing the three modes in which a subject is constructed by ideological practices. In this schema the first mode is understood as "identification," where a "Good Subject" chooses the path of identification with discursive and ideological forms. "'Bad Subjects" resist and attempt to reject the images and identificatory sites offered by dominant ideology and proceed to rebel, to "counteridentify" and turn against this symbolic system. The danger that Pecheux sees in such an operation would be the

counterdetermination that such a system installs, a structure that validates the dominant ideology by reinforcing its dominance through the controlled symmetry of "counterdetermination." Disidentification is the third mode of dealing with dominant ideology, one that neither opts to assimilate within such a structure nor strictly opposes it; rather, disidentification is a strategy that "works on and against dominant ideology."[5] Instead of buckling under the pressures of dominant ideology (identification, assimilation) or attempting to break free of its inescapable sphere (counteridentification, utopianism), this "working on and against" is a strategy that tries to transform a cultural logic from within, always laboring to enact permanent structural change while at the same time valuing the importance of local or everyday resistance struggles.

Judith Butler gestures to the uses of disidentification when discussing the failure of identification. In *Bodies That Matter,* Butler parries with Slavoj Žižek, who understands disidentification as a breaking down of political possibility, "a factionalization to the point of political immobilization."[6] Butler counters Žižek's charge by asking the following question of his formulations: "What are the possibilities of politicizing disidentification, this experience of *misrecognition,* this uneasy sense of standing under a sign to which one does and does not belong?" Butler answers her query by writing, "It may be that the affirmation of that slippage, that the failure of identification is itself the point of departure for a more democratizing affirmation of internal difference."[7] Both Butler's and Pecheux's accounts of disidentification put forward an understanding of identification as never being as seamless or unilateral as the Freudian account would suggest.[8] Both theorists construct the subject as a subject *inside* of ideology. Their models permit one to examine theories of the subject who is neither the "Good Subject," who has an easy or magical identification with dominant culture, nor the "Bad Subject," who imagines herself outside of ideology. Instead, they pave the way to an understanding of a "disidentificatory subject" who tactically and simultaneously works on, with, and against a cultural form.

As a practice, disidentification does not dispel those ideological contradictory elements; rather, like a melancholic subject holding onto a lost object, it works to hold onto this object and invest it with new life. Eve Kosofsky Sedgwick, in her work on the affect, shame, and its role in queer performativity, has explained as follows: "The forms taken by shame are not distinct 'toxic' parts of a group or individual identity that can be excised; they are instead integral to and residual in the processes by which identity itself is formed. They are available for the work of metamorphosis, reframing, refiguration, transfiguration, affective and symbolic loading and deformation; but unavailable for effecting the work of purgation and deontological closure."[9] To disidentify is to read oneself and one's own life narrative in a moment, object, or subject that is not culturally coded to "connect" with the disidentifying subject. It is not to pick and choose what one takes out of an identification. It is *not* to evacuate willfully the politically dubious or shameful components within an identificatory locus. Rather, it is the reworking of those energies that does not elide the "harmful" or contradictory com-

ponents of any identity. It is an acceptance of the necessary introjection that has occurred in such situations.

Disidentification for the minority subject is a mode of recycling or reforming an object that has already been invested with powerful energy. It is important to emphasize the transformative restructuration of that disidentification. With this notion of disidentification posited, I will be suggesting that it is simply not enough to say that Basquiat identified with his subject matter or "heroes," be they Batman or Warhol. Beyond that, it is not enough to say that Basquiat identified with the movement we understand as Pop Art or any of its derivatives. Which is not to say that he rejected these previous cultural players, forms, and practices. Instead, he acknowledged and incorporated their force and influence; *transfigured,* they inform his own strategies and tactics in powerful ways.

The mode of cultural production I am calling disidentification is indebted to earlier theories of revisionary identification. These foundational theories emerged from fields of film theory, gay and lesbian studies, and critical race theory. While these different fields do not often branch into one another's boundaries, they have often attempted to negotiate similar methodological and theoretical concerns. The term "revisionary identification" is a loose construct that is intended to hold various accounts of tactical identification together. "Revisionary" is meant to signal different strategies of viewing, reading, and locating "self" within representational systems and disparate life worlds that aim to displace or occlude a minority subject. The string that binds such different categories is a precariously thin one, and it is important to specify the different critical traditions' influence to my own formulations by surveying some of the contributions they make to this project.

My thinking about disidentification has been strongly informed by the important work of critical race theorists, who have asked important questions about the workings of identification for minority subjects within dominant media. Michele Wallace has described the process of identification as one that is "constantly in motion."[10] The flux that characterizes identification for Miriam Hansen when considering female spectatorship and identification is then equally true of the African American spectator in Wallace's article. Wallace offers testimony to her own position as a spectator:

> It was always said among Black women that Joan Crawford was part Black, and as I watch these films again today, looking at Rita Hayworth in *Gilda* or Lana Turner in *The Postman Always Rings Twice,* I keep thinking "she is so beautiful, she looks black." Such a statement makes no sense in current feminist film criticism. What I am trying to suggest is that there was a way in which these films were *possessed* by Black female viewers. The process may have been about problematizing and expanding one's racial identity *instead* of abandoning it. It seems important here to view spectatorship as not only potentially bisexual but also multiracial and multiethnic. Even as "The Law of the Father" may impose its premature closure on the filmic "gaze" in the coordination of suture and classical narrative, disparate factions in the audience, not equally well indoctrinated in the dominant discourse, may have their way, now and then, with interpretation.[11]

The story that Wallace tells substantiates the theory of disidentification that is proposed in this essay. The wistful statement that is persistent in Wallace's experience of identification, "she is so beautiful, she looks Black," is a poignant example of the transformative power of disidentification. In this rumination, the Eurocentric conceit of whiteness and beauty as being naturally aligned (hence, straight hair is "good hair" in some African American vernaculars) is turned on its head. Disidentification, like the subjective experience described in the above passage, is about expanding and problematizing identity and identification, not abandoning any socially prescribed identity component. Black female viewers are not merely passive subjects who are possessed by the well-worn paradigms of identification that the classical narrative produces; rather, they are active participant spectators who can mutate and restructure stale patterns within dominant media.

In the same way that Wallace's writing irrevocably changes the ways in which we consume films of the forties, the work of novelist and literary theorist Toni Morrison offers a much needed reassessment of the canon of American literature. Morrison has described, "a great, ornamental, prescribed absence in American literature,"[12] which is the expurgated African American presence from the North American imaginary. Morrison proposes and executes strategies to reread the American canon with an aim to resuscitate the African presence that was eclipsed by the machinations of an escapist variant of white supremacist thought that is intent on displacing nonwhite presence. The act of locating African presences in canonical white literature is an example of disidentification employed for a focused political process. The mobile tactic (disidentification) refuses to follow the texts' grain insofar as these contours suggest that a reader play along with the game of African elision. Instead, the disidentificatory optic is turned to shadows and fissures within the text, where Black presences can be liberated from the protective custody of the white literary imagination.

One of queer theory's major contributions to the critical discourse on identification is the important work that has been done on cross-identification. Sedgwick, for example, has contributed to this understanding of decidedly queer chains of connection by discussing the way in which lesbian writer Willa Cather was able to both disavow Oscar Wilde for his grotesque homosexuality and uniquely invest in and identify with her gay male fictional creations: "If Cather, in this story, does something to cleanse her own sexual body of the carrion stench of Wilde's victimization, it is thus (unexpectedly) by identifying with what seems to be Paul's sexuality not in spite of but through its saving reabsorption in a gender-liminal (and very specifically classed) artifice that represents at once a particular subculture and culture itself."[13] This example is only one of many within Sedgwick's oeuvre that narrates the nonlinear and nonnormative modes of identification with which queers predicate their self-fashioning. Butler has recently amended Sedgwick's reading of Cather's cross-identification by insisting that such a passage across identity markers, a passage that she understands as being a "dangerous crossing," is not about being beyond gender and sexuality.[14] Butler sounds a warning that the crossing of identity may signal erasure of the "dangerous" or, to use

Sedgwick's word when discussing the retention of the shameful, "toxic." For Butler, the danger exists in abandoning the lesbian or female in Cather when reading the homosexual and the male. The cautionary point that Butler would like to make is meant to ward off reductive fantasies of cross-identification that figure it as fully achieved or finally reached at the expense of the point from which it emanates. While Sedgwick's theorizations around cross-identification and narrative crossing are never as final as Butler suggests, the issues that Butler outlines should be heeded when the precarious activity of cross-identification is discussed. The tensions that exist between cross-identification as it is theorized in Sedgwick's essay and Butler's response to that writing represent important spaces in queer theory that have been insufficiently addressed, in my estimation. The theory of disidentification that I am putting forth is a response to the call of that schism. Disidentification, as a mode of understanding the movements and circulations of identificatory force, would always foreground that lost object of identification, establishing new possibilities while at the same time echoing the materially prescriptive cultural locus of any identification.

Operating within a very subjective register, Wayne Koestenbaum, in his moving study of opera divas and gay male opera culture, discusses the ways in which gay males can cross-identify with the cultural icon of the opera diva. Koestenbaum writes about the identificatory pleasure he enjoys when reading the prose of opera divas' auto/biographies:

> I'm affirmed and "divined"—made porous, open, awake, glistening—by a diva's sentences of self-defense and self-creation.
>
> I don't claim to prove any historical facts; instead, I want to trace connections between the iconography of "diva" as it emerges in certain publicized lives, and a collective gay subcultural imagination—a source of hope, joke, and dish. Gossip, hardly trivial, is as central to gay culture as to female cultures. From skeins of hearsay, I weave an inner life; I build queerness from banal and uplifting stories of the conduct of famous fiery women.[15]

A diva's strategies of self-creation and self-defense, through the crisscrossed circuitry of cross-identification, do the work of enacting self for the gay male opera queen. The gay male subculture that Koestenbaum represents in his prose is by no means the totality of queer culture, but for this particular variant of a gay male life world, such identifications are the very stuff on which queer identity is founded. In his memoir Koestenbaum explains the ways in which opera divas were crucial identificatory loci in the public sphere before the Stonewall rebellion, which marked the advent of the contemporary lesbian and gay rights movement. He suggests that before a homosexual civil rights movement, opera queens were some of the few pedagogical examples of truly grand-scale queer behavior. The opera queen's code of conduct was crucial to the closeted gay male before gay liberation. Again, such a practice of *transfiguring* an identificatory site that was not meant to accommodate male identities is to a queer subject

an important identity-consolidating hub, an affirmative yet temporary utopia. Koestenbaum's disidentification with the opera diva does not erase the fiery females that fuel his identity-making machinery; rather, it lovingly retains their lost presence through imitation, repetition, and admiration. After focusing on the theoretical underpinnings of disidentification, I will turn to the disidentification that is central to Basquiat's project. In what follows, I suggest the ways in which Basquiat and Andy served as divas for each other, divine creatures who inspired and enabled each other through queer circuits of identifications.

Superheroes and Supremacists

Only now is cultural studies beginning to address the tremendous impact of superheroes, cartoons, and comic books in contemporary culture. Basquiat, like Warhol, was fascinated by the persistence and centrality of these characters in the cultural imaginary. Warhol, Roy Lichtenstein, and others blew up such images, calling attention to the art that goes into creating these seemingly artless productions. They zoomed in on every zip dot and gaudy color that made these characters larger than life. Michael Moon and Sasha Torres have forcefully explained the powerful homo-social and homosexual charges that animate these characters in our contemporary cultural mythologies.[16] Although I do not want to foreclose similar inquiries into Basquiat's identification with such images, I want to investigate another salient characteristic of these graphic figures: race. By examining the origins and aesthetics of the superhero, I will suggest that the twentieth-century myth of the superhero was, in its earliest manifestation, a disidentifying cultural formation that informed Pop Art and its legacy.

The American icon Superman first appeared in *Action Comics* #1 in June 1938. It is important to contextualize this first appearance alongside early-twentieth-century racist imaginings of a race of supermen. In their history of the comic book superhero, Greg McCue and Clive Bloom outline some of the cultural forces that helped form the Man of Steel.

> The multitude of supermen in the air was not limited to adventures. In the early twentieth century, America was becoming aware of Nietzsche's *ubermensch* [superman] from *Thus Spoke Zarathustra*. Shaw's allusion to the idea in Man and Superman had made "superman" the translation of choice, replacing "over-man" or "beyond-man." Two young Jewish men (Superman's creators, Jerry Siegel and Joe Schuster) in the united states [*sic*] at the time could not have been unaware of an idea that would dominate Hitler's National Socialism. The concept was certainly well discussed.[17]

McCue and Bloom allude to a connection between the creators' status as Jews and the transfiguration of the anti-Semitic possibility encoded within the popular notion of a "superman." I would push their point further and suggest that the young writer and artist

team not only was "aware" of all the notions of supermen saturating both North American and European culture but also actively strove to respond to it by reformulating the myth of superman outside of anti-Semitic and xenophobic cultural logics. The writers go on to suggest the character's resemblance to other important figures within the Judeo-Christian tradition: "Superman, as a religious allusion, has been indicated as a contributing factor in his creation and continued popularity. The infant Kal-El's (who would eventually grow up to be Superman) space ship can be seen as a modem day cradle of Moses on the cosmic Nile."[18] I suggest that within the myth of Superman, a myth that Basquiat and Warhol both utilized in extremely powerful ways, a disidentificatory kernel was already present. The last son of Krypton is not only a popularized *ubermensch* but, at the same time, the rewriting of Moses, who led the Jews out of Egypt and through such obstacles as the Dead Sea and the desert. For the young Jewish comic creators and the countless fans who consumed their work, the dark-haired alien superman was a powerful reworking and reimagining of a malevolent cultural fantasy that was gaining symbolic force.

If one decodes the signifiers of Jewish ethnicity that are central to the superman's mythic fabric, it becomes clear that in working through the Superman character, its creators were able to intervene in another phobic anti-Semitic fantasy that figured the Jew's body as weak and sickly. Sander Gilman has addressed this issue in *The Jew's Body,* in which he describes the need of the racist science of eugenics to figure morphological difference when discussing the Jew's difference. Such discourses fed the scientific discourse during the Nazi era. Gilman explains the ways in which the Jew's body as weak and sickly was first registered and discusses the Zionist call for a new Jewish body, which was proposed as an antidote to this stereotype: "Elias Auerbach's evocation of sport as the social force to reshape the Jewish body had its origins in the turn-of-the-century call of the physician and Zionist leader Max Nordau for a new 'Muscle Jew.' This view became the commonplace of the early Zionist literature which called upon sport, as an activity, as one of the central means of shaping the new Jewish body."[19] With Gilman's valuable historical analysis posited, we can begin to understand the unique process of ethnic disidentification, a process, once again, of transfiguration and reorganization on the level of identification. Siegel and Schuster displaced dominant racist images of the Jew as pathological and weak by fusing together the dangerous mythologies of the *ubermensch* with something like Nordau's fantasy of the "muscle Jew." The Superman character held onto both these images, like lost objects that could not be dispelled no matter how hateful or self-hating their particular points of origin might be. What is left at the end of this disidentificatory process is a new model of identity and a newly available site of identification.

The eighties saw a painful resurgence of white supremacist activity in the subcultural models of the skinhead and neo-Nazi. With this in mind I want to consider Basquiat's rewriting/reimagining of Superman.[20] His painting titled *Action Comics* is a reproduction of the original cover art for *Action Comics* #1. Stylistically, the painting strays from the earlier Pop practice of reproducing and magnifying the hyper-real perfection of these images.[21] Basquiat's Superman is stripped of its fantasy aura of white

male perfection. Instead of faultless lines, we encounter rough and scrawl-like lines that translate this image to the graphic grammar of a child's perception. The disidentificatory strokes here retain the vibrancy of this fantasy of wanting to be Superman, of wanting to be able to accomplish awe-inspiring feats that only the Man of Steel can accomplish, without retaining the aestheticism of the image. In this painting Superman is, in a manner of speaking, brought back to his roots. Basquiat's rendition of the character and of the classic cover art works to resuscitate the disidentificatory force of the character's first incarnation and appearance.

The same childlike technique is deployed in Basquiat's rendition of Batman and Robin, titled *Piano Lesson*. The title implies the disidentificatory locus of such production, a space that might be imagined as the mandatory childhood piano lesson, a moment when fantasizing about superheroes is a tactic to transcend the boredom of childhood. Batman and Robin appear as though they are being rebuilt in the painting. The familiar superheroes' bodies are fragmented and incomplete. Such a representation connotes the revisionary and transformative effect of disidentification. The half-finished figures connote process, which is exactly how the process of disidentification should be understood.

This disidentificatory impulse is even more prominent in a later painting. The 1983 *Television and Cruelty to Animals* (plate 21) presents a mangled menagerie of cartoon characters. The canvas is populated by a large moose head that we might imagine as Bullwinkle, a stray black eight ball, the familiar Superman insignia, a curious conflation of that insignia and the bat signal, and two crossed-out swastikas. We can say the barrage of images represents a Pop media overload that characterizes postmodern North American childhood and adulthood. But I am more interested in the word images found near the top right-hand section of the painting. Here we see the phrase "POPEYE VERSUS THE NAZIS" written with a shaky black oil stick. This double voiced articulation explicates the schoolyard fantasies of which mythological figure is mightier, "who can beat whom up." More important, it reveals the ideologies of white supremacy that are never too distant from the "good guys" of this collective imaginary. Ideologies that Basquiat's disidentificatory process brings into a new visibility. Ideologies that can be, like the Batman insignia in *Television and Cruelty to Animals,* temporarily crossed out. The superhero insignia is just one of many of the symbols in contemporary culture that Basquiat worked with; other types of signifier on which the artist focused were those that indicated ownership, such as the trademark sign and the copyright symbol. I will now turn to Basquiat's disidentification with the commodity form and its signifiers.

Brand Basquiat

In the previous section I pointedly called attention to Basquiat's disidentification with the cartoon genre. That disidentification was certainly more radical than but not altogether dissimilar from the disidentification that characterized Pop Art's first wave. The variance is the intensity of the disidentificatory impulse and its relation to the image's

aesthetic "realism." A 1984 collaboration between Warhol and Basquiat sharply contrasts these strategies (plate 26). The right side of the canvas displays the classic Pop disidentificatory stance. This strategy was described by Lucy Lippard as the tension that is produced due to the narrow distance between the original and the Pop Art piece.[22] Warhol's Arm & Hammer symbol on the right has the appearance of a seamless reproduction. But the relationship to the original design or "model" is strictly disidentificatory. In Warhol's distinctly postmodern practice, the image's disjunctive relocation calls attention to the trace of human labor, personified in the rolled-up worker's arm that has always been central to the design. This strategy disrupts the normative protocols of the commodity form. Susan Stewart explains the workings of the commodity system in her important study of outlaw representational strategies: "For it is the nature of the commodity system, of its compelling systematicity per se, to replace labor with magic, intrinsicality with marketing, authoring with ushering."[23] The refiguration of the trademark on Warhol's side of the canvas interrupts the erasure of labor by calling attention to the trademark's very inscription, one that, when properly scrutinized, reveals the thematics of labor that the commodity system works to elide.

Basquiat deals with the same subject matter but approaches a critique of the commodity form from a vastly different perspective that is still, within the terms of this analysis, disidentificatory. The circular center in Basquiat's half of the painting is occupied by a dime that features a Black man playing the saxophone. This image calls attention to the often effaced presence of Black production. An intervention like this interrogates the ways in which the United States is, at base, a former slave economy that still counts on and factors in the exploitation and colonization of nonwhite labor. And this is especially true in the arenas of cultural labor. Basquiat's intervention does more than call attention to the artifice and "constructedness" of these images. Basquiat's half of the painting explodes a racial signifier that is often erased in the empire of signs that is the world of U.S. advertising.

Although the compulsive need to periodize different stages and levels of modernity is often the quickest route to stale and static conceptual grids, I do find some of Paul Gilroy's theorizations around the "pre-modern" in modernity a useful apparatus for contemplating the Black horn-blowing body in the center of Basquiat's half of the painting. In an essay whose title asks the provocative question, "Whose Millennium Is This?" Gilroy writes:

> Benjamin says that remembering creates the chain of tradition. His concern is with "perpetuating remembrance," and here, this modern Black consciousness shares something with his blend of Jewish eschatology and Marxism. They converge, for example, in a concern with dissonance, negativity, redemption, and aesthetic stress on pain and suffering. Looking at modern Black art and the social relations that support it can reveal how this remembering is socially and politically organized in part through assertive tactics which accentuate the symbolism of the pre-modern as part of their anti-modern modernism.[24]

The black face, starkly juxtaposed to the white arm, displays the vastly different cultural habitus of the two artists. The face, cartoonish and primitive, but primitive not in a contrived jungle fashion but with the primitivity of childhood, harkens back to a "pre-" moment that might be understood as pre-modern but is also pre- the congealing of subject formation. Its reference point is Black music, which, as Gilroy has argued, is a key signifying practice within Black Atlantic culture: "Music and its attendant rituals provide the most important locations where the unspeakable and unwriteable memory of terror is preserved as a social and cultural resource."[25] In the same way that shame cannot be expurgated in Sedgwick's understanding of the affect of shame's relation to identity formation, this terror, this "unspeakable" terror that Gilroy identifies as being central to diaspora aesthetics and cultural practices, must, like the melancholic subject's lost object, be retained in the matrix of identity and its representations. Basquiat's figure, a shirtless, crudely sketched Black male who plays a saxophone, is a melancholic reverberation that vibrates through the contemporary Pop Art project. Its "sound" evokes and eulogizes a lost past, a childhood, and a memory of racial exploitation and terror.

In Basquiat's disidentificatory project, one encounters a proliferation of trademarks and copyright symbols. Such symbols remind the viewer that the history of consumer culture on which Basquiat is signifying is an economy that was, in no small part, formulated on the premise that the ownership of other human beings was entirely possible. The quotidian dimensions of the commodity form are continually called attention to in paintings such as *Quality Meats for the Public,* where the words swine, poultry, or animated pig are trademarked. As Lauren Berlant, in an essay on national brands and the racialized body, reminds us: "A trademark is supposed to be a consensual mechanism. It triangulates with the consumer and the commodity, providing what W. F. Haug calls a 'second skin' that enables the commodity to appear to address, to recognize, and thereby to love the consumer."[26] I want to argue that the Basquiat brand trademark disrupts the triangulating mediation of consumer and commodity. It does so by producing an effect that Greg Tate has described, when writing about Basquiat's painting, as "an overloaded sensorium counterattacking the world via feedback loop."[27] If all the world's swine and poultry are exposed as always already trademarked, the special imaginary relationship that the trademark mediates is then short-circuited. The second skin is skinned.

Near the end of his too brief career, Basquiat began employing the trademark IDEAL. IDEAL, as used in his 1987 painting *Victor 25448,* clearly represents the national toy brand, but one is also left to think that the statement is reflective of the trademark's status as "consensual mechanism" that makes the commodity object the ideal for which the consumer is always shooting. The particular plight of the Black male consumer is embodied in the Black figure stumbling and falling in the direction of the floating ideal symbols. The Black male's flailing limbs and "x'd-out" eyes are descriptive of the figure's betrayal by the "consensual mechanism" contract. IDEAL is, of course, also reflective of Basquiat's own participation in such a process. Indeed, none

of his paintings can be understood as counter identifications, including straightforward attacks, on commodity culture's iconography insofar as he, too, deals in such practices. The "I" in ideal is a Basquiat who also "deals" like an art dealer or drug pusher in the same consumer public sphere. He is, as I have argued earlier, working on and against a cultural pattern, a pattern that he, through his disidentificatory process, can transfigure.

Stewart has forcefully argued that the connections to be made between "real" graffiti writers and graffiti artists like Basquiat who showed their work in galleries instead of subway trains are nearly nonexistent. I will argue that his mass proliferation of the copyright and trademark sign works in similar ways as the "tags" of the urban graffiti writers she discusses. I make this claim in part because Basquiat began, as the testimony of Fab 5 Freddy attests, as a graffiti artist on the trains and derelict walls of abandoned buildings in New York City. Stewart explains that the graffiti writer's use of the brand name has a disruptive effect on the symbolic economy of the commodity system:

> They have borrowed from the repetitions of advertising and commercial culture as antiepitaph: the names' frequent appearance marks the stubborn ghost of individuality and intention in mass culture, the ironic restatement of the artist as "brand name." Graffiti celebrates the final victory of the signature over the referent, by making claims on the very subjectivity invented by consumerism. In this sense they have gone beyond pop art, which always took on the abstractions of the exchange economy solely as a matter of thematic.[28]

Basquiat's repetitions of trademarks, brand names, figures, and words set up a parallel commodity system that, using the logic of Stewart's argument, produces an individual subject who disidentifies (restructures) the social holding pattern that is the mass-produced subject. Specificities, like race, that are meant to be downplayed or whitewashed in consumer culture rise to the forefront of his production. I do not detect a victory of consumerism in Basquiat's project in the ways in which Stewart sees the graffiti writer's project as being a triumph over consumer capitalism. Instead, I see Basquiat's practice as a strategy of disidentification that retools and is ultimately able to open up a space where a subject can imagine a mode of surviving the nullifying force of consumer capitalism's models of self.

Stewart's charge that Pop Art, because of its location and complicity within consumerism, has made its critique operational only on the level of iconography and thematics is ultimately too sweeping an indictment. The notion that one is either co-opted by consumerism or fighting the "real" fight against it poses a reductive binarism between representation and "reality." If Stewart's locution is uncontested, the work of making queer culture in a homophobic world, as in the case of Warhol, or representing Black male youth culture in places where it has been systematically erased (like the SoHo gallery) would register only as the rumblings of bourgeois society's assimilation

machine. In the next section I will explore the role of fame, assimilation, and the politics of disidentification that were central to the work of both Basquiat and Warhol.

Famous

This section is concerned with questions of Warhol's and Basquiat's interpersonal identifications and their collaborations as both celebrities and artists, and with the thematic of fame that concretely links these two personas. Before considering Basquiat's unstable identifications, disidentifications, and counter identifications with Warhol, I want to gloss some of the ways in which Jean-Michel meant much to Andy. First the art. In 1984 Warhol explained that "Jean-Michel got me into painting differently, so that's a good thing." Indeed if we look at Warhol's work after his collaboration with Basquiat, we see a renewed interest in painting by hand, which he had done little of, beyond some abstract backgrounds, since 1962. Warhol's star status was equally revitalized by Basquiat. Few would deny that making appearances with hot young art world superstars such as Basquiat and Keith Haring upped Andy's glamour ratings. Basquiat also provided Andy's infamous diary with many a juicy gossip tidbit. The following passage from Saturday, May 5, 1984, recounts a story that is uncharacteristically sentimental for Warhol:

> It was a beautiful and sunny, did a lot of work. Called Jean-Michel and he said he'd come up. He came and rolled some joints. He was really nervous, I could tell, about how his show was opening later on at Mary Boone's. Then he wanted a new outfit and we went to this store where he always buys his clothes. He had b.o. We were walking and got to Washington Square Park where I first met him when he was signing his name "SAMO" and writing graffiti and painting T-shirts. That area brought back bad memories for him. Later on his show was great, though, it really was.[29]

In this passage we hear a bit of the complexity of Warhol's identification with Basquiat. Warhol's sensitivity to Basquiat's "bad memories" of his seedy days as a graffiti artist selling hand-painted T-shirts in Washington Square Park might very well echo his own discomfort with his past, his own inability to reconcile completely that past with his present. The mention of joints further signifies with Andy's later disavowal of the crazy people and drug addicts who populated the Factory days. We also hear Warhol's bitchy "b.o." comment that served to temper his identification with Basquiat. But finally Basquiat's victory at Mary Boone is for the older artist both an identification with Warhol's former early successes and a victory for Warhol because of his, at the time, current investment in the twenty-four-year-old artist. There is also a much more poignant identification that Warhol records in the diaries, an August 5, 1984, outing to a party at the Limelight for Jermaine Jackson. The bouncers at the door are described as "dumb Mafia-type of guys who didn't know anyone." After being rejected at the door, Basquiat turned to Warhol and exclaimed, "Now you see how it is to be Black."[30]

Basquiat's formal disidentification—his simultaneous working with, against, and on Warhol's production—is uniquely thematized in a collaboration with Warhol that depicts one of Warhol's motorcycle images and one of Basquiat's distinctive distorted figures. The enlarged image of the motorcycle from a newspaper ad is an image that Warhol repeated throughout his mid-1980s black-and-white and Last Supper series. The Black figures that Basquiat contributes to the frame work once again to show the Black presence that has been systematically denied from this representational practice. These primitive jet-black images look only vaguely human and bare sharp fangs. Through such representations Basquiat ironizes the grotesque and distortive African American presentations in consumer culture. In this canvas, as in many of the other Warhol-collaborations, the smooth lines of Warhol's practice work as a vehicle for Basquiat's own political and cultural practice.

My essay's title is a riff taken from the Disposable Heroes of Hiphoprisy. In their 1992 song "Famous and Dandy like Amos 'n' Andy," the fictional characters are an entry point into a hip hop meditation on the history of Black media representation and the price of fame for African Americans. These are, of course, important thematics for Basquiat. (Basquiat used and trademarked names of characters from the early radio and TV show in some of his paintings.) To be sure, fame is of tremendous import for both of this essay's subjects, but a comparison of one of Basquiat's famous Black athlete images with Warhol's portraits illustrates the world of difference between these two disidentificatory impulses and the aesthetic effects they produce. Warhol's portraits of Liza, Marilyn, Liz Taylor, Elvis, and so on are not so much portraits of celebrities as they are of fame itself. Although it can be argued that Basquiat's paintings also treat fame as a subject, his formulations enact the disturbing encounter between fame and racist ideology that saturates North American media culture. The famous Negro athlete series reflects the problem of being a famous Black image that is immediately codified as a trademark by a white entertainment industry. The deployment of the word "Negro" is a disidentification with the racist cultural history that surrounds the history of both sports in the United States and the contested lives of African Americans in general. The simplicity of the following image exposes these dynamics of being famous and ethnically identified in U.S. culture: we see a trinity of three images, a hastily scrawled black head, a crown symbol that accompanied most of the paintings in this series and a baseball. The controversy that ensued in 1992 when the owner of one major league baseball team, Marge Schott, referred to one of her players as "a million-dollar nigger" makes a point that Basquiat was making in this series: the rich and famous Black athlete is not immune to the assaults of various racisms. Within such racist imaginings, the famous Black athlete is simply equated with the ball and other tools of the trade. Basquiat interrupts this trajectory by inserting the crown symbol between the man and the object. The crown was an image that Basquiat has frequently used to symbolize the rich history of Africans and African Americans. The crown, or the title of "King," is, as Stewart explains, a title used to designate the supremacy of graffiti artists who were best able to proliferate and disseminate their tags.

Fab 5 Freddy explained Basquiat's famous Negro artist series in the following way: "And like a famous Negro athlete, Jean-Michel slid into home. He stole all three bases, actually, and then slid into home. Home being Mary Boone's gallery."[31] I want to engage this metaphor further and speculate that home base was also embodied in Basquiat's relationship with Warhol. The painting *Dos Cabezas* (plate 9) depicts two rough sketches of both artists' faces lined up side by side, on an equal level. It also translates Andy's head into Spanish, setting up a moment of interculturation that is typical of both Basquiat's work and other examples of disidentification that can be found in U.S. culture.

The ways in which these two artists cross-identified, disidentified, and learned with and from each other also suggest the political possibilities of collaboration. The relationship of queerness and race is often a vexed and complicated one within progressive political arenas. When these identity shards are positioned as oppositional, they often split and damage subjects whose identifications vector into both identificatory nodes. Often the models and examples set by Pop Art in general and Andy Warhol in particular influenced Basquiat in innumerable ways. And, in turn, Basquiat rejuvenated both Pop Art and Warhol by exploding racial signifiers that had been erased, obstructed, or rendered dormant by the discourse. I want to make the point that these disidentificatory cultural practices and the coterminous interpersonal identificatory crossings and crisscrossing that Basquiat made with Warhol and Warhol with Basquiat were indispensable survival practices for both these marginalized men.

Melancholia's Work

My theoretical understanding of disidentification has been, as I have stated above, informed by the structure of feeling that is melancholia. In this final section I will further investigate the relationship of melancholia to disidentification within Basquiat's work, in an effort to make these connections more salient. I want to consider a photograph of Jean-Michel Basquiat. The portrait was one of the last photographs taken by James VanDerZee, the famous Harlem-based studio photographer whose career spanned five decades. The younger artist seems strangely comfortable in the gilded Edwardian trappings of VanDerZee's studio (see page 338). His look away from the camera and the heaviness of his head, being held up by his hand, connotes this certain quality of melancholia. I look at this image and feel the call of mourning. I reflect on the subject's short and tragic life in the New York avant-garde scene, his early death from a drug overdose, the loss of this artist, and all the paintings that were left undone. In this final stage of his career, VanDerZee produced many portraits of important African Americans, including Muhammad Ali, Romare Bearden, Lou Rawls, Eubie Blake, Ruby Dee and Ossie Davis, and Max Robinson, the first African American to land a position as a national newscaster. Robinson died of complications due to AIDS. To look at his portrait now is indeed to summon up the dead, to put a face and voice on the countless Black bodies that have been lost in the epidemic.[32] Basquiat, who died

of a drug overdose the same year as Robinson, also embodies this moment of crisis in communities of color where young men are mercilessly cut down by the onslaught of the virus, the snares of a too often deadly drug addiction, and a U.S. criminal justice system that has declared open season on young male bodies of color.

Basquiat understood the force of death and dying in the culture and tradition around him; his art was concerned with working through the charged relation between Black male identity and death. He, like VanDerZee, understood that the situation of the Black diaspora called on a living subject to take their dying with them. They were baggage that was not to be lost or forgotten because ancestors, be they symbolic or genetically linked, were a deep source of enabling energy that death need not obstruct.

Disidentification, as I have suggested above, shares structures of feeling with Freudian melancholia, but the cultural formations I am discussing are not, in the Freudian sense, the "work of mourning." Laplanche and Pontalis describe the work of mourning as an "intrapsychic process, occurring after the loss of a loved object, whereby the subject gradually manages to detach itself from this object."[33] The works of mourning here offer no such escape from the lost object. Rather, the lost object returns with a vengeance. It is floated as an ideal, a call to collectivize, an identity-affirming example. Basquiat saw the need to call up the dead, to mingle the power of the past with the decay of the present. bell hooks has recently commented on Basquiat's paintings of famous Negro athletes: "It is much too simplistic to a reading to see works like *Jack Johnson* or *Untitled (Sugar Ray Robinson),* 1982 [plate 13], and the like, as solely celebrating Black culture. Appearing always in these paintings as half-formed or somehow mutilated, the Black male body becomes, iconographically, a sign of lack and absence."[34] hooks is correct to shut down any reading that suggests these twisted shapes are anything like purely celebratory. But I do take issue with her reading of "lack" in the work. The lines that Basquiat employs are always crude and half-formed, and while they do signify a radical lack of completeness, they also hearken back to a moment when a child takes a pencil to paper and, in a visual grammar that is as crude as it is beautiful, records the image of a beloved object, of a person or thing that serves as a node of identification, an object that possesses transcendent possibilities. The power of this black painting has to do with the masterful way lack and desire are negotiated. The painting itself stands in for another lost object, childhood. The famous Negro athletes series works as a disidentification with the stars of an era when Black representations were only the distorted images of athletes and the occasional performer that the white media deemed permissible.

Jazz great Charlie Parker was another of Basquiat's heroes, and Basquiat produced a creation that works as gravestone/mourning shrine for a lost hero (plate 8). Again the lines are, as bell hooks would put it, half-formed. In these half-formed lines we find a eulogy of great power and elegance. The structure (a tied together wooden pole structure) records Parker's name and gives his place of death (Stanhope Hotel) and the month and day he was memorialized at Carnegie Hall. The artist bestows royal status

on the musician by renaming him Charles the First. Such a shrine is not as elegant and gilded as James VanDerZee's tributes to the dead. But this option is not available to Basquiat because the hurried pace of postmodernity no longer allows for the wistful and ethereal spaces of VanDerZee's portraits. Basquiat's objects also display the impulse to mourn, remember, and flesh out, but such achieved through different strategies than those of the portrait photographer. Basquiat's paintings effect this mourning through urgency, speed, and frantic, energized lines.

One of the artist's last finished paintings, *Riding with Death* (1988) (plate 35), poses the Black male body as death's horseman, riding and manipulating the pale specter. Many critics have read this painting in the light of Basquiat's death and found it ironic and delusional. I want to read *Riding with Death* under the pressure of the epidemics that now massacre millions of people of color. I want to read the painting as a call to do what Basquiat was able to do in his practice: to acknowledge and respond to the power of death and the dead in our lives. The Black body mounting the white skeleton is brown and fleshed out in ways that many of his Black male figures are not.[35] But the body is also highly abstracted, the face is crossed out by black scrawl, the hands and arms are only traces in black oil stick. This incompleteness is also true of the skeleton, which is missing a torso. The skeleton is a bright white that is almost illuminated by the gray-green background. Its whiteness is reminiscent of Warhol's own, overwhelming whiteness. This whiteness can then stand in for a fantasy of Black bodies not being burdened and mastered by whiteness, a fantasy space where the artist asserts his own agency in the relations of power in which he is imbricated because of his associations with the mainstream art world. I am not suggesting that whiteness is simply white people or the "white establishment." Instead, I read this painting as being about the complicated function of disidentification where oppressive, shameful, and sometimes dangerous cultural influences and forces are incorporated, mediated, and transfigured.

bell hooks has written that "Basquiat paintings bear witness, mirror this almost spiritual understanding. They expose and speak the anguish of sacrifice. It is amazing that so few critics discuss configurations of pain in his work, emphasizing instead its playfulness, its celebratory qualities."[36] hooks is right, again, to point out the problems in the artist's critical reception. To look at Basquiat as a ludic painter is to put the mask of the minstrel show on him. Like hooks, I see the pain and anguish in his productions, but to this I would add a powerful impulse in the artist's work to record a Black life world that is complex and multilayered.[37] *Riding with Death* is an excellent example; in it we see Black bodies tarrying with death and destruction. But Basquiat's images do more than connote the destruction of the Black body. They also strategize survival and imagine assertions of self in a cultural sphere that is structured to deny visibility to such bodies.

hook's greatest reservation about Basquiat's body of work is what she understands as his gender trouble: "What limits the body in Basquiat's work is the construction of maleness as lack. To be male, caught up in the endless cycle of conquest, is to lose out

in the endless cycle of fulfillment. Significantly, there are few references in Basquiat's work that connect him to a world of Blackness that is female or a world of influences and inspirations that are female."[38] Because Basquiat chose to represent Black males almost exclusively and almost always in crisis, hooks figures the masculinity depicted in his oeuvre as lack primarily because of the absence of the female.[39] This line of argument echoes a previous theoretical maneuver by Hortense Spillers, who, in her influential essay "Mama's Baby; Daddy's Maybe: An American Grammar," argues that African American culture in the United States has been misnamed as matriarchal by manifestations of white male patriarchy such as the "Moynihan Report."[40] The "Moynihan Report" figured the Black family as dysfunctional because of what was perceived as the weakness of Black male role models and the dominance of the Black woman.[41] Spillers challenges this cultural myth by arguing that "when we speak of the enslaved person, we perceive that the dominant culture, in a fatal misunderstanding, assigns a matriarchist value where it doesn't belong: actually misnames the power of the female regarding the enslaved community. Such naming is false because the female could not, in fact, claim her child, and false once again, because 'motherhood' is not perceived in the prevailing social climate as a legitimate procedure of cultural inheritance."[42] I want to call on Spillers's valuable appraisal of the way in which dominant culture figures an overabundance of Black womanhood as the problem when discussing the status of African Americans within U.S. culture. I am suggesting that hooks's thesis is a reversal of the very same logic that the "Moynihan Report" disseminated in 1965. This inversion (African American men as lack instead of African American women as excess) still subscribes to the ideology of Black men and Black masculinity as "an absence and a negation." It also positions Black women as something of a magical excess that can correct the failings of Black men. The point made by hooks thus seems like a reversal of psychoanalysis's understanding of woman as lack—once again, an inversion that seems just as unproductive. Representing the complicated and dire situation of Black masculinity in U.S. culture is important cultural work that should not be disavowed as a limitation. It is also important to note that the logic of hooks's argument relies on a presumption that if the artist incorporated more female influences and inspirations (assuming a spectator or critic can ever know what such forces might be), his lack would be filled. This formulation potentially reinscribes a heterosexist fantasy that the fulfilling of a normative male and female dyad would flesh out the incompleteness of the artist's production. While I do not mean to imply that no need exists for potentially productive alliances across gender (and sexuality) that can be formed in the African diaspora, I nonetheless see problems with hooks's formulation. The danger lies precisely at the point when any enslaved person, to use Spillers's description of people of color in the United States, is understood as incomplete because they chose to deal with the specificities of their gender and race coordinates without involving the opposite sex. I wish to suggest that such gender normative thinking, when not checked for its heterosexist presumptions, leads to politically unproductive ends.

There was a certain quality of melancholia intrinsic to the African American male cultural worker, a quality that was absolutely necessary to navigate his way through a racist and genocidal landscape. Which is not to say that mourning and genocide are salient thematics in the cultural production of African American women.[43] But it is to say that a recent history of African American masculinity would read like VanDerZee's funeral book.[44] And this is especially true of Basquiat's painting. The shrines, altars, and portraits that Basquiat produced are not limited to the status of works of mourning. I want to suggest that within them is the potential to become meditative texts that decipher the workings of mourning in our culture. They are melancholic echoes, queer reverberations, that make possible an identity or cluster of communal identifications that are presently under siege.

Notes

1. While the racism that Basquiat encountered in the eighties art world (or even now in his work's critical reception) is not my primary concern here, it is important to mention the adverse climate to which he was, in part, responding. This case has been documented in many of the essays published in the recent catalog of the Whitney Museum of American Art's retrospective of Basquiat's work. See Richard Marshall, ed., *Jean-Michel Basquiat* (New York: Whitney Museum of American Art, 1992). bell hooks offers a powerful reading of the racist slant in art journalism concerning Basquiat in her essay "Altar of Sacrifice: Remembering Basquiat," *Art in America*, June 1993, 68–117. Greg Tate elegantly defended Basquiat in his important essay "Nobody Loves a Genius Child: Jean-Michel Basquiat, Lonesome Flyboy in the '80s Art Boom Buttermilk," *Village Voice*, November 14, 1989, reprinted in *Flyboy in the Buttermilk: Essays on Contemporary America* (New York: Simon and Schuster, 1992). In that essay Tate produces a damning indictment of the New York art world: "No area of modern intellectual life has been more resistant to recognizing and authorizing people of color than the world of the 'serious' visual arts. To this day it remains a bastion of white supremacy, a sconce of the wealthy whose high walled barricades are matched only by Wall Street and the White House and whose exclusionary practices are enforced 24-7-365. It is easier for a rich white man to enter the kingdom of heaven than for a Black abstract and/or conceptual artist to get a one woman show in lower Manhattan, or a feature in the pages of *Artforum*, *Art in America* or *The Village Voice*." (234).

2. Fred Brathwaite, "Jean-Michel Basquiat," *Interview*, October 1992, 112.

3. J. Laplanche and J. B. Pontalis, *The Language of Psycho-Analysis*, trans. Donald Nicholson-Smith (New York: W. W. Norton, 1973), 206.

4. Louis Althusser, *Lenin and Philosophy and Other Essays*, trans. Ben Brewster (New York: Monthly Review, 1971), 127–87.

5. Michel Pecheux, *Language, Semantics, and Ideology* (New York: St. Martins, 1982).

6. Judith Butler, *Bodies That Matter: On the Discursive Limits of "Sex"* (New York: Routledge, 1993), 219. Žižek's discussion of disidentification can be found in Slavoj Žižek, *The Sublime Object of Ideology* (New York: Verso, 1991).

7. Butler, *Bodies That Matter*, 219.

8. One of Freud's accounts of identification can be found in *Group Psychology* and the *Analysis of the Ego*, trans. James Strachey (New York: W. W. Norton, 1959). In this book Freud schematizes three types of identification: the original emotional tie with an object, which is central to the theory of the Oedipus complex; identification with a substitute for a libidinal object; and a nonerotic identification with a subject who shares common characteristics and investments. The first route is clearly the road to normative heterosexual identity formation. The second notion of identification

is the pathologized and regressive possibility that can account for the taking on of various queer object choices. In this mode of identification the object is not successfully transferred as it is in the Oedipal identificatory circuit. Instead, what I understand as a *queer* introjection occurs and circumvents such identifications. The final option allows for identifications that are same-sex and decidedly nonerotic, thus permitting same-sex group identifications that are not "regressive" or pathological. Throughout Freud there is a curious interlacing of desire and identification. Identification with a same-sex model is necessary for the process of desiring an opposite-sex object choice. "Desire" is then, for Freud, a term that is reserved for normative heterosexuality, and homosexual emotional and erotic connections are talked about in terms of "identification." The theory of disidentification proposed here is offered, in part, as a substitute to this Freudian model, even though its workings also depend on certain forms of introjection, as described in Freud's second modality of identification. In what follows I make links between my understanding of disidentification and the Freudian and post-Freudian understanding of melancholia. Melancholia is a process that also depends on introjection. In my analysis this introjection is described as the "holding on to" or incorporation of or by a lost object.

9. Eve Kosofsky Sedgwick, "Queer Performativity: Henry James's *The Art of the Novel,*" *GLQ* 1, no. 1 (Summer 1993): 13.

10. Michele Wallace, "Race, Gender, and Psychoanalysis in Forties Film: Lost Boundaries, Home of the Brave, and The Quiet One," in *Black American Cinema,* ed. Manthia Diawara (New York: Routledge, 1993), 257.

11. Wallace, 264 (emphasis mine).

12. Toni Morrison, "Unspeakable Things Unspoken: The Afro-American Presence in American Literature," *Michigan Quarterly Review* 28, no. 1 (Winter 1989): 14. Morrison goes on to delineate these ideas further in her study *Playing in the Dark: Whiteness and the Literary Imagination* (Cambridge, MA: Harvard University Press, 1992).

13. Eve Kosofsky Sedgwick, "Across Gender, Across Sexuality: Willa Cather and Others," in *Displacing Homophobia: Gay Male Perspectives in Literature and Culture,* ed. Ronald R. Butters, John M. Clum, and Michael Moon (Durham, NC: Duke University Press, 1989), 65.

14. Butler, *Bodies That Matter,* 143–66.

15. Wayne Koestenbaum, *The Queen's Throat: Opera, Homosexuality, and the Mystery of Desire* (New York: Vintage, 1993), 84–85.

16. See their essays in this volume.

17. Greg McCue and Clive Bloom, *Dark Knights: The New Comics in Context* (Boulder, CO: Pluto, 1993), 20.

18. McCue and Bloom, 20.

19. Sander Gilman, *The Jew's Body* (New York: Routledge, 1991), 53.

20. A recent disidentification with the superhero form, operating on an entirely different cultural register, can be seen in the emergence of Milestone Comics. Milestone has rewritten Superman, for instance, in the form of Icon, an alien child who was not found by white Kansas farmers but instead by slaves on a nineteenth-century plantation in the United States. The shapeless alien took on the racial characteristics of the earth people who discovered him and "passes" as an African American human. It is interesting to note that the Milestone comic book universe is also populated with more gay, lesbian, Asian, and Latino characters than are the books of any other major U.S. comic company. For an informative journalistic account of the Milestone revolution in comics and a survey of the African American superhero, see Gary Dauphin, "To Be Young, Superpowered and Black, Interdimensional Identity Politics and Market Share: The Crisis of the Negro Superhero," *Village Voice,* May 17, 1994, 31–38.

21. Warhol himself, as Moon has shown us, was not content just to "reproduce" Superman's image. He also let the paint splashes rupture the illusion of comic book perfection. Basquiat, in my estimation, follows this lead in his "homages" to childhood heroes.

22. Lucy Lippard, *Pop Art* (New York: Praeger, 1966).

23. Susan Stewart, *Crimes of Writing: Problems in the Containment of Representation* (New York: Oxford University Press, 1991), 207.

24. Paul Gilroy, "Whose Millennium Is This? Blackness: Pre-Modern, Post-Modern, Anti-Modern," in *Small Acts: Thoughts on the Politics of Black Cultures* (New York: Serpent's Tail, 1993), 164.

25. Gilroy, 164.

26. Lauren Berlant, "National Brands/National Bodies: Imitation of Life," in *Comparative American Identities: Race, Sex, and Nationality in the Modern Text,* ed. Hortense Spillers (New York: Routledge, 1991), 121.

27. Tate, *Flyboy in the Buttermilk,* 231.

28. Stewart, *Crimes of Writing,* 227.

29. Andy Warhol, *The Andy Warhol Diaries,* ed. Pat Hackett (New York: Warner Books, 1989), 572.

30. Warhol, 592.

31. Quoted in Brathwaite, "Jean-Michel Basquiat."

32. See Philip Brian Harper, "Eloquence and Epitaph: Black Nationalism and the Homophobic Impulse in Responses to the Death of Max Robinson," *Social Text* 28, no. 9.3 (1991): 68–86, for an excellent discussion on the African American reception of Robinson's life and death.

33. Laplanche and Pontalis, *Language of Psycho-Analysis.*

34. hooks, "Altar of Sacrifice," 71.

35. hooks rightfully explains that "in Basquiat's work, flesh on the black body is almost always falling away." hooks, 71.

36. hooks, 74.

37. For an interesting discussion of the "Black life world," see Manthia Diawara, "Noir by Noirs: Towards a New Realism in Black Cinema," in *Shades of Noir,* ed. Joan Copjec (New York: Verso, 1993), 261–79.

38. hooks, "Altar of Sacrifice," 74.

39. Greg Tate also points out the occlusion of Black women in Basquiat's art, but he arrives at a very different understanding of this trend in the painter's work: "If you're Black and historically informed there is no way you can look at Basquiat's work and not get beat up by the Black male's history as property, pulverized meat, and popular entertainment. No way not to be reminded that lynchings and minstrelsy still vie in the white supremacist's imagination for the Black male body's proper place" (*Flyboy,* 238). I wish to assert that Tate's statement should not be seen as an attempt to deny the history of the Black female body's exploitation under white supremacy. Instead, I see his statement, like Basquiat's paintings, as an explication of the specific position of Black men in the dominant culture's imagination.

40. Hortense Spillers, "Mama's Baby, Papa's Maybe: An American Grammar Book," *Diacritics* 17, no. 2 (Summer 1987): 65–81.

41. Daniel P. Moynihan, "The Moynihan Report," in *The Negro Family: The Case for National Action* (Washington, DC: US Department of Labor, 1965), reprinted in *The Moynihan Report and the Politics of Controversy: A Transaction Social Science and Public Policy Report,* ed. Lee Rainwater and William L Yancey (Cambridge, MA: MIT Press, 1967), 47–94.

42. Spillers, "Mama's Baby," 80.

43. A more recent cultural text that examines the workings of mourning and melancholia from a female perspective is Toni Morrison's *Jazz,* a novel that, like this chapter's final section, is inspired by a James VanDerZee photograph. Set in Harlem in 1926, seven years after the armistice, the book concerns a door-to-door salesman who is married and fifty and who meets and completely falls in love with an eighteen-year-old girl. The affair ends with the older man, the aptly named Joe Trace, sick and mad with love, shooting the young woman, Dorcas, in a fit of passion. The tragedy becomes even more profound when Joe's wife, Violet, in a fit of blinding madness, lashes out with a knife during the girl's funeral. Mourners look on horrified as the beautiful, light-skinned girl's face is mutilated. And this is where the book begins. It goes on to tell the story of the way in which Dorcas's

face, captured in a photograph on the mantelpiece, haunts Joe and Violet. The character of Violet embodies an aspect of African American female mourning. Her story is, like the Basquiat paintings discussed in this section, a meditation on the workings of mourning in African American culture. Toni Morrison, *Jazz* (New York: Alfred A. Knopf, 1992).

44. See my essay "Photographies of Mourning: Melancholia and Ambivalence in Van der Zee, Mapplethorpe, and *Looking for Langston*," in which I offer an account of the specificities of Black male mourning in twentieth-century U.S. cultural production. In *Race and the Subject of Masculinities*, ed. Michael Uebel and Harry Stecopoulos (Durham, NC: Duke University Press, 1995).

LOST IN TRANSLATION
JEAN-MICHEL IN THE (RE)MIX

KELLIE JONES, 2005

> According to popular perception, both within the western metropolitan psyche and in
> the critical strategies of postcolonial discourse, the daydream of a diasporic community
> is always lodged in an imaginary locale, in an elsewhere, far from the articulate
> inscription of native utterance. It is usually symbolically invested, and ceaselessly
> organized outside the principalities of any originary geography.
>
> <div align="right">Okwui Enwezor[1]</div>

Prelude: Questions for Curators

1: Did you know Jean-Michel Basquiat?

On the Reverend Dr. Martin Luther King, Jr., holiday I get my inspiration for this
essay from a friend's five-year-old son, G, who has just learned about MLK in school.
He refers to him interchangeably as Dr. King, Dr. Martin Luther King, and Martin.
"And did you know, Mami, he got shot?"

2: How well did you know Jean-Michel Basquiat?

Everyone has a Jean-Michel story. It wouldn't be a Jean-Michel show without one.
Mine is this. I met him on the dance floor at a Spike Lee party at the Puck Building in
'87. . . . We wuz on top of the world. Or as Ntozake said, "We wuz girlz together." We
rocked and rolled in the eighties, when kolored wuz king (yit agin). But Jean-Michel
wuz in another realm, in the stratosphere. . . . Anyway, there I wuz on the dance floor
and Fab 5 Freddy introduces us. He says, "This girl's a curator" (translation: "This girl's
a curator and low and behold she's kolored"). But did he say I could dance?

The Artist in the World

For many years now the art of Jean-Michel Basquiat has commanded some of the
highest prices of any African American artist in United States history. Like that of
most of his African American compatriots, his work was under-appreciated by U.S.
cultural institutions during his lifetime. And also as with so many others, both he

Kellie Jones, "Lost in Translation: Jean-Michel in the (Re)Mix," in *Basquiat,* exh. cat. (New York: Brooklyn
Museum, 2005), 163–79.

and his oeuvre were more palatable after his death. But the irony is that with price tags in the millions, it is doubtful that many of these works will ever get into these same hallowed [hollowed?] halls except through the magnanimity of some private individuals.

But it is not just that prices are high, or that Basquiat has made it into the realm of famous art-star ancestors, commanding cash, recognition, and respect. The real deal is that Basquiat's aesthetic presence, his vision, his impact and effect, are, in the words of sixties R & B legends the Temptations, "So high you can't get over it, so low you can't get under it."[2] Or, as the anthropologist Grey Gundaker has argued about dynamic African American cultures generally, "[T]he fruits of the relatively new enterprise of African American studies suggest that there is too much information on too many levels—and too much more to learn—to expect anything less than a wide-ranging network of connections."[3]

Indeed, there is much more to Basquiat's work and intellect than meets the eye. He was a master of seemingly exposing things—the skeleton, the infrastructure, the core language of art and life—yet at the same time he occluded origins, influences, and skill with layers of a frenetic, always-in-a-hurry style.

He is, of course, an exquisite painter, as seen in the minute details that swim to the surface in works such as *Leonardo da Vinci's Greatest Hits* or the self-assured figure in *St. Joe Louis Surrounded by Snakes*. But he also created engaging color-field surfaces, as in *King Pleasure*. The drawings are phenomenal as well: some are spare, economical meditations, distillations of an idea into the meanderings of line; others are dense with deposits of marks and words. Basquiat's almost overwhelming wordplay points to the profound conceptualism of his project, which is also visible in his rare three-dimensional objects. A piece like *Untitled (Helmet)* (plate 7), with black hair glued to a football helmet, riffs on David Hammons's decade-long project in a similar vein (check out Hammons's *Nap Tapestry*, 1978). Basquiat's *Self-Portrait* (1985) reveals a surface cluttered with bottle caps that also echoes Hammons's *Higher Goals* of the same year, a take on sports as both ghetto exit strategy and unattainable dream of Black manhood. This dialogue with Hammons suggests Basquiat's ease in speaking on the conceptual plane. It shows he didn't have to be, but rather chose to be, a painter.

Part of Basquiat's strategy of occlusion was "playing the primitive." Selling shirts and objects in Washington Square Park. Affixing his name to urban corners, a middle-class boy from Brooklyn in the guise of graffiti artist. Like John Guare's protagonist, the gay hustler Paul, in the play *Six Degrees of Separation*, who makes his way into restricted social circles and homes by (mis)representing himself as the son of the actor Sidney Poitier, Basquiat cruised into the art world on the runaway subway train of graffiti, which was fueled in part by the stirrings of eighties multiculturalism. Basquiat's success and his investment in and comments on the art world's star-making process play a part in his fascination with brands and trademarks. As the cultural critic José Esteban Muñoz has written, the tag IDEAL, which appears in the late work, points at once to a nationally recognized brand name of a toy maker, to the false moral value

placed in consumer products, and to the artist himself, the "I" who not only "deals" in "the same consumer public sphere" but makes his way, rising to the top of the art-world heap.[4]

Basquiat and multiculturalism were the right combination, in the right place, at the right time. Indeed the critic Greg Tate has argued the same of Jimi Hendrix, who infused the British rock scene with new blood at a crucial moment. As Tate writes of Basquiat and crew at the turn of the 1980s, "Poised there at the historical moment when Conceptualism is about to fall before the rise of the neo-primitive upsurge . . . hip-hop's train-writing graffiti cults pull into the station carrying the return of representation, figuration, expressionism, Pop-artism, the investment in canvas painting, and the idea of the masterpiece."[5] Yet interestingly, as Tate also reminds us, Basquiat arrives not with the waves of bold color that signal outlaw urban painting, hues that would later characterize his own canvases, but with spare texts sprayed in black on peeling walls; he comes to us "as a poet."[6]

As Marc Mayer and Fred Hoffman point out in their essays in this book, there is no question that Jean-Michel Basquiat, though he sometimes chose to obscure the fact, knew how to "paint Western art," and was a formidable part of that tradition.* Yet American painting, specifically, and the Western art tradition in general were only one source of Basquiat's aesthetic. As Tate writes, "Initially lumped with the graffiti artists, then the Neo-Expressionists, then the Neo-Popsters, in the end Basquiat's work evades the grasp of every camp because his originality can't be reduced to the sum of his inspirations, his associations, or his generation. . . . He has consumed his influences and overwhelmed them with his intentions."[7] Indeed Basquiat is imbricated in, and draws on, not only the story of Western mark- and art-making but the immense history of the globe itself, *In Italian,* as one painting tells us, as well as in Greek, English, Ebonics, French, and Spanish. These paintings display modernity in their very facture but also overwhelmingly in their content. They constitute a chronicle of the world in modern form, connected through waves of history and histories of power. As the scholar Arjun Appadurai has pointed out, artists like Basquiat "annex the global into their own practices of the modern."[8]

To the extent that Basquiat is a New World citizen and an African American, he inherits a hybridized African culture that is a key ingredient in the cultures of the Americas. Speaking of the Cuban artist Wifredo Lam, the curator Gerardo Mosquera has discussed modernism as "space to communicate Afro-American cultural meanings."[9] A plethora of African civilizations arriving on American shores in continuous waves (as well as over them) from the seventeenth through the nineteenth centuries is carried in "religious-cultural complexes"[10] like Santeria, Voodoun, Candomble, and Shango, and I would add Hoodoo, as well as through folktales, gesture, performance, and aspects of attendant material culture production. Rather than seeing these as

* See Marc Mayer, "Basquiat in History," and Fred Hoffman, "The Defining Years: Notes on Five Key Works," in *Basquiat,* exh. cat. (New York: Brooklyn Museum, 2005), 41–57, 129–39.

struggling "survivals," Mosquera speaks of African culture "on the other side of the Atlantic" as flexible, appropriative, transformational, and dynamic, leading finally to Lam and his creative dialogues with the Caribbean and African Negritude poets in the fashioning of a "neological construction of a Black paradigm," or a twentieth-century, modernist, diasporic culture.[11]

The cultural critic Stuart Hall sees the New World of the Americas as a "primal scene" not simply of the encounter of cultures but of displacement and migration, and as one originary site of diaspora.[12] For Hall, within this geographic and psychic space "Africa, the signified which could not be represented directly in slavery, remained and remains the unspoken unspeakable 'presence' in Caribbean culture."[13] While this may seem to be the antithesis to Mosquera (and perhaps represents the differences of the Caribbean seen from Anglophone Jamaica and Hispanic Cuba respectively), Hall's focus on the "unspoken" and "unspeakable" African life of the New World derives more from its dialectical relationship to the over determining European presence there, "which is endlessly speaking—and endlessly speaking us." And he asks, "[H]ow can we stage this dialogue [with Europe] so that, finally, we can place it, without terror or violence, rather than being forever placed by it?"[14]

One aspect of Basquiat's genius was his ability to "consume his influences and over-whelm them with his intentions," as Tate has noted; that is, not to be placed by Euro-pean tradition but to place and reassign *it*, to remind us that Europe as it appears on this side of the pond is "always-already fused, syncretized"; in other words, it is a ver-sion of Europe in the process of becoming American.[15] His skill was also in his ener-getic articulations of the "neological construction of a Black paradigm," as outlined by Mosquera.

However, Basquiat's mischievous, complex, neologistic side, with regard to the fashioning of modernity and the influence and effluence of Black culture, is often elided by critics and viewers—lost in translation. The establishment of a comfortably canonical body of his work obscures the places where he connects with those "reli-gious-cultural complexes" whether as material, performative, or gestural subjects. For example, thematics such as "Negro" athletes and Black jazz musicians give a place and a face to Basquiat's Blackness and his masculinity in the work. Certain related history paintings, such as *Undiscovered Genius of the Mississippi Delta* (plate 24) are also fairly easily digestible forms of Black culture. Through the lens of multiculturalism, these scenes visually signify Blackness, are already over determined, and as self-contained, U.S. Black history can be assigned to "the margins of modernism"[16] as hermetically sealed dioramas of, dare I write it, "the other." As I have argued elsewhere, art by Black people is often seen as the conscience of Western humanism, a role that a work like *Native Carrying Some Guns, Bibles, Amorites on Safari* seems to easily fulfill.[17] And as Hall suggests, *haute couture* (and luxury objects like art) can always be supplemented by the air of sophistication carried by the Black transgressive.[18]

But even *Native Carrying Some Guns, Bibles, Amorites on Safari* has its eye toward the global, alluding to imperialistic adventures that repeated themselves worldwide,

and not just in the move from Africa to the U.S. The excess in Basquiat's work—the parts that cannot be so easily contained in the African American context of the U.S. or the centuries of Western painting—reasserts itself in the context of diaspora, in the outer-national culture that is at ease crossing borders and oceans. As the scholar Nicholas Mirzoeff points out, it is art with a "multiple viewpoint," that exchanges "the one-point perspective of Cartesian rationalism for a forward looking, transcultural and transitive place from *which to look and be seen*" (my emphasis).[19] And so the action that moves through Basquiat's painting is dialogic; it is an interactive process "between individuals, communities, and cultures" caught in the exchange of glances, the parrying of visuality and visibility.[20] It is this space of multiplicity and immense variability, this site of hybridity, and *mestizaje,*[21] not in the biological but the cultural sense, that has been consistently elided from Basquiat's oeuvre. It is this inheritance of the diaspora, which Hall finds in the "primal" site of the Caribbean, that Basquiat inherits in his Haitian and Puerto Rican routes to Brooklyn.

Semiotic Imagination

One overlooked aspect of Basquiat's oeuvre that somehow cannot be contained by either his identification as an African American citizen of the U.S. or as a Western painter is the preponderance of Spanish-language messages woven throughout the paintings and drawings over the entire span of his career. In my own marking of Basquiat as African American I refer back to the wider connotations of this term as engaged by Gerardo Mosquera. In his writings, Mosquera speaks of culture and peoples of the Americas (and more specifically the Caribbean) that display African cultural inheritances as "Afro-American," following not from the U.S. example but from the Latin American framework of Afro-Cuban, Afro-Brazilian, and so on. Let us not forget that more than ninety percent of the African peoples who arrived in the Americas as the result of the transatlantic slave trade landed in Latin America and the Caribbean, not the U.S., making the term *African American* even more appropriate in that context.

Like that great "political activist, bibliophile, collector, librarian, and figure of the Harlem Renaissance" Arturo Alfonso Schomburg—who at times in his life used an anglicized version of his name, Arthur A. Schomburg—Basquiat can be easily claimed by Black U.S. and Puerto Rican communities.[22] And that's not even getting to the Haitian side. However, as Greg Tate reminds us about Basquiat's captivation of the art world, "[I]t would be the Haitian boy-aristocrat with the properly French name who'd get to set their monkey-ass world on fire."[23]

Spanish is spoken by over 265 million people worldwide and more than 17 million in the U.S. alone.[24] In the U.S. context, some have viewed the Spanish language as reflecting private spaces and/or the migrant's nostalgia for home, family, the past; it is the voice of self-knowledge "in which people realize themselves in the act of speaking," a dynamic of interaction with others in "the plaza," as opposed to English, which is

construed as the primary *lingua Franca* of transnational commerce.[25] Spanish implies "a whole notion of conversation as pleasure, as dialogue, as intellectual inquiry, as social event, as ritual."[26] Language in this sense is not adopted for its pragmatics, to get from point A to point B in the quickest, most expedient manner, as often with English. Instead, with Spanish "there is a ludic element. There is a mystical element, there is a whole level of imagination; language for the sake of imagining, of inventing, of playing."[27] The passageway between the private realm and that of the public eye is the street: the space of code-switching (Spanish-to-English-to- Spanish-to . . .), Spanglish, or, in the Chicano context, the slang of *Calo.*

Other observers see Spanish as a form of communication that operates in both the private and public arenas of the U.S. In the latter case, print culture and, later, mass media have unified this community in the public realm. This has been the case, particularly in what is now the U.S. Southwest, since the sixteenth century. Indeed, the Spanish language can be seen as a discursive identity functioning as a site of cohesion apart from national origin or race. And beginning in the late twentieth century, nearly half the world's migrants have been women. This is crucial for us here because it is generally "women who determine the child's mother tongue."[28]

From the vantage point of the early twenty-first century, Spanish has certainly moved beyond isolated islands (or plazas) of speakers dotting the U.S. With the news in 2003 that Latinos were now the largest "minority" population of this country, the Spanish language has become more and more integral to the fabric of our national life, from the shores of Hollywood and the star power of Jennifer Lopez, to the Latin Grammy Awards broadcast from Miami, to almost every service industry, from banks to telephone companies, to major store chains, where we are given the option, "Para servicio en español por favor oprima el número dos."[29] Magazines like *Business Week* have devoted special issues to the "Hispanic Nation." And even more interestingly for our purposes here, *Black Enterprise*—that organ of African American economic strivers—has made the apparent phenomenon of *Black* Latinos a cover story.[30] Almost twenty years after he left us, Basquiat would perhaps have been gratified to see how much his vision has been recognized as a key aspect of contemporary life.

Spanish appeared in Basquiat's work from the beginning. Robert Farris Thompson has observed that Basquiat was fluent in the language, learned from his mother, Matilde, and honed while living in Puerto Rico for several years in the mid-1970s.[31] Printed words like POLLO (chicken), CABEZA (head), and MUJER (woman) surface repeatedly in his paintings. Some, like LECHON (pork) or GUAGUA (bus), are terms identified with the Caribbean, and in the case of the latter, specifically Puerto Rico. Parts of Basquiat's lexicon connote public space and reflect his fascination with commerce, such as PESO NETO (net weight) and ORO (gold).

In *The Nile* (plate 25), one of Basquiat's epic paintings, the artist connects the history of the U.S. with that of the ancient world by using Black subjects as icons or avatars of the forces of historical change. In the left panel, the word NUBA, denoting one of the earliest African cultures, floats above two masks. At the right, Greece and Egypt

rise to prominence in the words THEBES, HEMLOCK, PHARAOH, AND MEMPHIS. The Egyptian presence is further inscribed with hieroglyphs (an eye, waves), papyrus ships, and female figures seen in three-quarter view; the word NILE is crossed out. The third presence is American. We have not only Memphis of old but Memphis, Tennessee; the sickle cell trait floats across the water both above and below an image of a sickle-like tool that is also a ship. Yet in each of the three panels, words in Spanish appear as well. One of the silhouetted females on the left is identified with MUJER, her male counterpart on the right faces forward with ESCLAVO and SLAVE on his chest, crossed out; centered at the top, the artist has named this panorama of history, Blackness, and slavery EL GRAN ESPECTACULO (the grand spectacle). But the term ESPECTACULO also reads in a mass-media, kitschy sort of way, attached to the riotous display of Spanish-language variety shows or car sellathons; we are returned to commerce.[32]

"They called us graffiti but they wouldn't call him graffiti. And he gets as close to it as the word means scribble-scrabble. Unreadable. Crosses out words, doesn't spell them right, doesn't even write the damn thing right" [Rammellzee].[33] From this fragment, it seems that fellow painter Rammellzee did not approve of his friend's way with words, perhaps connecting Basquiat's actions to the continual elimination of Black people from records both historical and contemporary.[34] In the nineteenth century, Mirzoeff tells us, diasporas were configured as troublesome bodies existing outside national boundaries and controls, excess citizenry that needed to be restricted, resettled—crossed out.[35] As a Black man painting, and painting, and painting himself into view, Basquiat and his work demonstrate an "interrogation of persistent erasure and the denial of agency,"[36] or selfhood that engulfs the subject who is a Black, male, Caribbean, American, Spanish-speaking artist. But Basquiat takes this trope and reverses it by visibly embracing invisibility. Robert Farris Thompson's observation that "Jean-Michel cancels to reveal"[37] indeed reflects what the artist told him in an interview: "I cross out words so you will see them more: the fact that they are obscured makes you want to read them."[38] Basquiat's works are amazing in the scope of their form and content, as well as in their sheer numbers, making a case for a corpus that is both "transnational and translational."[39]

Many of the paintings that speak to us *en español* speak to us in more intimate terms that revolve around family, community, and food. *Arroz con Pollo* (plate 3), for instance, is one of Basquiat's few paintings showing the intimate interactions of a heterosexual couple, outside the worlds of masculine identity codified in sport or commerce.[40] It has a quasi-religious profile as the female figure offers her breast in sustenance to the male, a prophet crowned with a halo; the male figure in turn serves up a steaming plate of chicken. The dish, rice and chicken (which gives the painting its title), is a staple throughout Latin America—comfort food. The painting itself was made in Puerto Rico.[41]

Professor bell hooks has argued that the pain she perceives in Basquiat's work comes from the artist's concentration on the realm of masculinity to the exclusion of

a counterbalancing female life-world.[42] The scholar José Esteban Muñoz, however, has critiqued this position as one that opens itself to heterosexist thinking; the communion of men should not always be seen as a negative force. As he has written, "Representing the complicated and dire situation of Black masculinity in U.S. culture is important cultural work that should not be disavowed as a limitation."[43] It should not be presumed that "female influences and inspirations" can be arrayed to fill "his lack," Muñoz continues, "assuming a spectator or critic can ever *know* what such forces might be."[44]

Basquiat's "mother tongue" is Spanish. Not necessarily in the sense that he grew up in Puerto Rico or Brooklyn speaking it exclusively, but in the sense that his mother, Matilde Basquiat, was a Black Puerto Rican woman. The majority of the words he uses in his art, of family, food, and community, are ones that link him back to that world of intimacy; they create a link with the Spanish-speaking world, and the realm of the mother. If we want to speculate on what might constitute some female forces in Basquiat's work, it would be the continuous chatter *en español*.

Basquiat's canon revolves around single heroic figures: athletes, prophets, warriors, cops, musicians, kings, and the artist himself. In these images the head is often a central focus, topped by crowns, hats, and halos. In this way the intellect is emphasized, lifted up to notice, privileged over the body and the physicality that these figures— Black men—commonly represent in the world. With this action the artist reveals creativity, genius, and spiritual power. Basquiat has at least four paintings that use some form of the word *cabeza* (head) in their title. In the earliest *Cabeza,* the Black figure painted on a gold ground doesn't only seem to grimace through clenched teeth, but to smile. The contrasting background offers something new: exposed stretchers and a surface crafted from a quilted blanket. *Dos Cabezas* (plate 9) from the same year is a double portrait of the artist with Andy Warhol. As Munoz has pointed out, in this canvas Basquiat envisions himself as equal to his friend and mentor by painting the figures roughly the same size; here they are intellectual partners. But it is also a gesture of interculturation in which Basquiat makes Warhol speak *en español*. It is a voice of intimacy for Basquiat as well: the voice of the mother who herself was an artist, and inspired and promoted her son's creativity. As the artist recounted, "I'd say my mother gave me all the primary things. The art came from her."[45] The language of intimacy is thus the same as that of the intellect, and it is read through the accent of the mother.

Charmed Life

Okwui Enwezor has taken issue with the widespread belief in contemporary art circles that the show *Magiciens de la Terre* (Centre Georges Pompidou, Paris, 1989) is paradigmatic of today's global exhibition practice. As he comments, "The discourse in 'Magiciens' was still very much dependent on an opposition within the historical tendencies of modernism in Europe—namely, its antipathy to the 'primitive' and his functional objects of ritual, and, along with this process of dissociation of the

'primitive' from the modern, its attempt to construct exotic, non-Western aesthetic systems on the margins of modernism."[46] I would certainly agree with him on this account. Yet I also find that placing the marker for "globalism" in exhibitions at this starting point erases earlier transatlantic practices, at least on the part of African American artists, from Edmonia Lewis's Italian exhibitions and residency in the nineteenth century, to the coterie of artists of the African Diaspora connected to the Harlem Renaissance and Negritude movements in the early twentieth century—as well as, more recently, the 1980s investment in multiculturalism in the U.S., later documented in exhibitions such as *The Decade Show: Frameworks of Identity in the 1980s* (New York, 1990), and the dialogue between Black British and Black American artists during that same era, which was both intercultural and international in scope.

However, I believe as well that there is a place for art that celebrates spiritual and metaphysical sources, and that this type of practice should not be "off limits" because of our concerns with white Western confusion about who we might be. (Robert Colescott, Kara Walker, and numerous others, have jumped squarely into similar *caca* around the specter of Black stereotypes for exactly this reason.) All peoples and cultures have and require a connection to the otherworldly and the divine, to make it through life or even just the day. And so it is from this premise that I argue that Jean-Michel, toward what would unfortunately mark the ending of his amazingly creative career, drew more of such signs into his art, using objects and notions that tapped historical frameworks of African spiritual systems and their power. They were charms to ward off pain and death and to fight for life and strength on a mystical plane.

Basquiat's canon of heroic masculinity revolves around the year 1982, one of his most productive. But later, as the work progressed, it is clear that the artist was painting his way out of this, or perhaps painting into new structures that could combat the isolation that Tate has characterized as the "flyboy in the buttermilk"; he was painting into a space of communion, community, and connectivity. It was a place in which Basquiat was not only a (Western) painter and (Black) man; it was a realm where he could claim all that was excess to those axes of identity, where he could open himself out to the entire broad spectrum of his creativity and his soul. And he accomplished this in part by way of those "religious-cultural complexes" outlined by Mosquera, whose mark-making traditions are "symbolization(s) of the unity of life . . . where everything appears interconnected because all things—gods, spirits, humans, animals, plants, minerals—are charged with mystical energies and depend on and affect everything."[47]

In 1984 Basquiat created two works that link back to previous structures and yet move him simultaneously onto another plane. *Gold Griot* (plate 27) presents us with one of Basquiat's iconic figures, his skeleton revealed, crowned by a grinning/grimacing head that provides the major painterly focus for the image. It floats on gold-toned wooden slats that form a rectangular ground. In many ways it mirrors *Cabeza,* its Black figure shimmering on a golden surface, the structure not only of the body but of the painting revealed, the smooth round head, grin/grimace, and large, all-seeing

eyes. Within this formal play between these two works is the semiotic and cultural one, wherein the intellect and creativity of the Spanish mother (tongue) connect to the figure of the West African oral historian, custodian of the nation's stories, a keeper of the past who charts a vision for the future.

Gold Griot is also related to another work made the same year called *Grillo*. Formally, it seems markedly different; for one thing, *Grillo* is quite massive, three times as long as the other; in places it looms out a foot and a half from the wall. In English, we would rhyme the word "grillo" with "Brillo," as in the cleaning products made famous by Andy Warhol's boxes. In Spanish, however, "ll" produces the sound of the letter "y." Basquiat's *Griot* and *Grillo* are therefore punning homophones; they are transliterations in which words from one language are transposed into another. Basquiat (a musician as well) has given them the same sonic sensation and assigned them similar meanings.

In both paintings we see the same smooth-headed power figure. In *Grillo,* however, the figurative element is doubled: one body sports a crown and the other a halo composed of a black wood bar topped with spiky nails. Indeed, the strips of nails adding visual interest to the canvas recall the Nkisi power figures of the Kongo peoples of which Robert Farris Thompson writes in *Flash of the Spirit* (1983). Thompson and Basquiat met in 1984 (introduced, as I was, by Fab 5 Freddy). Basquiat's interest in Thompson's phenomenal work on Africa, America, and the Black Atlantic world led him to commission the scholar to write something for one of his shows at the Mary Boone Gallery, which took place in early 1985.[48] In the heavily collaged areas of *Grillo,* we see references to Thompson's *Flash,* and particularly to icons of power found there: the cosmic Nsibi writing and the leopard-skin power symbols of the Niger Delta, the Rada religion of Haiti, the Yoruba gods Esu (the trickster of the crossroads) and Ogun (war).

Jumping ahead two years, we come across *Gri Gri* (plate 28), again stylistically somewhat dissimilar yet taxonomically following directly from the 1984 works. Uncharacteristically, the artist limits his palette to four colors: red, black, white, and brown. The tone here is muted, almost simplistic, dark, and to some eyes just plain uninteresting. No darting linear patterns, save for the central figure's bar-like bared teeth. A single, almond-shaped eye leads us back through the genealogy of its brothers in *Cabeza, Gold Griot,* and *Grillo*. But this figure in profile has more in common with another that begins to come into view around this time. We can find it on the upper edge of a green painted panel in *Grillo,* a simple, black, mask-like head with eyes like ellipses. In *J's Milagro* the eye socket is filled in with red and the figure is more clearly articulated to resemble a superhero.

A Gri-Gri (sometimes spelled *gris-gris* in the French) is a Hoodoo charm, part of African American ritual and conjuring practices often associated with New Orleans. When a revolution created the first Black republic in the Western hemisphere, in the early nineteenth century, slave owners fled Haiti with their human property for this other outpost of their culture in the Americas, reinforcing French and New World

African production in architecture, food ways, and spiritual practices. Where *J's Mila-gro* (i.e. Jean-Michel's Miracle)[49] is busy, full of texture, and somewhat disjunctive, *Gri Gri* does its work quietly, without calling too much attention to itself; but its halo puts us on notice. In 1972 Betye Saar created a work called *Gris-Gris Box*. As with much of her work, its energy comes from ancestors, in this case her Louisiana forebears. It is strikingly similar to the Basquiat piece made not quite fifteen years later. Its central black figurative form has features that grimace and grin with a red mouth, and it regards the outside world through the half-lidded eyes of trance and power. In Saar's piece these powerful eyes partially ring the construction, giving us no doubt as to its intentions.

Elsewhere, I have linked Saar's *Gris-Gris Box* taxonomically to perhaps her most famous work, *The Liberation of Aunt Jemima*, also from 1972. Both share a central Black female figure laden with props of power; one brings with her strong magic and the other wields strength from the barrel of a gun.[50] Similarly, Basquiat's Gri-Gri reappears in other works and in other guises, and as such is what has been called a "'hyperquote,' an artifact generating multiple intertextual references."[51] It shows up again in a collaborative work with Warhol, *Untitled (Motorbike)* (1984–85), where Muñoz reads its appearance as signaling "the Black presence that has been systematically denied from this representational practice. These primitive jet-black images look only vaguely human.... Through such representations Basquiat ironizes the grotesque and distortive African American images of the Black body." The "smooth lines" of Warhol's silkscreen, Muñoz argues, become "a *vehicle* for Basquiat's own political and cultural practice."[52] And indeed the Gri-Gri is positioned in the driver's seat of Warhol's printed motorcycle.

In 1987 Gri-Gri drives itself into yet another context, that of Basquiat's cartoon culture. In *Untitled* of 1987, the black figure steers a bright red car with yellow and blue accents. Though possibly broken down, with a missing tire laid to one side, the vehicle has sprouted green wings to whisk it heavenward. The hue of the wings is almost identical to that of an image proclaimed as the LONE RANGER in *To Be Titled*, of 1987, whose black mask turns him into Gri-Gri. Indeed, in *Untitled* of 1987 Gri-Gri is transformed into a superhero traveling via Batman's Batmobile (forms of the superhero's emblem, the "Bat Signal," are found throughout Basquiat's work). In *Riddle Me This, Batman* (plate 32) from the same year, Gri-Gri shows up seemingly as an outline, a beige tone shadow of his former self. Beneath this chimera is the word TIZOL, the name of the Puerto Rican trombonist who figured in a number of Duke Ellington's bands and brought us major compositions such as "Caravan" and "Perdido."[53]

Muñoz has applied his brilliant thesis on disidentification to the cultural work of comics. The "disidentificatory" process is a "third mode of dealing with dominant ideology, one that neither opts to assimilate within such a structure nor strictly opposes it"[54] but "works on and against dominant ideology."[55] Strategies of disidentification allowed two Jewish cartoonists, Jerry Siegel and Joe Shuster, to create the character Superman, a "dark-haired alien," during the 1930s at the same moment that the term *Übermensch*

(super-man) was being used to denote Hitler's Aryan "master race." Like Brazilian modernist artists' philosophy of *antropofagia* (cannibalism) in the 1920s, it is a device that allows one to consume the dominant culture, recombine its useful and powerful bits in new aesthetic formulas, and discard the rest. It permits young Black boys like Basquiat and young Jewish ones like Shuster and Siegel to identify with Superman in their own way, shape, and form. Writing on Basquiat's *Television and Cruelty to Animals* (plate 21), Muñoz discusses how the artist brings Superman (as logo) into the picture to fight Nazism, displaying the artist's own knowledge of the superhero's original, if hidden, task. In this relatively small painting (five by five feet) the artist creates another epic, another EL GRAN ESPECTACULO (written across the bottom right), bringing in reinforcements for Superman in the figures of Batman and Popeye, the latter battling racism in both English and Spanish—POPEYE VERSUS THE NAZIS inscribed in the top right and then, further down on the left, POPEYE VERSUS LOS NAZIS. In the later works, the powers of African gods clearly become conflated with those of Western superheroes. In *Grillo*, Basquiat articulates his fascination with the Yoruba war deity, Ogun, by repeating his avatars, IRON and BLADE. On the left side of the painting, referring again to Ogun, he writes, HE IS PRESENT IN THE SPEEDING BULLET. The connection with Superman's likeness to ammunition ("faster than a speeding bullet") was not lost on the artist, and in fact, was probably an amazing discovery that allowed him to link his love for comics and his obsession with the histories of the Black diaspora.[56]

Exit, Stage Left

In contrast to the protective forces of Gri-Gri and other charms found in paintings toward the end of Basquiat's life, there are additional works that show (his) struggle. The difference is particularly evident in the eyes of his painted figures. The elliptical eye shape, unmistakable in pieces like *Gri Gri* and *Griot,* are half-lidded to marshal and conceal their power. In contradistinction, the villain (the Riddler) in *Riddle Me This, Batman,* for example, has round eyes that are X-ed out; he is drunk or poisoned from the beverage with a triple-X label that he holds in his right hand. Similarly, in *Victor 25448* of 1987, a man with a bandaged face and the same disk-like eyes that repeat the X pattern falls to the floor, red blood spurting everywhere and partially covering the phrase FATAL INJURY. In *Después de un Puño (After a Punch)* of 1987 (plate 30), the figure with the unseeing eyes is large and upright, skeletal but yet somehow also formal in his looming, stovepipe-style top hat.

The curator Richard Marshall has noted several reference books that Basquiat drew inspiration from in composing the dense catalogue of symbols that made up his work. One such source was Henry Dreyfuss's 1972 *Symbol Sourcebook.*[57] Among Dreyfuss's collected lexica are "Hobo Signs," simple pictographs, "chalk or crayon signs" drawn on "fences, walls and doors, which conveyed messages such as 'dangerous neighborhood,' 'easy mark,' 'sucker' and 'vicious dog here.'"[58] Certainly Basquiat could have considered such mark-makers forerunners of his own graffiti tagging cohort.

Two of the hobo images incorporate a top hat, signifying in one instance "a gentleman lives here" and in another "these are rich people." But I would argue that the guy in Basquiat's *Después de un Puño* is another kind of *caballero,* the regal and fatal Baron Samedi, Vodoun's keeper of cemeteries. In a photograph taken by his friend Tseng Kwong Chi in 1987, the year of *Después* and mere months before his death, Basquiat poses provocatively with a toy gun to his head in front of an unfinished painting showing the word VICTOR several times followed by various numeric combinations denoting the catalogue numbers of a discography and connecting us as well to *Victor 25448,* Basquiat's portrait of the fatally injured man. In the photograph, on a table loaded with brushes and paint, are also other things: a sculpture of seeming non-Western facture, and three drums, two of them Yoruba *batas,* the famous ritual "talking drums." Again, evidence of protective avatars.

Baron Samedi appears as early as 1982 in a less skeletal, more human guise in *The Guilt of Gold Teeth.* Yet Basquiat invoked death in some of his earliest paintings, including *Bird on Money,* in which the words PARA MORIR (in order to die) appear next to a drawing of Brooklyn's Green-Wood Cemetery, where Basquiat would indeed be laid to rest. In *Portrait of the Artist as a Young Derelict* the word MORTE (dead, in French) and a cross are inscribed over a black, boxy shape; it is surely a coffin, "buried" as it is below a towering New York skyscraper.

Among Basquiat's last paintings is a six-by-eight-foot canvas that to some may seem unprepossessing. At its center is a single fox-like creature, a wily coyote caught in a whirlwind, smiling from the eye of a storm. His head is surrounded by the eyes of power, which have appeared as Egyptian hieroglyphs (*The Nile*) and the elliptical stare of Gri-Gri. Above the smiling head floats the word EXU from which the piece takes its title (*Exu*) (plate 34). Exu, the Brazilian/Portuguese spelling of the god also known as Esu and Eleggua, is the Yoruba and New World African god of the crossroads; it is only through him that one can seek audience with other forces. And because he is known as a trickster, it's anyone's guess if you'll get there. Interestingly, the x in EXU is boxed in, held not within the circle of the saucer-like eyes Basquiat reserves for the beaten down, but within a box of containment. Speaking of Eleggua's elusive appearance in the paintings of Wifredo Lam, Mosquera writes, "[T]he mutant sense of Lam's paintings, where everything seems to transform itself into another unexpected thing, could be related to the god."[59] Or not. The boxed-in x of EXU could be the containment of the forces of death (the coffin). Or not. Rewind. Remix. The circular saucer-eyes that seem nonresponsive, dead, crossed out, also riff on Kongo culture's Four Moments of the Sun, the cosmogram for the continuity of life.[60] Basquiat includes the sign repeatedly in *Grillo;* nearby wait the words ESU, EXU, and BABALAO (priest). As Muñoz movingly writes: "Basquiat understood the force of death and dying in the culture and tradition around him; his art was concerned with working through the charged relation between Black male identity and death. He, like Van Der Zee, understood that the situation of the Black diaspora called on a living subject to take their dying with them. They were baggage that was not to be lost or forgotten because ances-

tors, be they symbolic or genetically linked, were a deep source of enabling energy that death need not obstruct."[61]

Enwezor reminds us that the diaspora is a place caught, at different times and to various degrees, between "speech and its attendant untranslatability," as people and their languages, gestures, codes travel the globe from the comfort of familiar places toward the challenges that await in unknown landscapes.[62] Yet in the twenty-first century, he insists, there is no need to perpetuate the same circular debates and "paradigms of lack that have persistently enfolded the body and subjectivity of the disrecognized figure of the sub-alternate by asking the same old question: can the subaltern speak?"—or, do non-dominant bodies possess tongues and other tools for communication, and are they allowed to use them? Instead, the question thrown back in the opposing court is rather, "Can the subaltern be heard?"[63] For those whose ears are "culturally prepared"[64]—es *pleno amor . . . y poder.*[65]

Notes

1. Okwui Enwezor, "A Question of Place: Revisions, Reassessments, Diaspora," in *Unpacking Europe: Towards a Critical Reading,* ed. Salah Hassan and Iftikhar Dadi (Rotterdam Museum Boijmans Van Beuningen, 2001), 234.

2. This line comes from the song "Psychedelic Shack." However, the phrase originally appeared in the spiritual "Rock My Soul in the Bosom of Abraham." Thanks to Barry Mayo for help with the Temptations reference.

3. Grey Gundaker, *Signs of Diaspora/Diaspora of Signs: Literacies, Creolization, and Vernacular Practice in African America* (New York: Oxford University Press, 1998), 8.

4. Jose Esteban Muñoz, "Famous and Dandy Like B. 'n' Andy: Race, Pop, and Basquiat," in *Pop Out: Queer Warhol,* ed. Jennifer Doyle, Jonathan Flatley, and Jose Esteban Muñoz (Durham, NC: Duke University Press, 1996), 161.

5. Greg Tate, "Nobody Loves a Genius Child: Jean-Michel Basquiat, Flyboy in the Buttermilk," in *Flyboy in the Buttermilk Essays on Contemporary America* (New York: Simon & Schuster, 1992), 236.

6. Tate, 239.

7. Tate, 241.

8. Arjun Appadurai, *Modernity at Large: Cultural Dimensions of Globalization* (Minneapolis: University of Minnesota Press, 1996), 4; quoted in Nicholas Mirzoeff, "The Multiple Viewpoint: Diasporic Visual Cultures," in *Diaspora and Visual Culture Representing Africans and Jews,* ed. Nicholas Mirzoeff (London: Routledge, 2000), 6.

9. Gerardo Mosquera, "Eleggúa at the (Post?)Modern Crossroads," in *Santeria Aesthetics in Contemporary Latin American Art,* ed. Arturo Lindsay (Washington, DC: Smithsonian Institution Press, 1996), 228.

10. Mosquera, 226.

11. Mosquera, 227, 230.

12. Stuart Hall, "Cultural Identity and Diaspora," in Mirzoeff, *Diaspora and Visual Culture,* 30.

13. Hall, 27.

14. Hall, 29, 30.

15. Hall, 30. I use the word *American* here in its most encompassing sense, to suggest the cultures of the entire Americas.

16. Okwui Enwezor, quoted in "Global Tendencies: Globalism and the Large-Scale Exhibition," *Artforum* 42, no. 3 (November 2003): 154.

17. Kellie Jones, "(Un)Seen and Overheard: Pictures by Lorna Simpson," in *Lorna Simpson* (London: Phaidon Press, 2002), 77.

18. Hall, "Cultural Identity and Diaspora," 26.

19. Hall, 26.

20. Ella Shohat and Robert Stam, "Narrativizing Visual Culture: Towards a Polycentric Aesthetics," in *Visual Culture Reader,* ed. Nicholas Mirzoeff (New York: Routledge, 1996), 46; quoted in Mirzoeff, "Multiple Viewpoint," 6.

21. Spanish, meaning "racial mixture," as in the French *métis,* or the English *miscegenation.*

22. Roberto P. Rodriguez-Morazzani, "Beyond the Rainbow: Mapping the Discourse on Puerto Ricans and 'Race,'" in *The Latino Studies Reader: Culture, Economy, and Society,* ed. Antonia Darder and Rodolfo D. Torres (Malden, MA: Blackwell, 1998), 145.

23. Tate, "Nobody Loves a Genius Child," 236.

24. Rosaura Sanchez, "Mapping the Spanish Language along a Multiethnic and Multilingual Border," in Darder and Torres, *Latino Studies Reader,* 110.

25. Coco Fusco and Guillermo Gómez Peña, "Bilingualism, Biculturalism, and Borders," in Fusco, *English Is Broken Here: Notes on Cultural Fusion in the Americas* (New York: New Press, 1995), 151–53. A version of this dialogue first appeared in *Third Text* in 1989.

26. Fusco and Gómez Peña, 152.

27. Fusco and Gómez Peña, 153.

28. Sanchez, "Mapping the Spanish Language."

29. In hip-hop music, African American artists have also incorporated words in Spanish, usually slang. Puff Daddy ("All about the Benjamins") and Missy Elliott ("Work It"), for instance, have both used the term *chocha,* a reference to female genitalia. Because many radio producers don't understand these words, they are often played unedited over the airwaves.

30. *Business Week,* March 15, 2004; and *Black Enterprise* 34 (February 2004).

31. Robert Farris Thompson, "Royalty, Heroism, and the Streets," in Richard Marshall et al., *Jean-Michel Basquiat* (New York: Whitney Museum of American Art, 1992), 29.

32. *Untitled (El Gran Espectaculo)* and *Untitled (History of Black People)* were other earlier titles for the work. The new title, *The Nile,* comes from simply checking the verso of the painting and finding Basquiat's original designation written there.

33. Quoted in Tate, "Nobody Loves a Genius Child," 236.

34. If these were indeed Rammellzee's concerns, they were not unfounded. Several years later, Julian Schnabel's film *Basquiat* (1996) offered a vision of an artist who had no Black/Latino community, where graffiti, hip-hop (and even punk rock), and multiculturalism did not exist. Instead, "Basquiat" becomes a foil for the Schnabel character (played by Gary Oldman). The film's one redeeming quality was a stellar performance by Jeffrey Wright in the title role.

35. Mirzoeff, "Multiple Viewpoint," 2.

36. Enwezor, "Question of Place," 241.

37. Thompson, "Royalty, Heroism, and the Streets," 32.

38. Thompson, 32.

39. Homi Bhabha, *The Location of Culture* (London: Routledge, 1994), 198; quoted in Enwezor, "Question of Place," 242.

40. Thanks to Franklin Sirmans for pointing this out.

41. Richard Marshall, "Repelling Ghosts," in Marshall et al., *Jean-Michel Basquiat,* 18.

42. To a certain extent, hooks's perception of pain is based on her misreading of Basquiat's frenetic Expressionism as painful disarticulation of the body, which I am not quite convinced of. See bell hooks, "Altars of Sacrifice: Re-membering Basquiat," in *Art on My Mind: Visual Politics* (New York: New Press, 1995), 35–48; first published in *Art in America* 81, no. 6 (June 1993), 68–75.

43. Muñoz, "Famous and Dandy," 175.

44. Muñoz, 175.

45. Jean-Michel Basquiat, quoted in M. Franklin Sirmans, "Chronology," in Marshall et al., *Jean-Michel Basquiat*, 233. Gerard Basquiat also states, "His mother got him started and she pushed him. She was actually a very good artist" (233).

46. Enwezor, "Global Tendencies," 154.

47. Mosquera, "Eleggúa at the (Post?)Modern Crossroads," 230.

48. Thompson, "Royalty, Heroism, and the Streets," 31–32.

49. Milagros are also Latin American religious folk objects and come in the form of stamped metal charms. Most often they depict body parts and are offered to saints as a request for healing.

50. See Kellie Jones, "Black West, Thoughts on Art in Los Angeles," in *New Thoughts on the Black Arts Movement,* ed. Margo Crawford and Lisa Collins (New Brunswick, NJ: Rutgers University Press, 2006).

51. Mirzoeff, "Multiple Viewpoint," 8.

52. Muñoz, "Famous and Dandy," 164.

53. Tizol's compositions in the 1930s are often seen as laying the groundwork for the explosion of Latin jazz in the 1940s. Basquiat also showed the figure of Tizol as part of the Ellington Band in a drawing from a bit earlier, *Untitled (Harlem Airshaft)* (1984), the year of Tizol's death.

54. Muñoz, "Famous and Dandy," 147.

55. Michel Pecheaux, *Language, Semantics, and Ideology* (New York: St. Martin's Press, 1982); quoted in Muñoz, 147.

56. Basquiat's references to Ogun come directly from Thompson's *Flash of the Spirit*, including the phrase "he is present in the speeding bullet" (53). The book was first published in 1983, with the paperback following in 1984. The painting *Grillo* is dated 1984. Basquiat, ever on the cutting edge, obviously read the book within the first year or so of its publication.

57. Henry Dreyfuss, *Symbol Sourcebook: An Authoritative Guide to International Graphic Symbols* (New York: McGraw-Hill, 1972).

58. Marshall, "Repelling Ghosts," 23.

59. Mosquera, "Eleggúa at the (Post?)Modern Crossroads," 231.

60. See Thompson, "The Sign of the Four Moments of the Sun: Kongo Art and Religion in the Americas," chap. 2 in *Flash of the Spirit.*

61. Muñoz, "Famous and Dandy," 168–69.

62. Enwezor, "Question of Place," 240.

63. Enwezor, 241.

64. Robert Farris Thompson, "The Song That Named the Land: The Visionary Presence of African American Art," in *Black Art, Ancestral Legacy: The African Impulse in African American Art,* ed. Robert V. Rozelle, Alvia Wardlaw, and Maureen A. McKenna (Dallas: Dallas Museum of Art, 1989), 98; quoted in Mirzoeff, "Multiple Viewpoint," 7.

65. "It is complete love . . . and power." Thanks to William Cordova for assistance with this translation and for his encyclopedic knowledge of Basquiat in general.

BASQUIAT'S POETICS

CHRISTOPHER STACKHOUSE, 2015

Jean-Michel Basquiat's use of language reveals his ability to observe and describe what he sees in people, places, ideas, and things of whatever type as an exceptionally skilled raconteur. Everything in the world around him is wrapped in the verbal. Words are tool and material for him. He meditates on them. Though famous as a figurative painter, he is, above and beyond all else, quintessentially, a poet.

Many painters have decisively turned to poetry *or* other writing as part of their practice. Pablo Picasso wrote poetry daily for nearly twenty-five years, starting at age fifty-four. Several of Basquiat's peer artists, excluding urban graffitists of his time, were interested in the effective use of words in place of, or in connection with, imagery to convey ideas. Jenny Holzer, Barbara Kruger, Christopher Wool, and, perhaps most relatable to Basquiat, Lawrence Weiner all used written language to enhance their expressive capacities in visual culture. Weiner's elliptical, allusive wall-text installations are often brimming with class consciousness and satire. Basquiat's work is more aggressive than Weiner's in this regard, but they share the impulse to use a wordsmith's approach to synthesize the art object and messaging. Instead of strict adherence to the formal properties of object making, an overriding tendency for such artists is to communicate more directly, to be more accessible to a greater public.

In turn, poets have used the visual arts to linguistic ends, extending lyrical reach into two- and three-dimensional objects. The poet-painter Brion Gysin (1916–1986), widely considered the inventor of the cut-up technique, whereby a chosen text is cut up and rearranged to produce creative writing, had lasting interest in developing a pictographic language fusing painting and poetry. Similarly, in his book *Miserable Miracle* (1956) the French poet-turned-painter Henri Michaux (1899–1984) rigorously integrated word and image into a condensed memoir of his life and studio practice. Ted Joans (1928–2003), who worked as a poet, musician, and painter, made a clear connection between surrealist writing and painting, prioritizing visuality and the extemporaneity of improvisational music in his poems. At age forty, the Belgian poet Marcel Broodthaers made the demonstrative shift from verse to object making, creating a tabletop sculpture for his first solo exhibition by placing dozens of unsold copies of his book *Pense-Bête* in a mound of plaster.

Poets and painters together compose a unique community of which Basquiat was abundantly aware. His serial objectification of words iterates ideas embedded in them.

Christopher Stackhouse, "Basquiat's Poetics," in *Basquiat: The Unknown Notebooks,* exh. cat. (New York: Brooklyn Museum, 2015), 61–77.

From a purely literary standpoint, Basquiat is an aphorist. For this artist, economical use of phrase is at once rhetorically strategic, while it also reflects an exceptionally urgent life. His highly successful career as a famous painter happened for many reasons, yet one underappreciated incentive for his pursuit of fame in art was his concerted effort to find an amplification model best suited for his brand of poetic expression.

Description and representation function as acutely in Basquiat's text drawings as in his painted figurative images. Even in the sparest poetic text, images are closely associated with words. The first page of Notebook 1 contains a sequence of statements including a single line that is crossed out: THIER DOGS THIER HARPOONS THIER WIVES. The entry functions as a sketch, or notation; the fact that it later reappears as a drawing indicates the editorial attention Basquiat gave to his use of phrase. In an untitled drawing from about 1982 written in light green oilstick on paper, accompanied by no drawn figurative imagery, is a three-line poem that reads as an abbreviated haiku:

tHIER DOGS
tHIER HARPOONS
tHIER WIVES

However dashed off the lines seem, they present a compression of thought, sentiment, social observation, and critique. The brevity of the poem, handily written in syllabic verse (2-3-2 syllable line pattern), allows for concise expressive disdain for the owners of "dogs," "harpoons," and "wives." The hostile distance between the poet and the subject of the poem is demonstrative. In six words he sketches a profile of wealthy, elite, heterosexual male power. Personhood carved in relief by possessions at once diminishes and enlarges those being described. The list of possessions signifying the assigned station of elite power might well include Basquiat's art. The snarky tone laced with an insecure ambivalence in the repetition of "thier" is perhaps attributable to the artist's recognition of his own professional dependence on "them" as collectors to purchase and support his work. Also implied here ("thier wives") are the sexual politics of heterosexual marriage, how it has been conventionally situated for male benefit; to consider a person, a woman, as a possession is problematic. The reference to weapons (harpoons) suggests violence, but what might these weapons be used for, and how? Are the harpoons (whatever they represent in the abstract) aimed at Basquiat or at some other sort of prey? Does he see himself as preyed upon—whether as a commodity on the art market as a counterculture artist or as a Black youth? Is he at the table or on the menu? In this poem Basquiat characteristically relishes affronting "established" taste. The munificent financial support that this twenty-one-year-old "untrained" Black male artist "from the streets" received from collectors—the very support that enabled him to taunt the status quo—had to inspire some hostility. *Philistines,* from 1982 (plate 10), with its loaded title and large scale, exemplifies the social critique that the earlier written poem carries succinctly with so few words.

Then there are the "dogs," which perform as accessories of leisure but also as personal protection to men who are both threatened and threatening. Evident in the poem is not only the extreme vulnerability the artist feels in himself at this moment in his life and career but also what he perceives and critiques in others—presumably powerful others. To him the veil of respectability in bourgeois ownership procedures—attaining a spouse, a house, and material items to be collected and protected—is thin. The artist is skeptical about the trappings of upper-middle-class life. This poses a dilemma for an upwardly mobile aspirant who is working in the economically heady art world of his time while remaining resistant to structures, symbols, and attitudes of its population.

He addresses some of the same ideas later in the same notebook:

I FEEL LIKE A CITIZEN IT'S TIME TO GO AND COME BACK A DRIFTER.

A page later he revises and expounds on the self-directing epigram:

I FEEL LIKE A CITIZEN IN THIS PARKING LOT COUNTY FAIR
IT'S TIME TO GREYHOUND AND COME BACK A DRIFTER
PUT IT ALL IN ONE BAG

This text exemplifies how literary devices of every kind are used throughout the artist's writing. When he writes MILK or OIL, for example, aside from the political, economic, or social allusions each one conjures, the words function as both noun and verb. Here, the proper noun Greyhound constitutes an expert use, however casual it seems, of anthimeria, better known as "verbing a noun." Basquiat is also appropriating and collapsing the corporate transportation brand name Greyhound into slang for "go."

He often used corporate logos and brand names (such as Rinso laundry detergent or Ideal Toy Company) to point to distortions of meaning when words are recontextualized from ordinary language and speech to mass-media influence through advertising. His transforming of "Greyhound" into a colloquial term expresses the ease with which language can be manipulated to serve anyone's interest. Going Greyhound also has the latent meaning in the poem of the poet's "going corporate" (participating in the art world), to get where he needs to go (to fame and success), so that he may COME BACK A DRIFTER, an outsider to the art world that he sees as a microcosm of mainstream bourgeois society. He looks at the necessity of being both a "citizen" of the art world and a "drifter," or an aloof outsider, as presenting a crisis. Because of this set of circumstances, he will, as he writes, PUT IT ALL IN ONE BAG, carrying everything he has physically and metaphorically on his shoulders.

His use of metonymy in the first line of the poem is sardonic and hilarious, too, especially if we understand that he is speaking about the inner corridors of the "big money" art world in which he is situated. The phrase THIS PARKING LOT COUNTY

FAIR likens the workings of the art market and world to the auctioning, bargain shopping, and sale of farm equipment and livestock at a provincial county fair—in an abandoned parking lot, no less. While he mocks the other participants at the "fair," he also subjects himself to his own ridicule for being there. In spite of his concerted pursuit of inclusion in the art world and his successful attainment of fame, from very early on Basquiat registered dissatisfaction with what it meant to be there. The all-too-tidy view of society was intolerable for him. As James Baldwin once put it, "art and ideas come out of the passion and torment of experience: it is impossible to have a real relationship to the first if one's aim is to be protected from the second."[1] Baldwin insisted that poets (which he considered all artists to be) inhabited the singular social station from which one could see and bravely explore the truths of a given society. The consistency of Basquiat's self-awareness, self-critique, and assessment of the worlds in which he traveled and lived adds up to an extended treatment of moral conflict in his body of work.

Basquiat's output has been categorized within the international movement of Neo-Expressionist painting for obvious reasons, but his work also coordinates African American art and culture with the canon of American painting and Conceptual Art. Beyond these pat categories, his intellectual thirst was unquenchable and he employed a rich framework of artistic strategies. As a writer, he should be considered a descendant of a constellation of American post–World War II literary movements that include the Language Poets, the New York School, and the Beat Generation. Basquiat's somewhat cursory connection to the Beats is often cited. A widely published photo of the artist clutching a copy of Jack Kerouac's novella *The Subterraneans* hints at his interest in that movement. Photos taken by Victor Bockris, a William S. Burroughs biographer, of Basquiat and Burroughs together at a cocktail party have been reproduced in exhibition catalogues and books. *Five Fish Species,* a painting from 1983 (private collection), makes direct reference to Burroughs's accidentally killing his wife, Joan Vollmer, in 1951 by shooting her in the head while playing a game of William Tell in a bar in Mexico; rather uncritically written on the canvas triptych are the phrases BURROUGH'S BULLET, MOTHERFUCKN SKULLBONE, AND MOTOR AREA. More productive associations in poetry, politics, and style, though, can be made by looking to less popular, more unusual poets of that era. Two very important older contemporaries, who are seldom linked to Basquiat by scholars, are the poets Bob Kaufman (considered the proto-Beat poet) and, at the other end of the spectrum stylistically, Norman H. Pritchard.

On the surface Bob Kaufman (1925–1986) and Jean-Michel Basquiat present contradictory mentalities: in contrast to the younger artist's pursuit and attainment of stardom, Kaufman once told the curator, writer, and publisher Raymond Foye in an interview, "I want to be anonymous."[2] Nevertheless, Kaufman and Basquiat had only a couple of degrees of separation between them. Foye founded a publishing imprint, Hanuman Books, with Francesco Clemente in 1986; Basquiat intermittently collaborated with Andy Warhol and Clemente from 1983 to 1985. It is a curious thought that

Kaufman and Basquiat never met (the former died in 1986, the latter in 1988), since they must have had several common acquaintances. Both were aesthetes with voracious capacities for language. Both were born into multicultural, multilingual households (in the case of Kaufman, German Jewish/Martinican French Creole; for Basquiat, Haitian/Puerto Rican). Both were encouraged to participate in the arts by their mothers. Each fundamentally used poetry as a means to interrogate Eurocentric power while asserting Black identity, yet both men found themselves straddling the cultural interstices between Black and white cultures. The sociopolitical common ground in their work is also underscored by mutual formal concerns. For instance, a rhetorical device they both constantly used is phrasal disjunction to give associative cues toward possible meaning, as when Basquiat writes, PULL IN A DOG TO DRAW SANDPAPER / CENSOR HIS HABITS.

The following short poem by Kaufman, "Why Write ABOUT" (1967), offers interesting parallels with Basquiat's texts:

WRITE HUNG THINGS, MAD MESS
ZEN TREE JOY, DAD, LIKE, YOU KNOW?
SWUNG OUT CATS, HUNG,
ON PUBLICITY, LIKE, YOU KNOW.
SICK MIDDLE CLASS CHICKS,
NYMPHO, CACAUSOIDS, EATING SYMBOLS,
LITTLE OLD BOYS, IN MONDAY BEARDS,
ATTENDING, ALL THE, SCHOOLS,
OF SELF PITY,
SELLING THEIR RIGHT
TO REVOLUTION,
TO A PIECE OF,
LIKE, YOU KNOW MAN,
ITS, A SCENE,
LIKE, YOU KNOW,
THE, MOTHER BIT.

GENETIC COMPLICATIONS.
LIKE MAN, LIKE
MAN, LIKE,
LIKE.[3]

This poem was originally published in all caps, as it is reproduced here. Nearly all of Basquiat's texts and text-drawings use block-capital sans-serif letters. Before mass electronic communications (tweeting, email, phone texting), where all caps indicates "shouting" or extra declarative stress, these two writers used them for emphasis and to signal volume.

Another correlation between Kaufman's and Basquiat's texts is how the musicality and sound of language take precedence over syntactic logic. Immediacy of feeling and

expression is the privileged mode, as both artists could readily incorporate ideas—about art, music, poetry, race, class, politics, and culture—into their art at will. These artists collected knowledge and information as raw material for work. Kaufman's poems were often composed orally and extemporaneously in live performance. Like Basquiat, he was a jazzhead, approaching his art in an improvisatory manner as would a jazz musician. Jazz influence can be heard and felt in the above poem. Much of what the elder poet left to be read was transcribed by other people: his publishers, his friends, and his wife, Eileen. With a comparable ear, Basquiat often transcribed what he overheard in conversations.

Both writers intentionally misspell words to bring attention to the duplicity laced in phonetics, language, and meaning. Kaufman's poetry is filled with neologisms that infuse the newly created words with distorted connotations of the original words from which they were derived, and with agency. In the above poem the word "cacausoids," for example, is a stutter, an underscore, inverting the first two syllables of the word, pointing to the absurdity of the once widely used anthropological term of classification "Caucasoid," an arbitrarily assigned racial category. It is almost as if Kaufman is vomiting up the word, with choked, halting sound. He looks both inward and outward as he spits out more hot phrases: SICK MIDDLE CLASS CHICKS, / NYMPHO, CACAUSOIDS, EATING SYMBOLS (he himself being a "symbol" of non-middle class and non-white) and OF SELF PITY. / SELLING THEIR RIGHT / TO REVOLUTION, / TO A PIECE OF, / LIKE, YOU KNOW MAN, / ITS, A SCENE (in other words, selling the right to [presumably Black] revolution for a piece of Caucasian ass). He qualifies this in the second, final stanza with more empathetic lines: GENETIC COMPLICATIONS. / LIKE MAN, LIKE. . . . Those "genetic complications" are attributable to Kaufman's mixed heritage. As a humanist, he questions what race means and why, and how it relates to other "complications" of human existence: sex, war, and general violence. Kaufman is talking to us and his ancestors right away in the first two lines of the poem: WRITE HUNG THINGS, MAD MESS/ ZEN TREE JOY, DAD, LIKE, YOU KNOW? Racial violence against Black men, particularly in pre-civil rights America, is enmeshed with the fear of miscegenation. Kaufman was regularly hassled by Irish American and Italian American police officers in the North Beach neighborhood of San Francisco, where he lived and wrote, because he quite publicly dated and eventually married interracially. Given his ethnic background, this "mad mess" (madness) had to baffle and infuriate Kaufman, who seems to be asking himself "Why even write about it?" in the poem's title. He reflects on his family "tree" (which includes African and European ancestry) in "zen"-like fashion, in spite of the "hung things," referring to the lynching of Black men for actual and imagined sex with white women. Yet there is "zen tree joy" in writing and reciting poetry, no matter how difficult the content of the poetry is to face. The latent references in this poem are layered, and specific to 1960s America, at once addressing America's racialized past and present. The content and subject (the complexity of Black American life) in the poem is integral to its employment of jazz idiom.

Basquiat was similarly affected by issues of race, sex, and political consciousness in America. Traces of his thoughts on these subjects are found throughout his notebooks, drawings, and paintings, mixed in with a vast range of subject matter. In various interviews given during his career, he spoke about his disappointment with how Black people are portrayed in art and art history, as well as how Black people are generally treated in Western society. His handling of social classification is not limited to dichotomies of Black or white, rich or poor, male or female, or whatever kind of split that can be named. His art reveals an arduous investigation of how culture takes shape, and how consciousness is formed by culture. Of course, *his* Black personhood is a constant in his complex artistic character. For instance, in an untitled drawing from 1981 (private collection), he writes A NEGRO PORTER IN A POST-DEPRESSION / MOVIE. / IN HUSH-HUSH TERMS A BLACK MARKET / VALISE. / IN ALL WALKS OF LIFE. He is punning on "depression," speaking to both his own mental state and the infamous economic downturn of the 1930s Depression era. His "depression" comes from seeing an analogy between himself, a Black painter, and the "Negro porter" who is carrying the baggage or "valise" of race "in all walks of life"; put more simply, Basquiat the "Negro" cannot escape the burden of race. He is still a Black body on the market, a chattel slave on the auction block of the art world. This reality has implications for all artists regardless of race. Every artist successfully working in the art world is subject to the bidding block, but Basquiat is wearing the mask of black skin, which compounds his sensitivity to the commercialization of his art. In the notebooks, he offers a terse, elegant piece of writing that takes stock of what Kaufman called "genetic complications," but in a more compressed, allusive manner:

THERE'S A SONG ON THE RADIO
WHERE THEY SAY WAVY HAIR INSTEAD OF BLACK

CONSIDERABLE CLOUDINESS

SO IT WAS SUNG BY SOME WHITEGIRLS
20 YEARS LATER.

This poem offers a cool and detached description of how an old popular song on the radio diverts attention from Black masculinity in favor of describing an ambiguous physical trait of African features, preferring to SAY WAVY HAIR INSTEAD OF BLACK. Nevertheless, IT WAS SUNG BY SOME WHITEGIRLS with affection 20 YEARS LATER. Basquiat casually pokes fun at the song's attempt to veil the reference to Black male beauty, offhandedly noting its CONSIDERABLE CLOUDINESS.

An untitled four-stanza prose poem of Basquiat's is even more stylistically in conversation with Kaufman. It is surrealist with an antiestablishment inflection:

FURTHER RESISTANCE TO THE FORCES OF THE
NATION OF LAW AND JUSTICE LIKE SOME
BAD STUPID COWBOY TURNING TO SEE THE
CLOCK

THE MAN IN THE WHITE HAT DROP IT
BEFORE DAWN WITH THEIR EXPRESSIONS
UNCHANGING SURROUNDED BY GUNS
THAT MELT SUNGLASSES

ECONOMICLY CRUMBLING FROM THE
B-29 RAY STALLING BEFORE IT ENDED
SUCCESS HAD BEEN ACHIEVED.

A YELLOW FLASH A2STORY HOUSE
BLOWN TO PIECES/WE TOOK PICTURES
RAPIDLY/IT'S TIME TO GET OUT OF
HERE.

Like Kaufman's poem, Basquiat's text subordinates grammatical convention to near stream-of-conscious expression that offers a biting critique of American capitalism, war, and bourgeois acquisitiveness. Basquiat reduces THE NATION OF LAW AND JUSTICE to a BAD STUPID COWBOY movie, where the actors remain UNCHANGING SURROUNDED BY GUNS. The political situation is so horrific to witness that it can sting the eyes, or MELT SUNGLASSES. In the poem Basquiat conflates war, violence, and the American military, which supports the economy that provides for and protects the American dream of owning A2STORY HOUSE while "blowing to pieces" someone else's house in another nation. The reference to the Boeing B-29 Superfortress, a heavy bomber used during World War II and the Korean War, is symbolic of the American war economy and its dependence on the military-industrial complex. For Basquiat the innocent narrative of American success is BLOWN TO PIECES by the revelation of the duplicity of the war economy, and he decides IT'S TIME TO GET OUT OF HERE—"here" being the socioeconomic circumstances of the America where he lives. Basquiat's gradual understanding of his place in America, as a complying citizen, was difficult to accept, as it was for Kaufman.

Basquiat's approach to language also parallels that of the little-known poet Norman H. Pritchard (1939–?). Pritchard was of West Indian descent and, like Basquiat, grew up in Brooklyn. He received a B.A. in art history from New York University and pursued graduate studies in art history at the Institute of Fine Arts (New York University) and Columbia University. In the early 1960s he was a member of Umbra, a poetry workshop that anticipated the Black Arts Movement.

The back cover of Pritchard's first book of collected poems, *The Matrix: Poems, 1960–1970* (1970), featured blurbs from the mathematician and game theorist W. F. Lucas, the Beat poet (and friend of Bob Kaufman's) Allen Ginsberg, and the literary

critic Maxwell Geismar. Geismar describes Pritchard's poetry as being "absolutely original, for I've read nothing quite like it and nothing half as good in all of contemporary poetry. He is involved with a type of supra-verbal communication that appeals to me immensely. From a conceptual standpoint, Pritchard's poems are very advanced and can be compared to the best abstract painting, for they are profoundly haunting in their invocation of sight, sound, and emotion."[4] Geismar uses "abstract painting" to index the visual nature of Pritchard's poems because they are composed in the mode of concrete poetry or visual poetry, where the appearance of the text on the page is as integral to the composition of the poem as other formal aspects such as line length, rhyme, stanzas, and meter. In *The Matrix* there is a poem entirely composed of ampersands, as well as instances where excessively large point sizes and bold lettering are used as design elements indicating shifts in meaning. There are pages in the book that are completely covered by text with no border other than the physical page itself; there are other pages where a single word placed at the center is a minimalist gesture.

Pritchard's literary output during his lifetime includes only two books. The second, *Eecchhooeess* (1971), is a continuation in style and content of *The Matrix*. Pritchard also made audio recordings reading his poetry. Aside from the interplay of image and language, his work relates to Basquiat's in its connection to sound and music, particularly jazz. He is featured on at least two compilation albums: *Destinations: Four Contemporary American Poets* (1965), with Calvin Hernton, Paul Blackburn, and Jerome Badanes; and *New Jazz Poets* (1967), which features twenty-four poets, including Ishmael Reed and David Henderson.

On the *New Jazz Poets* recording, Pritchard is heard reading an abridged improvised version of his poem "Gyre's Galax," in which he performs a sequence of variations that riff on the opening phrase of the poem, "Sounds variegated through beneath lit." The repetition eventually evokes melody, or fluctuating tone in his voice, creating song that is personal and impersonal at the same time. His text becomes abstracted to pure, methodical rhythm. Here are the first two stanzas of the poem as published; they could have been written across a Basquiat canvas:

Sound variegated through beneath lit
Sound variegated through beneath lit
through sound beneath variegated lit
sound variegated through beneath lit

Variegated sound through beneath lit dark
Variegated sound through beneath lit dark
sound variegated through beneath lit
variegated sound through beneath lit dark[5]

"Lit" is the multilayered hinge in the poem. It suggests the past tense of the verb *light* in two senses—illuminating and igniting—as well as the informal form of the word *literature*. The poem's title (*gyre* being a circle, and *galax* a flowering plant that grows in

shaded areas or "in the shadows") alludes to how the poem effects a cycling of language, progressively taking the language apart and, in so doing, igniting and illuminating. The last and longest stanza opens with three couplets that repeat the same phrase, "Twainly ample of amongst twainly ample of amongst," alternating uppercase and lowercase for the first word in each of the six lines. *Twain* literally means "two," and it signals the writer known by the pen name Mark Twain. The sociopolitical implications of casually pointing to Mark Twain (the socialist, abolitionist, liberal, anti-imperialist, and satiric American writer, whose name also figures in Basquiat's notebooks and later works) are near buried beneath the formal liberties taken by Pritchard. The doubleness implied by Pritchard hints at W. E. B. Du Bois's conception of "double consciousness," or the African American's challenge of reconciling Euro-American and African cultural influences. As a highly experimental writer, especially given the time period in which he was writing, Pritchard was an exponent of both an African American literary tradition and a burgeoning internationally recognized genre of avant-garde poetry. When he writes "twainly ample of amongst," he pushes on the fact of this double marginality in his field of expertise, saying that he has "ample" ability to synthesize these positions outside the Western literary canon to create transformative, universal art.

Twain functions as a metonym for American literature. And even more latent in Pritchard's reference to Twain is one of Twain's controversial characters: the runaway and subsequently freed Black slave Jim from the novel *The Adventures of Huckleberry Finn* (1884). Pritchard probably identifies with the character, though he does not mention him explicitly. He seems to be meditating on the "ample" role of Jim (as a stand-in for Pritchard himself, for the Black writer, or for Black personhood as a subject in literature) and of Twain (as representative of the American literary canon with which Black American writers contend). There is an abrupt break from the repetition of couplets with the line "In lit black viewly," which reappears as a refrain after a rhythmic repetition of single words and two-word phrases:

 viewly
 viewly
 in viewly
 viewly
 viewly
 in viewly
 viewly
 in viewly
 viewly
 in viewly
 viewly
 viewly
 viewly
 in viewly
 viewly

Vision as insight and as the physical act of seeing is iterated interchangeably with each "viewly." Adding the -*ly* suffix creates a neologism, turning the noun and verb form of the word *view* into an adjective of approximation and an adverb indicating manner. After the reader's attention is brought to the act of seeing or noticing, the phrase "In lit black viewly" appears again, followed by a series of line shifts that play on the phrases "In dark to stark lit," "In above beneath," and, finally, "above beneath lit." What is present but out of sight (above and beneath, in the dark, and in the stark light of day) is the voice of the Black writer (and the experience of Black life) in American literature, a voice-presence that Pritchard abstractly describes at the outset of the poem with the line "Sound variegated through beneath lit."

Attention to sound and sight recurs throughout Pritchard's experiments with concrete poetry. Using this poetic style, his books cover and borrow from a range of subject matter, including love, sex, nature, urbanity, mathematics, architecture, and existential questions. The unconventional form of Pritchard's poetry makes it challenging for the reader to engage with his lyrical treatment of these subjects and ideas. One of his more perplexing poems that marries the auditory with the visual is "C." This is an instance where, as Geismar put it, Pritchard's poems "can be compared to the best abstract painting." Forty-one lines (or horizontal rows) of the lowercase letter *c* cover both verso and recto pages, including the gutter and margins. In printing parlance the poem's image is reproduced on the pages "full bleed." At a glance it references Minimalist drawing or painting in the geometric abstract style of Agnes Martin. It also calls to mind countless examples where Basquiat uses the placement of letters, words, and symbols to suggest the quality of sound. "C" has a sonic quality built into it. When we read the text aloud or to ourselves in our heads, it sounds like repetition of the word *see*. After several repetitions, *see* takes on numerous meanings, depending on any one of various possible tones of voice in which it is said. Pritchard is interrogating verbal, visual, and aural aspects of language with this poem.

Pritchard and Basquiat have in common a masterful use of text to serve complex objectives in art and literature. They share with Kaufman a passion for, and obsession with language that runs as deep as their commitment to social and political ideals. Basquiat did not self-define as a Conceptualist in the nomenclature of art, but from his smallest to his most extravagant artistic expressions, the systematic transportation of ideas, often through text, is privileged over form. Even a late painting like *Untitled (Ter Borch)* from about 1987–88 conveys a layered conceptual gesture, combining the text TER BORCH: BOY REMOVING FLEAS FROM DOG, referring to a painting by Gerard ter Borch (1617–1681), with a horizontal rectangle. Basquiat is naming the painting on a painting to conjure the image of the painting for those who know the painting, and/or he is naming it in this way to send the inquisitive viewer off to find it. Either way, the artist prods the viewer's imagination. From the beginning of his career until the end, Basquiat's energetic use of text was fueled by the activity of looking and seeing.

Notes

1. James Baldwin, "Mass Culture and the Creative Artist: Some Personal Notes," in *The Cross of Redemption: Uncollected Writings,* ed. Randall Kenan (New York: Pantheon, 2010), 4.

2. Raymond Foye, introduction to Bob Kaufman, *The Ancient Rain: Poems 1956–1978*, 2nd ed., ed. Raymond Foye (New York: New Directions, 1981), ix.

3. Bob Kaufman, *Cranial Guitar: Selected Poems* (Minneapolis: Coffee House Press, 1996), 77. Previously published in Bob Kaufman, *Ancient Rain.*

4. Blurb on back cover, Norman H. Pritchard, *The Matrix: Poems, 1960–1970* (Garden City, NY: Doubleday, 1970).

5. Quotations from "Gyre's Galax" are from Pritchard, *Matrix,* 46–49.

CHRONOLOGY

1960 Jean-Michel Basquiat is born on December 22, 1960, at Brooklyn Hospital in New York. He is the first child of Gerard Basquiat (born 1935 in Port-au-Prince, Haiti, and immigrated to the United States via Miami in 1955)[1] and Matilde Andrades (born 1934 in New York to Puerto Rican parents).

1961 The Basquiats live in Park Slope, Brooklyn, which is undergoing important demographic changes.

1964 The Basquiat family welcomes its second child, a daughter named Lisane.

1965 Jean-Michel's mother, passionate about her son's education, encourages his interest in art. She takes him often to the Brooklyn Museum, the Museum of Modern Art, and the Metropolitan Museum of Art. Jean-Michel attends kindergarten at a school affiliated with the Head Start program—a project designed to provide early childhood academic opportunities (along with health, nutrition, and parent education) to low-income children and their families.

1966 The Basquiat family relocates to East Thirty-Fifth Street in the East Flatbush section of Brooklyn.

 Basquiat's father will later observe that much of Basquiat's iconography recalled the Brooklyn of his youth: "A lot of the imagery, I feel, is Brooklyn born. Jean-Michel's room was upstairs in the back of the building we lived in, so from his window he could see a fantastic skyline, and great buildings like the bank near BAM. I think that is the skyline he references in the early painting. The kids playing games on the sidewalks of Boerum Hill [where the Basquiat family moved in 1971] were also a clear source of inspiration. Then of course there was Flats Fix, *the F-L-A-T-S-F-I-X signs on Fourth Avenue in Brooklyn."[2]*

1967 The Basquiats' second daughter, Jeanine, is born. Jean-Michel enrolls at St. Ann's, a progressive private school, which he attends until the fourth grade. He develops a passion for reading and devours texts in English, Spanish, and French.

 Jean-Michel spends a large portion of his childhood making cartoonlike drawings inspired by comic books, films, and Mad Magazine (in particular, the Alfred E. Neuman character). In his 1983 untitled drawing, the artist lists his first artistic ambition as "CARTOONIST." *Among a list of early themes during elementary and middle school we find* "CARS (MOSTLY DRAGSTERS)," "WEAPONS," *and* "NIXON."

1968 Jean-Michel's parents separate.[3] In May, while playing ball in the street, Jean-Michel is hit by a car. He breaks an arm and sustains internal injuries, which require the removal of his spleen. As a result, he is hospitalized for one month at King's County Hospital in Brooklyn. During his stay, his mother brings

The following chronology builds on work done previously by Franklin Sirmans, who compiled the first comprehensive timeline of the artist's life and work for the catalogue of the retrospective exhibition *Basquiat* (New York: Whitney Museum of American Art, 1992), and by Phoebe Hoban, the author of the artist's first published biography, *Basquiat: A Quick Killing in Art* (New York: Penguin Books, 1998), as well as information in *The Andy Warhol Diaries,* ed. Pat Hackett (New York: Warner Books, 1989). Citations for other sources have been provided, wherever possible.

him a copy of the medical textbook *Gray's Anatomy*; it provides the seven-year-old Jean-Michel with a detailed view of the human body—a subject that would appear frequently in later works.

1971 Following the separation of his parents, Jean-Michel moves with his father and two sisters into a three-story brownstone in the Boerum Hill neighborhood of northwest Brooklyn. He also leaves St. Ann's for the New York City public school system: he first attends P.S. 101 in Bensonhurst (riding the bus to get to the other side of the borough as part of a school integration program), and then P.S. 181 in East Flatbush. Despite the separation, Jean-Michel's mother continues to visit on Sundays, often sitting outside on the stoop to talk and spend time with her three children.

The graffiti tag "TAKI 183," which begins to appear throughout New York, receives coverage in a July issue of the New York Times. The tag belongs to a seventeen-year-old teenager, identified in the article only by his first name, Demetrius. "Taki" is the traditional Greek diminutive for Demetrius; 183 refers to his home address on 183rd Street. Taki's insistence on tagging every wall, subway car, or ice cream truck he encounters with his Magic Marker seems to encourage other young writers to do the same.[4] The medium continues to grow throughout the 1970s, when artists like Lee Quiñones and Fred Brathwaite (a.k.a. Fab 5 Freddy) begin to paint whole MTA subway cars while they sit overnight in the trainyard. New York mayor John Lindsay declares the first "war" on graffiti in 1972.[5]

1973 *The exhibition* Akhenaten and Nefertiti: Art from the Age of the Sun King *opens at the Brooklyn Museum in September, featuring 175 objects on display. The next month the documentary* The Mystery of Nefertiti *is broadcast on WNET public television in New York. Such displays may have sparked an interest in Egypt for the young Jean-Michel, whose later paintings and drawings bear scattered references to Egyptian history and kingdoms.[6]*

1974 Gerard Basquiat takes a job working for Berlitz, and he and the children relocate to Miramar, Puerto Rico—a historic, upscale neighborhood located just outside the capital city of San Juan. Although the family will return to New York at the end of 1975, the island leaves an impression on Jean-Michel, who as an adult will travel to San Juan and the island municipality Culebra.[7]

1976 Once Gerard Basquiat and the children move from Puerto Rico back to New York, Jean-Michel attends public school (Edward R. Murrow High School) for just a short period, before he transfers to an alternative high school, City-as-School. The school, based out of a Greek Orthodox church in Brooklyn Heights, is designed for talented children who would benefit from experiential learning rather than the traditional educational format, taking direct advantage of the city of New York as a learning resource. Students were given subway tokens to travel to New York's museums and cultural institutions, where they would attend classes. They checked in with advisers once a week.[8] At City-as-School, Jean-Michel meets Al Diaz, a graffiti artist from the Lower East Side. The two become friends. Jean-Michel's drawing and writing begin to flourish under the encouragement of his teachers.

In December Jean-Michel runs away from home, shaving his head as a disguise. He camps for a few nights in Harriman State Park, then moves with a friend, Alvin Field, into a hippie commune on West Twelfth Street with a Jewish family. He eventually ends up in Washington Square Park, where his father

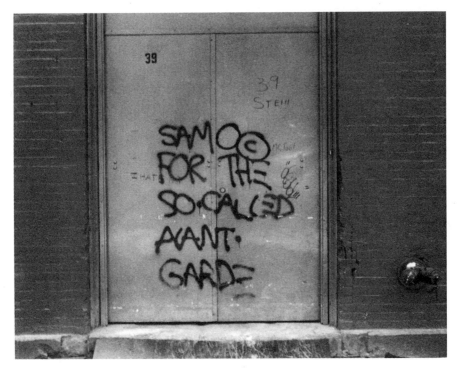

Figure 1. Henry A. Flynt Jr., *The SAMO© Graffiti Portfolio #18*, 1979.

locates him and brings him home to their Brooklyn brownstone with the help of the police.

1977 While attending City-as-School, Jean-Michel begins to publish stories and illustrations in the school newspaper, the *Basement Blues Press*. He develops a fictional character, SAMO, who makes a living selling fake religion. SAMO also appears as a character in the Upper West Side theater-therapy group called Family Life, in which Jean-Michel participates. The psychotherapist Ted Welch, who runs the group, later claims that "the concept [of SAMO] was that everything is just the same old thing, that society repeats itself, and you are just stuck in the loop."[9]

Basquiat and Diaz begin painting statements around Lower Manhattan, signing each prophecy or joke with SAMO©. They use first Magic Marker and later spray paints. SAMO writings appear downtown in the areas near the galleries of SoHo and Tribeca (figure 1).

1978 Basquiat attends Diaz's graduation from City-as-School in June. At the ceremony he dumps shaving cream onto the principal's head, adding to his earlier offenses that year, including making out with a girl on school premises and selling his CAS subway tokens for cash. Although he has only one year until his own graduation, Basquiat does not return in the fall to complete his senior year, saying, "there didn't seem much point in going back."[10]

Diaz and Basquiat continue to paint SAMO© statements in the streets, and they soon become a familiar downtown fixture. The September 12, 1978, issue of *SoHo News* runs a photograph of the SAMO graffiti, along with an invitation

(signed by Stephen Saban as STEVO©) for SAMO to get in touch. In response Saban receives a note that he would publish on September 28:

> SAMO© AS A MEANS OF
> DRAWING ATTENTION TO
> INSIGNIFICANCE
> WE'LL CONTACT YOU.[11]

In December the collaborators finally sell their story to Philip Faflick at the *Village Voice*; friend Shannon Dawson appears in the photograph, but only Diaz and Basquiat are identified by their first names.[12]

The Mudd Club opens on Halloween night 1978 in a six-story loft space located at 77 White Street. Envisioned by cofounders Diego Cortez, Anya Phillips, and Steve Mass as a punk alternative to the uptown, disco-oriented Studio 54, it soon becomes a regular hangout for new wave and no wave musicians, literary icons, and emerging fashion designers. Six months after it opens, the Mudd Club is cited in People *magazine: "New York's fly-by-night crowd of punks, posers and the ultra-hip has discovered new turf on which to flaunt its manic chic. It is the Mudd Club. . . . By day the winos skid by without a second glance. But come midnight (the opening time), the decked-out decadents amass 13 deep. For sheer kinkiness, there has been nothing like it since the cabaret scene in 1920s Berlin."[13]*

At the end of 1978, the Whitney Museum of American Art opens its exhibition New Image Painting, organized by Richard Marshall—the same curator who in 1992 will organize the first retrospective exhibition of Basquiat's work in a major US museum. The New Image Painting show signals a growing interest in figural painting after more than a decade of Minimalist and Conceptual art. Marshall's show features works by ten artists, including Neil Jenney, Susan Rothenberg, Jennifer Bartlett, and Robert Moskowitz.

1979 While wandering around the School of Visual Arts, Basquiat meets artists (and students) Kenny Scharf and Keith Haring. Basquiat and Haring have a close relationship for the rest of Basquiat's life. Glenn O'Brien, a former editor of Warhol's *Interview* who hosts the public access show *TV Party* from 1978 to 1982, later reflects that the two artists bonded over a shared mission. "He [Haring] and Jean-Michel both knew that they had to take painting and sculpture back from the academicians and spectators and give it back to the people. And they did."[14]

Just a few months after the *Village Voice* article was published, the line "SAMO© IS DEAD" begins to appear on walls around Lower Manhattan, as Diaz and Basquiat end their collaboration. Keith Haring performs a eulogy to SAMO© at Club 57—a nightclub located in the basement of the Holy Cross Polish National Church on St. Mark's Place.

Through Brathwaite, Basquiat meets Glenn O'Brien, who is at that point writing an influential music column for *Interview* magazine titled "Glenn O'Brien's BEAT." On April 24 Basquiat makes his first appearance on O'Brien's public access show *TV Party*.[15] Basquiat returns to the show frequently thereafter.[16]

Five days later, on April 29, Basquiat attends a party thrown at the loft of Stan Peskett and meets several people who will soon become friends and collaborators. Marketed as the "Canal Zone," and organized as a collaboration between Peskett and his friend Michael Holman, the party brings together the

downtown scene and the burgeoning hip-hop movement. Fred Brathwaite (Fab 5 Freddy) is in attendance, along with Lee Quiñones, a fellow member of the Brooklyn-based graffiti group known as the Fabulous Five. Brathwaite, who meets Basquiat that night, is popularly credited with spreading rap beyond the Bronx. He will introduce Basquiat to early hip-hop culture by playing mixtapes of underground groups. Brathwaite is also painting at that time; he called his infamous train piece of Warhol's *Campbell's Soup Can* "my Dadaist manifesto." Through him Basquiat meets other artists from this scene—Rammellzee, Toxic, and A-1—who would become close friends.[17]

At the Canal Zone party, Basquiat reveals himself as SAMO© for the first time publicly and spray-paints live. He and Holman decide to form a noise band. (Holman's account of this first meeting appears in section 4 of this volume.) They cycle through several band names: Channel 9, Bad Fools, Test Pattern. Basquiat plays clarinet, synthesizer, bell, and occasionally a guitar with a metal file run across its loosened strings; he also frequently plays clips of recordings he has made. Later that summer Shannon Dawson and Wayne Clifford, other Mudd Club regulars, join the band.[18]

Basquiat also meets Jennifer Stein (later Vonholstein) on the night of the Canal Zone party at Stan Peskett's loft, where Stein lived at the time. The two soon become artistic collaborators, working at times with another artist, John Sex. Taking advantage of the rather new technology of color Xerox (introduced in 1973), Stein and Basquiat compose a series of "Anti-Product Baseball Cards" by collaging existing print material onto small rectangles—four to a single letter-sized page. Then, Stein and Basquiat photocopy the page, mount the copy to cardboard, and cut it into fourths to create four 4¼-by-5½–inch postcards. Incorporating both the form and the content of mass media culture, "Anti-Product Baseball Cards" are clearly connected to the strategies of Pop artists. Like Warhol, who appropriated everyday Campbell's soup cans as a subject for fine art, Basquiat and Stein take the format of the trading card and transform it into an art object. But in the "Anti-Product Baseball Cards," the hand of the artist is an important factor in this transition; the painting over the collaged photographs marks them as a product of artistic rather than industrial labor. Stein and Basquiat sell their postcards on the street, specifically targeting audiences outside the Metropolitan Museum of Art and the Museum of Modern Art. According to recent research published by curator Eleanor Nairne, "on one occasion, the artist Howardena Pindell, who at the time was a curator in MoMA's prints department, invited them into her office before buying one for herself."[19]

In the spring of 1979, the eighteen-year-old Basquiat approaches Andy Warhol and Henry Geldzahler (the curator of twentieth-century art at the Metropolitan Museum of Art, who will later become the commissioner of cultural affairs for New York City) while they are eating in the SoHo restaurant WPA to sell them "Anti-Product Baseball Cards." Andy buys a postcard, while Geldzahler dismisses the young artist.[20] Basquiat and Geldzahler will later recall this first meeting in a 1983 interview commissioned for *Interview*.[21]

In fall 1979 Basquiat and Alexis Adler move into a sixth-floor railroad apartment at 527 East Twelfth Street, between Avenues A and B. It is Basquiat's first permanent address since leaving home. He paints on boxes, briefcases,

and old TVs he brings in from the street, as well as the floors, cabinets, and doors of the apartment itself. Adler is studying art history and organic chemistry; Basquiat begins painting many of the symbols from her biology and chemistry textbooks, as well as images from a copy of Janson's *History of Art*.[22]

By November Basquiat has arranged to exhibit some of his painted clothing at the storefront of Patricia Field; he markets it under the name "MAN MADE." Located on Eighth Street in the Bowery, Field's store frequently featured clothing made by artists; Keith Haring also sold works there. According to Field, the store was also "a hang-out for the club kids, graffiti artists and downtown kids who embodied the grit and culture of the SoHo scene."[23] Basquiat performs as part of the SAMO IS DEAD jazz band at A's, a performance art space and nightclub in the loft of Arleen Schloss at 330 Broome Street. According to Schloss, Basquiat also painted T-shirts on the floor of her loft.[24] Basquiat performs again with Test Pattern the following month at A's (plate 1), as well as at the punk and new wave nightclub Hurrah's, located on West Sixty-Second Street.[25] Nicholas Taylor, who had been acting as their roadie and photographer, joins the band after these performances.[26] They change the band's name to Gray, derived from *Gray's Anatomy*.[27]

1980 In June Basquiat exhibits work in the *Times Square Show*, a DIY art exhibition organized by the interdisciplinary artists' group known as Collaborative Projects (a.k.a. Colab) that had organized the *Real Estate Show* on Delancey Street on the Lower East Side in January 1980. The *Times Square Show* opens in an abandoned massage parlor at Forty-First Street and Seventh Avenue; works by approximately one hundred artists are installed guerrilla style on all floors of the unsecured building without any specifically assigned space or wall text to identify the artists who created them. Visitors are admitted twenty-four hours a day.[28] In a review of the show for *Art in America*, Jeffrey Deitch calls out the work of Basquiat (then exhibiting as SAMO©) as noteworthy.[29] A critic for the *Village Voice* calls the exhibition "the first radical art show of the '80s."[30]

In December Basquiat begins shooting *New York Beat*, a film written by Glenn O'Brien, directed by Edo Bertoglio, and financed by Rizzoli. Basquiat plays the main character of the film, a struggling artist, who wakes up disoriented in a hospital bed, evicted from his apartment, and desperate to find money (figure 2). The film, which also features main characters of the downtown scene like Debbie Harry, Fab 5 Freddy, Lee Quiñones, Kid Creole, and the Plastics, is not released until 2000 under the title *Downtown 81*.

Basquiat uses his fee from the film to buy art supplies, and he begins painting while living in the production office downtown on Great Jones Street. Some of the works—mainly depicting car crashes, faces, the letter *A* or the name *Aaron*—are used in the film itself. Basquiat sells a few canvases and drawings to production staff, as well as one work (*Cadillac Moon*, 1981) to Debbie Harry and one to Chris Stein—both from the group *Blondie*—for $100.[31] While working on the film, Basquiat begs O'Brien to introduce him to Andy Warhol. O'Brien brings him to the Factory, and Warhol buys one of Basquiat's MAN MADE sweatshirts.[32]

The graffiti scene is on the rise. In June 1980 Glenn O'Brien publishes an essay, "Graffiti '80: The State of the Outlaw Art," which features Basquiat.[33] On October 18, 1980, one of the very first exhibitions of graffiti art, Graffiti Art Success for America (GAS), opens at Fashion Moda, a not-for-profit art and performance space

Figure 2. Edo Bertoglio, production photograph on the set of *Downtown 81*.

opened by the Austrian artist Stefan Eins in 1978. Located in the South Bronx,
Fashion Moda is an important point of connection between the graffiti scene of the
outer boroughs and the art scene of Lower Manhattan, where the Colab-affiliated
artists of the downtown art scene come uptown to mingle with artists more typically
located on the margins of the art world. Curated by artist John Matos (a.k.a. Crash),
GAS features works by Lady Pink, Futura 2000, and John Fekner—some of which
were painted directly onto the walls of the gallery. The GAS show is a major catalyst
for the graffiti and street art movements.

1981 On January 31, 1981, Blondie's "Rapture" music video, featuring a rapping Deborah
Harry, premieres on the musical variety show *Solid Gold*. Basquiat, along with
graffiti artist Lee Quiñones, makes a cameo appearance in the video as a deejay.

 While finishing the filming of *New York Beat,* Basquiat meets Suzanne
Mallouk, a Canadian émigré, singer, and artist, who is working as a bartender at
the Manhattan dive bar Night Birds in the East Village.[34] In January, just a few
days after they meet, Basquiat moves into Suzanne's apartment at 68 East First
Street.[35]

 In February Basquiat gains his first major attention from an international art
audience. His work is included in a sprawling group exhibition of downtown artists,
New York/New Wave (February 15–April 5), organized by Mudd Club cofounder
Diego Cortez at PS1 in Long Island City. In response to Cortez's invitation to
participate, Basquiat produces more than twenty paintings and drawings on a wide
variety of surfaces: paper, canvas, wood, metal, and even rubber. He is one of 119

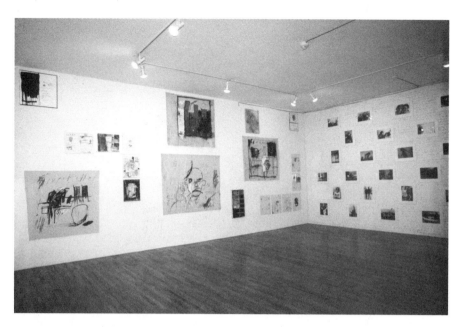

Figure 3. Installation view of the exhibition *New York/New Wave,* PS1, Long Island City, New York, February 15–April 5, 1981.

artists in the show of nearly a thousand works, and one of the only exhibiting artists showing paintings. He installs a selection of twenty-three works on paper and canvases of varying sizes along a single wall in one room, grouping the smaller works into L-shaped clusters (figure 3). Basquiat also contributes four large paintings on canvas such as *Untitled (World Trade Towers)* from 1981, as well as two other works on salvaged metal. *Jimmy Best . . .* (1981) combines a SAMO script ("JIMMY BEST ON HIS BACK TO THE SUCKERPUNCH OF HIS CHILDHOOD FILES") with a drawing of a car crash in the lower right corner bordered by the phrases "BOOM FOR REAL" and "PLUSH/SAFE HE THINK" above and below. An "untitled" work of yellow enameled metal with "New York/New Wave" written in spray paint is a DIY version of an exhibition's promotional sign and installed alongside works by graffiti artists like Fab 5 Freddy, Futura 2000, and Daze.[36]

Cortez's exhibition is intended as an antiestablishment alternative to the art establishment. In it, journalistic photographs, drawings, and other objects are hung alongside graffiti from floor to ceiling in several large rooms. The show reflects the new wave movement of downtown Manhattan—a constellation of music, film, and performance made by predominantly self-taught artists.[37] We can easily see how the range of Basquiat's artistic activities—as SAMO, as a member of the band Gray, and as a visual artist—reflected a similar multidisciplinary sensibility.

Basquiat's work is called out specifically by nearly every critic of *New York/ New Wave.* Dealers Emilio Mazzoli, Annina Nosei, and Bruno Bischofberger all take notice of him, and Mazzoli later invites the twenty-year-old Basquiat to have his first solo show at his gallery in Modena, Italy. Bischofberger buys a group of approximately ten paintings and twenty drawings from Diego Cortez.[38]

In April Fab 5 Freddy and Futura 2000 organize the exhibition *Beyond Words: Graffiti-Based-Rooted-Inspired Works* (April 9–24). Basquiat (as SAMO) is included in the show along with Tseng Kwong Chi, Daze, Keith Haring, Phase II, Iggy Pop, Rammellzee, and Kenny Scharf.

Basquiat travels to Modena with Cortez for the May opening at Emilio Mazzoli's gallery, where the exhibition *Paintings by* SAMO takes place and works still done under the name SAMO are shown (May 23–June 20). This is the artist's first trip to Europe. In Modena, Mazzoli provides the artist with painting materials to make more works in addition to the ones brought over from New York. The gallerist pays for all the works.

As Basquiat's painting career gains momentum, he performs less often with his noise band Gray. Sometime in the summer of 1981, Gray gives its last Mudd Club performance. Bandmate Michael Holman designs a dome structure to install on the stage using a combination of lumber and rented scaffolding that all the band members (except Basquiat, who shows up right before the performance) help to build. Holman's drums are inside a cavity made of twelve large blocks at the center of the stage, hiding all but his head from the audience. Nicholas Taylor plays his guitar standing atop the dome, and remaining bandmates Vincent Gallo and Wayne Clifford are attached to the interior, facing each other and leaning out at a forty-five-degree angle with their keyboards. When Basquiat shows up at the gig, he makes his own place within the installation, bringing in a three-cubic-foot wooden crate from the neighborhood outside the club. According to Holman, Basquiat throws it up onto the stage and climbs in with his synthesizer to play the twelve-minute show.[39] Within a few months of their sensational Mudd Club performance, Gray plays its last gig at Mickey One's in Tribeca.[40]

Impressed by his showing at *New York/New Wave*, in September Annina Nosei supports Basquiat with art supplies and offers him a basement studio beneath her gallery on Prince Street to work; while there he makes work for a group show organized by Nosei (*Public Address*, October 31–November 19), which also features socially focused work by Bill Beckley, Mike Glier, Keith Haring, Jenny Holzer, Barbara Kruger, and Peter Nadin. In December the poet and critic Rene Ricard publishes the first major essay on Basquiat, "The Radiant Child," in *Artforum*.

1982 During 1982 Basquiat's exhibition schedule picks up significantly, and he works constantly to keep up with the demand for new work, while still finding time to deejay at various Manhattan nightclubs, begin a brief relationship with Madonna (which runs from fall 1982 through early 1983), have lunch with Andy Warhol in October (a meeting organized by the eminent Swiss dealer Bruno Bischofberger), and sit for a portrait with the renowned African American photographer James VanDerZee (figure 4).

In January Annina Nosei arranges for Basquiat (then with Mallouk) to move to an apartment located at 151 Crosby Street in SoHo.[41] He will live and work there until the summer of 1983.

In the spring Basquiat's first solo show in the United States opens at the Annina Nosei Gallery in New York (March 6–April 1) and features works like *Arroz con Pollo*, *Crowns (Peso Neto)*, and *Untitled (Per Capita)* (plates 3 and 4). This is almost immediately followed by another big solo show in Los Angeles at the Gagosian Gallery (April 8–May 8), where all works are sold. Los Angeles–based

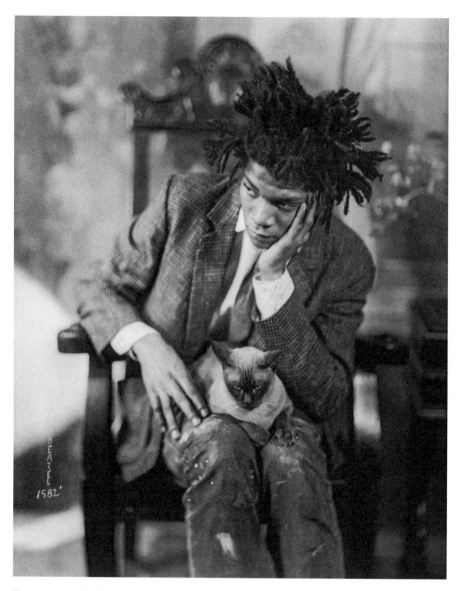

Figure 4. James VanDerZee, *Jean-Michel Basquiat*, 1982.

critic Hunter Drohojowska explicitly remarks on the "exotic mythology" that
encircles Basquiat: "a 22-year-old Black street artist . . . bombing graffiti
around the streets, is plucked from group show in alternative space in
prestigious SoHo gallery."[42]

In May Basquiat decides to leave Nosei's gallery. In a 1986 interview, Basquiat
cited the reason for his departure: "She sold paintings that weren't finished. She
said someone was interested in the painting and sold it despite my protests."[43]
Basquiat chooses Bruno Bischofberger, whom he has not yet met personally, to
become his worldwide exclusive dealer—an agreement that lasts until the artist's

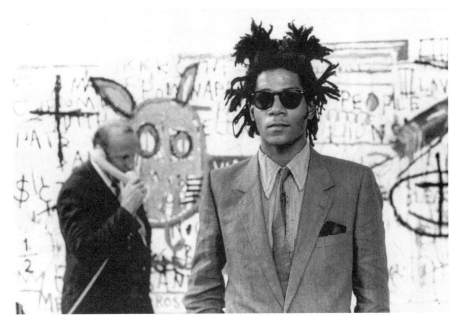

Figure 5. Bruno Bischofberger and Jean-Michel Basquiat at Galerie Bruno Bischofberger in Zurich, 1982.

untimely death (figure 5). Basquiat asks Bischofberger to find a partner gallery for exhibitions in New York. Basquiat's first choice is Leo Castelli, who declines, and his second choice is Mary Boone, who takes more than a year to agree.

In June Basquiat returns to Modena for a second exhibition at Emilio Mazzoli's gallery; he brings friend Kai Eric and Suzanne Mallouk with him. Basquiat is immediately shuttled over to an industrial space Mazzoli has rented, expecting the artist to produce paintings for the show.[44] By the end of his two weeks there, Basquiat has finished eight large canvases. Speaking about this time in Modena with an interviewer, Basquiat recalls that "they [Nosei and Mazzoli] set it up for me so I'd have to make eight paintings in a week" and that working in the rented space "was like a factory, a sick factory . . . I hated it." "I wanted to be a star," he continues, "not a gallery mascot."[45] Because of this experience, Basquiat cancels the exhibition, but he is still paid by Mazzoli. He and Mallouk return to New York, but not before being interrogated by the Italian police about all the cash they want to carry home.[46] Basquiat is forced to open a Swiss bank account to deposit the cash.[47]

In August he returns to his basement studio with his assistant Steven Torton and destroys the ten or so canvases that are there—slashing them, pulling them from their stretchers. Soon after, he has his first solo exhibition (of six during his lifetime) at Galerie Bruno Bischofberger in Zurich (September 11– October 9), showing works like *Man from Naples, Crown Hotel, Three Species,* and *Profit I.* Basquiat flies to Switzerland with Torton for the opening. Bischofberger drives them both to visit his birthplace in the mountain town of Appenzell, located about sixty miles east of Zurich.

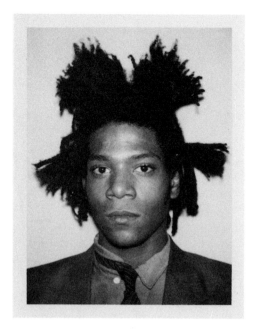

Figure 6. Andy Warhol, *Portrait of Jean-Michel Basquiat*, 1982.

Although we do not have many details, it seems that Basquiat and Warhol had several casual encounters, beginning in the late 1970s. Warhol wrote in his diary of "the kid who used the name 'Samo,' when he used to sit on the sidewalk in Greenwich Village and paint T-shirts, and I'd give him $10 here and there and send him up to Serendipity to try to sell the T-shirts there. He was just one of those kids who drove me crazy."[48] As noted above, in the spring of 1978, Basquiat approached Warhol, while he was with Geldzahler inside a restaurant, to sell him one of the postcards he was making with Jennifer Stein at the time.

Basquiat's attempts to connect with Warhol are finally rewarded on October 4, 1982, when the two are formally introduced by Bischofberger, who brings Basquiat over to be photographed for a portrait at the Factory, located at 860 Broadway (figure 6). Before they are to eat their lunch, Basquiat asks Bischofberger to take photographs of Basquiat and Warhol together with the same Polaroid camera Warhol used. Basquiat then takes one of the photographs, says he cannot stay for lunch, and leaves. Warhol writes in his diary that Basquiat "went home and within two hours a painting was back, still wet, of him and me together. And I mean, just getting to Christie [Crosby] Street must have taken an hour. He told me his assistant painted it."[49] Because the work is too large to fit into a taxicab, Steven Torton brings it back to the Factory, running the sixteen or so blocks with the painting under his arm. This painting, *Dos Cabezas* (plate 9), shows the two artists side-by-side, both looking out at the viewer. Warhol's head, accompanied by a blue disembodied hand raised up to his mouth in a characteristic gesture of contemplation, appears on the left side of the canvas, while Basquiat appears on the right side, wearing a black

turtleneck, and with a black mark in the middle of his smile to indicate the gap between his two front teeth. What is perhaps most interesting here, aside from the speed of execution, is that Basquiat's figure exceeds the frame of the right half of the composition. His dreadlocks, represented by long, black brushstrokes, radiate outward from his head and move across the dividing line into Warhol's space, even partially covering the older artist's face. There is a clear tension here, as the brash young artist threatens to overtake the older, more established one. While Warhol, Bischofberger, and some other people at the Factory stand around the painting as it lies on the floor, Warhol, who apparently likes the work, says, "I'm really jealous—he is faster than me."[50]

At the end of October, Basquiat has another exhibition in Italy at the Galleria Mario Diacono in Rome (October 23–November 20), showing only one painting, *Field Next to the Other Road,* which he had painted in Modena in 1981.

Basquiat's photo session with VanDerZee,[51] an iconic photographer who is then ninety-six years old, almost doesn't happen. Diego Cortez, who is originally asked to interview Basquiat for Andy Warhol's *Interview* magazine, later remembers: "In the fall of that year, Henry [Geldzahler] told me Andy [Warhol] wanted me to interview Jean-Michel for *Interview,* but I suggested that Henry do so and that they ask James Van Der Zee to do the photographs. The magazine replied that they didn't permit outside photographers to contribute so I urged Henry to ask Andy to make an exception which he did and the result was stunning."[52] Cortez accompanies Basquiat to the photo shoot in VanDerZee's Harlem studio. According to Cortez, "Van Der Zee first refused to take Jean-Michel's portrait as he felt it disrespectful that Jean-Michel came in ripped and paint-splattered jeans and a leather jacket—not exactly a Harlem Renaissance 'look.'"[53] In a spirit of compromise, Basquiat takes Cortez's Jhane Barnes sport jacket to wear with his jeans. Basquiat's encounter with VanDerZee is a significant moment for the artist. Speaking afterward with Geldzahler, Basquiat explains that the photographer was "really great. He has a great sense of the 'good' picture."[54] But beyond any mere technical sense, we can imagine that Basquiat's time with such a significant Black artist made an impact. Considering VanDerZee's longtime role as the documentarian of Black life in New York and his prominence in the Metropolitan Museum of Art's 1969 exhibition *Harlem on My Mind,* Basquiat's sitting for one of the greatest photographers of the twentieth century certainly signaled his own increasing importance—that is, as someone worth documenting..Shortly after their session, Basquiat painted a portrait of the photographer (*VNDRZ,* 1982).

On November 4 the Fun Gallery in New York—founded by Patti Astor and her partner, Bill Stelling—opens a show featuring thirty of the artist's paintings (figure 7), to great critical acclaim. The exhibition design is unconventional, conceived by Basquiat as "a total installation where the architecture reflected the rawness of the work. He designed . . . a couple of sheetrock walls dividing the gallery space into three areas [which] were left half-finished with exposed joint compound and metal studs."[55] The gallery windows are soaped so that visitors might draw on them. Many of the works use exposed stretchers, which feature crossbars held together with twine. These exposed stretcher bars (*Jawbone of an Ass, Three Quarters of Olympia Minus the Servant*) and edges (*St. Joe Louis*) match the raw energy of the East Village space. The critical response

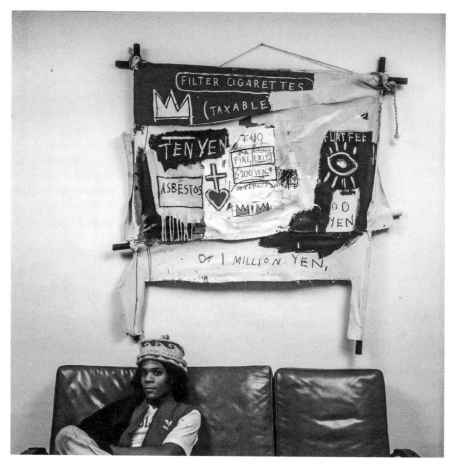

Figure 7. Tseng Kwong Chi, Jean-Michel Basquiat in front of *One Million Yen* for his exhibition at Fun Gallery, New York, November 4–December 7, 1982.

to the Fun Gallery exhibition is overwhelmingly positive. Nicolas Moufarrege wrote, "Jean-Michel Basquiat's show at the Fun Gallery was his best show yet. He was at home; the hanging was perfect, the paintings more authentic than ever."[56] Basquiat keeps most of the works from the show for himself.

In December a small exhibition of five paintings opens at the Galerie Delta in Rotterdam (December 1–31), showing the works *Portrait of VRKS, Kings of Egypt I* and *II, Sinhueso,* and *LNAPRK.*

Basquiat is also included in several group shows. He is the youngest artist invited to participate in *Dokumenta 7* in Kassel, Germany (June 19–September 28), where he shows two paintings: *Acque Pericolose (Poison Oasis)* and *Arroz con Pollo* (plates 2 and 3). He is also included in *Transavanguardia: Italia/America* at the Galleria Civica del Commune in Modena, Italy, and *The Pressure to Paint,* curated by Diego Cortez at the Marlborough Gallery in New York (June 4–July 9)—exhibitions that clearly position him as a Neo-Expressionist because of his association with Neo-Expressionist artists such as Sandro Chia, Francesco Clemente, Enzo Cucchi, Keith Haring, A. R. Penck, David Salle, and Julian Schnabel.[57]

For Basquiat, 1982 is also a time of formal experimentation. During this year, he produces his first portfolio of prints, *Anatomy* (eighteen silk-screened prints on paper, in an edition of eighteen, with seven artist proofs), printed by Jo Watanabe and published by the Annina Nosei Gallery. In November, while back in Los Angeles to prepare for a 1983 exhibition at Larry Gagosian's gallery, Basquiat begins working with art dealer Fred Hoffman to complete an edition of six prints that is published by New City Editions.[58]

Basquiat enters the art scene at the beginning of the hip-hop movement, which grows exponentially over the course of the 1980s. Charlie Ahearn starts working on his feature film Wild Style, *regarded by many as the first hip-hop film, in 1981.* Wild Style *brings what started as a regional movement to a national audience, featuring major graffiti artists, B-boys, MCs, and deejays such as Lee Quiñones, Patti Astor (also cofounder of the art space Fun Gallery), Fab 5 Freddy, Rammellzee, Cold Crush Brothers, the Fantastic Five, Rock Steady Crew, Sugar Hill Gang, Grandmaster Flash, Busy Bee, Crazy Legs, and Grand Mixer D.ST. In Fab 5 Freddy's words,* Wild Style *captured "a unique New York phenomenon started primarily by teenagers from some of the poorest parts of town."[59] This is a new avant-garde, sourced directly from the street. But for Basquiat, jazz is an important influence as well. Fab 5 Freddy later recalls that Basquiat's interest in jazz made perfect sense in the context of hip-hop—that is, the connections between "what was going on with hip-hop and the DJs battling, and Charlie Parker and Dizzy Gillespie battling."[60] In 1982 Frank Driggs and Harris Lewine publish the book* Black Beauty, White Heat: A Pictorial History of Classic Jazz, 1920–1950, *which proves to be an important source for many of Basquiat's references to jazz music throughout his work.[61]*

1983 Still without a New York dealer, as Mary Boone has yet to come to a decision, Basquiat starts the year by participating in a group exhibition, *Champions,* at the Tony Shafrazi Gallery (January 15–February 19), alongside John Ahearn, Donald Baechler, James Brown, Ronnie Cutrone, Brett De Palma, Futura 2000, Keith Haring, Tom Otterness, Kenny Scharf, and Zadik Sadikian; each artist shows one work. All the exhibiting artists are asked to provide the gallery with a written biography for the exhibition catalogue; Basquiat instead provides the drawing *Untitled (Biography)* (figure 8). The drawing appropriates the form of the short-form curriculum vitae with the artist's name, date, and place of birth centered at the top and a section devoted to education immediately below. But unlike other artists in the exhibition, whose submitted resumes would have included professional degrees and lists of group and solo exhibitions, Basquiat's version is a kind of antithesis. He includes his elementary and secondary schools, and his highlighting of his status as "11TH GRADE DROPOUT" at the upper right emphasizes his *lack* of the type of education and professional resources that would have been expected of someone at his level of accomplishment. He further highlights his unconventional path by boasting farther down of teaching "SECOND GRADERS WHEN I WAS IN THE FOURTH GRADE" in a way that promotes him as a child prodigy, a "genius child."

Annina Nosei exhibits works by Basquiat that she owned prior to the end of their business relationship in 1982 (February 12–March 3).

During the first few months of 1983, Basquiat lives off and on in Los Angeles while preparing for a second exhibition at Larry Gagosian's gallery (March 8–April 2). While in Los Angeles, he passes his time in Beverly Hills at the

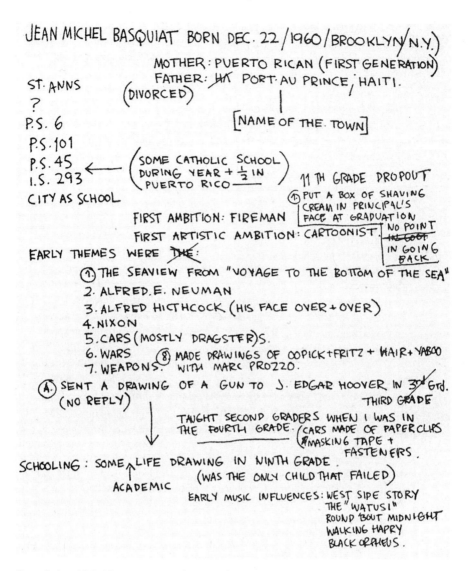

Figure 8. Jean-Michel Basquiat, *Untitled (Biography)*, 1983.

L'Hermitage Hotel and at Mr. Chow's restaurant. He trades paintings with proprietors Michael and Tina Chow for his food and drink tab at their restaurant.[62] He even meets Gene Kelly, who gives him the jacket from the film *Singin' in the Rain* (1952) as a gift. Rammellzee and Toxic join Basquiat in Los Angeles right before the Gagosian show opens; their visit is commemorated by the portraits of the three friends in the painting *Hollywood Africans* (plate 19).

 The Gagosian exhibition includes twenty-five paintings, many centered on fame—that is, African American boxers, musicians, and the Hollywood film industry (figure 9). Paintings in this exhibition included *Eyes and Eggs, Untitled*

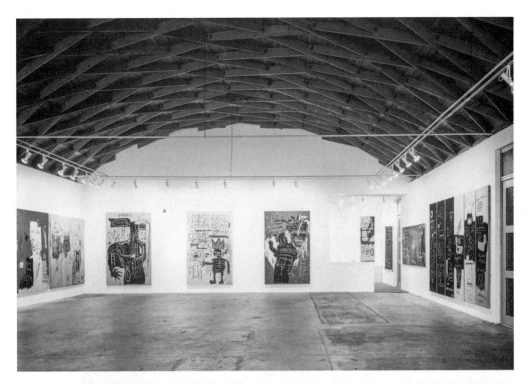

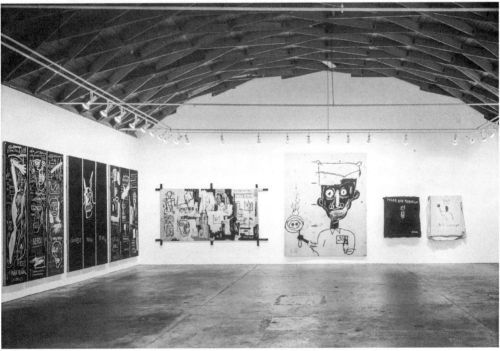

Figure 9. Installation view of *Jean-Michel Basquiat: New Paintings*, Larry Gagosian Gallery, North Robertson Boulevard, Los Angeles, 1983.

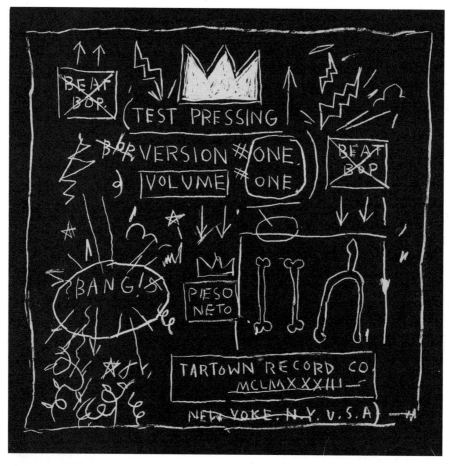

Figure 10. Rammellzee, K-Rob with Jean-Michel Basquiat (cover), *Beat Bop / Test Pressing*, 12-in. vinyl record. Tartown Record Co., New York, 2001.

(Sugar Ray Robinson), Museum Security (Broadway Meltdown), Dos Cabezas II, and *Big Shoes* (plates 15 and 13)—all bought from Annina Nosei and borrowed from Bruno Bischofberger.

Back in New York, Basquiat produces the single recording "Beat Bop"—a battle rap between Rammellzee and K-Rob (Malik Johnson)—on his own label, Tartown Record Co. (figure 10). He also designs the cover art for the album, which is featured on the soundtrack for the 1983 documentary *Style Wars*, a chronicle of early hip-hop and graffiti cultures that first airs on PBS television on January 18, 1984.

In March the Whitney Biennial includes two works by Basquiat: *Untitled (Head in Profile)* (1981) and *Dutch Settlers* (1982). Once again he is the youngest artist to participate in this prestigious exhibition. Around this time, Basquiat also begins a relationship with Paige Powell, an editor for *Interview* magazine, who is close to Andy Warhol and fosters the relationship between the two artists (figure 11).

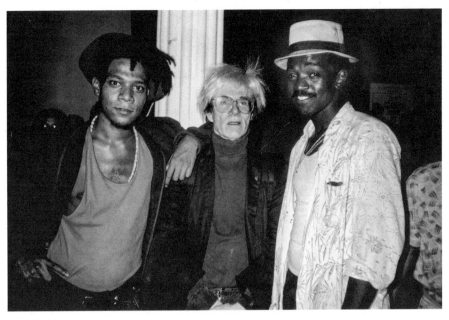

Figure 11. Jean-Michel Basquiat, Andy Warhol, and Fred Brathwaite, New York City, January 1, 1984.

Powell organizes a show of Basquiat's works in her apartment on West Eighty-First Street.

Basquiat returns to Los Angeles in June. While there he meets Lee Jaffe, a musician and painter who had lived and worked with Bob Marley in the mid-1970s. Basquiat invites Jaffe to travel with him to Tokyo, where he walks the runway in a fashion show for Issey Miyake. While in Tokyo, Basquiat also does a photo shoot with the Japanese photographer Yutaka Sakano; he is dressed head to toe in Miyake's clothes and flinging paint around.[63] Jaffe and Basquiat later travel to Thailand, then to Zurich and St. Moritz, where Basquiat visits Bischofberger at his vacation home. During this stay, Basquiat makes some drawings with Bischofberger's four-year-old daughter Cora in the guest book and also paints a canvas with her. Bischofberger speaks with Basquiat about collaborative works in art history (such as the "exquisite corpse" or *cadavre exquis* drawings of the Surrealists in the first part of the twentieth century) and asks whether he might be interested in doing collaborative works with Warhol and another artist. Basquiat agrees with great interest.[64]

Back in the United States, at the end of August, Basquiat moves into a new loft at 57 Great Jones Street, rented from Warhol and guaranteed by Bischofberger.[65] Basquiat uses the lower floor as his studio; a bedroom is upstairs. He will live there (with Warhol as his landlord) until his death five years later.

During the fall of 1983, Basquiat shows work in several solo and group exhibitions. His second solo show *Jean-Michel Basquiat: New Paintings* at the Galerie Bruno Bischofberger in Zurich runs from September 28 to October 22.

Hardware Store, Toussaint l'Overture Versus Savonarola, Florence, and *Maurice* are included among the sixteen works in the exhibition. Shortly afterward, his painting *The Philistines* (1982) (plate 10) appears alongside the works of Willem de Kooning, Jean Dubuffet, Joan Miró, and Jackson Pollock in the exhibition *Expressive Painting after Picasso* at the Galerie Beyeler in Basel (October–December). On the occasion of this exhibition, Basquiat paints over a poster he finds advertising a Picasso exhibition at the same venue in 1955, taking care to sign the work twice and cross out Picasso's own name (plate 14).

On October 5, Basquiat travels with Warhol to Milan; he stays for just a few days before moving on to Spain with Keith Haring on October 8. When he returns to New York the following week, Warhol slaps him in the face, protesting: "How dare you dump us in Milan!"[66]

In November Basquiat is included in two group shows in New York (at the Fine Arts Museum of Long Island and the Brooklyn Museum)[67] and travels again to Tokyo, where Bischofberger has organized his first solo exhibition in Japan at the Akira Ikeda Gallery (November 14–December 10).

Basquiat's work *Esophagus* is part of the group show *Post Graffiti,* together with works by Keith Haring, Crash, Futura 2000, Lee Quiñones, Rammellzee, and others, at Sidney Janis Gallery on Fifty-Seventh Street, New York (December 3–31), where he was shown previously in a group exhibition in 1982.

In December Basquiat returns to Los Angeles, accompanied by Madonna. They stay together on the first floor of Gagosian's house on Market Street in nearby Venice, which Basquiat rents from the dealer for a studio space. He begins a series of paintings on wood panels that his studio assistant Matt Dike has salvaged from a broken picket fence behind Gagosian's place.[68] Among the works produced during this period in Los Angeles are *Flexible, Water-Worshipper,* and *Gold Griot* (plate 27). Basquiat and Madonna stay together at Gagosian's house through Christmas; Madonna returns alone to New York shortly thereafter, reuniting with a former boyfriend.[69]

After taking months to reach a decision, at the end of 1983, Mary Boone finally agrees to become Bischofberger's partner in representing Basquiat and to show his work at her gallery in New York.

On September 15, New York Transit Police arrest the twenty-five-year-old African American graffiti artist Michael Stewart for spray-painting at the First Avenue station of the New York City subway. On his way to the District 4 Transit Police station, Stewart is beaten unconscious by the officers, as well as "hogtied"—that is, his ankles and wrists are bound and then tethered together by an elastic strap. After he is booked at the station for resisting arrest and unlawful possession of marijuana, officers (claiming Stewart appeared to be emotionally disturbed) transport Stewart to Bellevue Hospital for psychiatric observation. Suzanne Mallouk, Stewart's girlfriend at the time, recalled observing cuts and bruises on his body when she went to Bellevue with Stewart's parents to visit him. Thirteen days later, Stewart dies, ushering in a wave of protests about police brutality and calls for the removal of Dr. Elliot M. Gross—the city's medical examiner, who, according to the investigations conducted by Stewart's family, initially (and erroneously) classified the cause of death as

attributable to excessive drinking in his preliminary report.[70] *Immediately after Stewart's death, Basquiat paints a depiction of Stewart's beating on the wall of Keith Haring's studio at 600 Broadway:* The Death of Michael Stewart (Defacement) *(plate 22).*[71]

1984 The first part of the year is rather quiet for Basquiat, a time of relaxation. In January he travels to Hawaii, renting a house and studio in Hana on the eastern shore of Maui. Jean-Michel's father, Gerard, and his partner, Nora Fitzpatrick, visit the artist in Hana in February, along with Jean-Michel's sister Jeanine. Other friends visit Basquiat during his time in Maui, including Paige Powell, who later describes the location as "so lush and wild. We would take long meandering walks, ride horses, and cook every night." According to Powell, the artist was working on watercolor paintings on paper, which she "helped him with . . . filling in his drawings with colors."[72]

Basquiat returns to New York in March and is included in two group exhibitions that spring: *Since the Harlem Renaissance: 50 Years of Afro-American Art,* at the Center Gallery of Bucknell University (April 13–June 6), and *An International Survey of Recent Painting and Sculpture,* at the newly reopened Museum of Modern Art in New York (May 17–August 19).

In early spring, Bischofberger asks Warhol and Clemente—both of whom are represented by his gallery—to collaborate with Basquiat on a project of fifteen paintings. Warhol and Clemente agree, and all three artists soon begin work on these paintings (plate 26).

Later that spring, Basquiat has his first solo show with the Mary Boone/Michael Werner Gallery, organized in partnership with Bischofberger (May 5–26). The works shown include *Bird as Buddha, Brown Spots (Portrait of Andy Warhol as a Banana), Eye,* and *Death.* The catalogue for the exhibition includes "Poem for Basquiat," written by the German Neo-Expressionist artist A. R. Penck.[73] Reviews are mixed, with Nicolas Moufarrege writing in *Flash Art,* "It's quite absurd to speak of the decline of an artist who's barely 25. But at Boone/Werner one wonders whether Basquiat has gone in or out . . . The show is all orange juice and not enough beef. The colors are freshly squeezed and clean, the edge polished, the funk flattened."[74] Kate Linker, a critic for *Artforum,* also expresses dissatisfaction with these new canvases, remarking that "often it seemed as though Basquiat had been required to churn out canvases purely through permutations and combinations of the code."[75]

In August Basquiat travels with Bruno Bischofberger and his wife, Christina (Yoyo), to Edinburgh on the occasion of the artist's first-ever museum exhibition at the Fruitmarket Gallery (August 11–September 23); the exhibition, curated by Mark Francis, later travels to the Institute of Contemporary Arts in London (December 15–January 27) and the Museum Boijmans Van Beuningen in Rotterdam, Netherlands (February 9–March 31, 1985).

Also in August, Basquiat travels with the Bischofberger family to Italy and Mallorca. Their first stop is Ancona, where they meet Enzo Cucchi in his studio and have lunch together. The same day, they head to Rome for a family portrait by Francesco Clemente (figure 12).

During a break in the portrait session, Basquiat, Clemente, and Bischofberger go into a nearby restaurant, where Bischofberger produces reproductions of the

Figure 12. A visit in Rome, August 1984.

collaboration paintings and all three men work together to title them—an arrangement that Warhol had agreed to back in New York. One of the paintings is titled *Casa del Popolo* after the restaurant in which the deliberations take place. Two days later, Basquiat, Bischofberger, and Clemente fly to Mallorca for a two-day visit to Miquel Barceló, another artist represented by Bischofberger.

In September a small show of works titled *Jean-Michel Basquiat: New Paintings* opens at the Carpenter and Hochman Gallery in Dallas, Texas (September 20–October 20).

All fifteen of the collaboration paintings made with Clemente and Warhol are exhibited at Galerie Bruno Bischofberger in Zurich (September 15–October 13). The collaboration paintings are not well received by US critics; *Artforum* critic Max Weschler identifies himself as a "disappointed viewer" and describes the paintings as "essentially no more than the products of addition," lacking a synthesis between the three artists.[76]

In October Basquiat's friend Fab 5 Freddy introduces him to Robert Farris Thompson, a historian of African art at Yale University, who is writing an essay on the relationship between art and hip-hop. Thompson's book *Flash of the Spirit: African and African-American Art and Philosophy* (1983) was already an important source for Basquiat's artistic vocabulary, as well as his understanding of African cultural transmissions and adaptations in the Americas.[77] In a 1985 interview, Basquiat specifically refers to Thompson when asked whom he considered to be the most informed about his work.[78]

In the fall of 1984, and without Bischofberger's knowledge, Basquiat and Warhol begin to work on more collaboration paintings without Francesco Clemente.[79] The young artist convinces Warhol to give up silk-screening and to paint the works by hand, while Basquiat uses the silk-screen technique in many of his own contributions to these paintings. Their double collaboration continues for several months, producing more than one hundred paintings before their exhibition at Tony Shafrazi's gallery in September 1985.

Basquiat begins dating Jennifer Goode, whose brothers Christopher and Eric Goode cofounded the popular Manhattan nightclub Area.[80]

In December Basquiat's work is shown alongside that of Keith Haring, Kenny Scharf, Tseng Kwong Chi, Louis Jammes, and others at the exhibition ⅗ *Figuration Libre, France-USA*, at the Musée d'Art Moderne de la Ville de Paris (December 21, 1984–February 17, 1985).

1985 At the beginning of the year, Basquiat opens his third large solo exhibition at Galerie Bruno Bischofberger in Zurich (January 19–February 16), showing fifteen works that include *Max Roach, Zydeco, Tabac*, and *M*.

The Akira Ikeda Gallery in Tokyo shows four of the triple collaborative works by Basquiat, Clemente, and Warhol (January 14–31). This is followed almost immediately by an exhibition of drawings at the Akira Ikeda Gallery's Nagoya location (February 12–March 9). Both of these Tokyo exhibitions were organized by Bischofberger.

In February Basquiat appears on the cover of the *New York Times Magazine* dressed in a paint-splattered suit and no shoes; he also wears his characteristic dreadlocks (figure 13). In March Basquiat has a second (and final) solo show at Mary Boone/Michael Werner Gallery (March 2–23), in partnership with Bischofberger; the exhibition catalog includes an essay written by Robert Farris Thompson (see pp. 128–137 in this book). In late March Basquiat travels to Hawaii with Jennifer Goode; they then go to Hong Kong.[81]

In late spring, Warhol smilingly discloses to Bischofberger that he and Basquiat have been working on double collaborations. While the two artists think that Bischofberger holds no automatic claim to these paintings (since the works were not commissioned by him), Warhol agrees that Bischofberger is the most suitable buyer for them. Bischofberger enthusiastically purchases a group of twenty-six. But before he ships the works to Switzerland, Bischofberger, at Warhol's request, approaches Tony Shafrazi with a request to arrange a spontaneous, short-term exhibition. Shafrazi agrees.[82]

In May Basquiat, along with Francesco Clemente, Keith Haring, and Kenny Scharf, is commissioned to make work for the new nightclub Palladium. The nightclub, opened by the founders of Studio 54, Ian Schrager and Steve Rubell, is intended as a 1980s reincarnation of the disco landmark. The club is decorated with murals and installations by the artists. For the opening, Basquiat completes two very large paintings, which a critic for the *New Yorker* calls out as indebted to Twombly and "significantly better" than his previous work (figure 14).

Over the summer, Basquiat travels in Europe with the photographer Michael Halsband, Eric Goode—an artist turned entrepreneur and cofounder of the

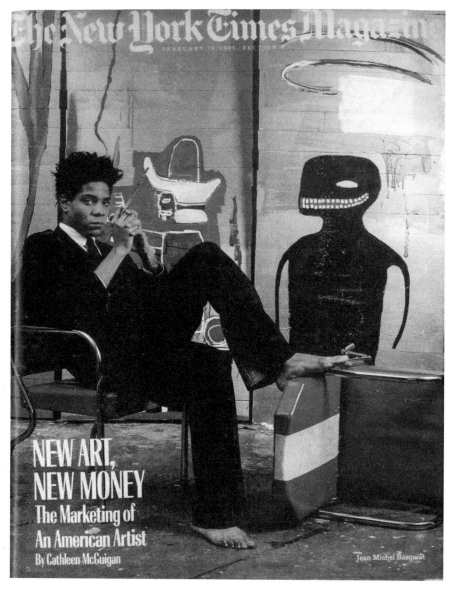

Figure 13. Jean-Michel Basquiat on the cover of the *New York Times Magazine,* February 1985.

popular downtown nightclub Area—and Eric's sister Jennifer. The group visits England, Portugal, and France. Basquiat continues on to St. Moritz to stay with the Bischofberger family, takes a brief eight-day driving tour of Italy, and takes a train to Amsterdam. After returning to the United States, Halsband shoots a series of photographs of Basquiat with Andy Warhol, both in boxing trunks and gloves, that will promote an upcoming exhibition of their collaborative paintings at the Tony Shafrazi Gallery in New York (figure 15).

Figure 14. Palladium nightclub showing view of mural by Jean-Michel Basquiat, New York, 1985.

Figure 15. Poster for the exhibition *Warhol and Basquiat: Paintings*, Tony Shafrazi Gallery, New York City, September 14–October 19, 1985.

On September 13 Basquiat attends the MTV Music Video Awards, hosted by Eddie Murphy, at Radio City Music Hall.[83] The following evening, the Tony Shafrazi Gallery opens its exhibition of the sixteen collaborative paintings lent by Bischofberger, *Andy Warhol and Jean-Michel Basquiat: Paintings* (September 14– October 18). Although the opening is well attended, the exhibition receives mixed reviews. In the *New York Times*, Vivienne Raynor characterizes Basquiat's works as "large, bright, messy, full of private jokes and inconclusive" and calls Basquiat a "willing accessory" to "Warhol's manipulations."[84] Critic Robert Mahoney,

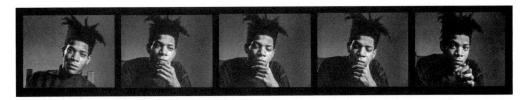

Figure 16. Jean-Michel Basquiat, 1985.

on the other hand, declares the collaborations "a success," despite "the hit-and-miss nature of any collaboration."[85] Disappointed by the critical reactions, Basquiat stops his collaborative painting sessions at the Factory, much to the displeasure of Warhol, who writes in his diary a month later, "And oh I really missed Jean-Michel so much yesterday. I called him up and . . . I told him I missed him a lot."[86]

At the end of the year, Basquiat has two exhibitions: *Jean-Michel Basquiat: Paintings* (December 2–25, Akira Ikeda Gallery, Tokyo), organized by Galerie Bruno Bischofberger, and *Jean-Michel Basquiat: Paintings from 1982* (December 14–January 9, Annina Nosei Gallery, New York).

Galerie Bruno Bischofberger publishes the catalogue *Jean-Michel Basquiat: Drawings,* with thirty-two works on paper made in the winter of 1982–83. The collectors who purchase all thirty-two name the works *The Daros Suite.*

On December 19 Basquiat and Eric Goode host a party at Area to celebrate both their birthdays. Basquiat creates the invitation card together with Fernando Natalici.[87] But by late 1985, Basquiat was much less involved in the downtown scene, preferring instead to remain isolated in his apartment and studio.

On December 22 there is a second (and more awkward) party for the artist's twenty-fifth birthday, hosted by Marcia May at the trendy uptown restaurant Mortimer's (figure 16).

1986 For what will turn out to be his final exhibition at the Gagosian Gallery, *Basquiat* (January 7–February 8), Basquiat returns to Los Angeles for two weeks. The exhibition includes *Link Parabole* and *Peruvian Maid.* Basquiat travels to Atlanta in February for an opening at the Fay Gold Gallery (February 7–March 5). In April Bischofberger organizes his fifth exhibition, *Jean-Michel Basquiat: Drawings,* that includes twenty-five drawings made from 1984 to 1986. From July to August *Jean-Michel Basquiat: Bilder 1984–86,* organized by Bischofberger, runs at Galerie Thaddaeus Ropac in Salzburg, Austria.

Basquiat tells Bischofberger of his desire to exhibit work in Africa. Although he does not know the exact location from where his ancestors came across the Atlantic, Basquiat feels a connection to the continent. Bischofberger manages to organize an exhibition in the capital of Ivory Coast, Abidjan, which takes place at the Centre Culturel Français (October 10–November 7)—a location secured with the help of the Swiss ambassador to Ivory Coast, Claudio Caratsch.[88] Basquiat agrees to exhibit a group of works from his own collection in New York. Bischofberger and his wife, Yoyo, travel to Abidjan for the exhibition, and Basquiat travels from New York with girlfriend Jennifer Goode and her brother

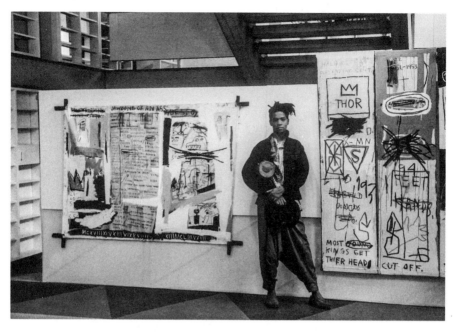

Figure 17. Jean-Michel Basquiat, Abidjan, Ivory Coast, 1986.

Eric, arriving a day after the opening (figure 17). Soon after, Basquiat, Bischofberger, their entourage, and some friends fly to Korhogo, in the north of the country, to meet people from the Senufo tribe. They travel the four hundred miles back to Abidjan in two cars. This is the artist's first and only trip to Africa.[89]

Back in New York, as the relationship with Mary Boone has worsened, Basquiat decides that he no longer wants to be represented by her. He asks Bischofberger to end his collaborative representation of the artist with Boone, which started at the end of 1983, and Bischofberger agrees.

The Akira Ikeda Gallery in Tokyo (September 8–30) shows a group of five double collaborations by Warhol and Basquiat, received from Galerie Bruno Bischofberger. Bischofberger buys all the double collaboration paintings that Warhol and Basquiat are willing to sell. He organizes a show with the ten paintings that he considers to be the best at his gallery in Zurich (November 14, 1986–January 17, 1987).

In November Basquiat is the youngest artist to have a solo exhibition at the Kestner-Gesellschaft in Hanover, Germany; the show, curated by Carl Haenlein, includes more than sixty of the artist's paintings and drawings.

By November 1986, Jennifer Goode decides to end her relationship with Basquiat, although the two continue to see each other afterward.[90]

Akira Ikeda Gallery, Nagoya, has another exhibition with drawings (November 11–29), organized by Bischofberger.

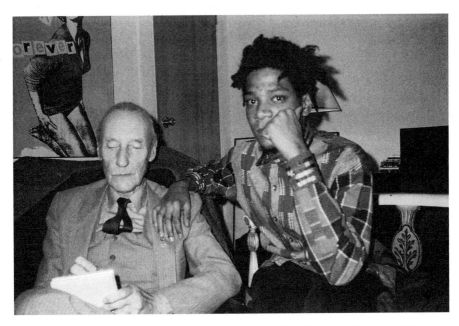

Figure 18. William Burroughs and Jean-Michel Basquiat in New York City around Christmas 1986.

Basquiat celebrates Christmas with musician Debbie Harry, artist Victor Bockris, and Beat writer William Burroughs at Burroughs's apartment at 222 Bowery, nicknamed "The Bunker" for its lack of windows (figure 18).

In a 1985 interview, Basquiat declared William S. Burroughs his favorite living author.[91] According to one biographer, the artist could frequently be seen carrying around Burroughs's first novel, Junk. *Burroughs was an important figure in the punk and East Village scenes of the 1970s and 1980s, and Basquiat visited "The Bunker" several times in 1986.[92] During one party there, both Burroughs and fellow Beat writer Allen Ginsberg made sketches in Basquiat's notebook. Burroughs later visited Basquiat's loft-studio on Great Jones Street, and the two eventually traded works. Burroughs took Basquiat's collaged sculptural work* Nod, *and Basquiat took Burroughs's* Woman as a Man, *a wood relief made with gunshots.[93]*

1987 In the first months of 1987, Basquiat has two international exhibitions: one in Paris at the Galerie Daniel Templon (January 10–February 7), showing twelve paintings, such as *Gin Soaked Critic, Gri Gri,* and *Sacred Monkey;* and another at the Akira Ikeda Gallery in Tokyo (February 7–28), organized again by Bischofberger.

On February 2 Andy Warhol unexpectedly dies after emergency gallbladder surgery at New York Hospital; he was fifty-eight years old. Basquiat has been quite close to Andy, but their relationship at this moment is strained. Basquiat is told by Fred Hughes of Warhol's Factory that no one outside of the family has been invited to Warhol's funeral in Pittsburgh. Basquiat attends the crowded public memorial held at St. Patrick's Cathedral on April 1. Soon after, Basquiat

paints a work titled *Gravestone* in homage to Warhol. According to Basquiat's friend Fab 5 Freddy, "Andy's death put Jean-Michel into a total crisis. He cried a lot and wore a black armband. I ran into him at a club a few days after Andy died, and it was really sad. Typical Jean-Michel. He's at Madam Rosa's being a total asshole. He's standing in the middle of the dance floor, crying in agony, and leaning his head on the wall. He couldn't even talk. I put my arm around him and bought him a drink."[94]

In response to Basquiat's request for a new partner gallery in New York— uptown, if possible—Bischofberger comes to an agreement with the owners of gallery Maeght Lelong, in New York and Paris; they plan two exhibitions, one at their New York gallery, on Fifty-Seventh Street, for fall 1987 and another at the Paris gallery. The agreement is the same as Bischofberger once had with Mary Boone, but it turns out that Basquiat's physical condition makes it difficult for him to work much.[95] Only two new works shown in a group exhibition make it to Maeght Lelong's uptown gallery.[96]

Since the exhibition of Warhol-Basquiat collaborations, no works by Basquiat have been shown in New York. At the end of May, the Tony Shafrazi Gallery in New York shows the drawing *Pegasus*, completed the night after Warhol's death, and two other large-scale drawings in the basement of the gallery (May 23– June 13). Vrej Baghoomian, Shafrazi's cousin, approaches the artist and is able to buy works from him directly.

In June a selection of drawings is shown at Galerie Ropac, Salzburg (June 6–30).

In September Basquiat travels to Paris to walk in the Comme des Garçons show for their spring/summer collection.[97]

Basquiat's last exhibition of the year takes place at the P.S. Gallery in Tokyo (October 8–December 4).

On October 19 stock markets around the world crash, beginning in Hong Kong and then spreading to Europe and the United States. The Dow Jones Industrial Average falls 508 points, or 22.61 percent—the largest single-day percentage decline on record to this date.

The large exhibition Jacob Lawrence: American Painter, *organized by the Seattle Art Museum, is on display at the Brooklyn Museum from October 1 through December 1. Like Basquiat, Lawrence (1917–2000) found early success and was marketed as an untrained prodigy; he was the first African American artist to be represented by a New York gallery (the Downtown Gallery) and became an art world sensation after the exhibition of his* Migration Series *in 1941, when Lawrence was only twenty-four years old. Lawrence's 1987 retrospective, which toured nationally, must have caught the attention of Basquiat, who is in New York when it comes to the Brooklyn Museum.*

This same year, Romare Bearden (1911–1988) was awarded the National Medal of Art.

It is worth noting, however, that Basquiat himself did not explicitly acknowledge the influence of Black artists on his own work. Basquiat did paint a portrait of the renowned photographer James VanDerZee, who made a photographic portrait of Basquiat in 1982 (see page 338), but this seems to be one of a few exceptions. Even in interviews, Basquiat went along with the critical silences that then existed around

African American artists such as Norman Lewis, Jacob Lawrence, and Romare Bearden, choosing instead to comment on white artists such as "Twombly, Rauschenberg, Warhol, and Johns."[98] In 1987, when Isabelle Graw informed Basquiat that he was "the only Black man to have become a very successful artist,"[99] he failed to correct her mistake. Clearly, the status of Black artists in the mainstream art world was still precarious at the end of the 1980s.

1988 In January Vrej Baghoomian's gallery in SoHo organizes a one-night show of new paintings at the Cable Building in SoHo before sending them on to Paris and Düsseldorf. This is the last show in New York during Basquiat's lifetime.

A few days later, Basquiat travels to Paris for his solo exhibition at Galerie Yvon Lambert (January 9–February 10); among the works shown are *Light Blue Movers, Riddle Me This, Batman, She Installs Confidence and Picks His Brain Like a Salad*. Another small exhibition, *Jean-Michel Basquiat: Peintures, 1982–1987*, is also on view in Paris at the Galerie Beaubourg (January 9–February 16). While in Paris, Basquiat sits for a series of intimate portraits with photographer Jérôme Schlomoff (figure 19) and meets the painter Ouattara Watts, who is from Korhogo—the same town in Ivory Coast that Basquiat, the Bischofbergers, and Jennifer Goode had visited two years earlier.

In mid-January, Basquiat leaves Paris for a quick trip to Düsseldorf on the occasion of his solo show at Galerie Hans Meyer (January 12–March 15) and then travels to Amsterdam. He returns to Paris, where he passes the next few months, staying at a hotel in the Marais. While in Paris together, Basquiat and Watts attend exhibitions of works by Julian Schnabel and Cy Twombly. Watts invites Basquiat to stay with him in Ivory Coast at the end of that summer.

In early spring, Basquiat asks Bischofberger to meet Fred Hughes at the Warhol Foundation in order to select Basquiat's half of the Basquiat-Warhol collaboration paintings (some of which are unfinished), saying that his physical and mental condition is not good enough to do the task himself. Basquiat sells his selected half of the works to Bischofberger. The other half of the Basquiat-Warhol collaborations will be sold later by the Warhol Foundation to Larry Gagosian, who sells most of them privately or in an exhibition in Los Angeles.[100]

In April Basquiat returns to New York. The Vrej Baghoomian Gallery (April 29–June 11) does another exhibition in some empty unrented and unrestored rooms at the Cable Building, with paintings such as *Eroica I, Eroica II,* and *Riding with Death* (plate 35). Basquiat then goes to New Orleans with his friends Ouattara Watts and Eric Bray (a young video director) to attend the Jazz and Heritage Festival. According to Watts, the three men go to a voodoo shop and buy gris-gris (protective amulets). They also make a trip to the Mississippi River.

Basquiat travels to Dallas and Los Angeles and in May returns to Maui in an attempt to treat his drug addiction. He asks his former girlfriend Jennifer Goode to join him, but she refuses. When his girlfriend Kelle Inman—a young woman he had met while she was waitressing at a downtown nightclub—comes to visit several weeks later, she finds that Basquiat is not doing drugs but has nevertheless been drinking heavily and is listening constantly to jazz tapes.[101]

At the beginning of the summer, the last exhibition of Basquiat's work during his lifetime, *Jean-Michel Basquiat: Paintings, Drawings*, organized by

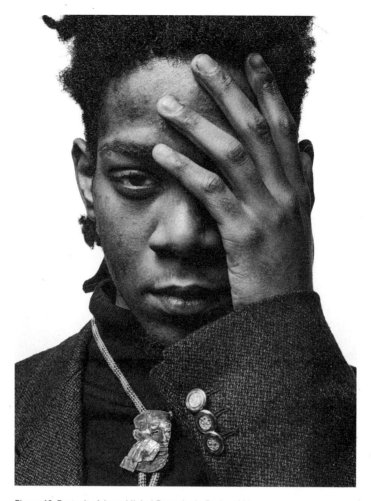

Figure 19. Portrait of Jean-Michel Basquiat in Paris, 1988.

Bischofberger, is mounted at Galerie Thaddaeus Ropac in Salzburg (June 15–July 26).

At the end of June, on his way back to New York from Hawaii, Basquiat stops in Los Angeles, where he spends a week with friends Matt Dike and Tamra Davis. When he returns to New York in mid-July, he runs into old friends Keith Haring and Vincent Gallo and also spends time with Inman and the painter Paul Martini.

In August Basquiat purchases tickets for himself, Ouattara Watts, and Kevin Bray to travel together to Abidjan, Ivory Coast, with the intention of undergoing a ritual cleansing to rid him of his drug addiction.[102] But Basquiat does not make it back to Africa.

On August 12 Basquiat dies in his Great Jones Street loft. The Office of the Chief Medical Examiner in Manhattan lists the cause of death as "acute mixed drug intoxication." At the time of his death, Jean-Michel Basquiat is only twenty-seven years old.

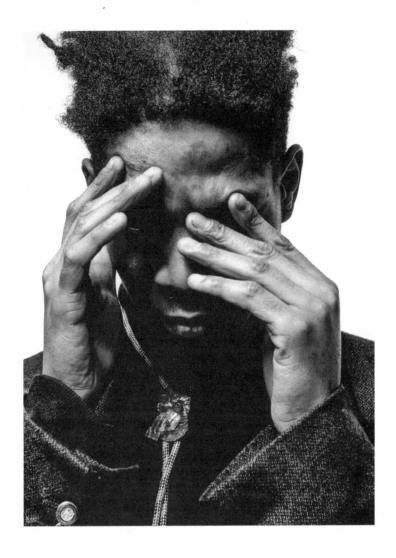

On August 17 there is a private funeral for Basquiat's immediate family and close friends at the Frank E. Campbell Funeral Chapel on Madison Avenue. The eulogy is delivered by Jeffrey Deitch, who proclaims that "Jean-Michel has left behind not just memories but a legend."[103] The artist is buried at Green-Wood Cemetery in Brooklyn, with a modest headstone inscribed "Jean-Michel Basquiat, Artist, Dec 1960–Aug 1988)."

On November 5 there is a memorial at St. Peter's Church on Lexington Avenue at Fifty-Fourth Street. Suzanne Mallouk reads A. R. Penck's "Poem for Basquiat," which he wrote for Basquiat's first exhibition with Mary Boone in 1984. John Lurie, cofounder of the experimental music group the Lounge Lizards and a friend from Basquiat's Mudd Club days, plays the saxophone.[104] Members from the band Gray perform, and Fab 5 Freddy recites the 1937 poem by Langston Hughes "Genius Child."

NOTES

1. Passenger manifest for flight 400, Compañia Domenicana di Aviacion C Por A, December 10, 1955. Flight originated at Port-au-Prince, Haiti, destined for Miami, Florida. Passenger and Crew Lists of Vessels and Airplanes Arriving at Miami, Florida, NAI no. 2771998, Records of the Immigration and Naturalization Service, 1787–2004, RG 85, National Archives, Washington, DC.

2. "Gerard Basquiat in His Own Words," in *Jean-Michel Basquiat 1981: The Studio of the Street* (New York: Deitch Projects, 2007), 90.

3. The exact date of their separation remains unknown.

4. "'TAKI 183' Spawns Pen Pals," *New York Times,* July 21, 1971, https://www.nytimes .com/1971/07/21/archives/taki-183-spawns-pen-pals.html. In this article TAKI 183 credits earlier tags by Julio 204, who also used Magic Marker and spray paint on city walls as early as 1968.

5. For more on this history, see Dimitri Ehrlich and Gregor Erlich, "Graffiti in Its Own Words," *New York Magazine,* July 3, 2007, http://nymag.com/guides/summer/17406/.

6. Jordana Moore Saggese, *Reading Basquiat: Exploring Ambivalence in American Art* (Berkeley: University of California Press, 2014), 35.

7. According to Nicholas Taylor, the trip to Culebra took place in the summer of 1982. This may be an error since Taylor also claims that Basquiat and Mallouk were staying in his apartment at the time. Basquiat and Mallouk moved into the loft on Crosby Street in January 1982. See "Jean-Michel Basquiat: An Intimate Portrait," accessed November 12, 2019, http://old.cepagallery.org/store /basquiat/8t.html. It is likely that this trip happened in the summer of 1981 considering the dating of a painting by Basquiat titled *Culebra.*

8. Phoebe Hoban, *Basquiat: A Quick Killing in Art* (New York: Penguin Books, 1998), 24.

9. Hoban, 27.

10. Hoban, 31.

11. The September 28, 1978, issue also included a retort from Saban that read "Okay, SAMO©, we've thought about it, but, try as we may, we can't think of a single fantasy that isn't totally boosh-wah-zee. You know, most of our fantasies are smug little concoctions revolving around money, sex, drugs, and sex. Up till now, we've been quite happy with them" Henry A. Flynt Jr., "Viewing SAMO© 1978–1979," accessed November 12, 2019, www.henryflynt.org/overviews/Samo /viewingsamo.pdf.

12. Philip Faflick, "SAMO© Graffiti: BOOSH-WAH or CIA?," *Village Voice,* December 11, 1978, 41. The role of Shannon Dawson in the SAMO collaborative is unclear. While Henry A. Flynt Jr. contends that Dawson was a participant, in an interview with Marc Miller Basquiat clearly asserts "it was me and Al Diaz." See page 17.

13. "Why Are the Lines Shorter for Gas than for the Mudd Club in New York? Because Every Night Is Odd There," *People,* July 16, 1979, https://people.com/archive/why-are-lines-shorter-for-gas-than-the-mudd-club-in-new-york-because-every-night-is-odd-there-vol-12-no-3/.

14. Glenn O'Brien, "Dozens of Rambling Red Roses for Jean," in *Basquiat* (Tony Shafrazi Gallery), 32.

15. *TV Party* was a public-access television show hosted by Glenn O'Brien, the music critic for *Interview* magazine, and Chris Stein, the guitarist from punk band Blondie. The show was broadcast on New York public-access cable. Basquiat appeared in nine episodes between 1979 and 1982. Other guests included David Bowie, David Byrne, the B-52s, Chris Burden, George Clinton, Iggy Pop, Mick Jones, John Lurie, Klaus Nomi, Kraftwerk, the Screamers, Robert Mapplethorpe, Kid Creole, the Offs, and the Brides of Funkenstein. Glenn O'Brien, "Glenn O'Brien's TV Party," *VICE,* November 14, 2014, https://www.vice.com/en_us/article/3b7en8/the-story-of-glenn-obriens-tv-party-151. See also Lotte Johnson, "Chronology," in *Basquiat: Boom for Real,* exh. cat. (London: Barbican Centre, 2017), 270.

16. "A Dialogue between Diego Cortez and Glenn O'Brien, in *Jean-Michel Basquiat 1981: The Studio of the Street,* exh. cat. (New York: Deitch Projects, 2007), 14. Basquiat referenced the show in several *TV Party* posters from 1981 as well.

17. Portraits of both Toxic and Rammellzee appear alongside the artist's in the paintings *Hollywood Africans* (1983) and *Hollywood Africans in Front of the Chinese Theater with Footprints of Movie Stars* (1983).

18. Dawson joined in May or June, followed by Wayne Clifford soon after. Michael Holman, email to the author, November 11, 2019.

19. See Eleanor Nairne, "Postcards, 1979," in *Basquiat: Boom for Real*, 106.

20. The exact date of this meeting is unconfirmed.

21. "Art from Subways to SoHo: Jean-Michel Basquiat," interview by Henry Geldzahler, *Interview*, January 1983. See page 32 of this volume.

22. Alexis Adler, "East 12th Street," in *Basquiat before Basquiat: East 12th Street 1979–1980*, exh. cat. (Denver: Museum of Contemporary Art, 2017), 15.

23. Patricia Field, quoted in Karyn J. Truesdale and Aldo Araujo, "The Genius That Is . . . Patricia Field," *CFDA Newsletter*, November 1, 2018, https://cfda.com/news/the-genius-that-ispatricia-field.

24. Hoban, *Basquiat*, 49.

25. The night was part of a series of performances hosted at Schloss's loft known as "Wednesdays at A's." Basquiat performed there a month before Test Pattern as part of the SAMO IS DEAD jazz band as well (plate 1). See Johnson, "Chronology," 270. Other bands that played at Hurrah's included the Cure, the B-52s, the Slits, New Order, and Klaus Nomi.

26. Nicholas Taylor, interview by Glenn O'Brien, "Gray: Michael Holman and Nicholas Taylor on Gray and Jean-Michel Basquiat," *Chronicle* 1, no. 2 (2014), https://www.tsovet.com/chronicle/vol-1-issue-2/gray.

27. Holman, email to the author, November 11, 2019.

28. See also Richard Goldstein, "The First Radical Art Show of the '80s," *Village Voice*, June 16, 1980, 1, 31–32; and Susana Sedgwick, "Times Square Show," *East Village Eye*, Summer 1980, 21. In 2012 Shawna Cooper and Karli Wurzelbacher organized an exhibition, *The Times Square Show Revisited*, for the Hunter College Art Galleries in New York City (September 14–December 8, 2012), accessed January 7, 2019, www.timessquareshowrevisited.com/exhibition.html.

29. Jeffrey Deitch, "Report from Times Square," *Art in America*, September 1980, 58–63.

30. Richard Flood, "The First Radical Art Show of the '80s," *Village Voice*, June 16, 1980, 32.

31. Franklin Sirmans, "Chronology," *Jean-Michel Basquiat 1981*, 242.

32. Hoban, *Basquiat*, 207. See also O'Brien, "Dozens of Rambling Red Roses," 33.

33. Glenn O'Brien, "Graffiti '80: The State of the Outlaw Art," *High Times*, June 1980, 53–54.

34. The bar was located at 92 Second Avenue at Fifth Street.

35. Mallouk does not recall the exact date of their meeting but notes that "he was homeless so moved in after knowing me about 2 weeks." Mallouk, email to the author, November 12, 2019. In *Widow Basquiat*, Mallouk writes, "I had only known Jean for a few days when I let him move into my apartment." See Jennifer Clement, *Widow Basquiat: A Memoir* (Shearsman Books, 2010), 28. Basquiat's move into Mallouk's apartment took place sometime in January 1981, so they may have met anytime after mid-December.

36. For further details on this show, including a reproduction of the original installation at PS1, see Lotte Johnson, "New York/New Wave," in *Basquiat: Boom for Real*, 66–67, 72–97.

37. For reviews of the show, see Peter Schjeldahl, "New Wave, No Fun," *Village Voice*, March 4, 1981, 69; John Perrault, "Low Tide," *SoHo News*, February 25, 1981, 49.

38. Hoban, 69. Amount later corrected by Bruno Bischofberger. Bischofberger, email message to the author, May 8, 2020.

39. "Michael Holman Speaks Music," in *Jean-Michel Basquiat 1981*, 105.

40. "Michael Holman Speaks Music," 107. This final performance was after Gray had disbanded. Gallo did not play this reunion gig. Holman, email to the author, November 11, 2019.

41. Mallouk moved out in June 1982. Mallouk, email to the author, November 12, 2019.

42. Hunter Drohojowska, "Schnabel and Basquiat: Explosions in Chaos," *Los Angeles Weekly*, April 23–29, 1982. See page 108 of this volume.

43. Interview with Isabelle Graw. See page 63 of this volume.

44. Frederick Ted Castle wrote of meeting Basquiat, along with Mazzoli and Nosei, during this trip to Modena. See page 216 of this volume.

45. Cathleen McGuigan, "New Art, New Money," *New York Times Magazine,* February 10, 1985. See page 119 of this volume.

46. Hoban, *Basquiat,* 113–15.

47. Eric Fretz, *Jean-Michel Basquiat: A Biography* (Santa Barbara, CA: Greenwood, 2010), 94.

48. Warhol, "Monday, October 4, 1982," in *The Andy Warhol Diaries,* ed. Pat Hackett (New York: Warner Books, 1989), 462.

49. "Monday, October 4, 1982," in *Andy Warhol Diaries,* 462.

50. Magnus Bischofberger, *Prehistory to the Future, Highlights from the Bischofberger Collection* (Milan: Electa, 2008), 264.

51. The exact date of the VanDerZee shoot is unknown, but it likely took place in the late fall of 1982. Diego Cortez, email to the author, November 11, 2019.

52. Diego Cortez, interview by Thierry Somers, *200% Magazine,* December 17, 2017, https://200-percent.com/jean-michel-basquiat-diego-cortez-interview/.

53. Cortez, interview by Thierry Somers.

54. "Art: From Subways to SoHo," interview by Henry Geldzahler.

55. Letter from Bill Stelling to Richard Marshall, November 22, 1991, Richard Marshall's uncatalogued papers, Archives, Whitney Museum of American Art, New York. Cited in Eleanor Nairne, "Performance of Jean-Michel Basquiat," in *Basquiat: Boom for Real,* 25.

56. Nicolas A. Moufarrege, "East Village," *Flash Art,* no. 111 (March 1983): 36–41.

57. See Jeanne Silverthorne, "The Pressure to Paint, Marlborough Gallery," *Artforum,* Summer 1982, 67–68. At this time, the term *Neo-Expressionism* was applied to paintings that privileged figuration, bold application of color, and an expressive, gestural painting style. For many critics, the emergence of the style in both Europe and the United States signaled a radical shift away from earlier movements (e.g., Minimal and Conceptual art) that had rejected painting as a medium.

58. The prints were published in 1983. Works included in the edition are *Tuxedo, Untitled, Back of the Neck, Untitled: From Leonardo, Leg of a Dog,* and *Academic Study of the Male Torso.* See also Fred Hoffman, *The Art of Jean-Michel Basquiat* (New York: Enrico Navarra Gallery, 2017).

59. Fred Brathwaite (a.k.a. Fab 5 Freddy), "Wild Style," in *Art in the Streets,* exh. cat. (Los Angeles: Museum of Contemporary Art, 2011), 51.

60. Brathwaite, quoted in Ingrid Sischy, "Jean-Michel Basquiat as Told by Fred Brathwaite, a.k.a. Fab 5 Freddy," *Interview,* October 1992, 119–23.

61. According to the artist's father, Jean-Michel also listened to classical music and left behind a collection of approximately one hundred albums. See "Gerard Basquiat in His Own Words," *Jean-Michel Basquiat 1981: The Studio of the Street,* 90. For more on Basquiat's relationship to jazz music, see Saggese, *Reading Basquiat,* 60–108.

62. "Biography," in *Jean-Michel Basquiat Paintings,* vol. 2, 3rd ed. (New York: Enrico Navarra Gallery, 2000), 280.

63. Lexi Manatakis, "Unseen Photos of Jean-Michel Basquiat Wearing Issey Miyake in the 80s," *Dazed,* November 27, 2018, https://www.dazeddigital.com/art-photography/article/42352/1/unseen-photos-jean-michel-basquiat-in-issey-miyake-1983-yutaka-sakano.

64. Hoban, *Basquiat,* 216. See also "Bruno Bischofberger Speaks with Dieter Buchhart," in *Menage à Trois: Warhol, Basquiat, Clemente,* exh. cat. (Bonn: Art and Exhibition Hall of the Federal Republic of Germany, 2012), 45. A month before Bischofberger's proposal, *Kunstforum International* had published a special issue on collaborative works. See Dieter Buchhart, "Collaborations as a Physical Conversation between Respect and Difference," in *Menage à Trois,* 122.

65. "Friday, August 26, 1983," in *Andy Warhol Diaries,* 524.

66. "Wednesday, October 5, 1983," "Saturday, October 8, 1983," and "Tuesday, October 18, 1983," in *Andy Warhol Diaries,* 533–35.

67. *Written Imagery Unleashed in the Twentieth Century,* Fine Arts Museum of Long Island, November 6, 1983–January 22, 1984; *Haitian Artists,* Brooklyn Museum of Art, November 6, 1983–December 4, 1983. A comprehensive list of all group shows including the work of Basquiat can be found in *Jean-Michel Basquiat Paintings,* vol. 2, 3rd ed. (New York: Enrico Navarra Gallery, 2010), 294–98.

68. Tobias Mueller, "Chronology," in *Basquiat,* exh. cat. (Trieste, Italy: Museo Revoltella, 1999), 201. The location of the studio is also confirmed in M. Franklin Sirmans, "Chronology," in *Jean-Michel Basquiat,* exh. cat. (New York: Whitney Museum of American Art, 1992), 244.

69. Hoban, *Basquiat,* 165.

70. The final report, issued on November 2, stated that Stewart died of "physical injury to the spinal cord in the upper neck" but cautioned that there were "a number of possibilities as to how an injury of this type can occur." Sam Roberts, "Injury Reported in Death of Man after His Arrest," *New York Times,* November 3, 1983, https://www.nytimes.com/1983/11/03/nyregion/injury-reported-in-death-of-man-after-his-arrest.html.

71. During the five-month trial of the officers involved in the arrest of Michael Stewart at the New York Supreme Court, witnesses testified to the beating and kicking of Stewart by officers, but experts could not agree on the ultimate cause of death, and the six officers were acquitted by an all-white jury in November 1984.

72. Paige Powell, quoted in Hayley Maitland, "American Graffiti: Memories of Jean-Michel Basquiat," *Vogue UK,* September 20, 2017, https://www.vogue.co.uk/article/jean-michel-basquiat-barbican-exhibition-boom-for-real-interviews.

73. After being forced to leave the former German Democratic Republic, Penck was enthusiastically welcomed by the New York art market and easily capitalized on the sudden fervor for Neo-Expressionist art. In New York he also came into contact with artists like Haring and Basquiat, who, according to Ferran Barenblit, clearly inspired a shift in Penck's own painting toward more dynamic compositions and the incorporation of non-European iconography. The 1981 *Triptych for Basquiat* is an example of this new style. See https://coleccion.caixaforum.com/en/obra/-/obra/ACF0211/TriptychforBasquiat, accessed November 2, 2019.

74. Nicolas A. Moufaregge, "Jean-Michel Basquiat, Boone/Werner," *Flash Art* 119 (November 1984): 41.

75. Kate Linker, "Jean-Michel Basquiat," *Artforum* 23, no. 2 (October 1984): 91. See page 117 of this volume.

76. Max Weschler, "Collaborations, Gallery Bruno Bischofberger," *Artforum* 23 (February 1985): 99. It is worth noting here that synthesis is not the intended result of exquisite corpse drawings. The Surrealists used the collaborative game to create absurd (or even grotesque) works.

77. Although we do not definitively know when Basquiat acquired Thompson's book, we do see references to it in paintings from 1983 and 1984. For example, the monumental painting *Flesh and Spirit* (1983) may have been directly inspired by Thompson's text, and art historian Kellie Jones has discussed the connections of Thompson's book to paintings like *Grillo* (1984). See Jones's essay "Lost in Translation: Jean-Michel in the (Re)Mix" on page 300 of this volume. There are many other examples of smaller appropriations from *Flash of the Spirit.* See *Reading Basquiat,* 42–43.

78. Basquiat, interview by Becky Johnston and Tamra Davis, 1985. See page 49 of this volume.

79. It is believed that while working on the triple collaborations together with Clemente, earlier that year, Basquiat realized that Warhol was a fantastic painter and that his hand painting was still as good as in his early years. He intended to convince the older artist to start painting by hand again. Bischofberger, *Prehistory to the Future,* 265.

80. The nightclub, open from 1983 to 1987, was perhaps most well-known for its celebration of constantly changing themes like *confinement, suburbia,* and *science fiction.* Each theme lasted for six weeks and was accompanied by elaborate art installations that could cost as much as $60,000. Basquiat's own work would be included in the *art* theme in May 1985. See also Jesse Kornbluth, "Inside Area," *New York Magazine,* March 11, 1985, 33–41.

81. "Thursday, March 28, 1985" and "April 8, 1985" in *Andy Warhol Diaries*, 636, 641.

82. Bruno Bischofberger, email to the author, May 8, 2020.

83. "September 13, 1985," in *Andy Warhol Diaries*, 677.

84. Vivienne Raynor, "Art: Basquiat, Warhol," *New York Times*, September 20, 1985. See page 138 of this volume.

85. Robert Mahoney, "Review of Andy Warhol/Jean-Michel Basquiat at Tony Shafrazi Gallery," *Arts Magazine* 60 (November 1985): 135. See page 139 of this volume.

86. "October 14, 1985," in *Andy Warhol Diaries*, 685.

87. See https://paddle8.com/work/jean-michel-basquiat/23839-Untitled/, accessed November 3, 2020.

88. Fretz, 151.

89. Bischofberger briefly discusses this trip and Basquiat's experience of Africa in the interview published on pages 164–70 of this volume.

90. Hoban, *Basquiat*, 282.

91. Basquiat, interview by Becky Johnston and Tamra Davis, 1985.

92. Victor Bockris explored the relationship between the two artistic bohemias—the Beats in the 1950s and the punks in the 1970s—in his book *Beat Punks* (New York: Da Capo Press, 2005).

93. Klaus Kertess, "Brushes with Beatitude," in *Jean-Michel Basquiat*, exh. cat. (New York: Whitney Museum of American Art, in association with Harry N. Abrams, 1992), 53.

94. Hoban, *Basquiat*, 283.

95. Anthony Haden-Guest, "Burning Out," *Vanity Fair*, November 1988, 192.

96. According to Jean Frémont, director of Galerie Lelong & Co:

After the summer I had a meeting with Bruno at Jean Michel's studio in New York. I remember it was raining a lot and Jean Michel was not at home. He finally came very late, bare feet, in the rain pushing his bike and he said he had a flat tire. He let us in and went up for a long time. He had prepared tacos and we had lunch in the studio. This is when he said that he had agreed to give a last show to Tony Shafrazi. Bruno reminded him that it [w]as against our agreement and that it was decided that the next show should be at Lelong on 57th street. And that showing uptown was part of the strategy we had all agreed on. . . . He then said: "This (meaning the show at Shafrazi) will be my swan's song to Soho." Then we started to look at paintings. There was one painting unfinished on the floor. He poured white paint on it in front of us and covered the whole surface in white, saying it was not good. Then he pulled two paintings from the racks and said, "You can have these." The next day I sent someone to take the paintings and that is the only two paintings we ever had. [. . .] But I am sure that at the date of that meeting in New York we had already paid the agreed amount every month. I think it was 6000$ each.

Jean Frémont, email message to Silvia Sokalski, January 9, 2020. Thank you to Silvia for sharing this message with me.

97. Although this is unconfirmed, Basquiat may have also walked in the Comme des Garçons show in 1985. See "Sunday, December 8, 1985," in *Andy Warhol Diaries*, 699.

98. Basquiat, interviewed by Démosthènes Davvetas, 1988. See page 61 of this volume. Basquiat does mention Jacob Lawrence in his interview with Geoffrey Dunlop and Sandy Nairne. See page 41 of this volume.

99. Basquiat, interviewed by Isabelle Graw, 1986. See page 63 of this volume.

100. The collaborations as such had their first comprehensive museum exhibition only in 1996, at the Fridericianum, Kassell; the exhibition traveled to the Museum Villa Stuck, Munich, and the Castello di Rivoli, Turin. In 2002 another big show of the collaboration paintings took place at the Museo Nacional Centro de Arte Reina Sofia, Madrid. After 2011 several other museums dedicated exhibitions to the collaborative works.

101. Hoban, *Basquiat*, 302.

102. The tickets were originally booked for August 7, but Basquiat rescheduled the trip for August 18. Hoban, 307.

103. Hoban, 311.

104. John Lurie, interview by Taka Kawachi, *King for a Decade: Jean-Michel Basquiat* (Kyoto: Korinsha Press, 1997), 41.

ILLUSTRATION CREDITS

FIGURES

PLATES (following page 180)

All works of art in the color plate section by Jean-Michel Basquiat, © The Estate of
Jean-Michel Basquiat/Licensed by Artestar, New York.

10. *Philistines,* 1982. Acrylic and oil stick on canvas, 72 × 123 in. Collection of Irma and Norman Braman.

11. *Self-Portrait as a Heel, Part Two,* 1982. Acrylic and oil stick on canvas, 96 × 61⅖ in. Private collection.

12. *Self-Portrait with Suzanne,* 1982. Oil stick on paper, 60 × 40 in. Courtesy The Brant Foundation, Greenwich, CT.

13. *Untitled (Sugar Ray Robinson),* 1982. Acrylic and oil stick on canvas, 42 × 42 × 5 in. Courtesy The Brant Foundation, Greenwich, CT.

14. *Untitled (Picasso Poster),* 1983. Acrylic on exhibition poster, 28 × 19¼ inches. Mugrabi Collection.

15. *Eyes and Eggs,* 1983. Acrylic, oil stick, and collage on cotton. Two panels, 119 × 97 in. The Eli and Edythe L. Broad Collection, Los Angeles.

16. *Boone,* 1983. Collage on paper; marker and oil crayon on Masonite on wood, 41 × 12 in. Private collection, Switzerland.

17. *Discography,* 1983. Acrylic and oil stick on canvas, 66⅛ × 59⅞ in. Private collection, Courtesy Galerie Bruno Bischofberger, Switzerland.

18. *Discography (Two),* 1983. Acrylic and oil stick on canvas, 66 × 60 in. Private collection, Courtesy Galerie Bruno Bischofberger, Switzerland.

19. *Hollywood Africans,* 1983. Acrylic and oil stick on canvas, 84 × 84 in. Whitney Museum of American Art, New York.

20. *Hollywood Africans in Front of the Chinese Theater with Footprints of Movie Stars,* 1983. Acrylic and oil stick on canvas mounted on wood supports, 35½ × 81½ in.

21. *Television and Cruelty to Animals,* 1983. Acrylic and oil stick on paper mounted on canvas with tied wood supports, 60 × 60 in. Private collection.

22. *The Death of Michael Stewart (Defacement),* 1983. Acrylic and marker on sheet rock, 25 x 30 in. (63.5 x 77.5 cm). Collection of Nina Clemente, New York.

23. *Undiscovered Genius,* 1983. Acrylic, charcoal, crayon, pastel, and pencil on paper, 22½ × 30 in. The Daros Collection, Switzerland.

24. *Undiscovered Genius of the Mississippi Delta,* 1983. Acrylic, oil stick, and paper collage on five joined canvases, 49 × 185½ in. Private collection.

25. *The Nile (El Gran Espectaculo),* 1983. Acrylic and oil stick on canvas mounted on wood supports, three panels, 68 × 141 in. overall. Private collection.

26. Jean-Michel Basquiat and Andy Warhol, *Untitled (Arm & Hammer II),* 1984. Acrylic, oil stick, and silkscreen on canvas, 65¾ × 112¼ in. Guarded by Bischofberger, Männedorf-Zurich, Switzerland. © The Estate of Jean-Michel Basquiat. Licensed by Artestar, New York. © 2019 The Andy Warhol Foundation for the Visual Arts, Inc./ Artists Rights Society (ARS), New York.

27. *Gold Griot,* 1984. Acrylic and oil stick on wood, 117 × 73 in. The Eli and Edythe L. Broad Collection, Los Angeles.

28. *Gri Gri,* 1986. Acrylic on canvas, 70 × 56 in. Private collection.

29. *To Repel Ghosts,* 1986. Acrylic on wood, 44 × 32⅗ × 4 in. (112 × 83 × 10 cm). Collection of Pierre Cornette de Saint Cyr.

30. *Despues de un Puño,* 1987. Acrylic, oil stick, and photocopy collage on canvas, 85 × 61 in. Private collection.

31. *Pegasus,* 1987. Acrylic, graphite, and colored pencil on paper mounted on canvas, 88 × 90 in. Private collection.

32. *Riddle Me This, Batman,* 1987. Acrylic and oil stick on canvas, 117 × 114⅕ in. (297 × 290 cm). Collection of Amalia Dayan and Adam Lindemann.

33. *Untitled,* 1987. Acrylic and oil stick on canvas, 47 × 41 in. Collection of Andrew L. Terner, New York, São Paulo. Photo: Courtesy Solomon R. Guggenheim Museum, New York.

34. *Exu,* 1988. Acrylic and oil stick on canvas, 79 × 100 in. Private collection.

35. *Riding with Death,* 1988. Acrylic and oil stick on linen, 98 × 114 in. Collection of Francesco Pellizzi.

INDEX

Exhibitions are listed by venue (exception: *Times Square Show*). Page numbers in *italics* denote illustrations.

police brutality: and Black activism of the 1960s, 5; Brazilian police, 65; interracial marriages and harassment by police, 321; and Michael Stewart's death, 65, 348–49, 365nn70–71. *See also* violence

politics: childhood context of, 5; critical reception of, 138; as theme in Basquiat's works, 5, 6, 11n24, 48, 105–6, 203–4, 275

Pollock, Jackson: Basquiat work appearing alongside, 348; as casualty, 229; referenced by critics, 94, 111, 119, 132, 150, 244–45n7, 254; and working process, photos of, 176

Pontalis, J.B., 279, 293

Ponti, Lisa Licitra, interview with Basquiat (1983), 13, 39–40

Pop Art: and "Anti-Product Baseball Cards," 333; Basquiat and, 278, 292; and consumerism, 289–90; graffiti-art as, 104, 105; race ideology of, 278–79, 292; referenced by Basquiat, 41, 278; and rejection of painting, 233; and the superhero/comic genre as disidentification, 284–86

Popeye, 198, 286, 311

popular culture and popularity of Basquiat: and artists as celebrities, 93, 95n4; and attendance at retrospectives, 7, 11nn28–29; canonization and, 199; vs. critical backlash against Basquiat's early commercial success, 177–78, 192; and danger of overexposure, 192; social media and, 178, 199

Portrait of the Artist as a Young Derelict (1982), 312

Portrait of VRKS (1982), 342

postcards ("Anti-Product Baseball Cards," Basquiat and Stein, 1979): as collaboration, 333; and Geldzahler, attempted sale to, 32–33, 125, 217, 244n6, 333, 363n20; production of, 333; sales outside art museums, 333; survival as motivating, 61; Warhol purchase of, 125, 217, 244n6, 333, 340, 363n20

Post-modernism, 108, 109

Poussin, Nicholas, 210

Powell, Paige, 349; 1983 show at apartment of, 347

PPCD (1982–83 drawing), 179

Pray (graffitist), 98

prices for Basquiat works: overview, 165; 1992, 263; 2016, 10n3; 2017, as record setting, 1, 9–10nn1,4–5, 177; as focus of critical backlash due to early commercial success, 93–94, 109, 115–16, 119–21, 126–27, 177, 211, 212–13; Kellie Jones on private ownership due to, 300–301; obituaries mentioning, 201, 205. *See also* art market; auctions

the primitive: and Black artists as Other, 275; modernist antipathy to, 307–8; the pre-modern and, 287–88; primitivism distinguished from primitive artists, 249, 252n1; success in graffiti-art critiqued as appropriation of myths around, 93, 191. *See also* primitive mythology about Basquiat; primitivism in Modernism

primitive mythology about Basquiat: the 1985 *New York Times Magazine* cover and, 3–4; ambivalent relationship of Basquiat to, 4; Basquiat as playing along with, 206, 274–75, 301–2; Basquiat interviews discussing, 13, 15, 21, 54; Basquiat works as challenging, 203, 238–39, 250; critical claims to questioning of, 238, 269; critical reception and, 94, 113, 114, 115–16, 142, 210–11, 214–15; critical reception as ironic inversion of modernist primitivism, and of taking on the role of the white borrower, 249–52, 254; critiqued as exploitation, 93; as devastating to Basquiat, 185; as erasing Basquiat's authentic link to primitive traditions, 254; and the mask motif, 3, 4, 125, 214–15. *See also* mythologies about Basquiat

primitivism in Modernism: appropriation of otherness and, 4; critical reception of Basquiat as ironic

inversion of, and taking on the role of the white borrower, 249–52, 254; and exclusion of artists of African descent, 4; ironic version of the 1950s, 252n2; obsession with, 3–4, 10–11n20; primitive artists distinguished from, 249, 252n1; *"Primitivism" in 20th Century Art: Affinities of the Tribal and the Modern*, MOMA (1984–85), 3–4, 10n17, 252n1; racist hierarchies as reinforced by, 4, 271; vs. Afro-Atlantic engagement with African references, 131–32

prints, 169–70; *Anatomy* (1982), 343; Hoffman/New City Editions (1983), 343, 364n58

Pritchard, Norman H.: compared with Basquiat, 197, 323–26. Works: "C," 326; *Destinations: Four Contemporary American Poets* (1965 compilation album), 324; *Eecchhooeess* (1971), 324; "Gyre's Galax," 324–26; *The Matrix: Poems, 1960–1970* (1970), 323–24; *New Jazz Poets* (1967 compilation album), 324–26

private property, 317–18

Profit I (1982), 339

P.S.1, 1981 *New York/New Wave* exhibition: overview, 335–36; Barbican retrospective re-creating Basquiat's wall from, 189; Basquiat in, 93, 122, 189, 206, 245n11, 335–36, *336*; Diego Cortez and, 53, 93, 122, 166, 186–87, 189; critical reception of, 211, 336; gallerist reception of, 337, 338; as group exhibition, 97; as inflection point, 61

P.S. Gallery (Tokyo), 1987 exhibition, 358

public-access television, 362n15

Public Enemy, 237

public television, 330, 346

Puerto Rico: childhood relocation to, 305, 330; family of Basquiat's mother originating in, 307, 329; references of interviewers to, 22; travel of Basquiat to, 330, 362n7

punk rock, 161–62

Puryear, Martin, 210, 227–28

Quality Meats for the Public (1982), 255, 288

queer culture, and disidentification, 277, 282–84, 289, 292

queer theory: and the cartoon/superhero genre, 284; and cross-identification, 282–84

Quiñones, Lee, 151, 330, 333, 334, 335, 343, 348

racism and Basquiat: appearance/clothing as cultivated to challenge, 157; Basquiat interviews discussing, generally, 62, 322; club experiences of, 290; the content of the paintings and challenge to, 158, 224–25, 256–57, 274; and critical misinterpretation of his work as graffiti, 3, 54; daily experience of, 157; disidentification and, 279, 284–86, 287–88, 289, 291, 292–96, 298n39, 310; and inquiries about working in the basement at the Annina Nosei gallery, 26; interviews and, 185; restaurants refusing service, 157; taxis refusing service, 63, 157, 185. *See also* racism and the art world

racism and the art world: overview as bastion of white supremacy, 221–24, 230, 296n1; Basquiat interviews discussing, 45, 54, 322; and Black crossover acts, 221–22; as burden, 322; buyers refusing to consider Basquiat's work, 185; as coded, 191; erasure of, and ability to see Basquiat's works, 261, 275; lack of Black representation and, 265; and lack of institutional support for African American artists, 227–28, 266–67; the modernist obsession with the primitive and reinforcement of racial hierarchies, 4, 271; in Pop Art, 278–79; in Warhol's works, 278–79; and white knowledge, vanishing point of, 221. *See also* critical backlash against Basquiat's early commercial success; mythologies about Basquiat; racism and Basquiat; white supremacy

women: as marginalized by the white-male dominated art world, 270. *See also* female, the

Wool, Christopher, 316

working process of Basquiat: overview, 126, 206–7; and Barbican retrospective showing film of Basquiat dancing, 175–76; Basquiat interviews discussing, 18–19, 24–31, 33–36, 47, 52, 54–55, 59–60, 63; and books, 125, 159, 168, 183–84; and collaboration with Warhol, 59–60, 138, 140–41, 351; and collaboration with Warhol and Clemente, 60, 126, 243–44n5; critical reception and descriptions of, 125; erasure in, 130, 131, 223, 240, 306; fear of gimmickry and, 158; on the floor, 122, 167, 184, 208; Cathleen McGuigan on, 124–25; moving from drawings to paintings, 188; multiple canvases at a time, 159, 167, 184, 187–88; and music, 129, 130, 159, 167, 183; photocopied drawings, 159, 187, 238; television and, 24, 54, 129–30, 131, 158, 159; Robert Farris Thompson on, 129–31. *See also* destruction of his works by Basquiat

WPA restaurant, 333

Wright, Jeffrey, 314n34

Wurzelbacher, Karli, 363n28

Young, Lester, 160

Zenith (Basquiat and Warhol) (1985), 139

Zephyr (graffitist), 98

Žižek, Slavoj, 280

Zulu Lounge, 183

Zydeco (1984), 351

Founded in 1893,
UNIVERSITY OF CALIFORNIA PRESS
publishes bold, progressive books and journals
on topics in the arts, humanities, social sciences,
and natural sciences—with a focus on social
justice issues—that inspire thought and action
among readers worldwide.

The UC PRESS FOUNDATION
raises funds to uphold the press's vital role
as an independent, nonprofit publisher, and
receives philanthropic support from a wide
range of individuals and institutions—and from
committed readers like you. To learn more, visit
ucpress.edu/supportus.